Crown Jewellery

and Regalia of the World

René Brus

The Pepin Press
Amsterdam & Singapore

The Pepin Press BV
P.O. Box 10349
1001 EH Amsterdam
The Netherlands

Tel: + 31 20 420 20 21
Fax: + 31 20 420 11 52
mail@pepinpress.com
www.pepinpress.com

Text: René Brus
Cover design: Pepin van Roojen
Book layout: Maria da Gandra,
Maaike van Neck
Project coordination and editing:
Femke van Eijk

Every effort has been made to ensure
that all information and original names are
accurate. However, due to historical and
langual ambiguities inherent to the subject
matter, the author and editor are not in the
position to guarantee, with absolute certainty,
the historical information provided.

ISBN 978-90-5496-090-4

10 9 8 7 6 5 4 3 2 1
2016 15 14 13 12 11 10

Manufactured in Singapore

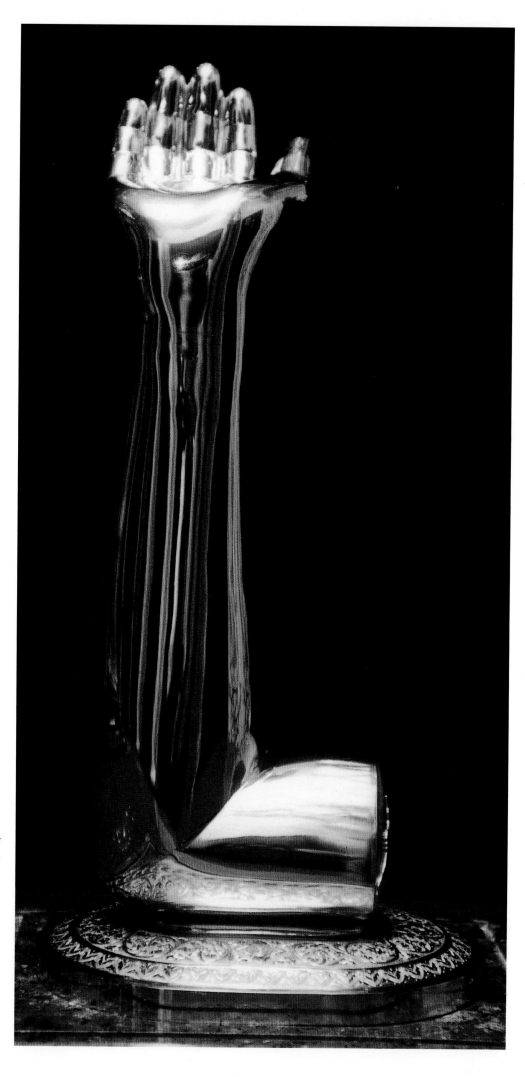

This golden arm is part of
the regalia of Brunei. This
object was placed under
the chin of the sultan
immediately after his
coronation, presumably
to carry the heavy
weight of the coronation
crown. Gold; date of
manufacture unknown.
Collection and
photo Royal Regalia
Museum, Bandar Seri
Begawan, Brunei

Contents

Preface

Who, as a child, did not pick up a pretty pebble, polished by the sea, and treasure it, hoping that it would be a precious stone? Hoping that this stone could tell the story of how nature had created it, and how it reached the different corners of the world. In my opinion, all minerals found on earth can be called precious stones, as they have been created by nature. The misleading term 'semi-precious' is used to make a distinction between the most precious and rare minerals, and the more common and less valuable ones, although these are no less beautiful. What is regarded today as a semi-precious stone has been precious in the past, as colour, shape, or even certain religious beliefs have made some minerals more important than others.

From the beginning of humankind, stones have been collected and offered to the gods, and have adorned the regalia of kings and emperors, who filled their treasure chests with items regarded as precious in their realm. Distinctions between precious and semi-precious, valuable, less valuable or even 'with no value' are often made when crowns and other emblems of sovereignty are discussed, especially when objects from different parts of the world are placed together. However, other aspects such as traditional, historical, religious and sentimental values are more important for many than the actual monetary value.

I witnessed the coronation of Queen Elizabeth II of England on television when I was just a few years old. This event, seeing images of royalty wearing glittering crowns and tiaras, and my passion for collecting minerals, led to my curiosity in the processes of making jewellery. I became a goldsmith at the end of the 1960s, which has been a fortunate choice. When I was first learning my profession, I was impressed by the skills of the unknown craftsmen of thousands of years ago who were able to create royal headdresses with less sophisticated tools than mine; modern goldsmiths have the comfort of today's electricity and natural gas. But I did not just admire their skills; I came to realise that the making of crowns and other emblems of power and sovereignty is not limited to the use of precious metals and stones; natural materials such as shells and feathers are also used.

In the early 1970s, I decided to leave home. With traveller's cheques tucked in my pocket I went on a journey to Ethiopia, which, according to the stories I had been told, was 'filled' with crowns. Ethiopia had been brought to my attention thanks to the state visit of Queen Juliana of The Netherlands and Prince Bernhard to this centuries-old monarchy.

I was informed by Her Majesty's secretarial office that Queen Juliana and Prince Bernhard had been shown crowns during their visit. My neighbour Jaap Jansen was a co-pilot and had flown the royal couple to Ethiopia and told me about the crowns. In January 1974, I arrived in Axum, the ancient capital of Ethiopia, with no clue on what to find or where to go. The next day I went to St Mary of Zion, the former coronation church. To my surprise the elderly caretaker trusted me enough to show me several, impressive – as I thought then – strangely shaped crowns in the small garden of St Mary of Zion. In 1974, I had to rely on my old traditional camera and rolls of film, and had no idea if the result would be to my satisfaction. Nowadays, digital cameras have fewer problems with tropical, humid, freezing cold or dry sandy climates. The development of my rolls of film could not take place for the next five months due to the revolution and the abolition of the Ethiopian monarchy. The border was closed and I could not leave the country. Back home my mother and others were more than eager to know what had happened to their crown-hunter, as I could not get in touch with them. All these obstacles vanished into thin air when I encountered the many friendly Ethiopians who helped me in my search for new crowns. I met Don and Geerteke Kroes, who gave me a 'Dutch shelter and food' for a couple of weeks. In the end I was able to locate, study and photograph no fewer than 175 Ethiopian crowns and the desire to search for more crowns in other faraway countries increased.

During my journeys, permission was granted to hold the crowns, tiaras and numerous other regalia and to study them closely. Often there was little objection to my trying to capture their splendour on film, although the cramped bank-vaults, crowded offices, or spacious throne rooms with attendants and armed guards required unusual solutions in making the pictures; it was not always easy to photograph the objects in these curious circumstances. My presence at the royal ceremonies was a dream come true from my youth. Not only was I able to observe the different installations, coronations, birthdays, marriages and funerals at close quarters, but I was also allowed to photograph these ceremonies, although there were moments when the use of a flashlight was not possible or was prohibited according to local traditions. The results were not always perfect, but keep in mind that these are records unlikely to be found anywhere else. My presence at these historical royal events provided me with the material to share my knowledge and experience through the publishing of this book.

When the publisher, Pepin van Roojen, agreed to publish a book on crowns and other regalia, we both realised how difficult it would be to select those objects and stories to be presented. I was aware that it is practically impossible to describe and illustrate all the crowns in the world and the various processes of creating them. So the idea of making a kind of encyclopaedia with all the countries in the world and its crowns was therefore abandoned: it was up to me to make a selection. First I selected some of the objects that I had been fortunate enough to see and study personally. However, there were many other objects to choose from, which I have not yet seen in person. This book is based on a personal journey, made to the best of my knowledge, and is an attempt to show that crowns can be found everywhere, in any form and design. We follow numerous crowns in royal ceremonies during childhood, weddings, coronations and funerals. This book shows that crowns can also be found in rituals in ordinary life, in times of war, in religion, in the performing arts and as gifts.

I would like to thank Femke van Eijk and Ros Horton who, during the process of making this book, showed great knowledge and patience in creating a stunning presentation. Further, I would like to express my appreciation to all who allowed me to share images for the publication of this book. To mention all the many owners, custodians, courtiers, officials, museum staffs, private collectors, jewellers, goldsmiths and other craftsmen is virtually impossible and hopefully no one will blame me if I do not mention them all by name and title. A big and sincere thank you to all of them should do, I hope. However, this project would have been much more difficult without: the great assistance of Dahan Yunus, who handled the jewels during the numerous photo-sessions; the moral and sometimes financial support of my colleagues Huub Broekarts, Loek Rozendal and Ineke Broekarts-van Lomwell; Maddy and Mark Stempels; the many times that Donald Tick and Hans Schnepper presented me with information on new and old objects; those who gave me 'shelter' during my 'crown-hunts'. Above all, I admire what my mother Antonia Gerritsen endured during her long life, as this book would not have been born without her.

René Brus

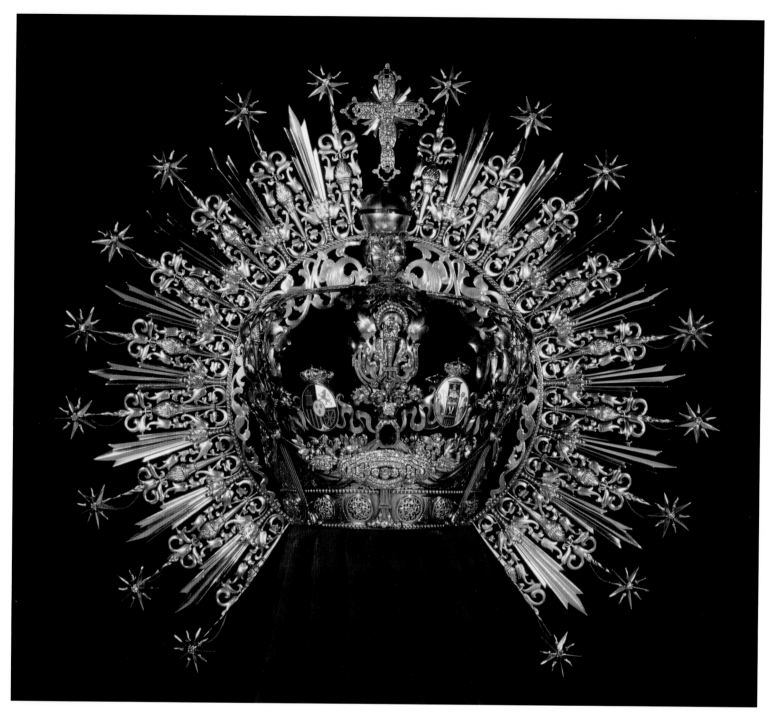

Crown of the Virgin
of the Macarena. This
crown and the statue
can be found in chapter
Crowns in religion, on
pages 318-319. Gold,
silver, diamonds,
emeralds, enamel; made
in 1913, altered in 1953
and 1963.
Collection La Basílica
de la Macarena,
Seville, Spain
Photo Hermandad de
la Esperanza Macarena,
Seville, Spain

Right:
Crown of Tsar Mikhail
Fyodorovich of Russia.
Gold, silver, pearls,
diamonds, emeralds,
rubies, sapphires,
enamel and sable fur;
made in 1627 by Kremlin
goldsmiths.
Collection The
Kremlin Armoury,
Moscow, Russia
Photo Russian
Embassy, The Hague,
the Netherlands

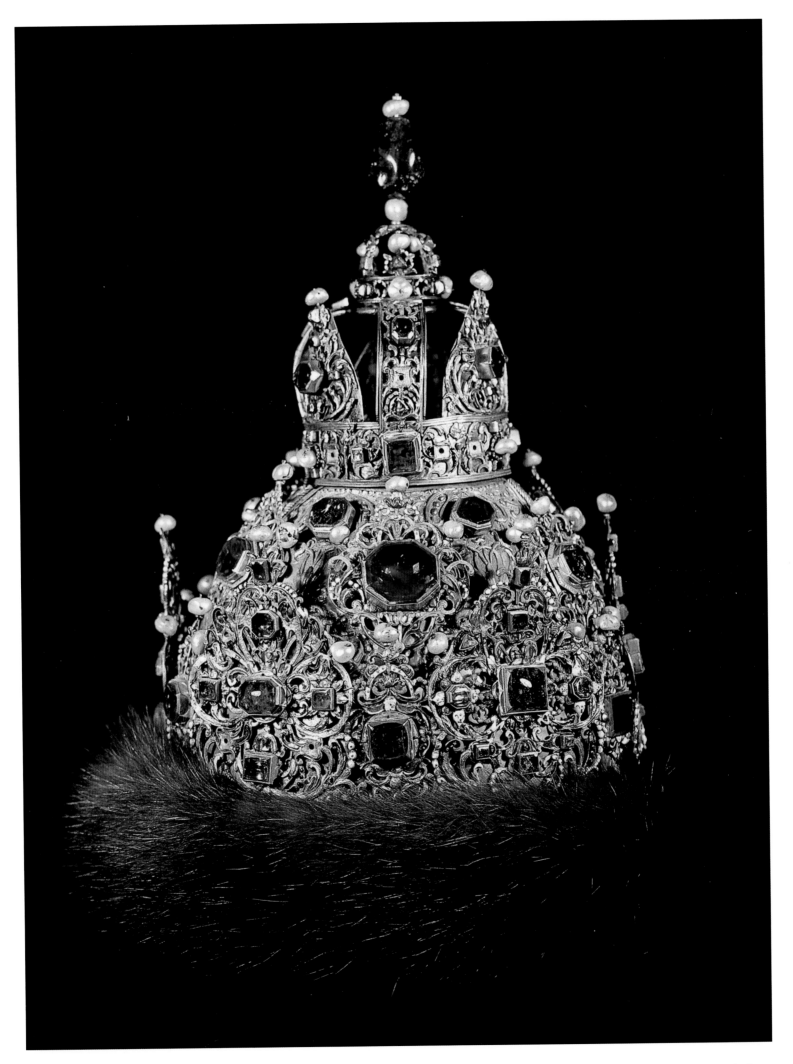

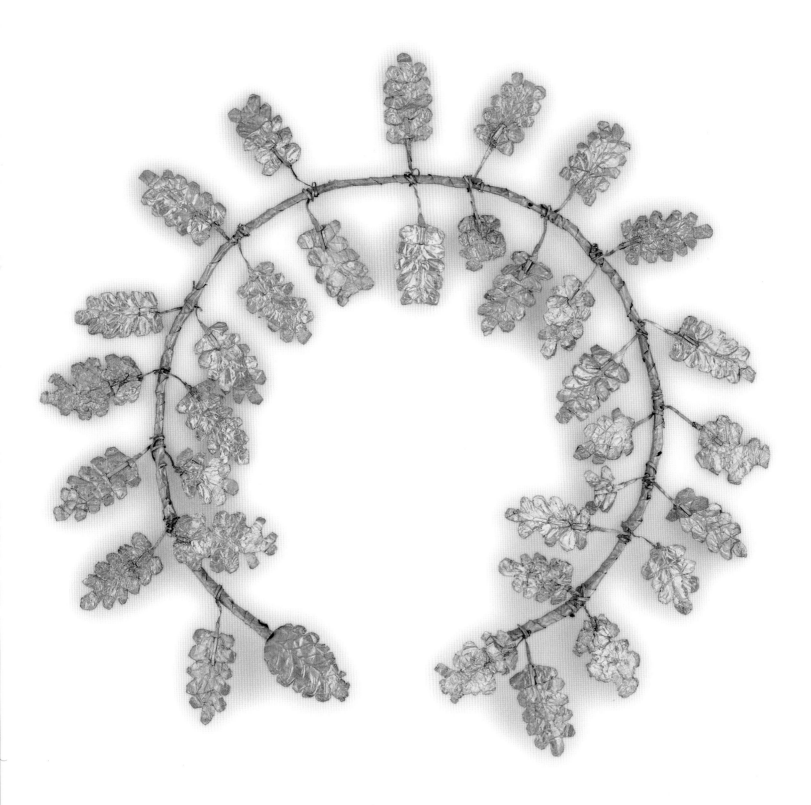

Wreath of oak leaves.
Gold; made in the
4th-3rd century BC.
Collection and photo
Benaki Museum,
Athens, Greece

The evolution of crowns

All over the world, crowns play an important role in society. They are found in proverbs and sayings, on coats of arms and coins, at festivities, as symbols of religious position and as signifiers of rank in the nobility and the monarchy. The origins of crowns are shrouded in mystery. Thousands of years ago, inherent human artistry must have inspired the creation of ceremonial head decorations using flowers, feathers, the teeth of powerful animals, shells and beads, some of the most ancient human adornments. These headdresses most likely came to symbolise rank in hierarchical societies, eventually being adopted by kings, priests and others to convey their worldly, spiritual or military position.

Words sometimes suggest the origins of things. The English word *crown* (French: *couronne*; German: *Krone*; Dutch: *kroon*) stems from the Latin *corona*. Originally this *corona* was a wreath made of twigs and flowers from trees and bushes consecrated to certain gods. What is regarded as a crown in Europe dates back to the ancient Greek *diademe*, which means band, hair band or headband. The modern diadem is generally a valuable gem-studded piece of jewellery, worn by noble and royal ladies in particular, and now more often called a *tiara*. This word originated in ancient Persia, where monarchs used to tie a band decorated with precious stones and pearls around a high hat, the *cidaris*.

The word *tiara* is also now the name for the papal triple crown. In many Islamic societies, the ceremonial headdresses of rulers are called *taj*, while in several south-east Asian Islamic countries, the words *mahkota* or *mahkuto* are also used. The origin of the latter is found in the Sanskrit term *kirita-mukuta*, which is generally translated as 'cylindrical crown', although the shape of the crown is implicit in neither the word *kirita* nor *mukuta* (matak, mukat or makut), for both words mean tiara, diadem or crown.

In a world with countless languages, dialects and cultures, it is nearly impossible to select a single word for this symbol of sovereignty. It is equally impossible for anyone to claim the right to know what kind of headdress is worthy of the name 'crown', as there are no exact rules as to how a crown should look. The various shapes of crowns depend on their country of origin. Some crowns owe their structure to practical considerations, such as protecting the wearer from the burning Sun or icy cold. The design might include figures or images that are significant to the wearer and his subjects, such as animals, heavenly bodies (Sun, Moon, stars) or religious symbols (cross, crescent). Whatever their shapes, colours and materials, all kinds of headdresses have evolved around the world to symbolise power and command respect for their wearers.

Diadem discovered in a woman's tomb in 1865 in Golfo di Sant'Eufemia, Italy. The centre depicts two Greek mythological figures. Gold; made between 340 and 330 BC by a goldsmith from Taranto, Italy.
Collection and photo British Museum, London

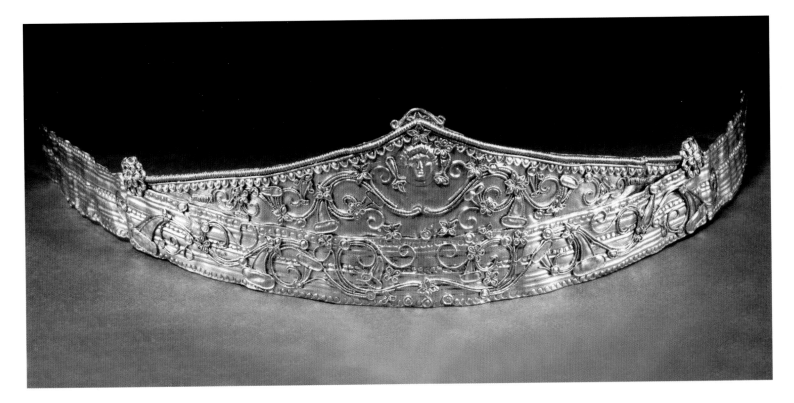

Wreaths

In nature, flowers and leaves appear with the seasons and most soon wither, making it impossible to wear wreaths made from particular leaves or flowers all year round. Over the course of time, craftsmen started making wreaths from metal, generally gold, imitating flowers and leaves. For the ancient Greeks, the laurel was sacred to the god Apollo, and was awarded to the victors of games and musical contests held in his honour. Roman Emperors adorned themselves with the laurel wreath as a symbol of triumph. History tells us that Julius Caesar refused to accept the laurel wreath three times before he was finally persuaded to become emperor. The fashion for wearing a wreath has continued through the centuries and today the designs of many tiaras find their origins in the beauty that grows in nature.

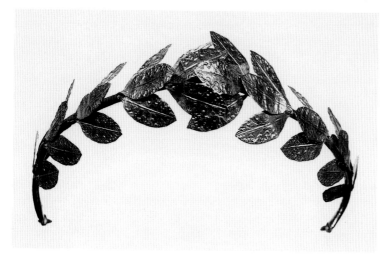

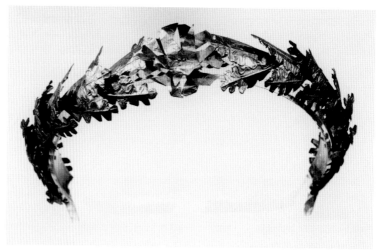

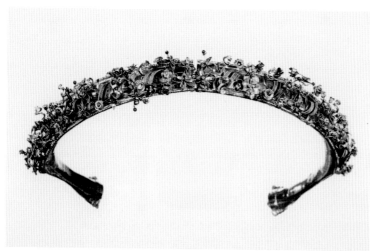

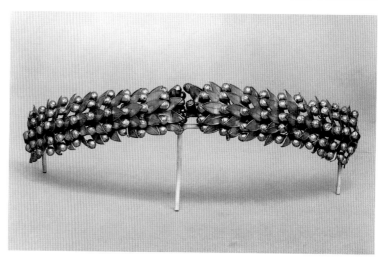

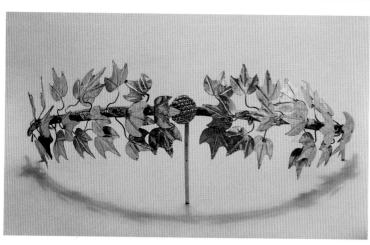

Top left:
Wreath used as a funeral ornament discovered in a tomb at Canosa, Italy. Made 3rd century AD.
Collection and photo Museo Nazionale, Taranto, Italy

Middle left:
Wreath formed of berries, leaves and flowers. Gold, garnet and enamel; made 3rd century BC, Ancient Greek-Tarentum.
Collection and photo National Museum, Taranto, Italy

Bottom left:
Gold ivy wreath.
Etruscan; 3rd century BC.
Collection and photo British Museum, London

Top right:
Laurel wreath with a central rosette. Gold; made 3rd century BC, Ancient Greek-Tarentum.
Collection and photo National Museum, Taranto, Italy

Bottom right:
Gold myrrh wreath.
Etruscan; 5th century BC.
Collection and photo British Museum, London

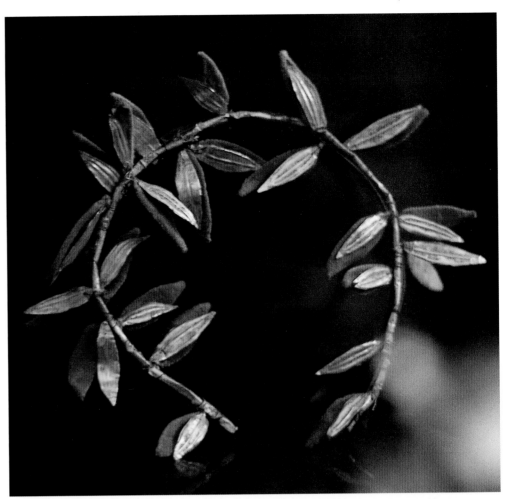

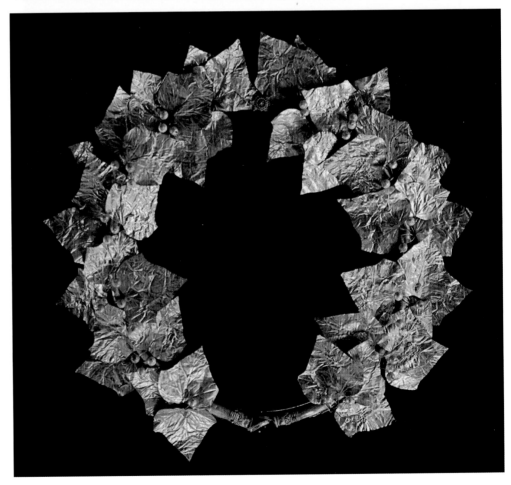

Top left:
29.5.1868; King Oscar II of Sweden. At several Swedish universities, the students wear wreaths made from laurel leaves when they receive their diploma. King Oscar II wore such a wreath when the University of Lund granted him the title of *Doctor honoris causa* (honorary degree).
Photo collection Lund University Library, Lund, Sweden

Bottom left:
Circa 1922; Princess Mary of England, the Princess Royal, wearing a diamond-studded laurel wreath.
Photo collection René Brus

Top right:
Gold laurel wreath. 3rd or 2nd century BC.
Collection National Archaelogical Museum, Athens, Greece
Photo René Brus

Bottom right:
Wreath of oak leaves and flowers. At the centre is a rosette with a repoussé representation of an owl. Gold. Made late 2nd-early 1st century BC.
Collection and photo Benaki Museum, Athens, Greece

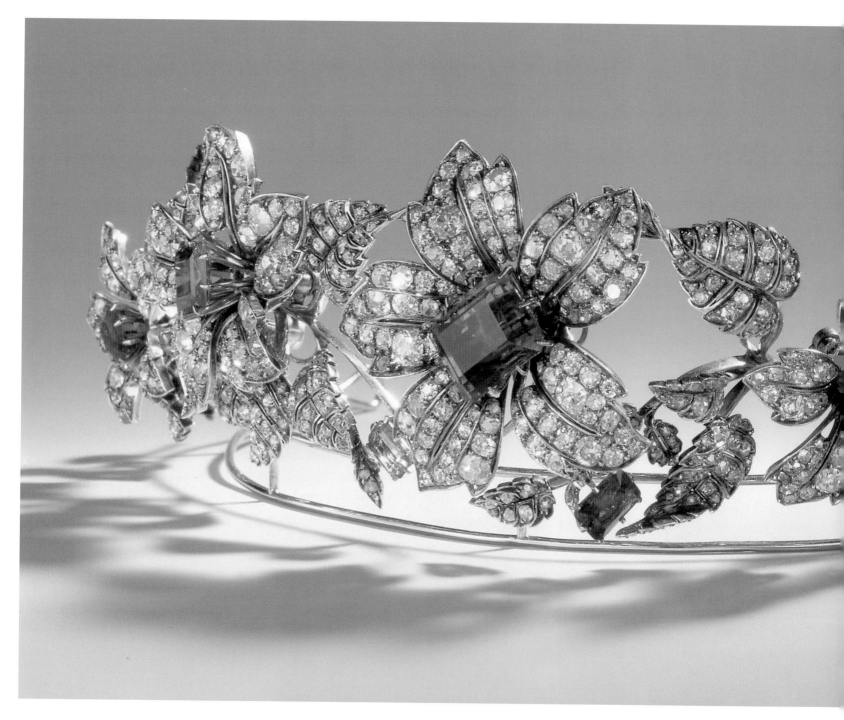

Above:
Tiara of Queen María Cristina of Spain. Gold, silver, diamonds and emeralds; made second half of the 19th century.
Privately owned
Photo Sotheby's, Geneva, Switzerland

Right:
Tiara with diamond wheat ears. Wheat ears are the symbol of the Greek goddess of the harvest Ceres, and a symbol of prosperity and abundance. Platinum and diamonds; made in the beginning of the 20th century by C. Bruno.
Photo Hennell, London, England

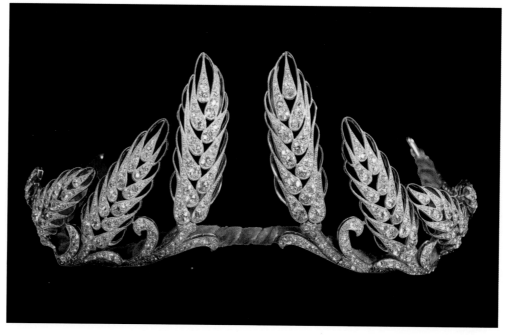

The design for this ivy leaved tiara was based on a diamond-set necklace from the Boucheron archive designed in 1890. Blackened gold and emeralds; made in 2003 by Boucheron.
Collection Queen Rania of Jordan
Photo Boucheron, Paris, France

Left:
Tiara of Princess Mathilde of Belgium. In 1938, this tiara with 631 brilliant-cut and 56 rose-cut diamonds was owned by a Mr White. In 1999, it was given to Princess Mathilde by the Nobility Council of Belgium, to mark her wedding to Crown Prince Philippe of Belgium. Platinum and diamonds; made in 1912 by the London jeweller Hennell.
Collection of Princess Mathilde of Belgium
Photo collection René Brus

Tiara. Gold, silver and
diamonds; made second
half of the 19th century
and altered in 1952 or 1953
by Cartier, London.
Privately owned
Photo Cartier Joailliers,
Paris, France

Tiara in the shape of a laurel wreath with a central rosette formed by a wild rose. This tiara was bought in 1868 by King Victor Emanuel II of Italy as a wedding present for his future daughter-in-law, Princess Margherita of Savoy, who was to marry with the future King Umberto I of Italy. Gold, silver and diamonds; made circa 1867 by Mellerio dits Meller, Paris, France.
Albion Art Collection, Tokyo, Japan
Photo Diana Scarisbrick, London, England

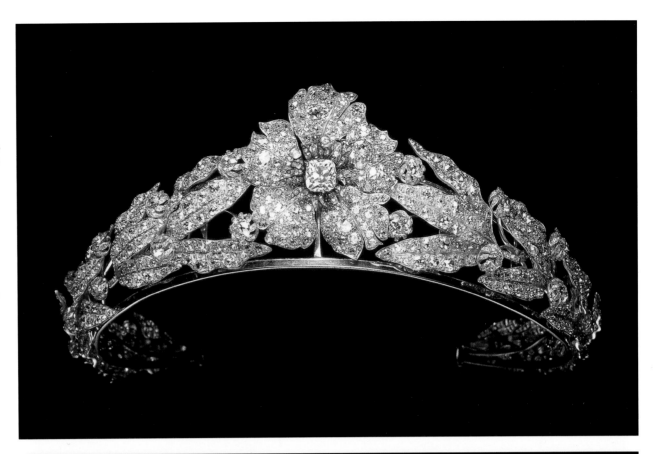

Tiara with sprays of fuchsias and eglantine roses. Originally part of the jewellery collection of the German Princely House of Thurn und Taxis. Sold in 1992 by Sotheby's for 65,000 Swiss francs. Gold, silver and diamonds; made circa 1845.
Photo Sotheby's, Geneva, Switzerland

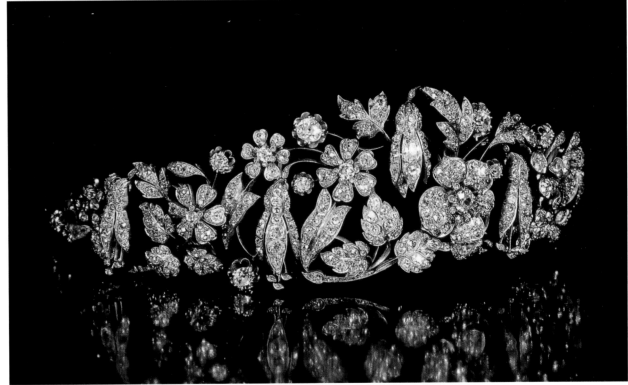

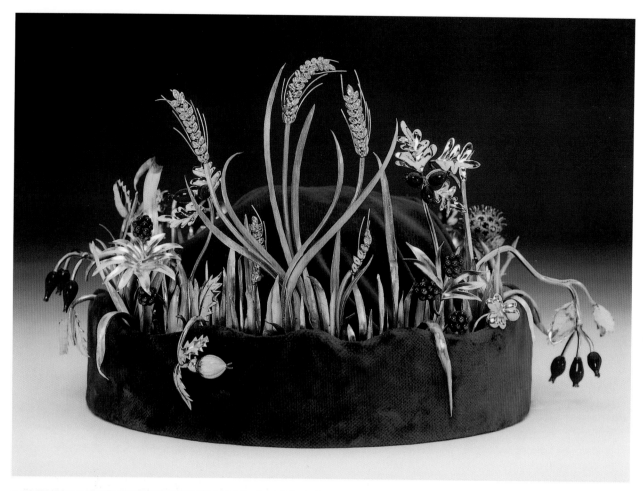

Front view of the Millennium 'Hedgerow' Crown. Gilded silver, diamonds, rubies, amethyst, enamel, and velvet; made by the London-based jewellers Asprey & Garrard for a September 2000 competition organised by *Blue Peter*, the BBC television flagship children's programme. The award-winner was 11-year old Georgina Elliott.
Photo Garrard, London, England

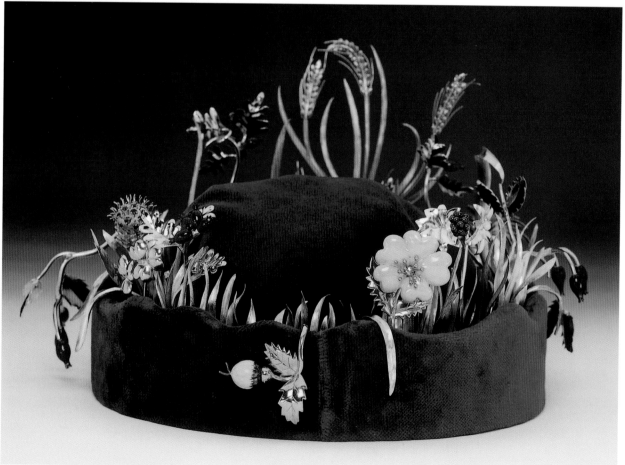

Back view of the Millennium 'Hedgerow' Crown.
Photo Garrard, London, England

Tiaras

Tiaras as we know them vary greatly in form and degree of ornamentation. One ingenious goldsmith created a tiara that could also be worn as a necklace, due to its skilful design. Such a multi-functional piece of jewellery is occasionally shaped in a graduated circle of vertical rows of stones, and is generally referred to as a fringed tiara. To many, this type of tiara clearly imitates the rays of the Sun, but others refer to it as a Russian tiara as its shape bears a resemblance to the Russian *kokoshnik*, the typical headdress worn by peasant women.

In the late 19th century, a diadem or tiara was the most impressive piece of jewellery any fashionable lady could wear. During royal receptions, a tiara was almost a necessity. However, it is not a comfortable piece of jewellery, as an English peeress wrote in her autobiography, *'every time I wear a tiara I have a headache after the first hour'.*

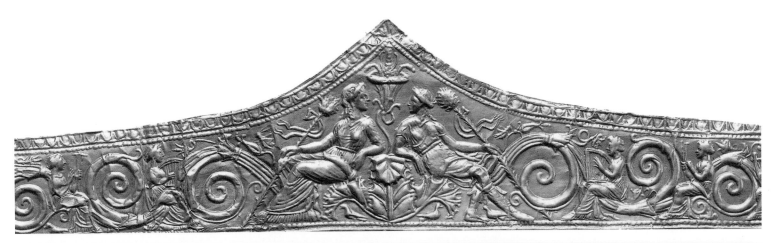

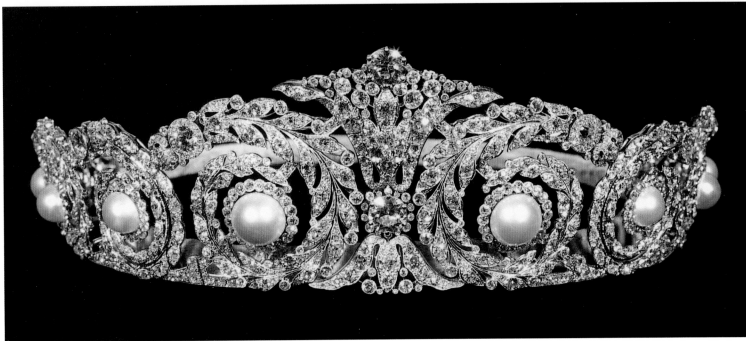

Top:
Pediment-shaped diadem depicting the wine god Dionysus and his wife Ariadne surrounded by muses playing musical instruments. Gold; made 330-300 BC.
Collection and photo The Metropolitan Museum of Art, New York, USA

Above:
Tiara of Queen Victoria Eugenie of Spain. Platinum, diamonds and pearls; made in 1920 by Cartier, Paris, France. Photo El Jefe de la Casa de S.M.El. Rey, Palacio de la Zarzuela, Madrid, Spain

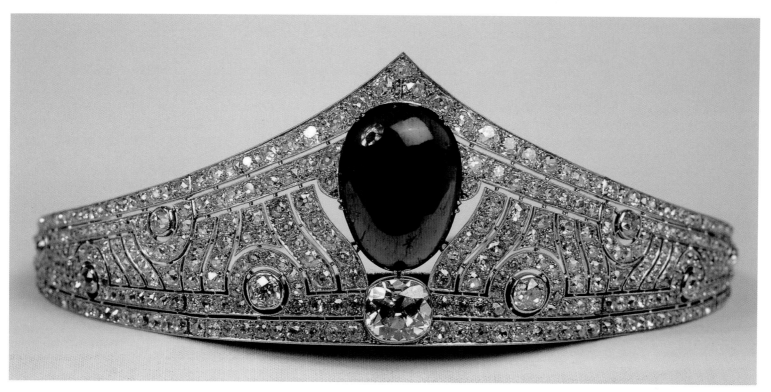

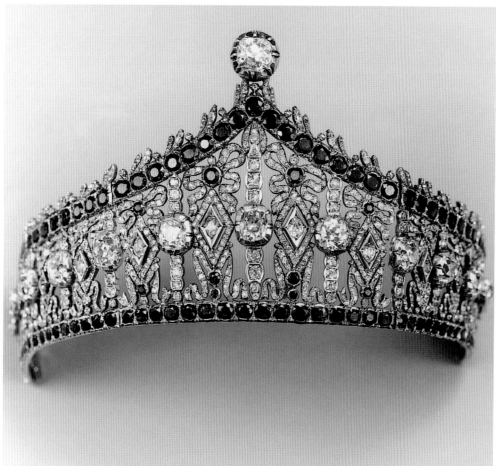

Above:
Tiara in Art Déco
style set with precious
stones. Numerous
stones were integrated
from the 19th century
jewellery belonging
to the Grand Ducal
House of Luxembourg.
Platinum, diamonds and
emerald; made in 1926 by
Chaumet, Paris, France.
Collection of the Grand
Duke of Luxembourg
Photo Photothèque de la
Ville de Luxembourg

Left:
Tiara; gold, silver,
diamonds and sapphires;
made second half
of the 19th century.
Auctioned in May 1976
for Sfr 55,000.
Privately owned
Photo Sotheby's, Geneva,
Switzerland

Opposite page, top left:
Circa 1900; Sultanah
Zainab I, consort of
Sultan Muhammad IV
of Kelantan.
Photo collection
René Brus

*Opposite page, top
middle:*
Coronation tiara of Raja
Perempuan Zainab II,
consort of Sultan Yahya
Petra of Kelantan. Used
during her coronation
on 17 July 1961, and on
30 March 1981 by her
daughter-in-law Raja
Perempuan Anis of
Kelantan. Platinum
and diamonds; made
in 1961 by H. Sena Ltd,
Singapore.
Collection the Sultanate
of Kelantan, Malaysia
Photo by René Brus

Opposite page, top right:
Circa 1900; Sultanah
Zainab I, consort of
Sultan Muhammad IV
of Kelantan, wearing her
tiara as a necklace.
Photo collection
René Brus

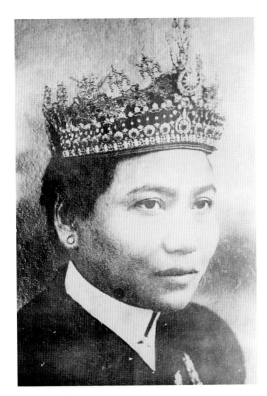 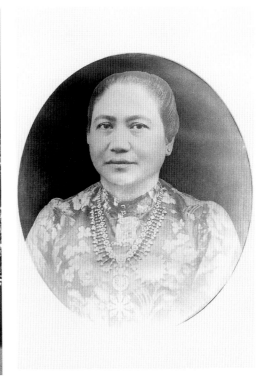

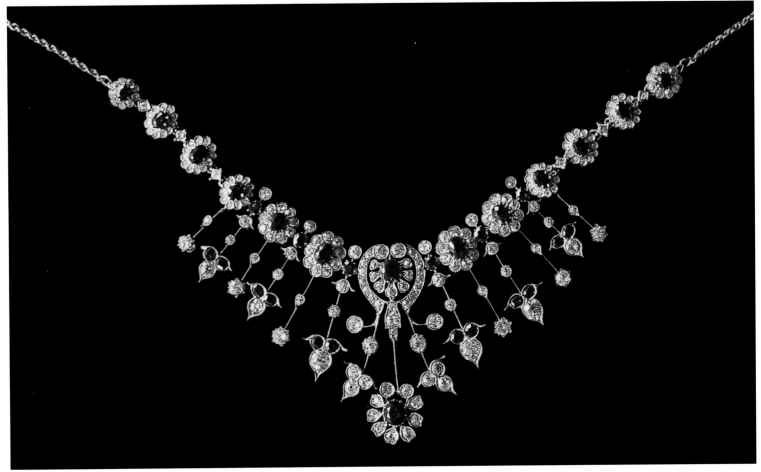

Circa 1900; necklace of Sultanah Zainab I, consort of Sultan Muhammad IV of Kelantan. This necklace was worn as a tiara on formal occasions. It was inherited by her three children, and was divided into three parts. The central piece was given to her daughter Maharani Putri, who passed it on to her daughter Raja Perempuan Zainab II, the consort of Sultan Yahya Petra of Kelantan. Gold, platinum, diamonds and rubies.
Collection the Sultanate of Kelantan, Malaysia
Photo René Brus

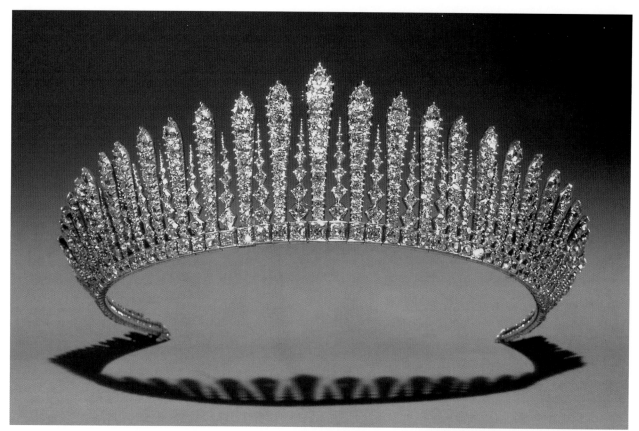

Tiara given in 1934 to Princess Marina of Greece by the City of London, to mark her marriage to Prince George, the Duke of Kent. Platinum and diamonds; made first half of the 20th century. Collection Prince and Princess Michael of Kent Photo with courtesy of Wartski Ltd, London, England

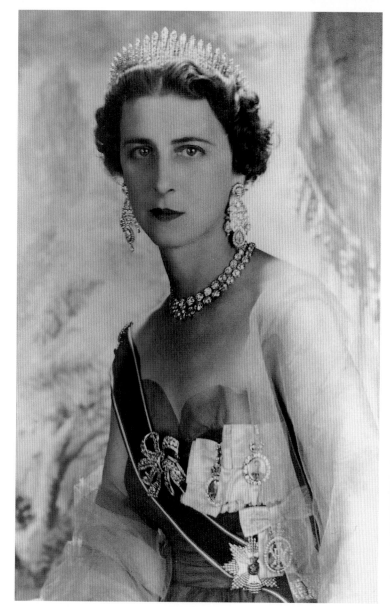

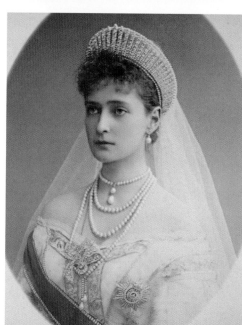

Far left:
Circa 1950; Princess Marina of Greece, Duchess of Kent. Photo Private Secretary to Princess Michael of Kent, London, England

Left:
Circa 1900; Empress Alexandra Feodorovna, consort of Tsar Nicholas II of Russia. Photo collection René Brus

Bottom left:
Headdress in *kokoshnik* style, which was part of the jewellery collection of the Imperial Family until the end of the First World War. Since the 1920s, its whereabouts is unknown. Gold, diamonds and pearls. Photo collection René Brus

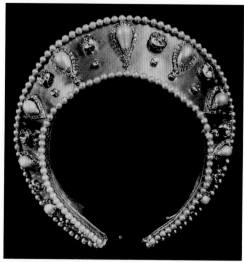

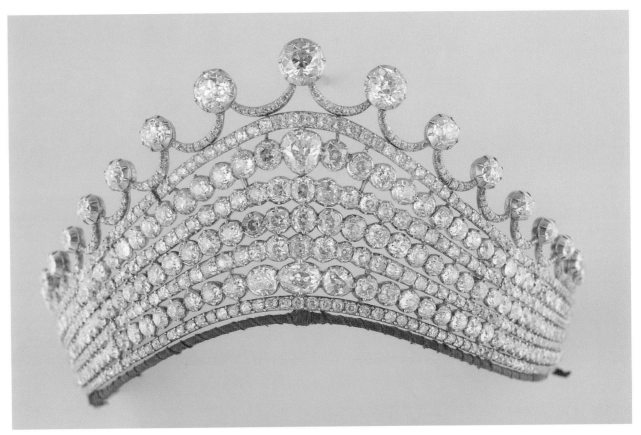

Above:
Tiara which, according
to family tradition,
was given to Princess
Franziska von Wrbna-
Freudenthal by her
husband Prince Karl von
und zu Liechtenstein.
Sold at Sotheby's in 1982
for SF 300,000.
Silver and diamonds.
Photo Sotheby's, Geneva,
Switzerland

Right:
Circa 1930; Maharaja
Hari Singh and Maharani
Tara Devi of Jammu and
Kashmir.
Photo The Hari-Tara
Charitable Trust,
Jammu, India

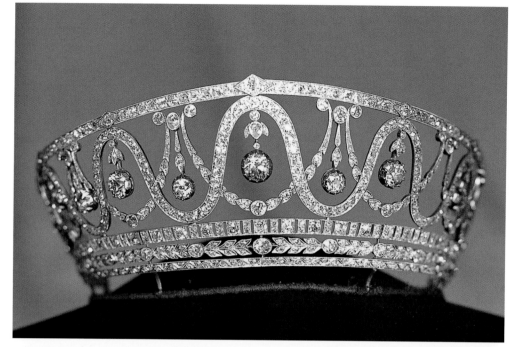

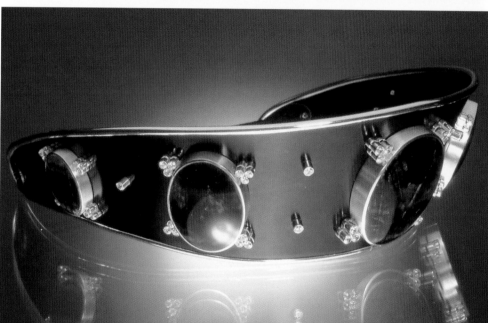

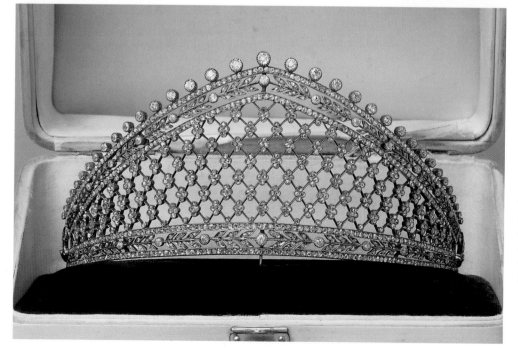

Top left:
Tiara of the Grand
Duchess Hilda of Baden.
Gold, platinum and
diamonds; made end of
the 19th century.
Collection Badisches
Landesmuseum,
Karlsruhe, Germany
Photo René Brus

Top right:
Circa 1900; Grand
Duchess Hilda,
consort of Grand Duke
Friedrich II of Baden.
Photo collection
René Brus

Middle left:
This modern steel
kokoshnik style tiara has
a blue finish that was
achieved by heating the
steel to a very constant
and precise temperature.
Steel, silver, cubic
zirconia and Blue
John stones; designed
and created in 2001
by Victoria Harper,
London, England.
Photo Victoria Harper,
London, England

Bottom left:
Tiara; gold, silver and
diamonds. Made circa
1900 by Fabergé.
Collection and photo
Wartski Ltd, London,
England

Opposite page:
Top left:
Diadem number 3
found at Royal Tomb III,
Mycenae, Greece. Gold;
made in 1550-1500 BC.
Collection and photo
National Archaeological
Museum, Athens, Greece

Top right:
Sketch of a tiara designed
by Hendry jewellers
in the 1930s, Kuala
Lumpur, Malaysia.
Photo René Brus

Bottom left:
Sketch of a tiara designed
by Carrington jewellers
in the beginning of
the 20th century,
London, England.
Photo René Brus

Bottom right:
19th century sketch of
a diamond-studded
tiara designed by Koch
jewellers, Frankfurt am
Main, Germany.
Collection Deutsches
Goldschmiedehaus,
Hanau, Germany
Photo René Brus

Sun, Moon and stars

Celestial bodies such as the Sun, Moon and stars have impressed and scared many civilisations, and have been worshipped by humans since prehistoric times. Archaeological discoveries provide evidence that the Sun as life bringer has been connected with numerous gods around the world, and its blazing rays have been used to decorate impressive, regal headdresses, for instance the ancient Roman *stellate*, or star-shaped, ornaments. In ancient times, gold was synonymous with the Sun, but when man found ways to use the glittering diamond for decoration, craftsmen had the perfect stone for imitating the rays of the Sun.

One of the oldest known examples of a head ornament with Sun motifs dates from about 1500 BC and was found in the grave of a woman in Mycenae. This object, like the other head ornaments discovered, is made from wafer-thin gold and must have been sewn onto a cloth headband, making it a splendid example of a genuine Greek *diademe*. This diadem was part of the gold treasures, weighing a total of 13.5 kilograms, discovered by the famous German archaeologist Heinrich Schliemann in November 1876. Schliemann was convinced that the 17 skeletons, buried where this treasure was found, were the remains of the ancient Greek King Agamemnon and his companions, and that the jewellery belonged to Helen of Troy, the woman whose beauty 'launched a thousand ships'. Schliemann's 'Treasure of Priamos' actually appears to have been made 500 years after the siege of Troy. After his discovery, Schliemann sent a telegram to the King of Greece stating *'These treasures will fill a great museum, the most wonderful in the world, and for centuries to come, thousands of foreigners will come to Greece to see them.'*

Comets have also influenced jewellery, particularly in 1758, when Halley's Comet was visible, and in 1843 and 1882, when the so-called Great Comets appeared. Diamond-set stars became very fashionable around these times, especially in Europe, and were commonly found in jewellery. By coincidence, the Islamic symbols of the star and crescent also became fashionable in the 19th century, when Islamic rulers visited European courts and members of the European aristocracy visited Islamic countries.

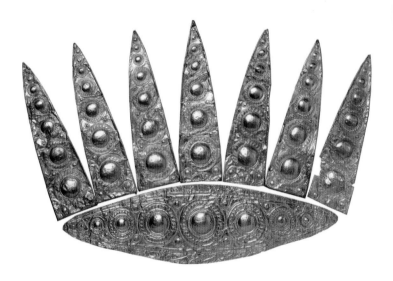

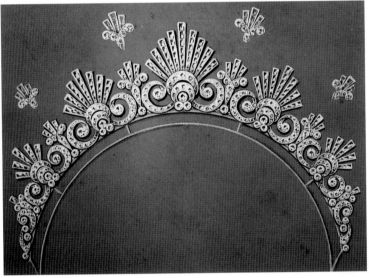

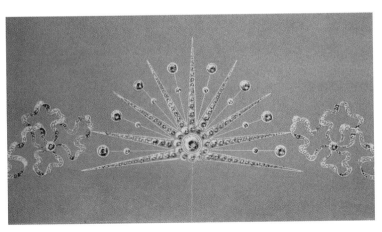

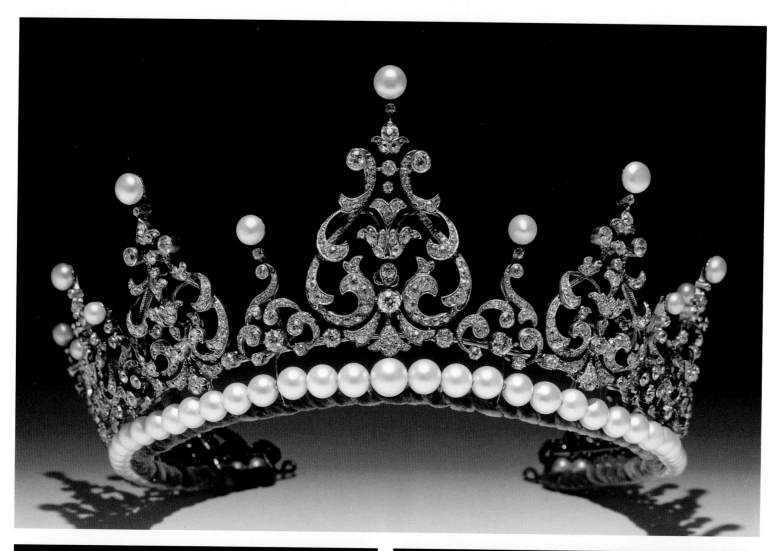

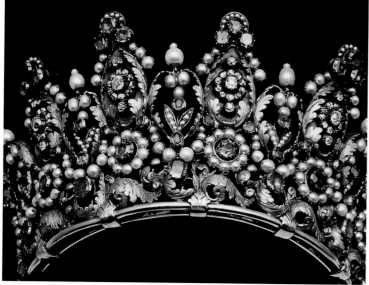

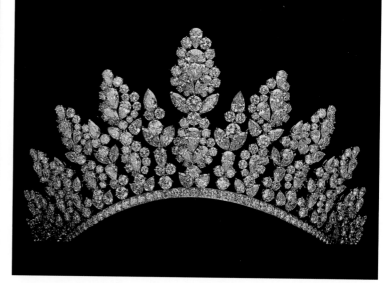

Top:
Tiara belonging to
Princess Marina,
Duchess of Kent, born
Princess of Greece.
Collection Prince and
Princess Michael of Kent
Photo Wartski Ltd,
London, England

Bottom left:
Tiara; gold, diamonds,
emeralds, rubies
and pearls. Made by
Chaumet, Paris, France,
probably during the
19th century.
Privately owned
Photo collection
René Brus

Bottom right:
Tiara worn by Pengiran
Isteri Mariam, the second
consort of Sir Muda
Hassanal Bolkiah
Mu'izzaddin Waddaulah,
the Sultan of Brunei.
Platinum and 557

diamonds with a total
weight of 190,67 carats;
made in 1992 by Fred
Joaillier, Paris, France.
Photo Fred Joaillier,
Paris, France

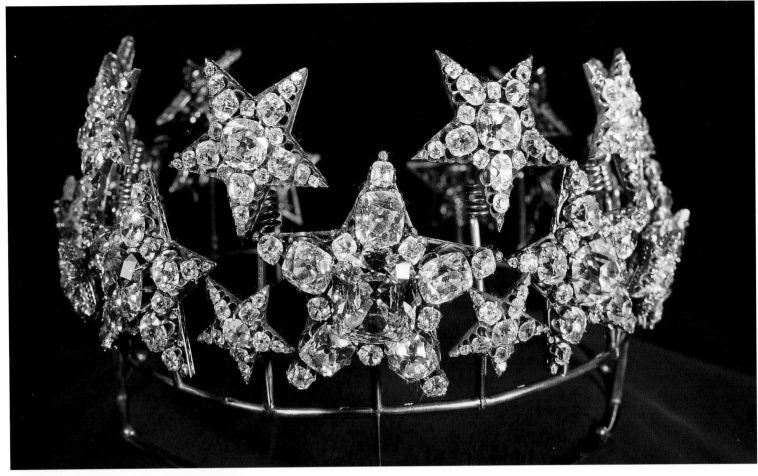

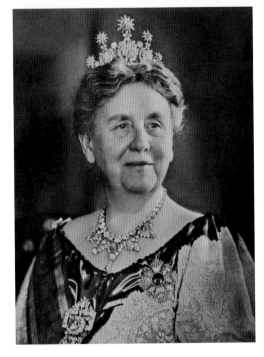

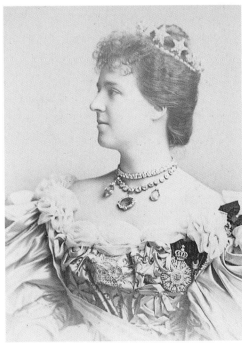

Top:
Tiara of Queen Maria Pia
of Portugal. Gold and
diamonds; made in 1876-
1878 by Estêvão de Sousa,
Lisbon, Portugal.
Collection and photo
Património Cultural,
Ajuda Palace, Lisbon,
Portugal

Bottom left:
1937; Queen Wilhelmina
of The Netherlands
wearing the tiara of her
mother Queen Emma,
made by Begeer.
Photo collection
Rijksvoorlichtingsdienst,
The Hague,
The Netherlands
Photo Godfried de Groot

Bottom middle:
Three tiara sketches,
designed in 1890 by
Begeer for Queen Emma
of The Netherlands. The
first design was chosen
by Queen Emma and
made by Begeer.
Collection Koninklijke
Begeer, Voorschoten,
The Netherlands
Photo René Brus

Bottom right:
Circa 1890; Queen
Amélia of Portugal.
Photo collection
René Brus

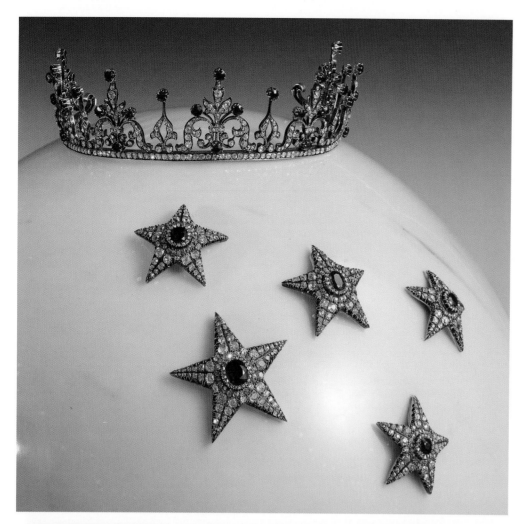

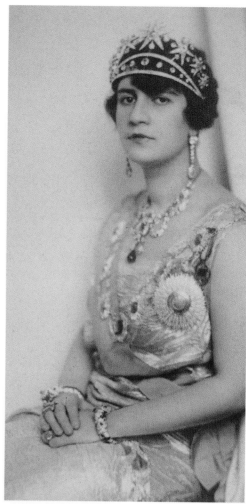

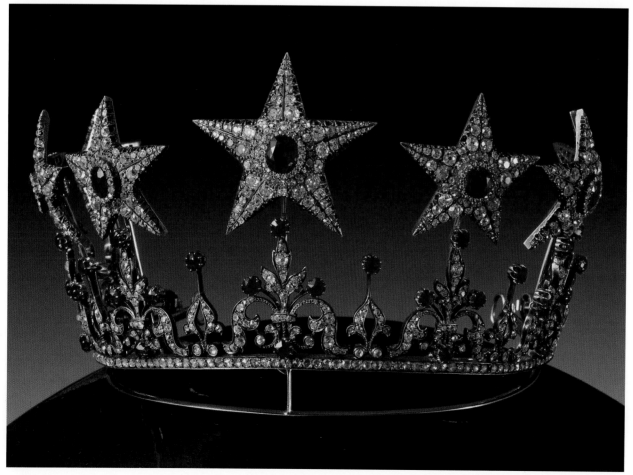

Left, top and bottom:
Tiara with detachable brooches. Gold, silver, diamonds and rubies; made first half of the 19th century.
Privately owned
Photo courtesy of Hemmerle Jewellers, Munich, Germany

Top right:
Circa 1928; Queen Soraya of Afghanistan.
Photo collection René Brus

Top left:
Raja Isteri Pengiran Anak Saleha was crowned with this tiara on 1 August 1968, when Sultan Hassanal Bolkiah Mu'izzaddin Waddaulah was crowned as ruler of Brunei. Gold, platinum, diamonds, rubies, emeralds and ermine fur; made in 1968.
Collection and photo Royal Regalia Museum, Bandar Seri Begawan, Brunei

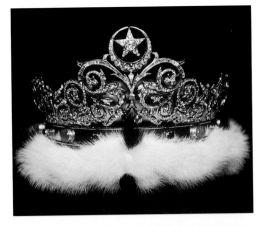

Top right:
Circa 1950; Maharaja Sawai Brijendra Singh of Bharatpur.
Photo collection Frits Veldkamp, The Netherlands

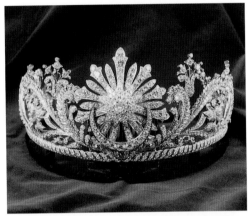

Middle left:
Tiara worn by the Queens of Malaysia since 1959. The eleven-pointed star represents the 11 states that formed the Kingdom of Malaysia upon independence in 1957. Platinum, gold and diamonds; made in 1959 by H. Sena Jewellers, Singapore, altered in 1984 and the late 1990s by Garrard, England.
Collection the State of Malaysia Photo Jabatan Perkhidmatan Penerangan Malaysia, Kuala Lumpur, Malaysia

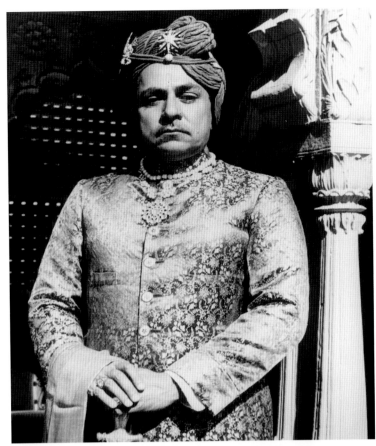

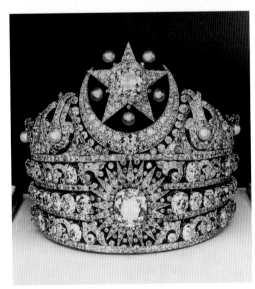

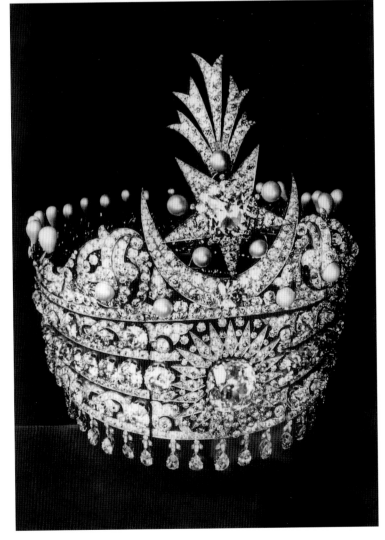

Bottom, left and right:
Crown of the Nawab of Bahawalpur. A large circular diamond of approximately 65 carats, is set in the centre of a diamond Sun. The star and crescent were joined to make a spectacular crown after the death of Sadiq Muhammed Khan IV, Nawab of Bahawalpur in 1899. The London jeweller Garrard added several diamonds and pearls to the crown in the 1950s. At the same time, the five-pointed star within its crescent was turned and heightened with a diamond plume. Left; In the old style. Right; Altered. Gold, diamonds and pearls; made end of the 19th century.
Present whereabouts unknown
Photo Henry J. Phillips, Garrard, London, England

From headband to crown

The metamorphosis of cloth headbands as worn thousands of years ago into costly, gem-set metal crowns with arches and spheres to represent the globe is one of the great examples of how craftsmen through the centuries have continuously developed new shapes to meet the desires of those who needed impressive headwear to signify their rank. The earliest were perhaps bands of linen or silk, richly embroidered and with metal decorations sewn onto them. These evolved into a flexible metal band, which in turn led to a closed metal circlet, later embellished with upward-pointing ornaments. This type of crown is generally referred to as an 'open' crown, while one with arches is regarded as a 'closed' crown.

One of the oldest surviving 'open' crowns in Europe is the 'Corona Ferrea', or Iron Crown, of Lombardy (also referred to as the Crown of Monza). This crown is basically in the shape of a cloth headband. It is made of a circle formed by six hinged gold plates and is adorned with 26 rosettes in gold relief, 22 precious stones and 24 enamelled ornaments. The crown is regarded with great reverence because legend has it that the inner band of iron was hammered out of one of the nails from the Cross of Christ. It is said to have been used for the coronations of all Lombard monarchs, and worn by the emperors of the Holy Roman Empire when they were crowned King of Italy. When Napoléon Bonaparte had himself crowned as Emperor of France in 1804, he also chose to accept the title of King of Italy and decided that the historic Iron Crown was quite suitable for that coronation. Due to the crown's small diameter of 15.3 cm, one hinge was loosened and, as in ancient Greece, the Iron Crown was sewn onto a band of cloth.

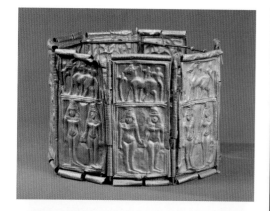

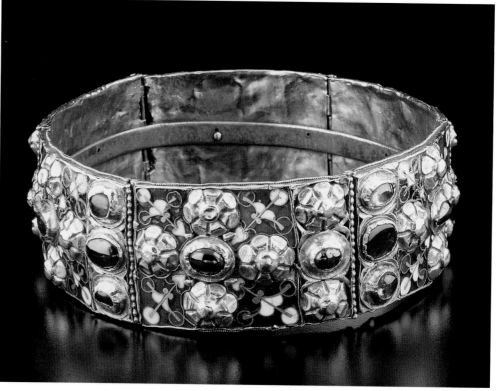

Left, top and bottom:
Two Phoenician crowns; gold; made in the 8th-7th century BC. Obtained by the museum possibly in 1929, after the auction held by Messrs Lepke, Berlin, of the collection of Baurat Schiller, the original owner of the objects. These two sets of gold plaques were discovered in separate pieces and were restored around the turn of the 20th century as crowns of the type worn by women pictured on ancient Phoenician ivories. Although the two objects are similar in form and both feature goddesses of fertility, the style and iconography depicted on the hinged plaques are quite different.
Collection and photo The Walters Art Museum, Baltimore, USA

Right:
Iron Crown of Lombardy. Gold, rubies, sapphires, amethysts and enamel; made 9th century AD. Collection Treasury Basilica San Giovanni, Monza, Italy Photo Parrocchia San Giovanni Battista, Duomo di Monza, Monza, Italy

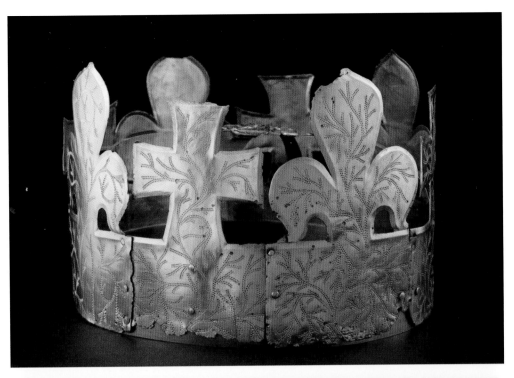

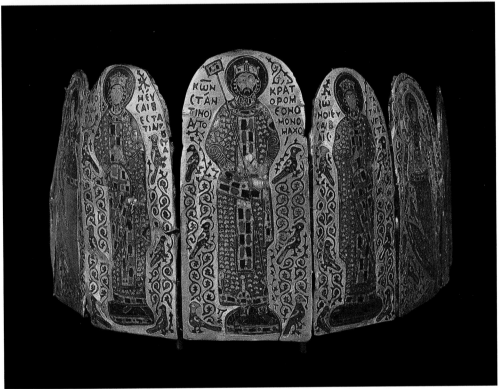

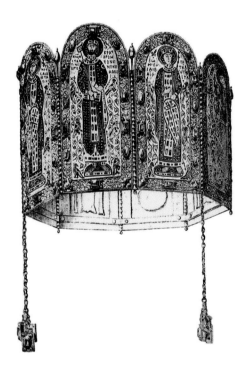

Top:
Funeral Crown of King
Premysl Otakar II of
Bohemia (died in 1278).
This crown was buried
in the St Vitus Basilica in
Prague, Czech Republic
and excavated in 1976.
Gilded silver.
Collection Prague Castle,
Czech Republic
Photo Jan Gloc for
Prague Castle,
Czech Republic

Bottom left:
Crown of Emperor
Constantine IX
Monomachus of
Byzantium. Gold,
enamel; made first half
of the 11th century. This
Byzantine crown was
given by Constantine IX
Monomachus to King
Andrew I of Hungary
in the 11th century. The
originally hinged

cloisonné enamel plaques
bear, among others,
portraits of the emperor
and his wife Zoë, who
ruled together with the
emperor's sister-in-law
Theodora between 1042
and 1050.
Collection and photo
Hungarian National
Museum, Budapest

Bottom right:
Artist impression of
how the enamelled
panels were originally
set into the Crown of
Emperor Constantine IX
Monomachus of
Byzantium.
Photo collection
René Brus

When Christianity became widespread, the cross was given a prominent position on or above the headband. Until the Middle Ages in Europe, there were no formal specifications for how royal or imperial crowns should be made, but as rank and degree became more and more important in relation to power, crowns became the perfect symbol of the wearer's position. A crown with one arch became the sign of an emperor, while the holiness of the empire was expressed by the addition of a bishop's mitre. For years, this shape of imperial crown was restricted to that worn by the Holy Roman Emperor of the Germanic nations, but other states, such as the Russian tsars, later adopted a similar imperial crown.

The most splendid piece of the goldsmith's craft, surmounted with one arch, is the principal achievement of a workshop established by Rudolf II in Prague at the Hradcany Palace. The frame of the mitre-shaped cap is in two parts, consisting of gold plates showing exquisite workmanship depicting four scenes in bas-relief. On the first, Rudolf II is depicted as a conqueror, armed, bare-headed, holding the sceptre in his right hand and in the company of five 'Victoriae', one of whom is winged and holds a laurel wreath above Rudolf's head. The second shows the emperor in armour, wearing the archducal hat and holding the sceptre in

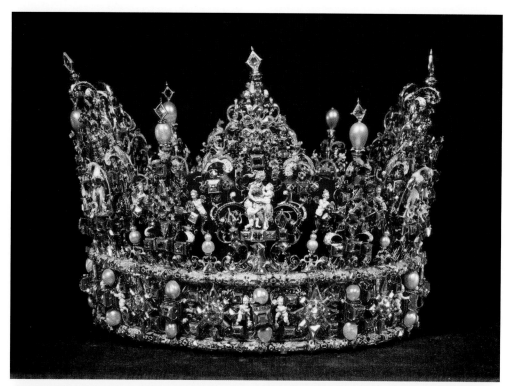

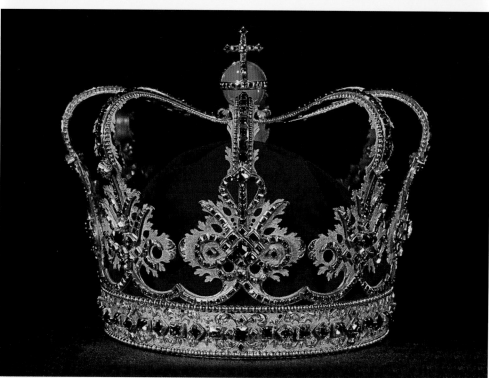

his right hand, passing in procession with halberdiers in the background. This is thought to represent the coronation procession at Prague. The third plate shows the emperor on horseback on a hillock, with a sword and wearing an open royal crown. This scene represents the ceremonies connected with the coronation of a Hungarian king. The fourth plate shows the imperial coronation at Frankfurt, when a mitred bishop places the Crown of the Holy Roman Empire on the head of the emperor. This crown has never served as a coronation object, not even when it became the Austrian Imperial Crown after 1804.

In regions that were conquered and taken as colonies, accepting the shape of the conqueror's crown was often a part of the new arrangement. In former British colonies, some crowns may appear superficially western in shape, but generally the inspiration is still local, with details derived from native plants or symbols connected with the local faith.

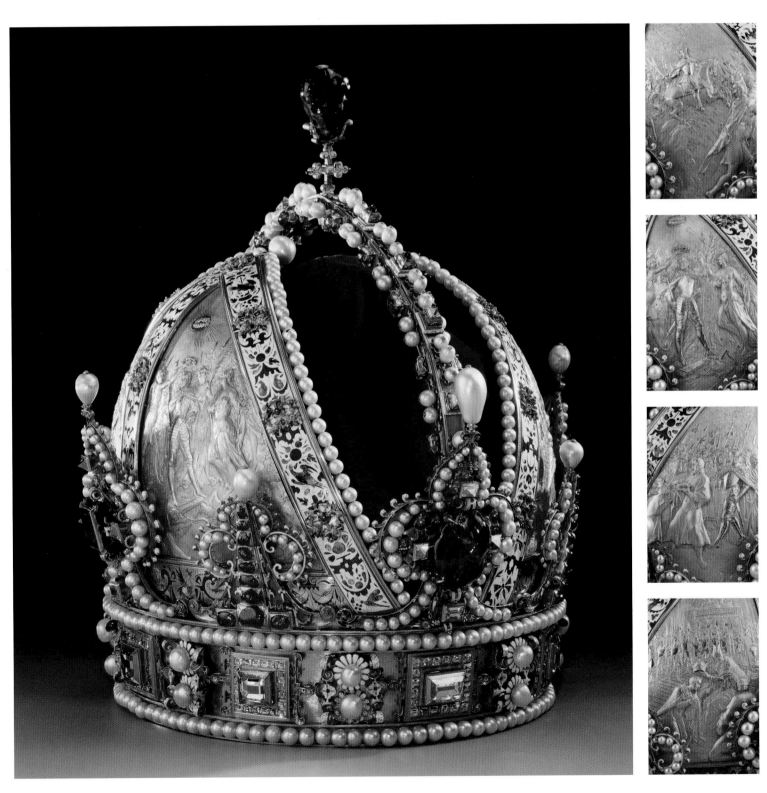

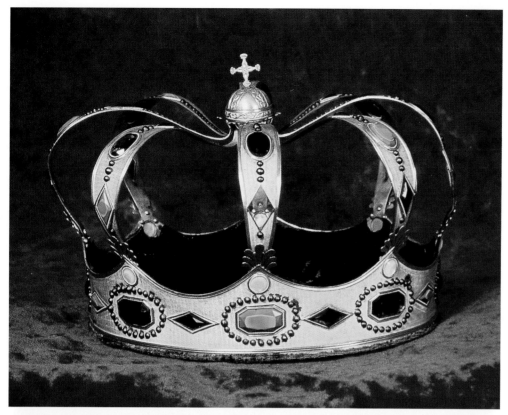

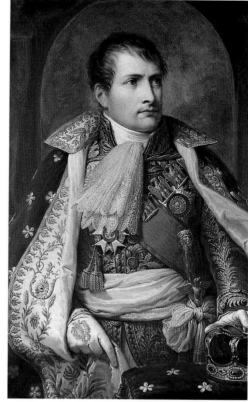

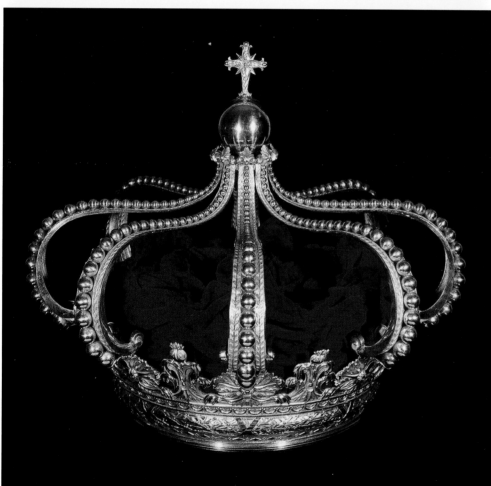

Top left:
The opening of Parliament in Milan on 7 June 1805 took place in the presence of the French Emperor Napoléon I, who was also King of Italy, and he wore this example of a closed crown. After Napoléon I lost his thrones, this crown became the property of Emperor Ferdinand I of Austria, who used it as his symbol of authority in the newly established Lombardo-Venetian Kingdom. Until 1921, this crown was kept in the treasury of the Hofburg Palace, Vienna, after which Austria and Italy agreed that it should be transferred to Milan. Crown of Emperor Napoléon I of France used in his capacity as King of Italy. Gilded, mother-of-pearl and paste; made in 1805.
Collection and photo Museo del Risorgimento, Milan, Italy

Top right:
Painting of Emperor Napoléon I of France as King of Italy, by Andrea Appiani.
Collection and photo Kunsthistorisches Museum, Vienna, Austria

Bottom:
Crown of the King of Portugal; made in 1817 in the workshop of António Gomes da Silva, Rio de Janeiro, Brazil, by the goldsmith Luiz da Costa o Fez. Gold and velvet. This example of a closed crown has never served as a coronation crown for the kings of Portugal as their accession was only marked by an inauguration ceremony during the 19th and early 20th centuries.
Collection and photo Instituto Português do Património Cultural, Ajuda Palace, Lisbon, Portugal

A subtle East-meets-West design is found in the Crown of Siak, one of the sultanates on the Indonesian island of Sumatra. The crown is adorned with a single arch running from left to right. Among the most prominent decorations are three golden blooming lotus flowers; one is placed on the top of the arch and two on the *tandok*, horn-like adornments at both sides above the ears. The horns may symbolise chieftainship, as found in several regions in south-east Asia, or they could be a reference to Alexander the Great, the powerful ruler of Macedonia who conquered Egypt. According to legend, this King had two small horns on his head and is, as some scholars believe, referred to in the Quran (chapter 18, Al-Kahf or the Cave) as Dhu'l-Qarneyn or Dhul-Qarnain, the two-horned. It is claimed locally that Alexander the Great is buried on Sumatra.

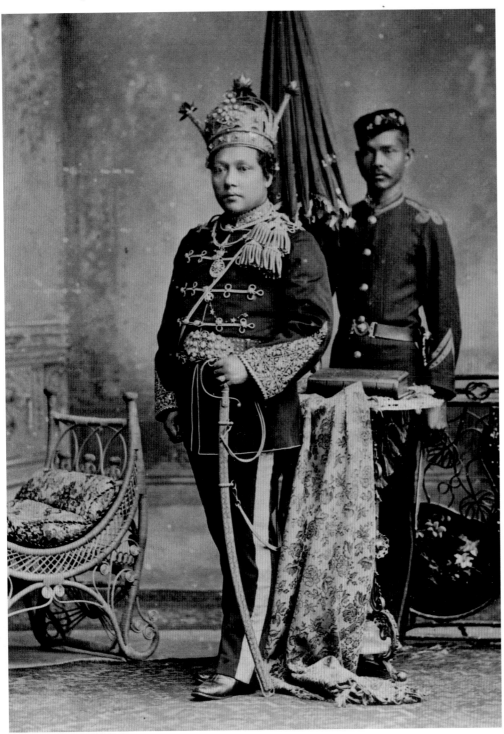

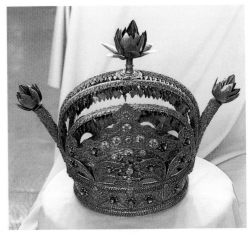

Left:
Circa 1915; Tengku Syarif Kasim, Sultan Abdul Jalil Saifuddin V of Siak, succeeded his father in 1908 as a minor, and assumed full power in 1915 until 1946.
Photo collection René Brus

Top right:
Crown of the Sultans of Siak. Gold, diamonds and rubies; made during the second part of the 19th century.
Collection Museum Nasional, Jakarta, Indonesia
Photo René Brus

Bottom right:
Detail, written in thin wire the Arabic phrase *Ta'et Bada' rah*, in Malay *Mahkota Emas*, which means *golden crown*.
Collection Museum Nasional, Jakarta, Indonesia
Photo René Brus

In 1920, the Terengganu state council Pen-lembagaan decided that two crowns had to be made for the coronation of Sultan Sulaiman of Terengganu and his consort Tengku Ampuan Meriam. The sultan's crown was to resemble an English crown in shape with arches, while that of his consort was to lack the arches. They apparently gave the goldsmith a drawing or photograph of the English crown, for it is said that, when the crown of the sultan was ready, the top was adorned with a cross just like the English crown. Such a symbol could not, of course, be used for an Islamic ruler, so the cross was quickly replaced by the star and crescent, ready for the coronation day on 3 March 1920.

At the same time as the western-style crown with arches was being introduced in Terengganu, neighbouring Kelantan obtained a similar symbol of kingly authority. This golden crown has a rim richly embossed with leaves of the local dala tree, above which are set 24 small ornaments depicting the crescent with a five-pointed star. This Islamic symbol is also represented on the top of the crown, where the eight arches meet, making a grand total of 25, Sultan Ismail being the 25th ruler on the throne of Kelantan. He was crowned with this elaborate new crown on 28 April 1921.

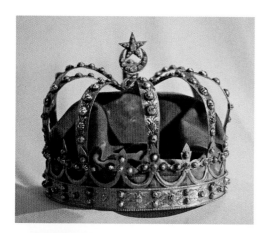 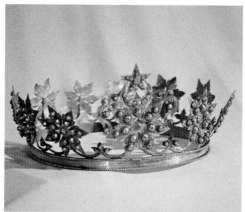 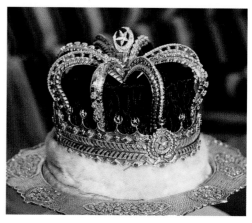

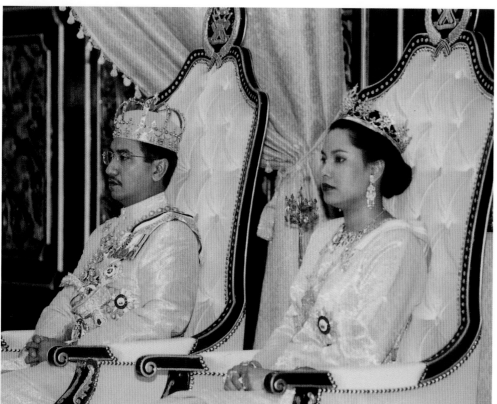

Top, left and middle:
Crowns of Sultan Sulaiman Badrul Alam Shah of Terengganu and his consort. Gold and diamonds; made in 1920 by a goldsmith Bijang and one assistant, Kampong Patani, Kuala Terengganu, Malaysia.
Collection the Sultan of Terengganu, Malaysia
Photos René Brus

Top right:
Crown of Sultan Ismail of Kelantan. Gold, diamonds and emeralds; made in 1921, altered in 1961 by the Singapore jeweller Sena and again in 1980 by the Kuala Lumpur jeweller Storch Bros.
Collection the Sultan of Kelantan, Malaysia
Photo René Brus

Bottom:
5.3.1999; coronation of Sultan Mizan Zainal Abidin and Permaisuri Nur Zahirah of Terengganu. The royal couple wear the crowns made in 1920.
Photo René Brus

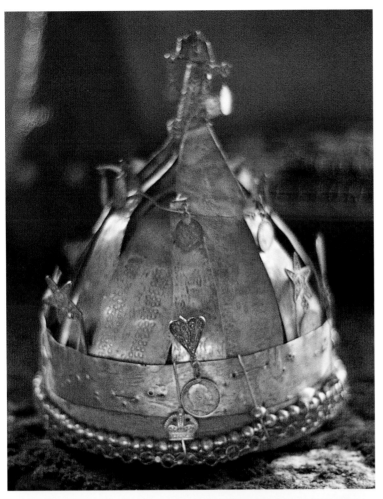

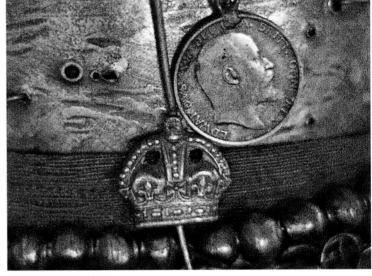

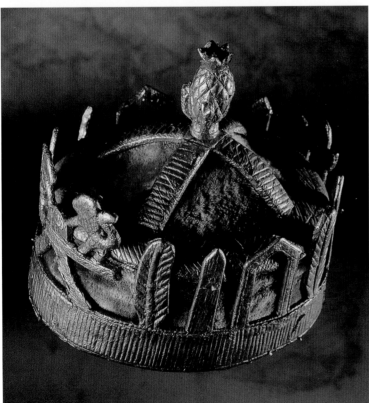

Bottom:
Crown of an Ashanti ruler. Gold foil; made circa 1930. This example of a closed crown is inspired by the English crown, but the lion decorations seem to have been adopted from the Dutch coat of arms. Other symbols used in its decorations are pineapples and feathers.
Collection and photo Wereldmuseum, Rotterdam, The Netherlands

Top, left and right:
Crown of Oba Oyewusi I, the Olokuku of Okuku. Silver; made early 20th century by a silversmith in Osogbo. This example of a closed crown reflects the first contact with the British. It is decorated with British coins and carries a small model of the British Crown. Right; Detail, British coin of George V and a miniature of a British Crown.
Collection the Olokuku of Okuku, Nigeria
Photos René Brus

Aigrette, jiga or sarpech

The *aigrette* refers to a spray of jewels and takes its name from the French for a bird's tuft or a plume made of the feathers of the silver heron. There appears to be almost no limit to the design of a jewelled *aigrette*, although some shapes are regarded as typically Persian (known as a *jiga* or *jigha*), or Indian (*sarpech, sarpenc* or *sarpesh*, from *sar* meaning head and *pech* meaning screw). These two types of jewelled head decoration merged, as illustrated when Shah Abbas I of Persia (1588-1629) sent a *jiga* studded with an engraved ruby, and black heron plumes known as a *kalagi*, with a pearl suspended at its tip to be worn behind the *jiga*, to the Mogul

Emperor of India, Jahangir (1605-1627) as a token of friendship. The whole piece was worth 50,000 rupees. The gift from the Shah started a new trend in India for royalty to wear both ornaments on their turbans. Foreign visitors were suitably impressed by these decorations. The Englishman Sir Thomas Roe described the jewels of the emperor when he departed from the city of Ajmer on 10 November 1616, *'On his head he wore a rich turban with a plume of heron tops (aigrette) not many, but long; on one side hung a ruby unset, as big as a walnut, on the other side a diamond as great; in the middle an emerald like a heart, much bigger.'*

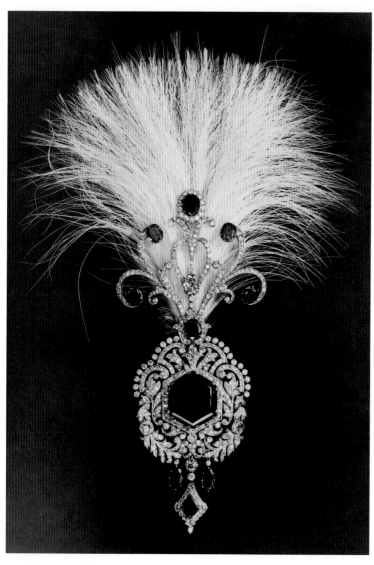

Aigrette made by order of Nawab Muhammad Bahadar Khan V of Bahawalpur. Platinum, diamonds and emeralds; made around 1900, altered circa 1950 by Garrard.
Privately owned
Photo Henry J. Phillips, Garrard, London, England

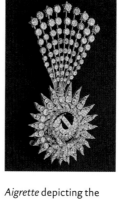

Aigrette depicting the crest or *Jata* of the Sultanate of Kedah, surrounded by stylised rays of the Sun. Each ray is set with three diamonds. The large plume above is studded with 69 diamonds. Worn in 1904 by Sultan Abdul Hamid Halim Shah of Kedah. Gold, diamonds, (black) agate or enamel.
Collection Sultan of Perak, Malaysia
Photo René Brus

This winged *aigrette*, made for Sultan Ismail Nasiruddin Shah of Terengganu, shows in minute diamonds the royal crest of Terengganu. The design for the three diamond feathers has been adopted from the so-called Prince of Wales feathers made in the second half of the 19th century. Platinum and diamonds; made circa 1970 by De Silva Jewellers, Singapore.
Collection the Sultan of Terengganu, Malaysia
Photo René Brus

Sketch of a diamond, ruby and emerald set turban *aigrette* made for the Rajah of Pithicapuram; made at the end of the 19th century.
Design collection Carrington, London, England
Photo René Brus

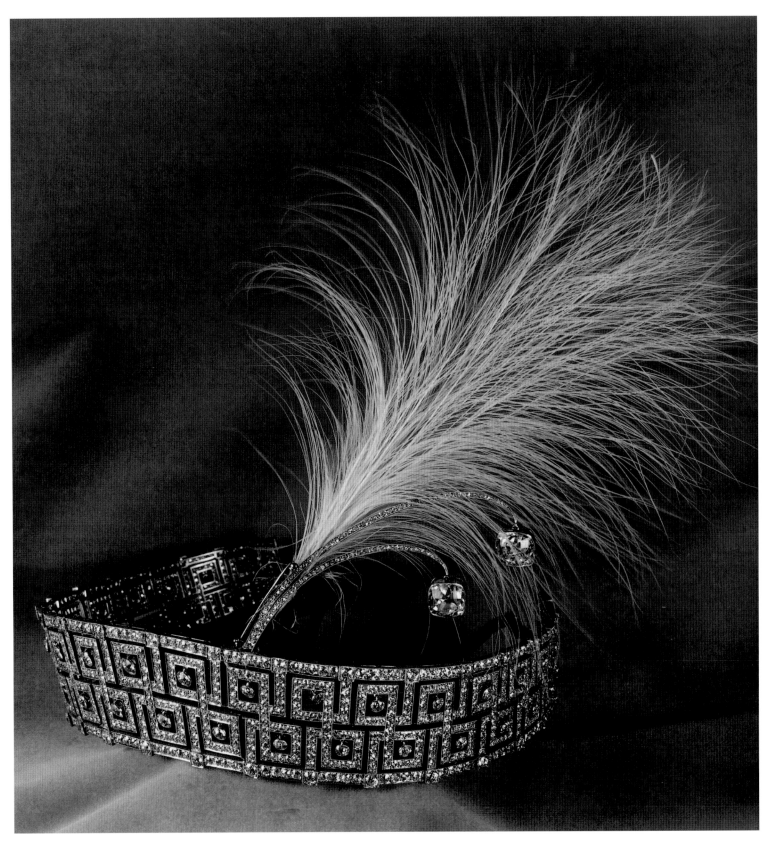

Tiara. Gold, silver, diamonds and osprey *aigrette*; made in the second half of the 19th century. This tiara, which in shape is a geometric bandeau with a Greek key pattern, is adorned with osprey feathers and a diamond-studded *aigrette*. Around the turn of the 20th century, feathered *aigrettes* had become fashionable as part of tiaras. The most popular feathers were those of the white egret. In England before the Second World War, it was mandatory for ladies being presented at court to wear ostrich plumes at the back of their jewelled headdresses.

Collection of the late Queen Elizabeth The Queen Mother Photo by gracious permission of Her Majesty Queen Elizabeth The Queen Mother

On 27 October 1826 Sultan Muhammed Shah of Selangor was crowned with the *Leleng* crown. Sometime after the coronation, this crown was deemed as '*haram*' (unsuitable) by Sahibul Fadzillah Tuan Sjeik Abdul Ghani, a religious authority from Bima (Sumatra). According to many believers, Islamic law prohibits men from wearing gold jewellery with a content of more than 50% gold. This religious rule might have been the reason why this crown was dismantled. To avoid any religious problems, a new crown was made in 1903 at a cost of 12,000 trade dollars. It was made of gold that was discovered in the Sultanate of Pahang. The gold used was not 24 carats, which is 100% pure gold, but only 10 carats (41.6% pure gold). This crown, used for the coronation of Sultan Alaeddin Sulaiman of Selangor, has a large spray with tiny, diamond-studded stars, representing the tail of the *ekor burong merak*, the male peacock. The new Crown of Selangor was made in such a way that the jewelled front with the *aigrette* can be worn separately.

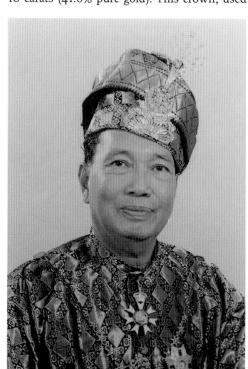

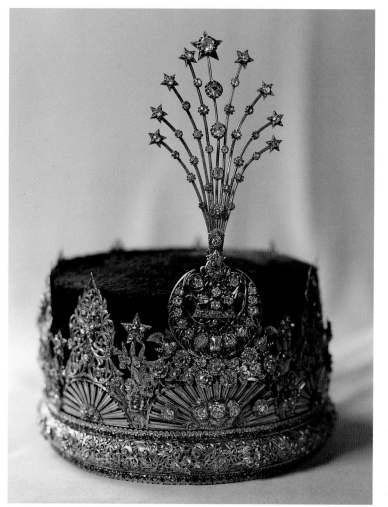

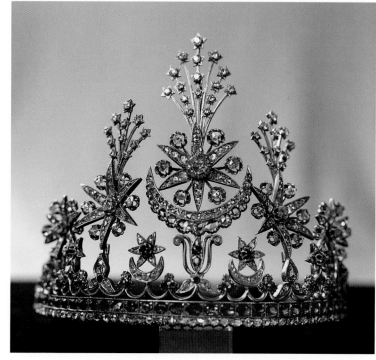

Top left:
1958; Sultan Sir Hisamuddin Alam Shah of Selangor.
Photo Jabatan Perkhidmatan Penerangan, Kuala Lumpur, Malaysia

Top right:
Crown of Sultan Alaeddin Sulaiman of Selangor.
Gold, diamonds and rubies; made in 1903 by Hassan from Balik Pulau on the island of Penang with the assistance of his friend, Enche' Mat.
Collection the Sultan of Selangor
Photo René Brus

Bottom left:
Circa 1938; Sultan Sir Hisamuddin Alam Shah of Selangor and his consort Tengku Ampuan Jemaah.
Photo collection René Brus

Bottom right:
Tiara of Tengku Ampuan Jemaah, the consort of Sultan Hisamuddin Alam Shah. This tiara has been used for the coronation of each successive Tengku Ampuan since the coronation of Tengku Ampuan Jemaah on 22 October 1903. Gold, diamonds and rubies; made by the goldsmith Hassan and Enche' Mat from Penang, Malaysia Altered by P. H. Henry jewellers, Kuala Lumpur, Malaysia on several occasions. Three plumes were added in 1938.
Collection the Sultan of Selangor, Malaysia
Photo René Brus

The British organised an exhibition in the city of Jaipur in 1883, and requested all the states in the Indian colony to send handicrafts and arts that would demonstrate the skills of the different regions. The Maharajah of Rewa decided to send no fewer than three royal headdresses, which were made of fabric covered entirely with jewels. One such headdress, known as the *Rajpat* Crown, had a plaque on the front with a beautiful sapphire cut into the form of the god Charurbhuj, the four-armed Vishnu, and worth 20,000 rupees at the time. Although many Hindus believe that the sapphire brings misfortune, the Maharajah regarded this impressive stone as important enough to decorate one of his state headdresses. All the stones in the three crowns were set in enamelled gold, and were backed by foil to reflect light, giving an extra glitter to the stones.

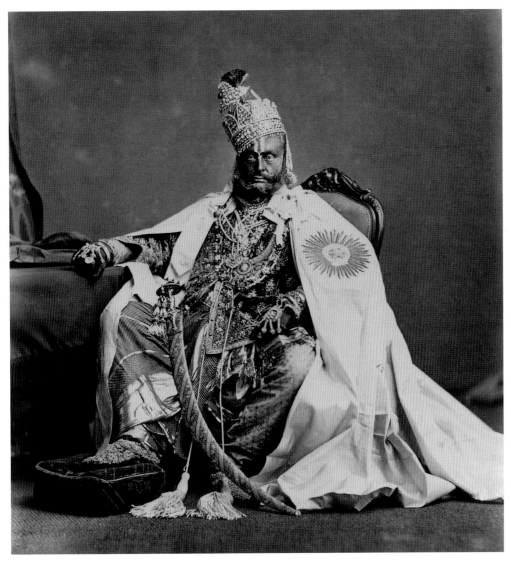

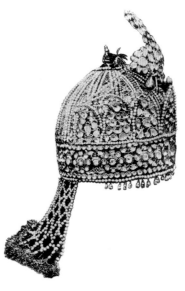

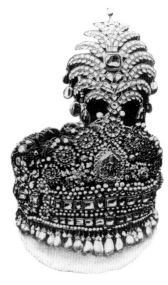

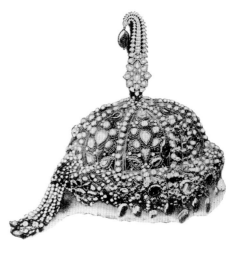

Left:
Circa 1883; Maharaja Venkat Raman Singh Bahadur of Rewa wearing the *Mukut* Crown with a *sarpech* (crown top right).
Photo collection René Brus

Right, top to bottom:
Three crowns from the collection of the Maharaja of Rewa.
Top; *Mukut* Crown with a *sarpech*.
Middle; *Rajpat* Crown, with an *aigrette* on the front locally known as *krit*.
Bottom; The *Pagri* Crown adorned with a *sarpech* on the top, without the usual side pieces. All set with diamonds, emeralds, pearls and other precious stones; made in 1883 in Delhi, India.
Current whereabouts unknown
Photo from 'Indian Jewellery, Ornaments and Decorative Designs' by Jamila Brij Bhusan

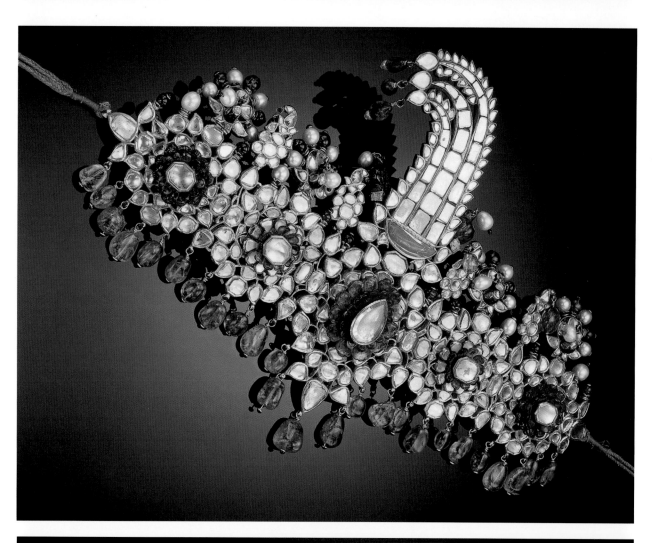

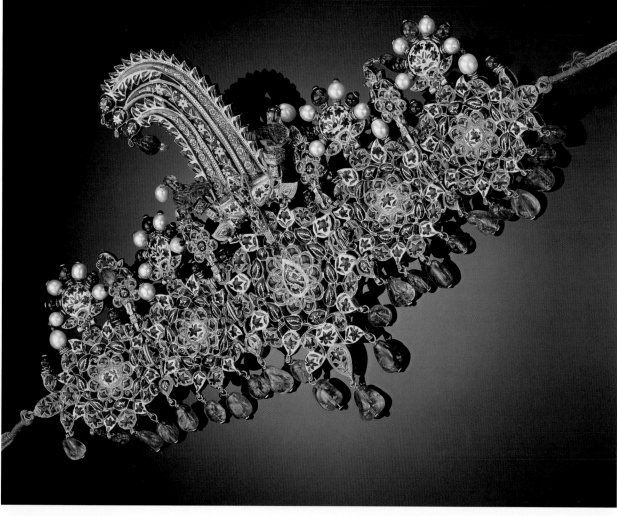

Two *sarpechs* made
for Maharajah Sir
Bhuphinder Singh
of Patiala.
Opposite page; Back
(top) and front (bottom)
view; gold, diamonds,
emeralds, rubies, pearls
and enamel.
This page; Back (top)
and front (bottom) view;
gold, rubies and enamel;
made second half of the
19th century.
Privately owned
Photo Sotheby's, Geneva,
Switzerland

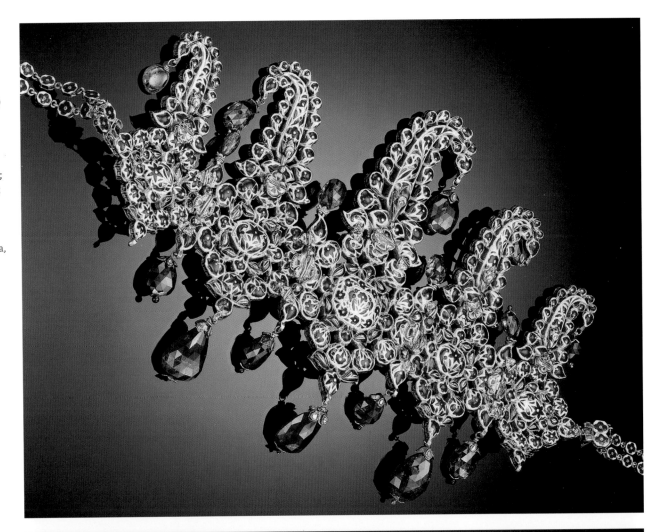

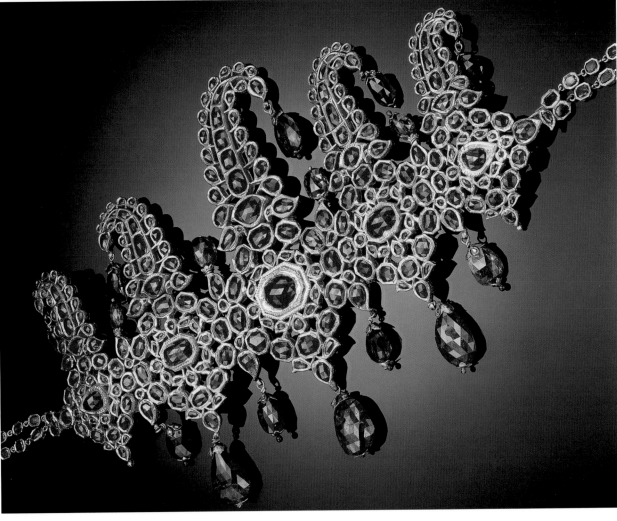

The 32 cm-high Kiani Crown of the Persian Qajar dynasty includes two splendid gem-set *aigrettes*, one fixed on the domed top and the other on the front. The shape of this splendid royal headdress is based on the ancient *cidaris*, the Persian head covering, and was made in 1798 for the coronation of Fath Ali Shah. The construction of this crown, with its approximately 1800 pearls, 300 emeralds, 1500 spinels and numerous diamonds, makes it possible to attach different kinds of *aigrettes* with or without the three black heron plumes that are locally referred to as the *kalagi*. According to the fabulous book *The Crown Jewels of Iran* by V. B. Meen and A. D. Tushingham, these heron feathers can only be worn by the Shah and are

the symbols of royalty. They were brought from Turkestan by the founder of the Afsharid dynasty, Nadir Qoli Beg, who took the throne of Persia in 1736 and ruled as Nadir Shah until his assassination in 1747. The Kiani Crown has been described in many different ways. In 1806, the French envoy to Persia, Pierre-Amédée Jaubert, described the crown as '*a sort of tiara of which a fabric of pearls, sprinkled with rubies and emeralds, formed the border. An aigrette of gems was placed on the front of this headdress, and above it rose three heron plumes*', while the Englishman Lord Curzon described the crown in 1889 as '*the mighty head piece, pearl-bedecked, and with flashing jika or aigrette of diamonds in front.*'

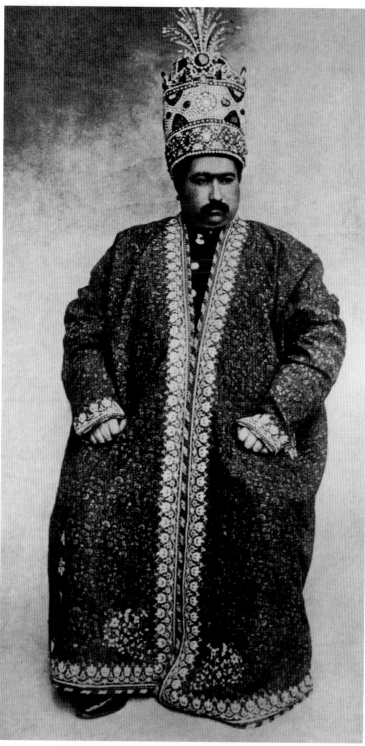

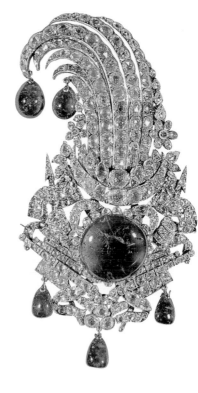

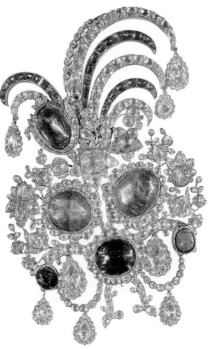

Left:
19.1.1907; coronation of Mohammad Ali, Shah of Persia.
Photo collection René Brus

Top right:
This *aigrette* is known as the *Nadir Shah Jiga*, referring to the Emperor of Iran. With a length of 12.8 cm, it depicts in minuscule diamonds a cannon, spears, drums and banners tied together with a ribbon shaped decoration. Gold, diamonds and emeralds; probably made end of the 18th century.
Collection and photo National Bank of Iran, Teheran, Iran

Bottom right:
Jiga of Fath Ali Shah of Persia. Gold, diamonds, emeralds, spinels and rubies; made circa 1800. Regarded as a favourite of Fath Ali Shah, since it is depicted attached to the Kiani Crown in many of his major portraits.
Collection National Bank of Iran, Teheran, Iran
Photo Bank Markazi Iran, Teheran, Iran

Opposite page:
Crown of Emperor Fath Ali Shah of Persia. Gold, pearls, diamonds, emeralds and spinels; made in 1798.
Collection National Bank of Iran, Teheran, Iran
Photo Bank Markazi Iran, Teheran, Iran

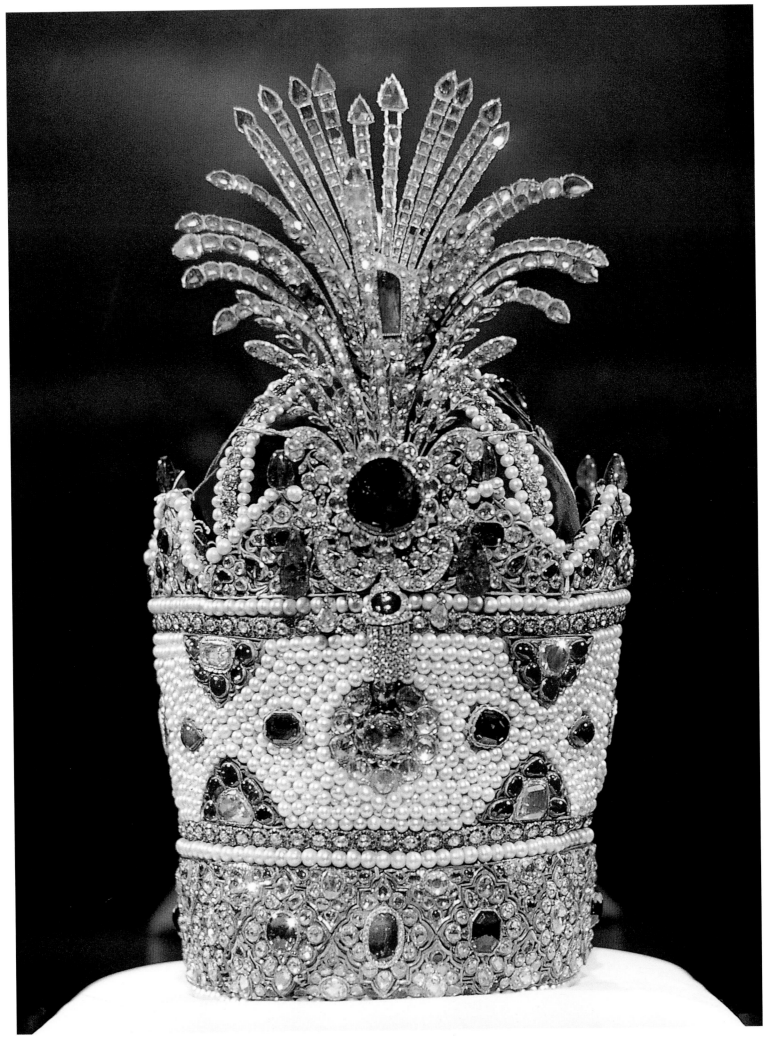

From cidaris to crown

In ancient Persia, the *cidaris* was a head covering that could only be worn upright by the sovereign, whereas others – including the heir to the throne – wore a similar head-covering at an angle. Similar high, tapering cylindrical head coverings, mostly made of fabric, were worn for thousands of years by the high priests of the Old Testament. Functionaries in the Greco-Roman era also wore a conical cap called the *frigium*, or Phrygian cap, as a sign of power. Numerous types of secular and religious headdress have developed from these different head coverings, for instance the papal tiara and the *saghavard*, the high, bulbous headdress worn by Armenian clergymen.

to restore the old order in Hungary, which included Transylvania; the Crown of Sultan Ahmed I was taken as booty and brought to the treasury of the Hofburg Palace in Vienna. The crown has its own case made of wood and covered with Persian silk brocade that shows a woman reading in a garden with a youth offering her a vessel. The book that the woman holds is signed with the word GHYIAS, the name of an artist who worked at the court of the Persian Shah Abbas I the Great (1588-1629) towards the end of the 16th century. This lead to speculation as to whether this crown was actually made in Turkey, or if it had originally been a gift from Persia to Turkey.

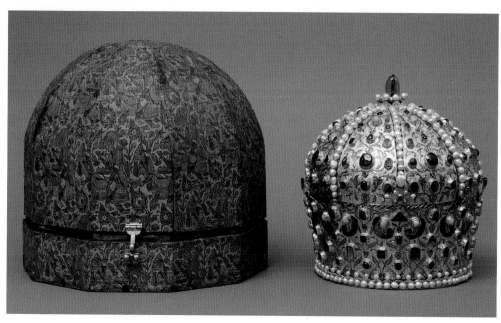

One of the oldest surviving crowns with its shape originating from the Persian *cidaris* is the one that Sultan Ahmed I of the Ottoman Empire presented to István (Stephan) Bocskay, Prince of Transylvania, in 1605. This gift by the sultan was seen by the Turks as a present to his vassal, and by the prince as a token of acknowledgement. The sphere-shaped crown, which is completely closed at the top, is adorned with rubies, emeralds, pearls and turquoises, the delicate blue stone that is a favourite in the Near East. Although the crown is of Islamic origin, a small cross is attached to the front of the headband. It appears that this symbol of Christianity was added by István Bocskay. The prince did not accept the rule of the Emperor of the Holy Roman Empire, Rudolf II, and mounted an insurrection against him. After Rudolf's death in 1612, the next Emperor Matthias tried

Mr A. D. Tushingham of the Canadian Royal Ontario Museum made a detailed study of the Iranian treasury in the 1960s. Among the many objects, he saw the frame of a crown that was ascribed to Agha Muhammad Khan, the founder of the Qajar dynasty, who was crowned in 1796. The shape of the crown is circular, slightly convex-sided with a domed top that, unlike the Crown of István Bocskay, terminates in a knob finial. This fully enamelled crown frame is made of copper, lined with leather and padded. Most of the enamelling would have been originally covered by jewelled decorations, including pearls. These were removed to be used in a new crown crafted in 1798 for the coronation of Agha Muhammad Khan's nephew and successor, Fath Ali Shah (1797-1834). This new crown became known as the Kiani Crown of the Qajar dynasty.

Left:
Crown given by Sultan Ahmed I of the Ottoman Empire to Prince István (Stephan) Bocskay of Transylvania. Gold, rubies, turquoises, pearls, emeralds; made end of the 16th, beginning of the 17th century.
Collection Treasury Hofburg, Vienna, Austria
Photo Kunsthistorisches Museum, Vienna, Austria

Right:
Crown frame of Emperor Agha Muhammad Khan of Persia. Copper, enamel; made circa 1796.
Collection Golestan Palace Museum, Teheran, Iran
Photo A. D. Tushingham, Toronto, Canada

From fez to crown

In the Islamic world, the *fez* or *tarboosh* is the predominant head cover. It is fashioned from truncated felt and usually adorned with a black tassel. The name *fez* originates from the city of Fez in Morocco, an ancient religious and political centre of Islam. The *fez* can be worn by Muslim worshippers while touching the ground with the forehead during prayer because it does not have a rim on the front. With the spread of Islam, the *fez* travelled to different countries where similar head coverings developed and were given local names. On the Indonesian island of Java, they are called *kuluk*, while on Sumatra they are known as *songkok*. When a white piece of cloth is wound around the base of a *fez*, a kind of turban is created.

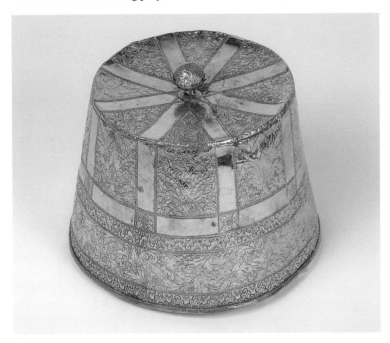

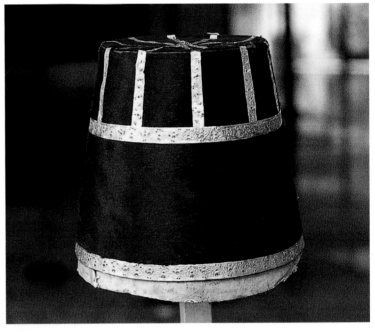

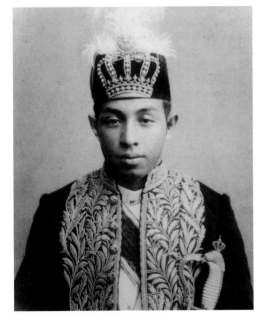

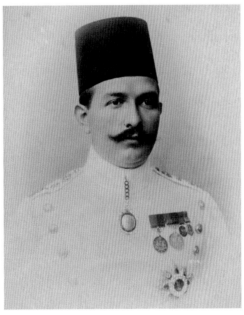

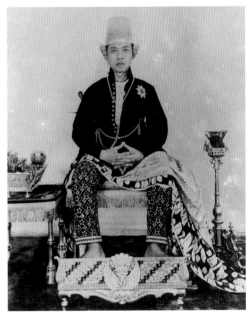

Top left:
Gold *Kuluk* from the Sultanate of Demak; made probably in the 16th century.
Collection and photo Tropenmuseum, Amsterdam, The Netherlands

Top right:
Kuluk berdji of Sultan Hamengku Buwono IX of Yogyakarta. Gold, diamonds and velvet; made circa 1940.
Collection the Sultan of Yogyakarta
Photo René Brus

Bottom left:
Circa 1900; Sultan Sharif Yusuf of Pontianak wearing a *fez* or *songkok* shaped headdress. The design of his diamond studded golden *aigrette* is adopted from the crown on the royal coat-of-arms of The Netherlands.
Photo collection René Brus

Bottom middle:
Beginning 20th century; Abbas Hilmi Pasha II, 7th and last Khedive of Egypt.
Photo collection René Brus

Bottom right:
18.3.1940; enthronement of Sultan Hamengku Buwono IX of Yogyakarta.
Photo collection René Brus

According to Brunei tradition, Sharif Ali, an Arab missionary directly descended from the Prophet Muhammad, married Puteri Ratna Kesuma, the daughter of Ahmad, the second Sultan of Brunei, in the beginning of the 15th century. As the sultan had no male heirs, he agreed that his son-in-law should be his successor. When Sultan Ali was enthroned in 1425, it is believed that he wound a piece of cloth around the rim of the crown as a reminder of his roots. The shape and decoration of his crown remained unknown until May 1906, when his descendant Sultan Muhammad Jamalul Alam II was crowned and the very first photograph of a Brunei ruler wearing his golden crown was taken. On that historic day, it became clear that the sultan wore a crown in the basic shape of a skullcap, with an embossed rim resembling a cloth turban similar to the oral tradition of Sultan Ali's Crown. When Mr M. S. H. McArthur, the first British Resident in Brunei, saw the sultan privately after the coronation at the palace, he 'had an opportunity to examine the regalia, and particularly the crown. I remarked that it was very heavy and that I feared His Highness must be tired, to which he replied that it weighted about 5 or 6 katies but on such a day it was as light as a feather'. Besides precious stones, eight spectacular tree-like structures adorn the rim of the Crown of Sultan Muhammad Jamalul Alam II, each consisting of three leaves with hanging pendants. There are also two pieces of jewellery attached to the rim of the crown in such a manner that they decorate the ears. The custom of piercing the ruler's ears has almost disappeared in south-east Asia, but some dynasties have kept impressive ear decorations as an integral part of the royal headdress.

During the 20th century, each successive sultan of Brunei has ordered a new crown and worn it on the day of his coronation. When Sultan Omar Ali Saifuddin III of Brunei abdicated in favour of his eldest son and heir on 5 October 1967, a workshop was set up in the Darul Hana Palace where goldsmith Pehin Abdul Rahman, a member of the Brunei nobility, designed and crafted the new sultan's crown with the assistance of the Singapore jeweller S. P. H. De Silva. The goldsmith brought symbolism to the skullcap, such as repoussé rice shafts to signify opulence and prosperity for the country. The entirely gold crown is set with numerous rubies, sapphires and diamonds as well as pearls, which were used in numbers significant in Islam in accordance with Malay tradition. The six pearls that topped the diamond *aigrette* (crafted by De Silva) denote the six pillars of 'iman', while the 99 sapphires set on the rim stand for the 99 virtues of the Islamic religion synonymous with the 99 names of Allah. An intricate feature is the miniature three-tiered umbrellas, which are a mark of the highest rank in south-east Asia. Referred to as *Payung Ubor-Ubor Tiga Ringkat*, the three umbrellas, descending in size, represent supremacy, glory and bravery. This 20th-century crown also upholds tradition in having an embossed representation of a turban at the rim, thus honouring the Crown of Sultan Ali.

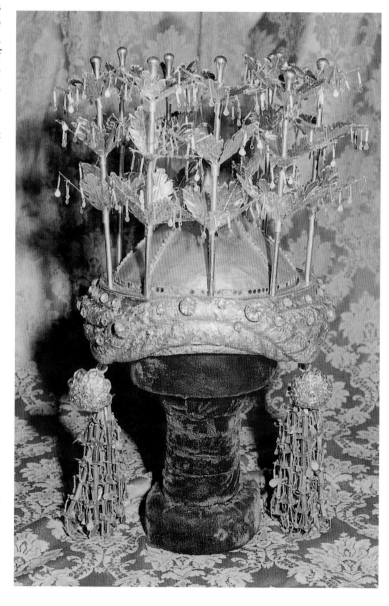

Crown of Brunei.
Gold, diamonds and turquoises; date of manufacture unknown, probably in 1918.
Collection the Sultan of Brunei
Photo collection René Brus

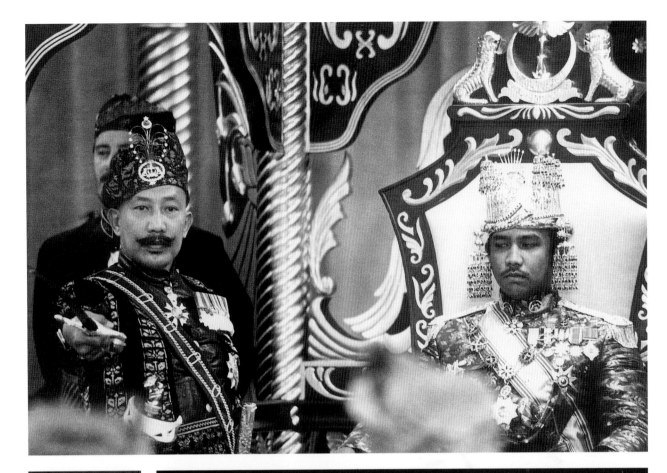

1.8.1968; coronation of Sir Muda Hassanal Bolkiah Mu'izzaddin Waddaulah as the 29th Sultan of Brunei.
Photo Radio & Television Brunei, Bandar Seri Begawan, Brunei

Crown of Sultan Sir Hassanal Bolkiah Mu'izzaddin Waddaulah of Brunei. Gold, diamonds, rubies, sapphires and pearls; made in 1968 by goldsmith Pehin Abdul Rahman and the Singapore-based jeweller S. P. H. De Silva.
Collection the Sultan of Brunei Photo collection René Brus

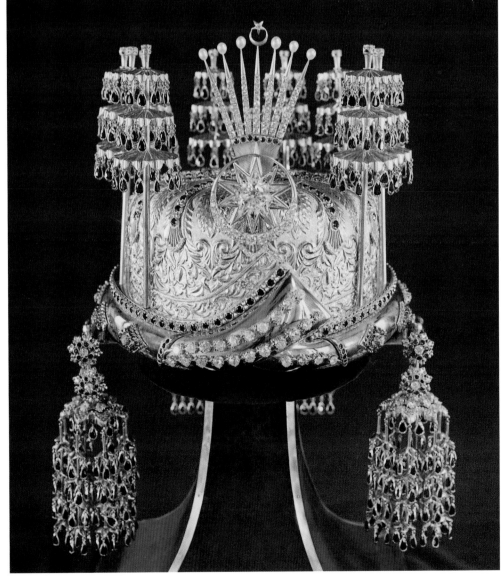

From cloth to crown

The method of decorating the head with a cloth head covering is found in many regions of the world, especially where men and women wear their hair long and fasten it in a knot with a strip of cloth. When rulers began to use their cloth headdresses as a status symbol, ordinary people were often forbidden to wear head coverings that were similar in form, colour or material. Once intricate, gem-studded ornaments became an essential part of a royal headdress, their value and imposing appearance became of great importance to the outsider. For a local, or an expert, the manner in which the cloth headwear was folded and wound was of much greater significance because this identified the different family groups, clans or even regions.

In India, the turban is made of several metres of cloth carefully wrapped around the head, and can be tied in a number of styles. A loose turban is referred to as *puggree*, while the *dastar* is a large white, wound turban worn by rulers up to the end of the 18th century. The different dynasties used numerous styles, such as the *peshwa*, worn by the Maratha dynasty, including that of Indore. In Rajasthan, turbans were tied in many styles, including the Bikaner, Bundi, Jaipur, Jaisalmer, Jodhpur and Kotah styles. Each style was specific to a particular state and the dynasty that ruled it.

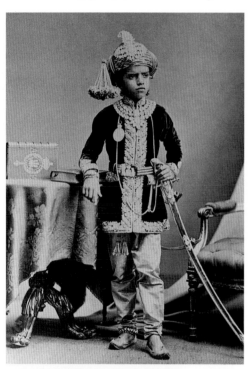

Top left:
Circa 1875; Gaekwar Sayaji Rao III of Baroda. Photo collection René Brus

Top right:
Turban or *puggree* of the Gaekwar of Baroda with *sarpech* and *tuar*. Gold, diamonds and enamel; made before 1875. Collection the Gaekwar of Baroda Photo Oriental and India Office Collections, London, England

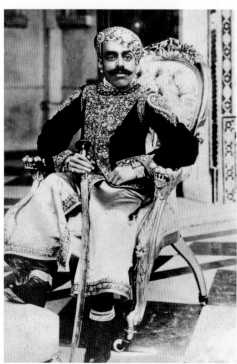

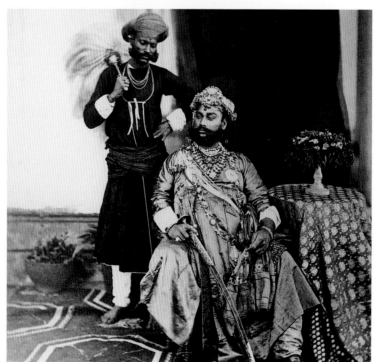

Bottom left:
Circa 1935; Sir Bhopal Singh, Maharana of Udaipur. Photo collection René Brus

Bottom right:
Circa 1880; seated Tukoji Rao II, Maharaja Holkar XI of Indore. Photo collection René Brus

The royal head-cloth worn by Malay rulers is made of the most elaborate or costly fabric available, namely *songket*, generally a square cloth with a broad patterned border worked in gold or silver thread, with single ornaments added at intervals on the remainder of the surface. Historically, at least one member of the royal household was trained in folding the cloth correctly, and had to know which shape was required for whom. In the Sultanate of Kelantan the *setangan* is worn, in Selangor the *tanjak* (*tanjok* or up-sticker), *saputangan* or *destar* while in Patani the head-cloth is folded in a style known as the *pemuntal* (the twisted). Nowadays the word *tengkolok* is generally given to this head-cover, a word that originates from the Sultanate of Perak where it means 'head wrapper'.

The Kingdom of Malaysia has a unique monarchy. Every five years, during the Conference of Rulers, a new constitutional monarch is chosen who, according to the constitution, 'takes precedence over all persons in the country and is not liable to any proceedings whatsoever in any court'. This system of an elected king was invented in 1957 when the British colony of Malaya became independent and had to choose between having a president or a monarch as head of state. The decision was made in favour of a kingdom because the country consisted of nine states; seven states had rulers bearing the title of sultan and two had elected chief ministers. Every newly elected king of Malaysia is invested with the appropriate ceremonies and, although not crowned, the king appears at his inauguration ceremony in royal splendour wearing the *Tengkolok di Raja*, the Royal Headwear, on which a diamond-studded jewel featuring the crescent and star is attached. The crescent is the symbol of Islam, the state religion of Malaysia, and the star has 11 points, a reference to the 11 member states of the new nation. The star is made of nine long and two short points symbolising the nine states with a ruler of royal birth and the two with a chief minister. These radiate out from a circle of 11 diamonds indicating the 11 member states. Three diamonds are set into each of the star's points,

indicating the population of the country: *orang asli* or 'original people', the Malays and other residents like the Chinese and Indians. The coat of arms of the Kingdom appears in the centre of the jewel and is comprised of a star and a half Moon between rampant tigers. It is made from yellow gold and is set on a green enamel background. Green is the traditional colour of Islam and represents paradise. In 1963 the states of Sabah and Sarawak joined Malaysia and the Wilayah Persekutuan Kuala Lumpur (the Federal Territory Kuala Lumpur) was created in 1974. The Kingdom was no longer made up of 11 states but it would not be until 1984 that the King's *aigrette* was changed from an 11-point to a 14-point star and three diamonds were added to the original 11 in the crescent.

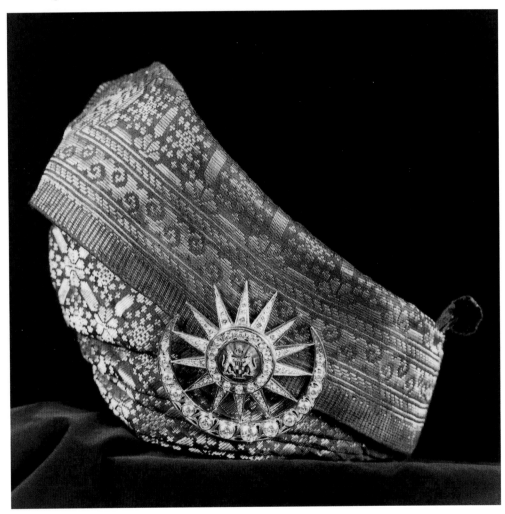

Tengkolok of the Yang di-Pertuan Agong of Malaysia. Platinum, diamonds, enamel and *songket* cloth; made in 1957 by the London-based jeweller Garrard, altered in 1984 by the same company.
Collection the State of Malaysia Photo Information Department, Kuala Lumpur, Malaysia

When Sultan Ahmad Shah of Pahang was crowned on 5 May 1975, his traditional head-cloth was enriched for the first time with an 18-carat white and yellow gold frontlet. This was set with diamonds weighing a total of 58 carats, the centre featuring the Pahang state crest, set in minute diamonds. This *tengkolok* is folded in the style of *Chogan Daun Kopi* or 'coffee leaf emblem', a style created in the 19th century during the reign of Wan Ahmad, the 9th Bendahara of Pahang. It was made to remind him of the occasion when he was fighting for the throne and his fortunes were at such a low ebb that he and his followers could only afford to drink black unsweetened coffee.

The coronation crown used by Sultan Mahmud of Terengganu on 21 March 1981 is composed of a *tengkolok* or *tanja* onto which a gold and platinum frontlet is attached. The entirely diamond-set ornament is decorated on the rim with five-pointed stars and crescents as symbols of Islam, while the centre of the crown is composed of the state crest of Terengganu surrounded by a sunburst wreath.

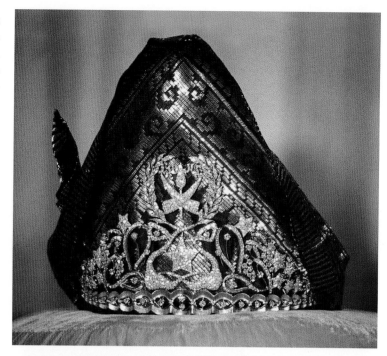

Crown of Sultan Ahmad Shah of Pahang. Platinum, gold, diamonds and *songket* cloth; made in 1975 by the Singapore jeweller S. P. H. De Silva.
Collection the Sultan of Pahang, Malaysia
Photo René Brus

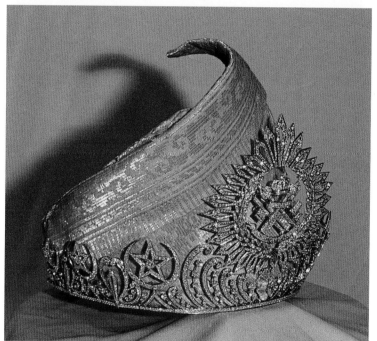

Crown of Sultan Mahmud of Terengganu. Platinum, gold and diamonds; made in 1980 at Garrard, London, by Henry T. Phillips.
Collection the Sultan of Terengganu, Malaysia
Photo René Brus

From hat to crown

For the Basotho people in Lesotho, a hat is needed to protect them against the blazing Sun. Their traditional hats are known by different names, such as *thoro*, *mokorotho* and *molianyeoe*. Usually these hats are made by men and herd boys, who use grass such as the flexible *loli*, the *mosea* and root fibres of the *lesuoane*. According to local tradition, this kind of headgear was introduced at the end of the 18th century as a rain hat by Molumi, a Kwena chief. These hats are made in different styles, such as the *khaebana* and *molianyeoe* (translated from Sesotho to English, *moliea* means 'to fall' and *nyeoe* 'case'). The latter is regarded as an important badge worn by the nobles of the Basotho, particularly when they had to judge court cases. Over the years, this striking head covering has become not only the national symbol of the Kingdom of Lesotho, but has also served as the model for the Crown of King Moshoeshoe II.

In 1972, the Government of Lesotho ordered a crown by the London jeweller Skinner & Co. based on the shape of the *molianyeoe*. Eighteen-carat gold was used, and the crown took almost six months to make. When it was ready, the King realised it was too heavy to wear, so a new, lighter crown was made from gilded silver. The front of the crown is decorated with the image of a crocodile in remembrance of the founder of the nation of the Basotho, King Moshoeshoe I (died in 1870), who was born end 18th century in the Bakoteli lineage – a branch of the Kuena (crocodile) clan.

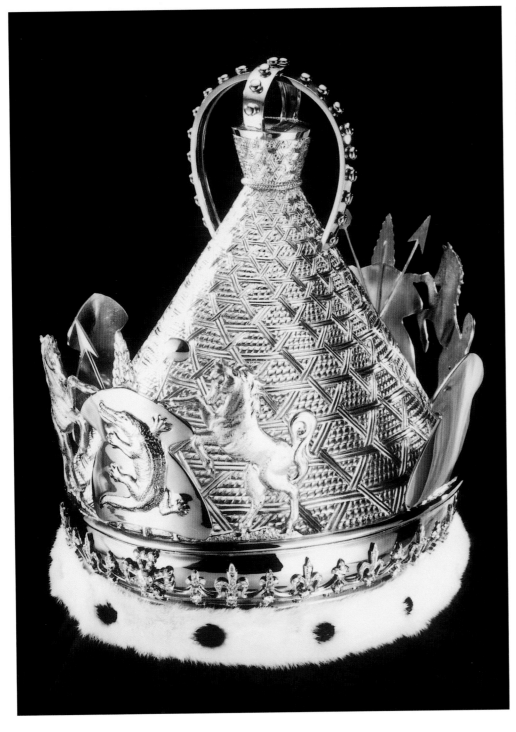

Bottom left:
14.5.1976; King Moshoeshoe II of Lesotho arrives at the Parliamentary buildings in Maseru to open the Lesotho Interim National Assembly wearing the new crown in public for the first time.
Photo The Friend, Bloemfontein, South Africa

Right:
Crown of King Moshoeshoe II of Lesotho. Gilded silver and diamonds; made in 1972.
Collection the King of Lesotho
Photo Skinner & Co, London, England

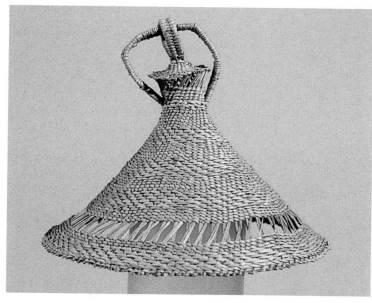

Molianyeoe of the Basotho people, woven in the *Khaebana* style Grass and roots; made in the 1970s.
Collection and photo René Brus

Left:
12.7.2000; a man from Mongolia wearing his traditional headdress during the Naadam festival at Ulan Bator.
Photo by Tony Dusamos, The Netherlands

Right:
First rank concubine's winter crown. Gold, pearls, silk and fur; made in the 18th or 19th century.
Collection and photo National Palace Museum, Taipei, Taiwan, The Republic of China

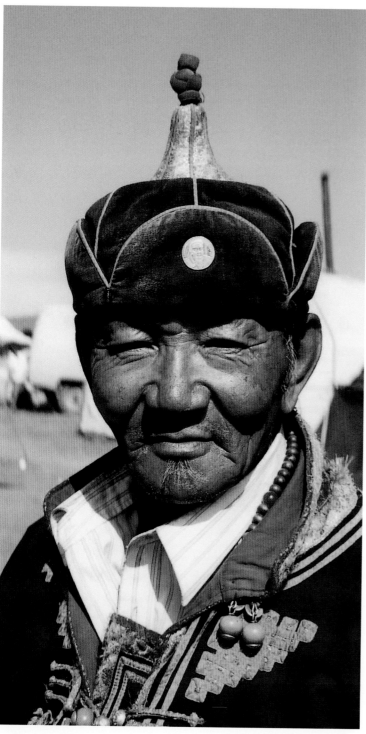

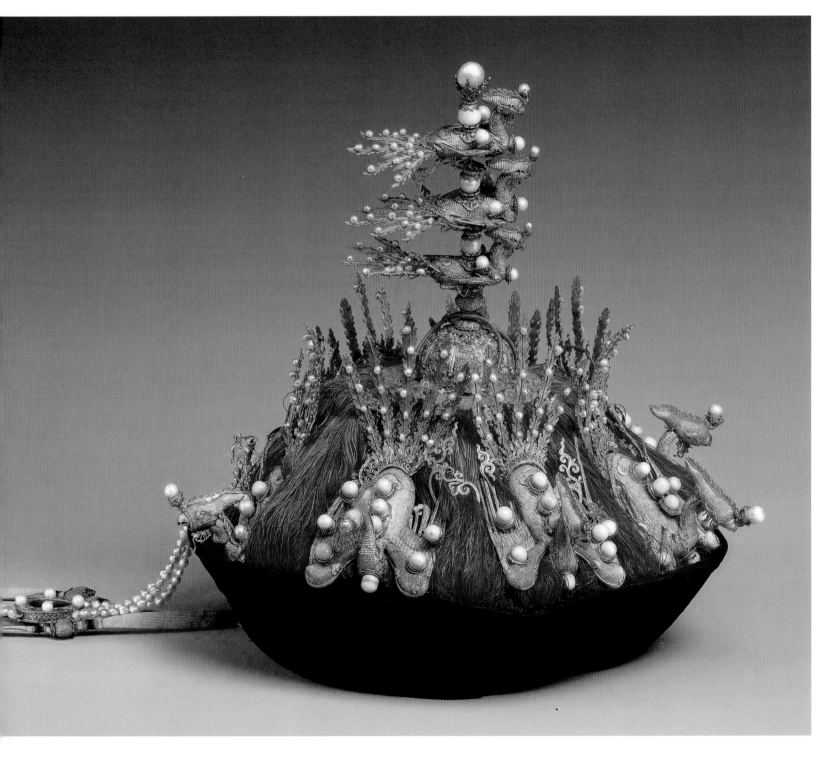

Feathers

Aeons ago, a feather in the unkempt hair of a primitive man may have marked his position of honour or chieftainship. The feather of a powerful bird, or one which was impressive due to its colour, size or design, was chosen: the bright red and yellow of the parrot, the bronze-green of the quetzal, the fluffy white of the ostrich, the heavenly blue of the kingfisher, or the tall, striped feather of the argus pheasant, whose loud cry can be heard throughout the hilly forest of Borneo – a beautiful bird that is so shy few have seen it alive. Feathers can be just as costly as precious stones, especially when the birds they belong to are rare or even extinct. The possession of significant feathers has become a requisite for ruling in some cultures and an important part of ceremonies in others.

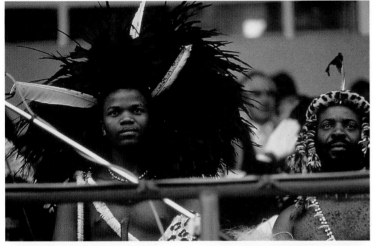

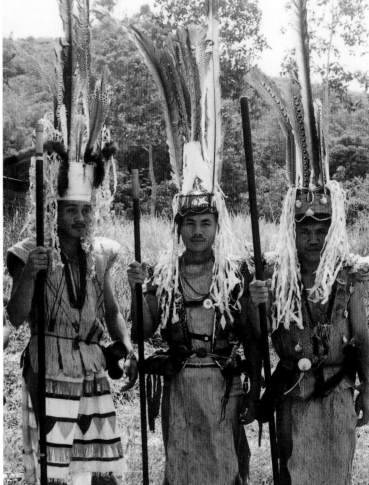

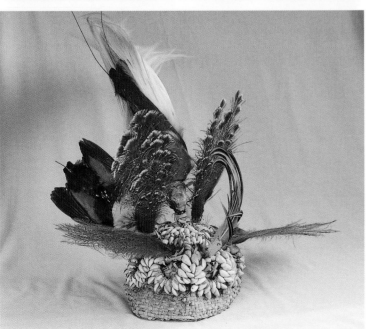

Left, top and middle:
25.4.1986; coronation of King Mswati III of Swaziland. During this historic event the 18-year-old king was adorned with a headdress with three large white feathers and red wing feathers of the knysna lourie bird. The next day, during a formal presentation to his people, a large black feathered headdress was added to the coronation headdress.
Photo Swazi National Administration Secretary, Kwaluseni, Swaziland

Bottom left:
A warrior headdress worn by one of the indigenous people of Papua New-Guinea. Made of fibres from the nipah palm, cowrie shells and feathers from several species of tropical birds, including the bird of paradise and the goura pigeon; made at the end of the 19th or beginning of the 20th century.
Private collection
Photo René Brus

Right:
Murut warriors, Sabah, feathers of the hornbill and great argus pheasant.
Photo Muhd. Yusuf Abu Bakar, Sabah, Malaysia

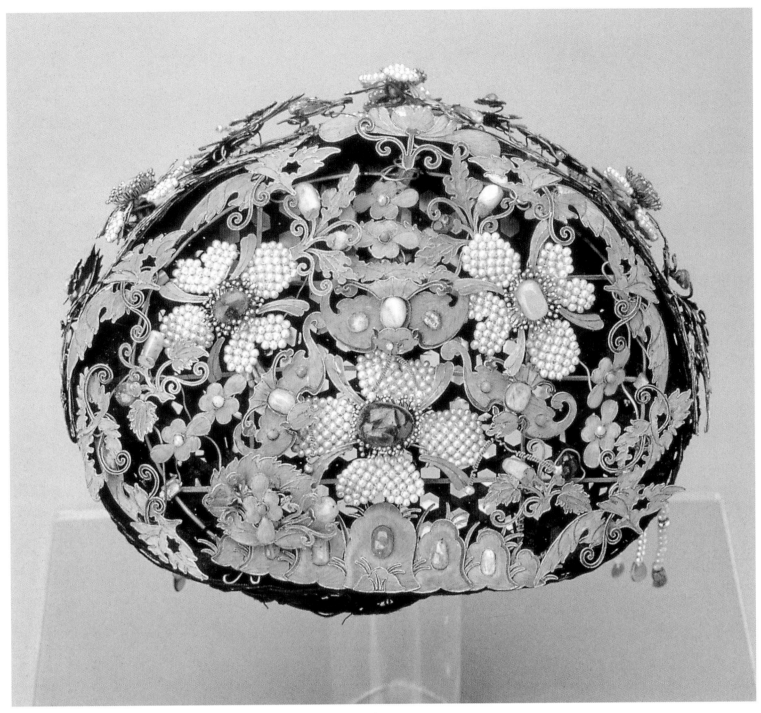

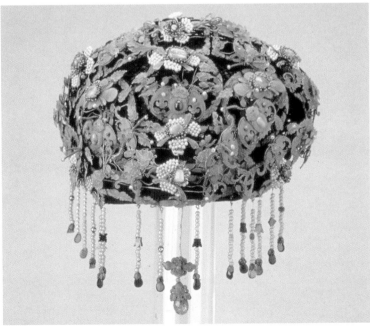

Tanzi or headdress worn by a Chinese lady of high birth. Silver-gilt, gold, pearls, precious stones, paste, and kingfisher feathers. Qing dynasty (also known as Ch'ing dynasty) 1644-1911. Collection and photo Hong Kong Museum of Art, Kowloon

The Crown of the Sultan of Ternate is adorned with feathers of the cassowary (*casuariidae casuarius*), a flightless bird resembling an ostrich. Some locals regard the feathers as human hair and associate them with the wings of the heavenly *bidadari* or nymphs. Legend has it the nymph Nurus Safa bore four sons for a certain Jafar Sadet. The youngest son, Mashurma-lama, became the first ruler of Ternate and received this headdress, locally known as *stampal*, from his maternal grandfather, Lord of Heaven, who resided in the World of Gods. Every newly crowned sultan has to visit Rua, the oldest settlement on Ternate, wearing his crown. This allows his subjects to see that this important relic is still kept on the island and that the feathers have regained their original black colour, since it is believed that when a sultan of Ternate dies, the black feathers turn white until an eligible successor is crowned.

Historically, the feathers on this crown were the centre of attention during celebrations to mark *Eid al-Adha*, an Islamic festival that takes place during the *Hadj*, the Muslim pilgrimage to Mecca. During this festival, which lasted for seven days and seven nights, the sultan presided over a ceremony in which parts of the feathers in the crown were cut. The pieces of feathers were then distributed to local fishermen, who were believed to catch more fish if they held their fishing rod in one hand and a piece of royal feather in the other. Tradition claimed that the feathers on the crown would grow back during the following year and thus the ceremony could take place indefinitely.

For those who did not accept that the Crown of Ternate originated from Heaven, it was said that goldsmiths from Tobuku created the royal headdress many centuries ago, influenced by the culture and fashions displayed by visiting Europeans. Whatever the origin of this mighty crown, today it is not just an object put on display in a glass case. Every Thursday evening, members of the sultan's family gather in the *Kamar Pudji*, the treasury room of the palace, to pay homage to the crown by offering colourful flowers, leaves and incense. It is believed that if this practice stops, all the grandchildren of the custodian of the crown will die and the royal dynasty of Ternate will cease to exist.

Left and middle:
1930s; photo and painting of Sultan Iskandar Mohamad Djabir of Ternate.
Collection Kedaton museum/The Sultan of Ternate, Indonesia
Photos René Brus

Right:
Stampal or Crown of the Sultan of Ternate. Feathers of the cassowary, gold, precious and semi-precious stones and paste. It is believed that several of the precious stones, such as the emeralds, were replaced by paste in the 1950s. Parts of this crown date back to the 16th century.

Collection Kedaton museum/The Sultan of Ternate, Indonesia
Photo Chris van Fraassen, Bureau Indonesische Studiën, Leiden, The Netherlands

In the Kingdom of Lesotho, there is a long-standing tradition that the ruler of the Basuto people receives a beaded headband with a single feather upon his investiture. This blue feather symbolises protection from his enemies and comes from a blue crane that is known locally as the *Mohololi*. The headdress used to crown *Motlotleki* (King) Letsie III of Lesotho on 31 October 1997 was made of a strap embroidered with beads of different colours that dated back to King Moshoeshoe I the Great, who died in 1870.

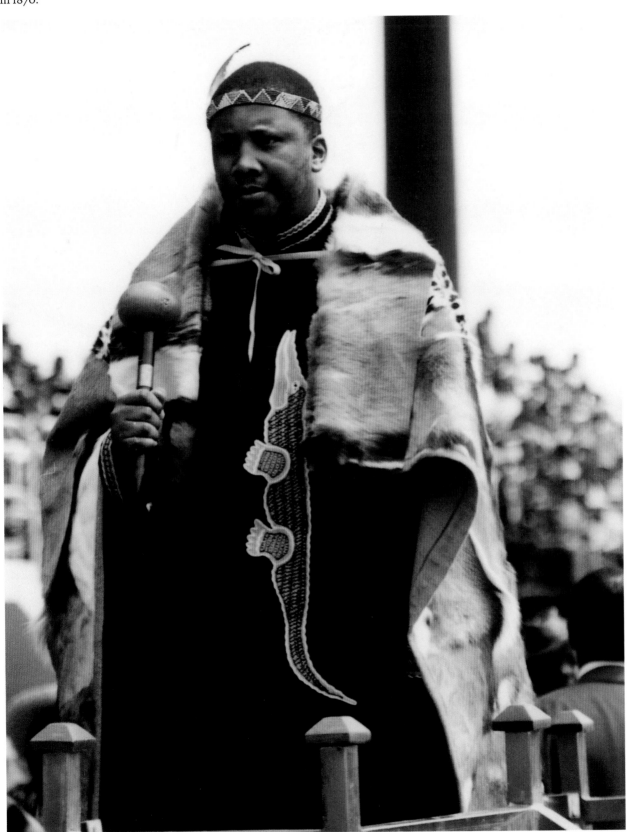

31.10.1997; coronation of King Letsie III of Lesotho. Department of Information, Maseru, Lesotho

In Cameroon, the Bamileke people regard the feathers of parrots to be pre-eminently suitable for the *ten* or *mansah*, which is a crown worn by the ruler and eight of the most important men in his realm. The feathers used originally were of different lengths and different colours. Since these parrots are becoming scarce, chicken feathers, dyed in the necessary colours, have become a substitute. The feathers are set into small tubes of straw, which are all tied together in a circle so that the feathers stand up high. The headdress is crafted in such a way that when it is put on, the feathers separate, spreading out in to become an enormous, elaborate waving crown.

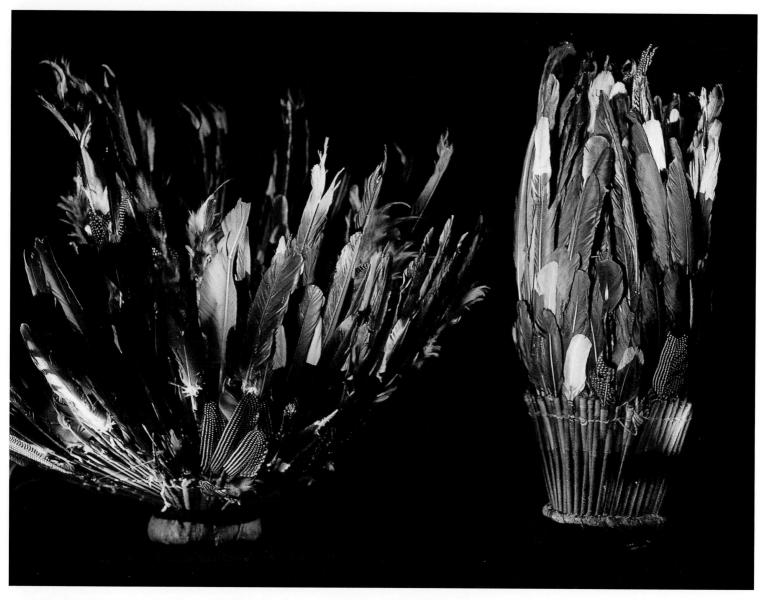

Crown of high-ranking men of the Bamileke people. Feathers, pre-eminently parrot feathers; made end of the 19th, beginning of the 20th century.
Collection and photo Wereldmuseum, Rotterdam, The Netherlands

Herman Cortez, a conquistador in Mexico, gave this impressive headdress to Emperor Karl V of the Holy Roman Empire around 1520. Emperor Karl V gave it to his brother, Ferdinand I. The headdress was placed in Ferdinand's collection of art and curios at Ambras, his castle near Innsbruck. The headdress only re-emerged in 1878 when it was discovered in a cupboard in a palace in Vienna. Unfortunately the headdress was moth-eaten and decaying. By the time restoration began, the cotinga – the source of the blue feathers – was extinct. Feathers of the kingfisher were used instead. The original headdress was made from the green feathers of the quetzal. Each bird only grows two (or at the most four) such feathers. It is estimated that no fewer than 500 birds were needed to supply enough feathers for this gigantic, 150 cm-wide headdress. Although attempts have been made to have this crown returned to Mexico, the original is still in Vienna. A replica was created and put on display in Mexico.

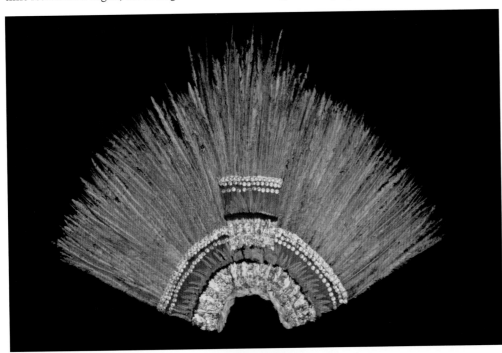

Penacho or alleged original Crown of Montezuma II, the Aztec Emperor. Gold, restored with kingfisher feathers; beginning of the 16th century.
Collection Museum für Völkerkunde, Vienna, Austria
Photo Kunsthistorisches Museum, Vienna, Austria

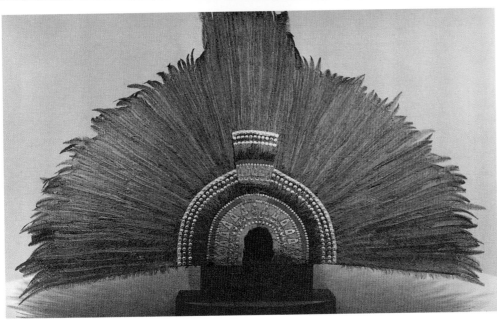

Replica of an ornament in the possession of the Museum für Völkerkunde, Vienna, which is often referred to as the *penacho* or Crown of Montezuma II, the Aztec Emperor. Gold, long green feathers of the macaw and blue feathers of the kingfisher. This replica was a gift of the former president of Mexico, General Abelardo Rodríquez. Its construction was started in the 1930s by an unknown craftsman, under the direction of the historian Eulalia Guzmán, who had studied the original in Vienna, and was completed in the 1950s.
Collection and photo Museo Nacional de Antropología, Mexico City, Mexico

Birds

Humans have often granted special powers to birds. Some cultures regard birds as bringers of peace or disaster and they have often been seen as one of the few creatures that can reach the gods. Some birds have even been seen as steeds of the gods, like the peacock, upon which the Hindu god of war, Karttikeya, usually sits with his bow and arrow. In ancient China, it was believed that Xi Wang Mu, the Queen Mother of the West, rode to the Western Paradise on a white crane. The prestigious position of birds in some societies has naturally resulted in birds occupying an important position in the decoration of various crowns around the world.

The top of the King of Bhutan's Crown shows the head of a raven. This symbolises the raven-headed *Legon Dongchen*, which is the manifestation of Mahakala, the protective deity of the first temporal and spiritual ruler of the country, Ngawang Namgyal, who assumed the title of Shabdung (literally 'at whose feet one submits') in 1639. The raven's head is decorated with the Sun and crescent Moon, symbols of longevity, steadfastness and enlightenment, and is topped with the *norbu* or sacred gem, which symbolises accomplishment of just endeavours. It is believed that the wearer of a crown topped with a raven's head is protected by the deity. Every king of Bhutan, since this country adopted a hereditary monarchy in 1907, has worn a similarly decorated headdress.

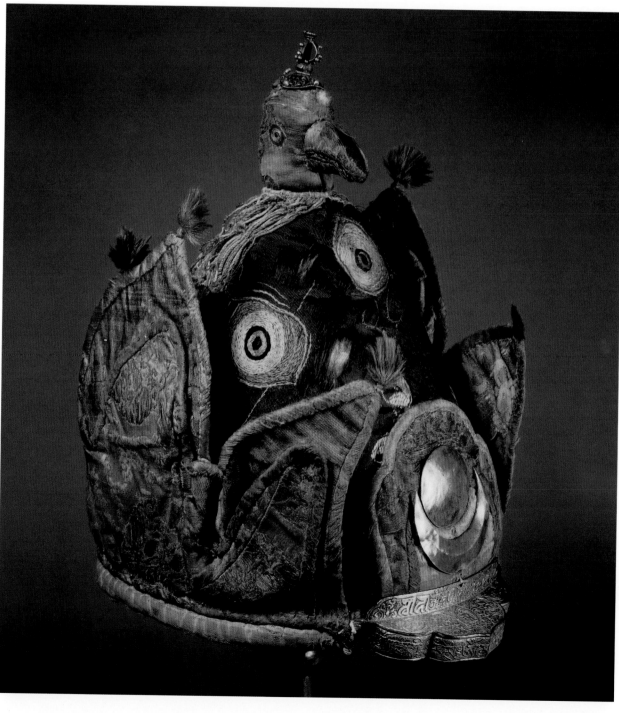

Usa Jaro Dongchen, the Raven Crown of Jigme Namgyal of Bhutan. Silver, cloth and embroidery; made in the 1820s.
Collection and photo National Museum of Bhutan, Ta-Dzong, Paro, Bhutan

In the complicated hierarchy of Yoruba rulers in West Africa, the image of a bird, the *okin*, tops the most important crowns. The *okin* represents the divine kingship of the ruler and his complicated magic communication with the gods, the *Orisha*. It is pointless to try to discover which species of bird the *okin* is modelled on, although some legends give a few clues. In the history of Benin, the *ahianworo*, or Bird of Disaster, might have been the ibis or hornbill. At the moment that King Esigye passed through the gates of his palace on his way to fight the ruler of Idah in 1515, a bird of 'evil omen' made discouraging sounds overhead. Soothsayers warned the King to call off the expedition since the omen meant he would certainly be defeated. The King ordered the bird to be killed and went on to win the battle. This event made it clear to many that the King was not subject to the fate of ordinary men (or birds).

Many crowns that have the *okin* on top possess magical powers and are surrounded by great symbolism. A Yoruba king will never look inside his crown because a horrible fate such as blindness or death will befall him, hence the new king is always crowned from behind or from the side. Many crowns decorated with birds also have faces on them. In many regions this alludes to the gods, 'who are all-seeing'. This is symbolic of the ability of the king to view all that occurs in his domain by supernatural means. Since the divine glance from a Yoruba king can be deadly to his subjects, a veil of beads is attached to the rim of the crown so that the face of the king remains covered during important ceremonies. In this way, the identity of the king remains hidden and his individual personality is replaced by the divine power of the dynasty.

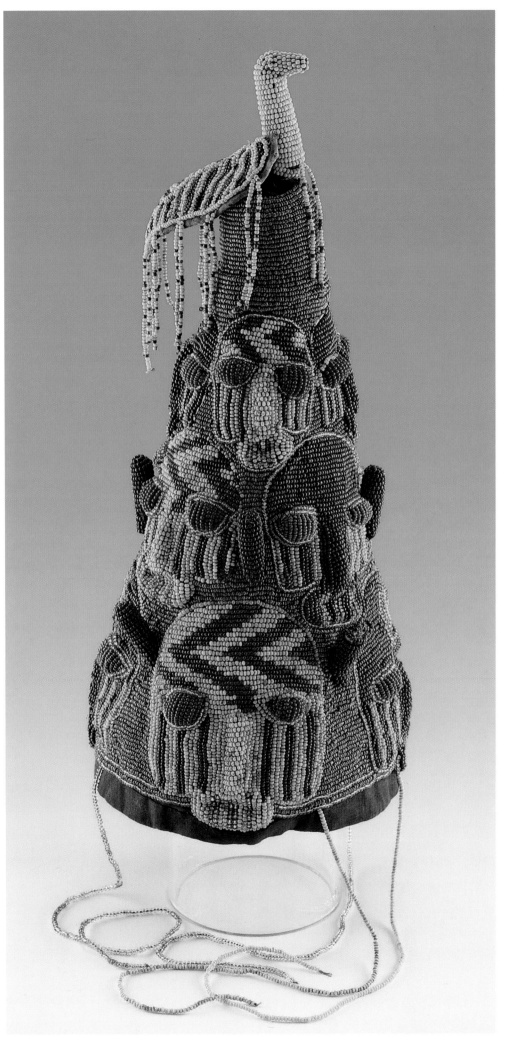

Crown of a Yoruba ruler. Wood, basketry, cloth and glass beads; made probably second half of the 19th century.
Collection and photo Museon Museum, The Hague, The Netherlands

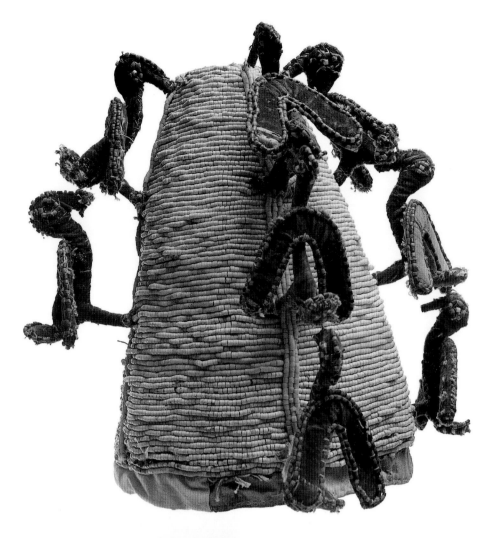

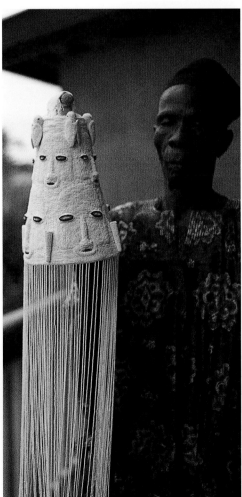

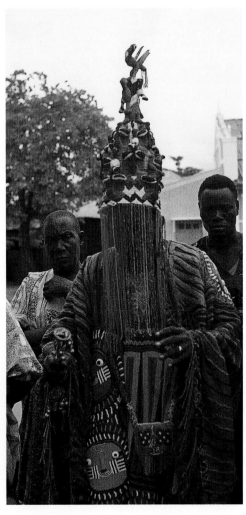

Far left:
Crown of the Osemawe
of Ondo-land. Glass
beads and wood;
made in the first half of
the 20th century.
Collection His Highness
the Osemawe of
Ondo-land, Nigeria
Photo René Brus

Left:
1976; Oba Ismail Idewu
Owojaje Soludero II,
Moloda of Odogbolu, in
regal attire and wearing
the coronation Crown of
Odogbolu.
Photo René Brus

Top left:
Yoruba Crown.
Cream-coloured cloth
over a brown bark
foundation and white
beads; made at the end of
the 19th century.
Collection Fowler
Museum of Cultural
History, University
of California,
Los Angeles, USA
Photo University
of California,
Los Angeles, USA

Above:
Circa 1900; King Akuffo
of Abrong wearing a solid
gold crown topped with
a bird with spread wings.
Collection
Linden-Museum,
Stuttgart, Germany
Photo by Lang

Crown of a Yoruba ruler. Wood, basketry, cloth and glass beads; made probably in the 19th century.
Collection and photo Museum of Ethnic Arts, University of California, Los Angeles, USA

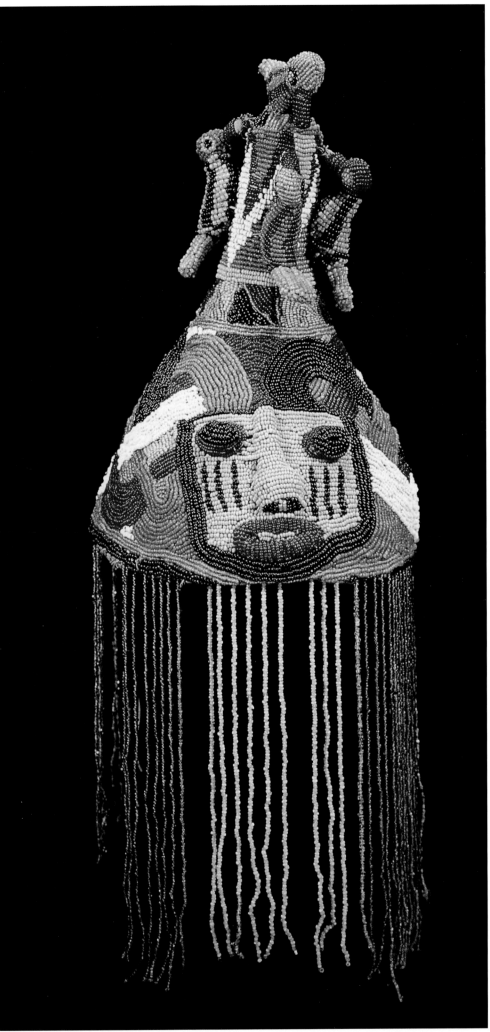

17.4.1971: coronation of Oba Ismael Idowu Owaje Soludero II, Moloda of Odogbolu, Nigeria.
Collection René Brus Photo G.T. Ojuri Photo Studio, Nigeria

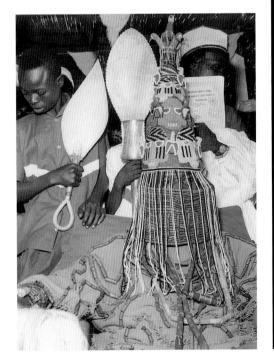

In Indonesian society, local traditions have blended with Islamic beliefs, sometimes contradicting one another. Before around 1751 when Wira Amir became the first Islamic ruler of Bulungan, taking the name Amiril Mukminin, his kingdom was ruled by an animistic Dayak dynasty. A crown was made during the Dayak dynasty that was typical of headdresses in Borneo. It was decorated with images from nature, including birds like the spectacular hornbill. For many Muslims, the representation of any animal or human is regarded as *haram*, 'not suitable'. Since the Sultan of Bulungan is ruler of two groups of subjects – Islamic and animistic – and because in Indonesia royal heirlooms or *pusaka*, even those inherited from a previous dynasty, should be treated with respect, Amiril Mukminin and his successors continued to use this crown at important court ceremonies. But the presence of a bird 'flying' on wire spring above the Crown of the Sultans of Bulungan might explain why it has never been worn and why it is carried on a cushion during court ceremonies.

One of the most important talismans of the Merina dynasty of Madagascar, the *Ingahibe* idol, was described by a certain Rainivelo on 9 September 1869 *as being in the shape of a bird with access to all the most potent magic in the realm.* That is probably why the crown with which King Radama II crowned himself on 23 September 1862 is topped with a bird with spread wings. This bird is known as the *voromahery,* or falcon. The front of the king's crown has a plaque in the shape of a fan, made of seven lances. In Madagascar, lances are a symbol of royalty, while the number seven is a sacred number and represents completeness. Although there are no records indicating who made this crown, it is believed that it was made in France since it was a present from Emperor Napoléon III of France.

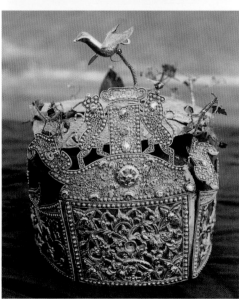

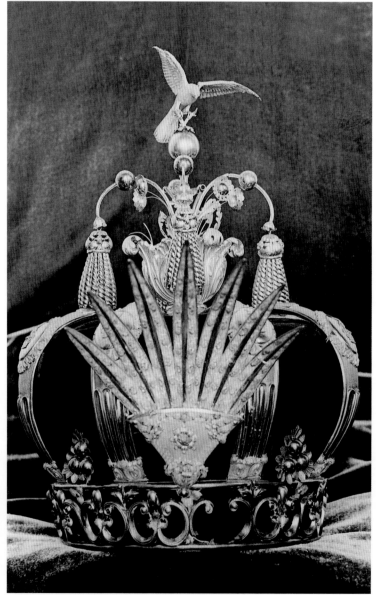

Top left:
Circa 1862; King Radama II of Madagascar, photographed by the missionary William Ellis.
Photo collection René Brus

Bottom left:
Crown of the Sultanate of Bulungan. Gold, silver, diamonds and rubies. The silver top part dates from the early 18th century, the golden crown dates from the 19th century.
Collection Bulungan Regional Government, Indonesia
Photo by Donald Tick, Vlaardingen, The Netherlands

Right:
Gold Crown of King Radama II of Madagascar. Made in 1862.
Collection Musée le Palais de la Reine, Antananarivo, Madagascar
Photo collection René Brus

Emperor Faustin I of Haiti was crowned on 18 April 1852 with a crown that had been made by the Parisian goldsmith Léon Rouvenat. The emperor was, like his predecessors Jean-Jacques Dessalines (crowned in September 1804 as Emperor Jacques I) and Henri I (crowned 2 June 1811), a great admirer of Emperor Napoléon I of France, who used the eagle as one of his most important symbols. It is therefore no wonder that the eagle was chosen as a major decoration in the Crown of Emperor Faustin I. Haiti was a French colony at the end of the 18th century but, with the French revolution of 1789, the slaves in Haiti revolted and the country achieved independence in 1804, the year that Napoléon I was crowned Emperor of France.

Although Emperor Napoléon III of France declined a formal coronation, unlike his uncle Emperor Napoléon I, he ordered crowns for himself and his wife, Empress Eugénie, and insisted that they include the eagle, thus honouring the founder of his dynasty. Both crowns, made by Gabriel Lemonnier, had eight arches supporting a globe with a cross. The arches were formed by four pairs of palm fronds and eight eagles with their wings stretched upwards. The major difference between the two crowns is their size. The emperor's crown was made to fit his head, while the empress's crown is only 10 cm in diameter and was worn on top of the head. Despite its small size, the crown of the empress is no less grand in appearance than that of the emperor, as it is set with no fewer than 1,354 brilliant-cut diamonds, 1,136 rose-cut diamonds and 56 emeralds. Many of the precious stones came from the French Crown Collection, but the goldsmith had to supply the rest, including eight large emeralds for the emperor's crown. In 1855, the year that both crowns were completed, they were put on display at the Universal Exhibition at Paris. The French monarchy ended in 1870 and the imperial couple went to live in exile in England. The Ministry of Finance decided a few years later that the crown of the emperor should be dismantled and the crown of the empress be given to her as financial compensation. After the death of Empress Eugénie in 1920, her godchild, Marie-Clotilde, Countess de Witt, born Princess Napoléon, inherited the crown. In the 1980s, a Mr Roberto Polo acquired the crown and, in 1988, he donated it to the Louvre Museum in Paris.

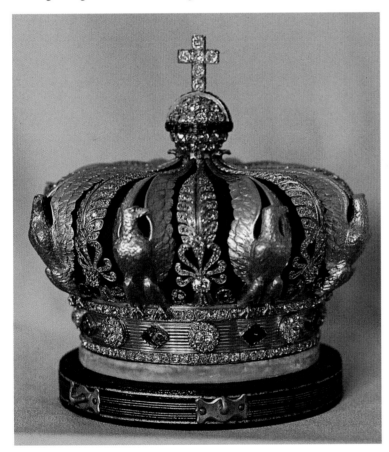

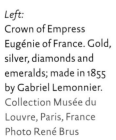

Left:
Crown of Empress
Eugénie of France. Gold,
silver, diamonds and
emeralds; made in 1855
by Gabriel Lemonnier.
Collection Musée du
Louvre, Paris, France
Photo René Brus

Right:
Crown of Emperor
Faustin I of Haïti. Gold,
diamonds, rubies and
sapphires; made in 1852
by Léon Rouvenat,
Paris, France.

Collection Banque de la
République d'Haïti,
Port-au-Prince, Haïti
Photo collection
René Brus

In Japan, crows are associated with ominous things, but for the Imperial family the figure of the three-legged crow, *Yata-garasu*, has a different symbolic importance. According to Japanese mythology, when the first Emperor, Jimmu Tenno, and his army became lost in the rugged mountains during an expedition to the east, a three-legged crow appeared from nowhere and led the way. With this guidance, the Emperor and his army were able to keep going and finally bring peace to the region. The legendary Emperor Jimmu Tenno, who ascended the Chrysanthemum Throne in the year 660 BC, was the offspring of Ninigi-no-Mikoto. Ninigi-no-Mikoto was the grandson of the Sun goddess Amaterasu Omikami and was sent to earth to govern the land. The Sun symbolises the foundation of the Japanese Imperial Family. The phoenix is another significant bird for the Japanese Imperial House.

This mythological bird signifies an enviable state of perfect peace throughout the country. The three-legged crow, the phoenix and the Sun are held in the highest regard in Japan and are particularly significant on important occasions such as the enthronement of the Emperor. For many centuries, these three symbols have been used to decorate the benkan or crown of the emperor and empress. The Shosoin Treasures in the city of Nara include fragments of an imperial crown from the Nara period of Emperor Shomu in the 8th century. These have been used as design templates whenever a new crown has been needed. Using the fragments in this way ensures that the original spirit of the 8th-century crown are maintained even though the shapes of the decorations or the use of colours might change. The essential mythological symbols of the birds and Sun have always been present.

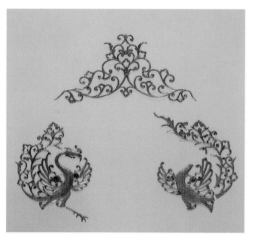

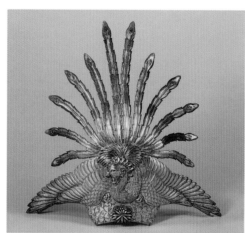

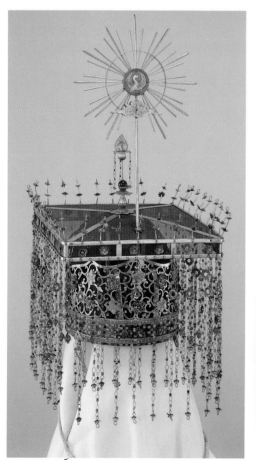

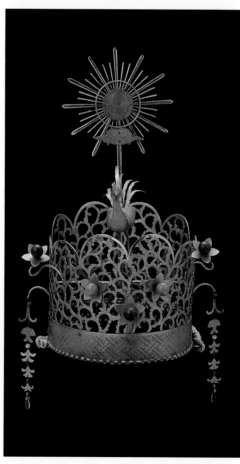

Top left:
Fragments of the Crowns of Emperor Shomu (reigned 724-729), Empress Komyo and Empress regnant Koken (reigned 749-758 and 764-770). Gold, silver; believed to have been made in 752 for the grand consecration ceremony for the Great Buddha of the Todai-ji temple in Nara.
Collection Shosoin Treasure House, Imperial Household Agency, Nara city, Japan
Photo Benrido Co. Ltd, Kyoto, Japan

Bottom left:
Crown or *benkan* of Emperor Komei. Gilt bronze, glass, lacquered fabric; made during the reign of Emperor Komei, who died in 1867.
Collections Gyobutsu Imperial collections (Imperial properties), Tokyo, Japan
Photo by courtesy of the International Society for Educational Information, Tokyo, Japan

Top right:
This *hoo no gosaishi* head ornament in the shape of the mythical phoenix has been worn only once, by Empress Shoken in 1889 during the proclamation ceremony of the Meiji Constitution by her husband Emperor Meiji. Gold, plated silver, diamonds; made in 1889.
Collection and photo Takakura Cultural Institute, Tokyo, Japan

Bottom right:
Crown or *hohkan* of Empress Gosakuramachi. Gold, gilded bronze, amber, turquoise; made during the second half of the 18th century.
Collections Gyobutsu Imperial collections (Imperial properties), Tokyo, Japan
Photo by courtesy of the International Society for Educational Information, Tokyo, Japan

Crown makers and replicas

Not only does it takes years before a crown maker has all the actual skills that are required to make a crown, but it usually takes a team of specialists to perform the work. Skilled goldsmiths and silversmiths, engravers, stone cutters, enamellers, furriers, milliners and other craftsmen work together to meet the demands of the client. In some countries, and in particular in the past, royal jewels were handled at a workshop in the palace grounds since the necessary materials, such as gold, silver, shells, beads and precious stones, came from the palace treasury. For most crowns made in the palace, a few of their makers' names are known, although in many cases only the names of the wearers are well documented.

Nowadays, a number of royal houses trust their crowns and other emblems of sovereignty to one person or company, who serves the palace for a long period of time. Many famous jewellers hold a Royal Warrant such as 'Court Jeweller', 'Crown Jeweller' or 'By Royal Appointment', although this does not necessarily imply that the company in question is actually responsible for creating, cleaning or restoring the crowns nor that a Mr or Mrs 'Cartier' or 'Garrard' actually sat at the workbench making them. Although the names of many of these excellent jewellers are associated with the provision of royal jewels to illustrious dynasties, it is generally an unknown craftsman who painstakingly creates the chosen headwear and makes it as comfortable as possible, or alters and restores the object if that is desired.

Despite the fact that gilding can wear off with use, several rulers have chosen to wear a gilded crown because solid gold crowns are so heavy. Since pure gold is rather soft, many crowns have been made from an alloy combining, for instance, copper, silver and gold. However, the strength of gold is not the only reason why the gold content in a crown might be reduced. Some religions and traditions specify a maximum gold content. Platinum, which is strong and light, became available for jewellery making in the 19th century, enabling jewellers to set an abundance of precious stones in one object without it becoming too heavy to wear.

Various stones are used in the making of crowns. The diamond is one of the most valued stones throughout the world. The earliest diamonds were found in the river gravels of India, where many world-famous stones have been discovered over the centuries. A diamond is made from a single element, carbon and its value is determined by a strict international system of evaluation, known as 'the four C's'

– colour, carat, cut and clarity. Precious metals and stones are synonymous with prosperity, property and power, but for some societies, other items with cultural or traditional value, for instance cowrie shells or beads made from different materials, are far more precious. In the past, these items were used as exchange media for marriage payments or market transactions, and were essential as part of sacrificial offerings. It is therefore unthinkable to ignore their value in ceremonial paraphernalia and as decorations on the ruler's headdress, as they display in tangible form the wealth and prosperity of the ruler, his subjects and his realm.

Numerous skilled craftsmen have not only created emblems of sovereignty through the centuries, but some of them have also taken great pains to imitate many historical pieces with precision. There are several reasons why people decide to make an accurate replica. The original crown might have been lost, or it might be too fragile or too valuable to put on public display for long periods of time. Several collections of replicas have been created so that the history and development of both public and hidden crowns can be better understood. A *replica* crown is sometimes made to be used by a court painter or during the dress rehearsals for a coronation and is known to be a replica. A *fake* crown is made with different intentions, and the maker or the 'customer' may try to present it as genuine.

Henry J. Philips and his colleagues at the workshop of Garrard worked long hours on repairing, cleaning and making new tiaras and coronets for the coronation of Queen Elizabeth II in 1953.
Photo collection Henry J. Philips, London, England

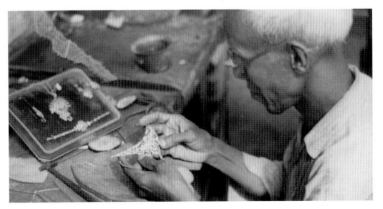

A goldsmith working on a tiara in the workshop of P. H. Hendry Jewellers, Kuala Lumpur, Malaysia. Circa 1940.
Photo collection René Brus

The material used for replica crowns is usually far less expensive than the originals, especially in the case of historic or large gemstones. These are usually substituted with paste or synthetic stones. Gold can be imitated either by gilding another metal or by using a combination of metals that produces a colour similar to that of genuine gold.

Countless items of royal headgear are locked away in inaccessible strong-rooms and palaces. They are regarded as private property or as sacred heirlooms that have to be treated with respect, and are more than simply art objects. However, in the recent past, more and more crowns have been put on public display in well-guarded vaults or museums and can be admired at close quarters.

Crown makers in the Kingdom of Bunyoro-Kitara, in Western Uganda, have to go to extraordinary lengths to create a crown. To craft the *kondo* or Crown for the Omukama, the King of Bunyoro, the maker first has to search for the right *mukondwa* tree. The fibre of its bark and the white fronds of palm-leaves are used as the foundation for the crown. The bark first has to be wrapped in moist plantain fibres and then buried so that it can decay. When the pulpy part has rotted, the fibre is gently combed and brushed with wooden instruments. This work is done by a specialist from the palace, but then it is up to the female members of the royal family to chew these cleansed fibres

gently, a few at a time, to soften and clean the fibres. Next, the fibres are rubbed with another kind of fibre, from the *mukomo* tree, until all have become white in colour. After this, the fibres are braided into a cord or twisted into a fine thread and dyed in different colours. Using these threads, the frame of the crown is woven with palm fronds into the desired shape. The crown is slightly narrow at the top, and is entirely lined with bark cloth. On this frame, beads and other decorations are stitched using a strong, white fibre thread. Around the edge of the crown of a reigning king there are 18 eyeless needles, the *anasoke*, made of iron, brass and copper. These needles are all six or seven inches long. Two of them, made of iron with twisted ends, are known as the 'males' and are taken out each time the crown is put away by its caretakers. These caretakers, appointed by the king on his coronation day, are two women from the clan of the king's mother whom he calls 'little mothers.' These ladies, who are nominal wives of the king but are not entitled to bear him children, are also guardians of the king's nail and hair-clippings.

The most remarkable thing about the King of Bunyoro's Crown is the false beard attached to it. This is made from the hair of the colobus monkey. According to local tradition, it represents a lion's mane and is intended to provide strength and signify the exalted position of the wearer in his kingdom, as the lion is considered the ruler of the animal kingdom..

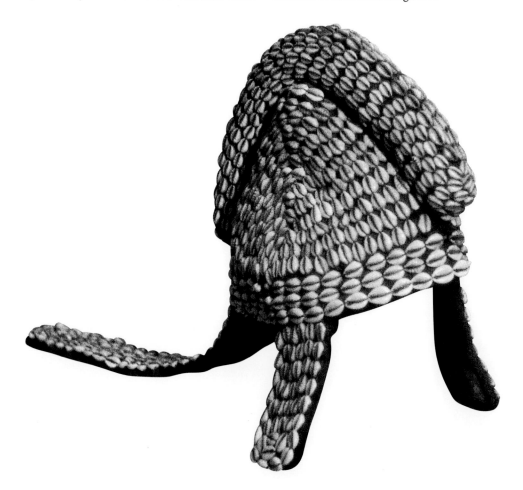

A headdress believed to be of Lango (Uganda) origin, although headdresses of similar shape and decoration appear in several other African societies, including Kuba (Democratic Republic of the Congo, the former Zaire), Ivory Coast and Mali. Leather and cowrie shells; made in the second half of the 19th century.
Collection Museon Museum, The Hague, The Netherlands
Photo René Brus

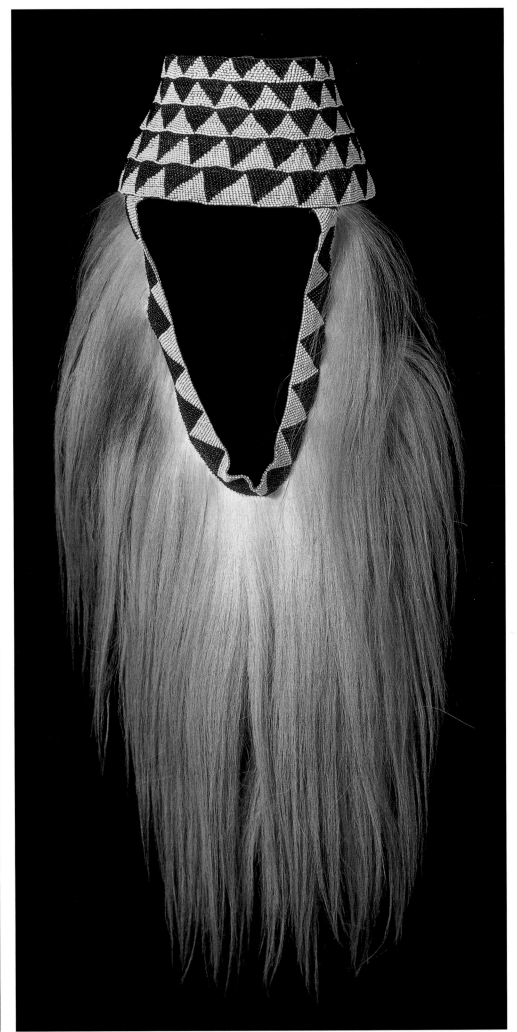

Left:
1908; coronation of King Kasagama of Toro. Like the kings of Bunyoro, this monarch wears a false beard attached to his crown as a symbol of power.
Photo collection René Brus

Right:
Crown from the Bunyoro or Nyoro. Glass beads and hair of the colobus monkey; made at the end of the 19th century.
Collection and photo Pitt Rivers Museum, Oxford, England

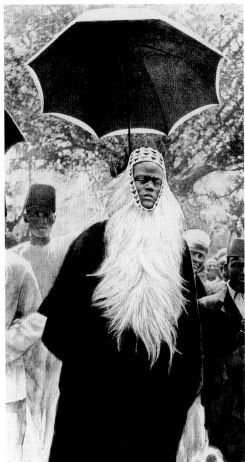

The Crown Jeweller

Visitors who admire the different crowns in the Tower of London do not always realise that, among the glitter of the biggest diamonds in the world, they are also being dazzled by imitations. These royal emblems are adorned with less valuable stones than the expected diamonds, sapphires, rubies and emeralds because, in past centuries, a number of crowns were set with hired stones during important events which were replaced by less valuable stones or paste after the ceremony had taken place. During the civil war of 1642-1651, many of the English regalia and crown jewels were lost or destroyed. When King Charles II was crowned in 1661, the cheaper option of renting gemstones against 4% of their value instead of buying them was taken to reduce the cost of the coronation. However, it was not always easy for a single jeweller to supply all the pearls and precious stones needed at short notice. The jeweller or goldsmith commissioned to make the crowns ready would in turn commission other goldsmiths and jewellers to help provide the necessary materials.

document shows that all the precious stones were removed from the crowns, including the extremely valuable ones that adorned the queen's State Crown. This crown, which was referred to in those days as the 'Rich Crown', had been set with 129 large pearls, 38 very large diamonds, and 523 'great' and small diamonds worth no less than £100,650.

A pencil drawing, originally part of a miscellaneous collection of papers put together by James II's brother-in-law, Lawrence Hyde, Earl of Rochester, and now in the British Library, depicts the crown. An annotation reads: *'This is the Origenall Draft of the Crowne which by Hur Maiesties Expraisse Commands I had the Honour to make.'* The document bears the signature of *Rich. De Beauvoir*, Richard de Beauvoir (sometimes referred to as Richard Beaver), a French protestant goldsmith-jeweller who fled to England after King Louis XIV revoked the Edict of Nantes in 1685. He achieved enough fame to make the Crown of Queen Mary and later

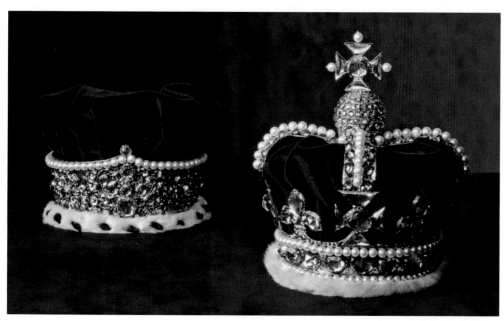

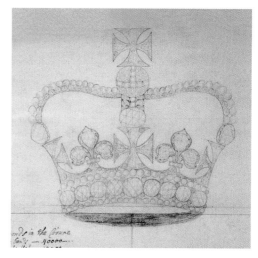

Numerous documents have survived that give a detailed insight into when the gemstones were set or taken out of the crowns. The *Calendar of Treasury Books*, for example, describes how, on 30 April 1685, a letter was sent to Sir Robert Vyner, the great banker-goldsmith, to inform him that *'Treasurer Rochester has moved the King about taking of the jewels from the crown called St Edward's Crown, her Majesty's two crowns, the coronet and her Majesty's sceptre which were lent. It is the King's pleasure that the jewels which were so lent be taken off accordingly.'* The King mentioned is James II, who was crowned with his wife Mary Beatrice d'Este, Princess of Modena, on 23 April 1685. The

became known as *'joaillier de feu sa Majesté Britannique la Reine Marie.'* (jeweller to Her Majesty the British Queen Mary). This was James II's daughter Mary, who was crowned with her husband, Dutch Prince Willem III of Orange, Stadtholder of the Republic of the United Provinces, on 11 April 1689 as King William III and Queen Mary II of England. During their hour-long coronation ceremony, Princess Anne (Queen Anne of England from 1702) seems to have said to her sister Queen Mary II *'Madame, I pity your fatigue'* whereupon the queen turned sharply with the words, *'A crown sister, is not so heavy as it seems.'*

Left:
Left; Queen Mary of Modena's Diadem.
Right; Queen Mary of Modena's State Crown. Gold, rock crystal and cultured pearls; made in 1685.
Collection the Tower of London, Jewel House, London, England
Photo Historic Royal Palaces, England

Above:
Drawing of the State Crown of Queen Mary of Modena, the consort of King James II, by Richard de Beauvoir. Made in 1685.
Collection and photo British Museum, London

Garrard

In the 18th century, various firms worked on the English Crown Jewels and regalia, but early in the 19th century it was decided that a single firm should be in charge. At first it was the company Rundell, Bridge and Rundell, but Garrard and Company took over in 1843, and held the Royal Warrant until 2007 as 'Goldsmiths and Crown Jewellers to Her Majesty Queen Elizabeth II'. The Warrant is regularly reviewed and is automatically cancelled on the death of a sovereign. It is therefore a particular honour for a company to have held the Warrant under successive sovereigns for more than 150 years. This company's ledgers dazzle with aristocratic names, not only from Great Britain but also from the far-flung corners of the British Empire.

Work on the English crowns is not a job for one person. A whole team of skilled craftsmen is usually needed to make a crown, clean it or restore it when parts are broken off or missing. Take, for instance, the coronation crown, the Crown of St Edward. When King William III used it, this crown was set with 680 large diamonds, 14 large rubies, 8 sapphires, 12 emeralds and almost 500 large pearls, which had a total value of £20,000 in 1689. More than 200 years later, the decoration on this crown was not to the liking of King George V and he gave instructions to Garrard to alter it in preparation for his coronation on 22 June 1911. The work was done by, among others, Dan Round and Bernard Wetherall. The latter provides an insight into those days at Garrards in his article *I was an apprentice silversmith* in the July 1978 issue of the magazine *Gem Craft*. Wetherall had joined Garrard in 1908 at the age of 14, following family tradition. '*I believe it (the St Edward's Crown) was found to sit too awkwardly on the King's head and it became necessary to adjust the shape. There was a double row of silver beads around the band which rests on the King's head and also on the two cross over bands surmounting it... King George didn't like these silver bands and asked for them to be removed and replaced with gold beads. The date of the coronation was drawing very near when the Crown was sent to Buckingham Palace for His Majesty's approval. It now rested comfortably on his head but he didn't like the gold beads. He thought the original silver beads looked better after all... There wasn't time to take them off again so the gold beads were silver plated. I remember old Dan Round, who handled the job from the beginning often worked all night on it to get it finished on time. One day, when the crown was in its skeleton form and denuded of all its precious jewels, he called me into a corner out of the foreman's sight and with mock solemnity, placed the crown on my head for a couple of seconds... Old Dan's been dead for years now so they can't sack him for it.'*

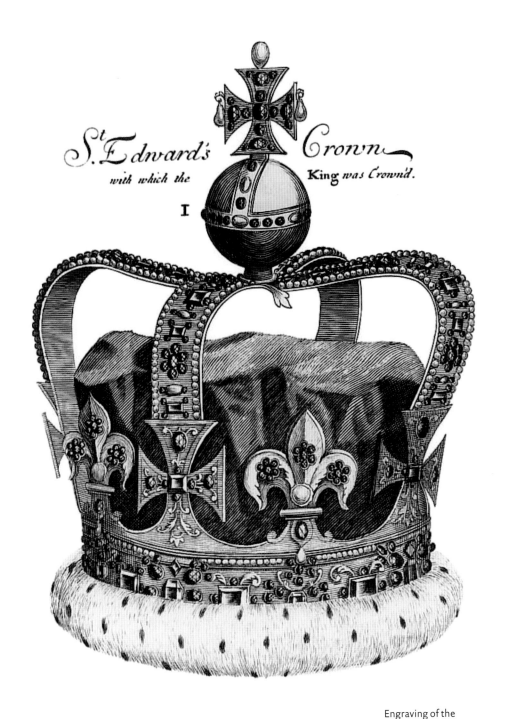

Engraving of the St Edward's Crown made by W. Sherwin as how it was worn by King James II. Date of engraving unknown.
Photo collection René Brus

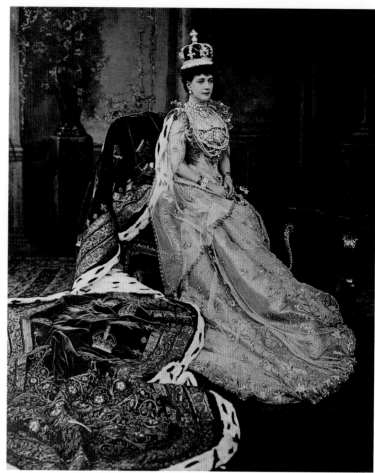

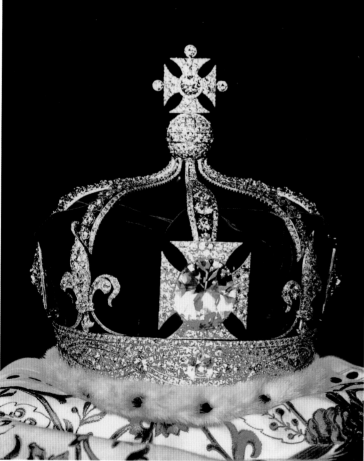

Top left:
1930s; King George V
of England and Queen
Mary dressed for the
Opening of Parliament.
The Queen wears her
coronation crown
without the arches. In
1914, Garrard altered this
crown so that it could be
worn as a simple circlet.
The King wears the
Imperial State Crown,
made for Queen Victoria
in 1838.
Photo collection
René Brus

Bottom:
Coronation Crown of
Queen Alexandra of
Denmark
Gold and silver; the
original diamonds have
been replaced by paste;
made in 1902 by E. Wolfe
& Co, commissioned by
Carrington.
Collection Museum of
London, England
Photo René Brus

Top right:
9.8.1902; Queen
Alexandra of Denmark in
coronation robes.
Photo W. & D. Downey

In addition to preparing the regalia and Crown Jewels for coronations and other state occasions, in 1852 Garrard was entrusted with one of the severest tests for any jewellery firm, namely recutting the historic Koh-i-noor diamond in the presence of many dignitaries, including the Duke of Wellington. According to legend, this 'duck's egg of a stone', weighing 186 carats in the mid 19th century, dates back to as early as the 14th century, when it was in the possession of the Indian Rajah of Malwa. Until 1739, it belonged to the Mogul emperors, at which time Nadir Shah of Persia captured the diamond after invading Delhi. On seeing it, he is supposed to have exclaimed *Koh-i-noor*, which is Persian for mountain of light. The diamond then appeared in the Punjab, a state annexed by the British in 1849. The ruler of the Punjab at the time, the Maharajah Dhulip (Dalip) Singh, under the Treaty of Lahore had to accept that all the state-owned property, including his collection of jewellery, was confiscated by the 'Honourable East India Company' as part-payment of the debt due to the British Government and the expenses of the war. The Koh-i-noor, set in an armlet/bracelet, was included in this treaty. On 6 April 1849, this historic stone was sent to England on board HMS *Medea*, which departed from Bombay.

Almost three months later, on 3 July, the Koh-i-noor was presented to Queen Victoria at Buckingham Palace. The presentation of this famous diamond is recorded in her journals and she wrote, '...*Unfortunately it is not set à jour, and badly cut, which spoils the effect.*' ('*À jour*' is a way of stone setting that allows the stone to absorb and reflect the light to the maximum effect.) Prince Albert, Queen Victoria's Prince Consort, shared this view, and the decision was made to have the diamond recut. Garrard, the Crown Jewellers at the time, were instructed to find skilled men for the recutting and they asked the Amsterdam company of Coster to carry out the job. The cutting of the diamond, done by two diamond cutters named Voorzanger and Fedder, lasted 38 days. In the end, the 186-carat stone was reduced to 108.93 carats, having lost almost 43% of its original weight. Queen Victoria decided to have the Koh-i-noor set as the centrepiece in a regal circlet that was made by Garrard. Above the headband were placed four fleurs-de-lys and four crosses patées, which were each detachable and could be replaced by four Greek honeysuckle ornaments. In total, 2,203 brilliants and 662 rose-cut diamonds were used in the circlet. Because the Koh-i-noor can be removed, it is quite easy to mount it in another ornament. In this way, the historic diamond glittered as the most important stone in the coronation Crowns of Queens Alexandra, Mary and Elizabeth when they were crowned in 1902, 1911 and 1937 respectively. The crown of this last Queen, Elizabeth (mother of Queen Elizabeth II), was set not only with the Koh-i-noor but also with the diamonds from Queen Victoria's circlet, which were removed from their setting for this purpose.

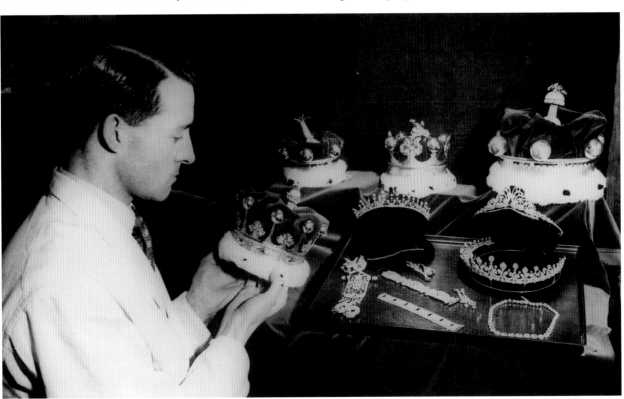

Henry J. Philips at the workshop of Garrard worked long hours on repairing, cleaning and making new tiaras and coronets for the coronation of Queen Elizabeth II in 1953.
Photo collection Henry J. Phillips, London, England

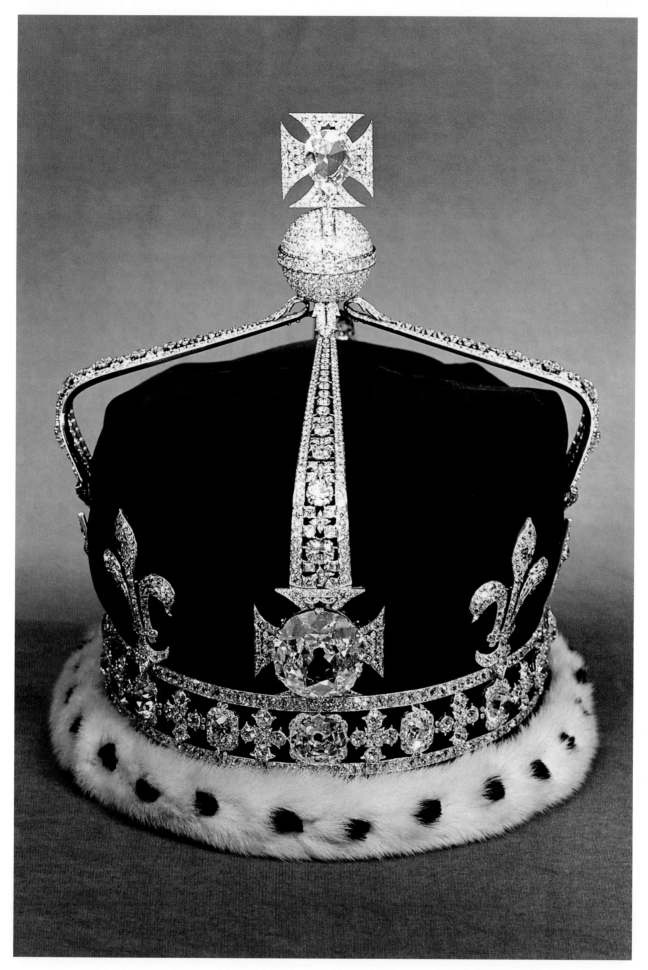

Coronation Crown of
Queen Elizabeth the
Queen Mother. Platinum
and diamonds; made in
1937 by Garrard.
Collection the Tower of
London, Jewel House,
London, England
Photo Historic Royal
Palaces, England

Opposite page:
Left:
1987; Queen Elizabeth II
and Prince Philip, the
Duke of Edinburgh,
during the annual State
Opening of Parliament.
The Queen wears the
Imperial State Crown,
which had been remade
exactly by Garrard in 1936
due to the fragility of the
old frame, using all the
original precious stones
and pearls (see also
Chapter 7, The death of a
monarch, page 204
and 205).

Right:
1987; the Imperial State
Crown is brought to the
Palace of Westminster in
a ceremonial procession
before the arrival of
Queen Elizabeth II.
Photo collection Henry J.
Philips, London, England

For the annual ceremonial State Opening of the English Parliament, the Crown Jeweller's duty is to inspect the regalia used on that occasion to make sure they are not damaged during their trip from the Tower of London to Buckingham Palace and then in a special carriage to the Houses of Parliament. The Crown Jeweller is also called on in more unusual circumstances, for instance, in the days before the Second World War. On 19 May 1938, Mr A. C. Mann of Garrard was summoned to the office of the Lord Chamberlain at St James' Palace to discuss what should be done '*should a state of emergency arise*'. Others who attended this meeting included a police officer from Scotland Yard, a court official from Windsor Castle and Sir George Younghusband, 'Keeper of the Crown Jewels' at the Tower of London. On Saturday 26 August 1939, that state of emergency arrived, and the entire Crown Jewels collection was packed into boxes. At 7.05 p.m., the keys of these boxes were handed over to Sir George Titman and within 20 minutes the valuables were on their way to Windsor Castle under the guard of six armed policemen, arriving at 8.30 p.m. As soon as the war ended, the jewels were brought back to the Tower of London, but before they were put back on display, Garrard's craftsmen made sure that they were properly cleaned and, if necessary, repaired.

During the Second World War, in 1943, Henry J. Phillips started working as an apprentice at Garrard. During his lifelong career there, he handled most of the English Crown Jewels. He retired as head of the jewellery department in 1989. However, even after his retirement, Phillips' skills as a diamond setter were called upon. In 1990, it became clear that the silver foil set behind the rose-cut diamonds of the St Edward's Crown to make them glitter was darkening with age and needed polishing. Phillips removed each diamond from its fragile setting, polished each tiny piece of silver foil, and replaced foil and diamond back in their original setting. Since this skilled work was of interest to many jewellery historians, the three-week restoration project was carried out not in the Garrard workshops, but in the British Museum.

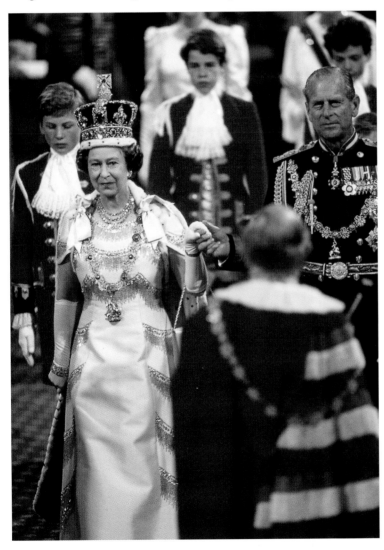

Another historical item that Henry Phillips had to take care of was the more than 100-year-old tiara of a Russian grand duchess, now owned by Queen Elizabeth II. This magnificent piece consists of interlinking circles of diamonds. A pear-shaped pearl or drop-shaped emerald pendant can be hung from the centre of each circle. Queen Elizabeth II inherited the tiara from her grandmother, Queen Mary, in 1953. The original owner, the Grand Duchess Maria Pavlovna of Russia, fled Russia during the Revolution and managed to keep most of her valuable jewels when she went into exile. After her death in Contrexéville, France, in 1920, her daughter the Grand Duchess Elena Vladimirovna of Russia, generally referred to as Princess Nicholas of Greece, inherited the tiara and sold it to Queen Mary of England in 1921. In 1988, Henry Phillips was asked to repair the fragile frame, but in his opinion this was no longer possible. He could not guarantee that Queen Elizabeth II would be able to wear the tiara without losing the stones. The decision was made to reset all the diamonds in a new frame. The old frame was not melted down, as was the usual practice of some jewellers, but was returned to Buckingham Palace to be kept for its historical value.

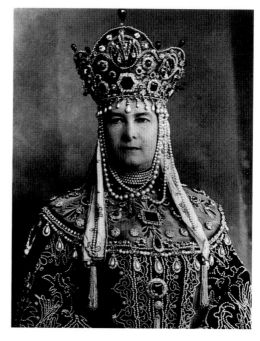

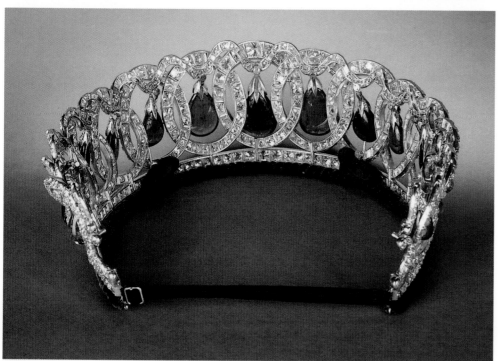

Left, top and bottom:
Front and back view of the tiara of Grand Duchess Maria Pavlovna of Russia, also referred to as the Grand Duchess Vladimir. Gold, silver, diamonds and emeralds.
Collection Queen Elizabeth II
Photo by gracious permission of Her Majesty the Queen, Press Office Buckingham Palace, London, England

Right:
4.2.1903; The Grand Duchess Maria Pavlovna of Russia dressed for the Hermitage Ball held to mark the bicentenary of the foundation of St Petersburg.
Photo collection René Brus

The discomfort of wearing crowns has been remarked on by several rulers. King George V of England recorded in his diary that the weight of his crown (978 grams) caused him great discomfort. He was not referring to his coronation crown, but to the one he wore in 1911 in Delhi, where he and Queen Mary (as Emperor and Empress of India) received the homage of the local rulers during an impressive ceremony, or *durbar*. Half a century earlier, in 1857, India had lost its emperor, the Great Mogul Bahadur Shah II, due to a mutiny (in the eyes of the English) or revolution (in the eyes of the Indians). This resulted in the ruling monarch of England, Queen Victoria, becoming Head of State of the colony. The British Prime Minister Benjamin Disraeli persuaded Queen Victoria to accept the title and position of Empress of India in 1876. No official installation ceremony took place in India and Queen Victoria never visited her Indian colony, nor did her son and successor King Edward VII. However, as Prince of Wales, Edward had visited India. After George V was crowned as King of England in 1911, he and his Government decided that he should be presented to his far-away subjects in India during a traditional *durbar*, during which hundreds of Indian rulers could pay homage to him as their Emperor. Constitutional practice forbids the royal regalia from being taken out of England, but it was regarded as essential that the King-Emperor wear a crown for the *durbar*. Garrard was commissioned to design and make a suitably impressive crown that could accompany the King to India.

The Imperial Crown of India was made in the traditional English shape, with eight arches rising from a headband and joining together under a jewelled globe with cross. The cost of this crown was £60,000 and it was paid for by the colonial department, known as the India Office. The crown travelled to and from India on the ship *Medina*. When King George V returned to England, the crown was added to the regalia collection in the Jewel House of the Tower of London. It has not been used since 1911. In 1947, however, shortly before India achieved independence, there were discussions regarding a possible *durbar* in Delhi for King George VI and Queen Elizabeth. On 24 September 1946, Mr Mann of Garrard was received at Buckingham Palace by the King and asked if it would be possible to alter the Crown of India. Not only did the King wish to have only four arches instead of eight, he also wondered if the arches could be bent so that the crown was not so tall. On 8 November, Mr Mann informed Sir George Titman, the Lord Chamberlain, that these alterations were possible, but later restoration to its original shape would not be possible due to metal fatigue. In the end, no alterations or restorations were necessary as the political situation changed, India achieved independence, and the Crown of India would not be worn again.

12.12.1911; the Delhi *durbar* ceremony of King George V and Queen Mary of England.
Photo collection The Royal Commonwealth Society, London, England

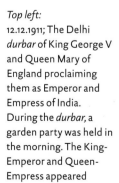

Top left:
12.12.1911; The Delhi *durbar* of King George V and Queen Mary of England proclaiming them as Emperor and Empress of India. During the *durbar*, a garden party was held in the morning. The King-Emperor and Queen-Empress appeared in regal and imperial attire and jewellery on the marble balcony of Shah Jahan's Palace, also known as the Red Fort, just as the great Mogul Emperors had done in the past.
Photo collection René Brus

Bottom left and right:
12.12.1911; The Delhi *durbar* of King George V and Queen Mary of England, where they were proclaimed Emperor and Empress of India.
Photo collection The Royal Commonwealth Society, London, England

Opposite page:
Crown of King George V of England, made for his proclamation as Emperor of India. Gold, silver, diamonds, emeralds, sapphires and rubies; made in 1911 by E. Wolfe & Co, commissioned by Garrard.
Collection the Tower of London, Jewel House, London, England
Photo Historic Royal Palaces, England

Throughout its long history as Crown Jeweller, Garrard has served numerous monarchies. In 1939, it received a request from the King of Buganda (in present south-central Uganda), Kabaka Daudi Chwa II, to design a crown for his upcoming silver jubilee. The king had ascended the throne on 14 August 1897 as a minor, and was crowned on 7 November 1914 by the Anglican Bishop of Kampala, using a cylindrical headdress made of fabric covered with gold-embroidered flowers. The headband and the insignia of Buganda attached to the front of this crown (a traditional shield with two crossed spears) were made of silver gilt. Above the crest, a cross showed the King's Christian faith, and above that stood a plume of snow-white feathers. The instructions that Garrard received in 1939 were simple: the new crown should resemble the old one in shape.

On 10 May 1939, the jeweller sent three sketches of the new crown together with a letter to the Kabaka;

'Sir,
We are despatching to Your Highness by separate cover at the request of Captain E. F. Twining, M.B.E. three drawings which we have prepared giving suggestions for a new Crown. These have been designed according to suggestions indicated by Captain Twining and from your letter to him of the 14th January 1939, reference 130/6/K.
Designs Nos. 1 and 2 show a white satin cap with silver and silver-gilt ornaments and a plume.
Design No.3 shows a white satin cap with silver and silver-gilt ornaments embellished with semi-precious stones and a plume.
The plume can be made of white horse hair, white ostrich feathers or white swan feathers and the semi-precious stones can be made in a combination of colours including orange, pink, yellow or green to your own choice which perhaps Your Highness will be kind enough to indicate.
Design No. 3 can also be made in silver and silver-gilt without the stones.
The cost of making these Crowns to any of the designs, without the stones, would be £60.0.0.
For Design No.3, using semi-precious stones, the cost will be £160.0.0.
We trust that one of these designs will please Your Highness and should we be favoured with your order we should require to know the exact size of the head for fitting purposes.
We have the honour to be, Sir,
Your Highness' obedient servants,
Garrard & Co.Ltd.'

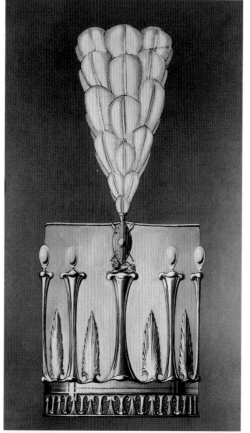
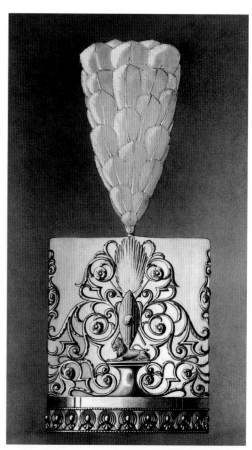

Coronation Crown of
Kabaka Daudi Chwa II of
Buganda. Gilded silver;
made in 1914.
Current whereabouts
unknown
Photo collection
René Brus

Middle and right:
Two designs made in
1939 for the Crown of
Kabaka Daudi Chwa II of
Buganda by Garrard.
Photo collection
René Brus

Kabaka Daudi Chwa II chose design number three, but he was never to wear it because he died on 22 November 1939, before the crown was ready. The heir to the throne was the 15-year-old son of the deceased King, who was crowned using this crown when he reached the age of majority in 1942. In his biography King Mutesa II describes his coronation, '...*Finally dressed in the royal robes, which had been specially designed and made for this occasion in London, I went back to the church and received the crown and ring of Buganda from Bishop Stuart. Although the crown had been specially made for me, it was a little too small. The Bishop told me later that he had not dared to press the crown firmly on my head and I almost died for fear of losing the crown, which wobbled dangerously on my head. I am afraid to think of what an effect it would have had on Buganda if the crown had fallen off.*'

In 1953, the young king and his cabinet ministers demanded independence from the English and as a result the Brittish banished him to England. Two years later he was allowed to return to his kingdom as a constitutional monarch. In 1962, the colony of Uganda became an independent federal state, in which the different kingdoms were integrated and each king kept his original position. The following year, King Mutesa II was elected as President of Buganda and a unique situation arose, with a king also holding the position of president. This lasted until 1966, when a coup took place in Uganda under the leadership of Milton Obote. An army officer by the name of Idi Amin was given the order to march to the Palace of Mutesa II at Mengo Hill to see if the king-president would resist the revolt. The king and his small army did indeed oppose the revolt and defended the palace grounds, but in the end the battle was unequal and the king was obliged to take permanent refuge in England, where he died in 1969. During the assault on the palace, all the valuables were taken and have never been found since, including the coronation Crown of Buganda's 35th king. When the monarchy was reinstated in Uganda in the 1990s by President Museveni, Mutesa II's son and successor, Ssabataka Muwenda Mutebi, was crowned as Kabaka Mutebi II on 31 July 1993, using a locally made, bead-embroidered cylindrical crown.

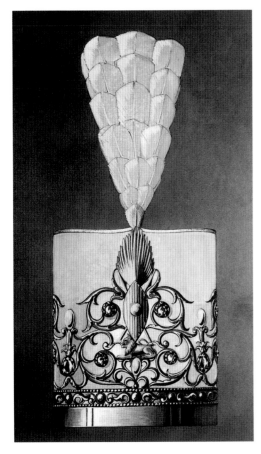

Final design made in 1939 for the Crown of Kabaka Daudi Chwa II of Buganda by Garrard.
Photo collection
René Brus

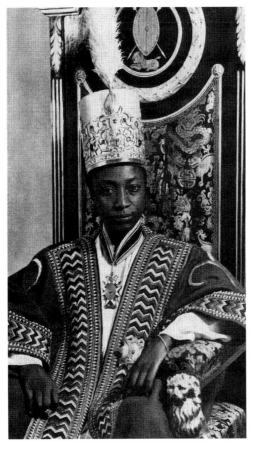

19.11.1942; coronation of King Mutesa II of Buganda.
Photo collection
René Brus

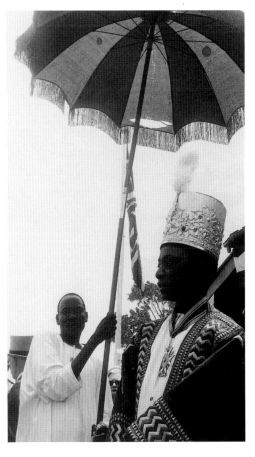

July 1955; the return of King Mutesa II of Buganda after being exiled to England for two years.
Photo collection
René Brus

Louis Osman

In 1958, Queen Elizabeth II of England announced that she had conferred the title of Prince of Wales on her son Charles and that he would be invested accordingly on the day he reached the age of maturity. Eleven years later, Prince Charles received his coronet during an impressive ceremony at Caernarfon Castle in Cardiff. Although the Jewel Room of the Tower of London could have provided a coronet designated for the use of a Prince of Wales, a more modern emblem of his position was placed on his head by his mother. This coronet was an interesting break with tradition, not only because it was dramatically 20th-century in design, but also because it was manufactured using a technique never before employed on this scale.

Prince Charles's coronet was not an object 'completely studded with precious stones', as the designer Louis Osman made known during interviews, and the modern design could be said to be frankly striking. The main structure of this coronet was produced by a team of young graduate chemists who 'grew' it in an electroplating bath in the laboratories of a modern chemical plant. The coronet was formed electrolytically, a process by which gold is deposited onto an epoxy resin mould. Electroforming, as the process is called, was not in itself new, but it had never been used for the manufacture of so large and important an item as a crown.

Four crosses consisting of 22-carat gold 'nails' from Wales hardened with iridium platinum were attached to the coronet. Square-cut diamonds were mounted at the ends of the arms and at the centre of each cross. Emeralds were placed on the four modern fleurs-de-lys, positioned between the crosses. A globe with a cross, also set with diamonds, was attached atop the undecorated arch. The globe and cross are free-standing to imply that the universe is expanding, and the horizontal and vertical bands of the globe are fitted with blue enamel. The 13 diamonds in the vertical band represent the constellation of Scorpio, the astrological sign under which Prince Charles was born. Fourteen diamonds decorate the horizontal band of the globe, seven symbolising the seven deadly sins and the other seven representing divine gifts. Prince Charles's symbols, the Welsh dragon, sheaves of corn from the county of Cheshire and the traditional Prince of Wales feathers, are engraved on the globe.

It is interesting to note how quickly this coronet was made, for the electroforming process started on 8 June 1969 and the coronet was worn by Prince Charles on 1 July 1969 The London Guild of Goldsmiths, who donated the crown to the Prince of Wales, paid £3,600 for this coronet, a much lower price than if the true labour costs for making it had been charged. Although the hallmark on the coronet reads 22 carat, being the highest marking standard in Great Britain, the 1.3 kilos of gold used for the coronet is in fact 24 carat, gold of the maximum purity.

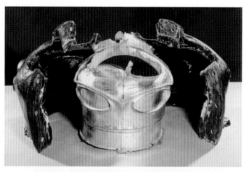

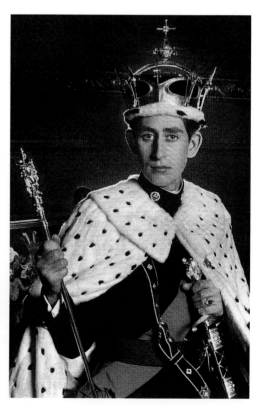

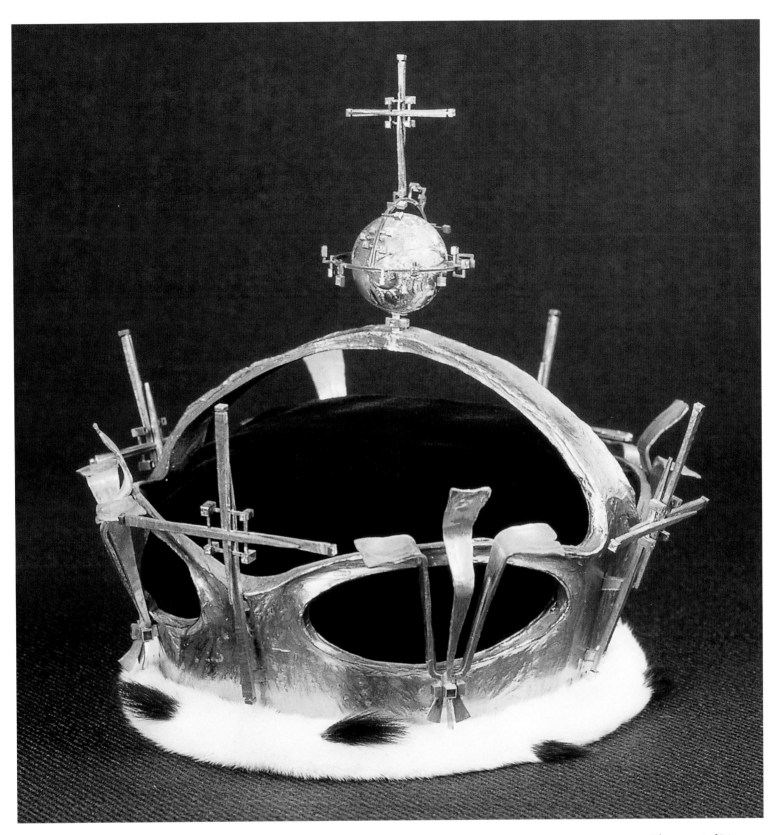

Opposite page:
Left:
David Mason, the 28 year-old leader of the team of Engelhard Ltd. inspects the 'growing' of the golden coronet of the Prince of Wales.
Photo collection B. J. S. Electroplating Company, London, England

Top middle:
The 24-carat golden coronet appears from its epoxy mould.
Photo collection B. J. S. Electroplating Company, London, England

Bottom middle:
Louis Osman attaches the different parts to the frame of the coronet of the Prince of Wales.
Photo collection B. J. S. Electroplating Company, London, England

Right:
1.7.1969; investiture of Prince Charles as Prince of Wales.
Photo collection René Brus

The coronet of Prince Charles, the Prince of Wales. Gold, iridium platinum, diamonds, emeralds, enamel, velvet and fur.
Collection The Royal Collection Trust/ National Museum of Wales, Cardiff, Wales Photo collection B. J. S. Electroplating Company, London, England

Replica English crowns

The English crowns, such as the St Edward's and Imperial State Crowns, have probably been imitated and duplicated more than any other crowns in the world. One reason to replicate their splendour and craftsmanship through gilding, paste and other less valuable materials is that the original crowns, kept in the Jewel Room of the Tower of London, are the property of the Crown and, as state property, cannot be taken out of the country. An Act of Parliament dating from the time of King Edward III, who tried to pawn the Crown Jewels in Flanders to finance a war with France, prevents these heirlooms from being taken out of the United Kingdom. Should anyone wish to display these ornaments anywhere other than the Tower of London, replicas are the only option.

The tri-centennial exhibition 'William and Mary', held in 1988-1989 in the New Church in the Dutch capital, Amsterdam, depicted the lives and reign of the Dutch Stadtholder Prince Willem III and his wife, who together became sovereign rulers of England in 1688 as William III and Mary II. A group of craftsmen worked painstakingly for three months to make accurate replicas of some of the coronation ornaments used in 1689. The St Edward's Crown, the State Crown and the diadem of Mary's step-mother were replicated, as were the coronation ring of Queen Mary II, the Curtana sword and the anointing spoon.

Replicas of the English regalia are highly sought after, as several auctions in the past have shown. On Thursday 24 May 1984 in London, the Bloomfield Place office of Sotheby's auctioned a collection of objects made of gilt-metal and set with paste, comprising the Imperial State Crown, the St Edward's Crown, the sovereign's orb, two sceptres, the mace, St Edward's Staff, five swords including the jewelled Sword of State, the Ampulla, the Anointing Spoon, St George's Spurs, a pair of bracelets and the coronation ring. The collection was valued at between £3,000 and £4,000 in the catalogue, and was sold for £9,000. Five years later, on 22 June 1989, Sotheby's London auctioned another replica set of the Crown Jewels of England, in total 21 items. The estimated value mentioned in the catalogue was between £10,000 and £15,000 and total sale £27,000. On both occasions, no information was given as to why these replicas had been made or for whom.

The Museum of Westminster Abbey has an interesting set of replicas of the English coronation regalia, and this time their provenance is known. In 1953, when preparations for the coronation of Queen Elizabeth II were being made, the theatrical costume maker Rob Robinson provided carefully crafted replicas for the rehearsal which, although they had been made of gilded copper and set with paste, were similar in weight to the originals. On 26 May 1953, a handful of people on their way through Dean's Yard to see the Abbey's museum unexpectedly encountered the full dress rehearsal of the regalia procession moving through the ancient 13th-century cloisters, with church and other dignitaries carrying the replica symbols of majesty.

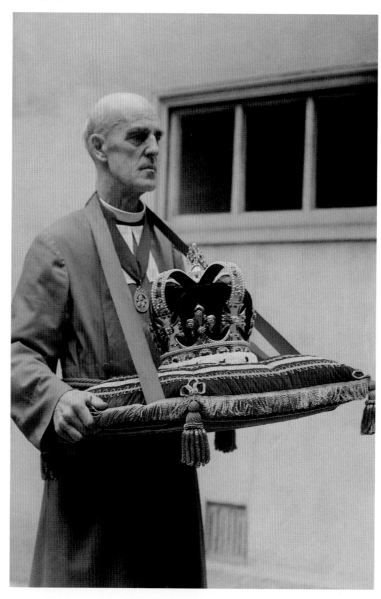

26.5.1953; the Dean of Westminster carries the replica of the St Edward's Crown on a cushion supported by a ribbon over his neck during the full dress rehearsal for the coronation of Queen Elizabeth II.
Photo collection René Brus

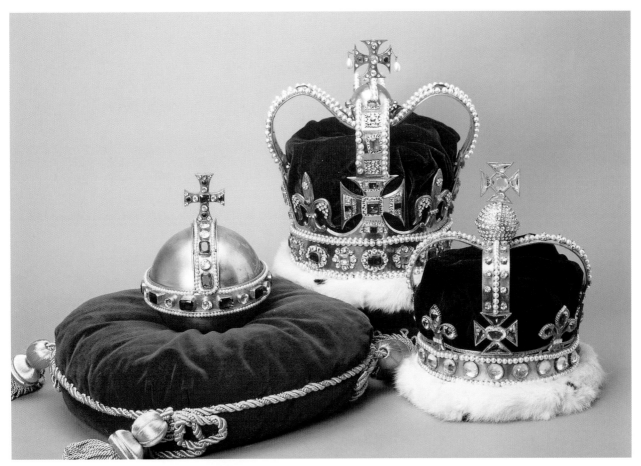

A set of replicas of
the English regalia,
comprising 21 items,
including the St Edward's
Crown (background) and
the State Crown of Mary
of Modena (right).
Auctioned by Sotheby's,
London on 22 June
1989 for £27,000.
Gilt metal, paste and
imitation pearls.
Photo Sotheby's,
London, England

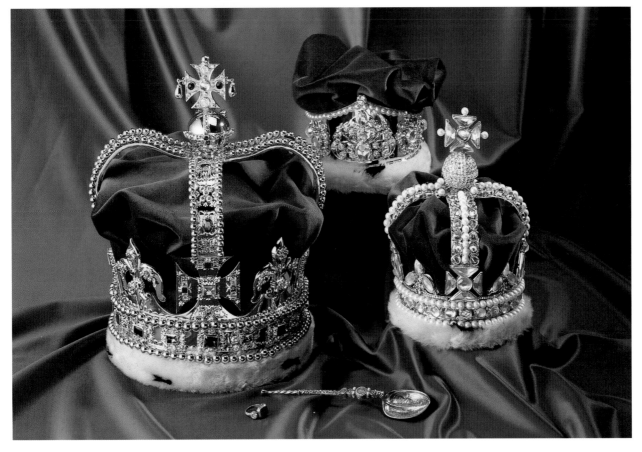

Replicas of the
St Edward's Crown,
State Crown and Diadem
of Mary of Modena. Gold,
gilded silver, rock crystal,
amethysts, tourmaline,
garnet, synthetic stone
and imitation pearl.
Collection René
Brus & Kunsthandel
'De Edelsteen', The
Hague, The Netherlands
Photo René Brus

Jürgen Abeler

During a visit to the Imperial Palace in Vienna in 1965, the Austrian Imperial Crown Jewels made an impression on the German jeweller, Jürgen Abeler. He asked himself why the Crown of the Holy Roman Empire was in such bad condition. After all, if it were restored it would attract much more attention. Abeler decided to copy this crown, and did so with excellent results. The idea was born to create a collection of replica crowns from all over the world. A large number of people, including stone-cutters and polishers, engravers, goldsmiths, silversmiths and milliners, have been involved in putting together this collection of around 100 crowns.

1970s: Jürgen Abeler and his wife with a detailed sketch of the Crown of the Holy Roman Empire. Photo collection Jürgen Abeler, Wuppertal-Elberfeld, Germany Collection Jürgen Abeler

1970s: a lady goldsmith at the workshop of the jeweller Jürgen Abeler with a small selection of the crown collection. Photo collection Jürgen Abeler, Wuppertal-Elberfeld, Germany

Fabergé

Some famous jewellers, goldsmiths and silversmiths have been involved in the construction of replicas. The jeweller Fabergé copied the imperial regalia of Russia for the Paris Universal Exhibition in 1900. The organisers of this world fair had asked for the original coronation insignia, but the Russian Imperial Government did not want to part with them. Fabergé's master gold- and silversmiths made miniature replicas using real diamonds, pearls and stones such as sapphires and spinels. The Emperor's Crown was set with 1,083 diamonds and 245 rose-cut diamonds, the Empress's Crown with 180 diamonds and 1,204 rose-cut diamonds, the orb contained 65 diamonds and 654 rose-cut diamonds and the sceptre one large stone cut to resemble the historical Orlov diamond and another 125 rose-cut diamonds. The skilled craftsmanship used in making these replicas was recognised when Fabergé was awarded the gold medal at the Paris Fair and the honorary medal of the *Légion d'honneur*. Shortly after the exhibition, the Russian Tsar Nicholas II purchased this miniature set, and it was placed in the Jewellery Gallery at the Hermitage in St Petersburg.

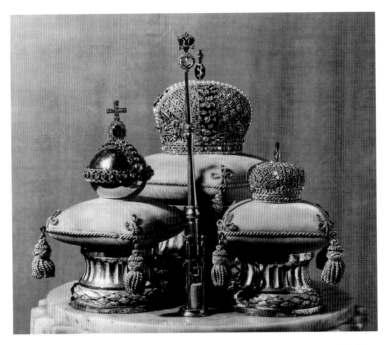

Miniature replicas of the regalia of Russia created by Fabergé. Gold, diamonds, spinel and sapphire; made in 1900 at the workshop of August Wilhelm Holmström. Collection and colour photo The State Hermitage, St Petersburg, Russia Black and white photo Lord Twining Collection/ Library, Goldsmith's Hall, London, England

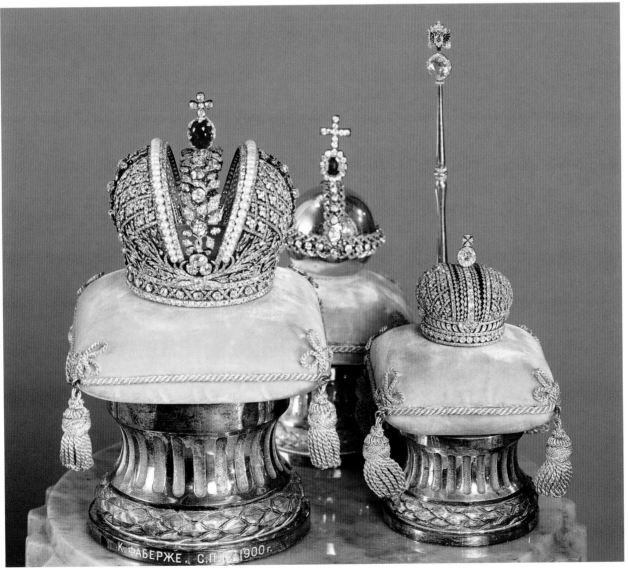

Van Cleef & Arpels

The making of a crown can sometimes be time-consuming and wearisome. The Paris jeweller Pierre Arpels was chosen to make the coronation Crown for Empress Farah, the wife of Mohammad Reza Shah, Emperor of Iran, in 1967. The emperor, who had come to the throne in 1941, judged that the time had come for him to be crowned with the crown made in 1925 for his father. In the entire 2,500-year history of this country, no woman had ever been crowned, and in 1967 the coronation of the empress was a symbol to many of a new phase in Islamic Iran, because it highlighted the emancipation of women. The Shah took another revolutionary step in appointing his wife as regent should their son not be old enough to ascend the Peacock Throne when his father died.

Iran's state-owned Crown Jewels did not include a crown for the empress, so one had to be created. Pierre Arpels submitted 60 designs in October 1966. Two months later, he was asked to come to Teheran and choose from the precious stones and pearls available in the National Bank of Iran. It took him three days, working ten hours a day, to select the most suitable stones from the vast collection of jewellery and gemstones. This process led him to change his design because he had not realised that some rather large stones were available. Pierre Arpels chose a 150-carat emerald as the centrepiece

and set 1,469 brilliants, 34 rubies, 2 spinels, 36 emeralds and 105 pearls in the crown. Arpels had a problem because, while the crown was to be fashioned in his workshop in Paris, the precious stones that had to be set into the crown could, under no circumstances, leave the vaults of the National Bank in Teheran. Wax impressions were made from the original stones, and then metal reproductions of the stones were created in Paris. The crown was crafted from platinum and gold using the reproduction stones as models. After travelling between Paris and Teheran some 25 times, the empty frame was finally taken to Iran and the genuine stones were set, bringing the total weight of the crown to 1,480.9 grams. On 11 October, 15 days before the coronation, Pierre Arpels showed a carefully crafted replica of the Empress's crown at a press conference at the Place Vendôme. He told the assembled journalists that Empress Farah had complimented him on the finished crown when she saw it for the first time.

Design made for the coronation Crown of Empress Farah of Iran. Photo Van Cleef & Arpels, Paris, France

Replicas of the original precious stones for the Crown of Empress Farah of Iran, pressed in wax. Photo Van Cleef & Arpels, Paris, France

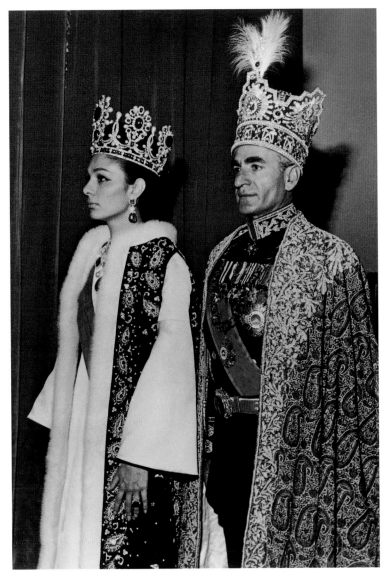

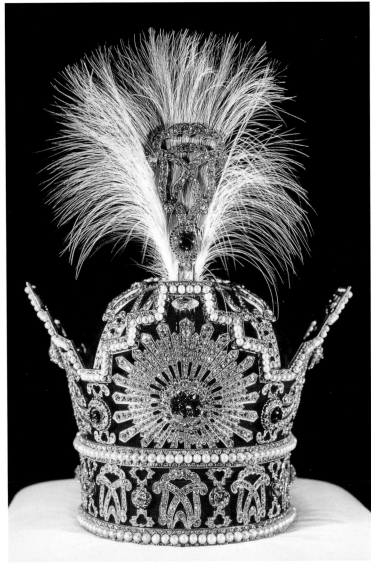

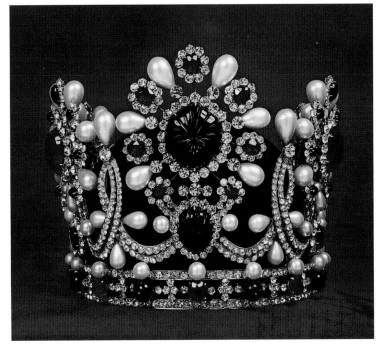

Top left:
26.10.1967; coronation
of Emperor Mohammad
Reza Shah and Empress
Farah of Iran.
Photo Van Cleef &
Arpels, Paris, France

Top right:
Coronation crown of
Emperor Reza Shah
Pahlavi The Great. Gold,
platinum, diamonds,
emeralds, sapphires and
pearls; made in 1925 by
Iranian goldsmiths under
the supervision of the
Teheran-based jeweller
Serajeddin.
Collection National Bank
of Iran, Teheran, Iran
Photo Bank Markazi Iran,
Teheran, Iran

Bottom:
Coronation Crown of
Empress Farah of Iran.
Platinum, diamonds,
rubies, emeralds and
pearls; made in 1967 by
Van Cleef & Arpels.
Collection National Bank
of Iran, Teheran, Iran
Photo Van Cleef &
Arpels, Paris, France

Falize

In 1923 the Paris jeweller Falize Frères received a request from Loie Fuller, one of the pioneers of modern dance, to make a replica of the crown that had been worn the year before by Queen Marie of Romania. Fuller was acting as a mediator for the American Mrs Alma de Bretteville-Spreckles, who had attended the Romanian coronation. Queen Marie was aware that her crown was going to be duplicated, as she had a lifelong friendship with the jeweller's wife, Alice, and also knew Mrs de Bretteville-Spreckles. Falize was chosen to make the replica crown because he had made the actual coronation crown. According to the book *A History of the Crown Jewels of Europe* by Lord Twining, the design of the crown followed that of Despina, the consort of a 16th-century Wallachian *hospodar* (prince) Neagoe Basarab, who is depicted in the frescoes of a church at Curtea de Arges, Romania. The choice of precious stones for the crown was not left to the jeweller. His ledger indicates instructions were given that '*pierres de lune, turquoises matrix, amethystes (grenats ou tourmalines), chrysoprases*' had to be used. In the end, rubies,

emeralds, amethyst, turquoises and opals were used for the heavy crown, which weighed four pounds (1.8 kg). The base of the crown is decorated with grains of wheat, a symbol of fertility, above which are eight large and eight small flower ornaments connected by interlacing branches. Eight arches rise from the large flower ornaments and meet under a globe with a cross. On both sides of the headband, above the ears, are unusual *pendulae* which are said to have been copied from medieval Byzantine and neo-Byzantine head ornaments, such as those depicted in the 6th-century mosaic of Empress Theodora in the church of San Vitale, Ravenna, Italy. The coat of arms of Romania is represented in relief on both discs and three chains are suspeneded from each. At the end of each chain is a cross within a golden circle. The jeweller was commissioned to start making the crown on 5 August 1921, and agreed to deliver it in January 1922. However, it took longer than expected to make and was not delivered until 30 September 1922.

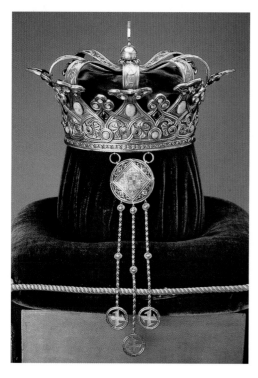 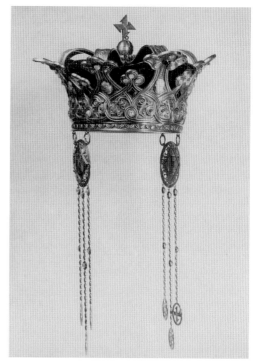

Left:
Replica of the Crown of
Queen Marie of Romania
Silver-gilt, moonstone,
turquoises, amethysts,
rubies and peridots;
made in 1923.
Collection and photo
Maryhill Museum of Art,
Washington, USA

Middle:
15.10.1922; coronation of
Queen Marie of Romania
Queen Marie was
crowned by her husband
King Ferdinand in the
centre of the public
square of Alba Iulia. The
coronation was attended
by the future King
George VI of England,
who remarked that
the event was '*So very
picturesque*', to which
Queen Marie replied,

'*Yes, and also intensely
moving. I carry off the
huge golden-incrusted
crown and overpowering
mantle splendidly. I think
it must have been a fine
sight and I hope that His
Majesty and I did our part
well and looked as well as
we could in our somewhat
overwhelming getup.*'
Photo collection
René Brus

Right:
Crown of Queen Marie
of Romania. Gold, rubies,
emeralds, amethysts,
turquoises and opals;
made in 1922 by
Falize Frères.
Collection and photo
Romanian National
History Museum,
Bucharest, Romania

There was already a queen's crown among the royal regalia of Romania at the time. It had been used for the first time when Queen Marie's parents-in-law, King Carol I and Queen Elisabeth, were crowned on 10 May 1881. This golden crown is in the shape of a traditional European crown with eight arches, but was not suitable for the coronation of Queen Marie in 1922 because, apparently, she said '*I want nothing modern that another Queen might have. Let mine be all medieval.*' Her husband, King Ferdinand, wished to use the crown of his father, as it was highly symbolic for both him and the nation. During the Russian-Turkish war of 1877-1878, a cannon was captured from the Turkish army and the Crown of the King of Romania was made from the steel of this cannon, giving the crown its proud name of *Couronne d'Acier*.

Something similar had also taken place in another Balkan state. In Serbia, steel from a cannon captured by George Petrovitch during the War of Independence from the Turks in 1804 was crafted into the coronation crown used by his grandson, King Peter I of Serbia in 1904. On 14 June of that year, the Serbian consul to Paris, Milenko Vesnic, commissioned Falize to make the crown, together with a sceptre, globe and mantle clasp, at a cost of 20,000 francs. Falize was chosen because the King's younger brothers, Djordje and Arsen, had lived in Paris for a long period and much appreciated the firm's reputation and their meticulously enamelled work on gold. When King Peter I crowned himself in the Belgrade Cathedral on 19 September 1904, his gilded bronze crown, made in what was known as the Byzantine-Serbian style, was not only set with artificial stones in the colours red, white and blue to symbolise the colours of the Kingdom, but was also decorated with bright enamel in the same shades.

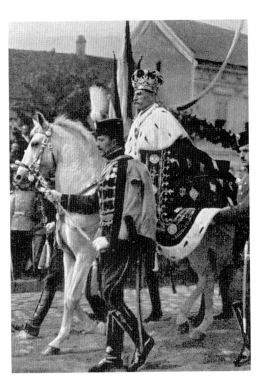

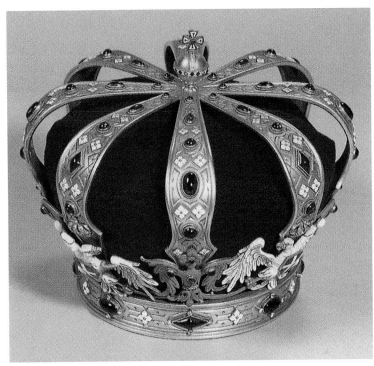

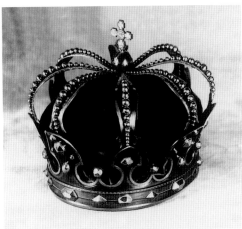

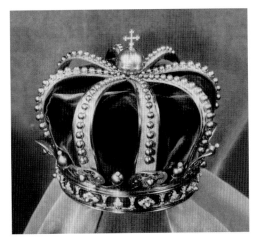

Top left:
19.9.1904; coronation of King Peter I of Serbia.
Photo collection René Brus

Top right:
Crown of King Peter I of Serbia. Designed in 1904 by the Belgrade architect Mihailo Valtrovic and made in the workshops of Falize Frères, Paris, France. Gilded bronze, topaz, synthetic rubies and sapphires, and red, white and blue enamel.
Collection and photo Historical Museum of Serbia, Belgrade, Serbia

Bottom left:
Crown of King Carol I of Romania. Steel; made in 1881 at Arsenalul Armatei.
Collection and photo Romanian National History Museum, Bucharest, Romania

Bottom right:
Crown of Queen Elisabeth of Romania. Gold; made in 1881 in Bucharest.
Collection and photo Romanian National History Museum, Bucharest, Romania

Wan Mohammad Zaidi

In late autumn 1998, René Brus was granted permission by Sultan Mizan Zainal Abidin of the Malaysian Sultanate Terengganu to make an inventory of the Crown Jewels and regalia in conjunction with the upcoming coronation of the sultan and his consort, Permaisuri Nur Zahirah. It soon became clear that some of the more than 150-year-old ornaments needed to be cleaned and repaired to return them to their original splendour. During the inventory, Prince Tengku Ismail bin Tengku Su, a great grandson of Sultan Sulaiman Badrul Alam Shah of Terengganu (crowned in 1920) noticed that a golden *songkok* was no longer among the collection. The prince produced a photograph taken in 1951 of the wedding of Princess Azmak and Prince Abdul Halim bin Sultan Ali, where the bridegroom could clearly be seen wearing this headdress during the traditional *Mandi Sapat*, the lustration ceremony. Since this ceremonial ablution, held in the seven-tiered *Pancha Persada* pavilion, is also an essential part of a Terengganu coronation, and the special crown worn by the sultan's wife during that ceremony was still available, discussions began as to whether the sultan needed a replacement for the lost *songkok*. Several authorities involved in preparing the coronation discussed this matter at great length. Eventually the Terengganu company The House of Tengku Ismail was commissioned to design a new *songkok*. As soon as the design was approved, the Kota Bahru jeweller Wan Mohammad Zaid, of *Kembang Jaya Kedai Emas*, was asked to make the *songkok*, using white gold and more than 800 yellowish and white diamonds. The order was given to the jeweller at the beginning of January 1999, just a few weeks before the coronation. Due to the short period of time available, Wan Mohammad Zaidi employed Hassan Daub to make the golden frame and Mohammad Salleh to make the filigree parts; Abdul Halim, Azman, Amirruddin, and Shamsul Iskandar were responsible for the setting of the diamonds. On 1 March, at around five in the afternoon, the proud jeweller Zaid and Prince Tengku Ismail bin Tengku Su handed over the finished *songkok* to the sultan in his personal residence, the Nur Nadhirab Palace. The sultan tried the close-fitting headdress on immediately, and the jeweller showed him how the different flower-like, diamond-studded ornaments and top decoration could be unscrewed. He informed the sultan that he would provide brooch or hairpin fittings after the coronation so that these ornaments could be worn individually.

The ceremonies surrounding the coronation of the Sultan Mizan Zainal Abidin began on 27 February 1999, but the main day was 4 March. Early in the morning, the royal couple arrived with their two young children at the Madziah Palace, where they first dressed in white attire for the purification ceremony. At exactly 7.30 in the morning, the *Nobat*, or royal orchestra, accompanied the royal couple as they appeared in the palace gardens, where the bright morning Sun shone on their glittering head adornments. The crowning of the royal couple took place in the throne-room of the Madziah Palace in the afternoon of that same day. This historic ceremony was telecast live in Malaysia. The Proclamation was read, the Royal Pledge was given, the homage ceremony performed and finally the actual crowning took place.

Top left:
Jeweller's working model of the *songkok* of Sultan Mizan Zainal Abidin of Terengganu. Silver, silver-gilt and cubic zirkonia.
Collection Prince Ismail bin Tengku Su, Kuala Terengganu, Malaysia
Photo René Brus

Top right:
Balalai Gajah Crown, worn by female members of the Terengganu royal family during their lustration ceremony. The name *Balalai Gajah* is given to this crown due to the two elephant trunk-like structures at the extremities of the headband, which are positioned above the ear. In the Malay language *gajah* is elephant. Another interesting feature of this lustration crown is the bird-like ornament with spread wings that covers the crown of the head. Gold, silver and diamonds; made circa 1920.
Collection the Sultan of Terengganu
Photo René Brus

Bottom:
5.3.1999; lustration ceremony of Sultan Mizan Zainal Abidin and Permaisuri Nur Zahirah of Terengganu. The royal couple are photographed immediately after they were showered with, among other things, coconut and scented water.
Photo René Brus

Israël Rouchomovsky

In the spring of 1896 a golden crown attracted the attention of the Viennese art world. According to its provenance, the crown had been discovered in southern Russia together with other treasures. It was supposed to have been excavated from a site where gold and silver objects from classical antiquity had previously been discovered. On the headdress, which due to its shape was referred to as a tiara, an inscription describes how Greeks from the city of Olbia beg a certain King Saitapharnes not to attack them. Splendid mythological reliefs on the tiara alternate with charming animal figures between graceful tendrils. Eminent collectors Count Wilczek, Mr Dumba, Mr Mauthner and Baron Rothschild studied the piece and it was offered to the Hofburg Palace Museum by Professor Benndorf, who acted as a mediator. However, the museum did not have sufficient funds to buy this piece of art and the director of the museum, Robert von Schneider, doubted the tiara's authenticity. The object was offered to the British Museum, but in the end it was the Louvre Museum that bought the almost technically perfect ornament for no less than 200,000 francs. The 'real or false' debate was still in full swing when, in 1903, the newspaper *Le Matin* published a letter from a Russian antiquary-

jeweller from Paris. The writer, Mr Lifschitz, knew who the maker was, namely the Russian goldsmith Israël Rouchomovsky. The tiara had been constructed in eight months, and had cost 2,000 roubles. When Rouchomovsky was tracked down, he admitted that the story was true. Some experts were still not convinced, and Rouchomovsky was brought to Paris to display his skills. It was clear that he could reproduce parts of the tiara without having seen the original. The scholars were flabbergasted. The tiara was taken out of the display case and stored in the cellars of the Louvre, and the goldsmith was regarded as the hero of the day.

Rouchomovsky's fame spread, and he made several miniature replicas of his fake tiara, displayed in 1904 together with other objects he had made 'in archaeological style'. An American wished to tour the United States of America with the goldsmith, together with the tiara of Saitapharnes, and offered the Louvre the same price that they had paid for it. But nobody in the Louvre wished their bad bargain to be remembered in such a manner, so the tiara was kept where it was, hidden from the view of curious visitors.

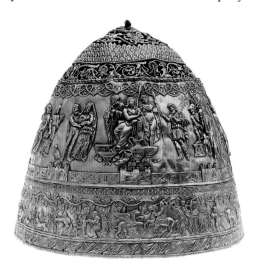

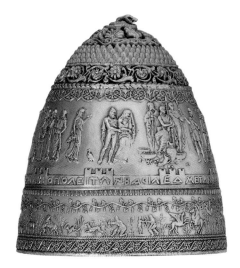

Left, top and bottom:
Two views of the so-called Tiara of Saitapharnes. Gold; made circa 1896 by Israël Rouchomovsky.
Collection and photos Musée du Louvre, Paris, France

Right, top and bottom:
Miniature Tiara of Saitapharnes. Gold; made in 1904 by Israël Rouchomovsky.
Collection and photo Wartski Ltd, London, England

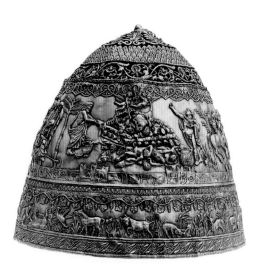

James A. Adetoyi

There must be few countries in the world where the profession of crown maker still exists. In Nigeria, the trade of crown maker is still practised because most of the crowns used by the rulers of the Yoruba people are made from beads sewn together. Due to frequent use, these crowns are in constant need of repair. The particular skills for making crowns is generally handed down from one generation to the next, as it is not simply a question of putting multicoloured beads together. The making of a Yoruba Crown involves many traditional procedures, including the use of *oogun ashe*, a powerful medicine that is placed inside the crown to protect the head of the king. This medicine is made by the *babalawo*, the traditional medicine man. The crown maker will always start with an offering to the god of iron, *Ogun*, because he uses metal needles. Offerings will also be made to *Umale Okun*, the god of the sea, because tradition says that he presented the first crown to the Yoruba people. Last, the crown maker will make an offering to *Obalufun*, the god who invented beads.

James A. Adetoyi is a member of the Adésìnà from the Nigerian town of Effon-Alaiye. He is an expert in making beaded crowns. Hundreds of royal headdresses probably passed through his hands during the second half of the 20th century. As a youngster, he learned his skills from his father, starting by threading tiny beads onto strings for his father to use in decorating the crowns he was making. Although there are different ways of making beaded crowns, the skilled makers usually work with a single-colour strand, which is attached to the surface of the crown frame. The frame is generally wicker or is made of twigs, cardboard or canvas over which wet starched unbleached muslin or cotton is stretched and allowed to dry in the Sun. When faces are used as decoration, pieces of cloth are dipped in wet starch to shape the visages. When the crown is decorated with birds, their three-dimensional shapes are carved from very light wood, which is then covered with wet starched cloth. Gifted crown makers do not sketch the individual decorations on the frame; they create the designs and colour combinations from memory or their imaginations. They only deviate from tradition when a ruler orders a new shape or design, or wishes to imitate a royal headdress seen elsewhere.

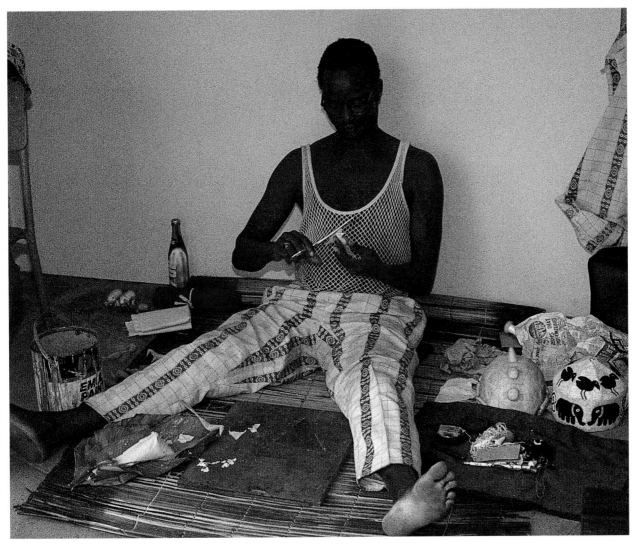

1976; James A. Adetoyi, traditional Yoruba crown maker, working in one of the inner courts of the National Museum, Lagos, Nigeria.
Photo René Brus

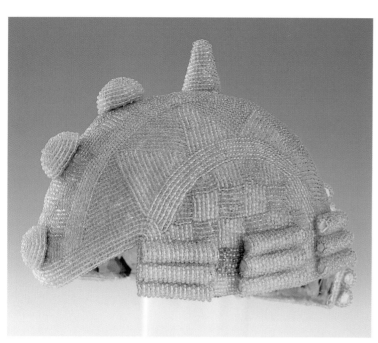

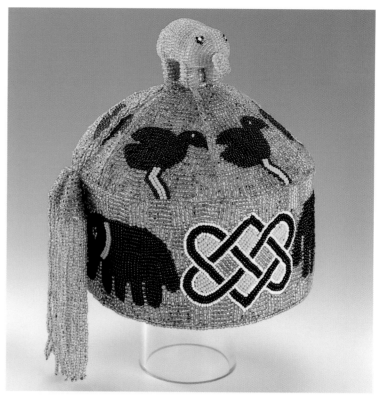

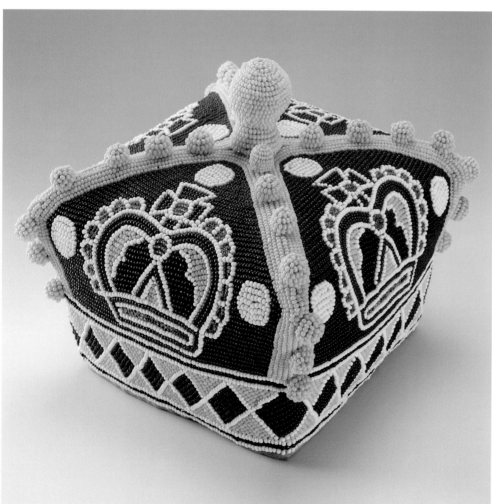

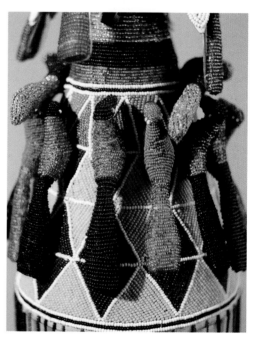

A traditional Yoruba coronation Crown, known as *Ade Eleiye Merimodinlogun*. Glass beads; made in 1976 by James A. Adetoyi. Collection and photo René Brus

Opposite page:
Top left:
A Yoruba crown, known as *Ade Loya*, Lawyers' Cap or Facing Cap. Its shape is based on the wigs worn by English lawyers. Glass beads; made in 1976 by James A. Adetoyi. Collection and photo René Brus

Top right:
A Yoruba crown, known as *Ade Elerin* or Elephant Crown. Its shape is based on the *Fez*. Glass beads; made in 1976 by James A. Adetoyi. Collection and photo René Brus

Bottom left:
A Yoruba crown, known as *Olorimefa* or *Orijogbofo*. According to some, ts shape is based on a European crown with arches; others see in it the headgear of catholic clergymen. Glass beads; made in 1976 by James A. Adetoyi. Collection and photo René Brus

Bottom right:
The back of the traditional Yoruba coronation crown, depicting six birds made of glass beads. Collection and photo René Brus

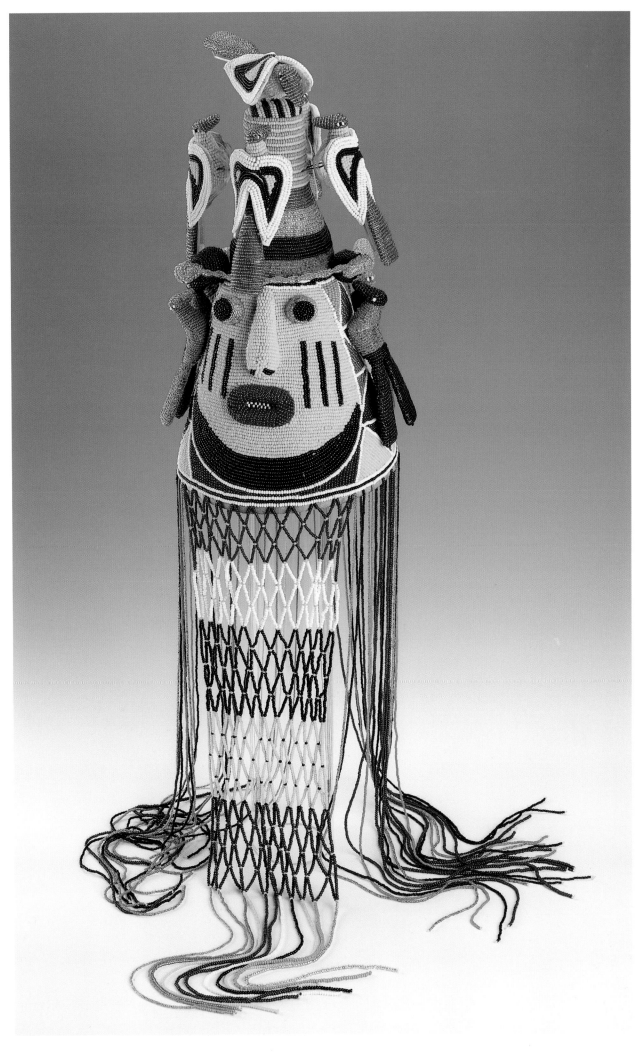

Cylindrical beads made from jasper and agate were used by the Yoruba before Europeans arrived in Africa and started importing thousands of mainly glass beads. These were generally sold by weight and were therefore often called pound beads. In the early days, these beads arrived in sailing ships at West African ports where the trade winds blew, and are often referred to as 'trade-wind beads'. This term should not be confused with 'trade beads', which refers to all beads used as a medium of exchange. The most valuable beads in the eyes of the Yoruba are those which, according to oral tradition, were given to Oba Esigie of Benin in around 1500 by the god of the sea on the condition that they forever be reserved for kings. These beads were said to be made from red coral, which was introduced into West Africa by Arab traders as early as the 12th century and traded for gold. The Portuguese, too, brought this type of coral into the region for trading, in the 16th century.

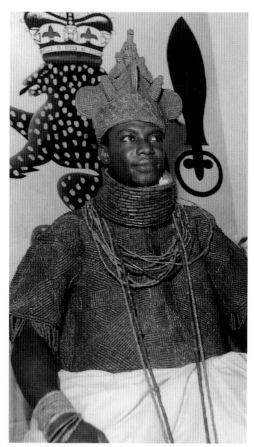

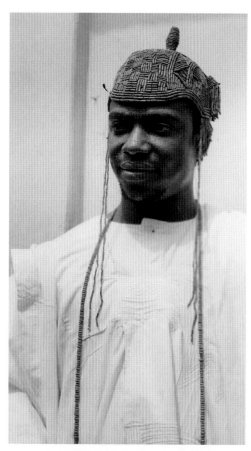

Top left:
18-19.12.1968;
Obi Ikenchuku I of Agbor just after being crowned.
Photo Ministry of Information, Ibadan, Nigeria

Top right:
18-19.12.1968;
Obi Ikenchuku I, the 17th Obi of Agbor, dressed before his coronation.
Photo Ministry of Information, Ibadan, Nigeria

Bottom left:
Crown of Oyebade Lipede, the Alake of Abeokuta. Substitute red coral beads; made circa 1960s-70s.
Collection the Alake of Abeokuta
Photo René Brus

Bottom middle:
State Crown of the Obi of Agbor. Red coral; made at the end of the 19th or beginning of the 20th century.
Collection the Obi of Agbor
Photo René Brus

Bottom right:
Crown of the Moloda of Odogbolu. Basketry, glass beads. Believed to have been made in the 19th century. The picture on the left reveals the basketry frame of the partly damaged crown.
Collection the Moloda of Odogbolu
Photo René Brus

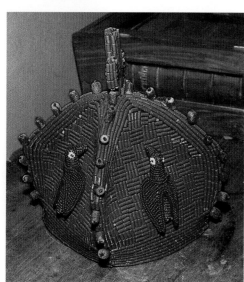

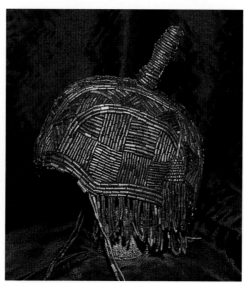

The coronation Crown of the Oni of Ife is unlike most traditional Yoruba coronation crowns. It is not conical in shape but cylindrical. The veil hanging from the rim is made solely of red beads. The front of the crown does not display a face, but has a fascinating structure with four long, cylindrical jasper beads attached to a disc-like base. At the back of the crown is another interesting ornament made out of beads and resembling a flower. Arch-like decorations made of jasper beads rise halfway and meet at the top of the crown, where little red feathers are placed in front of these arch-like ornaments.

The reasons for the difference in shape and decoration of the Ife Crown compared with the more traditional conical crowns could not be established by the author René Brus, when Adesoji Aderimi, the Oni of Ife, granted him permission to study and to photograph this crown. Some have named this crown the 'Olokun', as a reference to the very first crown of the Yoruba people, given by Olokun, the god of the sea. The design is obviously highly symbolic, but none of the courtiers could explain the hidden meaning of its shape or decorations. Or perhaps tradition did not allow them to disclose these facts to an outsider. The spiritual role and significance of the Oni of Ife, the direct descendant of Oduduwa, the first of all Yoruba Kings, might be the main reason why the origin of this coronation crown remains a mystery..

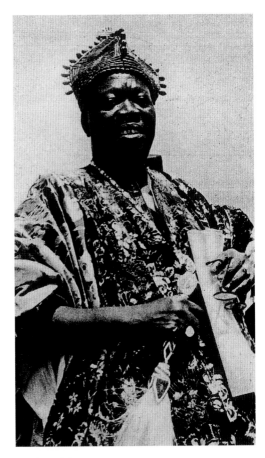

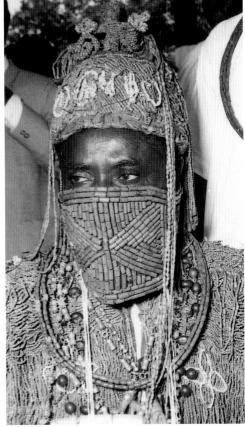

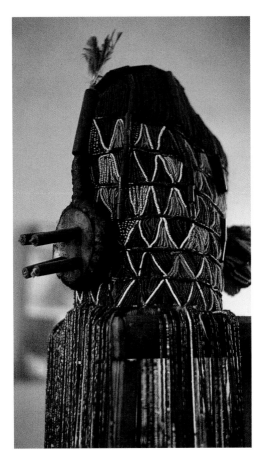

Top left:
1938; Oni Adesoji Aderemi of Ife during his state visit to England.
Photo collection the Oni of Ife

Bottom:
Crown of Adesoji Aderemi, Oni of Ife. Red coral; made first quarter of the 20th century.
Collection the Oni of Ife
Photo René Brus

Middle:
24.3.1951; Oba Erejuma II after being crowned as Olu of Warri with the traditional red coral beaded coronation crown.
Photo Information Department, Ibadan, Nigeria

Right:
Coronation Crown of the Oni of Ife. Beads of jasper, red coral and glass; age unknown, although it was already in existence around 1900.
Collection the Oni of Ife
Photo René Brus

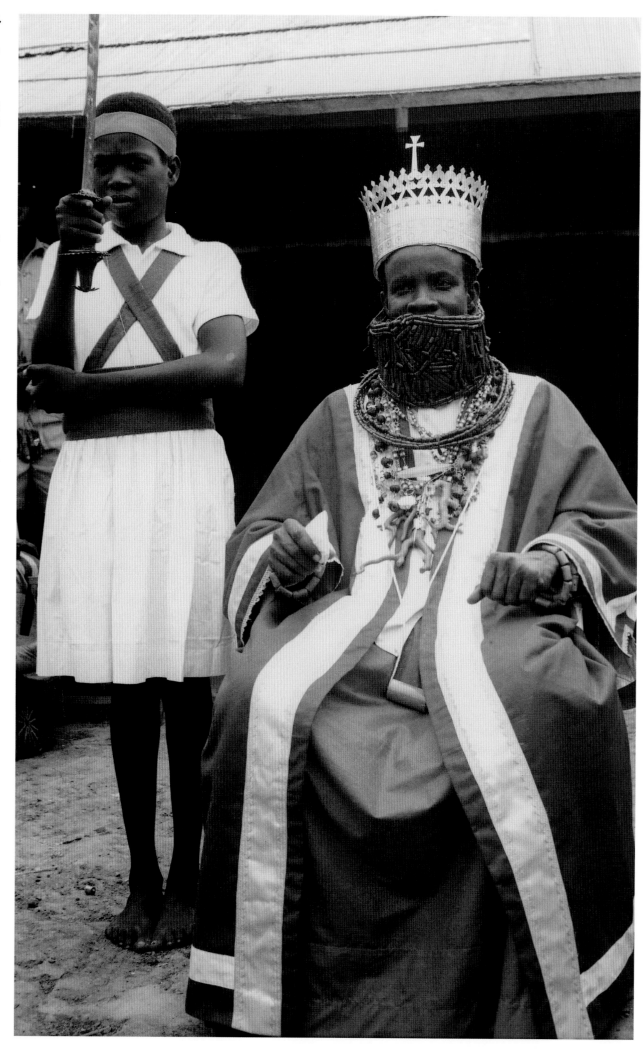

24.3.1951; Oba Erejuma II, Olu of Warri, during his coronation celebrations, wearing a silver crown set with polished red coral. Oral tradition holds that this ornament was a gift from King John IV of Portugal in the 17th century. King Mingo decided to convert to Christianity as soon as a white woman would marry him. A catholic priest persuaded a Portuguese woman from the island of St Thomé to marry the king. Their son, Don Antonio Mingo (also known as Antoni Dominico) went to Portugal around 1640 as the guest of King John VI for some time. When Don Antonio Mingo decided to return to the Kingdom of Warri, he received two almost identical crowns, studded with red coral, for his parents. These two crowns have been the coronation ornaments of the Olu of Warri and his consort ever since.
Photo Information Department, Ibadan, Nigeria

Royal children and marks of rank

In most countries, succession to the throne is regulated by age-old traditions. Generally it is the first-born child of the ruling monarch who becomes the next sovereign, either after death or if the monarch becomes too ill or too old to rule. In some societies succession might be determined by rotation among the different branches of a dynasty or by election through a council of elders or chiefs. Women have been excluded as ruling monarchs in many countries although, since the mid 19th century, legislation has changed for some monarchies and women are now entitled to become a monarch. Some monarchies formally invest or 'crown' the heir to the throne (the crown prince or princess, the heir presumptive or the heir apparent) in the presence of members of the aristocracy and government officials when he or she reaches the age of maturity. Others have a special headdress that is worn on formal occasions to show that the wearer is first in line to the throne.

In the past, a ruler was the source of all authority and could, in theory at least, hold power over life and death. The realm was administered by members of the aristocracy, who either received their title by inheritance or from the monarch. Noble titles came with emblems of their position and sometimes included the right to wear a headdress to denote their rank. The position of power gained by some members of the aristocracy led, in some cases, to the nobles adopting a crown similar in shape or decoration to that traditionally reserved only for their sovereign ruler. These nobles, however, regarded themselves more as independent rulers than as vassals.

France

The heir to the throne of France is called the *Dauphin*. This title finds its origin in the principality on the east bank of the Rhone River, where the Counts of Vienne ruled from the 14th century. The coat of arms of the Counts of Vienne includes two dolphins, therefore the count was referred to as the *Dauphin* (French for dolphin). King Philippe V of France took over the county of Vienne in 1349. His grandson, Charles V, was the first king to inherit the title of *Dauphin*. On his accession as King of France in 1364, Charles V transferred his title of *Dauphin* to his eldest son Charles VI. From that moment on, the heir to the throne bore the title of *Dauphin*, and was at the same time sovereign of the county of Vienne.

For the coronation of King Charles X on 29 May 1825, the goldsmith Cahier was commissioned to make a crown for the *Dauphin*, who also possessed the title of Duke of Angoulême. The gilded silver crown was made in the form of a headband with eight fleurs-de-lys. Four arches in the shape of dolphins rise to form two arches and their tails meet to support a double lily at the top. No precious stones were set into this crown; only enamelled decorations in the form of stones adorned the headband. This crown was never part of the official French Crown Collection. When it became an ornament that was no longer worn, it was first placed in the *Musée des Souverains* in the Louvre Palace in the mid 19th century, and then transferred to the *Garde-Meuble* or *Mobilier National*, a storehouse of furniture and other royal utensils in Compiègne, in 1874.

Finally, the *Dauphin's* Crown was moved from Compiègne to Reims in 1949. Many French monarchs had been crowned in Reims Cathedral, and the *Dauphin's* Crown joined various exhibits in the sacristy. Unfortunately, it was stolen from the cathedral in 1952 and its whereabouts is unknown.

Crown of Prince Louis-Antoine, Duke of Angoulême, Crown Prince of France. Silver-gilt and enamel; made in 1825 by Cahier. Stolen in 1952 from the sacristy of Reims Cathedral, Reims, France.
Photo collection René Brus

Opposite page:
Left:
Sketch of how peeresses should be dressed for the coronation of Queen Victoria of England. Made 1838.
Photo collection René Brus

Right:
A diamond and pearl studded tiara placed in front of a marchioness's coronet. Photo 1937.
Photo collection René Brus

England

England is one of the few countries today where the nobility still wear a crown of rank, known as a coronet, at the coronation of their sovereign. As soon as the king or queen receives the coronation crown, both sexes of the English nobility don their coronets. The peer's coronet fits his head firmly, while that worn by the peeress is small in size and thus placed on top of the head. These small coronets often have small sliding rods, like miniature hairpins, permanently attached to the rim of the coronet, which keep them more or less steady and secure on the head. The wearing of coronets dates back many centuries. In 1625 it was recorded that the viscounts carried their coronets in their hands during the procession from Westminster Hall to Westminster Abbey for the coronation of King Charles I. Barons have been wearing coronets since the coronation of King Charles II (1660), and the shape and decoration of these coronets are regulated by letters patent dated August 1661. By the time King William III and Queen Mary II were crowned in 1689, the system was codified in full detail, and it remains largely unaltered to this day.

In 1902, permission was granted for the ladies to wear a bejewelled tiara at the coronation and it became the tradition for their coronets to be small enough to be worn inside the tiara. This innovation dismayed the courtier Sir Almeric FitzRoy, '*The revolt of the Peeresses against wearing no diamonds has ended in tiaras being conceded which, with coronets, will produce as dubious an effect as a man's attempt to wear two hats, beside making it improbable that many will be able to place their coronets on their heads.*' Despite his and undoubtedly others' objections, the 1903 State Opening of Parliament brought another change. The peeresses were no longer required to wear their coronets and replaced them with the more costly and glittering tiaras.

Tradition dictates that the coronets of the English nobility must not be set with precious stones. Those worn by members of the royal family are embellished with ornaments resembling precious stones, and the positioning of these metal gemstones resembles the coronet worn by the heir apparent. The coronets of the royal family also have alternating crosses patées and *fleurs-de-lys*, but only that of the heir apparent is entitled to display an arch and an orb. For a duke and duchess, the circlet is made of gold; all other peers and peeresses may use silver-gilt, and their coronets are chased with jewels, with the exception of that of a baron and consort, whose circlets are unadorned. When strawberry leaves adorn the rim, genuine gold or gilding is used. Balls are wrought from silver. Inside the coronet, there is a cap of crimson velvet topped with a golden tassel. Ermine is attached to the rim to make the coronet more comfortable to wear.

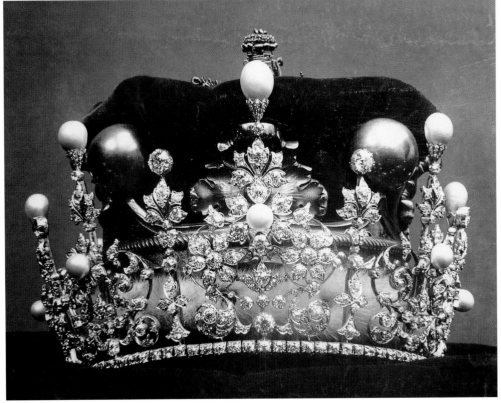

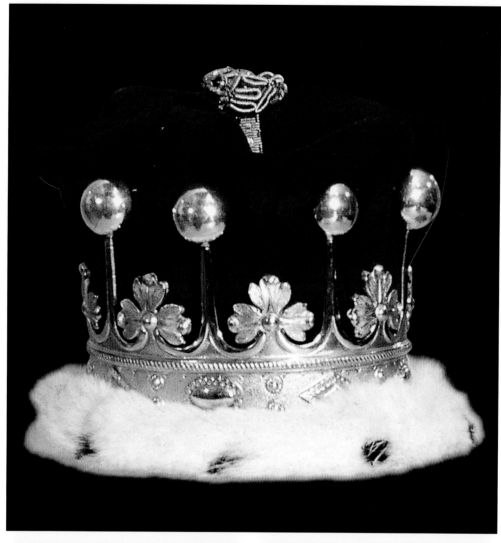

Right:
Coronet of a marquess.
Gilded silver and silver;
made in 1937.
Collection Garrard,
London, England
Photo René Brus

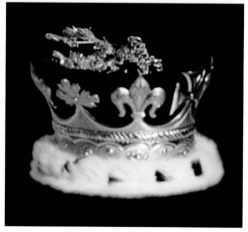

Left, top and bottom:
Top; The coronet of the
Duchess of Albany, with
a design intended for the
daughter of a sovereign.
Silver-gilt; made in 1902.
Bottom left; The coronet
of Countess Gertrude of
Dudley. Silver-gilt; made
in 1936.
Bottom right; The
coronet of Princess Alice,
with a design intended
for the granddaughter of
a sovereign. Silver-gilt;
made in 1902.
Collection London
Museum, England
Photo René Brus

In 1937, Garrard was asked to make two small golden coronets for the coronation of King George VI and Queen Elizabeth, which were to be worn by their daughters, the 11-year-old Princess Elizabeth and her six-year-old sister Princess Margaret. These coronets were finished off in the traditional manner with a velvet cap and ermine. In the end the royal couple and the princesses's grandmother, the Dowager Queen Mary, agreed that gilded silver coronets weighing 200 grams would suit the two sisters much better without the ermine and cap. The Dowager Queen Mary wrote about the coronation day in her diary, *'Lilibet and Margaret looked too sweet in their lace dresses and robes, especially when they put on their coronets.'* It was the first major official event in which the two princesses took part. In a composition about the coronation, Elizabeth, the heiress to the English throne, wrote, *'When Mummy was crowned and all the peeresses put on their coronets it looked wonderful to see arms and coronets towering in the air and then the arms disappeared as if by magic... What struck me as being rather odd was that Grannie did not remember much of her own Coronation. I should have thought that it would have stayed in her mind for ever...'*

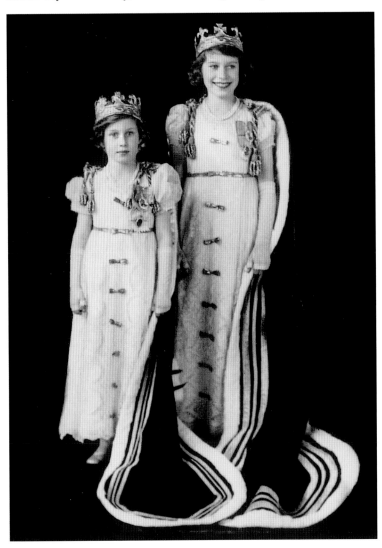

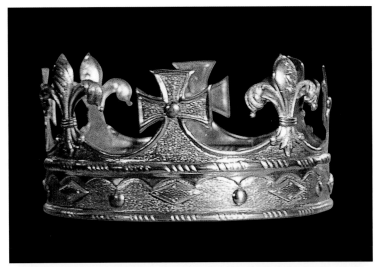

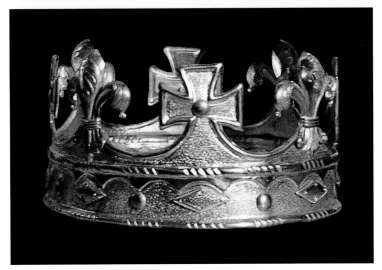

Left:
12.5.1937; the Princesses
Margaret (left) and
Elizabeth (right) in
regal attire during
the coronation of
their parents.
Photo collection
Windsor Castle, England

Right, top and bottom:
Top; The coronet of
Princess Margaret
Bottom; The coronet of
Princess Elizabeth.
Gilded silver; made
in 1937 by Garrard,
London, England.
Collection London
Museum, England
Photo René Brus

Prince of Wales

The eldest son of the ruling monarch of England receives at birth the title of Duke of Cornwall, and only at the pleasure of the sovereign is the heir to the throne created Prince of Wales by patent. In 1677, King Charles II sanctioned the heraldic use of a single arch on the coronet of the Prince of Wales to distinguish it from those of the sovereign's other children. '*The Son & Heir apparent of the Crown... shall use & bear his Coronet composed of Crosses and flowers de Liz with one Arch & in the midst a Ball & cross...*' But it took half a century before a Prince of Wales's coronet was actually made, for Prince Frederick Louis, son of King George II. The coronet was carried in front of the Prince of Wales when he took his seat in the House of Lords and placed before his seat when the king opened Parliament. Wigs were the fashion for both men and women in those days, and wearing this coronet without a wig is virtually impossible because, at 22.2 cm in diameter, it is too large for the average head.

For the coronation of King Edward VII in 1902, a new Prince of Wales's coronet was ordered from Garrard. It was similar to the 1728 coronet, but smaller so that it could be worn without a wig, and with the arch rising high above the headband rather than bent. When the Prince of Wales himself was crowned King George V of England in 1911, his son and heir Prince Edward wore the coronet that his father had worn during the 1902 ceremony.

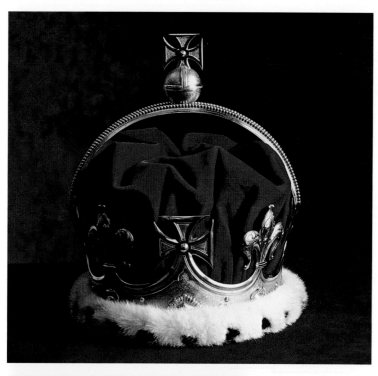

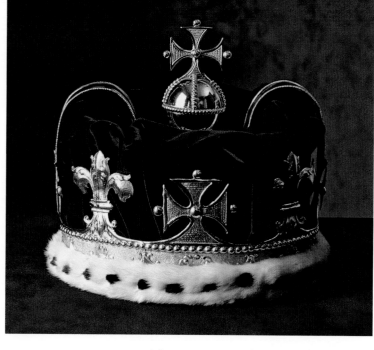

Bottom:
1911; Prince Edward, wearing the coronet of the Prince of Wales, which was made for his father in 1901.
Photo collection René Brus

Top left:
Coronet of Prince George, Prince of Wales. Gold, velvet and ermine; made in 1901.
Collection Tower of London, Jewel house, England
Photo Historic Royal Palaces, England

Top right:
Coronet of Prince Frederick Louis, Prince of Wales. Gold; made in 1728.
Collection Tower of London, Jewel house, England
Photo Historic Royal Palaces, England

Shortly after King George V ascended the throne, the politician David Lloyd George suggested that it might be a good idea to invest the heir to the throne, Prince Edward, formally as Prince of Wales. As such a formal investiture had not taken place for several centuries, historians and others drew on past ceremonies and attire, like the clothing that King Charles I had worn as Prince of Wales in 1616, for inspiration. It was decided that Prince Edward would be dressed in a similar manner, which, according to his memoirs, 'proved arduous' for him to wear. On 13 July 1911, during a heatwave, the outdoor investiture ceremony took place at Caernarfon Castle, Wales, in the presence of 4,000 spectators. A new coronet had been made by Garrard, to the designs of Welsh sculptor Sir William Goscombe John. The designs had only been submitted for the King's approval on 19 May 1911, so the coronet had to be made in less than two months. This coronet has no arch, but has four crosses patées alternating with fleurs-de-lys at intervals above the headband. The crosses and the fleurs-de-lys were pierced. Within the outlines of the former ran sprays of the rose of England and in the latter the daffodil of Wales. The spaces in between were filled with rosebuds. The gold used to make the coronet was mined in Wales, in the vicinity of Caernarfon.

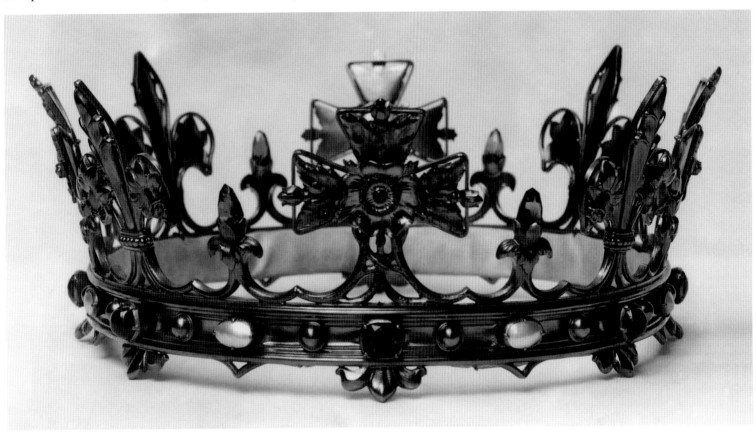

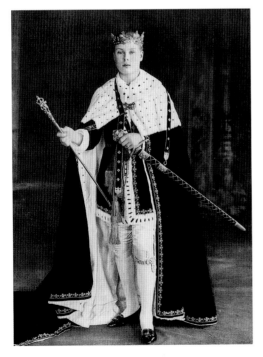

Bottom:
13.7.1911; investiture of Prince Edward as Prince of Wales.
Photo page from *the Illustrated London News*

Top:
Coronet of Prince Edward, Prince of Wales. Gold, amethyst and pearls; made in 1911 by Garrard, London, England.
Photo René Brus

Austria

In the days of the Holy Roman Empire in Europe, the electors who chose the emperor wore an official costume. Part of the costume was a purple cap trimmed with ermine. After the treaties of Westphalia in 1648, these electors' hats, or coronets, were raised in status with the addition of an arch or hoop. This was invariably decorated with precious stones and pearls and usually surmounted by an orb and a cross. In the complicated hierarchy of the Empire, several aristocratic houses gradually began using headdresses that, in their eyes, had the status of royal crowns.

The nobility in the Austrian patrimonial dominions used similar dynastic hats to show their position. The oldest preserved example is the ducal hat of Styria, which dates from around 1450 and has a broad ermine rim like the elector's hat. The ducal hat of Styria was brought to Vienna during the reign of Empress Maria Theresa (1717-1780), but returned to its county of origin at the request of Styria in 1766. Before it was handed over, the hat was restored. Drop-shaped pearls were added to the ten silver-gilt gables and the moth-eaten cap was replaced.

The most elaborate archducal hat was ordered by Archduke Maximilian III 'to ensure a closer connection between the Roman Catholic Church and the ruling dynasty of Austria'. The broad rim was again ermine, while the gables, arches and the globe and cross on top were made of gold and studded with numerous precious stones, pearls and enamel. When the hat was completed, Maximilian III presented it to the Monastery of Klosterneuburg on 15 November 1616, during the feast day of his forebear St Leopold. At the ceremony, God's eternal punishment was invoked upon anyone who took the hat away, with the exception of each archduke when he needed it for his investiture as ruling Archduke of Austria. Four years later, this archducal hat was used at the investiture of Archduke Ferdinand II, and then at all such subsequent ceremonies up to that of the last Archduke, Ferdinand the Good, who accepted the title of Emperor of Austria in 1835 but abdicated in 1848.

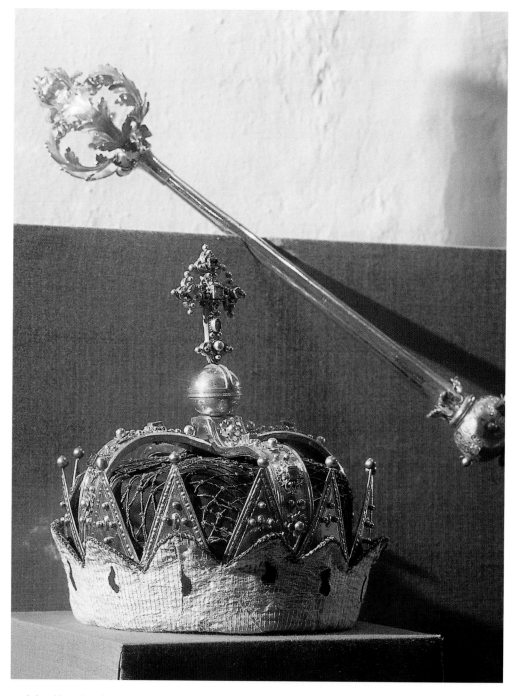

Archducal hat of Tirol. Gilded silver, paste and silk; made during the first half of the 16th century. Schlossmuseum Wallfahrtskirche, Mariastein, Austria Photograph by courtesy of Tourismusverband Wörgl-Angerberg-Mariastein, Wörgl, Austria

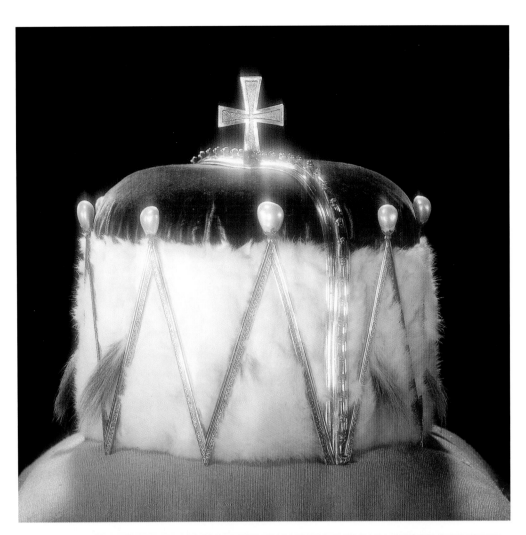

Ducal hat of Styria.
Gilded silver, pearls and
enamel; made circa 1450.
Collection and photo
Landesmuseum
Joanneum, Graz, Austria

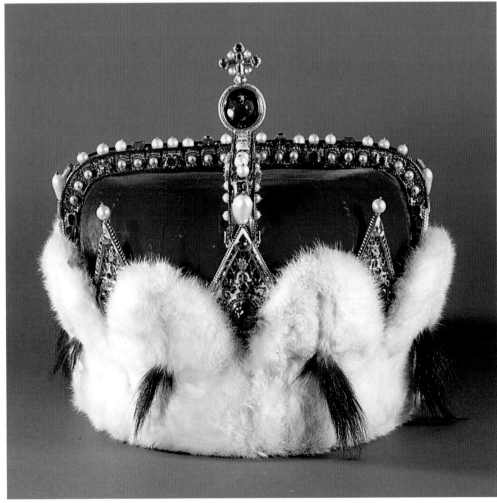

Archducal hat of Austria.
Gold, diamonds, rubies,
emeralds, sapphires,
pearls and enamel;
made in 1616.
Collection Treasury
Klosterneuburg
Monastery, Austria
Photo Stiftmuseum,
Klosterneuburg
Monastery /
Inge Kitlitscha,
Klosterneuburg, Austria

Sweden

In Sweden, Karl Gustav, Hereditary Prince, wore a large, burgundy red velvet hat with gold and silver flame embroidery and a white brim, trimmed with ermine, during the coronation of Queen Kristina on 20 October 1650. An open crown was placed over this hat. The crown was made by Jürgen Dargeman using ornaments from the crown that had been made by Ruprecht Miller in 1606 for Queen Kristina the Elder. In 1762, the hat was replaced by a blue, gold-embroidered cap, and in this altered form it was worn by Crown Prince Gustav. When he was crowned King Gustav III in 1772, the crown was altered by the court jeweller Johan Adam Marcklin, who replaced two small pearl-topped spires with two black enamel sheaves to symbolise the Vasa dynasty. Since Gustav III's reign, this crown has served as the crown of the heir apparent and has been worn on a number of occasions, including at the ceremonial opening of the 'Riksdagen', the Swedish Parliament. Other male and female members of the Swedish dynasty were also entitled to wear similar crowns as symbols of their position. This custom was dropped in 1907. The current dynasty, the House of Bernadotte, honours the tradition of displaying the crowns of the princes and princesses during important dynastic events, such as baptisms and funerals.

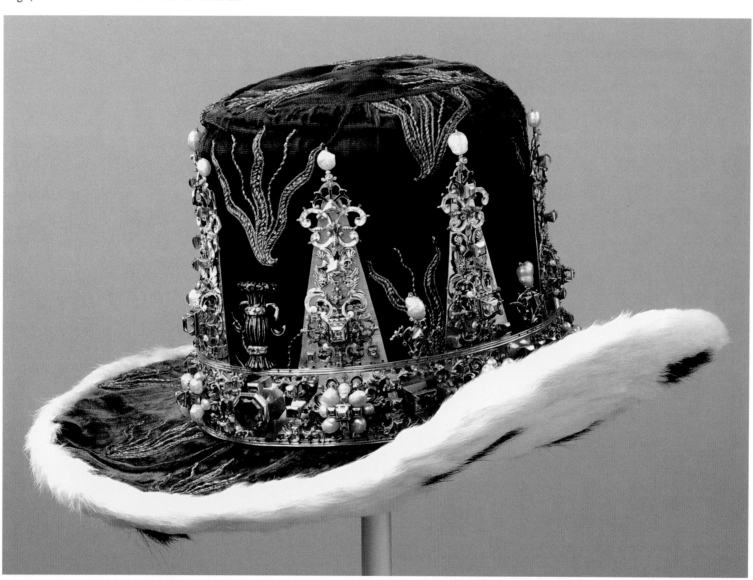

Crown and hat of Prince Karl Gustavus, Hereditary Prince of Sweden. Gold, diamonds, sapphires, rubies, pearls and enamel; made in 1650 by Jürgen Dargeman using parts of a crown that was made in 1606 by Ruprecht Miller for Queen Kristina the Elder of Sweden.
Collection and photo Royal Treasury Skattkammaren, Stockholm, Sweden

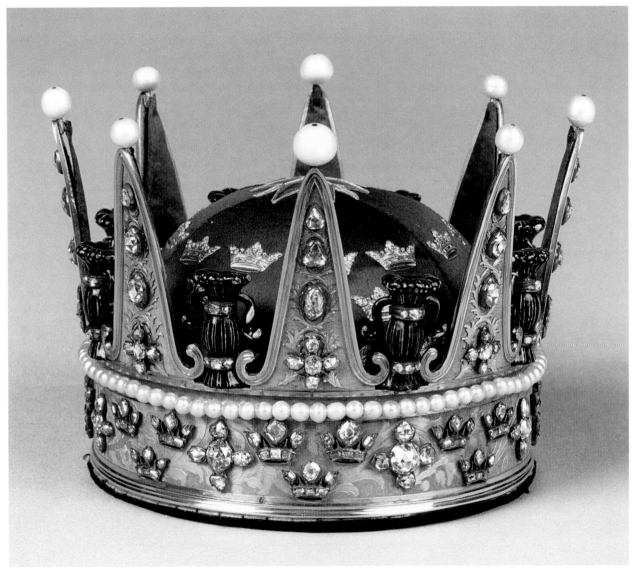

Top left:
1905; opening of the
Swedish Parliament
by King Oscar II,
with several of his
sons wearing their
princely crowns.
Photo collection
René Brus

Top right:
1977; the baptism
ceremony of Crown
Princess Victoria of
Sweden. Next to the
baptismal font is a
special altar for the
Crown of Princess Sofia
as a symbol of the baby's
royal position.
Photo The Embassy of
the Kingdom of Sweden,
The Hague,
The Netherlands

Bottom:
Crown of Princess Sofia
Albertina of Sweden
Gold, diamonds and
pearls; made in 1772 by
Johan Adam Marcklin.
Collection and photo
Royal Treasury
Skattkammaren,
Stockholm, Sweden

Norway

Norway's Crown Prince has a crown that was actually made for the Swedish Crown Prince. In 1814, Norway was given the status of *'a free, independent and indivisible Kingdom, united with Sweden under one king'*. This meant that the Swedish monarch was crowned in both Sweden and Norway. When King Karl XIV of Sweden, the former French general Jean-Baptiste Bernadotte, was crowned King Karl XIV Johan of Norway on 7 September 1818, Crown Prince Oscar brought his Swedish Crown to Norway to wear during the ceremony. It was 1846 before Norway acquired, for 330 ducats, a crown prince's crown, which in shape closely resembled that of the Swedish Crown Prince's crown. However, this Norwegian princely crown has never been worn. In 1905, the union between Sweden and Norway ceased to exist, and the Danish Prince Carl agreed to become King of Norway. When he and his wife Queen Maud were crowned on 22 June 1906, their son Olav, the future king, was too young to attend the ceremony wearing the princely crown. By 1908, Norway's constitution made it clear that it was no longer compulsory for its sovereign ruler to be crowned, which implied that there was also no need for the crown prince to wear his crown in public.

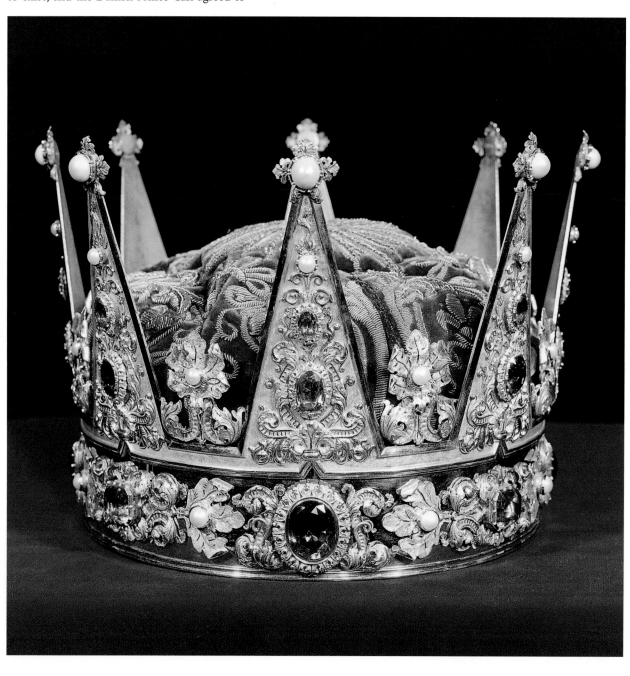

Crown of the Crown Prince of Norway. Gold, amethysts, topazes, peridots and pearls; designed by Johannes Flintoe and made in 1846 by Herman Colbjornsen Oyset. Collection Treasury Nidaros Cathedral, Trondheim, Norway Photo Sverre Ustad, Jakobsli, Oslo, Norway

Ethiopia

In 1902, Ras Makonnen represented his sovereign, Emperor Menelik II, at the coronation of King Edward VII of England. On his return to Addis Ababa, this Ethiopian nobleman reported what he had seen in detail to his ten-year-old son Tafari. The boy was particularly impressed by his father's opinion that a king must be regarded by his people as powerful and splendid so that they feel they share his glory. Twenty-eight years later, Ras Tafari was to be crowned Emperor Haile Selassie I of Ethiopia with a great display of pomp and ceremony that harmoniously blended the ancient rituals of the Ethiopian church with a ceremony drawn from the English coronation service. Fourteen coronets were ordered from the Goldsmiths and Silversmiths Company in London (in later years known as Garrard). These were designated for several high nobles, members of the imperial family and the Crown Prince Asfaw Wossen. Although these coronets were different from their English counterparts in detail, the main emblems being the Lion of Judah facing the Rising Sun, the Cross of Ethiopia and the Ethiopian Star, all the coronets showed the rank of the wearer and had a velvet cap inside. On 2 November 1930, an eyewitness account by the American Brigadier-General Harts noted that not only was the crown prince crowned with his emblem of rank, but his four sisters were also crowned. This signified that female members of the ruling dynasty were not excluded from the possibility of being called upon to rule the country in the future as 'The Elect of God, the Conquering Lion of the tribe of Judah, Negus Negesti (or King of Kings) and Emperor of All Ethiopia.'

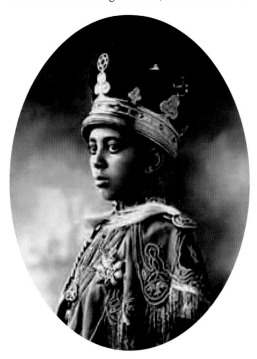

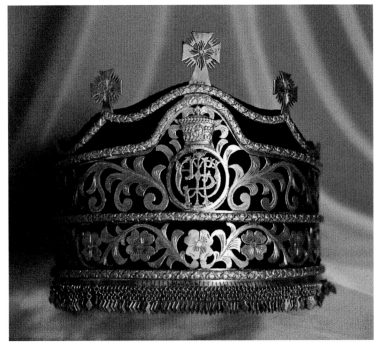

Top left:
Photo of Prince
Makonnen of Ethiopia,
Duke of Harrar.
Photo collection
René Brus

Top right:
Coronet of Ras Bitwoded
Makonnen Endalkachew.
Gilded silver; made
in 1930.
Collection Ethnological
Museum, Addis Ababa,
Ethiopia
Photo René Brus

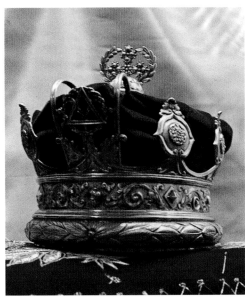

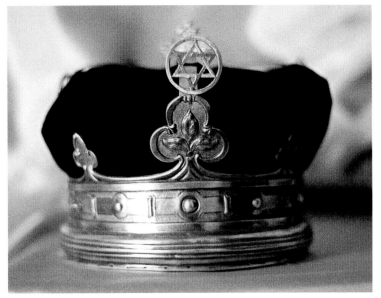

Bottom left:
Coronet of Ras Seyum.
Gilded silver; made in
1930 by Garrard.
Collection Treasury
Entoto Mariam Church,
Addis Ababa, Ethiopia
Photo René Brus

Bottom right:
Coronet of Prince
Makonnen of Ethiopia,
Duke of Harrar.
Gilded silver; made in
1930 by Garrard.
Collection Treasury
Trinity Cathedral, Addis
Ababa, Ethiopia
Photo René Brus

Nigeria

In the world of protocol it is nowadays generally accepted that an emperor is 'king of kings', and therefore a king is second in the hierarchy. In the days when a country became a colony, the position of local or native rulers came into question. The problem for the coloniser was not only to establish how the aristocracy were ranked, but also who had the right to stipulate what symbols of kingship the members of the aristocracy in the colony were entitled to use. In 1947, the Nigerian ruler Aderemi I, Oni of Ife and, according to the Yoruba people, their religious head, asked whether the colonial British Government was prepared to '*consider the advisability of regulating its (crowns with beaded fringe) wearing by legislation*' during a meeting in the Western House of Assembly. The colonial government answered in the negative, because the British authorities were convinced that the existing, traditional, rules were sufficient for the Yoruba. The British ignored the fact that some local rulers were not obeying these traditional rules and wore the wrong type of crown.

The Yoruba maintain a complicated hierarchy of hundreds of rulers, locally referred to as Oba, whose forefathers sometimes ruled vast kingdoms. According to legend, Oduduwa (Odudua or Odua), the mythical forefather of the Yoruba dynasties, divided his kingdom between his 16 sons, creating kingdoms such as Oyo, Ijebu-Ode, Abeokuta and Ife. Each of these kingdoms was divided into provinces, which were ruled by nobles (aristocrats) of a lower rank, and the highest authority in the major towns was given the title of Bale. The kings, who were descended from the 16 sons of Oduduwa and known locally as 'first class Obas', were entitled to wear a conical crown with a beaded fringe that covered the face and was decorated with birds and faces. The 'second class Obas', who had family connections with the ruler of Ife, were sometimes given the privilege of wearing similar crowns. Other rulers did not have the traditional privilege of wearing a fringed crown; they could wear headdresses known as the *orikogbofo* and the *akoro*.

It is curious that the British colonial authorities decided not to regulate the shape or the wearing of certain crowns for Yoruba society, as they had solved a similar problem in their Gold Coast colony by proclaiming a 'native customary law'. In the Gold Coast, the local rulers were powerful enough to use gold for their regalia, and had started to wear elaborate crowns and other headdresses. The British decided that this could not continue and, in 1929, H. Bleasdell, Commissioner of the Eastern Province, proclaimed that those in rank of the Adontenhene, Wifashone, Benkumhene, Oseawuhene, Gyasehene, Takwahene, Otweresohene or Odauhene and Asamankeshene '*may own, possess and use... a coronet of velvet or silk cap or fillet with three or four gold and silver pieces.*'

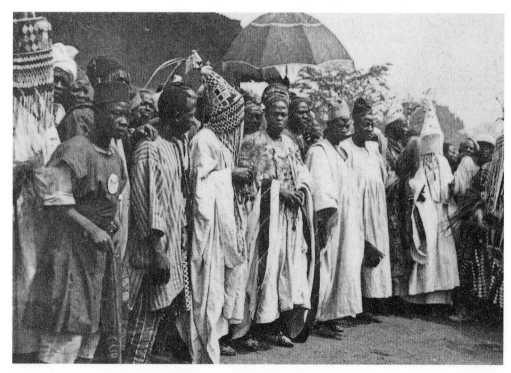

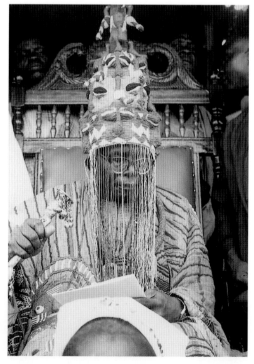

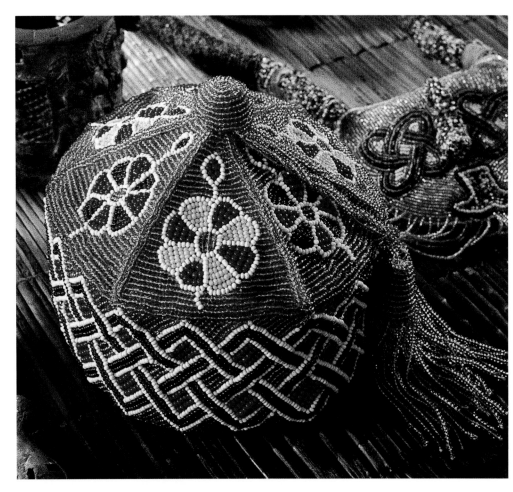

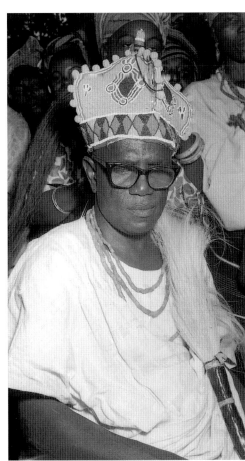

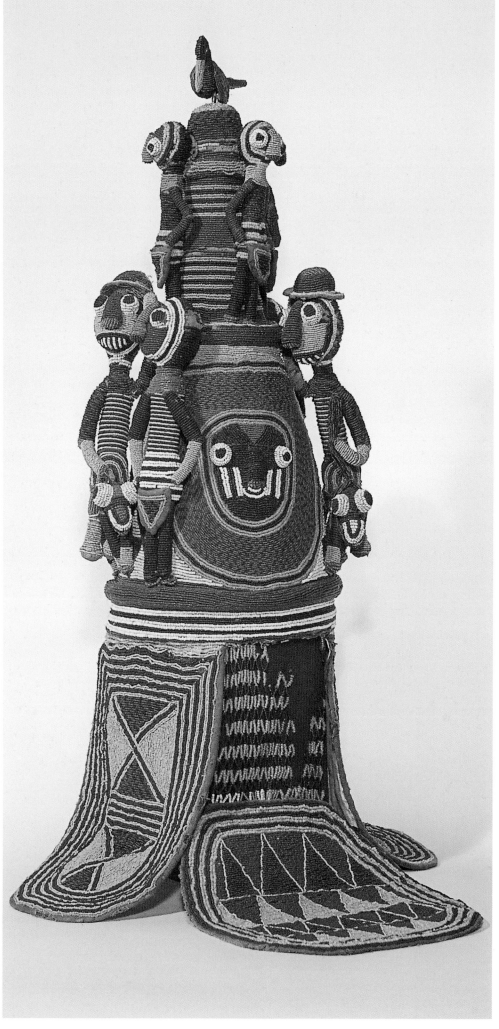

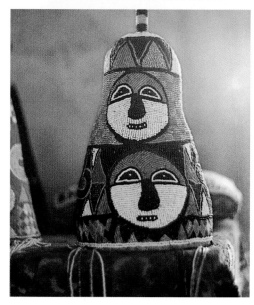

Left:
Yoruba Crown. Glass beads; made end 19th century.
Collection and photo Brooklyn Museum, New York, USA

Top right:
Crown confiscated by the British Government end of the 19th beginning of the 20th century due to the fact that the Elepe of Epe claimed his position as king. This claim was disallowed and the crown with beaded fringe was sent to England and became the property of the Museum of Mankind in 1904. Glass and cloth.
Collection Museum of Mankind, London, England
Photo René Brus

Bottom right:
Crown of Oba Oyekanbi, the Olokuku of Okuku. Cloth and glass beads; made beginning of the 19th century. This crown is referred to locally as *Balolaiye*, which means 'The Oba who owns the World', and was originally worn during the Osun festival (the festival named after the wife of Sango, the god of thunder and the mythical founding King of Oyo). The original bird on top has vanished.
Collection the Ruling House of Okuku, Nigeria
Photo René Brus

Persia

During the 18th and 19th centuries, it became a tradition in Persia for the Crown Prince of the Qajar (or Kadjar) dynasty to wear a high cylindrical headdress during important dynastic events such as *No Ruz*, or the New Year celebration. The shape of the headdress was inspired by the glittering *Kiani* Crown, the coronation Crown of the Qajars, decorated with thousands of pearls, diamonds, rubies and emeralds. The shape of both crowns is derived from the *cidaris*, the high, tapered cylindrical headdress that was worn thousands of years ago by kings and high priests from the Old Testament, and around which a band of costly stones and pearls was sometimes attached. Only one Persian crown prince's crown is still preserved, that of Crown Prince Abbas Mirza. This crown is mainly one vast work of embroidery, consisting of thousands of spangles and small pearls attached by thread to a cloth base. It is believed that it is because no large quantities of precious metals and valuable stones adorn this crown that it has been saved from destruction. Many other crowns were destroyed and stripped of their valuable materials.

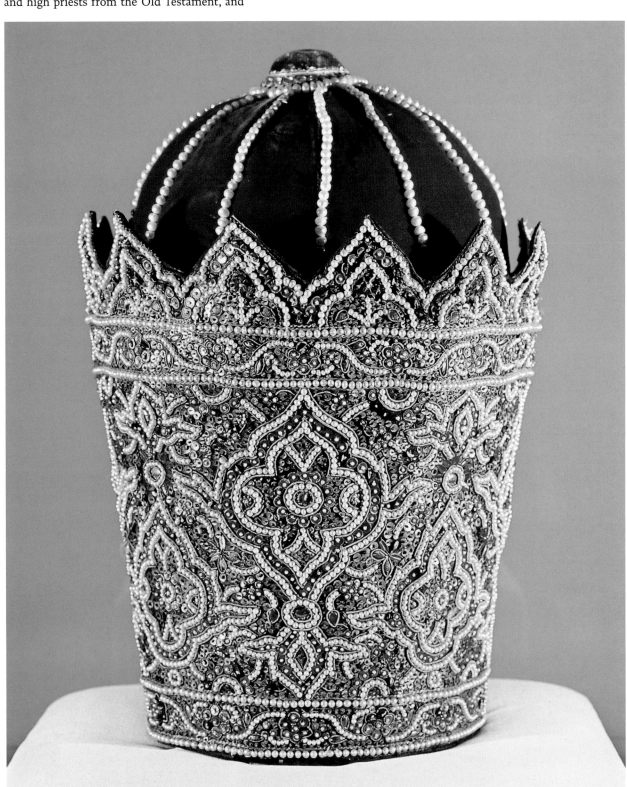

Crown of Prince Abbas Mirza, Heir Apparent of Persia. Gold, diamonds, emerald and pearls; made end 18th century.
Collection Treasury National Bank of Iran, Teheran
Photo National Bank of Iran, Teheran

China

Historically in China, regulations on special headdresses for high officials or members of the nobility are widespread. In 1759, Emperor Ch'ien-lung (also referred to as Qianlong) of China laid down the rules that made special head coverings and ornaments an important sign of recognition for high functionaries, the nobility and members of the imperial family. These rules were derived from the Manchu tradition, and were described in 1636 and 1644. In the Western world, these headdresses are known as mandarins' hats, while in Chinese they are known as *Ji guan*. The hats are decorated with a 'knob' that showed the importance of the wearer by its colour and the material from which it was made. Only the emperor and the crown prince were allowed to wear a knob made of an enormous pearl in a gold mounting on their semi-official hat. A knob incorporating

a blood-red ruby was worn by the heir to the throne and a number of high mandarins. The lower echelons in the Chinese hierarchy were allowed to wear knobs of white jade, rock crystal and sapphire, generally replaced by white or blue glass, although lapis lazuli was regarded as a proper substitute for the much more valuable sapphire. Peacock feathers were also a striking feature of the mandarin hat and were presented by the emperor in person as a special sign of imperial favour. When the 'eyes' in these feathers were clearly visible, this indicated a higher honour for the favoured one. When the traditional deep bow, the *kowtow*, was performed by a mandarin with peacock feathers attached to his hat, his face would be bent so near the ground that the plume would be slightly raised, resembling somewhat the impressive tail of the male peacock.

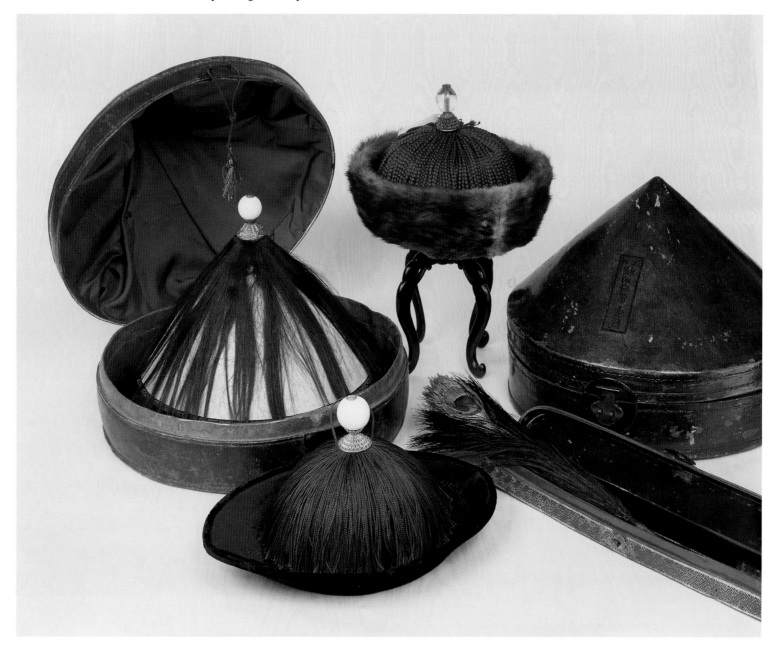

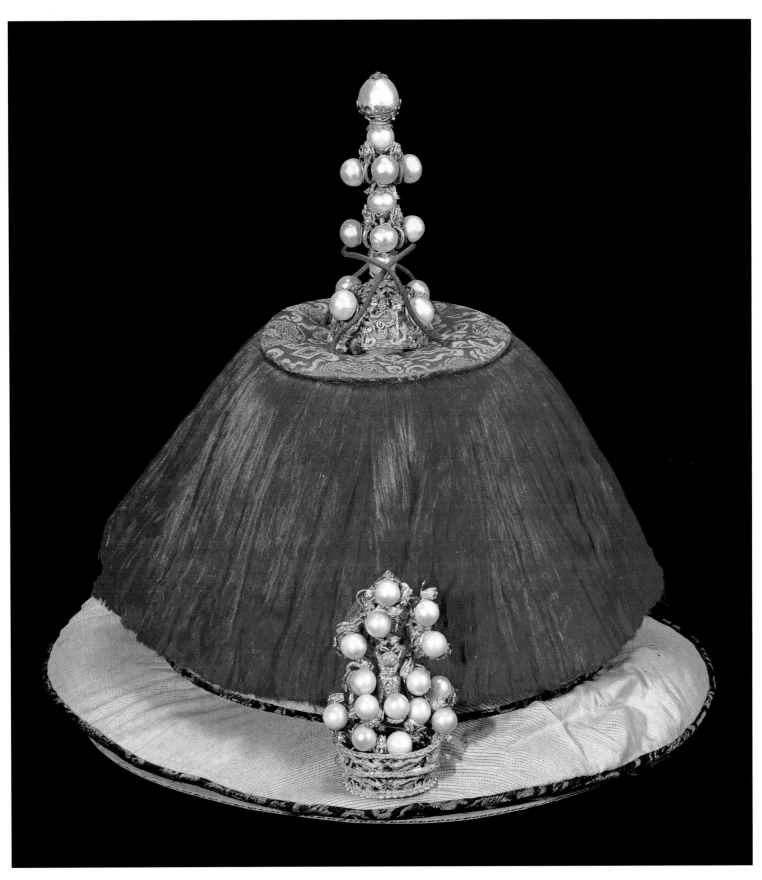

Opposite page:
A collection of *Ji guan* or
mandarins' hats. Gold,
Peking glass and silk;
made 19th century.
Collection and photo
Linda Wrigglesworth,
London, England

Summer hat of Emperor
Ch'ien-lung. Gold, pearls,
rubies and silk; circa 1778.
Collection and photo
National Palace Museum
Taiwan, People's
Republic of China

Brunei

In Brunei, there are two ceremonies in which the position of the heir presumptive is publicly shown. First is the 'coming-of-age' ceremony, and second, usually a few years later, his investiture as *Pengiran Muda Mahkota* or Crown Prince. Although neither ceremony involves a coronation, the prince usually wears an impressive headdress studded with precious stones.

The crown worn by Crown Prince Al-Muhtadee Billah, son of Sultan Hassanal Bolkiah Mu'izzaddin Waddaulah, during his coming-of-age ceremony in 1989 and during his investiture as crown prince in 1998, was a reconstruction of the coronation crown of his grandfather,

Sultan Omar Ali Saifuddien III, and the crown which his father wore in 1961 during his investiture as crown prince. In shape, the crown of Crown Prince Al-Muhtadee Billah closely resembles the *songkok*, the traditional head covering of many Muslims in south-east Asia. It consists of a floral open-work golden frame studded with gemstones placed over a velvet cap. The front of the crown is adorned with the crest of the Crown Prince of Brunei. Attached to the rim of the crown are ten ruby-studded structures taken from his father's crown when he was invested as crown prince, which represent a three-tiered umbrella.

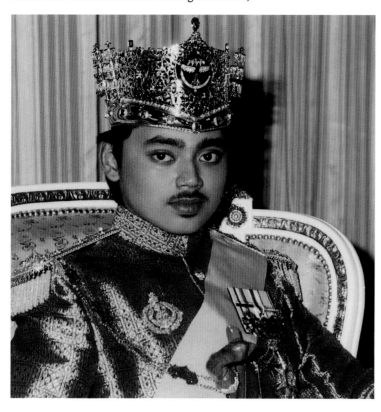

August 1989; the coming-of-age ceremony of Prince Al-Muhtadee Billah of Brunei.
Photo collection
René Brus

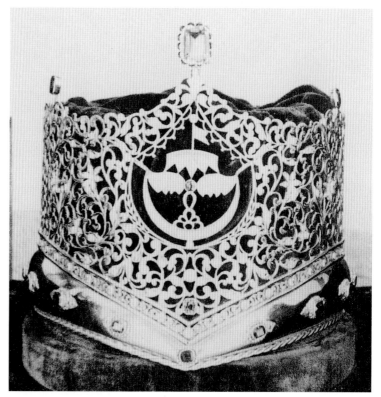

The coronation Crown of Sultan Omar Ali Saifuddien III of Brunei, made in 1951, became the crown of his grandson Prince Al-Muhtadee Billah in his capacity as Crown Prince of Brunei. Gold, diamonds, rubies and emeralds.
Photo Brunei Museum, Bandar Seri Begawan, Brunei

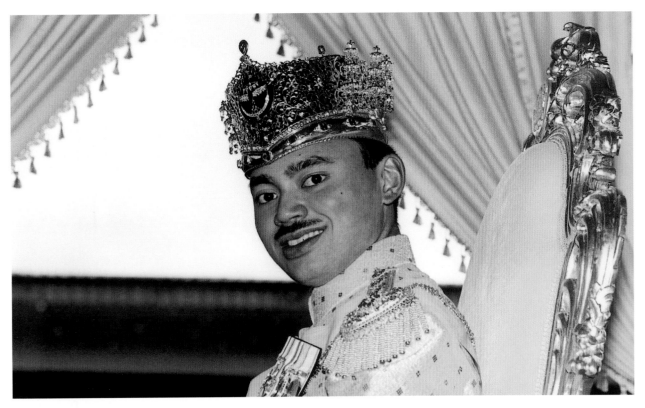

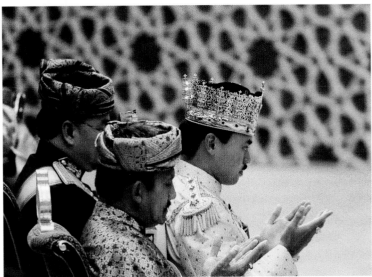

10.8.1998; investiture
ceremony of Prince
Al-Muhtadee Billah as
the Crown Prince
of Brunei.
Photo collection
René Brus

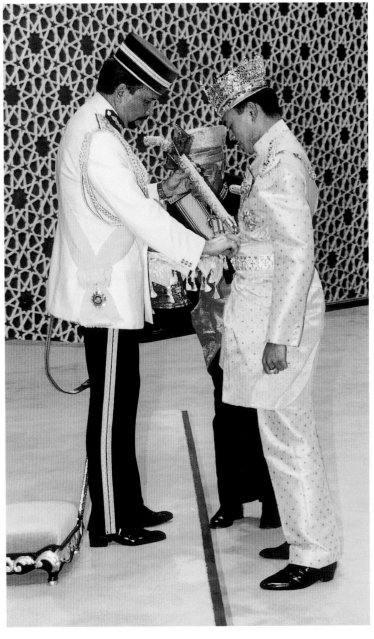

Thailand

Thailand did not name a crown prince until 1878. Previously, the monarch would appoint a deputy king when he ascended the throne, usually either his brother or eldest son. Only on his deathbed would the king make the final decision concerning his successor. Contact with the West in the 19th century brought changes to Thailand. King Chulalongkorn Rama V adopted the custom of the eldest son's right to inherit the crown, and in 1878 Prince Vajiravudh was officially proclaimed as Crown Prince. King Chulalongkorn Rama V decided to mark this historic occasion with a grand investiture at the Royal Palace. The numerous ceremonies performed included the ancient custom of the Sacred Water Rite, the ceremonial bathing of the prince. A large pool of water was first blessed by the Brahmin priests, who threw in silver and gold fish and silver and gold cocoa-nuts. One of the top-ranked princes then plunged the young heir to the throne – dressed in sumptuous royal garments – into the water. When the gold and silver fish and cocoanuts floated towards the crown prince, the Brahmins blessed him aloud, upon which the king proclaimed his son his successor amidst the noise of cannon salvoes and trumpet fanfares. The prince was not actually crowned that day, although during parts of the investiture he wore a crown that was similar in shape to the coronation crown of his father. Mr Jacob Child, the American representative in Thailand, wrote a very detailed and colourful account of the ceremonies to his president, in which the glitter of jewels is mentioned frequently. *'The procession having passed, the King and Prince retired and soon appeared, the King with his royal robe on, a cloak of gold that reached nearly to his ankles and on his head a crown, made in the shape of a pagoda, fourteen inches in height, of the purest gold, studded with jewels, surmounted with a diamond of fabulous value, weighing a number of pounds. He was forced to fasten it on to keep it from toppling to one side, a very uncomfortable headgear out of the assertion "uneasy is the head that wears a crown". The Crown Prince also wore a crown of similar shape, a mass of jewels, he was dressed in white silk and before he put on his crown his topet or tuft of hair that each Siamese youth wears, was encircled with a coronet of diamonds set in silver; his collar, at least eight inches deep, was elaborately embroidered with diamonds as was the breast and cuffs of his coat, around his neck was swung a medallion of his father encased with brilliants, his fingers were hooped with gems and around each ankle were six anklets of gold encrusted with precious stones, the fastenings of his coat were five buttons as large as a filbert, diamonds set in filigree of gold, his belt and slippers were also a mass of priceless gems, making up a costume regally beautiful, the value of which could not be computed under a half million dollars.'*

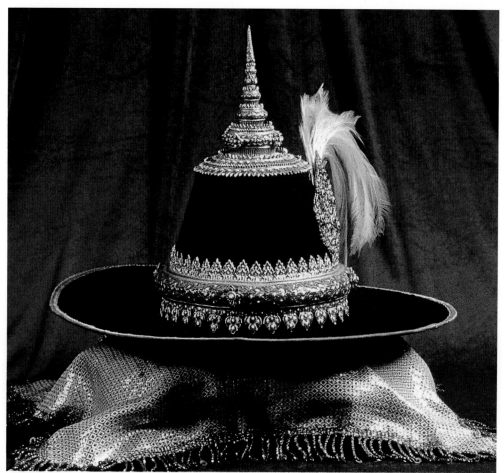

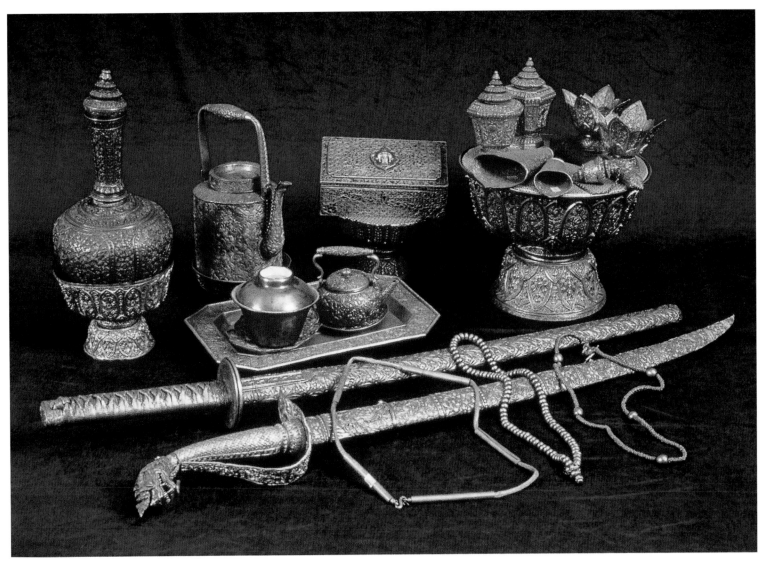

Opposite page:
Left:
The *Phra Mala Sao Sung*
or Royal Ceremonial
Felt Hat of the Crown
Prince of Thailand.
Gold, diamonds, rubies
and enamel.
Collection Royal Thai
Decorations and Coin
Pavilion, Grand Palace,
Bangkok, Thailand
Photo collection
René Brus

Right:
Bejewelled hat of
Charles the Bold, Duke
of Burgundy. Lost during
the battle of Granson
in 1476.
Watercolour from the
volume Cgm 896, fol
8r *Ehrenspiegel des
Hauses Österreich*
from the collection
of the Bayerische
Staatsbibliothek,
Munich, Germany

Part of the regalia of
the Crown Prince of
Thailand. In front, the
ceremonial sword with
the three-headed *naga*
or sacred serpent and the
personal sword. Other
ornaments are three
ceremonial chains; one
golden chain, one golden
rosary with 108 beads,
and a golden chain with
a sacred scroll (*Phra
Takrud*). Behind the two
swords is a tray with a
cover cup and teapot
and on the right a betel
nut set.
Collection the
King of Thailand
Photo collection
René Brus

Next page:
28.12.1972; installation
of Prince Maha
Vajiralongkorn of
Thailand as Crown
Prince.
Photo collection
René Brus

Religious and spiritual considerations are important in Thailand, and royal ceremonies are usually only held after precise calculations by the court astrologers concerning the movements of the stars and planets. Twelve twenty-three p.m. on 28 December 1972 was designated as the most auspicious time for His Majesty King Bhumibol Adulyadej to pour consecrated water on his son, Prince Maha Vajiralongkorn, and to anoint his forehead to mark the 20-year-old prince's investiture as crown prince and heir to the throne of Thailand. In the central hall of the Ananta Samakhom Throne Hall, in the presence of members of the Government, high religious and court officials and diplomatic corps, the king presented the crown prince with decorations and emblems of rank which are believed to ensure the recipient prosperity and happiness and to protect him from any disaster. The prime function of these ceremonial ornaments, however, is to remind the crown prince to perform his duties with devotion and justice. Among the 21 objects that were handed over to Prince Maha Vajiralongkorn by his father was the crown of the crown prince and the *Phra Mala Sao Sung*, a ceremonial hat reserved solely for the heir to the throne of Thailand, which has as its main decoration a feather attached to the bejewelled hatband.

This type of hat appears to have been introduced in the 17th century. Thai envoys to Europe must have noted that most male members of the European aristocracy and nobility wore graceful, stylish hats, often adorned with feathers and jewels. In 1608, the Dutch Stadtholder Prince Maurits received a Thai envoy in The Hague, and in 1684 King Narai of Thailand sent his ambassador to the court of King Louis XIV of France. Broad-brimmed hats made of black felt, decorated with a feather stuck to the side, were regarded as the royal ornament in the Thai court. The top of the felt hat was usually embellished with a small replica of the royal crown. The ceremonial hat of the heir to the throne is known as *Phra Mala Sao Sung*. The *Phra Mala Soa Sathoen* has no feather and is only reserved for members of the royal family, nobles and others who have the rank of Chao Phrya. The *Muak Song Praphat* hat was generally given to the heads of the Thai colonies. This was a royal cloth to be wrapped around the head in accordance with Islamic traditions, replacing the hat.

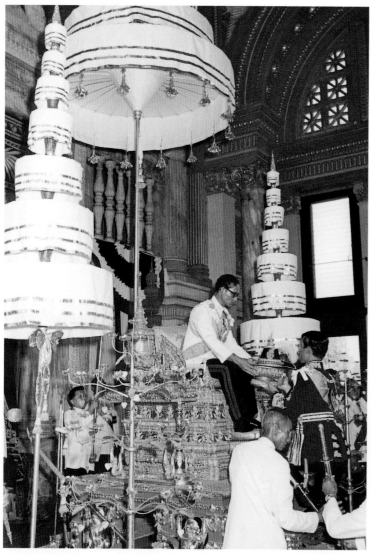

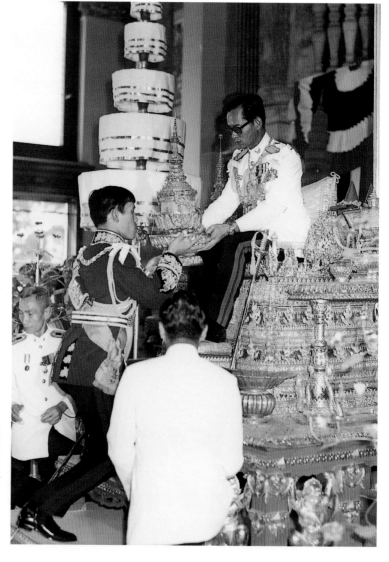

Royal and aristocratic weddings

The weddings of royalty and the nobility are occasions of great ceremony and splendour, featuring fabulous jewels. For many centuries, such marriages were seldom about love and more often to do with political arrangements, satisfying the requirements of equal birth, or the result of an acceptable financial offering, or dowry, which included costly jewellery. In some societies, jewellery was given to the bride by her husband-to-be, and in others precious trinkets of equal value were exchanged between bride and groom to show that the bride could not be bought. The wealth of the family would be displayed at the marriage, an important dynastic event, and often the family jewels or official crown jewels would be worn.

The designs of many royal nuptial headdresses often draw on nature and symbols associated with the families involved. The flower chosen for a wedding headdress can be influenced by ancient traditions or by religion. Royal wedding crowns also sometimes incorporate important jewels, including precious stones handed down from generation to generation, and some of the biggest diamonds known to man. Nuptial headdresses vary greatly in design, material and decoration. Nowadays, the tiara, the diadem and the wreath are the most frequently used forms for a royal bridal headdress, although a crown is regarded as the most royal form of all in western societies. Family heirlooms are frequently used or re-used for royal weddings. Numerous new jewels have been made by jewellers for royal weddings, so it is not possible to describe all existing royal bridal headdresses.

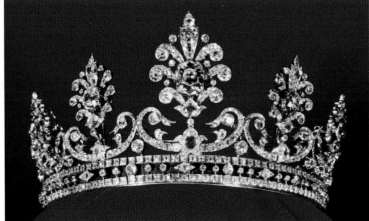

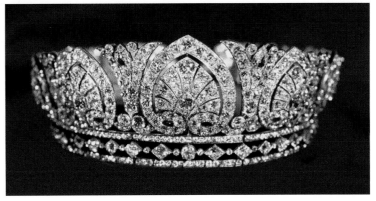

Left:
6.6.1987-8.6.1987; wedding of Lalla Asmaa, Princess of Morocco with Khalid Bouchentouf. During the various wedding ceremonies, the daughter of King Hassan II of Morocco wore fabulous jewellery, including a diamond tiara, a gift from her father which was designed and made by the Paris jeweller Chaumet.
Photo Embassy of the Kingdom of Morocco, The Hague, The Netherlands

Top right:
Tiara, some parts of which can be worn separately as a necklace, brooches and a bandeau. Gold, silver and diamonds; made circa 1870.
Collection and photo the Duke and Duchess of Devonshire and Trustees of the Chatsworth Settlement, England

Bottom right:
Spencer Cavendish, the 8th Duke of Devonshire, ordered this tiara for his wife, Louisa von Alten, the former Duchess of Manchester. Some parts of this tiara can also be worn as a necklace, brooches and a bandeau. Gold, silver and 1,907 diamonds of which 1,041 stones were taken from old jewellery supplied by the duke; made in 1898 by A. E. Skinner, London, England.
Collection and photo the Duke and Duchess of Devonshire and Trustees of the Chatsworth Settlement, England

Bridal parure

The word *parure* is used for a set of jewellery where all items match in design and in the choice of material. An extensive *parure* can include a tiara or diadem, a set of earrings, a necklace, one or more brooches, buttons, bracelets, rings and a belt or buckle. In some countries the jewellery for the bride – either as a ceremonial gift or to be worn – is referred to with specific words. In German the word *Brautschmuck* is used for bridal jewellery. The French word is *corbeille*, literally a sculptured basket of flowers or fruit as decoration, and is used as a design for a set of bridal, and sometimes other, jewellery.

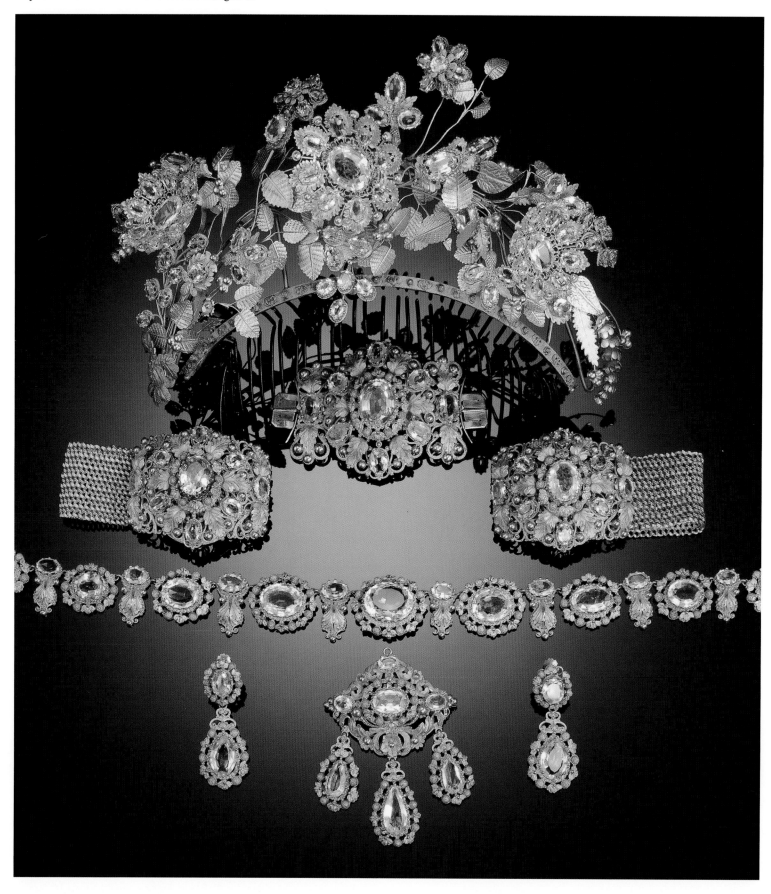

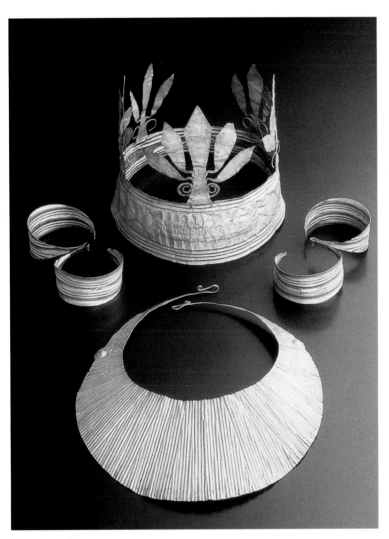

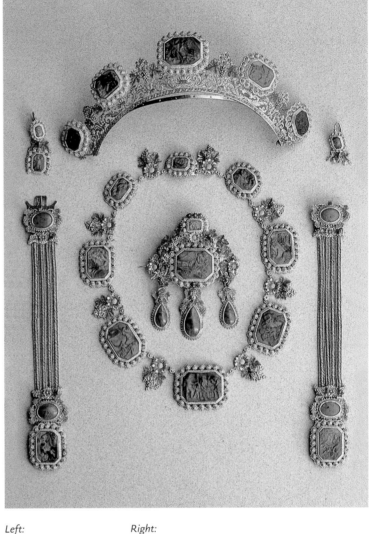

Opposite page:
Bridal *parure* including
a tiara, a pair of ear
pendants, a necklace, a
brooch, two bracelets
and a buckle. Offered
for sale at Sotheby's
in June 1993. Gold and
aquamarines;
made circa 1830.
Private collection
Photo Sotheby's,
London, England

Left:
Parure including a
crown, a necklace and
earrings. This type of
jewellery has been worn
by the consorts of the
aristocratic Nias chiefs
(in Indonesia) and used
as part of the ritual
display during weddings
and other celebrations.
Gold; made end of the
19th century.
Collection
Barbier-Mueller
Museum, Geneva,
Switzerland
Photo from Alit
Djajasoebrata,
The Netherlands

Right:
Parure including a tiara
with comb, a necklace,
two bracelets, brooch
and a pair of earrings.
This *parure* belonged
to Princess Sophia von
Nassau-Weilburg, who
married Prince Oscar of
Sweden in 1857. Prince
Oscar became King
Oscar II of Sweden in
1873. Gold and malachite.

The rectangular
malachite stones are
carved into classical
scenes after the
Danish sculptor Bertel
Thorvaldsen (1770-1844);
made circa 1828 by
Simon Petiteau,
Paris, France.
Collection and photo
Nordiska Museet,
Stockholm, Sweden

Couronnette

Through the centuries, it has been fashionable for royal and aristocratic brides to wear a small crown high on their heads. During the 19th century, such a crown was every so often designed with leaves along the headband, from which arches rose to the centre, ending in a tiny globe with a cross. The usually diamond-studded leaves were typically inspired by ivy, red currant or strawberry leaves. These crowns, sometimes referred to as *couronnettes*, were often crafted in such a manner that some parts could be taken off the frame and worn separately. The leaves were the most common parts to be worn separately as brooches on the lapel or cuffs.

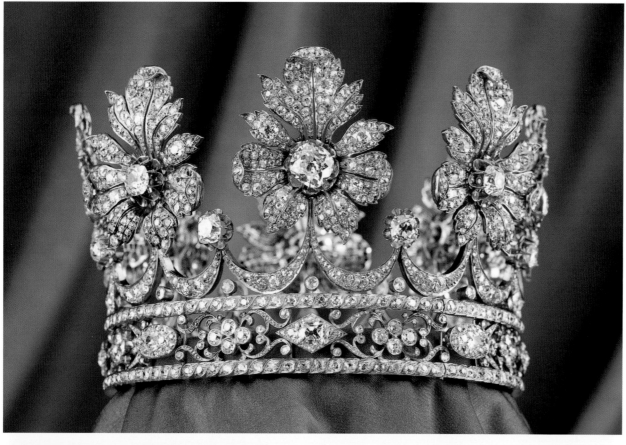

Open crown with 8 *fleurons*. Gold, silver and diamonds; made circa 1860.
Private collection
Photo A. C. Cooper and S. J. Phillips Ltd, London, England

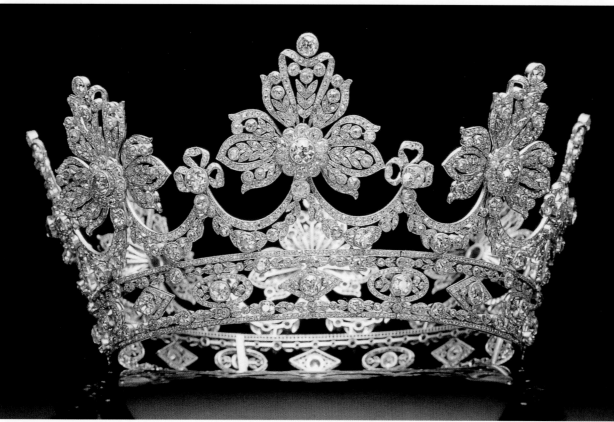

Couronnette with rows of palmette motifs, ribbon bows and swags above a frieze of lozenge-shaped and oval motifs. Auctioned by Sotheby's, Geneva, Switzerland in May 1991 for SF 165.000. Platinum and diamonds; made circa 1900-1910, attributed to Cartier.
Photo collection Sotheby's Geneva, Switzerland

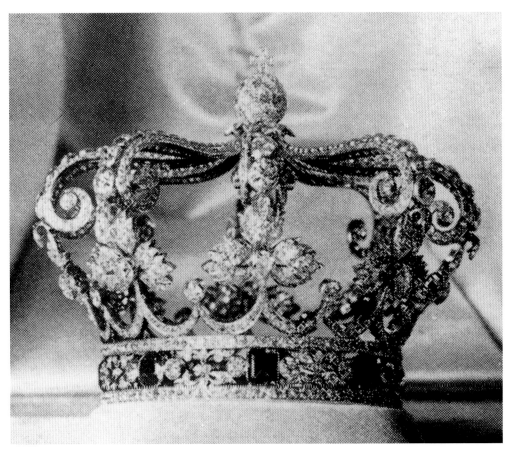

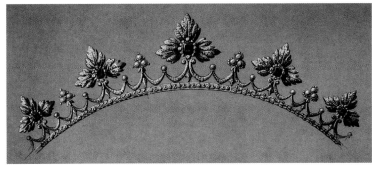

Top left:
King Alfonso XIII of Spain ordered this wedding *couronnette* in 1906 for his bride Princess Victoria Eugénie von Battenberg. Platinum, diamonds, rubies and emeralds; made in 1906. Believed to have been dismantled, probably in the 1940s or 1950s.
Photo Illustrated London News issue 2 June 1906

Bottom left:
Sketch of a diamond and sapphire studded *couronnette*; made second half of the 19th century.
Collection Mellerio dits Meller, Paris, France
Photo René Brus

Right:
1920s; Queen Victoria Eugénie, consort of King Alfonso XIII of Spain wearing her wedding *couronnette*.
Photo Illustrated London News

Designs from nature

Sometimes the gold- or silversmith placed the flower heads on thin wire so that they could move like real flowers touched by the wind. If a large number of such flower pins are arranged close together on a headdress, it can appear as if the wearer is adorned with a garden full of flowers. Flowers were not only appreciated by their beauty, but were also used as important symbols. In the 19th century, the 'language of flowers' was used by the Victorians as a way of expressing feelings that otherwise could not be spoken, and many pieces of jewellery were decorated with flowers to hide secret messages of love. This language was described in numerous books, providing a guide to the interpretation of all the different flowers. For example, bluebells meant constancy; forget-me-nots, true love; ivy, friendship, fidelity and marriage;

honeysuckle, the union of love; lily of the valley, return to happiness; and rosemary stood for remembrance. The rose was often used as a token of love and devotion in bridal pageantry. A red rosebud stood for purity and loveliness; a single rose simplicity; a white rose meant 'I am worthy of you'; and the Musk rose stood for capricious beauty. The white lily is often seen as a symbol of purity. For Christians it is the flower of the Virgin Mary and therefore the right choice as main motif for many royal bridal headdresses. The lily has been used as a motif on the coat of arms of French kings since the 12th century and this symbol is closely linked to the Bourbon dynasty. This 'French' lily is also called the *fleur-de-lys*, and has become to many a symbol synonymous with the monarchy.

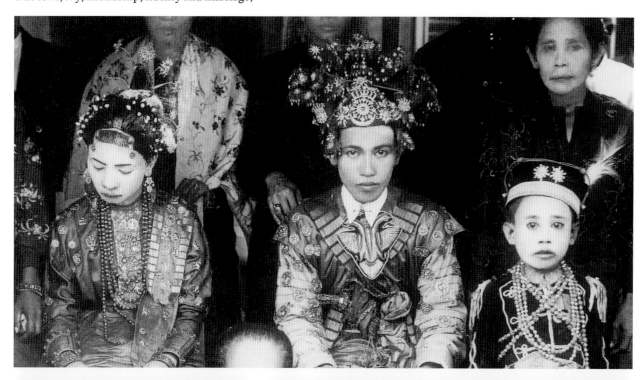

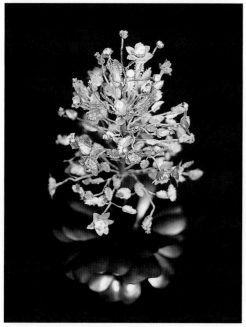

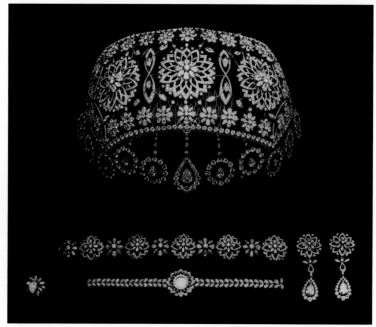

Top:
31.8.1931; wedding in the family of the Raja of Gowa, Indonesia. The bride and groom wear large hairpins decorated with flowerheads on tin wire.
Photo collection Nederlands Instituut voor Militaire Historie, The Hague, The Netherlands

Bottom left:
The *Berbulan*, like a miniature tree with numerous flowers on spring wire, adorns the top of the bridegroom's headgear in some Malay states. Gold and semi-precious stones; made in the 19th century.
Collection Raja Perempuan Anis of Kelantan, formerly collection the late Raja Perempuan Zainab II of Kelantan
Photo René Brus

Bottom right:
Bridal *parure* of a Middle Eastern princess with a bridal frontlet containing three large rosettes, representing flowers in full bloom. Platinum and diamonds; made in the 1950s by Garrard, London, England.
Photo collection René Brus

Sweden

On 19 June 1976, King Carl XVI Gustaf of Sweden married Silvia Renate Sommerlath in the Cathedral of Stockholm. The Crowns of King Erik XIV and Queen Lovisa Ulrika were placed on both sides of the altar to indicate the regal status of the royal couple.

The coronation Crown of King Erik XIV of Sweden was made in 1561 by the Flemish goldsmith Cornelius ver Weiden. This crown was restored to its original splendour in 1909 and 1970. Female figures, to represent the seven virtues, can be seen around the rim. The leopards and hearts depicted have an historical significance with the Kingdom of Denmark and the lion with the Kingdom of Norway. The Crown of King Erik XIV has not been used as a coronation crown since the coronation of King Oskar in 1873. The son of King Oskar II of Sweden, King Gustaf V had no official coronation and never wore a crown. The crown and sceptre of King Erik XIV were present during the annual state opening of the Swedish Parliament or Riksdag until 1974.

The Crown of Queen Lovisa Ulrika was made in 1751 by Andreas Almgren and designed by Jean Eric Rehn. It is rather small in size, with a diameter of 13.1cm. It was originally set with 695 diamonds, some of which came from an older crown belonging to Queen Ulrika Eleonora the younger. The 44 largest stones were provided by Queen Lovisa Ulrika. Shortly after her coronation, Queen Lovisa Ulrika had her stones removed and replaced by rock crystal. In 1772, during the reign of King Gustav III, genuine diamonds were again used to decorate this historical crown. The coronation Crown of King Erik XIV of Sweden and the crown of Queen Lovisa Ulrika were present at the accession ceremony of King Carl XVI Gustaf on 18 September 1973 and at his wedding in 1976.

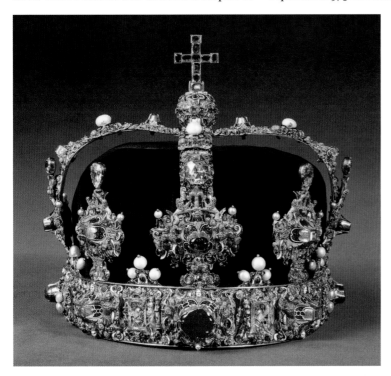

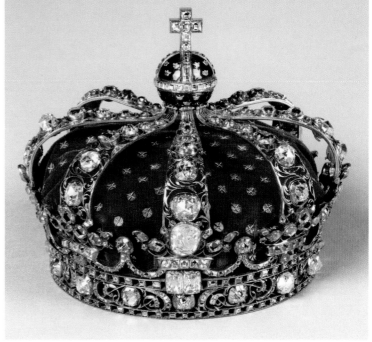

Top left:
Coronation Crown of King Erik XIV of Sweden. Gold, pearls, emeralds, rubies, diamonds and enamel; made in 1561.
Collection Royal Collections, Stockholm, Sweden
Photo Alexis Daflos

Top right:
Crown of Queen Lovisa Ulrika. Silver, gilt, gold, diamonds, enamel and velvet; made in 1751.
Collection Royal Collections, Stockholm, Sweden
Photo Alexis Daflos

Bottom:
19.6.1976; the wedding ceremony of King Carl XVI Gustaf and Queen Silvia of Sweden.
Photo Embassy of Sweden, The Hague, The Netherlands

The Netherlands

One of the most valuable nuptial crowns featuring the *fleur-de-lys* is undoubtedly that drawn in his sketchbook by Thomas Cletscher, the 17th-century court jeweller of the Dutch Stadtholder Frederick Hendrik, Prince of Orange. This golden crown, decorated with red, white and black enamel, was set with diamonds and pearls. The rim contained large table-cut diamonds, including the approximately 30 carat diamond the Mirror of Portugal. The centrepiece of the crown included the 55.23 metric-carat historic Sancy diamond. The crown belonged to Queen Henriette-Marie of England and is believed to have been worn by this French-born princess at her wedding. It is also assumed to have been worn by her daughter, Princess Mary. At the age of nine, Princess Mary married the 14-year-old Dutch Prince Willem at the Whitehall Palace, London, on 2 May 1641. The young bride stayed with her parents after the wedding ceremony, but left England in 1644 to live with her husband in The Netherlands. Queen Henriette-Marie accompanied her daughter to The Netherlands to see if she could pawn some of her personal jewels and those from the English Crown Jewels to raise money for supplies and ammunition needed in England by her husband, King Charles I. It is generally agreed that the nuptial crown was dismantled during this period, and most of the pearls and stones (with exception of the Sancy diamond) pawned in Rotterdam together with other precious stones and pearls from the Queen Henriette-Marie collection. A part of this collection is depicted and partly described in the sketchbook of Thomas Cletscher, one of the creditors of the queen's loan. With the information in this sketchbook on the size, shape and cut of the pearls and gemstones, it can be assumed that most of the valuables were auctioned in the 1650s, as the queen's loans of 1641 and 1644 were not redeemed.

Thomas Cletscher has left us an unfinished drawing of a crown containing some of the English diamonds. Was this design intended for a wedding crown of one of the daughters of the Dutch Stadtholder? Descriptions of their weddings, as well of their nuptial crowns, studded with unquestionably valuable pearls and diamonds, have proved that some of these precious stones are still owned by the present Royal Dutch Family.

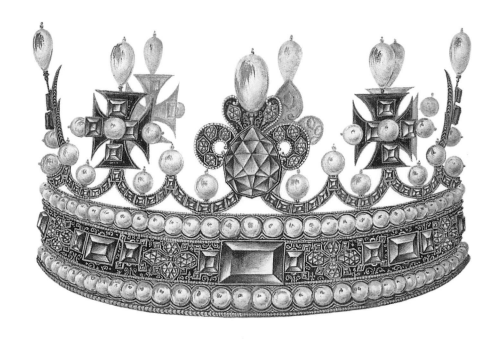

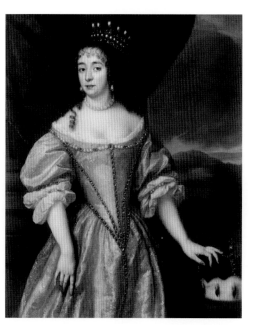

Top:
Sketch from the album of Thomas Cletscher, jeweller to the Dutch Stadtholder and his family in the first half of the 17th century. This crown is believed to have been worn by the French Princess Henriette-Marie when she married King Charles I of England in 1625.
Collection and photo Museum Boijmans Van Beuningen, Rotterdam, The Netherlands

Middle:
An unfinished sketch by Thomas Cletscher for a royal bridal crown. Thomas Cletscher has drawn pearls and the English diamonds in the rim. It is still uncertain if this is the original sketch used for the bridal crown worn by various brides of the Royal Dutch Family during the 16th century.

Collection Museum Boijmans van Beuningen, Rotterdam, The Netherlands
Photo Tom Haartsen

Bottom:
Some scholars believe that this portrait by Jan Mijtens shows Princess Louise Henriëtte, daughter of the Dutch Stadtholder Frederik Hendrik, who married Friedrich Wilhelm, Margrave of Brandenburg, on 7 December 1646. Others claim that it is her sister, Princess Maria, who married Ludwig Heinrich Moritz, Palgrave of Simmern in 1666. The crown worn by this noble lady is believed to be her nuptial crown.
Collection and photo Stichting Historische Verzamelingen van het Huis Oranje-Nassau, The Hague, The Netherlands

In 1830, Princess Marianne, the daughter of Dutch King Willem I and Queen Wilhelmina, married her cousin Albrecht, the son of King Frederick Wilhelm III of Prussia. Her parents gave Princess Marianne an enormous collection of jewellery. Months before the wedding, the Amsterdam court jeweller Joseph Truffino Junior created earrings, necklaces, brooches and different headdresses, including a nuptial crown that cost the king 60,000 guilders. On the wedding day, 14 September 1830, the crown was placed on the bride's head during a special ceremony at the Noordeinde Palace in The Hague. Courtier Ragay, the Treasurer, entered the room escorted by two palace servants carrying the crown on a cushion, and handed the crown over to the eldest lady in waiting, Baroness van Estorff. The baroness then presented the crown to the mother of the bride, who placed it on her daughter's veil. After the marriage ceremonies were over, the crown was returned to Mr Ragay, who returned it to the palace treasury as it was intended to be an heirloom worn by future brides of the Dutch royal family.

After the death of King Willem I, his successor King Willem II received this crown together with the rest of the family jewellery, and signed a document dated 9 May 1844 describing the handing over of the heirloom. When King Willem II died in 1849, his heirs decided to sell part of their inheritance to pay their father's debts, which resulted in the dismantling of the family wedding crown. Towards the end of 1850, a number of jewellers were approached by the palace to see if they were interested in buying the crown. Several of them were invited to The Hague to estimate the value, including a Mr Hunt from the famous London jeweller Hunt & Roskell. On 6 January 1851, Mr Martin, an employee of Hunt & Roskell, arrived at the palace, removed the diamonds from the frame and made the gold-work unfit for use; thus the Dutch Royal Family no longer had a crown suitable for future brides.

Artist's impression of the bridal Crown of Princess Marianne of The Netherlands, made in 1830, commissioned by her father King Willem I at a cost of 60,000 guilders. Detail of a painting by Wiertz, dated 1833.
Collection Amsterdams Historisch Museum, Amsterdam, The Netherlands
Photo René Brus

A number of family jewels remained available for future weddings. When Queen Wilhelmina married Duke Hendrik of Mecklenburg-Schwerin in 1901, she wore a tiara set with the 'House diamonds, the historic stones of the House of Oranje-Nassau'. The main diamond in this tiara, a large pear-shaped, rose-cut diamond of around 39.75 carats, was removed for the occasion to lower the height of the tiara.

The present design of the tiara dates from 1897/98 and was created by the Frankfurt jeweller Schürmann in such a manner that parts could be removed and worn separately. The pear-shaped, rose-cut diamond has a blue colour and was bought by Queen Mary II, the wife of King-Stadtholder King Willem III in 1690, as a rough stone from Sir William Langhorne for £12,338. The diamond was cut, probably in Amsterdam, into a stone of approximately 39.75 carats. After the deaths of Mary and Willem, this great diamond became part of the jewellery collection of the House of Oranje-Nassau and is inherited by each successive head of the family. The diamond was referred to as 'the Holland diamond' in the 19th century, and sometimes 'the Cone', but it is more appropriate to call this historical stone 'the Queen Mary II (Stuart) diamond'.

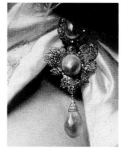

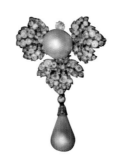

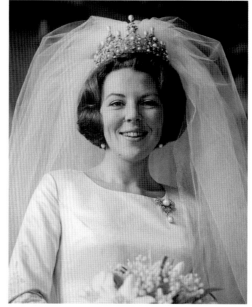

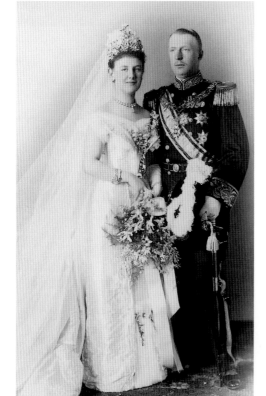

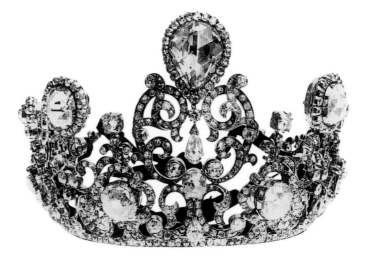

Top left:
Queen Sophie of The Netherlands, born Princes von Württemberg. This painting, executed in 1845 by Nic. de Keyzer, shows a leaf-shaped brooch on the sleeve of Queen Sophie's dress. This brooch is part of Queen Sophie's diadem Crown and can be worn separately.
Collection Sophia Stichting, The Hague, The Netherlands
Photo René Brus

Top middle:
Brooch. Gold, silver, diamonds and pearls. One of the leaves of Queen Sophie's *couronnette*.
Collection photo Stichting Historische Verzamelingen van het Huis Oranje-Nassau, The Hague, The Netherlands
Photo Rijksvoorlichtingsdienst, The Hague, The Netherlands

Top right:
10.3.1966; wedding of Crown Princess Beatrix of The Netherlands and Claus von Amsberg.
Photo Max Koot, The Hague, The Netherlands
Collection Rijksvoorlichtingsdienst, The Hague, The Netherlands

Bottom left:
1901; wedding of Queen Wilhelmina and Prince Hendrik of The Netherlands.
Collection Koningklijk Huisarchief, The Hague, The Netherlands
Photo H. Deutmann

Bottom right:
Tiara set with the so-called 'House diamonds' of the Dutch Royal Family. Gold, silver and diamonds.
Collection The House of Oranje-Nassau, The Hague, The Netherlands

Photo Rijksvoorlichtingsdienst, The Hague, The Netherlands

Queen Sophie of The Netherlands owned a *couronnette*, which she called her 'diadem crown', indicating that it could be made into a crown or a diadem. Some parts of this diadem could be worn separately and the leaves have been used frequently as brooches. Since her death in 1877, no female member of the Dutch royal family has ever been seen wearing this heirloom in public in its original form. When Queen Beatrix of The Netherlands married in 1966, one of the diamond studded leaves was used as a brooch. The *fleur-de-lys* motif of the diamond and pearl tiara worn by the bride on her wedding day was an inspiration for the designer of her wedding dress, Caroline Bergé-Farwick of Maison Linette, who had this motif woven into the dress. The tiara had originally been made in 1839 for Queen Sophie, the daughter of King Wilhelm I of Württemberg. The King had ordered it from the Stuttgart-based jeweller A. H. Kuhn for his daughter's wedding and paid 22,986 guilders for it. During the 20th century, the headband of Queen Sophie's *couronnette* has been adorned with five pearls and diamond-set rosettes, also originally from the jewellery collection of Queen Sophie. In 2002, five glittering stars were set on the raised points for the wedding of Máxima Zorreguieta to the heir to the throne of The Netherlands, Prince Willem-Alexander.

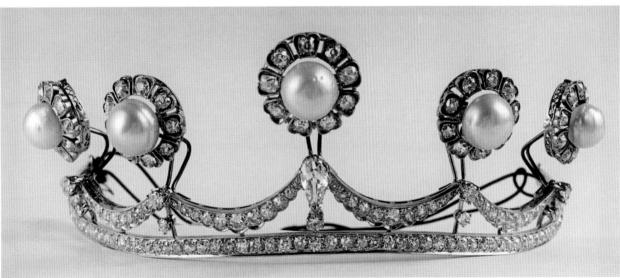

Bottom:
Tiara comprised of the headband of Queen Sophie of The Netherlands *'the diadem Crown'* and five of her *'boutton'* brooches Gold, silver, diamonds and pearls; made circa 1850-1860.
Photo Rijksvoorlichtingsdienst, The Hague, The Netherlands

Top left:
Engraving of Queen Sophie of The Netherlands by André Benoit Barreau Taurel, after the painting by Jan Willem Pieneman, 1845.
Collection and photo Stichting Historische Verzamelingen van het Huis Oranje-Nassau, The Hague, The Netherlands

Top middle:
10.1.1967; wedding of Princess Margriet of The Netherlands and Lippe-Biesterfeld to Pieter van Vollenhoven. The bride wears as her wedding tiara the base of Queen Sophie's diadem Crown, surmounted with five semicircular pearls, each surrounded by a row of large diamonds, which according to many newspapers at the time represented marguerite flowers.
Photo Rijksvoorlichtingsdienst, The Hague, The Netherlands

Top right:
2.2.2002; wedding of Prince Willem-Alexander and Máxima Zorreguieta. The bride wears the *couronnette* of Queen Sophie, set with five glittering stars.
Collection ANP, The Netherlands
Photo Jerry Lampen

Prussia

The tradition of royal brides wearing a simple crown frame adorned with valuable diamonds and pearls already existed in the Kingdom of Prussia during the 18th century. When the Prussian Crown Prince Frederick Wilhelm III married Princess Louise of Mecklenburg-Strelitz in 1793, 47 large, 5 small brilliants, 30 round and 6 pear-shaped pearls were made available by the treasury. This nuptial crown frame was worn several times over the years, but various documents reveal how its decoration altered. The last time it was used, and the first time it was photographed, was for the wedding of Princess Viktoria Luise in 1913. The photograph shows that no pearls were used, only rather large diamonds. In later years the princess wrote about her wedding, describing how her mother helped her to put on the veil and bridal wreath early in the afternoon. Thus properly dressed, they went to the so-called Chinese cabinet in the Imperial Palace in Berlin, where at exactly 4 p.m. the Imperial Treasurer brought in the '*Prussian princess' crown*', accompanied by members of the Imperial Guard with drawn swords. The empress's senior lady-in-waiting, Countess Brockdorff, took the crown and presented it to the empress, who placed it on her daughter's head. The First World War, which engulfed Germany and many other European countries soon afterwards, put an end to the monarchy in Germany.

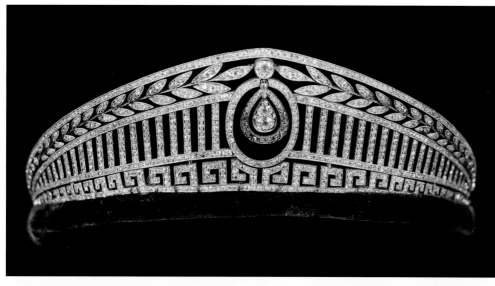

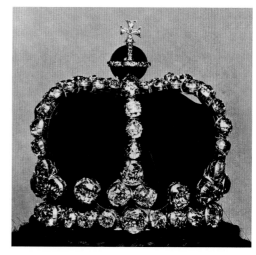

Top:
Tiara of Queen Sofía of Spain. This tiara was ordered by Empress Auguste Viktoria of Germany in 1913 as a wedding present to her daughter Princess Viktoria Luise who was to marry Duke Ernst August von Braunschweig. In 1938 Princess Viktoria Luise gave it to her daughter Princess Friederike, who wore it during her wedding with Prince Paul of Greece. In 1962 Queen Friederike gave the tiara to her daughter Princess Sofía, who wore it during her wedding with Prince Juan Carlos of Spain. Platinum and diamonds; made in 1913 by the court-jeweller Koch, Frankfurt am Main, Germany.
Collection the Queen of Spain
Photo El Jefe de la Secretaria de S. M. la Reine, Palacio de la Zarzuela, Madrid, Spain

Bottom left:
24.5.1913; drawing published in the *Berliner Illustrirte Zeitung* showing the marriage of Princess Viktoria Luise of Prussia to Duke Ernst August III of Braunschweig in the Imperial Palace at Berlin.

Bottom right:
The diamond-studded bridal crown of the Hohenzollern dynasty, photographed in 1913 around the time Princess Viktoria Luise, daughter of Emperor Wilhelm II of Germany, married Duke Ernst August III of Braunschweig.
Photo collection René Brus

Mecklenburg-Schwerin

Some nuptial crowns were constructed by joining loose components temporarily, such as that used by the Grand Ducal House of Mecklenburg-Schwerin, and often referred to as 'the Princess' Crown'. On 15 December 1909, Duke Johann Albrecht, Regent of the Grand Duchy from 1897 to 1901 and Regent of Brunswick from 1907 to 1913, married Princess Elisabeth of Stolberg-Roßla. For this occasion, the frame of the bridal crown was set with 157 brilliant-cut diamonds, including seven *pendeloques*, or drop-shaped stones, as shown in the first photograph ever taken of this crown. These seven stones were placed in between the eight arches of the crown and undoubtedly could have been worn on other occasions, for instance as earrings.

The history of the nuptial crown of Mecklenburg-Schwerin is not fully known. Its shape closely resembles that of a crown portrayed in a pen drawing of a crown of the House of Mecklenburg-Schwerin, which clearly shows that the headband has attachments, such as flowers and stars, which could be worn separately as brooches. Although this drawing is undated, it is believed to depict the diamond wedding crown given or lent by the Grand Duchess Alexandrine von Mecklenburg-Schwerin, daughter of King Friedrich Wilhelm III of Prussia, to her daughter-in-law and niece Princess Alexandrine of Prussia, who married the grand duchess's second son, Duke Wilhelm. Were this marriage not to produce any sons, it was stipulated that the wedding crown would become part of the heirlooms of the Grand Ducal dynasty. Indeed, no sons were born, but the crown remained with Duke Wilhelm's widow. She then lent it to her daughter, Princess Charlotte, for her wedding in 1886, with the restriction that, when Grand Duchess Alexandrine passed away, the diamond-set crown would then pass to the sovereign ruler of Mecklenburg-Schwerin. All these documents and restrictions were set up to ensure that the valuable crown was not seen as private property, but would be kept for future generations. The last time this wedding crown appeared in public was when Princess Viktoria Feodora of Reuß-Schleiz married Duke Adolf Friedrich of Mecklenburg-Schwerin on 24 April 1917.

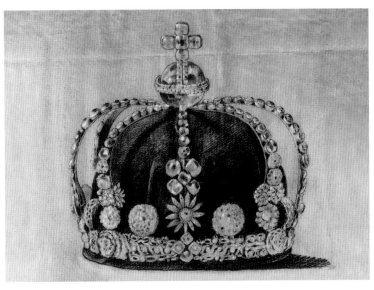

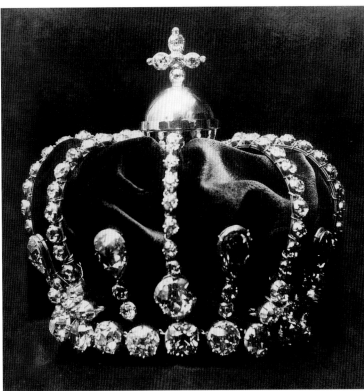

Hohenzollern-Sigmaringen

In 1913, when preparations were under way for the wedding of Princess Augusta Victoria of Hohenzollern-Sigmaringen to the exiled King Manuel II of Portugal, the Sigmaringen-based court jeweller Johann Gustav Zimmerer was commissioned to craft a small, diamond-studded bridal crown featuring the *fleur-de-lys*. The four *fleur-de-lys* ornaments on this bridal crown were attached in such a manner that they could be taken off the frame and worn separately. When Swedish Princess Birgitta married Prince Johann George of Hohenzollern-Sigmaringen in 1961, her bridal crown used the base of the 1913 nuptial crown, with the *fleur-de-lys* replaced with diamond-studded leaf-like ornaments. The bride wore this altered crown during the religious service in Sigmaringen on 30 May 1961, five days after a civil wedding in the capital of Sweden, Stockholm.

4.9.1913; wedding of Princess Augusta Victoria of Hohenzollern-Sigmaringen and King Manuel II of Portugal.
Photo collection René Brus

Hanover

Among the heirlooms of the former Kingdom of Hanover is a wonderful small crown profusely set with brilliants, several of notable size. From the junction of the arches spring four slightly curved golden rods, and from the end of each rod hangs a pendant formed by a large solitaire *pendeloque* diamond, which sways splendidly when worn. This crown is English in style, for the circlet carries alternate *crosses patées* and *fleurs-de-lys*, and is closed by two arches surmounted by an orb and cross. Not only does its shape indicate its origin, but a plate attached to the outside of its case bears the inscription '*CR This box contains the crown which I found at my arrival in the year 1761*', placed there on the instructions of Princess Charlotte of Mecklenburg-Strelitz, who married King George III of England at St James's Palace, London on 8 September 1761.

George III was not only ruler over England, but also over the German realm of Hanover. This co-sovereignty started after the death of Queen Anne of England in 1714. She had no children or other direct descendants, so her relative George Louis, Elector of Hanover, was crowned George I, King of England. His grandson, King George III of England, adopted the title King of Hanover in 1814, and the dual kingship then went to his successors, George IV and subsequently William IV. The bridal crown was also handed down, but William IV did not leave any surviving children when he died in 1837 and this led to a dispute over its ownership. William IV's successor in England was George III's granddaughter Victoria, but the ancient Salic law that prevailed in Hanover did not allow women to inherit land or a ruling position, and so the dual kingship had to end. While England came under Queen Victoria's rule, the Kingdom of Hanover went to William's brother, who became King Ernst Augustus.

With the separation of the Kingdoms of England and Hanover, the ownership of the diamond bridal crown came into question. The dispute continued until 1857, when a court ruled in favour of the King of Hanover. Queen Victoria was in possession of the bridal crown at the time, and on 23 January 1858 her deputy, the Earl of Clarendon, handed the crown over to Count Johann-Adolf von Kielmansegg, Court Chamberlain and deputy of the King of Hanover. Since then, female members of the House of Welf, the dynasty from which the House of Hanover was descended, have worn the diamond nuptial Crown of Queen Charlotte at their weddings. During the Second World War, the bridal crown and other important pieces of jewellery returned to England for safe keeping in Windsor Castle. The nuptial crown returned to Germany in 1960, when Princess Alexandra of Ysenburg-Büdingen married Prince Welf Heinrich of Hannover. According to *The Times* newspaper of 20 September 1960, the crown was the size of a 'large apple' and was worn on the back of the head.

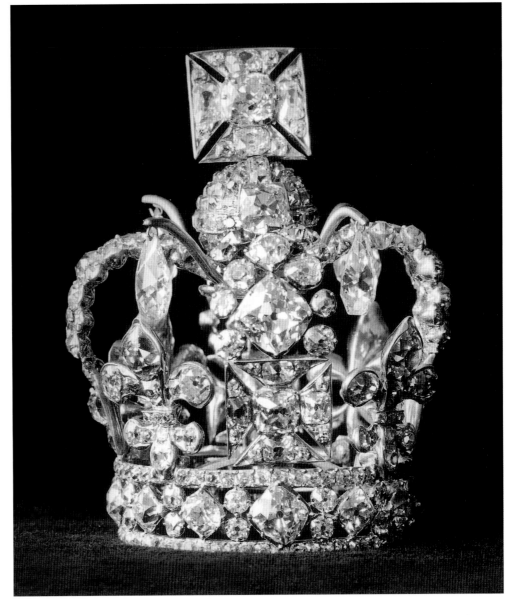

Nuptial crown of Princess Sophie Charlotte of Mecklenburg-Strelitz, consort of King George III of England. Gold, silver and diamonds; made in 1761.
Collection of the House of Hanover, Germany
Photo collection René Brus

Bulgaria

When Prince Ferdinand I of Bulgaria married Princess Marie-Louise of Bourbon-Parma in 1893, he commissioned the Paris jeweller Boucheron to design a small crown for his bride that featured the *fleur-de-lys* in honour of her illustrious family. The crown was set with emeralds and rubies, chosen to represent the national colours of Bulgaria, the country of which Prince Ferdinand, born as Prince Ferdinand of Saxe-Coburg and Gotha, had become sovereign prince on 14 August 1887. For the same marriage another jeweller, Köchert in Vienna, created a splendid tiara also set with diamonds, rubies and emeralds, also featuring five large fleurs-de-lys. According to some sources, this tiara was ordered by the 'Ladies of Bulgaria' as a wedding present for their princess, or *Fürstin*. Princess Marie-Louise died in 1899, and Prince Ferdinand married Princess Eleonore of Reuß-Köstritz in 1908, the year that his principality was raised to the status of Kingdom and he assumed the title of tsar. Both the crown and tiara, as heirlooms of the dynasty, were worn by the new queen. Although the tiara has since been worn by female members of the Bulgarian royal family during their weddings and on other occasions, nothing is known of what happened to the small crown after the Bulgarian monarchy was abolished and the royal family went into exile.

Top left:
1908; wedding of Princess Eleonore Reuß-Köstritz, to Prince Ferdinand I of Bulgaria, who assumed the title of Tsar in the same year. The new Queen wears the crown that had been made by the jeweller Boucheron in 1893 for Prince Ferdinand's first wife, Princess Marie-Louise of Bourbon-Parma.
Photo collection René Brus

Bottom left:
Circa 1896; Princess Marie-Louise of Bourbon-Parma, consort of the Sovereign Prince of Bulgaria, wearing the *fleur-de-lys* tiara.
Photo Staatsarchiv Coburg, Germany

Right:
21.2.1957; wedding of Princess Marie Louise of Bulgaria and Count Karl of Leiningen. The bride wears the *fleur-de-lys* tiara made by the jeweller Köchert in 1893.
Photo collection René Brus

Liechtenstein

Fringed necklaces have been made in numerous variations and are often worn as tiaras. As the spiky fringe turns up in the tiara form, resembling the rays of the Sun, these pieces of jewellery are also often referred to as Sun tiaras. In 1890, a fringed necklace or Sun tiara was made for Princess Maria Theresa of Braganza, Infanta of Portugal, who was the third wife of Archduke Karl Ludwig, the brother of Emperor Franz Joseph of Austria. After the death of Princess Maria Theresa in 1944, her daughter Elizabeth Amalie, consort of Prince Alois of Liechtenstein, inherited the fringed necklace and tiara. This jewel is now an heirloom of the Princely House of Liechtenstein.

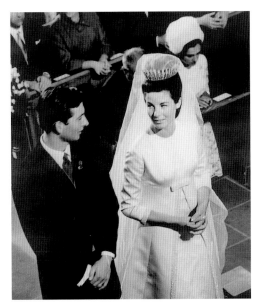

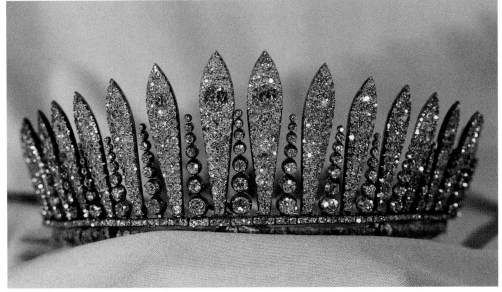

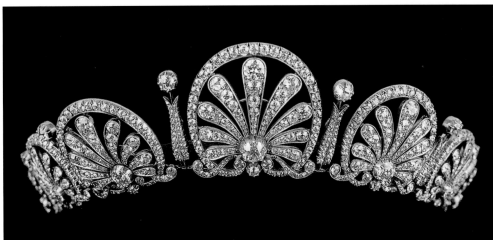

Top left:
29.7.1967; wedding of Countess Marie Kinsky of Wchinitz and Tettau and Hans-Adam II, Hereditary Prince of Liechtenstein.
Photo from the Office of the Prince of Liechtenstein, Vaduz, Liechtenstein

Top right:
Tiara of Princess Maria Theresa of Braganza, Infanta of Portugal, wife of Archduke Karl Ludwig of Austria. Gold, silver and diamonds; made circa 1890.
Collection Princely House of Liechtenstein, Liechtenstein
Photo René Brus

Bottom left:
5.7.1999; wedding of Princess Tatjana of Liechtenstein and Philip of Lattorff.
Photo Secretarial Office of the ruling Prince of Liechtenstein, Liechtenstein

Bottom right:
Bridal tiara worn by Princess Tatjana of Liechtenstein on 5 June 1999. Gold, silver and diamonds. According to family tradition, this honeysuckle tiara, which can also be worn as a necklace, was presented to Princess Marie of Liechtenstein by her husband Prince Ferdinand Kinsky circa 1870.
Collection Princely House of Liechtenstein, Liechtenstein
Photo Sotheby's, Geneva, Switzerland

Luxembourg

For the Grand Ducal family of Luxembourg, the most important tiara is known as the '*grand diadem*', and is pre-eminently suitable to be worn by a bride. The diamonds in this 10.5 cm high golden tiara are set in silver, which, along with its 'palmettes' design and other features, indicates that it was made in the beginning of the 19th century. Family documents dated 27 October 1829 indicate that Duke Willem of Nassau-Weilburg took much of the dynastic jewellery to the Frankfurt-based jeweller Speltz to be repaired, reset or altered. That year Duke Willem of Nassau-Weilburg was to be married for the second time, to Princess Pauline of Württemberg, and undoubtedly the family heirlooms were to be made suitable for the new duchess.

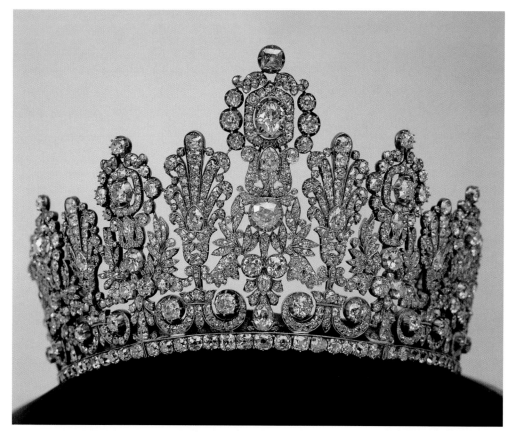

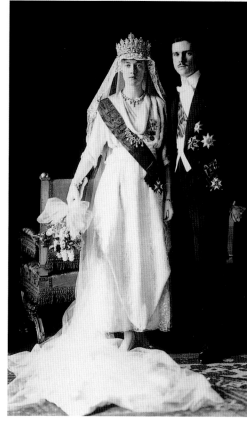

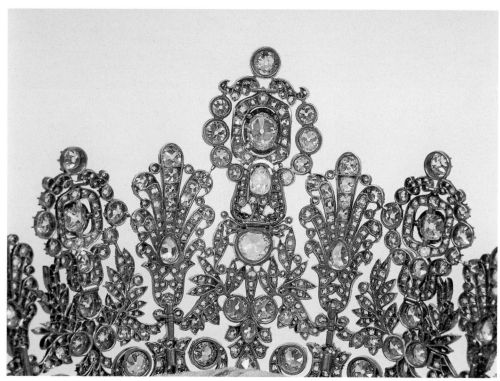

Left, top and bottom:
Front and back of the tiara set with the so-called '*Family diamonds*' of the Grand Ducal Family of Luxembourg. Gold, silver and diamonds; made first half of the 19th century, perhaps circa 1829. Collection of the House of Nassau, Luxembourg. Photo courtesy of the *Maréchalat de la Cour*, Luxembourg City, Luxembourg

Right:
6.11.1919; wedding of Grand Duchess Charlotte of Luxembourg and Prince Felix of Bourbon-Parma. Photo by Edward Kutter Collection Photothèque Municipale, Luxembourg City, Luxembourg

France

On the occasion of the marriage of Emperor Napoléon III of France to the Spanish-born Eugénie de Montijo on 29 January 1853, a set of pearl and diamond jewellery was ordered from several Paris jewellers, including an impressive tiara and coronet. The tiara was made by Gabriel Lemonnier and contained no fewer than 212 drop and round pearls that were set in slender volutes with foliage, together with 1,998 tiny diamonds. The complete *parure* became part of the French Crown Jewels, an extremely valuable collection that was the major highlight of the Paris Universal Exhibition in 1878. In 1884, Louis Énault described the pearls in his book *Les Diamants de la Couronne*, 'The shape, colour, regularity and lustre are the finest one could imagine... everything is of such grace, charm and poetry that Nature herself, that all-powerful enchantress, would take centuries to create its like again...'

By 1870, France had become a republic and Emperor Napoléon III and his wife had been exiled to England. In 1887 the Government of France decided to sell most of the crown jewels, including the pearl *parure*, by public auction. A Mr Julius Jacoby paid 78,100 francs for the pearl tiara, even though the reserve price had been set at 100,000 francs. A year later, a Dresden-based jeweller, Ellimayer, got hold of this notable piece and found a client for it, Prince Albert of Thurn und Taxis. The German prince acquired it as a wedding present for his bride, the Austrian Archduchess Margarethe Klementine, whom he married in Budapest on 15 July 1890.

Almost 90 years later, Empress Eugénie's tiara was worn again by a bride, this time by Countess Mariae Gloria Countess of Schönburg-Glauchau, who married Prince Johannes of Thurn und Taxis in the town of Regensburg. Princess Gloria wore the pearl tiara in 1986 at Prince Johannes's 60th birthday celebrations, but it broke in two pieces. The tiara was fixed temporarily for the festivities, but the prince ordered it to be properly restored later by the court jeweller Albrecht in Regensburg. The goldsmith had the difficult task of removing all the pearls, most of them drilled, from their golden pins before he could solder the broken pieces back together.

Prince Johannes of Thurn und Taxis died on 14 December 1990. His widow Princess Gloria decided to sell some of the family heirlooms to meet death duties and other costs. On 16 and 17 November 1992, some 150 objects were auctioned at Sotheby's in Geneva, including Empress Eugénie's tiara, which was sold within minutes for 932,000 Swiss francs. The buyer was the *Association des amis du Louvre*, who thus returned one item of the famous pearl *parure* of Empress Eugénie to France after more than a century.

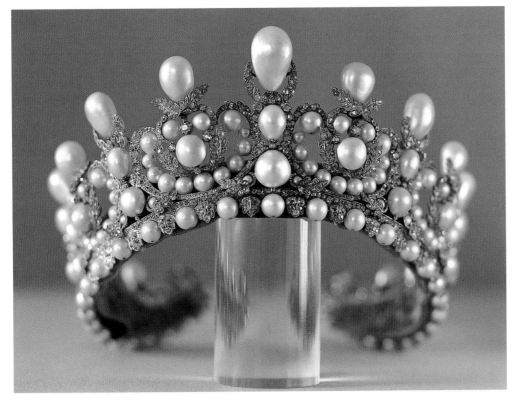

Left:
Tiara of Empress Eugénie of France. Gold, silver, diamonds and pearls; made in 1853.
Collection Musée du Louvre, Paris, France
Photo collection René Brus

Right:
31.5.1980; wedding of Mariae Gloria, Countess of Schönburg-Glauchau and Prince Johannes of Thurn und Taxis.
Photo collection Princely House of Thurn und Taxis, Regensburg, Germany

England

When wedding bells rang for England's Princess Elizabeth on 20 November 1947, her mother lent her a tiara set with diamonds that had originally had been the property of King George III, and then used in 1830 by the court jeweller, Rundell, Bridge & Rundell, in a fringed necklace. During the reign of Queen Victoria, a golden frame was made for the necklace so that it could also be worn as a tiara, and it was to be worn thus for Princess Elizabeth's wedding in 1947. As recorded in several publications, the thin golden tiara frame broke shortly before the bride was due to leave Buckingham Palace for Westminster Abbey, where her bridegroom, Prince Philip of Greece, was waiting. Fortunately, the tiara was taken under police escort to the court jeweller Garrard and repaired in time, so that England's future queen could wear it as planned for her wedding.

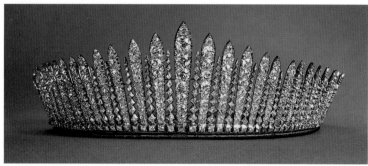

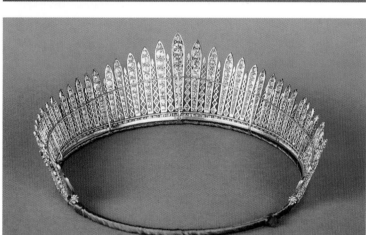

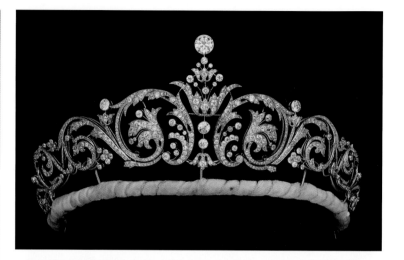

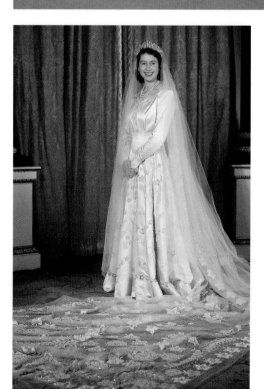

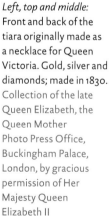

Left, top and middle:
Front and back of the tiara originally made as a necklace for Queen Victoria. Gold, silver and diamonds; made in 1830.
Collection of the late Queen Elizabeth, the Queen Mother
Photo Press Office, Buckingham Palace, London, by gracious permission of Her Majesty Queen Elizabeth II

Bottom left:
20.11.1947; wedding of Princess Elizabeth of England and Prince Philip of Greece.
Photo Mr Baron
Photo Press Office, Buckingham Palace, London, by gracious permission of Her Majesty Queen Elizabeth II

Top right:
Tiara made of scrolled leaves and berries worn by Sarah Ferguson on 23 July 1986. At first the tiara was loaned out for the occasion by her mother-in-law Queen Elizabeth II, but eventually the Queen gave the tiara to Sarah. Platinum and diamonds; made between 1908 and 1911 by the London jeweller Peake.
Photo Sotheby's Press Office, London, England

Bottom right:
Tiara with open scrolls enclosing star-shaped flowers and leaves worn by Princess Diana, Princess of Wales, on her wedding day, 29 July 1981. Gold, silver and diamonds; said to have been made for Viscountess Montagu in 1767.
Collection of the Earl Spencer
Photo Wartski Ltd, London, England

Russia

The Nuptial Crown of the Russian Imperial Family is 9 cm in diameter and contains no fewer than 1,530 diamonds. It is difficult to establish precisely when the diamond ornaments were first used to decorate the Russian nuptial crown, although it is believed that its present setting dates from 1884, when it was worn at the wedding of Grand Duke Konstantin Konstantinovich of Russia and Elisabeth of Sachsen-Altenburg. Before that time, the diamond ornaments had decorated a belt of Empress Yekaterina (Catherine) II, or a caftan of the Empress's son, Prince Pavel (Paul) Petrovitch. The diamond ornaments are attached to the crown frame with silver wire curved and wound round the frame in a rather unusual, imprecise fashion. The crown was found in a box in Moscow after the end of the First World War. The new, communist rulers in Russia, having murdered Tsar Nicolas II and his family, decided that they did not need this bridal crown, nor many other valuable objects from the Imperial Treasury, and some were sold by public auction in London, at Messrs Christie, Mansoon & Wood, on 16 March 1927. The French jeweller Fourrès acquired the crown for £6,100. Fourrès then sold the crown to the American Mrs M. de Kay, and after her death, it was auctioned at Sotheby's Parke Bennet Galleries in New York in 1966. The estimated selling price was £50,000. The next owner was Mrs Marjorie Merriweather Post, whose residence Hillwood was turned into a museum after her death. The crown that once adorned the heads of Russian imperial brides is now one of the major highlights of the Russian art collection at what is now known as the Hillwood Museum.

In his book *Cartier, jewellers extraordinary*, Hans Nadelhoffer mentions the melancholy account of Prince Christophe of Greece (son of King George I of Greece), who had an unexpected encounter with this crown. '*At the time I was in New York visiting Pierre Cartier in his office, Suddenly he said, "I would like to show you something". He took a velvet case from his private safe, laid it on the table and opened it. Within lay a diamond crown with six arches rising from the circlet and surmounted by a cross. "Do you recognize it?" he asked me. I nodded wordlessly, seized by a sense of melancholy that rose from the depths of my memory. It was the crown of the Romanovs. My mother had worn it and her mother before her; it had adorned all the princesses of the imperial house on their wedding days. All at once, it seemed to me the room was filled with shades of long-dead brides.*'

A Russian imperial bride wore not only the diamond-set nuptial crown, but also other items of the Crown Jewels, including a costly tiara. From wedding photographs taken during the second half of the 19th century and the beginning of the 20th century, it is clear that the same tiara was always used. This wonderful tiara was commissioned around 1800 by Tsar Paul I for his daughter-in-law Elizabeth, who married the heir to the throne of Russia. At its centre, the tiara has a flat, pink diamond of 13.35 carats. There are also 39 briolette-cut, slightly yellow diamonds, which originally came from India. Unlike the nuptial crown, the authorities in Russia decided after the First World War that this tiara should be kept as a relic of the imperial past.

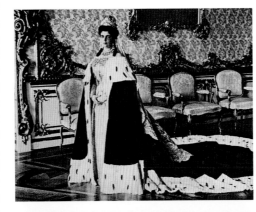

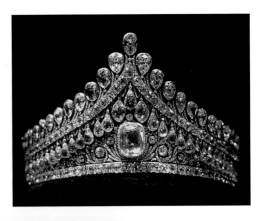

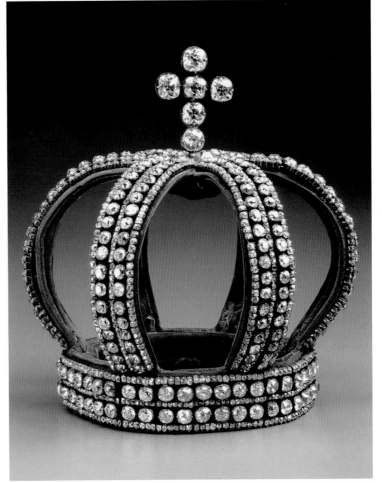

Top left:
29.8.1902; wedding of Grand Duchess Elena Vladimirovna of Russia and Prince Nicholas of Greece.
Photo collection René Brus

Top right:
Tiara of Tsarina Elizabeth Alexeievna, wife of Tsar Alexander I of Russia. Gold, silver and diamonds; made circa 1800.
Collection Diamond Fund, Moscow, Russia
Photo Embassy of Russia, The Hague, The Netherlands

Bottom:
Nuptial crown of the Russian Imperial Family. Gold, silver and diamonds; parts from the 18th century, present construction probably second half of the 19th century.
Collection Hillwood Museum, Washington, DC, USA.

Iran

Wedding headdresses often feature notable and, in particular, large diamonds. The approximately 60 carat Light of the Eye diamond, better known as the Nur-Ul-Ain (Nur-ol-Eyn), is one such notable stone. It was used by the New York jeweller Harry Winston in 1959, along with 324 other diamonds, to create a platinum tiara for Farah Diba, who was to marry Emperor Mohammad Reza Shah Pahlavi of Iran. The jeweller surrounded the Nur-Ul-Ain with yellow, pink, blue, and colourless diamonds above a border of undulating baguettes (gemstones cut into long rectangles). The Nur-Ul-Ain, which was regarded in those days as the world's largest rose-pink diamond of brilliant cut, came from the Golconda mines of southern India. Its recorded history begins in 1642, when Jean-Baptiste Tavernier, the eminent 17th-century French traveller and gem merchant, reported seeing a large pink diamond for sale in south-west India. The owner of this extraordinary stone allowed Tavernier to make a casting of it, which he sent to two of his friends in Surat, drawing their attention to its great beauty as well as its price. This diamond came to be known as the Great Table diamond. When Persian invaders under Nadir Shah sacked and pillaged Delhi in 1739, they carried off several famous diamonds. According to the most painstaking research by a team of researches from the Royal Ontario Museum in Toronto, two stones in the Iranian crown jewels had once been the historic Great Table diamond. They based their conclusions on the rose-pink colour and the combined weight of the Darya-e Nur or 'Sea of Light' and Nur-Ul-Ain diamonds.

When discussing any of the former imperial Crown Jewels of Iran, superlatives become meaningless. However, it must be said that the tiara with the Nur-Ul-Ain diamond certainly ranks among the most important pieces ever created for a wedding.

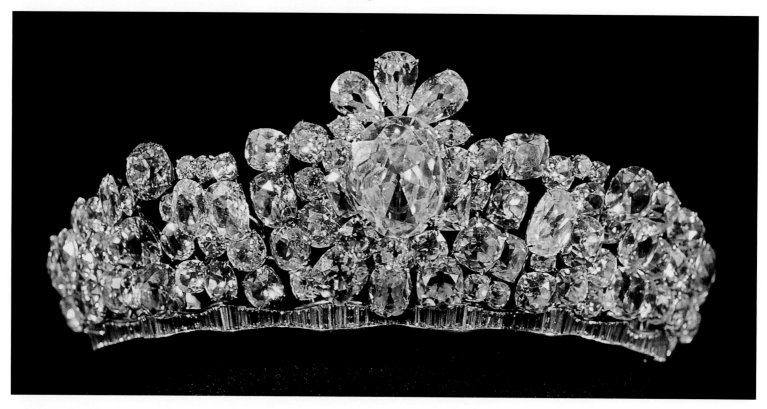

Bridal tiara of Empress
Farah of Iran. Platinum
and diamonds; made in
1959 by Harry Winston,
New York.
Collection National Bank
of Iran, Teheran, Iran
Photo Bank Markazi Iran,
Teheran, Iran

Japan

The formal wedding attire for male members of the Imperial Family of Japan includes the traditional *kanmuri* headdress made of bamboo, Japanese paper and black silk cloth. The bride's hair decoration is known as the *saishi*, which in colour and shape looks like the rising morning Sun, starting to warm the world with three of its countless rays. This hair adornment is regarded as a badge in honour of *Amaterasu Omikami*, the Sun goddess, whose grandson Ninigino-Mikoto (or Ninigi) was sent to earth to govern the land and whose descendant, Jimmu Tenno, founded the Japanese Imperial House in 660 BC.

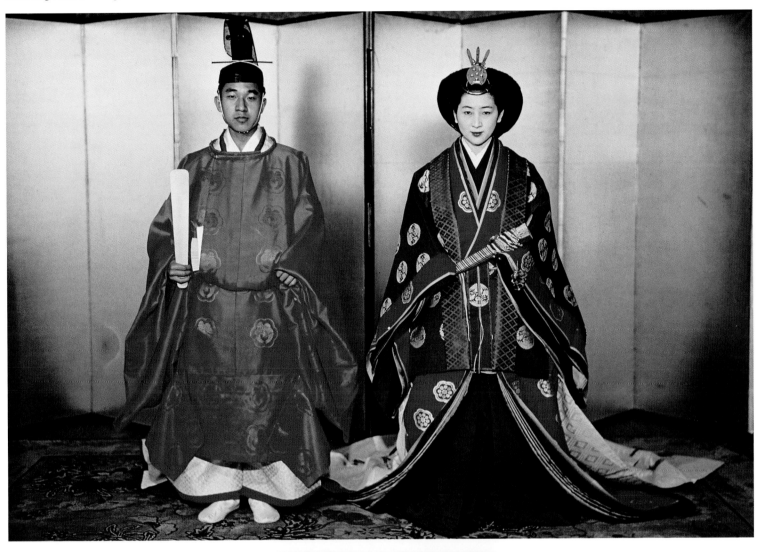

Bottom left:
Kanmuri worn by the 36th head of the Tokakura family in 1915. The *kanmuri* has been worn by male members of the Imperial Family and the nobility since the Heian era (794-1192). Bamboo, Japanese paper, black silk cloth, lacquered inside. Collection of Takakura Cultural Institute, Tokyo, Japan

Bottom right:
Saishi, gilded copper. Collection of Takakura Cultural Institute, Tokyo, Japan

Top:
10.4.1959; wedding of Emperor Akihito of Japan and Empress Michiko Shoda. Photo Imperial Household Agency, Tokyo, Japan

Malaysia – Kedah

In 1904, Prince Ibrahim, the eldest son of Sultan Abdul Hamid Halim Shah of Kedah was to marry Princess Aisha, the only child of the Regent Prince Abdul Aziz. A large amount of valuable jewellery, including bracelets, anklets, necklaces, buckles, fans and epaulettes, was ordered, and almost all of the pieces were set with diamonds and rubies. A wedding headdress referred to locally as a *tengkolok* was made for the bridegroom. It was composed of a turban wound five times around a flat, cylinder-shaped *fez* or *kopiah*. The frame was made of gold brocade and gold thread, on which different, mainly gold filigree, ornaments were attached. Diamonds sparkled all over the crown, and also in the 23 golden flowers attached to it on wires. The front of this headdress had a half-

Moon-shaped diamond *aigrette* with a five-pointed star attached, from which sprouted a plume. This rather uncomfortable wedding crown was also inspired by the sultan's crown that had been lost during one of the 19th-century wars. The wedding festivities lasted 40 days and 40 nights. Not only Prince Ibrahim and Princess Aisha were married during this period; two other members of the sultan's family were also married. After the festivities, the sultan found himself in a rather uncomfortable financial position, but thanks to financial help in the form of a loan from befriended Siam (present-day Thailand), the sultan was able to pay his debts. The Kedah wedding crowns were saved from the melting pot and have been worn ever since during royal weddings.

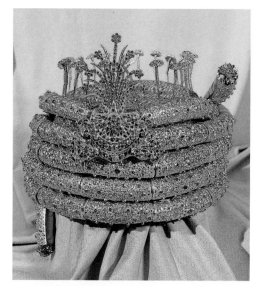
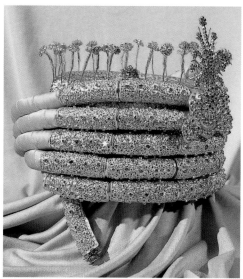
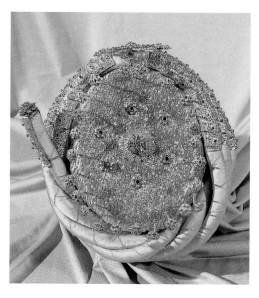

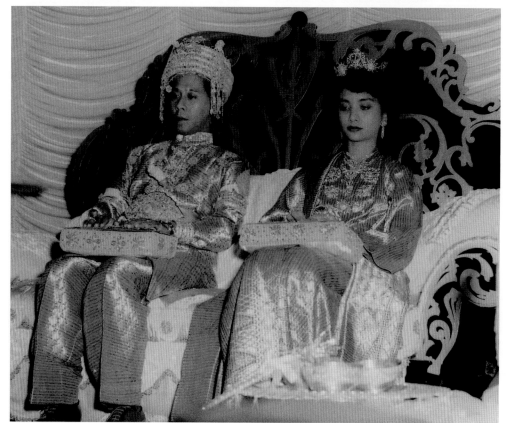

Top:
Wedding crown of Prince Ibrahim of Kedah. Gold and diamonds; made in 1904.
Collection of the Sultan of Kedah, Malaysia
Photo René Brus

Bottom:
1.3.1956; wedding of Princess Bahiyah of Negeri Sembilan and Crown Prince Abdul Halim Mu'adzam Shah of Kedah.
Photo Ministry of Information, Kuala Lumpur, Malaysia

Malaysia – Pahang, Kelantan

On 19 June 1981, the *berinai* (henna staining) ceremony was held in the Negara Palace in the Malaysian capital of Kuala Lumpur in conjunction with the marriage of Princess Muhaini of Pahang and Prince Ibrahim Petra of Kelantan. The bride and groom underwent the ceremony separately. Both were dressed in wedding attire of the same gold and green *songket* material and wore elaborate new and traditional jewellery. The head decorations of the bride included numerous glittering and moving, diamond-studded hairpins. On either side of her head, above her temples, were golden flower-garlands, which are locally referred to as *sunti malai* or 'virgin garlands'.

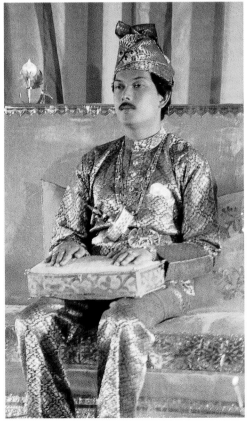

Above:
19.6.1981; the *berinai* (henna staining) ceremony of Princess Muhaini of Pahang held in the Negara Palace, Kuala Lumpur, Malaysia.
Photo René Brus

Left:
19.6.1981; the *berinai* (henna staining) ceremony of Prince Ibrahim Petra of Kelantan.
Photo René Brus

Brunei

In some societies, the royal wedding ceremonies take place over several days and sometimes even weeks. The royal couple has to dress up numerous times in different attire and wear impressive jewellery in abundance. A Brunei bride, royal or not, has to endure some painful moments while her rather complicated headdress is being arranged on her head for the *Istiadat Berinai* or henna tinting ceremony. Usually two senior ladies, known as the *pengangun*, are responsible for dressing the bride, and they know the exact order in which the hairpins and decorations must be attached. The long hair of the bride is combed firmly and the first item, an ornament with two flower-like structures set on spring wires, known as the *tajuk*, is placed in position. The *karang tembulsa* comes second, a large metal plate that hangs down from the back of the head. The third item is decorated with two *nagas*, followed by the *sisir malo*, or comb. The fifth piece is in the shape of a large diadem with shimmering flowers, the *bunga coyang*. The sixth ornament consists of two crescent-shaped items of which one, the *sardang*, adorns the forehead while the other, the *gegatar*, is placed at the back of the head. Last, a wreath of sweet, fragrant jasmine flowers completes the Brunei bridal crown.

The two *nagas* are the most remarkable ornaments on the Brunei bridal headdress. They stand high on the head of the bride and some see them as two fearful snakes, while others regard them as dragons. The snake is an important symbol throughout the world, representing both good and evil. This animal is also identified with a long life, wisdom and caution. In Greek mythology, Hercules strangled two snakes with his bare hands, hence ornaments bearing two snakes are worn as protection against disaster. In Hinduism, the snake is associated with the god Shiva, while in Buddhism, Mucilinda, the king cobra, protected Buddha against Mara, the god of evil. In Christianity, the snake is a symbol of the devil. Dragons have an equally diverse range of attributes. They are often seen as symbolising satanic powers, or linked in folklore to earthquakes and eclipses, while in Chinese mythology, the dragon stands for justice, authority and power. It is difficult to establish the significance of the *nagas* on the bridal headwear of Brunei, since several religions and cultures have influenced this country over the centuries. But presumably the Brunei bride wears this mythical animal for its positive effect on her marriage.

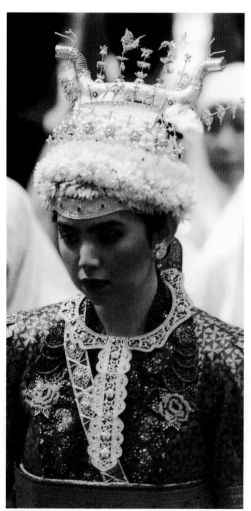

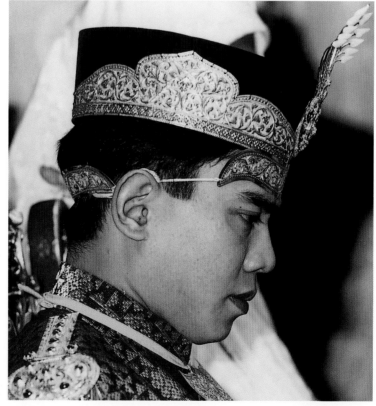

15.8.1996; the wedding of Princess Rashidah Sa'adatul Bolkiah of Brunei and Pengiran Anak Abdul Rahim included a henna tinting ceremony, the *Istiadat Berinai*. This ceremony was held separately for the bride and groom; for the bride, in her father's residence, the Nurul Iman Palace, where henna paste was applied to the palms of her hands. For the groom, this ceremony was held in his father's residence. During this ceremony the bridegroom's black velvet headcover, locally known as *pisnin*, is adorned with embossed metal decorations and gem-set *aigrette*.
Photo René Brus

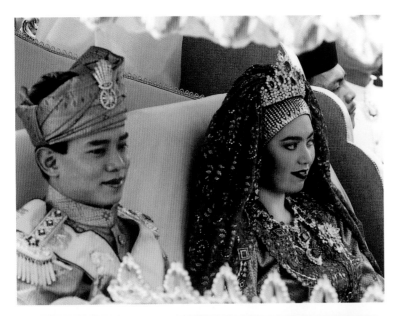

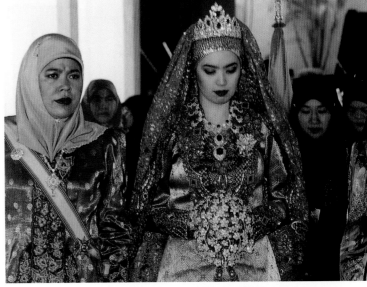

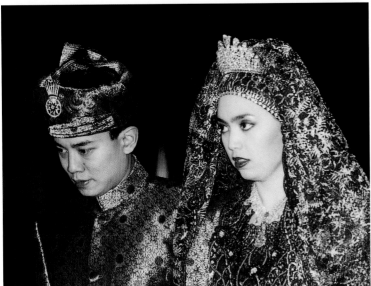

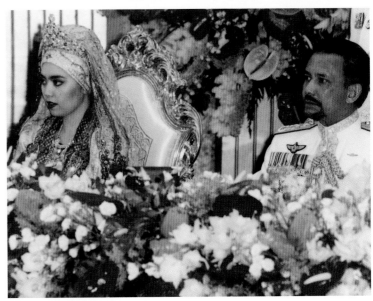

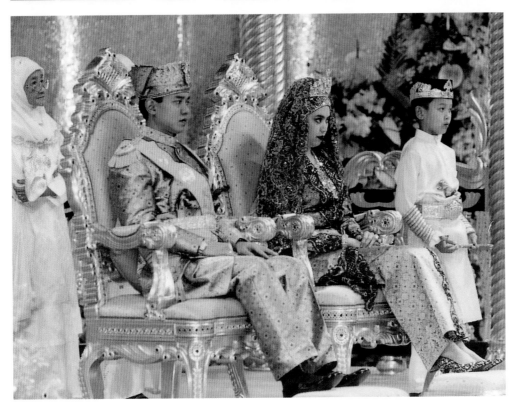

The ceremonies held during the wedding of Princess Rashidah Sa'adatul Bolkiah of Brunei and Pengiran Anak Abdul Rahim were spread over 16 days and included the *berbedak* or powdering ceremony (Wednesday evening, 14 August 1996), the henna tinting ceremony (Saturday, 17 August 1996), the *bersanding* or Sitting-in-state ceremony (Sunday morning, 18 August 1996) and a state banquet (Sunday evening, 18 August 1996). On all occasions both the bride and groom wore different matching colourful dresses and jewellery.

Photos René Brus

Indonesia – Kutai

A royal wedding in some countries ensures that goldsmiths and other craftsmen are kept very busy. In the Sultanate of Kutai, it is traditional to make a large array of jewellery for both bride and bridegroom. During the later part of the 19th century, Sultan Aji Mohammad Sulaiman was a passionate collector of diamonds. His collection of coloured diamonds was so famous that the King Chulalongkorn Rama V of Thailand once sent an emissary to Kutai to try to persuade the sultan to part with his coloured stones. The sultan, however, wished to keep his collection for dynastic events, such as the wedding of the Crown Prince Aji Batara Agung Dewa Sakti of Kutai in 1886. After the death of the 18th Sultan of Kutai in 1910, his successor found himself with such debts that the Dutch colonial authorities decided to sell many of the sultan's possessions. Luckily, Dutch Government officials recognised the importance of the Kutai crown jewels, and these priceless pieces were kept for the sultan and his family to use during important events.

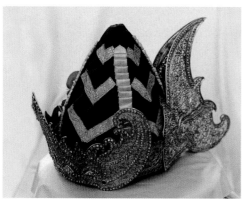

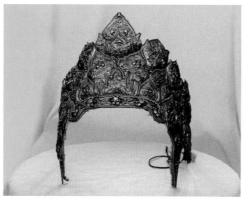

Top left:
Bridal crown designated for a prince of Kutai. Gold and diamonds; made during the second half of the 19th century.
Collection Museum Nasional, Jakarta, Indonesia
Photo René Brus

Top right:
Bridal crown designated for a princess of Kutai. Gold, diamonds and rubies; made during the second half of the 19th century.
Collection Museum Nasional, Jakarta, Indonesia
Photo René Brus

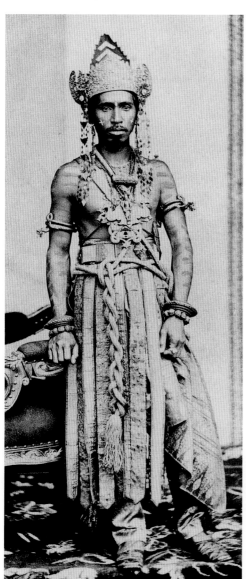

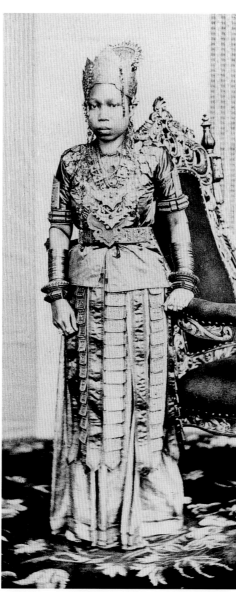

Bottom left:
1886; Crown Prince Aji Batara Agung Dewa Sakti of Kutai in bridal costume.
Photo collection René Brus

Bottom right:
1886; Princess Poetri Djoendjoeng Boewik on the day of her marriage to the Crown Prince of Kutai.
Photo collection René Brus

Coronations

The founding of a monarchy, the arrival of a new dynasty or the accession of a new ruler is typically marked with a ceremony, often involving swearing allegiance to a constitution and, in many cases, featuring a crown and other emblems of sovereignty – the regalia. In many cases, there are no official rules for the format of the ceremony, and often the government and the sovereign decide together how allegiance between the two should be demonstrated. Each country or society creates a ceremony that is appropriate according to the local religious, traditional and political circumstances. The regalia used during such a ceremony are not necessarily intrinsically valuable, but may have historical, national or dynastic importance.

The emblems of sovereignty can generally be divided into two categories. First, there are the ornaments that are closely connected with the position of ruler. These are handed over during the accession ceremonies and are subsequently worn by the sovereign or kept nearby during other important occasions. Second, there are emblems of sovereignty that enhance the splendour of the ruler. Both categories can include any number of objects, such as a sword, spear, shield, war club, flywhisk, fan, spur, miniature animal, throne, sceptre, globe, chain, necklace, bracelet, ring, water-jug, spittoon, cigarette case, sirih-container, talisman, musical instrument or even an umbrella or parasol. The importance of such items differs enormously among different ruling dynasties, but for countless societies throughout the world a crown or other type of impressive headdress is the most important object connected with the sovereign's high position.

In most cases, the regalia have been handed down to the head of the ruling family from generation to generation and these ornaments have become synonymous with the ruler's prestige and dignity. Sometimes religious or other authorities have claimed custody of the regalia in order to give them a national status. In some cases, it became tradition that the regalia could not be taken out of the country, as they were no longer the private property of one person or family. In some rare cases one particular object or even the whole regalia reached the status of being the palladium of the nation, with the ruler acting as its custodian, to such an effect that without these objects, the sovereign had no power to rule.

The ruler is usually crowned by a figure of authority, such as a religious or political leader, except in societies where the head is regarded as the most sacred part of the body. In these cultures, it is extremely rude for someone younger in age or lower in rank to touch another person's head. It might even be unacceptable for the hand or even the shadow of a subject to appear above the head of the ruler. Under these circumstances, rulers crown themselves, usually after being formally presented with the crown by the person highest in rank after the monarch.

England

Coronations are usually solemn events and rehearsed extensively, especially if the ceremony is to be broadcast live. In earlier times, coronations did not always proceed as solemnly as might have been expected.

A violent incident occurred at the coronation of Henry I on 5 August 1100. English monarchs are traditionally crowned by the Archbishop of Canterbury, but for this particular coronation, the archbishop had not arrived by the appointed hour. Instead, the king was crowned by the Bishop of Salisbury. Immediately afterwards, the archbishop arrived, and was shocked to find the king already crowned. He asked who had performed the ceremony, but received an evasive answer. This annoyed the archbishop so much that he knocked the crown off the king's head with his staff and then crowned the king again himself.

The coronation of James II in 1685 was performed using St Edward's Crown, which had been made for James' predecessor Charles II, his brother. But Charles' head was bigger than James', and the crown threatened to fall off. A footman pushed it back on to the king's head just in time. This event was seen as a very bad omen, and was one of several. A piece of glass on which the royal insignia were painted fell out of a window, a flag in the abbey tore in half and one of the poles of the throne canopy broke, so that the King was nearly buried underneath it. James II was a Catholic and during his reign persecuted the Protestants with increasing severity, suggesting to the people that the portents at his coronation came true. After four years, in 1689, James II was deposed by his nephew, the Dutch Stadtholder Willem III. Willem was also the husband of Mary, the daughter of James II. This couple became the joint sovereigns of England as William III and Mary II.

Problems surrounding the coronation of King George IV in 1821 were partly financial. The new king had led a licentious lifestyle as Prince Regent and had rarely been seen by his subjects. He decided he could increase his popularity by making the coronation into a gigantic spectacle. A new crown was designed by Philip Liebart, working with the Crown Jewellers Rundell, Bridge and Rundell. The crown incorporated 12,314 borrowed diamonds and 204 pearls. Designing and making the crown cost £735, and borrowing the gemstones for a year cost an enormous £6,525, 10% of the value of the pearls and stones. George IV was very keen to have the crown set permanently with diamonds, and after the coronation he tried to persuade the government to buy the stones. However, he failed to convince them, and the crown was eventually dismantled and the stones returned to the Crown Jewellers in 1823.

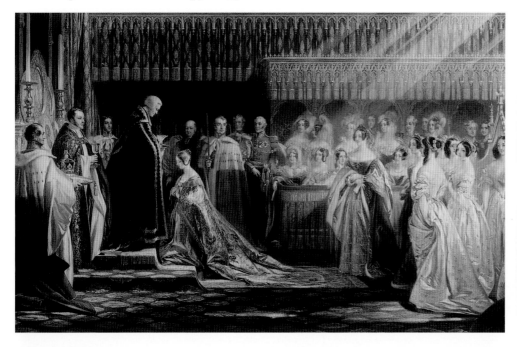

Left:
28.6.1838; coronation
of Queen Victoria
of England.
Photo collection
Victoria & Albert
Museum, London,
England

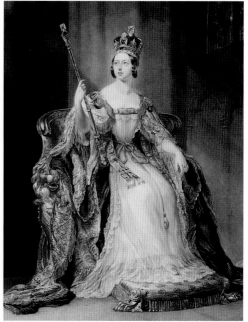

Right:
Queen Victoria
wearing her coronation
crown, the Imperial
State Crown.
Photo collection Royal
Archives, Windsor
Castle, England

On 28 June 1838, the 19-year-old Princess Victoria was crowned Queen of Great Britain and Ireland. The St Edward's Crown was too heavy for Victoria to wear, and so a new crown was made. This crown is known as the Imperial State Crown, and since that event it has been worn by the reigning monarch each year during the Opening of Parliament. Queen Victoria kept a journal, and we have her own account of the coronation. '*Thursday, 28th June! – I was awoke at four o'clock by the guns in the Park, and could not get much sleep afterwards on account of the noise of the people, bands &c.,&c. ...I reached the Abbey amid deafening cheers at a little after eleven o'clock; I first went into a robing-room quite close to the entrance, where I found my eight train-bearers all dressed alike and beautifully, in white satin and silver tissue, with wreaths of silver corn ears in front, and a small one of pink roses round the plait behind, and pink roses in the trimming of the dresses. After putting on my Mantle, and the young ladies having properly got hold of it, and Lord Conyngham [The Lord Chamberlain] holding the end of it, I left the robing-room and the Procession began... At the beginning of the Anthem where I've made a mark, I retired to St Edward's Chapel, a small dark place immediately behind the Altar, with my Ladies and Train-bearers; took off my crimson robe and kirtle and put on the Supertunica of Cloth of Gold, also in the shape of a kirtle, which was put over a singular sort of little gown of linen trimmed with lace; I also took off my circlet of diamonds and then proceeded bare-headed into the Abbey; I was then seated upon St Edward's chair where the Dalmatic robe was clasped around me by the Lord great Chamberlain. Then followed all the various things; and last (of those things) the Crown being placed on my head; – which was, I must own, a most beautiful impressive moment; all the Peers and Peeresses put on their Coronets at the same instant... The shouts, which were very great, the drums, the trumpets, the firing of the guns, all at the same instant, rendered the spectacle most imposing... After the Homage was concluded I left the Throne, took off my Crown and received the Sacrament; I then put on my Crown again, and re-ascended the Throne, leaning on Lord Melbourne's arm;...the Archbishop had put the ring on the wrong finger, and the consequence was that I had the greatest difficulty to take it off again, which I at last did with great pain. At about four o'clock I re-entered my carriage, the Crown on my head and Sceptre and Orb in my hand, and we proceeded the same way as we came – the crowds if possible having increased. The enthusiasm, affection and loyalty was really touching, and I shall ever remember this day as the proudest of my life. My kind Lord Melbourne was much affected in speaking of the whole ceremony. He asked kindly if I was tired; said the Sword he carried (the 1st, the Sword of State) was excessively heavy. I said that the Crown hurt me a good deal.*'

An important part of the English coronation ceremony is the recognition of the rights of the king or queen by those who are present at Westminster Abby. The Archbishop of Canterbury says, '*I here present unto you (mentioning the name), the rightful inheritor of the crown of this realm; wherefore all ye that are come this day to do your homage, service, and bounden duty, are ye willing to do the same?*' This is repeated four times, with the archbishop turning to the east, south, north, and west and the king or queen standing and turning in the same direction. The practice is to answer each question with loud acclamations, and at the last one the trumpets sound and the drums beat. An anthem is sung, the archbishop and the bishops attending the monarch don rich capes, and the king or queen rises, advances towards the altar uncovered, and kneels down upon the cushions. In addition to these acts, the monarch has to take the coronation oath.

The coronation of Queen Elizabeth II in 1953 was the first such ceremony broadcast to the nation. Only around 1.5 million people in Britain possessed a television at the time, and initially, the Archbishop of Canterbury and members of the Coronation Committee felt that it was not worth broadcasting the coronation. They believed that the benefits did not outweigh the discomfort that the bulky lights and cameras would cause the Queen and other participants. But when it became clear that three quarters of a million people had bought a television set especially for the occasion, the coronation was broadcast after all.

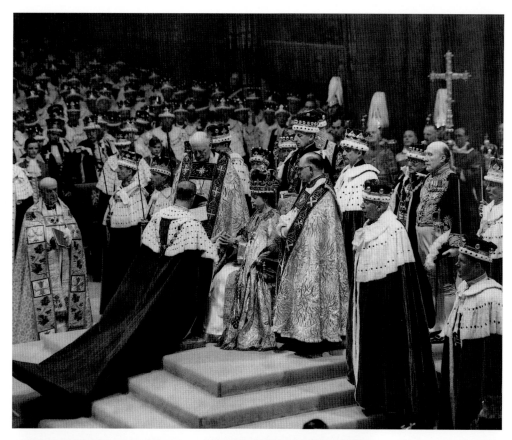

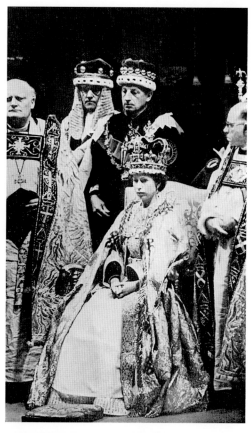

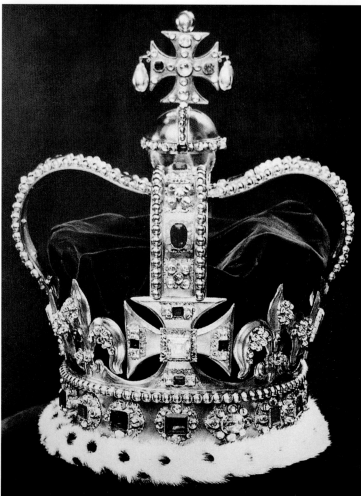

Top left:
2.6.1953; coronation
of Queen Elizabeth II.
Picture shows the Duke
of Edinburgh pledging
homage to his wife.
Photo collection
René Brus

Top right:
2.6.1953; coronation of
Queen Elizabeth II.
Photo collection
René Brus

Bottom left:
Engraving of the
St Edward's Crown
made by W. Sherwin
as how it was worn by
King James II. Date of
engraving unknown.
Photo collection
René Brus

Bottom right:
For the coronation of
King George VI and
Queen Elizabeth of
England on 12 May
1937, the coronation
crowns and regalia were
inspected by the Crown
Jewellers. The objects
displayed were the Sword
of State, the Sword of
Spiritual Justice, the
Sword of Temporal
Justice, the Curtana, the
Jewelled State Sword, the
King's and Queen's Ring,
the Spurs, the two maces
of Sergeants at Arms, the
St Edward's Crown, the
St Edward's Staff,

the Sceptre with the
Cross, the Sceptre with
the Dove, one Golden
Chalice, one Golden
Paten, the Ampulla, the
Anointing Spoon, the
Bible, the Imperial State
Crown, the Queen's
Crown, the Ivory Sceptre
with Dove and the Ivory
Sceptre with Cross.
Photo Twining collection,
Library, The Worshipful
Company of Goldsmiths,
Goldsmith's Hall,
London, England

The Netherlands

When Emperor Napoléon I of France was deposed and sent into exile at the beginning of the 19th century, a congress of politicians and other important figures was held in Vienna to decide what to do with those parts of Europe that had been under the dominion of France. For about two centuries preceding the French Revolution, The Netherlands had been ruled by a Stadtholder, who was also head of the House of Oranje-Nassau. The exiled Stadtholder Prince Willem V had died in exile and, in a letter dated 5 March 1813, his son and heir Prince Willem Frederik was advised by his mother, the Dowager Princess Wilhelmina, not to take the position of king. She thought such a title was sensitive in the eyes of the Dutch people. The prince himself preferred the old position of Stadtholder, but a compromise was found in offering him the position of 'Sovereign Prince'. On 30 March 1814, Prince Willem I of Oranje-Nassau swore allegiance to the constitution in the New Church in Amsterdam. The ceremony was clearly an inauguration, but no crown or other tokens of rank were used.

21.9.1815; Etching of the inauguration of King Willem I of The Netherlands. As the constitution of 1815 prescribed, this ceremony had to take place in Brussels in the open air. The King took the oath in the specially erected pavilion at the King's Square. For the first time in history the Dutch Regalia, comprising a crown, sceptre, globe and banner, were displayed at the inauguration ceremony.
Photo collection René Brus

A year and a half later, the European powers decided to expand the territory of The Netherlands to act as a buffer against France, adding what is now known as Belgium. This time, Willem I decided to accept the title of king and a new, more elaborate investiture was planned. The ceremony was due to take place in Brussels and, because of political and social circumstances, the king wished to be inaugurated as quickly as possible and then crowned at a later date. The Amsterdam jeweller Ciovino and Truffino designed a royal crown with four arches, increased to eight at the request of the king. However, the coronation never took place, and there are no documents to suggest that the jeweller ever made a crown or other emblems of royal regalia. At the time, a coronation ceremony was practically unthinkable. No agreement could be reached on whether a Protestant pastor or a Catholic bishop or other (political) authority should perform the coronation. The king crowning himself, as Emperor Napoléon did, was out of the question. It was therefore decided not to perform a coronation ceremony. Nevertheless, on 20 September 1815, on the eve of the inauguration, Mr Spaen Lalecq, director of the *Hoge Raad van Adel*, the High Council of Nobles, informed the king by letter that he had brought a crown, sceptre, globe and the Kingdom's banner to Brussels and wished to show them to the king that evening.

Despite that fact that there was no coronation ceremony on 21 September 1815, King Willem I took his oath to the constitution, and the crown, sceptre and globe were on display near his throne. The crown was simple, fashioned from gilt copper and with a headband set with glass stones on coloured foil. The stones are clearly not placed symmetrically and there are superfluous holes along the lower rim. It is still a mystery why such an 'amateur' crown was used for the 1815 ceremony. Had the courtiers found an old crown? Perhaps it was the funeral crown of Stadtholder Willem IV, who was buried on 4 February 1752. This suggestion is supported by the fact that this crown is 20 cm in diameter, meaning that it was not intended to be worn as it is too large for the average head. The average size of a comfortable crown is generally 18 cm.

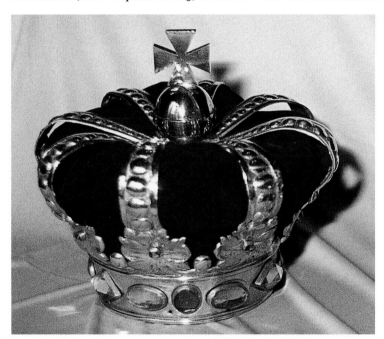

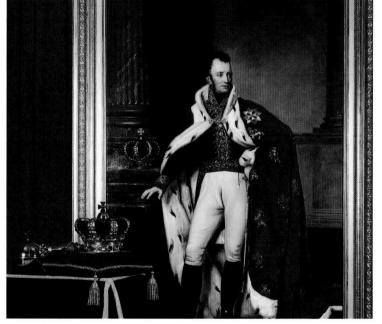

Left, top and bottom:
The crown of King Willem I of The Netherlands.
Collection Stichting Historische Verzamelingen van het Huis Oranje-Nassau, Royal House Archive, The Hague, The Netherlands
Photo René Brus

Right:
Crown and sceptre used by King Willem I of The Netherlands during his inauguration in Brussels on 21.9.1815.
Photo Nationaal Museum Paleis Het Loo, Apeldoorn, The Netherlands

In 1840, King Willem I abdicated in favour of his son, Willem II. It can be assumed that the old regalia were considered inappropriate for the new king's inauguration ceremony because they had served as the symbols of the Kingdom, which included the Northern and Southern Netherlands. Partitioning in 1830 had separated the South from the North, and led to the founding of the Kingdom of Belgium. A new crown was commissioned, again its diameter too large for the average head, and this time of gilded silver, but basically similar in shape. The finished crown was delivered to the Royal Palace in Amsterdam by the Amsterdam jeweller Adrianus Bonebakker on 27 November 1840, one day before the ceremony took place. On the same day, Bonebakker submitted his bill of 1400 guilders, but it took seven months before he received his payment from the King's Treasurer. Theodorus Gerardus Bentvelt, who had crafted the crown, was paid 600 guilders out of the total for his labour.

Many people doubted the authenticity of the stones that decorated the crown, but the legend that these were precious gems was sustained for a long time. Even as recently as 1948, when Queen Juliana was inaugurated, the government press agency described the crown as being set with four oval rubies, four oblong sapphires, eight round emeralds and numerous pearls. The truth about the stones only came to light when the jewellery company that still bears Bonebakker's name today published *Commemoration Book 1792-1976*. The book states that the stones used to make King Willem II's crown were in reality cut glass, and the pearls were imitation. To make matters worse, the 80 pearls (72 on the arches and 8 above the headband) deteriorated and had to be replaced at around the time of the inauguration of Queen Wilhelmina in 1898. Apparently the jeweller commissioned to do this, C. P. 't Hart of The Hague, did not have enough large imitation pearls in stock and so each arch was only adorned with five pearls rather than the original nine.

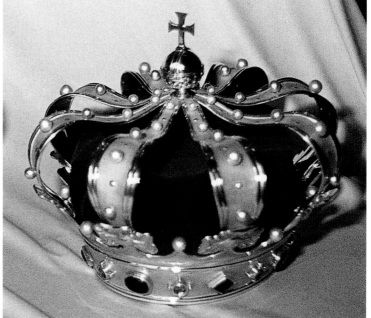

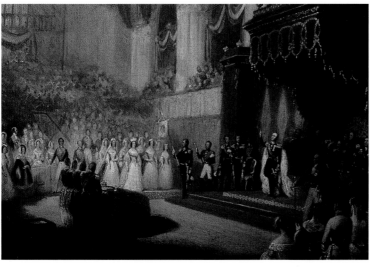

Top left:
Design of the crown of King Willem II of The Netherlands. Made in 1840.
Collection Bonebakker jeweller, Amsterdam, The Netherlands
Photo René Brus

Top right:
Crown of King Willem II. Gilded silver, paste and imitation pearls; made in 1840.
Collection Stichting Historische Verzamelingen van het Huis Oranje-Nassau, Royal House Archive, The Hague, The Netherlands
Photo René Brus

Bottom:
28.11.1840; Inauguration of King Willem II of The Netherlands in the New Church of Amsterdam. The new crown, sceptre and globe were placed in front of the throne. Painting by N. Pieneman.
Collection Stichting Historische Verzamelingen van het Huis Oranje-Nassau/ Nationaal Museum Paleis het Loo, Apeldoorn, The Netherlands
Photo by René Brus

Whatever the value of the Dutch royal crown, each succeeding monarch has preserved its symbolic value at his or her inauguration. Writers, journalist and others over the centuries have provided us with numerous eye-witness accounts of this virtually unchanged ceremony. In 1840 Queen Anna Pavlovna, the wife of King Willem II, wrote to her brother, the Russian Tsar Alexander I, that she had dressed herself warmly in a robe of white satin trimmed with ermine, a court mantle of gold *lamé* and had worn her diamonds, including a pearl and diamond tiara in the *Pavlovnik* style. Nine years later, the author Paul Jonas was fortunate enough to obtain a ticket to attend the inauguration of King Willem III, but was very surprised to find that there were only nine seats for 20 writers and journalists. On 30 April 1980, the author Jaap Verduyn had a much more comfortable seating allocation for the inauguration of Queen Beatrix, '...*I am sitting in the splendidly situated press gallery in the New Church in Amsterdam. Less than twenty metres from me stand the Louis Quinze chairs from Noordeinde Palace, on which Queen Beatrix and Prince Claus will later take their places. Just in front of them is the credence-table covered with red velvet, and on it are the regalia, on cushions also covered in velvet: the crown, sceptre, orb and constitution. ...The public meeting of the States General that is starting now hardly interests me; it is just part of the occasion. After all, this whole investiture is nothing other than a meeting of the States General. At precisely one minute to three, I hear the sound of the Intrada by J. Andriessen, and the royal procession enters the church. And then the queen appears, Queen Beatrix... The oath is now sworn by Her Majesty, the sixth time that this has occurred in this church: "I swear to the Dutch people that I shall always support and uphold the constitution. I swear that I shall defend and preserve the independence and territory of the State with all my powers; that I shall protect the general and particular liberty and rights of all My subjects, and shall use all means that the laws make available to Me for the preservation and furtherance of the general and particular welfare, as a good king is bound to do. In truth so help me God Almighty!".*

After the formalities of the investiture have been completed, the elder of the two kings-of-arms proclaims at the top of his voice, on his ho our: "The queen is inaugurated!" The Speaker answers: "Long live the queen!" and all those present join in with a threefold "Hooray".'

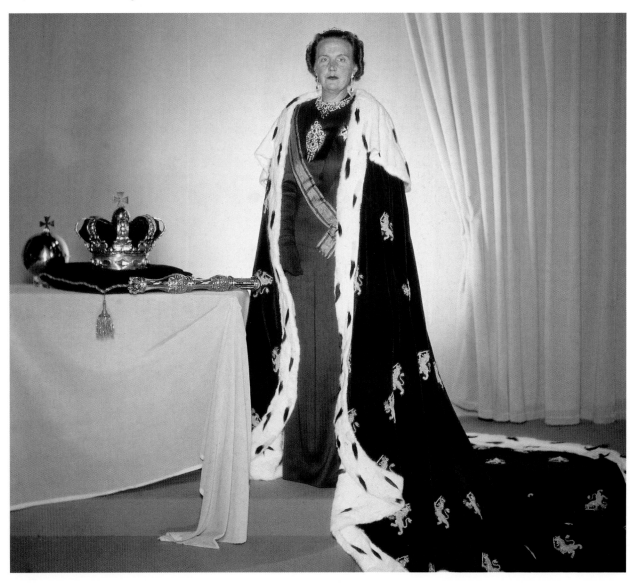

6.9.1948; this state portrait taken on the day of Queen Juliana's inauguration shows the crown, sceptre and globe used by King Willem I of The Netherlands in 1815. The crown of King Willem II, which was used during the queen's inauguration as a symbol of kingship, was not available for the state portrait as it was on display in the New Church of Amsterdam.
Photo collection René Brus

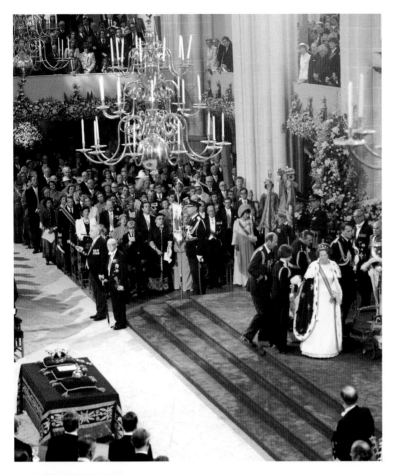

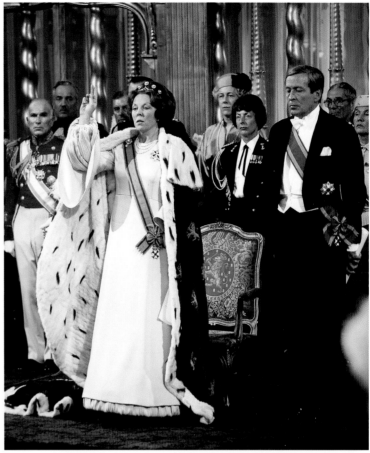

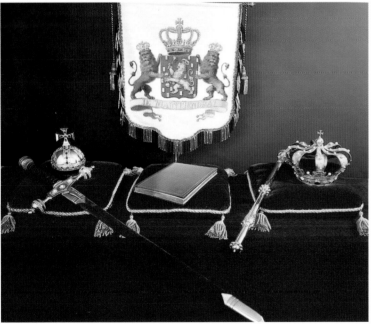

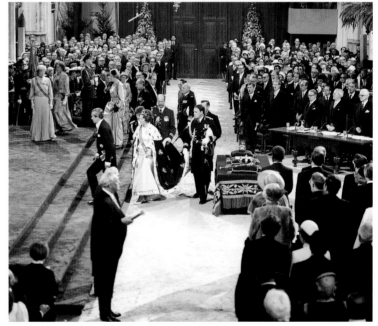

Top left:
30.4.1980; the inauguration of Queen Beatrix was broadcast live by Dutch television and seen at the same time in many other countries through Eurovision.
Photo collection René Brus

Top right:
30.4.1980; Queen Beatrix of The Netherlands entered the New Church in Amsterdam at 3.00 p.m. and the National Anthem was played. Queen Beatrix first gave a speech before she took the oath as prescribed in Article 53 of the Dutch constitution.
Photo collection René Brus

Bottom left:
Since 1840, a crown, sceptre, globe, sword, banner and a copy of the constitution have been present at the inauguration of each Dutch sovereign ruler. The banner of State (rijksvaandel), attached to a gilded spear, is carried by an attendant during the inauguration ceremony.
Photo Rijksvoorlichtingsdienst, The Hague, The Netherlands

Bottom right:
30.4.1980; Queen Beatrix of The Netherlands approaches the regalia. The regalia of King Willem II was present for the 5th time in 1980 for the inauguration of the Dutch Head of State as symbols of the royal dignity.
Photo collection René Brus

Germany

On 18 January 1871 a remarkable ceremony took place in the Hall of Mirrors in the royal palace at Versailles, France. Five years before, the great German statesman Otto E. L. von Bismarck had persuaded a number of German states to unite in a federation against France, and they had recently secured victory in the Franco-German War of 1870-1871. Now, in occupied France, almost all the rulers of the North German Federation proclaimed the Head of the Hohenzollern dynasty, King Wilhelm I of Prussia, as Emperor of Germany.

But there was no crown and no coronation ceremony in Versailles, even though the new German Emperor had a crown, set predominantly with large rose-cut diamonds, in his possession. This crown, used when Wilhelm was crowned King of Prussia on 10 October, 1861, had been specially ordered to replace the

existing Prussian crowns, which were too large in diameter having been made to accommodate the then-fashionable wigs of Wilhelm's predecessors. The 1861 coronation, which took place at Königsberg (now Kaliningrad, Russia), included the traditional procession of the regalia from the palace to the church, a religious service and the coronation ceremony itself. The king entered the church wearing the Black Eagle cloak and neck chain. While he knelt in prayer at the altar, Crown Prince Friedrich Wilhelm took these from him, and then court officials hung the coronation cloak round his shoulders.

Then the king took the crown from the altar and placed it on his head himself. He picked up the sceptre and orb, placed the orb back on the altar, transferred the sceptre from his left hand to his right hand, and finally took the coronation sword in his left hand. As well as crowning himself, the king also placed a crown on the head of his wife Queen Augusta.

After 1871, the regalia of the Kingdom of Prussia became the symbols of imperial dignity for many people, and were therefore used during the funeral of Emperor Wilhelm I in 1888, and again a few months later for the funeral of his son and successor Friedrich III, who ruled for only 99 days. The regalia were also present as symbols of monarchy and Empire when the new Emperor, Wilhelm II, took the oath on 15 June 1888. As at Versailles, there was no coronation of Wilhelm II, either as King of Prussia or as Emperor of Germany, but he soon decided that he needed a better crown than his grandfather's heirloom. In 1889 he gave an order to the Berlin jeweller Jumbert and, in a letter to his courtier dated 27 February that year, the emperor explained in detail how the new crown should be made and what kind of precious stones should be used. As soon as this crown was ready, it was included with the other regalia during court ceremonies, and during meetings of the *Landstage*, the assembly of the German states, but not worn.

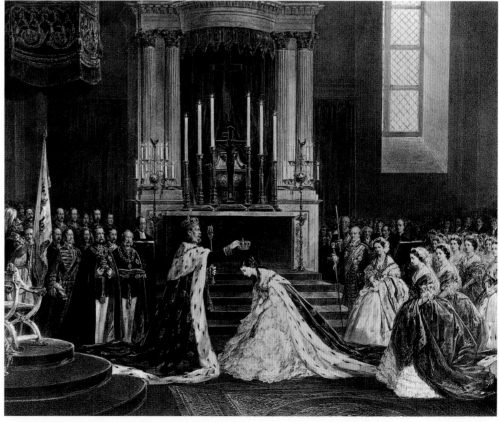

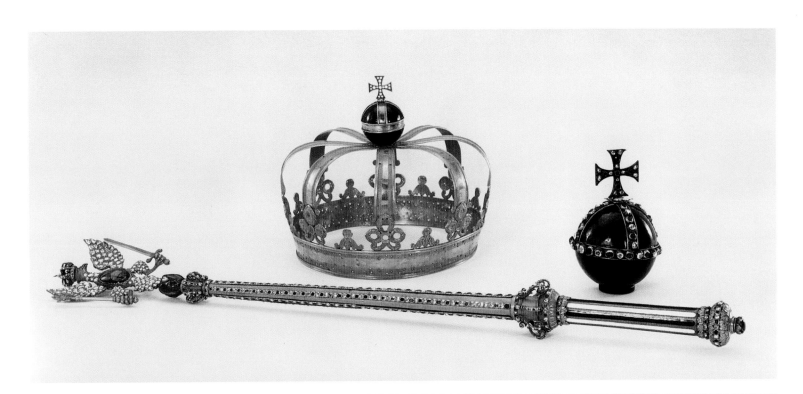

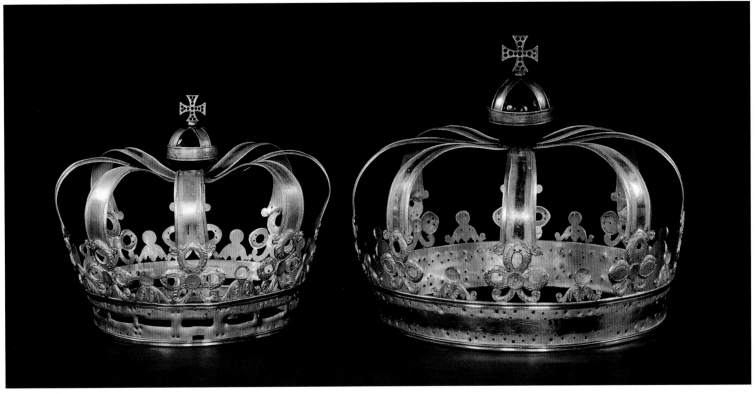

Opposite page:

Left:
King Wilhelm I of Prussia, who became Emperor of Germany in 1871.
Photo Geheimes Staatsarchiv Preussischer Kulturbesitz, Berlin, Germany

Right:
10.10.1861; coronation of King Wilhelm I and Queen Augusta of Prussia.
Photo Geheimes Staatsarchiv Preussischer Kulturbesitz, Berlin, Germany

Top:
Regalia of the Kingdom of Prussia, including the crown frame, a globe and sceptre, used by King Friedrich I during his coronation on 18 January 1701. Gold, diamonds, rubies, garnet and enamel; made in 1700.
Collection des Hauses Hohenzollern, SKH Georg Friedrich von Preussen/Stiftung Preussische Schlösser und Gärten Berlin-Brandenburg, Germany
Photo Jörg Anders

Bottom:
Crown frame (left) of Queen Sophie Charlotte and crown frame (right) of King Friedrich I of Prussia, worn during their coronation on 18 January 1701. Gold and enamel; made in 1700.
Collection des Hauses Hohenzollern, SKH Georg Friedrich von Preussen/Stiftung Preussische Schlösser und Gärten Berlin-Brandenburg, Germany
Photo Jörg Anders

After the First World War, monarchy ended in Germany and Emperor Wilhelm II went to live in exile in The Netherlands, taking with him a large portion of his possessions. The crown stayed in the Monbijou Palace in Berlin as part of the emperor's personal property until the Second World War, when it was decided to place the crown and other valuables from the former emperor's dynasty in Berlin Cathedral. By 1944, the war had reduced much of Berlin to ashes, and General Freiherr von Plettenberg, the plenipotentiary of the former Prussian royal house, took these historical objects to the village of Klein Bremen on the river Weser. Together with a priest, Martin Strathmann, he hid the crown in the church crypt, bricking it up in a hole under the stairs. In 1945, the German secret state police, the Gestapo, arrested von Plettenberg and tried to discover where the crown of the former emperor was hidden. On the way to his interrogation, von Plettenberg managed to commit suicide without giving the Gestapo any clue of the whereabouts of the crown. At the end of the Second World War, the British occupying powers were informed of the hiding place of the crown. Wilhelm II had died in 1941, but his fifth son, Prince Oskar, was present in January 1946 when the crown and other treasures were extracted from their hiding place. It was not until 1948 that the British were convinced that the crown was the private property of the former royal and imperial house and should therefore be given back. On 17 September that year, a representative of the Hohenzollern dynasty, Count Hardenberg, received the crown and other valuables from a Mr Parker, director of the English 'Property Control Branch', during a short official ceremony at Melita House in the city of Minden. The crown that had never been worn was taken to the ancestral castle of the Hohenzollerns near the town of Hechingen and put on display in the treasure chamber.

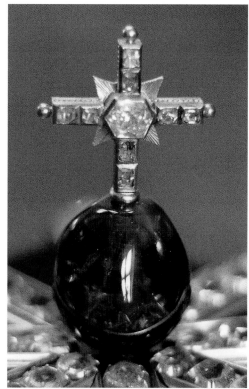

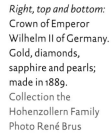

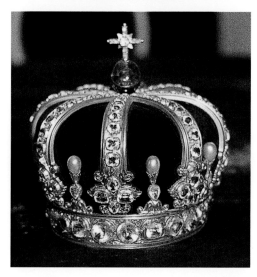

Left:
Beginning 20th century;
Emperor Wilhelm II of
Germany.
Photo collection
René Brus

Middle:
17.9.1948; Prince
Louis Ferdinand of
Hohenzollern and
his wife Princess Kira
looking at the just-
returned crown of
Emperor Wilhelm II of
Germany.
Photo collection
René Brus

Right, top and bottom:
Crown of Emperor
Wilhelm II of Germany.
Gold, diamonds,
sapphire and pearls;
made in 1889.
Collection the
Hohenzollern Family
Photo René Brus

France

A new dynasty began in France on 18 May 1804, when the senate bestowed the imperial title on General Napoléon Bonaparte. The new emperor regarded himself as the successor to the Frankish Emperor Charlemagne, and aimed to follow in the footsteps of the ancient emperors of Rome. His coronation was set for 2 December that year. The crown attributed to Charlemagne had been destroyed in the 1789 French Revolution, so a new crown had to be made. The new gilded copper crown was made by Guillaume Biennais. It was studded with 40 antique *cameo* and *intaglio* carved stones, including some from ancient Rome and others dating from the 12th to the 14th century, which came from the collections of the *Musée Central des Arts* (now the Louvre Museum) and had been selected by the director of the museum, Vivant Denon.

At the last moment, Napoléon decided that he wanted to be crowned with a golden laurel wreath, which he viewed as the oldest symbol of power because it dated back to the Roman emperors. Biennais set to work again and created a wreath made up of 44 large leaves and 12 smaller ones attached to an oval velvet headband. The wreath weighed 42 *grains* (2.73 grams), and cost 8,000 francs. A crown also had to be made for the emperor's wife, Joséphine, and hers was set mainly with pearls. The pearls came from the collection of state jewels, the *Trésor*, which were a legacy from the previous dynasty.

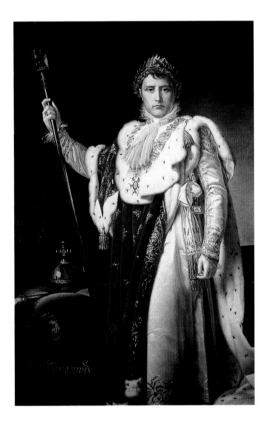

Left:
Painting of Emperor
Napoléon I of France.
Made between
1804-1810.
Collection Rijksmuseum,
Amsterdam,
The Netherlands
Photo René Brus

Right:
Gold leaf from the laurel
wreath of Emperor
Napoléon I of France.
Made in 1804 by
Guillaume Biennais.
Collection and
photo Château
de Fontainebleau,
Fontainebleau, France

In the year 800, the Holy Roman Emperor Charlemagne was crowned by the Pope on Christmas Day. As a consequence, therefore, Napoléon wanted to have the Pope present at his own coronation. However, Napoléon planned to place the laurel wreath on his head himself. The story that he snatched the laurel wreath out of the Pope's hands in order to crown himself is not true. The entire coronation ceremony had been prepared down to the last detail, and the Pope was only expected to bless the coronation regalia – cloak, ring, crown, sword and sceptre. The artist Jacques-Louis David painted the coronation, depicting the moment when Napoléon crowned his wife. In the painting, the Pope is making a gesture of blessing, although in reality he was sitting with his hands in his lap as the empress was crowned.

One fine, chiselled gold leaf from the laurel wreath has been preserved in the collection of the Château de Fontainebleau since 1984. It was previously owned by Jean-Baptiste Isabey, a French painter and pupil of Jacques-Louis David, who had requested the jeweller Leferre to craft a casket for one golden leaf which had belonged to the wreath of Napoléon I in 1852. Only this leaf from the laurel wreath survives. Much of the rest of Napoléon's coronation regalia, generally referred to as the *Honneurs de l'Empereur*, were destroyed during the reign of King Louis XVIII, who came to the throne in 1814 after Napoléon I had abdicated and been sent into exile.

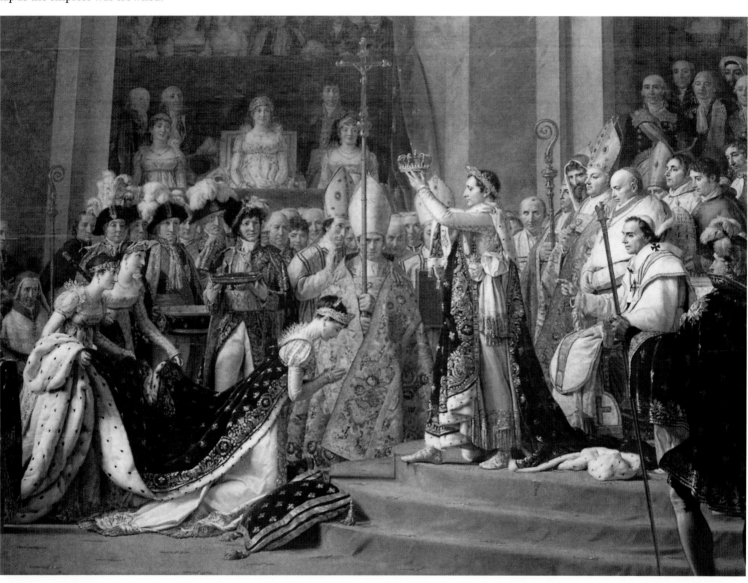

2.12.1804; coronation of Emperor Napoléon I and Empress Joséphine of France. Painting by Jacques-Louis David.
Collection Musée du Louvre, Paris, France
Photo René Brus

Opposite page:
So-called Crown of Charlemagne. Gilded copper, cameo-cut and intaglio-cut stones; made in 1804 by Guillaume.

Collection Louvre Museum, Paris, France
Photo l'agence photographique de la Réunion des musées nationaux, Paris, France

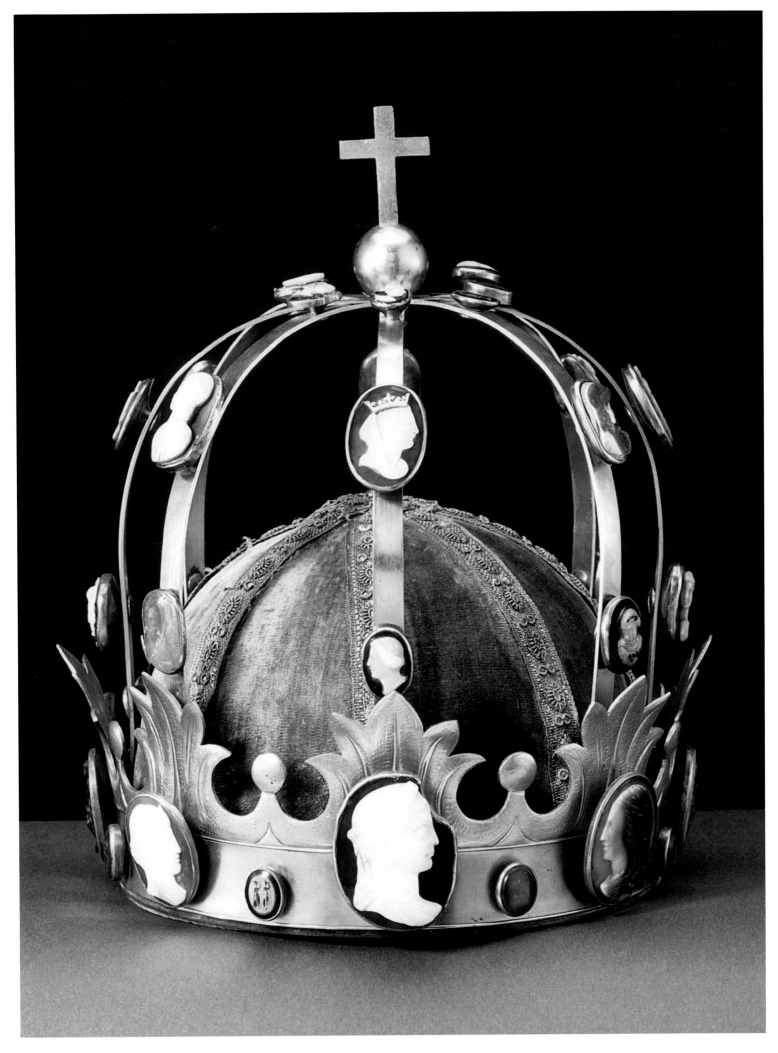

Spain

The Spanish Royal Crown is displayed – together with a crucifix, the Bible and a sceptre – during the accession ceremony of each Spanish sovereign ruler, but has never been worn or used as an actual coronation ornament. The crown shows different plates with eight heraldic emblems of the Kingdom including a three towered castle representing the Kingdom of Castile, a crowned lion representing the Kingdom of Leon, a pomegranate representing the Kingdom of Granada and *fleurs-de-lys* representing the Bourbon dynasty. This crown has also been used during funerals. It is believed to have been made in the 18th century. Some references mention the year 1775 and Fernando Velasco as the maker of this crown.

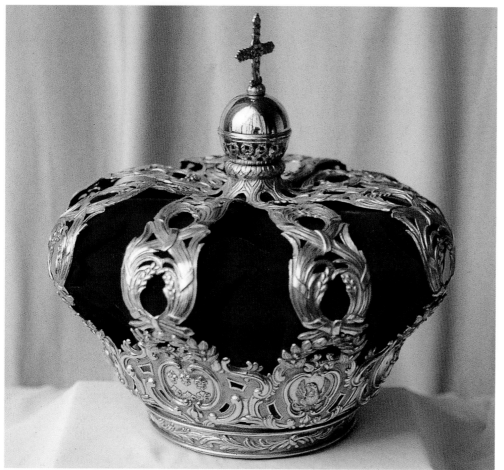

Top:
The Spanish Royal
Crown and five details of
the plates.
Collection Patrimonio
Nacional, Palacio Real,
Madrid, Spain
Photos René Brus

Bottom:
22.11.1975; inauguration
of King Juan Carlos I of
Spain and his consort
Queen Sophia.
Photo Embassy of Spain,
The Hague,
The Netherlands

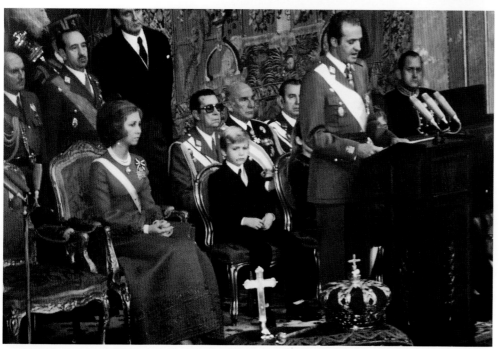

Norway

On 20 October 1814 the union between Norway and Sweden was ratified and the Swedish King Carl XIII was declared King of Norway. According to the constitution the King of Norway had to be crowned in the Nidaros Cathedral in Trondheim, however King Carl XIII died before he was crowned. His successor King Carl XIV was crowned as King of Norway on 7 September 1818. The dual kingship ended in 1905, when Norway became an independent kingdom with its own, independent ruler. King Haakon VII of Norway, born as Prince Carl of Denmark, was crowned on 22 June 1906 at Trondheim Cathedral together with his consort, Queen Maud. Two years later the article of crowning the monarch was removed from the constitution, but the two crowns still serve as symbols of the Kingdom during dynastic ceremonies, including the funeral of the ruler.

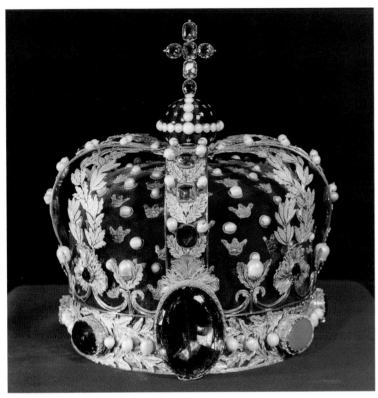

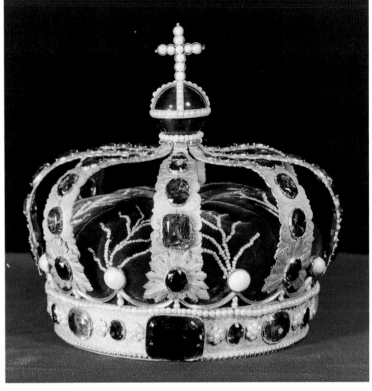

Top left:
Coronation crown of King Carl XIV of Norway. The King financed the creation with his own money and donated the crown to the Norwegian nation. Gold, pearls, tourmaline, chrysoprase, amethyst, topaz, alexandrite, emerald, opal, sapphire and enamel; made in 1818 by the Stockholm goldsmith Adolf Zethelius.
Collection Nidaros Cathedral, Trondheim, Norway
Photo Sverre Ustad, Kakonsli, Norway

Top right:
This crown was made for Queen Desideria for her coronation, which never took place as her husband King Oscar I was never crowned as King of Norway. In 1860, Queen Louise was the first Queen to be crowned with this crown during the coronation ceremony of her husband King Carl XV. Gold, amethysts, topazes, pearls and enamel; made in 1830 by the Stockholm goldsmith Erik Lundberg.
Collection Nidaros Cathedral, Trondheim, Norway
Photo Sverre Ustad, Kakonsli, Norway

Bottom:
22.6.1906; coronation of King Haakon VII and Queen Maud of Norway.
Photo collection René Brus

Nepal

Until the abolition of the monarchy in 2008, the King of Nepal had to submit himself to numerous ceremonies which were surrounded by Vedic rituals. Cows were given to Brahmin priests, prayers were made to various gods such as Indra (chief of the Vedic gods), Ganesh (the elephant-headed god) and Agni (the fire-god), and food was sacrificed in commemoration of ancestors. On his inauguration, the king also received *Indra Jatra*, the blessing of the Kumari, a virgin girl who is worshipped as a goddess and symbolises the Great Devi, the Divine Mother. According to local custom, the King of Nepal received his power to rule through the presence of the Kumari. The climax, the coronation, took place in Nepal's capital Kathmandu, in the courtyard of the centuries-old Hanuman Dhoka Palace.

At the culmination of the coronation ceremony on 24 February 1975, King Birendra Bir Bikram Shah Dev and Queen Aishwarya Rajya Laxmi Devi Shah were led to the ceremonial place (*mandap*) for ritual purification. Clarified butter kept in a golden jug, milk in an earthenware jug and water from eight rivers, also stored in an earthenware jug, were used. Four people from the traditional Hindu castes, Brahmin, Kshatriya, Vaishya and Shudra (a Brahmin, a warrior, a merchant and a labourer) sprinkled the contents of the jugs over the royal couple. Then the King was anointed with soil from a mountain, an anthill, the Vishnu temple, the Indra temple, the courtyard of the palace, an elephant's tusk, the horns of a bull, the bottom of a lake, an elephant stall, a cowshed, a stable and the wheels of a cart. This anointing signifies that the king is ruler over earth and space, and all the elements from the mountain peaks to the bottom of the sea pay homage to him.

At exactly 8.35, a time that the court astrologers deemed as the most opportune moment, the queen received her platinum tiara set with diamonds and the king his coronation crown. On top of the crown, attached to the frontal *sarpech*, towers a plume of bird of paradise feathers. According to tradition, the most valuable stone in the crown is an emerald that once belonged to Genghis Khan (a Mongolian warrior and ruler), but perhaps the most valuable 'jewels' are actually the feathers of the birds of paradise.

The coronation Crown of Nepal in its present helmet shape was probably first worn by King Rajendra Bikram Shah, who ruled the Kingdom from 1816-1847. The current decoration of numerous pearls and precious stones appeared during the reign of the young King Prithvi Bir Bikram Shah Dev (1881-1911). Some of the diamonds were described in 1956 as being '*about five eights of an inch square*', while some of the rubies glowed like fire. This crown is one of the heaviest coronation crowns in the world and is therefore removed from the king's head for several moments during long ceremonies. In 1950, the Englishwoman Erika Leuchtag, who worked at the palace in Kathmandu as physiotherapist for the first queen of King Tribhuvan, was allowed to see the crown at close quarters The king asked Mrs Leuchtag to make a fist, on which he placed the glittering ornament. Despite the fact that Mrs Leuchtag had strong muscles due to her profession, she would have dropped the crown had it not been caught by the king.

Between 1856 and 1951, the role of Prime Minister of Nepal was hereditary, and successive prime ministers underwent an investiture that was regarded, particularly in the eyes of the prime minister's powerful family, as an enthronement. As described in Chapter Military headdresses and War Booty (page 265), on 6 August 1856 King Surendra (1847-1881) was forced to cede powers to Jung Bahadur Kunwar Rana, who became the de facto ruler of Nepal. During a *durbar* on that day, the king announced to all the nobles, high government and military officials that the hereditary title of Maharaja of Lamjung and Kaski was conferred upon Jung Bahadur Kunwar Rana and his family. Jung Bahadur Kunwar Rana could not be king, but the crown he ordered was so costly and studded with so many precious stones – including diamonds, emerald and pearls – that it matched, or even outshone, the coronation crown of the King of Nepal. This valuable trinket was handed down to each succeeding prime minister until the hereditary position ended in 1951.

24.2.1975; coronation of King Birendra and Queen Aishwarya of Nepal.
Photo René Brus

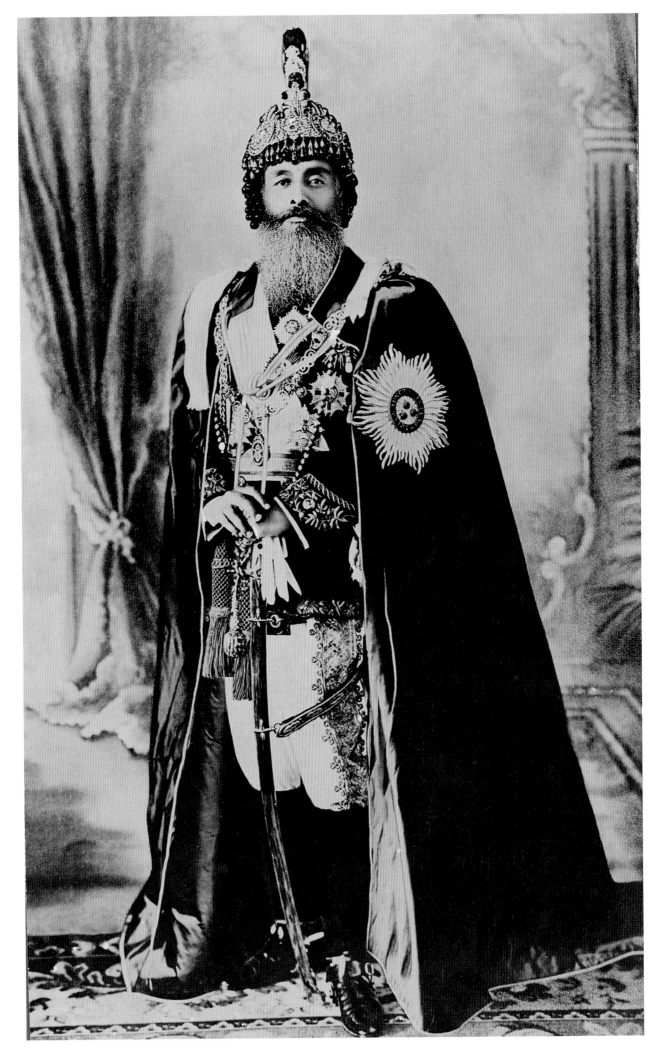

Circa 1930; Bhim Shamsher Jung Bahadur Rana, Maharaja of Lamjung and Kaski, 6th Hereditary Prime Minister of Nepal.
Photo collection René Brus

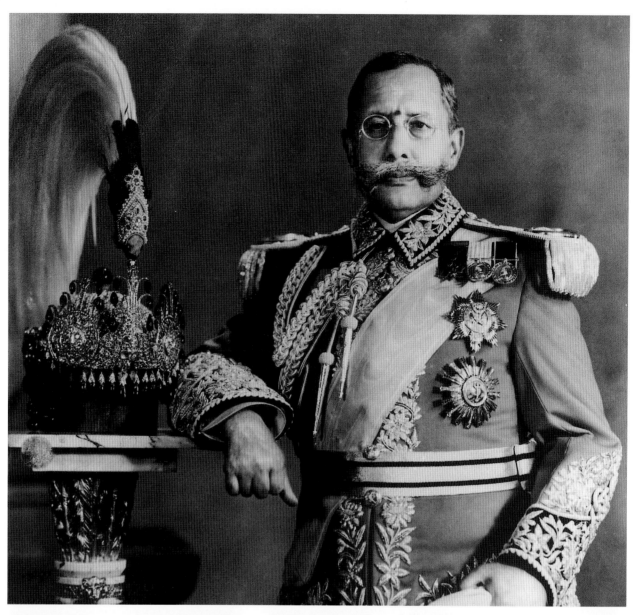

Right:
1950; Mohan Shamsher
Jang Bahadur Rana,
Maharaja of Lamjung and
Kaski, last Hereditary
Prime Minister of Nepal.
Photo collection
F. Veldkamp

Bottom left:
Before 1877; Sir Jung
Bahadur Rana, 1st
Maharaja of Lamjung
and Kaski, 1st Hereditary
Prime Minister of Nepal,
with his first wife.
Photo collection
René Brus

Bottom right:
Second half of the 19th
century; King Surendra
Bir Bikram Shah of Nepal.
Photo collection
René Brus

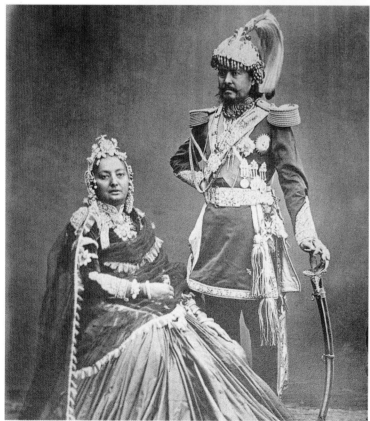

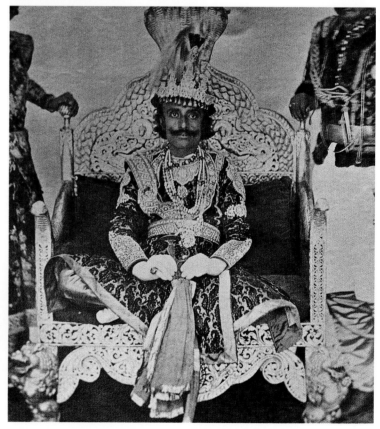

Thailand

The coronation of a Thai king includes numerous ceremonies, usually spread out over several days. One of these is the ceremonial bath of purification, during which the Brahmin high priest anoints the king with water that has been collected from the five chief rivers of the realm, the four holy ponds of Subarna and the 17 provinces. After these opening rites, the king, barefoot and dressed in a simple white robe, withdraws. He then reappears in full regal robes with a procession of Brahmin priests and the high priests of Shiva and Vishnu, and proceeds to Baisala Hall, one of the throne halls of the Grand Palace. On entering, the king sits on the fig-wood Octagonal Throne beneath the seven-tiered White Umbrella of State to receive further anointment. The eight seats of the throne face the eight zones of the realm, and after being anointed with water from an elaborately decorated conch, the king moves round the throne, sitting on each seat in turn and responding to invocations from the Pandits from each zone promising his protection. After completing the ceremony on the Octagonal Throne, the king, preceded by the priests, court chamberlains and pages bearing the regalia, moves to the Bhatthrabit Throne, which is made of gilded fig wood and is situated in the western part of the throne hall. The king sits on the Bhatthrabit Throne beneath a seven-tiered umbrella. After he has been crowned, this umbrella is replaced by a nine-tiered umbrella, the emblem of full sovereignty. The highlight of the coronation is when the king receives the Golden Tablet of Style and Title (bearing the ruler's curriculum vitae) from the high priest of Shiva, followed by the offering of the *Phra Maha Pichai Mongkut*, or *Phra Maha Mongkut*, which is literally the Great Crown of Victory. In accordance with Thai custom, the king places this crown on his own head.

The coronation crown of Thailand weighs 7.3 kilograms and was made during the reign of Rama I. The expert goldsmiths who created this heavy ornament decorated it with enamel and diamonds. The largest diamond, set at the pinnacle of the crown, was purchased in India, in the city of Calcutta, during the reign of King Rama IV, who ruled between 1851 and 1868. This diamond, in an old-fashion India cut and gives the Thai coronation crown its other name, *Pramaha Vichien Mani* or '*the Greatest of All Crystals.*' In 1855, Sir John Bowring, Governor of Hong Kong from 1854 to 1859, mentions seeing the diamond during a visit to Thailand. On 17 April 1855, King Rama IV asked the Englishman if he wanted to see the Royal Crown Jewels '*and sent one of the nobles for the crown in which he had been crowned and which, he said, had been that of His Royal grandfather.*' Sir John described the crown as '*of pyramidical shape, and weighs about four pounds. It is covered with beautiful diamonds, the one at the top being of enormous size and extraordinary splendour; two flaps or wings of gold with diamonds descended by the side of the ears and the crown is tied under the chin.*'

The Betelnut Set.
Made circa 1782.
All items are from the
collection of the
King of Thailand
Photos René Brus

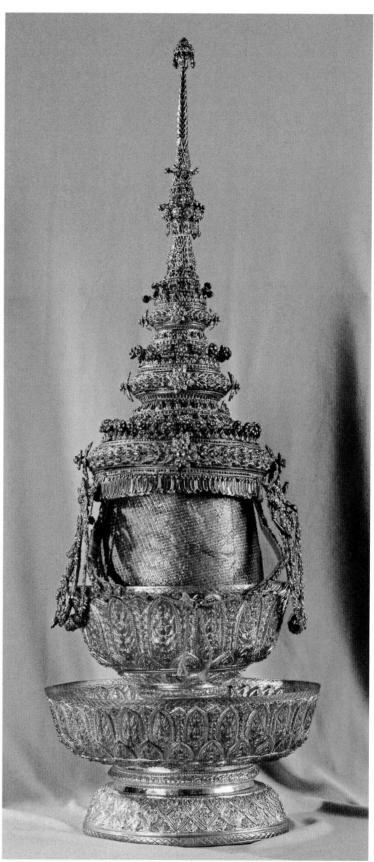

Top left:
Royal Fan and Fly Whisk.
The Fan dates from circa
1782 and the Fly Whisk
was made in the
mid-19th century.
Gold, diamonds, enamel,
talipot palm leaf and tail
of a white elephant.
Collection the King of
Thailand
Photo René Brus

Middle left:
Royal Slippers. Gold,
diamonds and enamel;
made circa 1782.
Collection the King of
Thailand
Photo René Brus

Bottom left:
The Libation Vessel.
Made circa 1782.
Collection the King of
Thailand
Photo René Brus

Right:
The royal regalia, the
royal utensils and the
eight royal weapons of
sovereignty, comprising
a total of 28 items, are
traditionally presented
to the King of Thailand at
his coronation ceremony.
Each ornament has a
unique symbolism. The
coronation crown of
Thailand is generally
referred to as the *Phra
Maha Pichai Mongkut*
or the Great Crown of
Victory. Gold, diamonds,
enamel; made circa 1782.
Collection the King of
Thailand
Photo René Brus

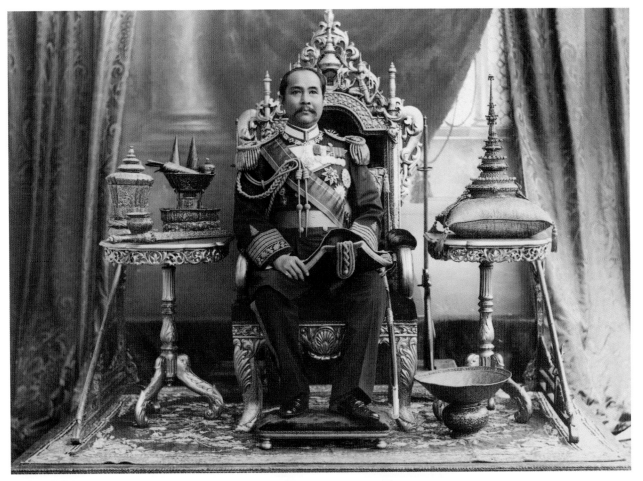

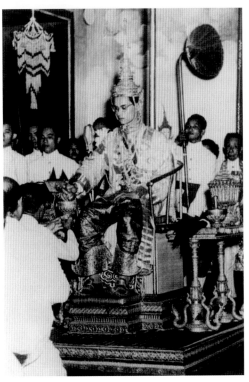

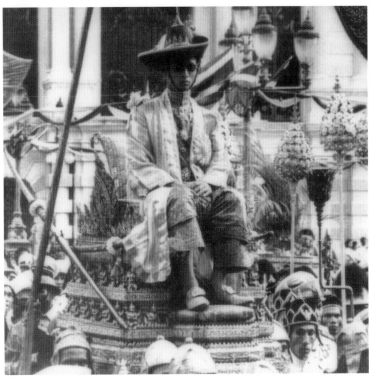

Tonga

The Lord of Tonga (Tui Tonga) ruled some 150 islands and was believed to be descended from the God Tangaloa. He was considered a spiritual monarch and during his reign other kings of a more temporal and temporary nature, the Tu'i Kanokupolu and Tu'i Ha'atakalaua, actually ran the Kingdom. These separate regimes were brought together under King George Tupou I, known as Taufa'ahau Tupou until he was baptised as a Christian in 1831. In 1844, England offered to become the 'Protector' of the Kingdom of Tonga, and elements of European protocol became incorporated into the royal court. Several old traditions were discarded as a result, but some were retained, in particular those connected with the succession of a new monarch. The most important of these is undoubtedly the 'kava' ceremony. Kava is a drink prepared by partially digesting (by chewing) and fermenting a pulp of kava (*Piper methysticum*) roots. During the ceremony, chiefs and members of the nobility sit in a circle, each placed according to his rank. The Master of Ceremonies offers cups containing kava and, after drinking it, those present speak the new king's title for the first time.

During the second part of the 19th century, two golden crowns arrived in Tonga, most likely ordered by King George Tupou II, one for himself and one for his consort, Queen Lavinia Veiongo. It is believed that the king's grandson, Uelingatoni Ngu Tupoumalohi, was responsible for the designs of both crowns as he has also designed the royal standard, coat of arms and the national flag of Tonga.

Up until the 1960s, centuries-old royal heirlooms were still used during important functions. For instance the *ta'ovala*, a dress made of bark cloth wrapped around the waist, which had been worn during each king's inauguration for some 600 years. In 1967, during preparations for the coronation of King Taufa'ahau Tupou IV and his wife, Queen Halaevalu Mata'aho, it was decided that they would wear velvet coronation robes trimmed with ermine. These were supplied by the London-based tailors Gieves, and 300 pelts from Canada and Russia were used to make the ermine trims.

The coronation ceremony was planned by a committee consisting of the British Representative and Consul in Tonga, Mr A. C. Reid, Male Tonga, the secretary to the Privy Council, Baron Vaea, one of the paramount chiefs, and Mr George C. Harris, the royal chaplain. The committee decided to use the 1953 coronation of Queen Elizabeth II of England as a guideline, and so the ceremony included the anointing of the king and queen, placing a coronation ring on the king's finger and the crowning of the royal couple. As the royal chaplain placed the crown on the king's head, he spoke the words '*God crown you with a crown of glory and righteousness, that having a right faith and manifold fruit of good works, you may obtain the crown of an everlasting kingdom by the gift of Him whose kingdom endureth for ever.*'

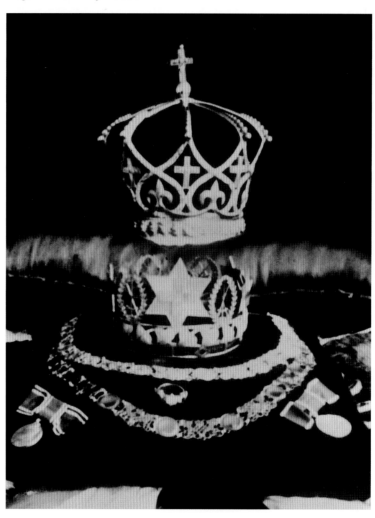

Regalia of the Kingdom of Tonga. Made second half of the 19th century.
Photo from the book *Queen Salote and her Kingdom* by Sir Harry Luke

Opposite page:
4.7.1967; coronation of King Taufa'ahau Tupou IV and Queen Halaevalu Mata'aho of Tonga.
Photo the Royal Palace, Nuku'alofa, Tonga

Hawaii

Ancient Hawaiian customs decree that no human hand or even its shadow should pass across the head of the ruler of Hawaii, with the penalty being death. Discussions held in the Hawaiian House of Parliament on 9 August 1880 to decide if King David Kalakaua and his Queen Kapiolani should be crowned agreed that nobody in the Kingdom could crown the monarch other than himself, and that the monarch should crown his spouse.

In earlier times, Hawaiian kings had been inducted using an extremely valuable feather cloak made of minute feathers from the oo and iiwi birds. The cloak was made from tail feathers and extremely rare wing feathers, of which only two grow each year. During the 19th century, the Kingdom of Hawaii came into increasing contact with western culture, and an 1880 parliament debate saw Hawaiian Prime Minister Walter M. Gibson declare that crowning King Kalakaua with a pure golden crown studded with gemstones would make the Kingdom more civilised in the eyes of '*all the nations in the world.*' The crowns for the king and queen were not made from pure gold; the king's is 18-carat gold and that of the queen

– identical in shape but slightly smaller – is 15-carat gold. But the two crowns were splendidly set with gemstones, the king's crown having one large brilliant-cut diamond of 6 carats and 561 other diamonds, 20 opals, 8 emeralds, 8 rubies, 1 spinel and 54 pearls. Although the crowns are western in shape, having arches and a globe with a cross on the top, the decoration contains Hawaiian features. The eight arches that rise from the headband represent the eight islands of the Kingdom, and are fixed to *taro* leaves, one of the most ancient and honoured symbols of chiefly power in Hawaii, signifying the *alii* as the staff of life of their people. Including *taro* leaves showed that King Kalakaua traced his geneaology back to the very origins of the Hawaiian people. Both crowns were made by Sigmond Hoffnung, the owner of a flourishing trade and jewellery company based in London. Hoffnung was the brother of Abraham Hoffnung, the Hawaiian ambassador to England. The total cost of making the two crowns, one ring, one sceptre and invitation cards for the coronation was £1,472.19.4.

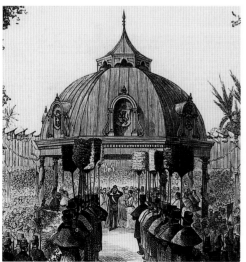

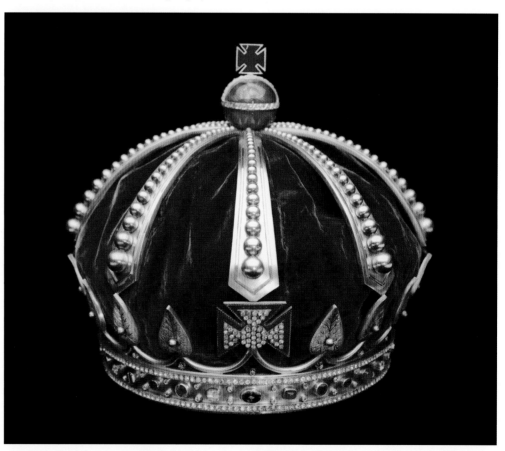

Top left:
Circa 1885; King David Kalakaua of Hawaii
Photo Public Archives, 'Iolani Palace grounds, Honolulu, Hawaii

Bottom left:
12.2.1883; coronation of King Kalakaua and Queen Kapiolani of Hawaii, the garlanded pavilion which was specially erected in front of the 'Iolani Royal Palace.
Photo collection René Brus

Right:
Crown of King Kalakaua. Gold, originally set with different precious stones; made by Sigmond Hoffnung, London in 1882-83.

Collection Bishop Museum, Honolulu, USA
Photo by Christine Takata, Bishop Museum, Honolulu, USA

The coronation ritual was drawn up by the King in consultation with his courtiers and the Anglican clergy. It was decided that all the coronation emblems, such as the royal feather cloak, tabu sticks, sceptre and ring, would be carried by members of the royal family. Princes Kawananakoa and Kalanianaole carried the two crowns. The ceremony took place on 12 February 1883, and was attended by a large number of diplomats. The American consul, Mr Rollin M. Dagget, wrote an eyewitness account to his superiors, '*Their Majesties King Kalakaua and Queen Kapiolani were crowned about 12 to-day, in the presence of between 4,000 and 5,000 persons. The ceremonies were quite imposing. The coronation took place in a pavilion in front of the Palace. The King placed the crown on his own head, and then crowned the Queen. All is quiet.*' But not for long. King Kalakaua died in 1891 and his sister Lili'uokalani succeeded him, and many American planters feared that they would lose their privileges. In 1893 the Queen was deposed and Hawaii declared a republic, with Sanford B. Dole as President.

Mary H. Kraut, an English reporter, visited the deserted royal palace on 4 March 1893, as she wrote in her book '*Hawaii and a Revolution*'. She was allowed to inspect the former royal regalia of Hawaii, including the two crowns. A month later Mary Kraut was asked by a former chief of police if she had seen the crown of the late king and if it, according to her judgement, was a valuable one. Miss Kraut replied that the diamonds had not impressed her very much, although the opals and rubies appeared to be of good quality. The reason for this enquiry was that the king's crown was stolen on the night of 2 April 1893. Three months later the thief, George Ryan, who had served as a palace guard, was arrested. He had taken the precious stones out of the crown and generously distributed them among his friends and family. The king's crown was restored with semi-precious stones and glass and, although it was the property of the State of Hawaii, placed in 1936 in the Bernice Pauahi Bishop Museum, a memorial to the last 'ali'i' of the the Kamehameha royal dynasty, together with the queen's crown and other regalia.

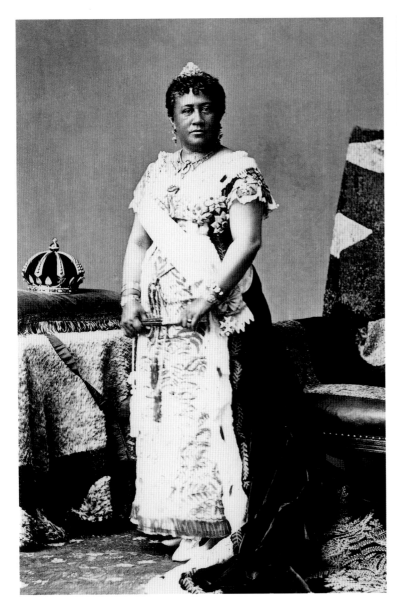

Left:
Circa 1885; Queen
Kapiolani of Hawaii.
Photo Public Archives,
'Iolani Palace grounds,
Honolulu, Hawaii

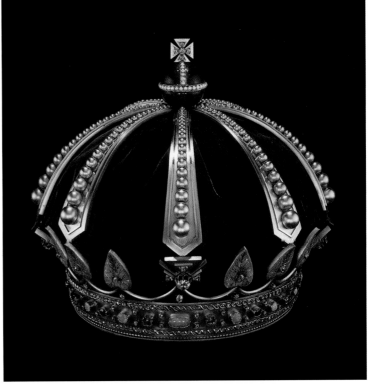

Right:
Crown of Queen
Kapiolani of Hawaii.
Gold, diamonds,
emeralds, rubies, opals
and pearls; made in
1882-83.
Collection and photo
Bishop Museum,
Honolulu, Hawaii

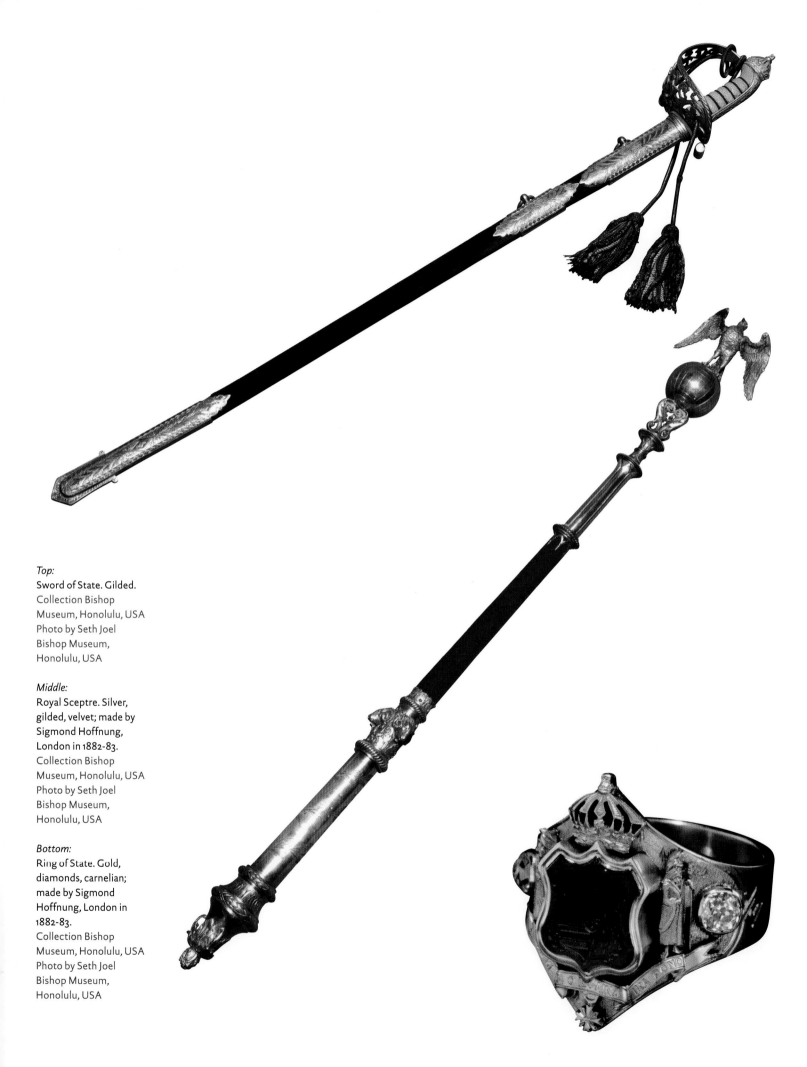

Top:
Sword of State. Gilded.
Collection Bishop
Museum, Honolulu, USA
Photo by Seth Joel
Bishop Museum,
Honolulu, USA

Middle:
Royal Sceptre. Silver,
gilded, velvet; made by
Sigmond Hoffnung,
London in 1882-83.
Collection Bishop
Museum, Honolulu, USA
Photo by Seth Joel
Bishop Museum,
Honolulu, USA

Bottom:
Ring of State. Gold,
diamonds, carnelian;
made by Sigmond
Hoffnung, London in
1882-83.
Collection Bishop
Museum, Honolulu, USA
Photo by Seth Joel
Bishop Museum,
Honolulu, USA

Crowns as gifts

Headdresses, crowns and tiaras are not merely valuable objects, but are seen in several societies as the most impressive gift imaginable. The presentation of such a valuable object has been seen by some monarchs as the equivalent of granting a medal for meritorious service or as a diplomatic gesture to sovereigns of other countries. Presenting a crown to a fellow ruler also served to display the skills and workmanship of the country's culture and craftsmen. When a crown was given to a vassal state, it might be seen as a kind of peace offering, although sometimes the recipient regarded this gesture as raising them in rank.

In the 19th and 20th centuries, it became fashionable to present spectacular tiaras to female members of the European monarchies, in particular to mark dynastic events such as a wedding or an enthronement. The intended recipient would be contacted to see if such a valuable present would be accepted; this would be followed by a consultation to determine her preferred design. The cost of these tiaras was substantial because, not surprisingly, they were made from precious metals and set with valuable gemstones such as diamonds, so donations were collected to cover the expense. When the fundraising for such a precious tiara was nationwide, one might expect that the piece would be kept as a token of the nation's humble appreciation. However, many such tiaras were regarded as private property and seldom kept for the nation for the use of future queens. In some cases, the tiara was altered or dismantled after a while because its design, shape or weight were not appreciated by the recipient. In other cases, the end of a monarchy saw the tiara become part of the possessions of the deposed or exiled dynasty, and frequently sold when its monetary value was considered to be more important than its historical value.

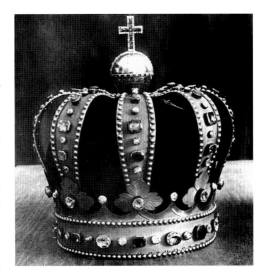

Crown of King George XII of Georgia, who ruled from 1798 until 1800. This crown was a gift from Emperor Paul I of Russia. After Georgia lost its independence to Russia in the beginning of the 19th century, this crown was deposited in the Armoury Museum in the Kremlin of Moscow. On the 6 February 1923 the crown was returned to Georgia. On 23 April 1930 the crown was brought back to the Kremlin again on the orders of the Soviet authorities. Rumours have it that the crown was dismantled, or that it was purchased by one of the founders of Shell, Henri W. A. Deterding. Gold, diamonds, rubies, emeralds and amethysts; made by Nathanael Licht and the brothers Pierre and François-Claude Théremin.
Photo collection René Brus

England

In 1888 the Prince of Wales, later King Edward VII, and Princess Alexandra celebrated their silver wedding anniversary. The peeresses of the United Kingdom decided that a diamond tiara was an appropriate gift for the future queen. After consultation with the Princess of Wales, it became clear that she would be extremely pleased if the piece was made in the then fashionable *kokoshnik* style, similar to a tiara owned by her sister, the Empress of Russia. Garrard was appointed to craft the tiara. Sixty-one platinum bars graduating from the centre were encrusted with 488 diamonds and the two largest were 3.25 carats each. On 10 March 1888, the Princess of Wales received the tiara from the Marchioness of Salisbury, together with an album signed by 365 peeresses. It was '*a lovely diamond spiked tiara*' according to Princess May, the daughter-in-law of the Princess of Wales and future Queen Mary, in a letter to her aunt the Grand Duchess Augusta of Mecklenburg-Strelitz, while the correspondent of the *Times* newspaper regarded the tiara as being '*in the form of the simple old Roman coronet*'. In 1925, this tiara was inherited by Queen Mary, who in turn bequeathed it in 1953 to her granddaughter, Queen Elizabeth II.

Upon her wedding in 1947, Queen Elizabeth II received numerous gifts in the form of jewellery. The Nizam of Hyderabad, Mir Osman Ali Khan, gave a platinum tiara with roses and foliage, a style typical of the early 19th century. This tiara had been in stock at Cartier's in London in 1939, but it is not known whether the Nizam bought it then to add it to his extensive jewellery collection, or bought it in 1947 as a wedding gift. Nizam Mir Osman Ali Khan, who died 24 February 1967, was one of the world's richest men in his time.

The large central rose and the two slightly smaller roses at the sides of the tiara are detachable and can be worn independently as brooches. These three diamond roses have remained in their original setting, but in 1973 Queen Elizabeth II decided to use the remaining diamonds from this tiara for a new one, to be made by Garrard. The new tiara included Burmese rubies from a golden necklace that she had received as a wedding gift from the Burmese government. This necklace contained 96 rubies, a number significant in Burmese tradition as there are 96 diseases that can affect the human body. Using 96 rubies in the wedding gift symbolised a charm against illnesses so that '*the recipient will be as impervious to the ninety-six diseases as is the lotus leaf to water.*'

Queen Elizabeth II has several tiaras to wear on grand occasions and one, set with diamonds and large aquamarines, is not a family heirloom, but a gift from Brazil. For the occasion of her coronation in 1953, the President and people of Brazil presented her with a necklace and matching earrings, set with diamonds and aquamarines. It had taken an entire year to collect the perfectly matched sea-blue stones. The queen at first had a relatively simple tiara made by Garrard's to wear with this jewellery, but she received a V-shaped 'hair ornament' from the Governor of São Paulo during her first state visit to Brazil in 1968, and both pieces were incorporated into a new tiara in 1971 by the craftsman Henry J. Phillips of Garrard.

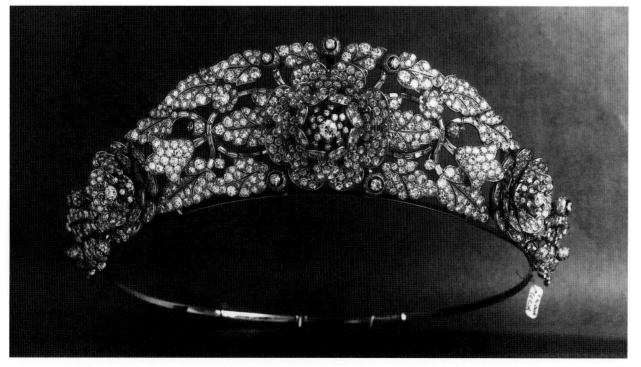

Tiara given to Queen Elizabeth II of England by Nizam Mir Osman Ali Khan of Hyderabad as a wedding present in 1947. Platinum and diamonds; made 1930s. The tiara has been dismantled and parts reused.
Collection Queen Elizabeth II
Photo Cartier, London, England

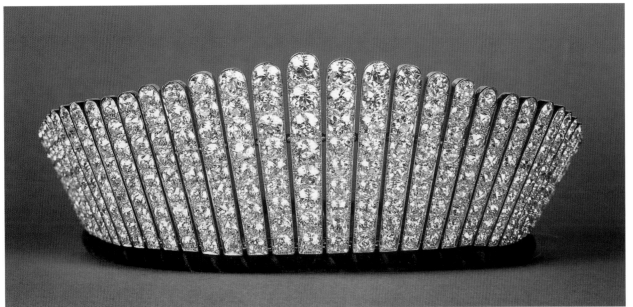

Tiara given to Alexandra, Princess of Wales by the 'peeresses of England' on 10 March 1888 to mark her silver wedding celebrations. Gold, silver and diamonds; made in 1888.
Collection
Queen Elizabeth II
Photo Press Office, Buckingham Palace, London, by gracious permission of
Her Majesty
Queen Elizabeth II

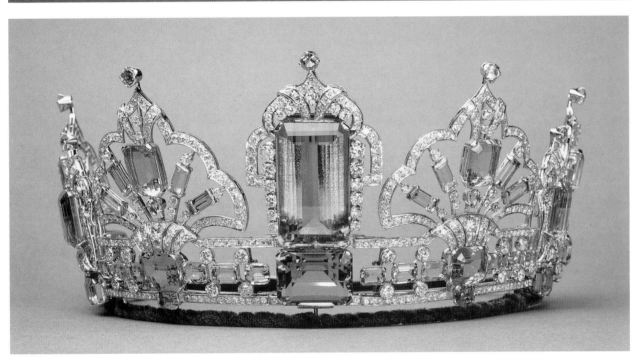

Front and back view of tiara of Queen Elizabeth II using stones which were given to her in 1953 by the President and people of Brazil, and in 1968 by the Governor of São Paulo. Platinum, diamonds and aquamarines; made in 1971.
Collection
Queen Elizabeth II
Photo Press Office, Buckingham Palace, London, by gracious permission of
Her Majesty
Queen Elizabeth II

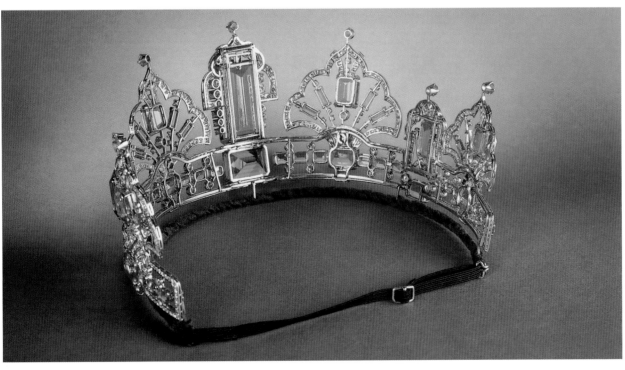

Crowns and tiaras given as gifts are not always worn, sometimes because the design or choice of material is not to the taste of the recipient, and sometimes because the piece is not intended to be worn but is presented to demonstrate the arts and crafts of the country of origin. The latter was certainly the case for a crown intended as a gift from the Queen of Shoa to Queen Victoria. The crown was received on Queen Victoria's behalf by the Englishman and traveller Captain William Cornwallis Harris, at a ceremony in the palace of the King Sahle Selassie and Queen of Shoa in southern Abyssinia (Ethiopia) in 1843. When Harris returned to England, he delivered the crown and other gifts to Queen Victoria. *The Illustrated London News* of 2 September 1843 reported that '*Many of the ornaments that we saw do eminent credit to the taste and invention of the savage.*'

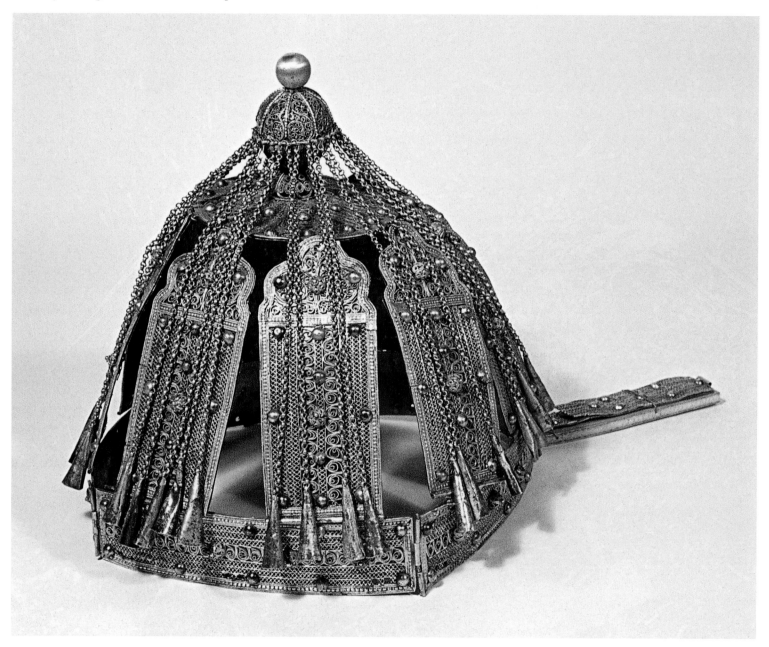

Crown given to Queen
Victoria of England by
the Queen of Shoa in
1843. Gilded silver;
made circa 1843.
Collection The Royal
Collection Trust/
Windsor Castle, England
Photo The Lord
Chamberlain's Office,
London, England

Members of the English Royal Family have been given countless presents over the past 150 years, some of which include precious stones and are quite valuable. For instance, the Prince of Wales (later King Edward VII) visited India in 1876, and on 7 January entered the throne room of the Kaiserbagh, the former palace of the Kings of Oudh in Lucknow, where the noblemen of Oudh, the *Taluqdars*, presented him with a jewelled head-piece. This turban-shaped crown has eight jewelled gold tapering semi-arches over a velvet cap, and at the point where these arches meet is set a rosette of diamonds combined with enamelling, emeralds and pearls. That this crown was specially made for the Prince of Wales is shown from the inclusion of his motto *Ich Dien* (I serve), which is embroidered on the cap below the royal arms, and the Garter motto *Honi soit qui mal y pense* (Old French for *shame on him who thinks evil of it*).

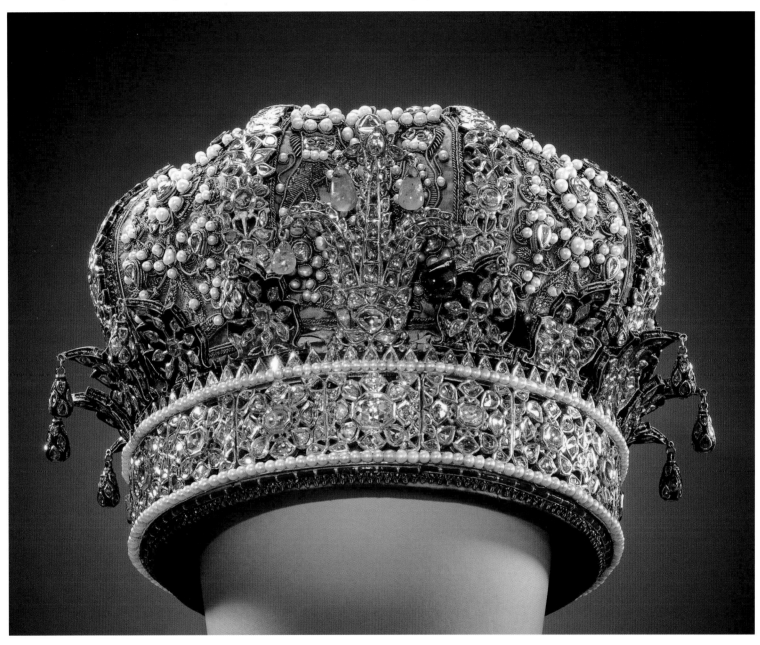

Crown given to the Prince of Wales by the *Taluqdars* of Oudh, in 1875. Gold, enamels, pearls, diamonds, emeralds and embroidery; made circa 1875.

Collection The Royal Collection Trust/ Windsor Castle, England Photo Royal Collection Enterprises, Windsor Castle circa 2004, by gracious permission of Her Majesty Queen Elizabeth II

Some crowns given as presents have actually been worn by the recipients, like the one given by King Charles II of England (1660-1685) to the Dowager Queen Anne of the Pamunkey Indians around the year 1671. It was not a particularly valuable piece, consisting of a red velvet cap with a silver plate as a frontlet, to which were attached many chains. This crown, accepted by the dowager queen and worn with pride, was sent in recognition of her husband's service to the Kingdom – Totopotomoi had been killed fighting with the English under Colonel Edward Hill. In 1800, when parts of the United States were still struggling to be joined under one flag, the Pamunkeys were determined to move westwards. They were given shelter and protection by a farmer, Arthur Alexander Morson, and upon leaving, expressed their gratitude by presenting Mr Morson with the crown of Charles II, still in its original shape and their

greatest treasure. Over the years, the velvet cap became moth-eaten and the chains lost and scattered. Eventually only the frontlet remained, and it was acquired by the Association for the Preservation of Virginia Antiquities.

In the days when travel was time-consuming, gifts from one monarch to another in a faraway land sometimes did not reach the intended recipient in time for the occasion the gift was intended to honour. This was certainly the case for the crown sent by the government of England through the London Missionary Society to King Pomare II of Tahiti in 1824. King Pomare II died that same year, leaving his four-year-old son to inherit the throne as King Pomare III. The crown, with its diameter of 19.5 cm, was clearly not meant to be worn on the head of a child.

Left:
Silver frontlet of a crown given to the Dowager Queen of the Pamunkey by King Charles II of England circa 1671.
Collection and photo Association for the Preservation of Virginia Antiquities, Richmond, USA

Right:
Coronation crown of King Pomare III of Tahiti. Gilded silver; made 1823 or 1824.
Collection and photo Musée de Tahiti et ses îles, Punaauia, Tahiti

The Netherlands

Over the past 150 years, the Dutch people have presented various pieces of valuable jewellery to members of the Dutch Royal Family. On 7 March 1901, one month after her marriage to Duke Hendrik of Mecklenburg-Schwerin, a *parure* – a set of jewellery comprising a tiara, a necklace and two bracelets – was offered to Queen Wilhelmina as a wedding present. The *parure* was to be made by the Amsterdam jeweller Hoeting, using diamonds and sapphires obtained by the Amsterdam diamond broker E. Vita Israël, but not all the stones had been obtained by the time of the presentation. Instead, the queen was presented with a large book containing the signatures of the thousands of people who had contributed money towards the gift, and detailed drawings of the jewellery. Later that year, the first photos of Queen Wilhelmina were taken, in which she appears wearing the dazzling new jewels. The necklace had a large brilliant in the centre of the '*purest water*'. The tiara had in its centre a brilliant from the old Golconda mines in India, as large as '*the egg of a pigeon and pure as a dewdrop.*' These jewels had great sentimental value for Queen Wilhelmina and she was photographed wearing them several times during her 50-year reign. Unfortunately, her daughter and successor Queen Juliana did not keep the tiara, perhaps because it appeared to be rather uncomfortable. After the death of Queen Wilhelmina, the tiara was dismantled, the diamonds and sapphires used in new pieces of jewellery and the gold frame given as part-payment to the jeweller, who after a few years decided to melt the tiara frame down and reuse the gold for new jewellery.

Another tiara given to Queen Wilhelmina is also no longer used in its original shape. Since her granddaughter Queen Beatrix ascended the throne in 1980, parts of this tiara have usually been worn as brooches. When Queen Wilhelmina reached her constitutional majority at the age of 18 in 1898, she was formally inaugurated as queen. This was an occasion of much importance, even for the inhabitants of her colony, the Dutch East Indies. The government invited delegations from the local ruling houses to attend the ceremony in Amsterdam, and Sultan Aji Mohammad Sulaiman of Kutai decided that his delegation should present his 'overlord' with a jewel of local craftsmanship. In May 1898, Mr A. J. A. F. Eerdmans, representing the sultan, entered the jewellery shop of Van Arcken & Co in Batavia (now Jakarta) and poured gold and a number of valuable diamonds onto the counter, along with the request that these materials be used for the new tiara.

At the request of the sultan, the tiara was designed based on a headdress depicted on a Hindu statue that originated from the Prambanan, a famous temple on the island of Java. The gold and diamonds came from the treasury of the sultan and had been found on Borneo. The Sundanese goldsmiths working with the jeweller constructed three large, triangular ornaments which contained the largest diamonds, and which could not only be set on the headband, or double *bandeaux grecs* as they were referred to, but could also be worn on tortoiseshell combs. Since the Sultan of Kutai did not attend the inauguration of Queen Wilhelmina, his valuable gift was presented a few days before the ceremony by two princes from his family, Mangku Negoro and Sosro Negoro, at the Noordeinde Palace in The Hague.

Tiara given to Queen Wilhelmina of The Netherlands by Sultan Aji Mohammad Sulaiman of Kutai in 1898. Gold and diamonds; made in 1898. The three triangular-shaped parts of this tiara are part of the collection of the House of Oranje-Nassau
Photo collection René Brus

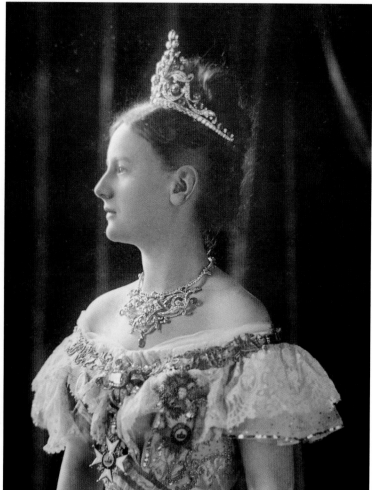

Queen Wilhelmina
of The Netherlands
photographed in 1901
wearing the diamond and
sapphire *parure* which
she received that year as
a wedding gift from the
Dutch people.
Photo collection
René Brus

Opposite page:
Drawing of the *parure*,
consisting of a tiara,
two bracelets and a
necklace, given to
Queen Wilhelmina of
The Netherlands in 1901.
Photo collection
René Brus

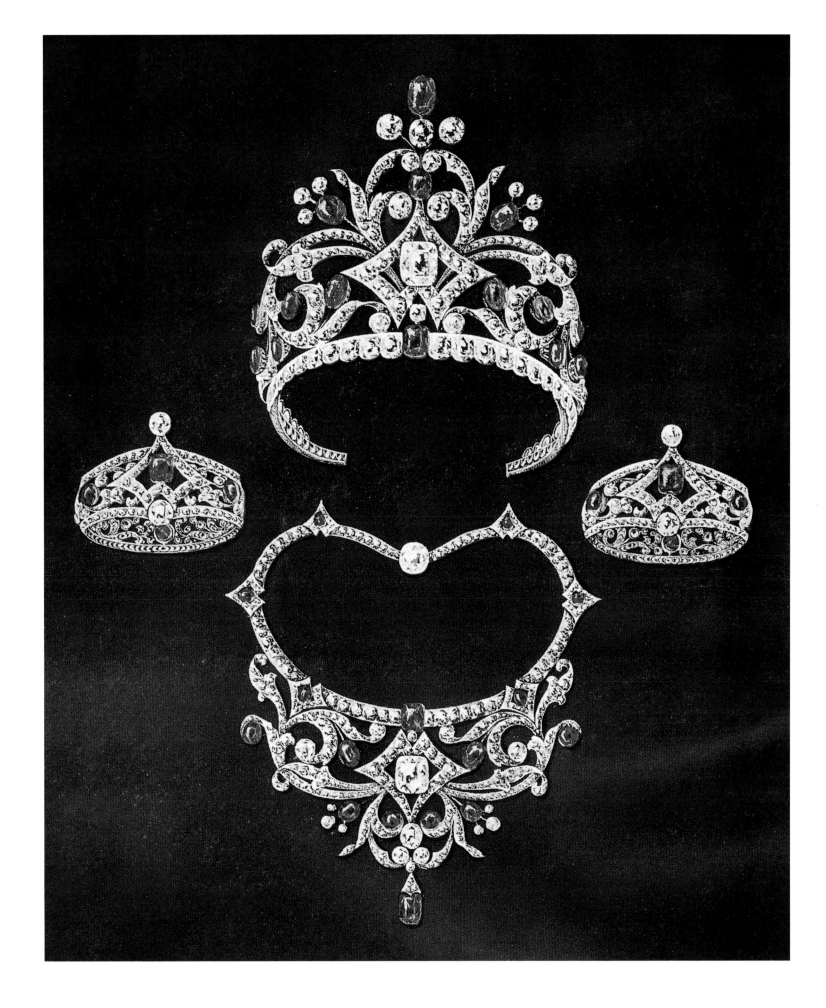

Belgium

A diamond-set tiara was given to Queen Marie-Henriette of Belgium on the occasion of her silver wedding anniversary with King Leopold II. On 22 August 1878, Mrs Anspach, the wife of the Mayor of Brussels, presented the tiara to the queen at the town hall of the Belgian capital on behalf of the 'Ladies of Brussels'. The tiara was made by the jeweller M. Buls in the shape of a diamond headband containing 106 very large stones upon which five diamond-studded (rose and brilliant-cut) ostrich feathers were placed. The largest diamond was 23 carats and valued at the time at 45,000 francs; another stone of 3 carats was the gift of Baron Morpurgo. Before this magnificent tiara was presented to the queen, it was on public display at the town hall, from 19-22 August 1878.

After the death of Queen Marie-Henriette in 1902, her three daughters, Louise, Stéphanie and Clémentine, inherited her jewellery. In 1907, the late queen's jewellery, including her silver wedding tiara, was put up for sale in order to raise funds to pay off the creditors of the Princesses Louise and Stéphanie. In November that year, the princesses applied to the Court for an injunction, as they hoped to be able to pay their debts, and the sale was postponed until 28 November. The creditors' lawsuit aiming to oblige the king to pay the sums due had failed, and instead they had placed a lien on the legacy to be sold publicly, as was normal practice in Brussels. It was hoped that the king would pay up to avoid a scandal, but King Leopold II refused to purchase the late queen's jewellery at the experts' valuation of £9,200. The following year, the public sale had still not taken place and what happened to the tiara of Queen Marie-Henriette remains a mystery today.

Left:
Jewellery of Queen Marie-Henriette photographed in 1902, including the tiara which was a silver wedding gift to the queen from the 'Ladies of Brussels' on 22 August 1878. Gold, silver and diamonds; made in 1878. The present whereabouts of the tiara is unknown

Right:
Painting by Emile Delpérée depicting the official presentation of the diamond-studded tiara to Queen Marie Henriette of Belgium by a deputation of the Ladies of Brussels. Collection and photo de la Communauté française de Belgique en dépôt au Musée de l'Art Wallon de la Ville de Liège, Belgium

Liechtenstein

The Austrian archdukes were in a position to grant titles to others, and it was Archduke Matthias who raised Fürst or Prince Karl von Liechtenstein, who had acquired the dukedom of Troppau, to the status of sovereign ruler in 1608. With this new and higher position, Prince Karl needed emblems of sovereignty and thus in 1623 he ordered a ducal crown from Daniel de Briers, a goldsmith who worked in Frankfurt am Main. This bejewelled crown, which was decorated with colourful enamels according to the tradition of the time, was delivered to the prince in 1626, and after his death in 1627 it was taken to the Liechtenstein Palace in Vienna. After the death of Prince Josef Wenzel in 1772, the crown could not be found by his heirs. Its only reminder is a picture executed in colour on parchment dating from 1756.

Two hundred years later, the Government of the Principality of Liechtenstein decided that their ruler, Fürst Franz Josef II, should be presented with a symbol of sovereignty to mark his 70th birthday. A copy of the lost ducal hat of Liechtenstein was created, using the 1756 drawing as a model. While this 20th-century crown is considerably less valuable than the original, since it was made of silver-gilt, and set with cultured pearls and synthetic stones, the Government and people of Liechtenstein accorded it great symbolic value. The new crown was presented to their beloved sovereign Prince Franz Josef II by the mayor of Vaduz, Himar Ospelt, on 13 August 1976.

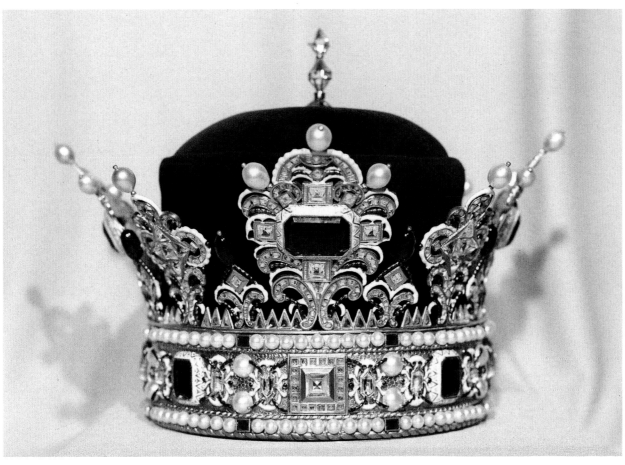

Top:
Replica of the *Herzogshut* of Liechtenstein. Gilded silver, copper, cultured pearls, synthetic spinels and rubies, enamel; made in 1976 by the Zurich jeweller Meister, Switzerland.
Collection Liechtensteinisches Landesmuseum, Vaduz, Liechtenstein
Photo René Brus

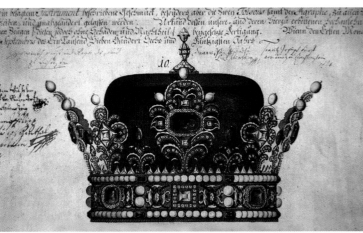

Bottom:
Drawing of the lost *Herzogshut* of Liechtenstein.
Collection the Prince von und zu Liechtenstein
Photo René Brus

Thailand

In an explanatory note on the royal utensils at the Royal Palace in the Thai capital Bangkok, it is mentioned that crowns known as *Chada* were usually made to the order of the king. These were granted to the *Uparaja*, generally the king's brother, to the princes of vassal states who had performed significant service or to sovereigns of faraway countries for diplomatic purposes. Through the centuries a number of such crowns have been made. In 1511 a crown, a ruby ring and a sword of gold were sent to King Manuel I, who ruled Portugal from 1495–1521. The exchange of such gifts continued during the Chakri dynasty (the present royal dynasty of Thailand). In 1794, King Rama I accorded Prince Ang Eng of neighbouring Cambodia with equal honours, and upon receiving a crown, the prince was styled King Narai Rama Tibodi. The son of King Ang Eng, the 15-year-old Prince Ang Chan, was crowned in 1806 by his overlord King Rama I of Thailand. In 1848 Prince Ang Duong received a crown for his coronation from King Rama III of Thailand.

In 1855, the British government sent Sir John Bowring, the British Governor of Hong Kong, to Siam (Thailand) as the envoy of Queen Victoria. Sir John Bowring left us a colourful narrative of his mission, including a description of how King Mongkut Rama IV consulted him about gifts the monarch intended to send to Queen Victoria. Although the king was thinking of sending her a royal crown, he mentioned that the necessary jewels were too expensive for the royal coffers. The governor replied that Her Majesty would be far better pleased with a different and less costly sign of his regard, in the shape of some Siamese craft items. Nevertheless, on 19 November 1857, Queen Victoria received the Thai crown. She wrote in her private journals that the ambassador Phya Montrisuriyawong brought a '*beautifully crafted replica of the Thai coronation crown*' as well as other valuable, gem-studded golden gifts.

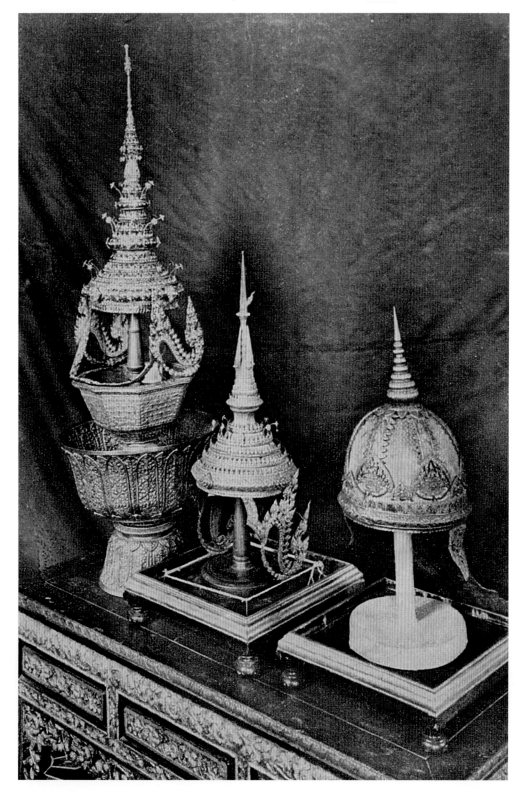

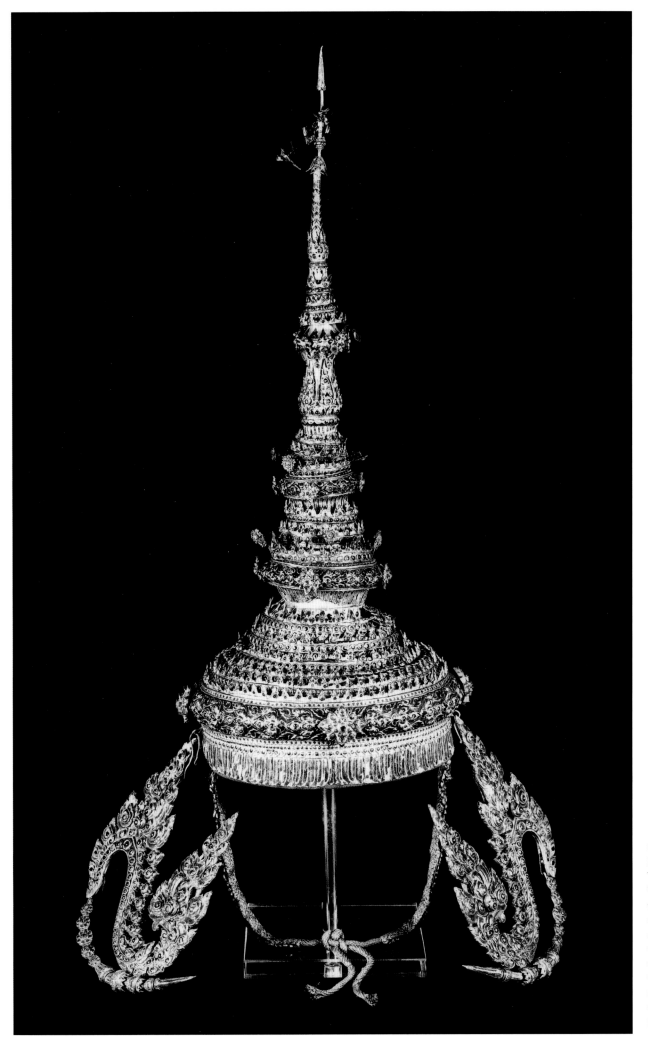

Crown given by King Mongkut Rama IV of Thailand to Queen Victoria of England on 19 November 1857. Gold, diamonds and rubies, enamel; made in 1857.
Collection The Royal Collection Trust/ Windsor Castle, England
Photo The Lord Chamberlain's Office, London, England

Crowns as gifts 193

Another European monarch, Emperor Napoléon III of France, also came into possession of a notable Thai crown. On 27 June 1861, the Siamese ambassador, Phya Montrisuriyawong, arrived at the Palace of Fontainebleau, where court officials had been informed in advance that the gifts had to be presented according to the Siamese tradition. At first, Napoléon III requested that this formality be dispensed with, but when he was told that this would cause offence to the Siamese, he permitted them to proceed. The ladies of the court were informed by the French courtiers, who knew the Siamese ways, '*to be very careful not to laugh at what they were to see.*' When the Siamese delegation arrived in the hall, the ambassador, bearing a large golden cup containing some of the gifts, presented himself by advancing on his elbows and knees, as was the Siamese way. As soon as the ambassador had reached the throne, the emperor arose and helped the ambassador to his feet, taking the gifts and thanking him warmly. That evening, the emperor remarked to a small circle of friends '*There would be fewer courtiers here in France if that were the way in which they had to approach the throne. Perhaps that is why the King has introduced the custom in Siam.*'

On 14 August 1992, Queen Sirikit, consort of the Thai King Bhumibol Rama IX, was presented with a Thai headdress in the shape of a tiara to mark her 60th birthday. The tiara was a gift from the people of Thailand, and given to her by Prime Minister Anand Oanyarachun. Along with 600 zircons, the tiara includes a 2.7 carat diamond, emerald, topaz, garnet, sapphire, moonstone, chrysoberyl, ruby and hyacinth (a yellow-red to red-brown variety of zircon). The choice of these nine precious gemstones stems from the Indian tradition that the god Shiva possessed a necklace with nine precious stones. This jewel, the *nagakundala*, was actually the skin of the snake *Vasuki*, which had nine different coloured spots. In Thai astrology, the nine gemstones used in Queen Sirikit's tiara correspond in colour to the planets that 'rule' each day of the week. The importance of these nine gemstones is shown in the *Sangwannopharat* or 'Necklace with the Nine Precious Stones', which was worn by the rulers of ancient Ayutthya until the end of the 18th century, and the collar of the *Navarathna (Nopharat)* Order, which every king of the present Thai dynasty receives on the day of his coronation.

Tiara given to Queen Sirikit of Thailand by Prime Minister Anand Oanyarachun of Thailand on 14 August 1992. Gold, diamonds, emeralds, rubies, sapphires, topazes, garnet, moonstone, chrysoberyl and zircon; made in 1992.
Collection Queen Sirikit of Thailand
Photo The Fine Arts Department, Bangkok, Thailand

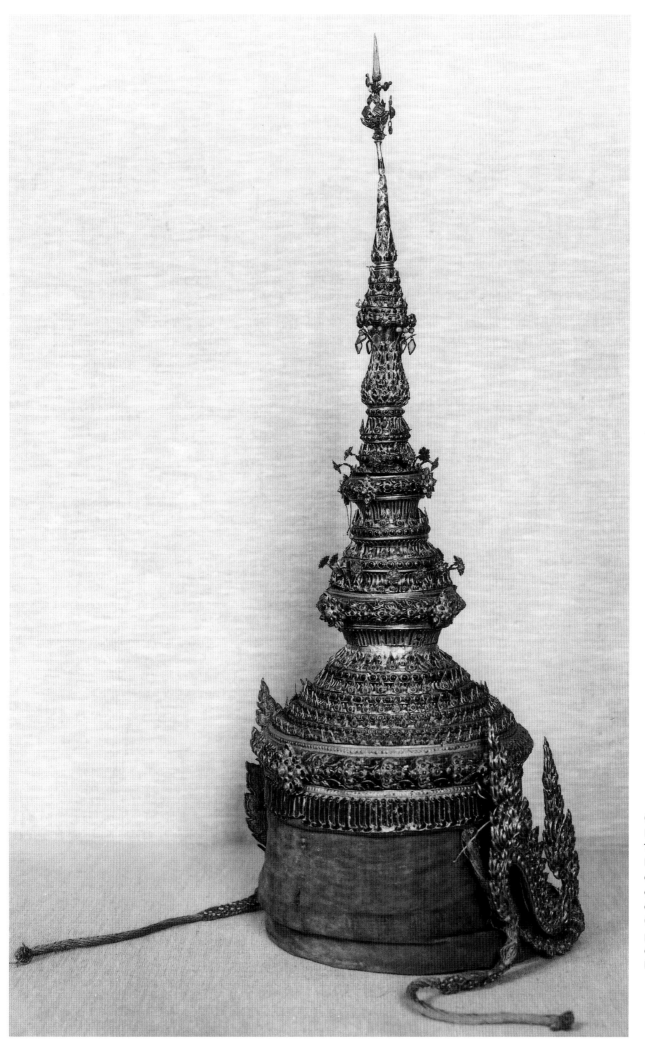

Crown given by King
Mongkut Rama IV of
Thailand to Emperor
Napoléon III of France
on 27 June 1861. Gold,
diamonds and rubies,
enamel; made in 1861.
Collection and
photo Château
de Fontainebleau,
Fontainebleau, France

Malaysia

On 19 February 1959, a deputation of school-girls comprising one Malay, one Chinese and one Indian girl, arrived at the royal palace of the Sultan of Kedah in the Malaysian state capital of Alor Star. During a short ceremony in the throne room, they presented a diamond-set platinum tiara to Sultanah Bahiyah, the wife of Sultan Abdul Halim Mu'adzam Shah. This was the first tiara made for the consort of a Malaysian ruler, which has as its centrepiece the state crest crafted in minute diamonds, with the state motto in *Jawi* characters. Jeweller H. Sena from Singapore had used 645 diamonds totalling 48 carats, including 34 marquise-cut stones. The tiara took two months to make at a cost of 48,000 Malaysian dollars, and part of the money had been collected by schoolchildren. After the sultanah had received the tiara, which was regarded as state property, she wore it for the first time in public the next day when her husband was inaugurated as the 27th ruler of Kedah.

19.2.1959; a deputation of Malay, Chinese and Indian schoolgirls presents the diamond-studded tiara to Sultanah Bahiyah of Kedah in the throne room of the Bukit Palace in Alor Star.
Photo Information Department, Kuala Lumpur, Malaysia

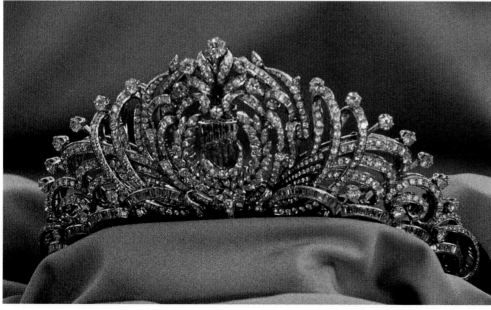

Tiara given to Sultanah Bahiyah of Kedah on 19 February 1959 as a state present to mark the installation of Sultan Abdul Halim Mu'adzam Shah. Platinum and diamonds; made in 1959.
Collection the late Sultanah of Kedah, Sultanah Bahiyah
Photo René Brus

The death of a monarch

There are numerous rituals that surround burials or cremations, some of which go back hundreds or thousands of years. The death of a ruler is often followed by a lying-in-state where subjects, important government officials and others come to pay homage. The funeral or cremation of a monarch is a state affair, and amid the pomp and pageantry, crowns and other emblems are sometimes displayed to mark the monarch's high position. When the original crown cannot be used, a replica may be used instead. The monetary value of the replica crown is generally much lower than that of the original one. Funeral crowns have been made from gilded wood, tin and silver, and coloured glass has been used instead of precious stones. In many countries, black is the colour associated with death; in others white is the primary colour for mourning. The maker of the funeral ornaments must always respect the ruling traditions. If the funeral or cremation of a royal personage does not take place soon after death, a funeral effigy might be made out of wax. This effigy can then be dressed in royal garments and a crown, and placed on the coffin in full view when the funeral finally takes place.

There are also traditions surrounding the manner in which a ruler should be buried, from the type of grave to the items that should be put in it to accompany the deceased to the next world. Many elaborate headdresses have been found in graves, helping researchers learn how people lived in the past. Some of the oldest crowns found have been wreaths, made of laurel, myrrh or olive branches, or of metals such as gold. Even when large parts of the crowns have decayed, the pieces that remain can provide information on how these objects were crafted, what they were used for and who wore them hundreds or even thousands of years ago. These excavated objects provide us with information on vanished civilisations and long-forgotten rulers. Despite the fact that modern techniques have eased the work of archaeologists and age-old crowns can be investigated, the opening of a grave is regarded as sacrilegious in some countries. Therefore, some crowns that may have unfamiliar shapes and adornments are still hidden from us.

Excavated crowns and headdresses can show remarkable differences and similarities in shape and decoration. In the numerous crowns found in European graves, the *fleur-de-lys* motif is often evident, even though the crowns were made in different centuries and discovered many hundreds of miles apart. Crowns excavated in South and Central America often feature small golden discs, usually attached to the crown frame by very thin wire so that they shake and glitter at the slightest movement. Amazingly, crowns excavated across the Pacific Ocean in Korea, dating back to the Silla Kingdom of the 5th and 6th centuries, are decorated with very similar golden discs set on thin wire. The crowns from these two regions also feature structures regarded as stylised feathers on the American crowns and as wing-like on the Korean crowns. Since beautiful feathers have been admired through the centuries, it is perhaps not surprising that they have been imitated in gold and used to decorate crowns on different continents.

The use of feathers, wings, animals and trees to decorate crowns probably originates in the shamanistic rituals and symbols that played a major role in ancient societies. Shamanism can be defined as 'a religious phenomenon centred on the shaman, an ecstatic figure believed to have power to heal the sick and communicate with the world beyond.' Shamans often use objects to help them to attain an ecstatic state and these objects can range from drums, metal rattles, staffs and gowns to elaborate headdresses. Ritual artefacts depicting animals or containing animal features are also of great importance to all tribes and cultures that depend on riding, herding and hunting. This wealth of imagery and magical meaning is carried over into the decorations used on crowns for both living and deceased rulers.

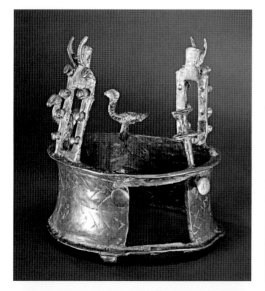

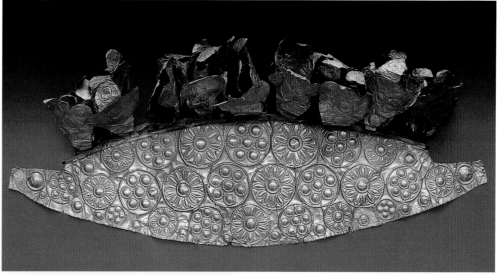

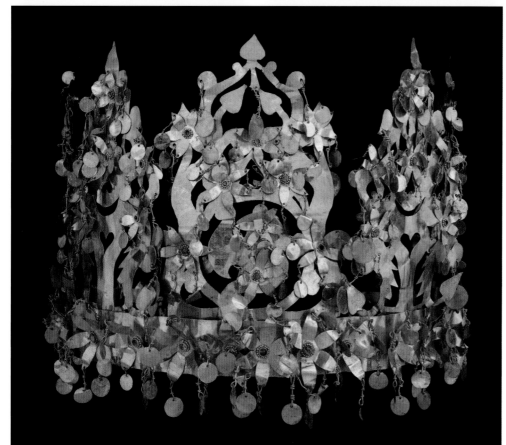

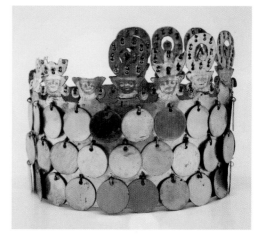

Bottom right:
Gold burial crown with
two god-like figures
above the rim and tiny
circular golden discs
dangling from the rim.
Vicús culture.
Collection and photo
Museo Larco, Lima, Peru

Top left:
Crown excavated in 1961
by the team of Pessah
Bar-Adon in Nahal
Mishmar in the Judean
Desert – Dead Sea region
Copper; made circa
3200 BC.
Collection and photo
The Israel Museum,
Jerusalem, Israel

Top right:
Diadem number 1 found
by Heinrich Schliemann
at Royal Tomb III,
Mycenae in 1876. Gold;
made in 1550-1500 BC.
Collection and photo
National Archaeological
Museum, Athens, Greece

Bottom left:
Crown of a young
woman, decorated
with tiny circular discs,
excavated from grave
number 6 in Tillya Tepe,
Afghanistan in 1978.
Gold and imitation
turquoises.
1st-2nd century AD.

Collection National
Museum of Afghanistan,
Kabul, Afghanistan
Photograph Musée
Guimet/Thierry Ollivier,
Paris, France
Photo with courtesy of
Press Office Stichting
De Nieuwe Kerk,
Amsterdam,
The Netherlands

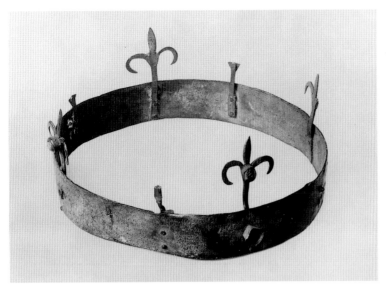

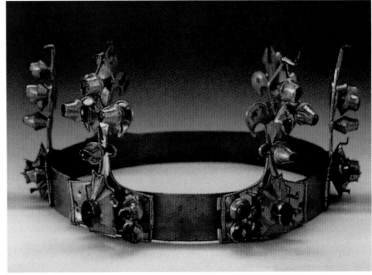

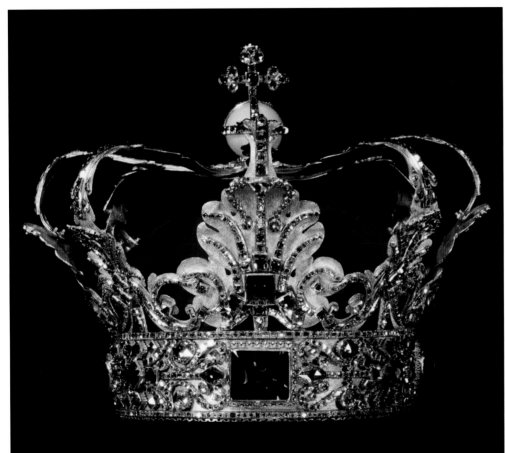

Sweden

Pearls can lose their lustre or even disintegrate due to age or high levels of aridity or humidity. When the grave of Swedish Queen Katarina Stenbock was opened in 1886, more than 200 years after her death in 1621, her pearl-set burial crown had lost its original splendour as several of its pearls were missing. Queen Katarina was the third wife of King Gustav I Vasa (who died in 1560), and was buried in the crypt of Uppsala Cathedral, alongside the bodies of her husband and his first and second wives, Katarina of Sachsen-Lauenburg (who died in 1535) and Margareta Leijonhufvud (who died in 1551). Burial crowns were found with each body. Gustav I died at the age of 64, and after his body was embalmed, it lay in state for eight weeks. The two queens who had died before him were re-interred with the king, and for the funeral procession of 21 December 1560, life-sized wax figures of the king and his two queens were placed on their coffins, all wearing gem-studded crowns on their heads and holding sceptres in their hands. An account dated 3 March 1561 shows that goldsmith Hans Rosenfelt was paid for the delivery of five crowns and five sceptres, together with other articles for the funeral, and since they were not seen during the procession, this suggests that at least two of these crowns had been placed inside the coffins. The tomb of Gustav I was opened again in 1945 and researchers discovered that some of the coffins were severely damaged. They were restored, and the remains of the king were exhibited on 25 February 1946. More than 7000 people visited the exhibit. The king lay in an oak coffin wearing a black velvet coat ornamented with golden monograms, a velvet cap and slippers, and he was found with a sword, a sceptre and a crown. These burial regalia were placed in the silver room of the cathedral.

The tombs of King Karl X, who had ruled Sweden from 1654-1660, and Queen Maria Eleonora, who died in 1655, located in the Riddarsholmchurch in Stockholm, were opened in 1920. The queen was found with a crown, a sceptre and an orb, but her remains and burial ornaments were photographed and left undisturbed. After inspection, the tomb was closed again.

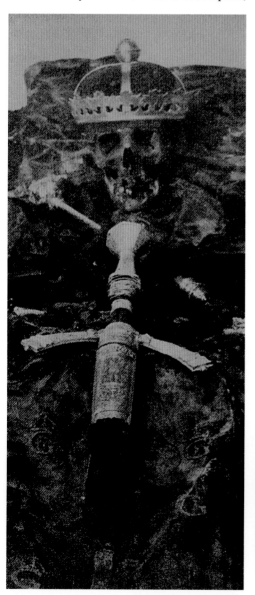

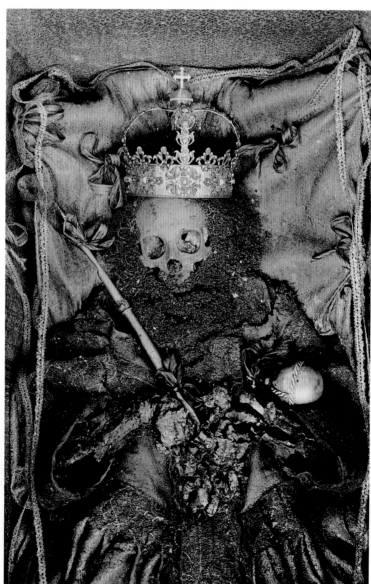

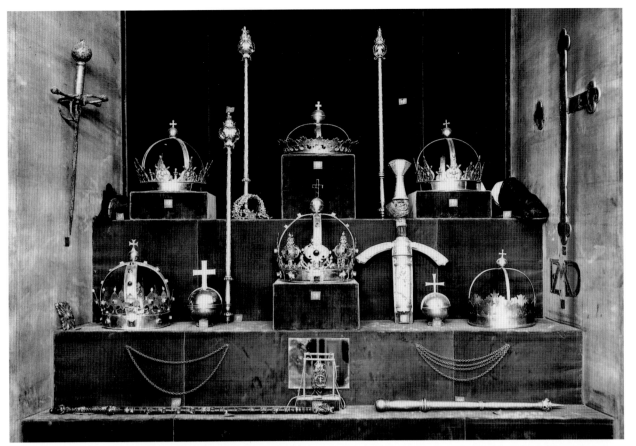

Burial regalia of several Swedish kings and queens as displayed in the 1950s in the Silver Chamber of Uppsala Cathedral. The top crowns were retrieved from the coffins of King Gustav I Vasa and his three queens. The bottom row shows the crowns from King John III and his two queens.
Collection Uppsala Domkyrka, Silver Room, Uppsala, Sweden
Photo collection René Brus

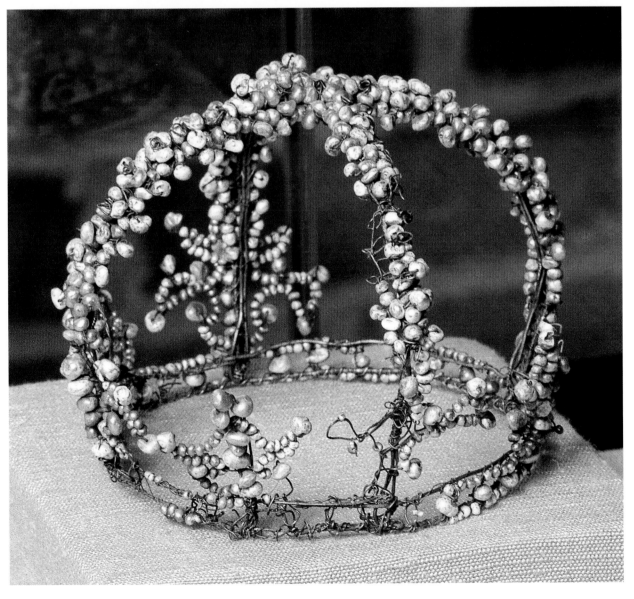

Burial crown of Queen Katarina Stenbock of Sweden. Silver and pearls; made early of the 17th century.
Collection Uppsala domkyrka, Silver Room, Uppsala, Sweden
Photo Bo Säfström, Chancellor Uppsala Domkyrka, Sweden

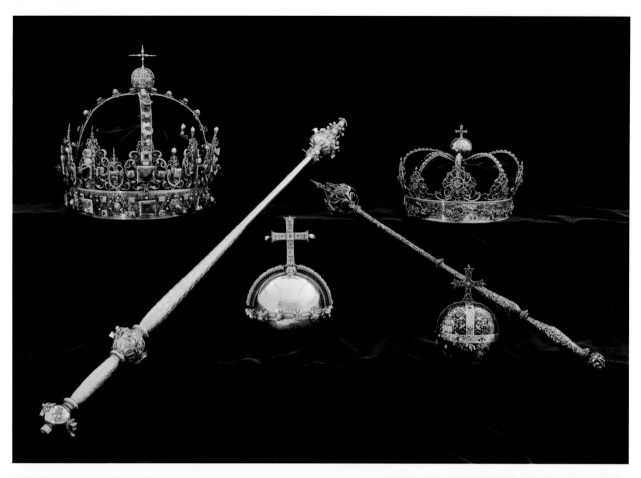

Top:
Burial regalia of King Karl IX of Sweden (left) and his second consort Queen Kristina (right). King Karl IX (died in 1611) and his queen (died in 1625) were both buried at Strängnäs Cathedral with elaborately crafted burial regalia. The Queen's burial regalia was decorated with black and blue enamel on the instructions of her son, King Gustavus II Adolphus, as she had been a widow upon her death. The graves of this royal couple were opened in 1830 and the burial regalia removed. King's regalia; gold, rock crystal, pearls and enamel.
Queen's regalia; gold and enamel. The King's crown was made by Antonius Groth from Stockholm. Collection Strängnäs Cathedral. Deposited in 1980 in the Kungliga Livrustkammaren (The Royal Armoury), Royal Palace, Stockholm, Sweden Photo archive Kungliga Livrustkammaren, Stockholm, Sweden

Bottom:
Gold burial crown of King Karl X Gustavus of Sweden. Made between 13 and 22 February 1660 by an unknown goldsmith from Götenborg. Collection Kungliga Livrustkammaren (The Royal Armoury), Royal Palace, Stockholm, Sweden Photo archive Kungliga Livrustkammaren, Stockholm, Sweden

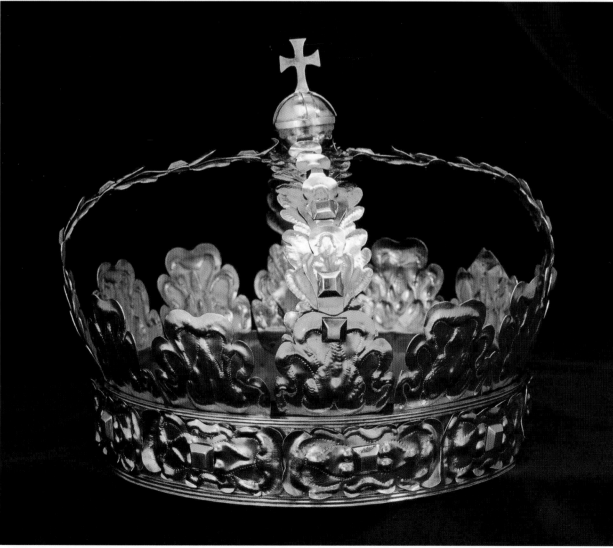

England

In England, wax figures are no longer carried in royal funeral processions, and replica crowns are no longer used. When King Edward VII died in 1910, photographs recorded for the first time that the genuine St Edward's Crown had been taken from the Jewel Room in the Tower of London to the throne room of Buckingham Palace to adorn the coffin. However, when the deceased sovereign was brought to Westminster Hall for the public lying-in-state, the coffin was no longer decorated with this centuries-old crown, but with the 62-year-old Imperial State Crown, which also accompanied the king's body on its final procession. The St Edward's Crown might have been regarded as too fragile for such a procession, although the Imperial State Crown was probably not in much better condition judging by what happened to it some 26 years later.

King Edward VII's successor, King George V, died in Sandringham on Monday 20 January 1936, and his body was brought to London by train three days later. On arrival at King's Cross Station in London, the Imperial State Crown was placed on the coffin. The coffin was then placed on a gun carriage and taken in procession to Westminster Hall, but on the way the diamond-studded globe and Maltese cross on the top of the crown fell off. The *Illustrated London News* of 1 February 1936 described the event as follows, '*During the later stages of the funeral procession which brought King George's body from King's Cross Station to Westminster Hall, it was noticed that the cross of which this sapphire is the centre (also known as the St Edward's sapphire) was missing. In fact, it had become detached, owing to the vibration of the gun carriage on which the coffin, surmounted by the Crown, was carried. It was placed up and, after the procession had reached Westminster, duly restored.*'

George V's successor, Edward VIII – later the Duke of Windsor – also wrote about this event. '*That simple family procession through London was, perhaps more impressive than the State cortège on the day of the funeral, and I especially remember a curious incident that happened on the way and was seen by very few. In spite of the rubber-tyred wheels the jolting of the heavy vehicle must have caused the Maltese cross on top of the crown – set with a square sapphire, eight medium-sized diamonds, and one hundred and ninety-two smaller diamonds – to fall. For suddenly, out of the corner of my eye, I caught a flash of light dancing along the pavement. My natural instinct was to bend down and retrieve the jewels, least the equivalent of a King's ransom be lost for ever. Then a sense of dignity restrained me, and I resolutely marched on. Fortunately, the Company Sergeant-Major brings up the rear of the two files of Grenadiers flanking the gun carriage had also seen the accident. Quick as a flash, with scarcely a missed step, he bent down, scooped up the cross with his hand, and dropped it into his pocket. It was one of the most quick-witted acts that I have ever witnessed.*'
The person who saved the cross of the Imperial State Crown was Lieutenant Huntington, the Grenadier Guards officer in charge of the bearer party.

Upon arrival at Westminster Hall, the crown underwent temporary repairs, but it wasn't long before Garrard were requested to take all the precious stones and pearls out of the crown and reset them in a new frame, a duplicate of the worn-out original. The old frame was not melted down, but given to the London Museum as an historic heirloom in 1953, at the beginning of the reign of Queen Elizabeth II.

Wax effigy of Edmund Sheffield, second Duke of Buckingham and Normanby, with a peers' coronet. Coronet gilt metal. The coronet seen on this effigy is a replica of the original peers' coronet used by the duke, but which was stolen from the Abbey in 1737. The *Daily Gazetteer* of 15 June 1737 described the robbery as follows, '*On Monday night last some villains concealed themselves in Westminster Abbey and having broken the glass case which was over the Effigie (effigy) of the late Duke of Buckingham found means to carry off the Flap of his gold Waiscoat (waistcoat); some of the Blood of their Fingers was perceived on his Ruffles.*'
Collection Westminster Abbey, London, England
Photo by courtesy of the Dean and Chapter of Westminster Abbey, London, England

Top left:
23 and 24 January 1936;
lying-in-state of King
George V of England
in Westminster Hall,
London, with the
Imperial State Crown.
Photo collection
René Brus

Top right:
May 1910; lying-in-state
of King Edward VII of
England in the throne
room of Buckingham
Palace with the
St Edward's Crown.
Photo collection
René Brus

Bottom:
The empty frame of the
Imperial State Crown
of Queen Victoria of
England. Gold, silver and
ermine; made in 1838.
Collection Museum of
London, England
Photo René Brus

Opposite page:
The Imperial State
Crown. Gold, diamonds,
sapphires, emeralds,
rubies, spinel and pearls;
made in 1937 after the
original crown frame
from 1838 had become
too fragile.
Collection Tower of
London, England
Photo British Crown
Copyright/Department
of Environment, London,
England

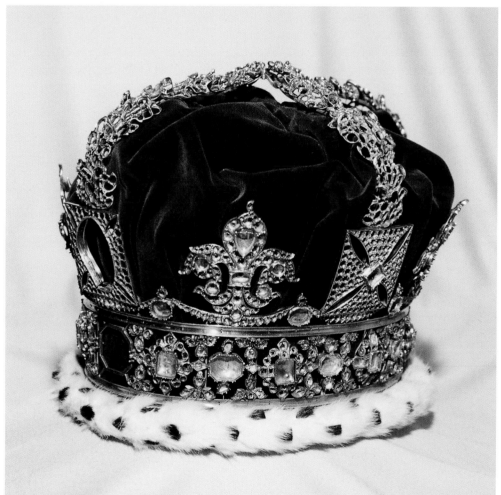

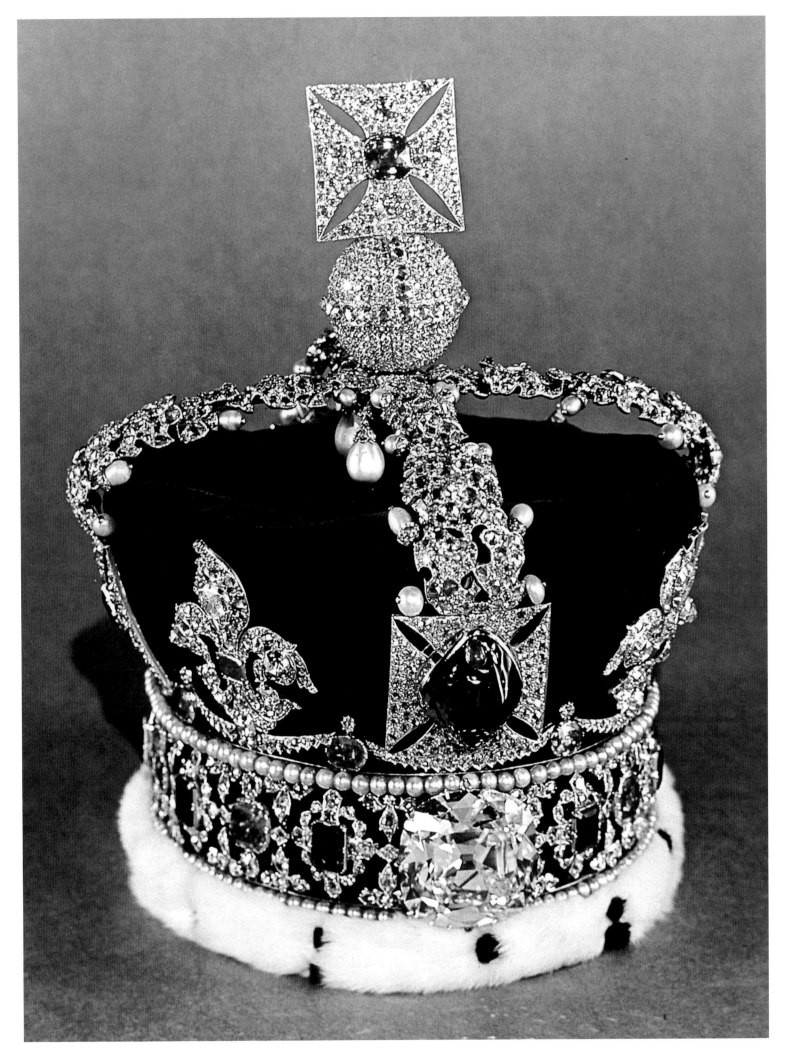

France

On 21 January 1815 a solemn funeral was celebrated for King Louis XVI of France and his Queen, Marie-Antoinette, in the Abbey of St Denis. Both were guillotined in 1793 after the French Revolution. For many centuries, this house of worship had been the burial place of members of the French royal family, and it was traditional for the coffin of the deceased to be placed on a catafalque for 40 days before the burial. On many occasions, special funeral crowns were made and placed on the coffin. During the French Revolution, however, most of these funeral ornaments had been destroyed, and at the beginning of the 19th century King Louis XVIII ordered several new funeral crowns from the bronze caster Feuchères. In the 1970s, these crowns were found to be in very poor condition and needed to be repaired.

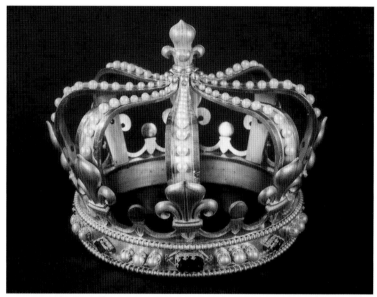

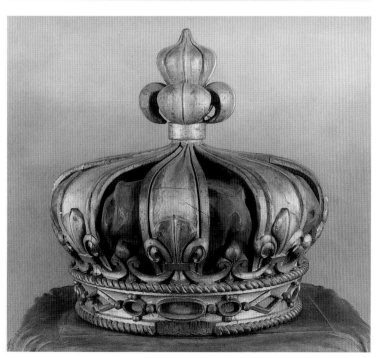

Left, top and middle:
Top; funeral crown of King Louis XVI of France. Gilded bronze, imitation pearls, the original lost cameos have been replaced by mouldings, originally made in 1814-15 by Feuchères.
Middle; parts of the funeral crown of King Louis XVI as found in the treasury of the Abbey of St Denis prior to restoration in the 1970s.
Collection Treasury Abbey of Basilique cathédrale de Saint-Denis, France
Photo la Caisse Nationale des Monuments Historiques et des Sites, Paris, France

Bottom left:
Funeral crown of King Louis XVIII of France used in 1824. Gilded bronze; made in 1824 by Feuchères.
Collection Treasury Abbey of Basilique cathédrale de Saint-Denis, France
Photo la Caisse Nationale des Monuments Historiques et des Sites, Paris, France

Right, top and bottom:
Top; funeral crown of Queen Marie-Antoinette of France. Gilded bronze, imitation pearls and paste; originally made in 1815 by Feuchères.
Bottom; parts of the funeral crown of Queen Marie-Antoinette as found in the treasury of the Abbey of St Denis, prior to restoration in the 1970s.
Collection Treasury Abbey of Basilique cathédrale de Saint-Denis, France
Photo la Caisse Nationale des Monuments Historiques et des Sites, Paris, France

The Netherlands

Dutch Stadtholder Willem III reigned together with his wife as King William III and Queen Mary II of England. For William's funeral in 1702 in London, an imitation of his coronation crown was made of gilded wood studded with imitation pearls; this adorned his funeral effigy. During the funerals of his predecessors and successors in The Netherlands, only crowns representing their rank were displayed. At first, the funeral crown was only a princely circlet honouring the Principality of Orange, but from the mid 18th century a crown with arches was used. In the 19th century, it also became the tradition for other members of the royal family to be accompanied to their resting place by the crown that was present during the inauguration of successive Dutch sovereigns. This crown was not always treated respectfully. For the funeral of King Willem III of The Netherlands in 1890, who was buried in the city of Delft, the regalia of the Kingdom, including the crown, were brought into the burial church like a '*package*' and, according to a newspaper, the coffin was dragged in like a '*piano*'.

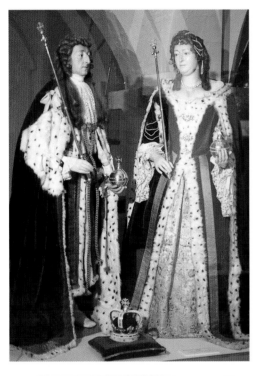

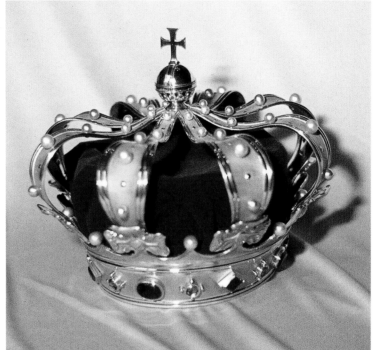

Left, top and bottom:
Crown and wax effigies of King William III of England, Stadtholder of The Netherlands, and his wife Queen Mary II of England; made end of the 17th century.
Crown of King William III made of gilded wood and imitation pearls.
Collection Westminster Abbey, London, England
Photo René Brus

Top right:
The crown of King Willem II of The Netherlands. This crown was used for the last time for the *Castrum Doloris* and funeral of Queen Emma in 1934.
Photo René Brus

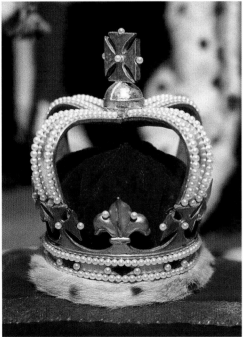

Bottom right:
22.3.1934; the lying-in-state of Queen Emma of The Netherlands in the vestibule of the palace 'Lange Voorhout', The Hague, with the crown of King Willem II on the coffin almost hidden by the floral tributes.
Photo collection René Brus

Germany – Baden

In 1811, Grand Duke Karl Friedrich of Baden decided that his dynasty needed a crown and sceptre, and these were ordered from the jeweller C. W. Dressler. But the grand duke died on 10 June 1811, before the crown was finished. Despite the fact that only a few precious stones had been set into golden ornaments, and the crown frame was not yet made, it was decided to finish the crown quickly so that it could be used during his funeral. A temporary frame was fashioned out of cardboard and embellished with gold embroidery, and on 16 June 1811, the Baden Crown accompanied the grand duke to his final resting place. Since nobody regarded a cardboard frame as unsuitable, the Baden crown remained as it was made, although every year it was inspected to see if any parts needed repair. When the crown was due to be inspected in 1856, the key of the chest in which it was kept could not be found, and the chest had to be opened by force by the court key maker, Weiss. The Baden Crown has never been worn; it has only been displayed as a symbol of grand ducal majesty during the investiture of a monarch, the opening of the state parliament and funerals.

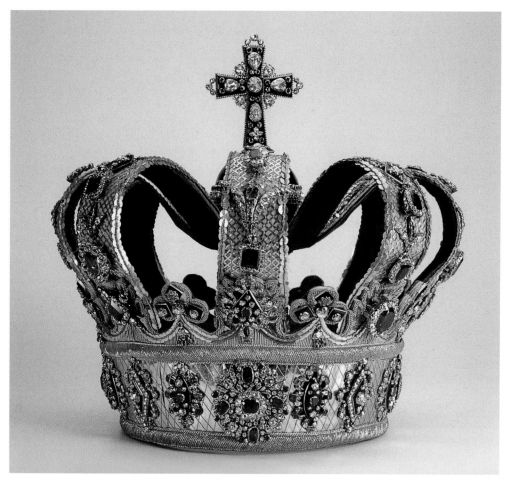

Crown of Grand Duke Karl Friedrich of Baden. Gold, silver, diamonds, rubies, emeralds, sapphires, hyacinth, garnet, enamel and gold embroidered cardboard frame; made in 1811. Collection Staatsschuldenverwaltung Baden-Württemberg, Karlsruhe, Germany Photo René Brus

1907; funeral procession of Grand Duke Karl Friedrich of Baden, on the far right the bearer with the Grand Ducal crown. Photo collection Generallandesarchiv Karlsruhe, Germany

Opposite page:
Top:
1916; lying-in-state of Emperor Franz Joseph I of Austria in the Hofburg chapel, Vienna. Funeral crowns are placed at the four corners of the coffin as symbols of the parts of the realm over which the deceased sovereign ruled. On the left is the funeral Crown for Hungary, on the right the funeral Crown of the Austrian Empire, being a replica of the Crown of Emperor Rudolf II. Photo Österreichische Nationalbibliothek, Vienna, Austria

Bottom left:
Funeral Crown of Emperor Leopold II of the Holy Roman Empire. Gilded metal, enamelling, paste and imitation pearls; made in 1792. A replica of the Crown of St Stephen of Hungary. Collection Bundesmobiliendepot, Vienna, Austria Photo René Brus

Bottom right:
Funeral Crown of Emperor Franz I of Austria. Gilded metal, paste and imitation pearls; made in 1835. A replica of the Crown of Emperor Rudolf II. The side plates of the mitre are embossed with the same scenes as the original crown. Collection Bundesmobiliendepot, Vienna, Austria Photo René Brus

Austria

The rulers of the Habsburg dynasty, who first served as Emperors of the Holy Roman Empire and later Emperors of Austria, also held the titles of King of Hungary and King of Bohemia. The insignia of these Kingdoms never belonged to the Imperial Treasury in Vienna (except for a short while during the reign of Emperor Joseph II, who ruled from 1765 to 1790) and could not easily be lent for the funeral of their Habsburg ruler. For the funeral of Emperor Leopold II in 1792, it was decided to make a copy of the Hungarian coronation Crown, which was done with painstaking accuracy, in contrast to the very simple wooden burial Crown of Bohemia. For the funeral of Emperor Franz I of Austria in 1835, an equally well-crafted replica of Emperor Rudolf II's crown was used, even though the original crown was available. Presumably the value and delicate workmanship of the original was behind the decision to use a replica crown.

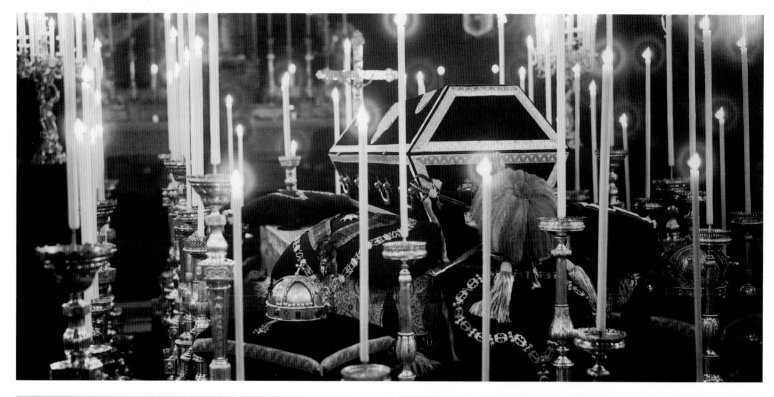

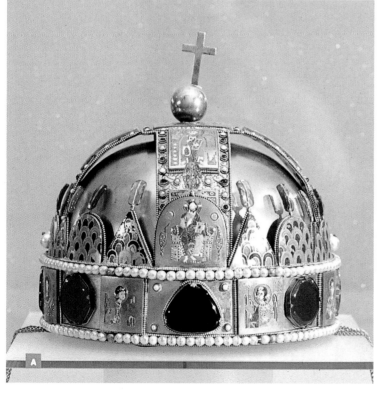

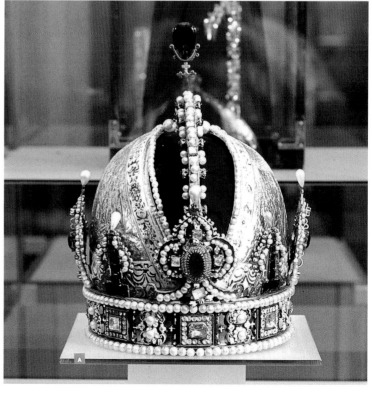

Malaysia

On the death of a sovereign, the powers and responsibility of the state are usually handed over immediately to his or her successor. In the Sultanate of Johor, during the first few hours after the sultan's death, his personal standard is raised from half to full mast for a short while in honour of the new ruler. After this, the chief of ceremonies seeks the royal decree from the new sultan to proceed with the funeral preparations. For this ceremony, the actual coronation crown, set with many precious stones, is placed on the coffin of the deceased sultan by his successor. This crown was made by the London jeweller J. W. Benson for the coronation of Sultan Abu Bakar, which took place on 29 July 1886, and was used for his funeral in 1895. Although this crown is similar in shape to many of its western counterparts, the setting and design are oriental, incorporating five-pointed stars, crescents and the Arabic characters for 'Allah' and 'Muhammad' studded in flawless rubies and emeralds.

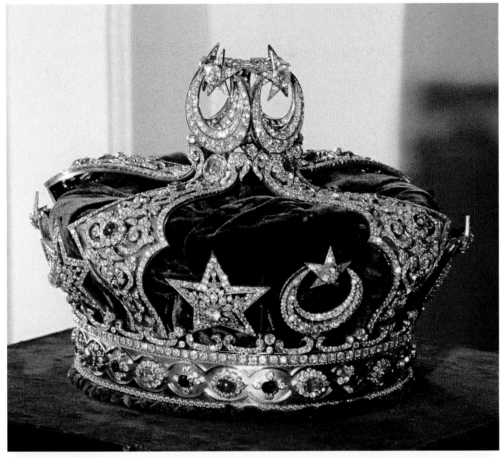

Crown of Johor. Gold, platinum, diamonds, rubies, emeralds and sapphires; made in 1886.
Royal House of Johor, Bahru, Malaysia
Photo René Brus

5.6.1959; lying-in-state of Sultan Sir Ibrahim of Johor in the banquet hall of the Besar palace, Johor Bahru, Malaysia.
Photo collection René Brus

Opposite page:
Burial crown attributed to Queen Baña Thau or Shin Sawbu of Burma. Gold, semi-precious stones and paste; made end of the 14th, beginning of the 15th century.
Collection Victoria & Albert Museum, London, England
Photo collection René Brus

Burma

In 1855, coolies working for the British Army were clearing the ground on a south-eastern slope at Yangon in Burma (now officially the Union of Myanmar) when a cache of solid gold objects was uncovered. Among the objects discovered in a hidden chamber, part of the country's once most important pagoda, was a headdress or helmet. For a number of years, it was referred to as Queen Shin Sawbu's (or Baña Thau's) crown. More recently, scholars have found evidence that the headdress might have been in the possession of King Rajadhirat, who reigned from 1383-1421. But researcher Noel F. Singer believes that the headdress was worn by Queen Baña Thau or Shin Sawbu, who was crowned in 1453 and died in 1472. He explains that the objects must have been enshrined in the pagoda by the royal family after Baña Thau's cremation. The crown did not remain in Burma, but became part of the collection at London's Victoria & Albert Museum.

Not only is the name of the original owner of this headdress difficult to determine, its shape and decorations also provide a mystery. The shape has been described as being based on a headcloth, or on a hairstyle called 'sanmeik gwin' (hair switch loop). The distinctive features of this headdress, such as a bulge and a leaf-shape extension below the brim, also make it difficult to determine which part of the crown was the front. Only when similar crowns are discovered in the future might such questions be answered.

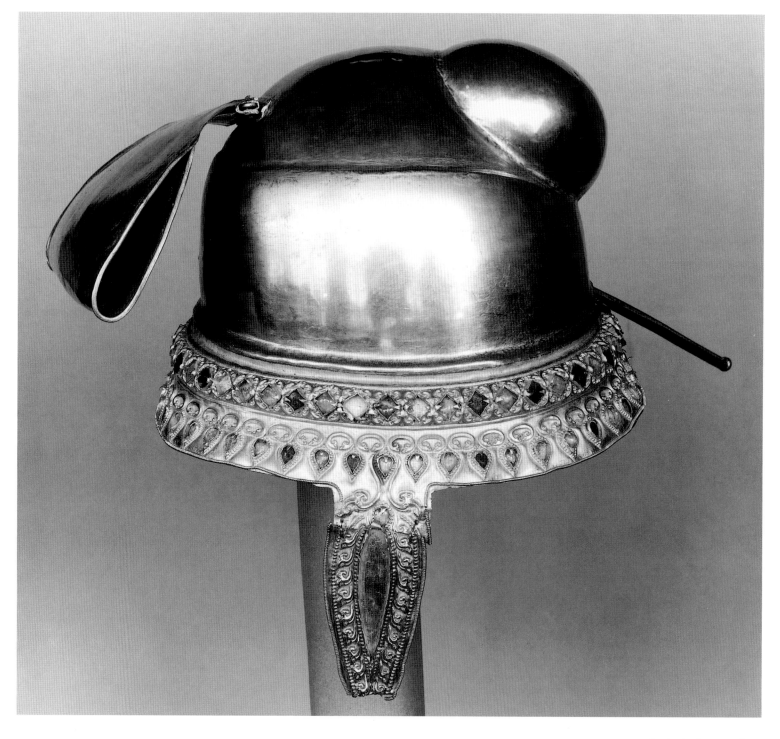

China

In China, ancient custom decreed that the emperor and his empress(es) were interred after their death with all conceivable valuables and utensils so that they could live with the same comforts in the after-life as on earth. The grave was the centre of the world, and with its many buildings and temples, the mausoleum was virtually an underground city.

Thirty-five miles to the north of Beijing are the burial mounds of various Ch'ing rulers. In 1958, the Dingling Mausoleum of Emperor Wan-li (also referred to as Zhu Yijun and Shenzong, 1573–1620) was discovered. The crown found in the emperor's coffin is made of extremely thin 20-carat gold wire, shaped into a remarkable latticework. Two golden dragons playing with a golden flaming pearl – symbolising wisdom and long life – can be discerned in the latticework. No actual pearls or precious stones were found on this crown, although these were used generously on the four crowns placed in the coffins of the two consorts of Emperor Wan-li, Empress Xiao Duan and Empress Xiao Jing. The empresses' crowns are dazzlingly coloured and could almost be the work of coiffeurs instead of goldsmiths. The kingfisher feathers, which adorned the crowns in abundance, retain their shining metallic blue lustre. The crowns of the two empresses are shaped similarly and constructed on a foundation of thin lacquered bamboo strips. A crown of the first Empress, Xiao Duan, weights 4.6 pounds and is the most elaborate, showing dragons, birds and phoenixes, and includes 57 large cabochon-cut rubies, 58 cabochon-cut sapphires and no fewer than 5,449 pearls.

Graves of other Chinese empresses probably also contain similar phoenix crowns, but since ancestor worship has been a fundamental part of daily life for many Chinese for centuries, disturbing the dead is not looked on kindly. Imperial China came to an end in 1912 with the abdication of the child Emperor Pu Yi. Members of the former imperial family and their supporters were horrified when the mausoleums of the royal family were plundered in 1928 by the military under the command of Sun Dianying of the 42nd army of Chiang Kai-shek. The grave of the despotic Empress Dowager Cixi (or Tz'u-Hsi), who had died in 1908, was ransacked. Her golden crown was taken apart and, according to the biography of Emperor Pu Yi published in 1964, the large pearls it had been set with were presented to Soong Mei-ling, the young wife of General Chiang Kai-shek. These pearls ended up as adornments on Soong Mei-ling's shoes, a fact that must have filled China's last emperor with horror.

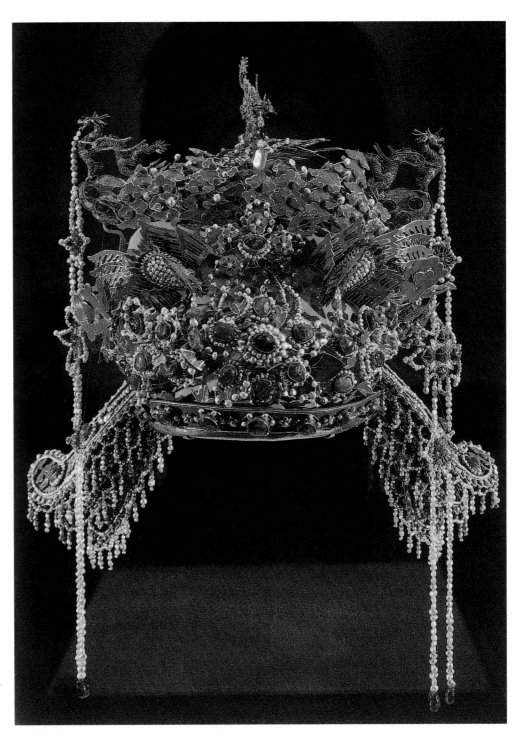

Burial crown of Empress Xiao Duan. Gold, rubies, sapphires, pearls and kingfisher feathers; made beginning of the 17th century.
Collection Dingling Mausoleum, Beijing, China
Photo collection René Brus

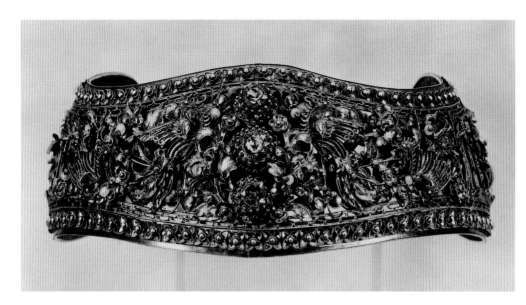

Burial crown from the Song dynasty (960-1279 AD). Silver gilt and kingfisher feathers.
Collection The Metropolitan Museum of Art, New York (Fletcher Fund), USA
Photo The Metropolitan Museum of Art, New York, USA

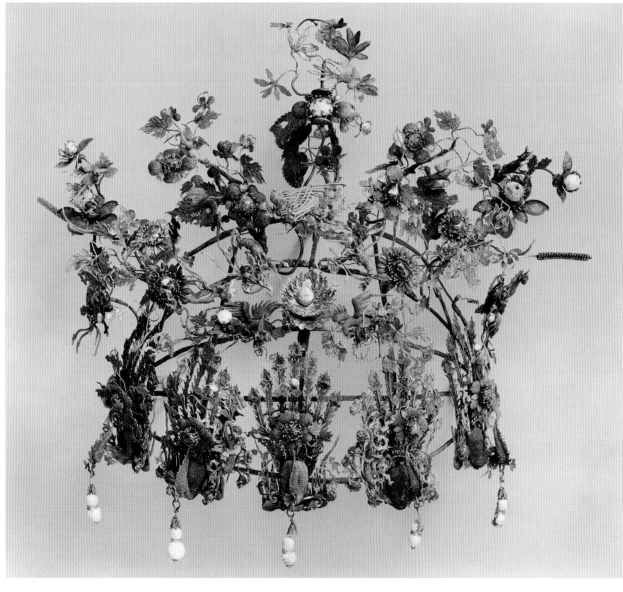

Burial crown from the late Tang or early Song dynasty. Gold, pearls, precious and semi-precious stones and kingfisher feathers; made 9th or 10th century AD.
Collection The Metropolitan Museum of Art, New York (Fletcher Fund), USA
Photo The Metropolitan Museum of Art, New York, USA

Korea

On 24 September 1921, a group of children playing on a patch of waste ground in the Korean town of Gyeongju, once the capital of the ancient Kingdom of Silla, stumbled across the burial mound of a king who had been buried in the beginning of 6th century AD. Fortunately, the children's find led to excavations, which brought to light some 30,000 glass beads and a fabulous cache of jewellery, including an exquisite, fragile gold crown that had survived intact and which would become one of the most important symbols of Korean culture. As a consequence of this discovery, the tomb became known as the Gold Crown Tomb or *Geumgwanchong*. Subsequent excavations unearthed crowns from burial mounds such as the Lucky Phoenix Tomb (*Ponghwang*), the Great Tomb of Hwangnam (*Hwangnamdaechong*), the Golden Bell Tomb (*Geumnyeongchong*) and Heavenly Horse Tomb (*Cheonmachong*).

It is not clear whether the excavated golden crowns of Silla and the other monarchies on the Korean peninsula were actually worn or were used specifically as grave objects. The crowns that have been unearthed so far are basically of the same shape and are generally made of cut sheet gold. Some of the crowns are decorated with wing-like structures, which presumably have their origins in shamanistic symbols of birds, since the shamans donned wings or feathers to prepare themselves for their journey into the spirit world. The comma-shaped

jade pendants that are used on some crowns, known in Korea as *kogok* or *gobeunok*, may also relate to shamanism and represent the teeth or claws of captured and killed animals. However, other opinions on the origins and meaning of the *kogok* suggest that it originated from the embryo as symbol of fertility, or from the half Moon. The earliest examples of the *kogok* from Bronze Age Korea are half-Moon shaped. Some scholars believe that the *kogok* represents the Moon as symbol of *yin*, while bronze mirrors, often found with the *kogok*, represent the Sun and thus the symbol *yang*, as mirrors reflect the Sun. Thus the *kogok* beads and the use of disc-shaped gold decorations on the Silla crowns could be the representations of *tai-chi*, the universal *yin* and *yang*, the worldwide symbol for female and male, cold and warmth, light and dark and other dualities of opposites from Taoism, developed from the teachings of the Chinese philosopher Laozi, or Lao Tse, who lived around the year 500 BC.

Many of the extant Korean treasures originate from Gyeongju because this city has never been the site of a battle. Its works of art escaped plunder, and most of its historical monuments remained intact. Another factor in the preservation of its art was the unique Silla method of tomb construction. Subterranean vaults were sealed in such a way that they could not be entered after burial, thus preserving their contents for modern historians.

Excavations in Gyeongju in 1973 revealed the tomb of King Muryeong of Paekche, whose wooden, walled chamber was opened on 26 July and revealed that the king was buried wearing numerous golden objects, including a crown.
Collection National Museum of Korea, Gyeongbok Palace, Seoul, Korea
Photo Korean Overseas Information Service, Ministry of Culture and Information, Seoul, Korea

Opposite page:
Burial crown from a Silla dynasty tomb. Gilded bronze; 5th-6th century AD.
Collection Musée Guimet and Le Musée de l'Homme, Paris, France, former collection Mayuyama
Photo l'agence photographique de la Réunion des musées nationaux, Paris, France

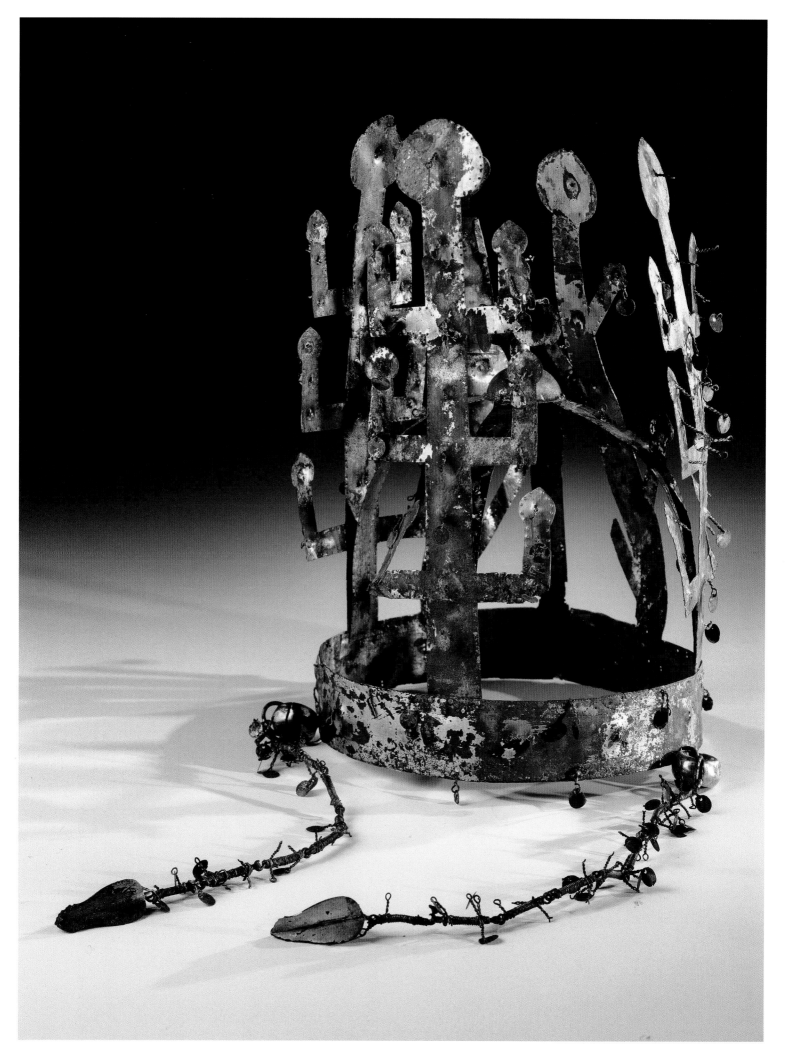

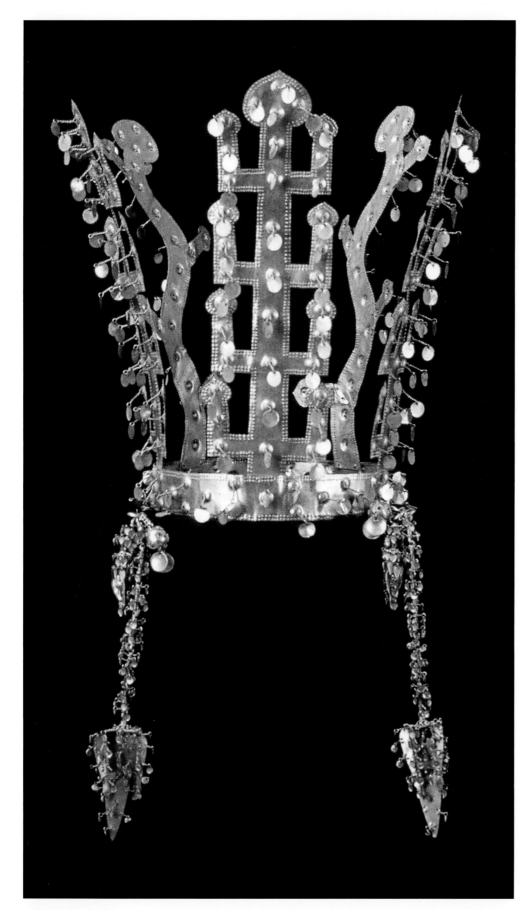

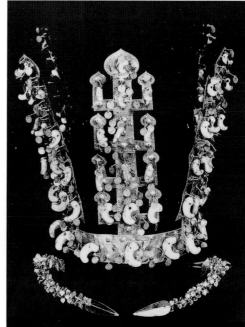

Top right:
Funeral crown of King Muryeong of Paekche. Gold and jade; old Silla dynasty, late 5th-6th century AD.
Collection Gyeongju National Museum, Gyeongju, Korea
Photo Korean Overseas Information Service, Ministry of Culture and Information, Seoul, Korea

Bottom right:
Funeral gold cap from the *Cheonmachong*, Flying Horse or Heavenly Horse Tomb. Old Silla dynasty, late 5th-6th century AD.
Collection Gyeongju National Museum, Gyeongju, Korea
Photo Korean Overseas Information Service, Ministry of Culture and Information, Seoul, Kore

Left:
Burial crown from the Silla dynasty tomb called *Geumnyeongchong* or the Golden Bell Tomb. Gold, glass ornaments; old Silla dynasty, late 5th-6th century AD. Excavated in 1924.
Photo National Museum of Korea, Gyeongbok Palace, Seoul, Korea

Egypt

In the past 200 years, a number of impressive head ornaments have been discovered in Egypt from the time of the ancient pharaohs. At the end of the 19th century, the French Egyptologist Jacques de Morgan dug up jewels belonging to princesses from the family of Pharaoh Senusret III, also referred to as Sesostris III (who lived from approximately 1872 to 1853 BC). The Frenchman found the jewels in graves inside Senusret III's pyramid complex in Dashur and among them was the crown of Princess Khnumit, described in *the Illustrated London News* of 7 March 1896. The body of Princess Khnumit was found in a sarcophagus, and she had been buried with much valuable jewellery inlaid with cornelian, turquoise and lapis lazuli. The English magazine published a sketch showing Jacques de Morgan lifting the golden circlet from the grave. This circlet, or closed headband, has also been described as a crown, a fillet and a coronet. It is made of rosettes linking eight groups of three lyre-shaped calyces (two horizontal and one vertical) and a central rosette. Over the centre of the circlet, between two vertical calyces, is a golden vulture with outspread wings and the hieroglyph shenu in its claws. The details of the bird's body and wings are engraved on the metal. On the inner side of the headband, at the back, is a little tube to hold a spray of golden leaves.

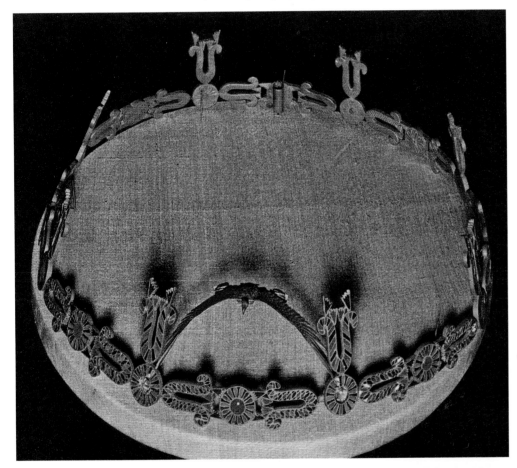

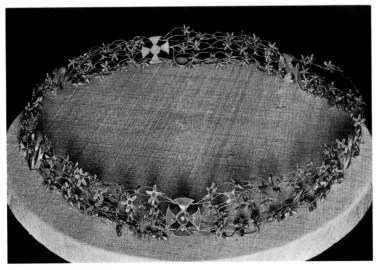

Left, top and bottom:
Two circlets excavated from the grave of Princess Khnumit. Gold, carnelian, lapis lazuli and turquoise; 12th dynasty, around 2140 BC.
Collection and photos Egyptian Museum, Cairo, Egypt

Right:
1896; an artist's impression as printed in *the Illustrated London News* of the discovery of the crown of Princess Khnumit by Jacques de Morgan.
Photo collection René Brus

For generations both men and women of noble or royal blood wore similar jewelled circles in ancient Egypt. They have often been described as a stylised boatman's fillet or headband, having probably originated in the cord or piece of cloth that was tied around the brow to keep straying locks of hair out of the eyes in windy weather. Gradually this developed into a more festive headdress during canoe tournaments, when boatmen would tie their hair back with linen tapes and thread water lilies through them, all around their heads. Once the linen became gold, the flowers were inlaid with semi-precious stones and the symbolic spitting cobra ('uraeus') and vulture were added, a crown fit for a pharaoh or his close relatives was born. In 1914, Mr Guy Brunton, who was in the service of Egyptologist Flinders Petrie at the excavation site of Lahun, discovered such a crown in the pyramid complex of Pharaoh Senwosret II, who ruled Egypt from circa 1897-1878 BC. The golden diadem he discovered belonged to

Princess Sithathoryunet (Sit-Hathor-yunet), the daughter of Pharaoh Senwosret II, and is decorated with 15 rosettes each of four lily-like flowers inlaid with cornelian, lapis lazuli and green feldspar, sometimes referred to as green faïence. The front of the headband is adorned with the serpent of royalty, which has a head carved from lapis lazuli, eyes made of garnet and a body inlaid with cornelian, lapis lazuli and a green vitreous substance. The back of the fillet has a split, vertical, golden band resembling a feather, which is referred to as the plume of the goddess Hathor, patroness of love and beauty. Two similar plumes hang down from the circlet, near each ear.

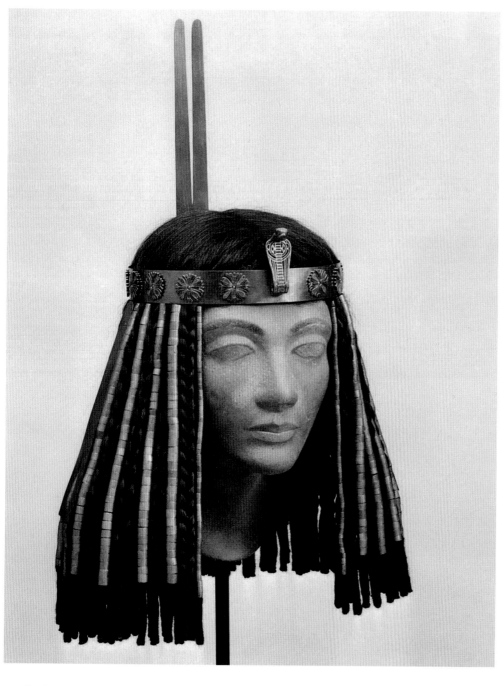

Burial diadem of Princess Sithathoryunet. Gold, carnelian, lapis lazuli and paste. Parts of this diadem are original and date from circa 2140 BC, while the circlet and half of the tubing are early 20th-century reproductions of the originals in the Egyptian Museum, Cairo.
Collection and photo The Metropolitan Museum of Art, New York, USA

Opposite page:
The back and front of the burial circlet of Pharaoh Tutankhamen. Made most likely during the reign of Tutankhamen, who ruled from 1361-1352 BC. Gold, cornelian, turquoise, lapis lazuli, obsidian, chalcedony, malachite and paste.
Collection Egyptian Museum, Cairo, Egypt Photo Andreas F. Voegelin, Antikenmuseum Basel und Sammlung Ludwig, Basel, Switzerland

The most impressive royal circlet discovered must be the one that was excavated by the world-famous Howard Carter, when he opened the tomb of Tutankhamen in 1922 and revealed its fabulous contents. The jewel, which is sometimes referred to as *seshnen*, is also made of gold, and decorated with ornaments inlaid with semi-precious stones and paste. The circlet is clearly royal because it has both the uraeus *Buto* and the vulture *Nekhbet* or *Nechbet* on the front, representing two goddesses who were closely tied to the River Nile and adorned the crowns of Lower and Upper Egypt. The goldsmith who constructed the diadem of Tutankhamen made the uraeus and vulture detachable so that they could adorn any royal headwear.

For thousands of years gold was regarded as the most precious metal, and associated with the Sun, whereas silver was seen as closely tied to the Moon. In ancient Egypt, the pharaohs used large amounts of gold, and very few silver ornaments and jewellery were found until the 1930s. The English archaeologists Walter B. Emery and Mr L. P. Kirwan opened up burial chambers in Ballana and Qustul, and it became clear that the Cushites from the Kingdom of the Nubians in southern Egypt had chosen silver above gold for their crowns. In one of the chambers, they found the skeleton of a king lying on his right side, and on his head, which was turned to the south, there still sat an imposing silver crown set with garnets and carnelians. The front of this crown was decorated with a silver ram's head, and the top had the structure well known in Egypt from the pharaohs' *atef* crowns. The *atef* crown belonged to the god *Ra*, the cosmic deity who ruled over the earth when gods and mortals lived alongside each other in peace. When other chambers were opened, further skeletons were found with crowns, with decorations that showed their close links with the ancient Egyptian pharaohs and their extensive pantheon of gods and goddesses.

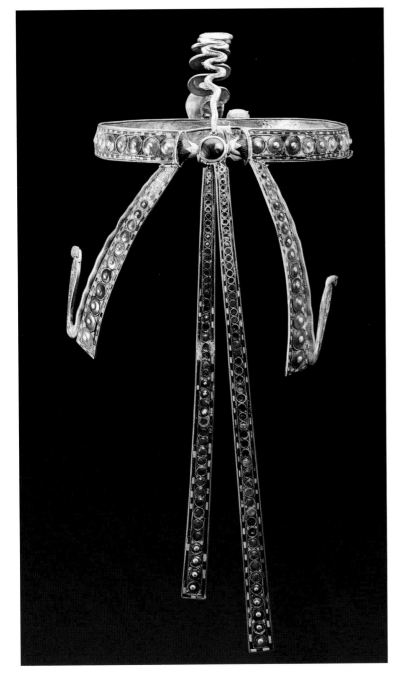

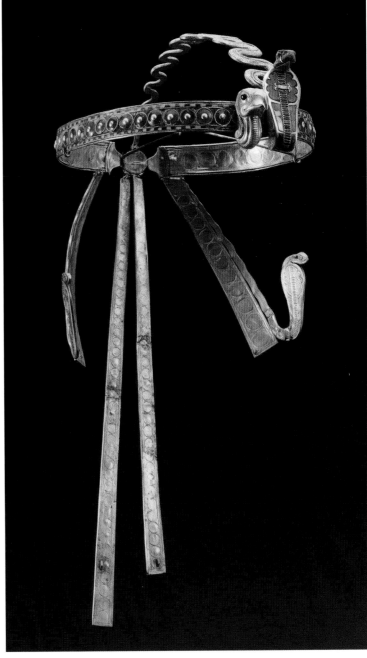

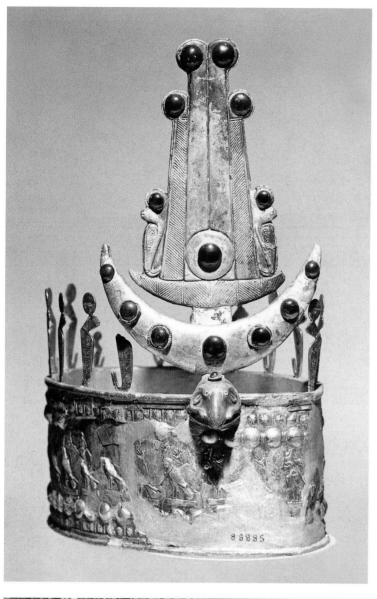

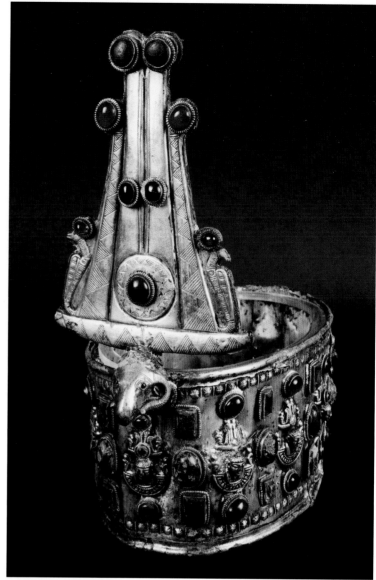

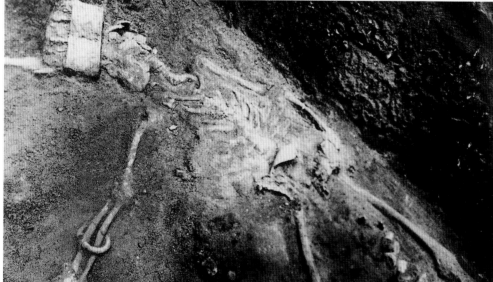

Top left:
Burial crown of a king of
Kutch. Silver, garnet and
carnelian; made during
5th-7th century AD.
Collection and photo
Egyptian Museum,
Cairo, Egypt

Top right:
Silver crown excavated at
Ballana Tomb number 95,
by W.B. Emery and L.P.
Kirwan in 1933.
3rd-7th century AD.
Collection Egyptian
Museum, Cairo, Egypt
Photo Sandro Vannini/
Corbis

Bottom:
During the excavations
of 1931-1933 at Ballana,
tomb number B80,
the skeleton of a king
was found in Room C
wearing a burial crown.
Photo Egyptian Museum,
Cairo, Egypt

Ghana

The lying-in-state of the rulers of Ghana used to be accompanied by human sacrifices, but fortunately this custom is no longer practised. What remain are the human skulls that decorate the drums of the court musicians. During the funeral ceremony, drums are sounded continuously; this is regarded as conversing with the gods. The body of the deceased king lies inside the palace, where his subjects and officials pay their last respects, surrounded by all the golden state regalia.

The deceased king wears a golden crown with stylised palm-tree leaves. This crown once narrowly escaped being melted down when it was stolen by two princes, Birikoran and Bosumphar (the sons of Nana Sir Ofori Atta I, who died in 1943). The princes were arrested before the crown was destroyed, and confessed their guilt to the magistrate of Suhum. The princes were sentenced to jail and penal servitude, and the crown was returned to its rightful place.

Painting by Cowan Dobson of Nana Sir Ofori Atta I, Omanhene of the Akyem Abuakwa Paramount Stool.
Photo collection René Brus

3.6.1976; lying-in-state of Nana Osagyefuo Ofori Atta III, Okyenhene of the Akyem Abuakwa Paramount Stool in the throne room of the Palace of Kibi.
Photo René Brus

Ecuador and Peru

Windsor Castle is not just the place where various kings and queens of England are buried; it is also where the burial crown of the unknown ruler of a vanished civilisation is kept. The object is made of pure gold, with an undecorated headband on which a crescent-shaped raised portion ends in a ten-part *aigrette*. In 1862, Antonio Flores Jijón, envoy from the Republic of Ecuador, arrived in England in order to present this crown as a gift to Queen Victoria on behalf of his president. The crown had been found in 1854 during an excavation in Cuenca. A plaque is attached at the back of the crown, engraved with a mountain, a ship, the Sun and the date 1862 surrounded by an eagle with spread wings.

The name *El Dorado*, meaning man of gold or golden land, referred to a number of countries in South and Central America where, in former times, powerful rulers had possessed enormous quantities of golden objects. With the discovery of the American continent by Christopher Columbus in 1492, the first stories about these golden treasures started to appear in Europe, which led Spanish soldiers and explorers or *conquistadores* like Francisco Pizarro to journey to the new continent. They penetrated the heart of the unknown kingdom, where in Cajamarca, Peru, they lured the last Inca ruler Atahualpa into a trap and killed him. The Incas' wealth was immeasurable because for centuries they had respected a tradition that the palaces of a dead monarch must remain intact with all their valuables and must not be touched by his successors. So every new Inca ruler had to build a new palace for himself, and the gold- and silversmiths had to make new ornaments. The *conquistadores* were only interested in the Inca gold and silver because of its financial value, and countless objects were destroyed or melted into gold bars. Luckily, however, some exquisitely fashioned ornaments and utensils from South and Central American culture have been preserved.

In 1889, a local resident was digging a drain near a monastery in the Ecuadorian city of Sigsig when he discovered a slab of gold attached to a wooden rod. After further digging, a grave was unearthed containing two bodies and a large number of golden objects, including two crowns. Both crowns have an upside-down crescent-shaped decoration on the headband on which a human face is depicted. One of the crowns has decorative golden plumes. The plume at the front boasts numerous little golden discs attached to small golden threads, which sway back and forth with the smallest movement. The crowns belong to the Chavín culture, which existed in Peru and Ecuador from 900 to 200 BC.

A man named Nicolas A. Robadenyra heard about the finds at Sigsig and travelled to the town. He was able to purchase a number of the discovered objects, including the two crowns. The crowns were put on public display as *llauto*, or Inca headdresses, in the town of Guayaquil in Ecuador, in November 1899. Five years later, Archbishop Federico González Suaréz published an article about this remarkable gold treasure with photographs. In September of the following year, the American archaeologist Marshall H. Saville visited Ecuador, heard about the existence of the Sigsig treasure and, on the eve of his departure back to the United States, managed to make arrangements to purchase the golden crowns and other objects from the grave. Ultimately, these archaeological treasures ended up in New York, where they are displayed as the Heye Foundation Collection in the National Museum of the American Indian.

Opposite page:
Burial jewellery,
including a crown.
Chimú culture. Gold;
circa 1300 AD.
Collection and photo
Museo Larco, Lima, Peru

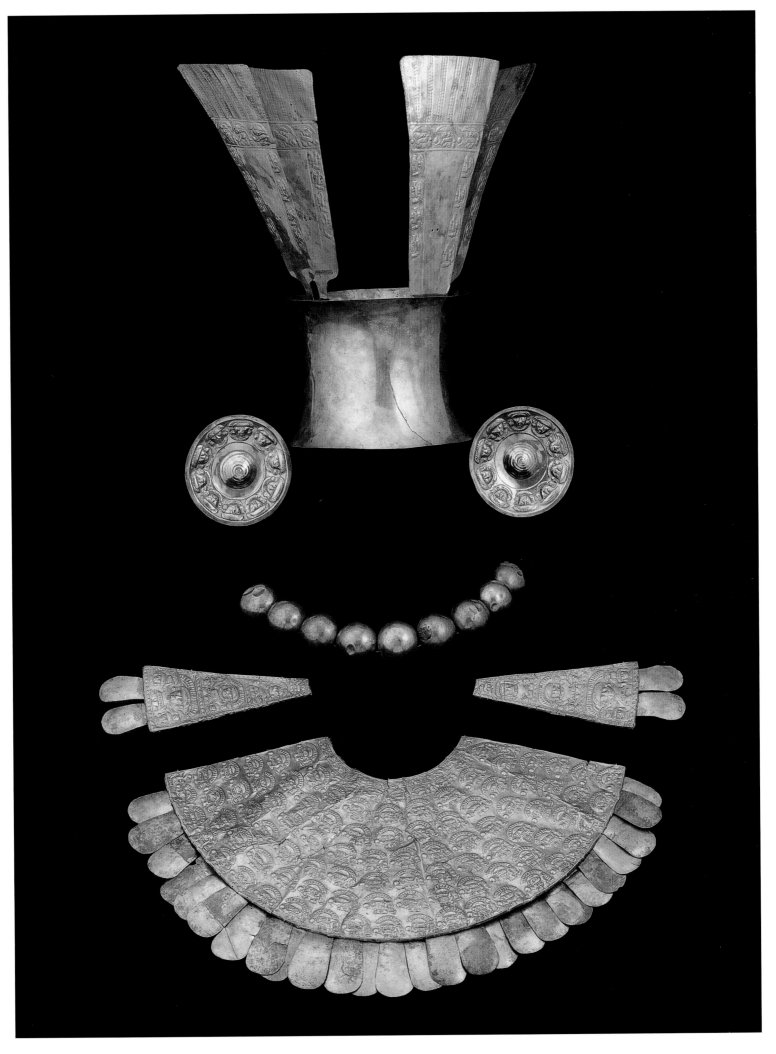

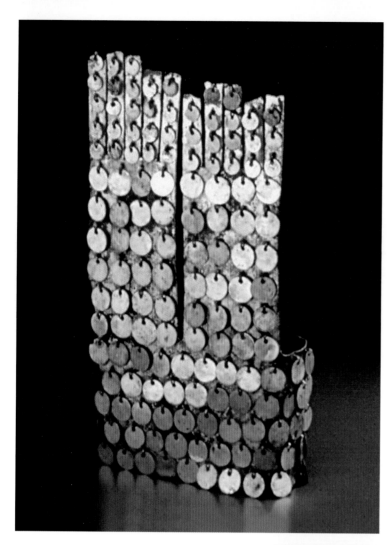

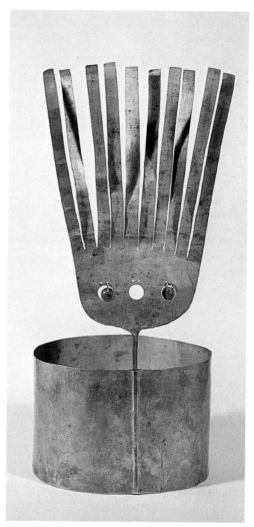

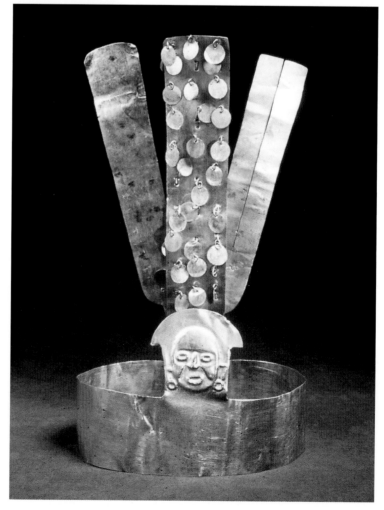

Crowns and the rituals of ordinary life

It is not just royalty and the nobility who wear crowns and elaborate headdresses. There are numerous ceremonies and rituals during which common people wear crowns or other types of highly crafted headdresses. These include the various rites of physical and spiritual passage that children go through, marriage ceremonies, inaugurations into guilds or other societies, and the type of events that have evolved into today's beauty pageants, to name just a few.

In many societies, some type of headdress or crown plays a part at various stages during the growth and development of a child. Cutting or shaving the hair may mark the passage from childhood to adulthood. This ritual is accompanied by festivities that include colourful clothes and a particular emphasis on decorating the hair with crowns, coronets, hairpins or other headdresses. There are also ceremonies associated with spiritual education in which particular types of headgear have a religious symbolism; these include receiving confirmation in the Catholic Church, initiation as a monk or novice in several religions, completing reading and studying the 114 chapters of the Quran and circumcision.

Weddings are an excuse for everyone to get dressed up, and special headdresses for the bride and sometimes also for the groom are common. In ancient times, nuptial wreaths made from flowers, especially snow-white flowers, were worn by brides as a sign of their virginity. The flowers and leaves used in these headdresses were generally associated with particular gods, and were intended to confer a long and happy marriage on the wearer. Gradually, wreaths made of more durable materials began to replace those created from short-lived plants or flowers. These became ornate and precious, using designs and colours that varied depending on the region and the wearer.

The symbolism of a crown that identifies a ruler or leader has been adopted by various guilds. When a guild choses a new chairman or leader, he is often crowned. For some guilds, this ceremony is hidden from the outside world and is only witnessed by a select group of people. Other guilds see an election and coronation as the perfect time for members of the guild to show the world their splendour. The guild of goldsmiths on Bali honour their new leader in a ceremony using headdresses similar to the splendid dance crowns or wedding headdresses worn in Balinese society. The crowns used by *meisterkranzes* or guilds in 17th- and 18th-century Switzerland were similar in shape

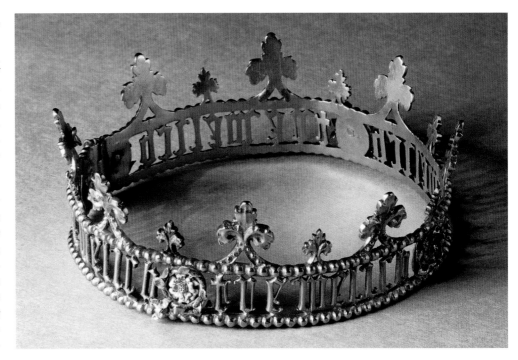

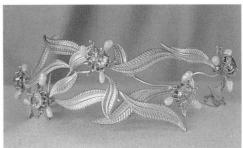

Top:
Bridal crown with the Middle English word *trewelich*, 'faithful', written on the headband four times. Gilded silver and enamel; made circa 1450.
Collection and photo Germanisches Nationalmuseum, Nuremberg, Germany

Bottom:
Bridal wreath worn in 1996 by a bride in Rijswijk, The Netherlands. Silver, cultured pearls and synthetic spinel; made in the 1980s.
Private collection Photo René Brus

to the wedding crowns worn in the region, and included motifs from nature, such as leaves, flowers, fruit or spider webs, to signify each particular guild.

In traditional agricultural communities, the election and coronation of a female virgin was often thought to bring a prosperous harvest. The 'Harvest Queen' was believed to symbolise fertility and was one of several traditional or religious positions given to young girls. Nowadays, the coronation of a young female in many societies has become increasingly commercial, taking the form of beauty competitions with elaborate crowns for the winner and sometimes for the runners-up as well. In most cases, the tiaras and crowns used to crown beauty queens are not very valuable. They are typically studded with paste or with synthetic stones such as *cubic zirconia*, used since the 1980s as diamond imitations. These inexpensive crowns become the property of the winner. In the few cases where the crown is made of precious metal and set with valuable gemstones and pearls, it remains in the possession of the competition organisers and is passed on to the next winner.

Hair cutting ceremony

The *tonsure* ceremony was for many centuries a very important rite of passage for children in several Asian countries, and was carried out throughout Thailand up until the end of the absolute monarchy in the 1930s. During the ceremony, which marked a child's transition into adulthood at around the age of 10 or 11, a hank of hair that had been allowed to grow since birth was cut. This hair would have been kept carefully combed and wound into a knot, and the rest of the head shaved. During the *tonsure* ceremony, the child would be adorned with beautiful clothes and jewellery. The hair knot would be fixed with an elaborate hairpin, sometimes up to seven centimetres long. This *pin chuk* was often made of gold adorned with enamel and precious stones.

For ordinary people, the *tonsure* festival usually took place in the grounds of a temple and many children would participate at the same time. During the ceremony, the hair knot was divided into three separate strands and each strand was wrapped with different *sincana*, wires of yellow gold, red gold and silver. Three elderly family members would then cut the three decorated locks of hair and the rest of the head would be shaved by a barber or another person with the appropriate skills.

Children of the nobility and princes and princesses of low rank wore jasmine or other sweet-smelling flowers around their hair knot and pin to simulate a coronet. The children of the king or a prince of high rank wore a genuine crown set with precious stones around the knot during important state functions. This ornament was often tapered in shape, resembling the king's crown, although much smaller in size and less elaborate.

At the Royal Palace, the special hairpin was call the *pin klau* or *pin ket*, and was an imitation of the bejewelled hairpin *cuda-mani* of the god Shiva. Princes and princesses of lower rank and the children of the nobility participated in joint ceremonies, whereas the son of a ruling monarch had an elaborate *tonsure* ceremony just for him. This ceremony was considered so important that, up until the late 19th century, it was regarded as the most significant ceremony following that of the king's coronation.

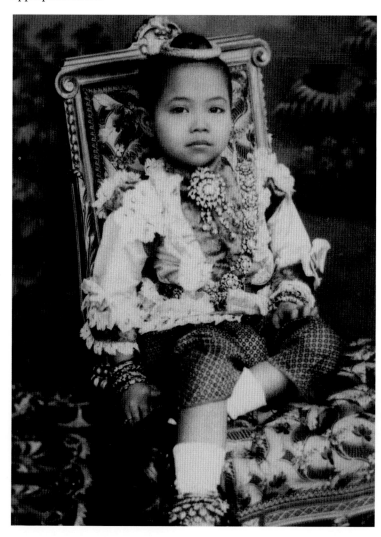

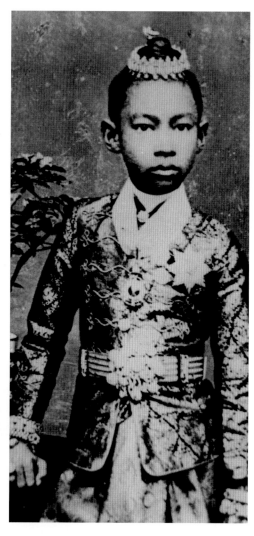

Left:
Circa 1890; one of the numerous Thai princes who underwent the traditional haircutting ceremony.
Photo collection René Brus

Right:
Circa 1890; Prince Purachatra Jayakar of Thailand, Prince of Kambaengbejra, wearing the traditional hair knot and coronet.
Photo collection René Brus

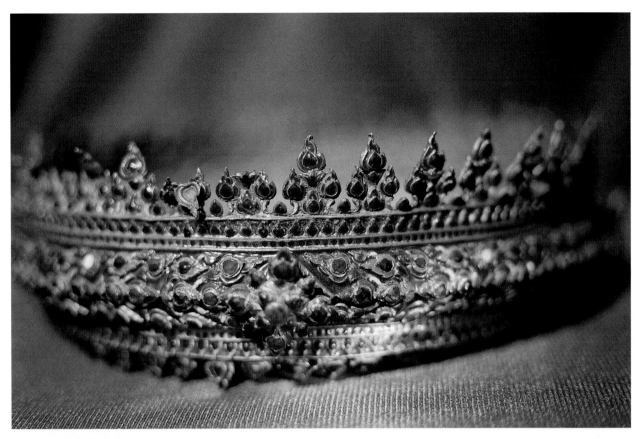

Coronet used for the *tonsure* haircutting ceremony. Gold, diamonds, rubies and enamel; made second half of the 19th century.
Collection Royal Thai Decorations and Coin Pavilion, Grand Palace, Bangkok, Thailand
Photo René Brus

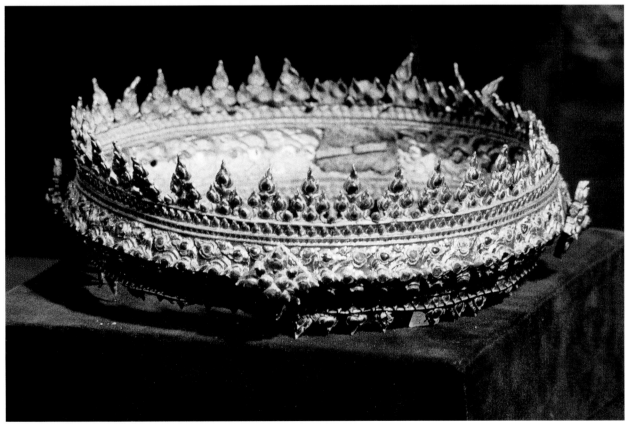

Tonsure coronet. Gold, diamonds and enamel; made second half of the 19th century.
Collection Royal Thai Decorations and Coin Pavilion, Grand Palace, Bangkok, Thailand
Photo René Brus

Circumcision

In Islam, male circumcision is an essential part of growing up, and usually occurs when a boy is between 10 and 12 years old. The day the circumcision is to take place starts with a feast. The boy is dressed magnificently, like a prince, to show that he is the centre of attention. He wears a crown that includes the important Islamic symbols of the five-pointed star and crescent. In south-east Asia it is not unusual to include other ceremonies during circumcision, such as the *Khatam al-Quran*, which marks when a Muslim child has completed reading and studying the 114 chapters of the Quran. This ceremony sometimes includes a public sitting-in-state, which is normally held for a newly married couple. During the circumcision ceremony, the boys are sometimes 'given' girl partners, usually a sister or another young female member of the family.

The circumcision ceremony of a prince in Kelantan is seen as the perfect occasion to display all the riches of the dynasty, including special ornaments that have been handed down from generation to generation, as well as those made specially for the event. On the circumcision day of Prince Mansor in 1933, he wore a costume of pale green silk interwoven with gold thread, which had been made for the day under the critical eyes of his mother. His long-sleeved tunic was high-necked with a raised collar, and a golden pendant hung around his throat. On each upper arm he wore three golden bracelets in the form of a dragon. At his waist an oval golden buckle was fastened, on which diamonds glittered in the raised filigree rosette. His golden filigree wire crown was set with small diamonds.

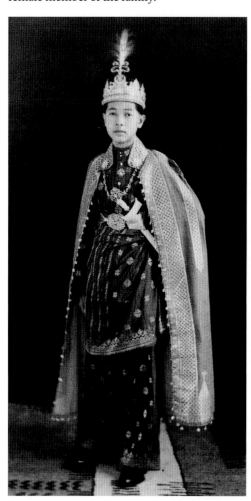

Left:
End 1930s; circumcision of Prince Salahuddin Abdul Aziz Shah of Selangor (born in 1926). The young prince wears the coronation crown of Selangor as his circumcision crown, but without the original diamond-studded spray with tiny stars, as this has been replaced by an *aigrette* made by Garrard in the 1920s.
Photo collection
René Brus

Right:
End 1930s; a boy and girl dressed in Javanese traditional attire for either the boy's circumcision ceremony or to mark the completion of their studies of the Quran.
Photo collection
René Brus

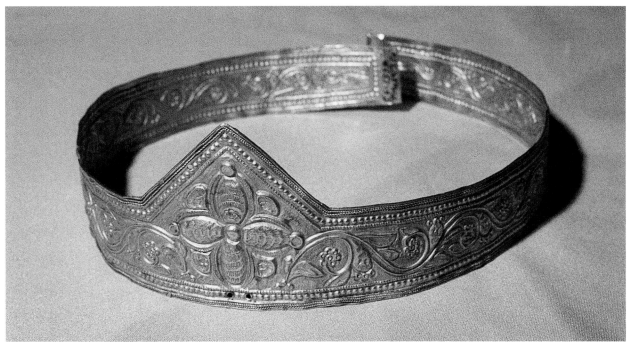

Gold tiara worn by female members of the Kelantan ruling family for their *Khatam al-Quran* ceremony. The original stone decoration is missing; made second half of the 19th century.
Collection Muzium Negara Malaysia, Kuala Lumpur, Malaysia
Photo René Brus

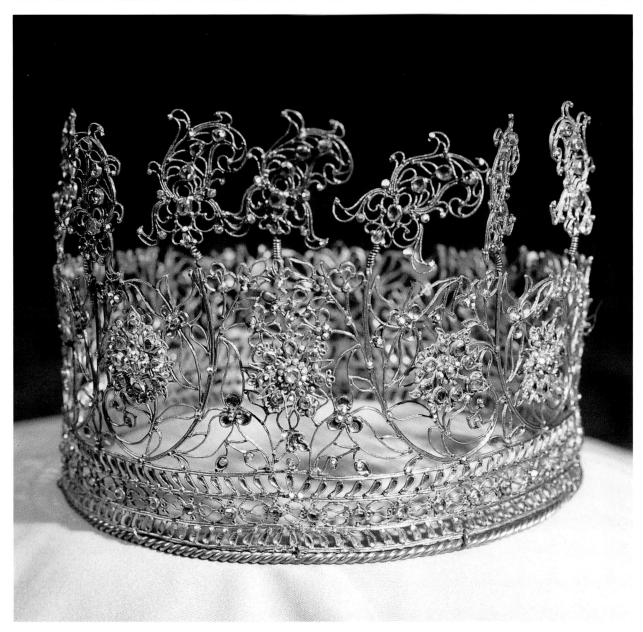

Circumcision crown of the Kelantan Sultan's family. This precious ornament, which, according to oral tradition, must date back to the end of the 18th or beginning of the 19th century, has been conserved by the sultan's family, although it has not been worn during a traditional circumcision ceremony since 1933. Gold and diamonds.
Collection of Raja Perempuan Anis of Kelantan, formerly collection of the late Raja Perempuan Zainab II of Kelantan
Photo René Brus

Novice initiation

The most important moment in the life of a young Burmese boy is his initiation into the order of monks as a novice, *shin-pyu*. To become 'human', he must withdraw from secular life for a few weeks or even several months, following the example set by Buddha when he left his family to seek enlightenment. During this time, the boy must study Buddhist scripture and adhere strictly to the codes of discipline. The boy's time as a monk generally occurs between his ninth and twelfth birthdays, and traditionally starts with an extravagant festival to which the whole village or neighbourhood is invited. At this festival, the boy is dressed in princely garments of silk and wears an impressive crown shaped like those worn by the kings of ancient royal Burma. Not every family can afford such an elaborate festival for their son, so it is often celebrated in a more modest, communal manner, with a number of boys entering *shin-puy* together, all dressed in princely costumes alongside their sisters dressed as princesses.

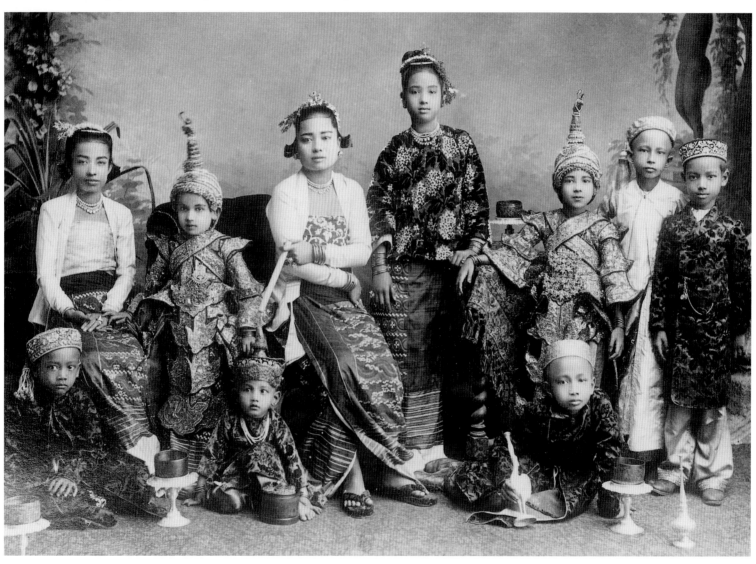

End of the 19th century; a group of Burmese youngsters probably dressed for initiation as novitiate monks.
Photo collection
René Brus

Celebration of the Holy Ghost

In the Azores, children wear crowns when they are the focus of the celebration of the Holy Ghost. The insignia of the Holy Ghost play a vital part in these celebrations and consist of a crown, a sceptre and a silver dish, all of which are decorated with a dove. These ceremonial objects are given to the 'emperor', usually a child, who keeps them at home in a special place. On the first Sunday after Easter (*Octave of Easter*), a 'coronation' ceremony is held at the local church, where the crown is placed on the head of the 'emperor'. After the ceremony, the crown, sceptre and dish are handed to another custodian, who is responsible for their safe-keeping for one week. Every successive Sunday, the insignia are handed over to another custodian until the final feast day, when they are placed in the chapel (*imperio*) or 'empire'.

1980s, celebration of the Holy Ghost in the Azores, Portugal.
Hans van Eyden and Bjørn Kleiberg, Amstelveen, The Netherlands

Oppernball

The long tradition of presenting the youngest scions of the aristocracy did not end with the abolition of the monarchy in Austria. On the Thursday before Ash Wednesday, the day after Shrove Tuesday when the traditional fasting in the Catholic Church starts, 186 young dance couples between the ages of 17 and 24 make their grand entrance in the Vienna State Opera to the strains of the slow march Fächer Polonaise. The debutantes are wearing their white dresses and metal dance crowns set with paste.

2003; opening Opernball
in the Vienna State
Opera building, Austria.
Photo collection
Robbert Koets,
The Hague,
The Netherlands

Kumari coronation ceremony

In the Kingdom of Nepal, a young girl known as the *Kumari* or *Kumari Devi* is worshipped and venerated as if she were a goddess. The Kumari is selected from girls aged between three and five years old; she must come from a 'pure' family and must never have shed blood, from a wound or menstruation. The Kumari is invested in a coronation ceremony and, at the moment she is crowned, the spirit of the goddess she represents enters her body.

The Kumari is crowned with the *motu*, or crown of gold, which consists of a broad shield of six jewel-encrusted horizontal bands fastened to fabric. The top part of the crown is always decorated with a fringe of fresh blossoms. The rim of the crown is set with nine large gemstones, in a talisman symbolising the nine planets and known as the *navaratna* or *navaratan*. Each planet has its own gem and the gem is worn to pacify that planet and the Hindu god associated with it. Jewellery containing the nine gemstones in a certain arrangement is therefore believed to become a storehouse of energy or power and enhance the life of the person who wears it. The use of *navaratna* gemstones differs in some societies, but they generally include a diamond, pearl, ruby, sapphire, emerald, topaz, cat's eye chrysoberyl, coral and hyacint zircon.

After the coronation ceremony, the Kumari was taken for an audience with the King of Nepal. Subsequently, the king paid homage to her every year during the Indra Jatra festival, which honours the weather god, Indra. Since the abolition of the monarchy in 2008, some parts of this ceremony might have changed. The Kumari also appears to the public during other important religious feast days, dressed as a goddess and wearing her crown. As soon as the Kumari reaches the age of puberty or hurts herself and sheds blood, she can no longer be a 'the Living Goddess' and her crown is passed to the next girl selected as the Kumari.

1970s; the Kumari or
The Living Goddess of
Kathmandu, Nepal.
Photo collection
René Brus

Weddings

The design, materials and colours used for bridal crowns varies from region to region. Bridal crowns can be decorated with human or animal figures, flowers, fruit, or the Sun, stars and crescent. Sometimes specific symbols are used, such as two clasped hands (a symbol of love and fidelity), a baby in a cradle (fertility) or household objects such as baskets and soup bowls (prosperity). The materials used for bridal crowns can vary from natural materials to precious metals and precious stones. For many, the pearl is pre-eminent in the adornment of the bridal headwear. According to the ancient Romans, the pearl belonged to the goddess Venus, as legends claim that pearls are her frozen tears. For many Christians, the virgin pearl belongs to the Virgin Mary, while the Hindus claim that the pearl is closely connected with the god Vishnu. Today, the diamond or pearl tiara is a common sight at weddings around the world, while some cultures preserve their own particular style of wedding headdress. White is usually used in abundance, to symbolise the bride's chastity. In some cultures, red in the form of blood coral, ruby or cornelian is believed to protect the bride against miscarriage. Green is an auspicious colour in Islam, and sky-blue represents virginity for some Christians (in the early Middle Ages, the Virgin Mary was frequently portrayed wearing a blue robe). Blue can also be associated with the hope that the first-born will be a boy so that the family name (and possessions) can be kept in the family.

Whatever the origin for using the colour blue, many English-speaking countries have a saying that a bride should always wear *something old, something new, something borrowed, something blue* on her wedding day. This saying used to include the line, *and a silver sixpence in your shoe*. By putting a coin in her shoe, the bride forestalled money troubles later. A specific belief was attached to each element in the rhyme, *something old* and *something new* symbolising the transition of the new married couple from the old life to the new. The *something borrowed* should come from a happily married woman, to create happiness in the marriage. A piece of jewellery is usually borrowed for the occasion, or different types of jewellery, including buttons, brooches and earrings, are assembled from members of the family to create a spectacular, temporary headdress for the bride, and sometimes for the bridegroom as well. *Something blue* can be used as a colour for every optional item, and symbolises fidelity, good fortune and love. Although generally the bride steals the attention with her costume on her wedding day, some societies dress the bridegroom equally splendidly, as they regard the wedding couple as 'king and queen for a day'.

Wreaths are commonly used as bridal head decorations. At the time of the Roman Empire, bridal headdresses were made using myrtle, because it symbolised Venus, the goddess of beauty. Other sweet-smelling blossoms were also used in bridal wreaths, including jasmine, orange, lemon and bitter orange, all associated with Pomona, the goddess of fruits and fruit trees. Since it was not possible to find these blossoms all year round, the tradition arose of imitating these 'natural jewels' with precious metals, pearls, precious stones and other valuable materials. In the 14th century, European bridal wreaths modelled on leaves and flowers were also known as *guirlandes*. The Italian family of goldsmiths, the Bigordi, were given the nickname *Ghirlandaio* as they were well known at the time for creating such wreaths.

Bridal crown worn
by Brigitta Stuyling
when she married
Pieter Schaak in 1664.
This crown contains
numerous decorative
figures that are symbolic
for a happy and
prosperous marriage
blessed with many
children. Gold, silver, iron
and glass; made in 1664.
Collection and photo
Amsterdams Historisch
Museum, Amsterdam,
The Netherlands

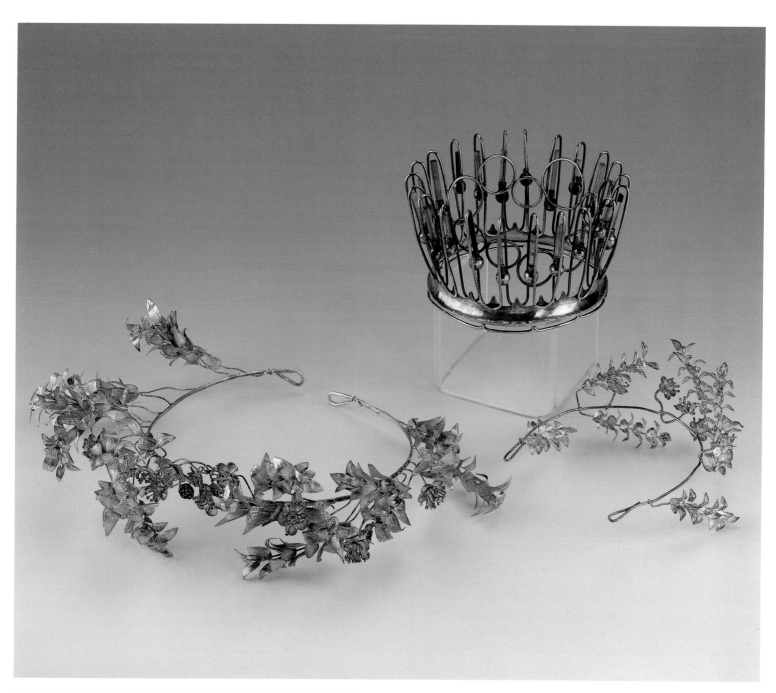

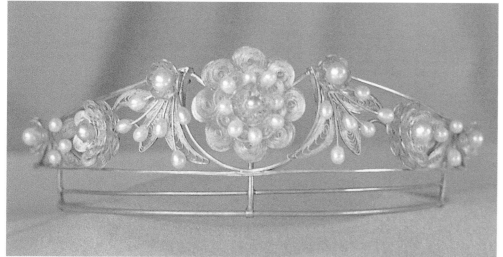

Top:
Two silver myrtle
wreaths from the
second half of the 19th
century and one gold
bridal crown set with
tourmaline crystals from
the 1960s. These types of
wreaths were still made
in the beginning of the
20th century in German
jewellery-making and
stone-cutting centres,
such as Pforzheim,
Hanau and
Idar-Oberstein.
Collection and photo
René Brus

Bottom:
Tiara worn in the 1990s
by a bride from Seville,
Spain. Gilded silver and
cultured pearls.
Private collection
Photo René Brus

Chinese bridal crowns

Chinese brides and grooms who marry in the traditional manner dress like an emperor and empress; this includes the wearing of impressive jewellery. The bride wears a *chao guan*, a very large, impressive headdress resembling a garden in full bloom based on the headdresses worn by Chinese empresses. Stylised flowers, fruits, birds and other symbolic and auspicious tokens were poised on wires and tiny springs so that the whole piece trembled at the slightest movement. The bride's crown almost always includes a phoenix and a dragon. The phoenix is a symbol of eternal youth and immortality in many cultures because, when this fabled bird grows old, it incinerates itself on a nest of spices and then rises rejuvenated from the ashes. In Chinese tradition the phoenix, or *fenghuang*, is associated with the empress, while the dragon, or *long*, is associated with the emperor and represents justice, authority and power. In Chinese mythology, the fire-breathing dragon is also associated with the gods of the four cardinal directions, along with the tiger, tortoise and vermilion bird.

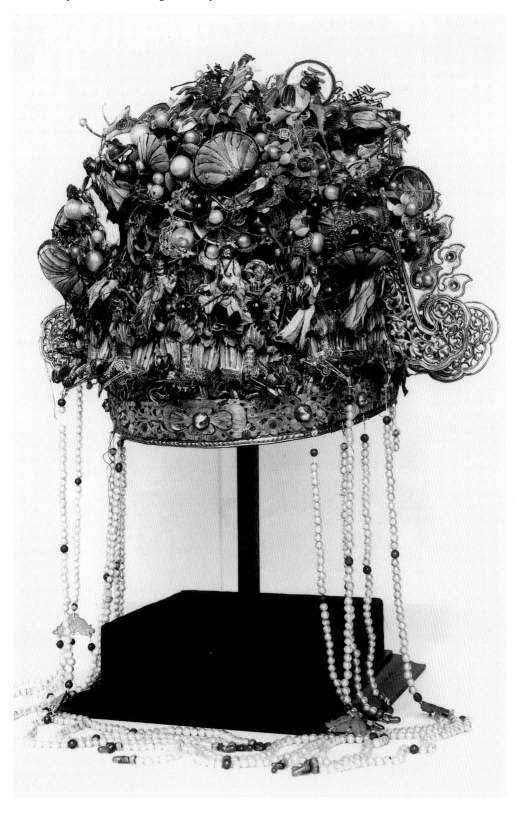

Left:
Bridal crown from the collection of the Summer Palace of the Chinese Emperor. Gold, (gilded) silver, pearls, jade, cornelian, blood coral, tourmaline and glass; made in the 19th century.
Collection and photo Victoria & Albert Museum, London, England

Right:
A Chinese bride photographed around the turn of the 20th century.
Photo collection René Brus

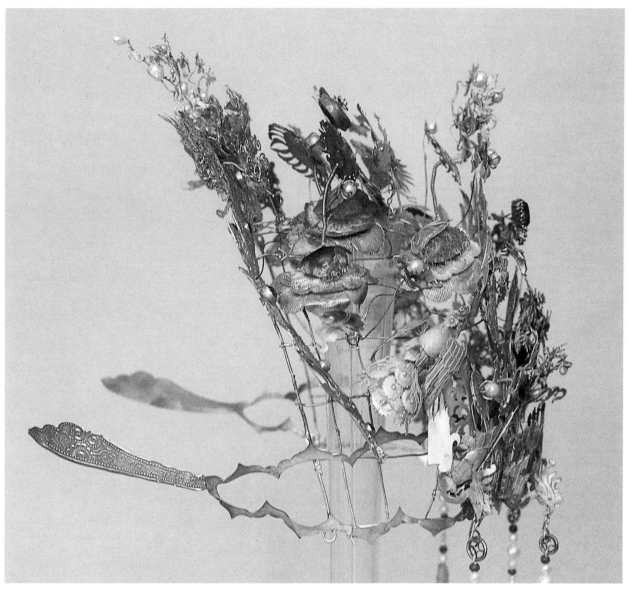

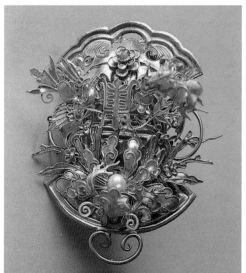

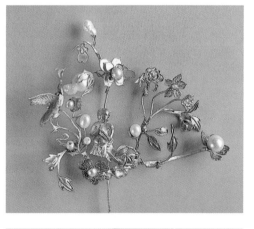

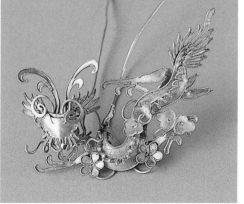

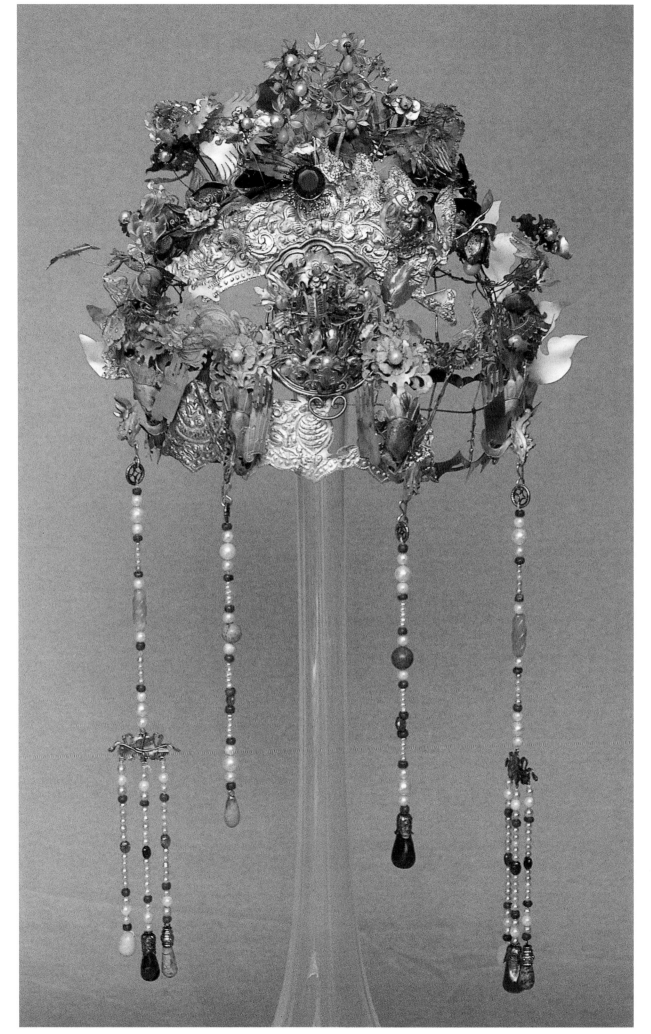

This and opposite page: This bridal crown has adopted its decorations from the crowns worn by Chinese empresses during the Ch'ing dynasty. It is decorated with several mythical and symbolic figures including the phoenix, dragon crane and bat. Gilded, silver, pearls, red coral, turquoise, turmalin, jade and Pekin glass; made in the 19th century.
Private collection
Photo René Brus

Headdresses worn by Chinese brides include numerous other symbols, such as the peony for love and female beauty, and plum-tree blossom for winter, female innocence and marriage. Long life and wisdom are represented by the figure of Shou-Hsing, the god of long life, leaning on a stick and with a plum in one hand, which represents immortality. For the *Peranakan* (local born or Straits) Chinese in south-east Asia, the wedding headband almost always includes a three-dimensional figurine of Shou-Hsing along with miniature figures of the eight immortals of Daoism. These immortals protect the bride during the time she is believed to be most vulnerable to evil influences. As charms or amulets they protect the wearer against misfortune. The eight immortals represent ordinary people who were deified after a lifetime of good works and miracles, and are normally depicted as a group because they are the heroes and heroines of many Chinese folk tales and anecdotes. The true identities of some of these eight immortals (*Ba Xian* or *Pa Shien*) are much disputed and their names vary. Their most common names are Zhongli Quan, Han Xiang, Cao Guojiu, Lan Caihe, Li Tieguai, Zhang Guolao, Lü Dongbin and the only female member He Xiangu.

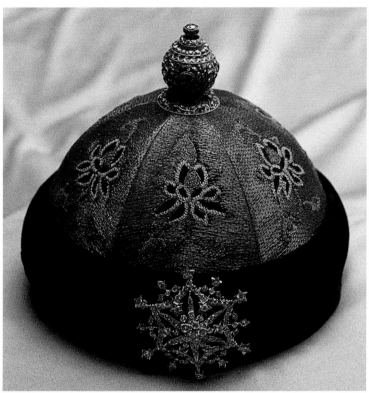

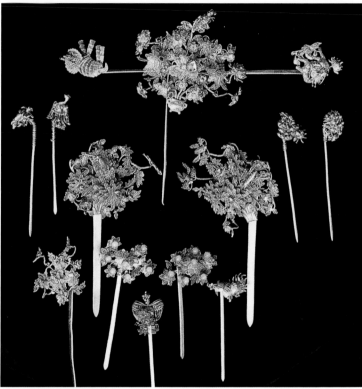

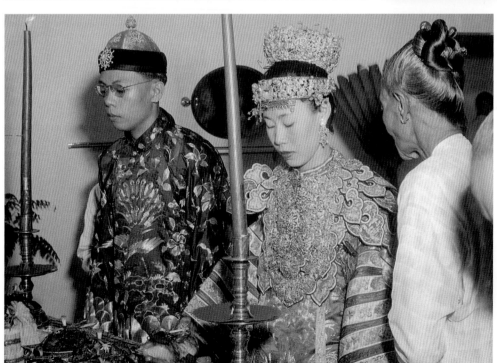

Top left:
Bridal hat based on Chinese mandarin hats. Gold, diamonds, velvet and embroidered silk; end of the 19th century.
Collection Ong family, Malacca, Malaysia
Photo René Brus

Top right:
Hairpins like the sundal melor and bunga emas are carefully pushed into the hairbun of the bride. Between 100 and 150 of these hairpins form the wedding crown of a Peranakan bride. Gold, silver, diamonds and pearls; made end of the 19th century.
Collection Ong family, Malacca, Malaysia
Photo René Brus

Bottom:
24.7.1952; Mr and Ms Ong Sek Choo during their wedding ceremony in the Malaysian town of Malacca. The bride and groom are both wearing precious family jewels of the Ong family.
Photo collection René Brus

The figurines of the eight immortals were sewn onto a headband made of black cloth, known to the *Peranakan* Chinese as the *pak sian*. This headband finds its origins in the *jin yu*, the headband worn on the brow by women of the aristocracy and high officials at the court of the Chinese Emperor, and was already known during the Ming dynasty (1368-1644). The *jin yu* was made of separate golden plaques set with precious stones, such as blood coral, lapis lazuli and pearls. Only women of high rank were permitted to wear such costly headbands; women of lower ranks wore headbands made of black satin.

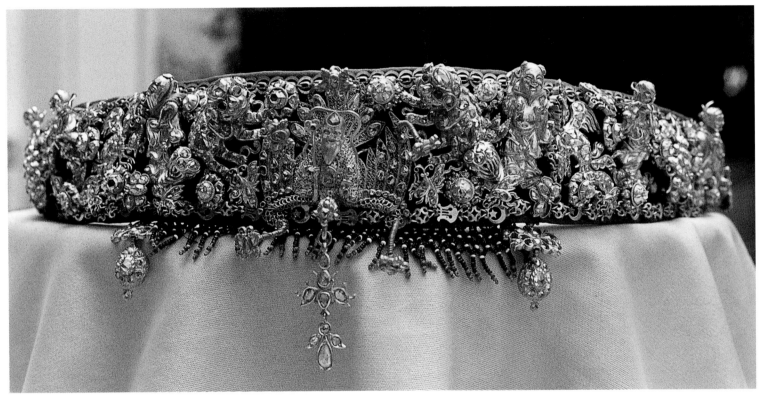

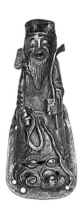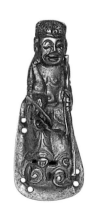

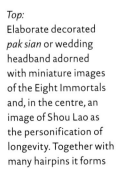

Top:
Elaborate decorated *pak sian* or wedding headband adorned with miniature images of the Eight Immortals and, in the centre, an image of Shou Lao as the personification of longevity. Together with many hairpins it forms the traditional bridal headdress of the Peranakan Chinese bride. Gold, silver, diamonds, glass beads and velvet; end of the 19th century.
Collection Ong family, Malacca, Malaysia
Photo René Brus

Bottom:
Silver miniatures depicting seven of the eight Chinese Daoist immortals. Second half of the 19th century.
Collection and photo René Brus

Southeast Asian bridal crowns

In some societies, it is customary for the bride to wear her hair loose on her wedding day as a sign of her virginity. In southeast Asia, the bride usually wears her hear tied into a knot, or fastened in some other way, which gives her the ability to use one or more hair decorations. Poetry describing the celebration of a wedding sometimes mentions in detail the jewellery that the bride wears. The popular version of the Indonesian work *Jaya Langkara* describes the appearance of a Javanese beauty as follows, '*she bound up her hair, fastening it with the glung (or knot), and decorating it with the green champaca flower; and in the centre of it she fixed a golden pin, with a red jewel on the top, and a golden flower ornamented with emeralds ... her jimang (tiara or head ornament) was of fashion sado soar and richly chased ...*'

Javanese bridal coiffure includes an ornament in the form of a Garuda, a mythical giant bird and mount of the god Vishnu, with wide, outstretched wings. This ornament is used to hold the bride's hair coils in place and is arranged to point backwards, so that it can only be seen from behind the bride. Javanese men also used to hold their long hair in place with a similar ornament during their wedding. The brow-piece is a headband made up of thin embossed plates depicting all kinds of figurines, stylised flowers, flower tendrils and fruits. In a number of districts, this diadem or *djamang* is attached to the bridegroom's *kuluk*, the truncated head cover.

In the *Ramayana*, literally 'the wanderings of Rama', one of the two great epics of India, Princess Sita Dewi wore jewelled butterflies in her raven-black hair on the day she married Prince Rama. In south-east Asian folk stories, if a *rama-rama* or *kupu-kupu* (butterfly) enters the house where an unmarried, eligible lady lives, she can expect a wedding proposal or *meminang* very soon. In some districts of the Indonesian island of Sulawesi, hairpins worn by a bride have filigree tops shaped like a butterfly, and the hairstyle of a Javanese bride, who dresses in the traditional bridal attire of the Surakarta and Yogyakarta dynasties, also includes hairpins in the shape of quivering butterflies. The butterfly is regarded in some cultures as a symbol of the higher emotions, including love, and represents Psyche, the mistress of Eros, the god of love in Greek mythology. However, in western civilisations the butterfly is also found in mourning jewellery, because it symbolises Christ's resurrection

and therefore the resurrection of all humans. The life cycle of a butterfly is compared with that of humans, the larva representing life, the chrysalis death and the adult butterfly the resurrection. In several types of Chinese bridal headdresses, the beautiful butterfly also symbolises sadness, for it tells the legend of Liang Shanbo and Zhu Yingtai, two lovers who, in this Chinese version of Romeo and Juliet, are reborn as two beautiful butterflies after their tragic death. However, the butterfly in the Chinese tradition is also synonymous with the summer, a long life, joy and marital blessings.

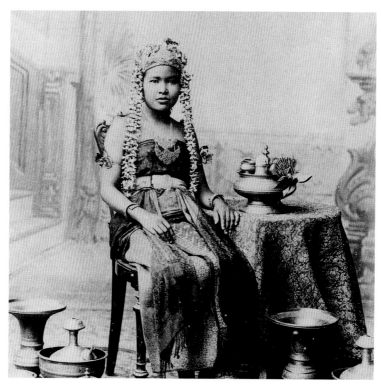

Top and bottom:
A Javanese bridal couple traditionally attired, photographed end of the 19th, beginning of the 20th century.
Collection and photo Koninklijk Instituut voor de Tropen, Amsterdam, The Netherlands

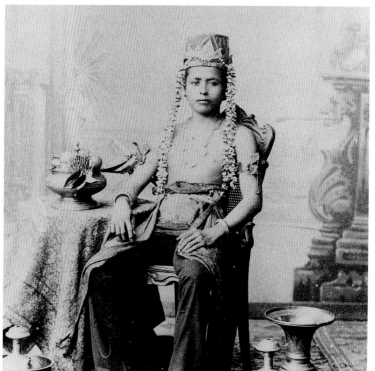

Opposite page:
Bridal tiara from southern Sulawesi. Silver and diamonds; made around the turn of the 20th century by a Chinese silversmith for a Dutch lady.
Collection and photo René Brus

Javanese *garuda songga galung* bridal tiara. Gilded silver; made end of the 19th century. (The photographer mistakenly placed the Garuda bird in front of the headband instead of at the back.)
Collection and photo René Brus

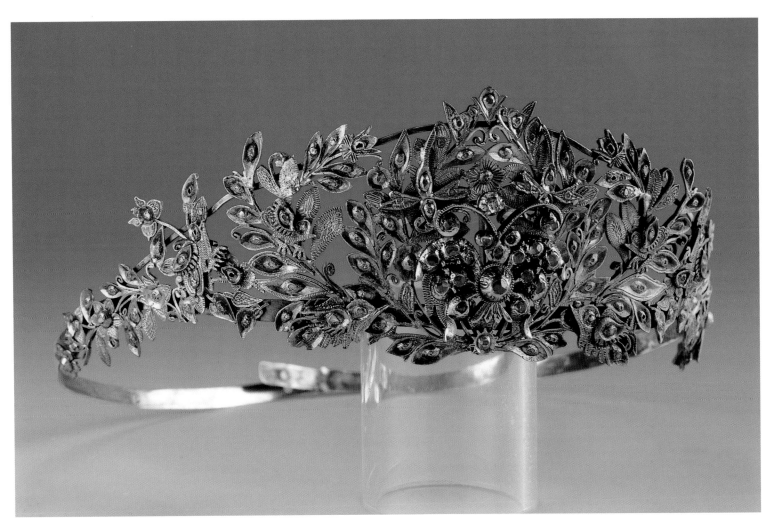

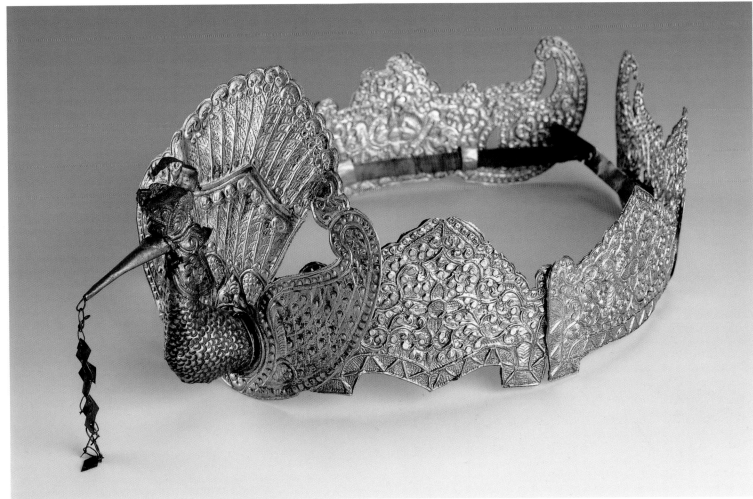

Scandinavian bridal crowns

Bridal crowns can be expensive and in some societies a bridal crown can be borrowed if the family of the bride or groom cannot afford such a valuable piece of jewellery. In Scandinavia, bridal crowns loaned out by the church or town hall might originally have been the nuptial headdress of a member of the aristocracy.

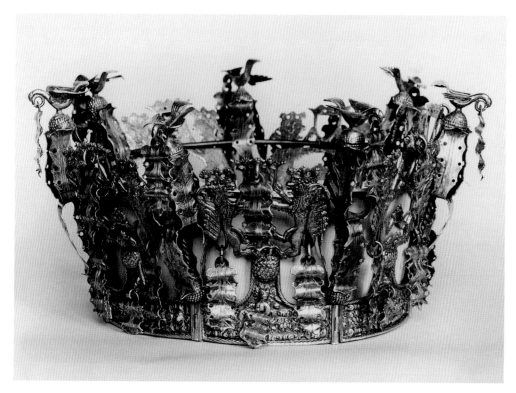

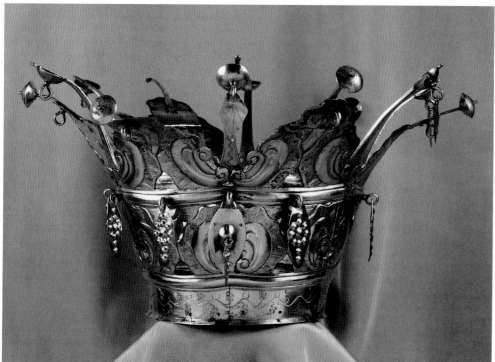

Top left:
Norwegian bridal crown. Silver-gilt; made in the 17th century.
Collection Victoria & Albert Museum, London, England
Photo René Brus

Top right:
A Norwegian bride in traditional bridal costume and jewellery from Gloppen N. Fjörd.
Photo collection Norsk Folkemuseum, Oslo, Norway

Bottom:
Norwegian bridal crown. Silver and silver-gilt; made in the 19th century.
Collection Victoria & Albert Museum, London, England
Photo René Brus

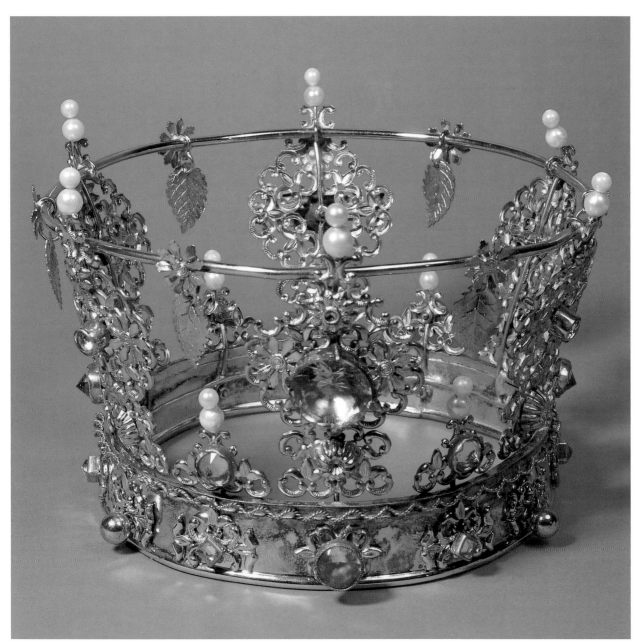

The design of this bridal crown is based on 16th and 17th century old Scandinavian bridal crowns. Gilded silver, rock crystal and pearls; made first half of the 20th century.
Private collection
Photo René Brus

Bottom, left and right:
Bridal *parure* (a suite of matching jewellery) includes a circlet, two brooches, earrings, a pendant, two bracelets and 19 hairpins, which was given to the Stjärnorp Church in 1781 by Countess Märta Catharina Douglas, born a Montgomery. The crown was also worn by female members of the Douglas family during their weddings. Silver, rock crystal and diamonds; made in the 18th century.
Collection Vreta kloster kyrkliga samfällighet, Ljungsbro, Sweden
Photo René Brus

Religious wedding crowns

In some societies, royal crowns are used during the religious marriage ceremony of common people. In Orthodox Christian churches, two often identically shaped and decorated crowns are held above the heads of the bridal couple, thus bestowing divine power upon them. In some Orthodox churches, for instance the Coptic Church, these wedding crowns are actually placed on the heads of bride and groom and worn on two occasions, during the religious celebration of their engagement and subsequently during the church blessing of their marriage.

The treasury of Trinity Cathedral, built in the Ethiopian capital Addis Ababa in 1941, contains several crowns that have been donated to the Church and which are used as wedding crowns, unlike many other votive offerings, which usually adorn the statues of saints. The tiara of Empress Wayzaro Menen, wife of Emperor Haile Salassie of Ethiopia, includes a Latin cross and is worn by a bride during the wedding consecration, while the princely crown with the cross and Star of Ethiopia is worn by her bridegroom.

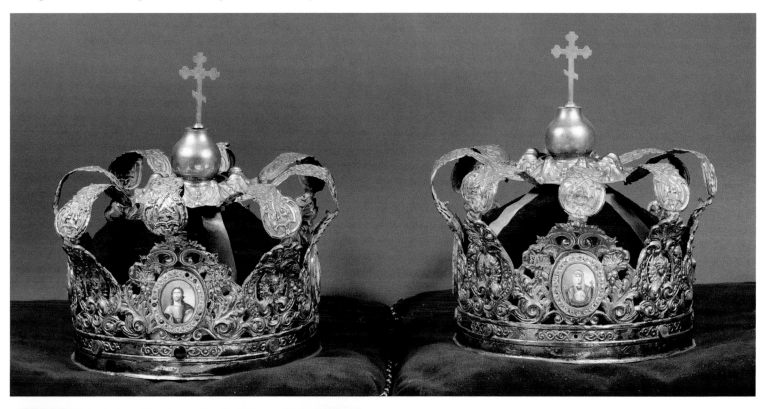

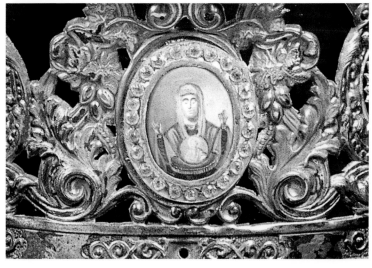

Wedding crowns from the Royal Chapel, Athens. Said to have been originally used in weddings where members of the Greek Royal family were best men or bridesmaids. Gold, enamel and precious stones; made in the 19th century.

Collection National Historical Museum/ The Historical and Ethnological Society of Greece, Athens, Greece Photo by courtesy of the General Secretary of The Historical and Ethnological Society of Greece, Athens, Greece

Crown of a prince belonging to the Ethiopian Imperial Family used nowadays as a wedding crown. Gilded silver; made in the 1930s.
Collection Holy Trinity Cathedral, Addis Ababa, Ethiopia
Photo René Brus

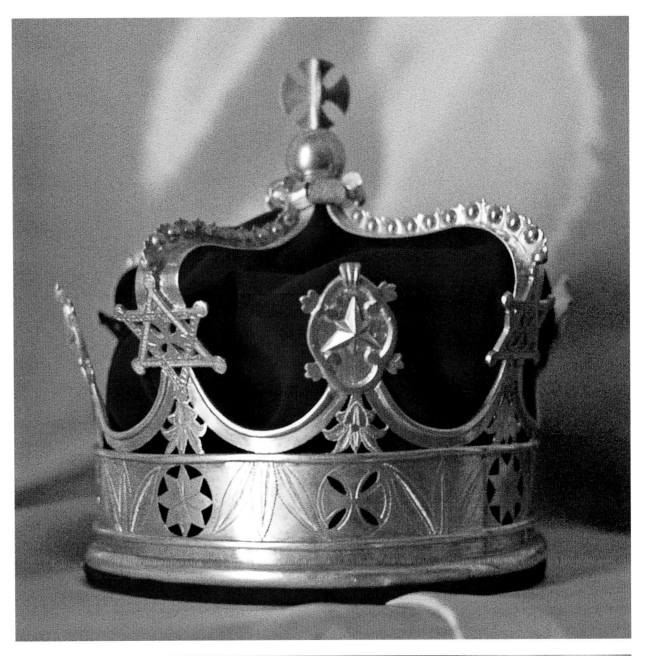

Tiara of Empress Wayzaro Menen used today as a wedding crown. Gold, diamonds and amethysts; made circa 1930.
Collection Holy Trinity Cathedral, Addis Ababa, Ethiopia
Photo René Brus

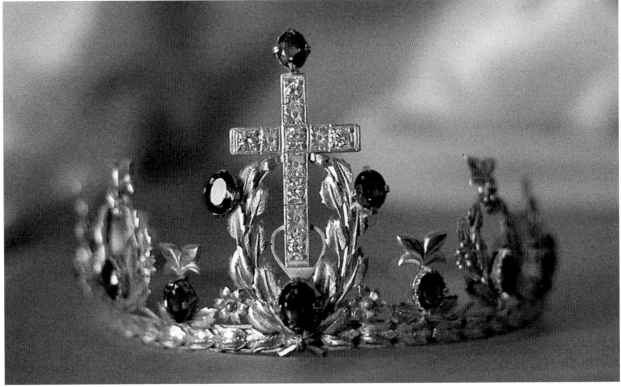

Guilds

Guilds are associations of craftsmen or merchants formed to protect their mutual professional interests. They often determined quality standards, maintained stable prices and trained apprentices. Merchant and trade guilds came into their own in mediaeval Europe. As they grew and evolved, they developed internal hierarchies that resembled those in a royal court. In England in 1448, Cuthbert Beeston, the Master of the Girdlers' Guild, presented the guild with a crown made of fabric embroidered with gold wire, the so-called 'cloth of gold'. Ever since then, the Master, who holds the appointment for 12 months, has been crowned after his election. There are also coronets made of fabric embroidered with gold wire for the three Wardens – the Upper Warden, Middle Warden and Renter Warden – and the Master will have served in each of these posts for 12 months before succeeding as Master.

The election and coronation of the Master takes place annually on 27 July. The original crown of the Master of the Girdlers is no longer used for this ceremony, as it was badly damaged on 29 December 1940, during the bombing of London by Nazi Germany. The Royal School of Needlework in South Kensington, London, made a copy of the damaged crown and the three wardens' coronets, and the school's principal, Lady Smith-Dorrien, presented the new crowns to Lionel Vincent Straker, Master of the Girdlers' Company, in 1941.

1922; coronation of George Brigs as the Master of the Girdlers' Company. Photo *the Illustrated London News*, London, England

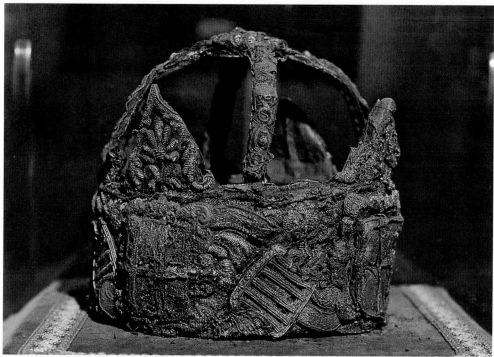

The damaged crown of the Masters of the Girdlers' Company. Gold embroidery; made in 1448. Collection The Girdlers' Company, London, England Photo René Brus

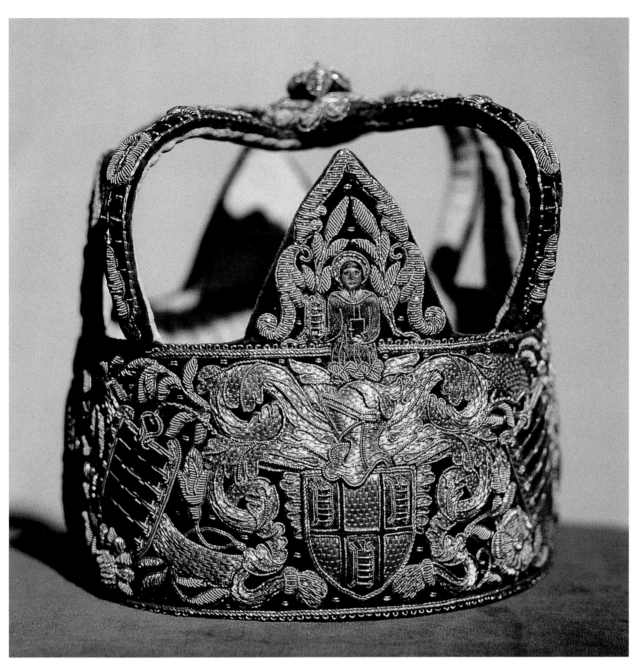

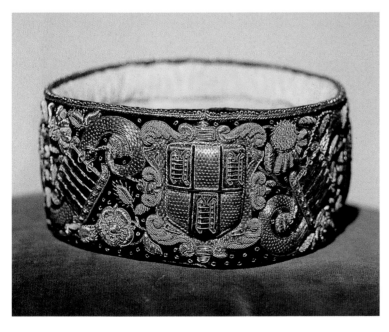

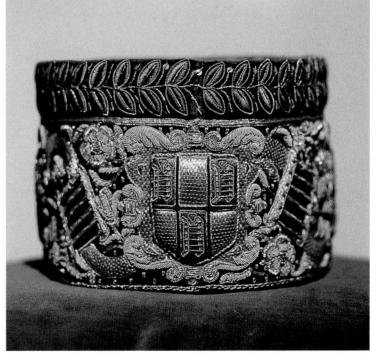

Top:
Crown of the Master of
the Girdlers' Company.
Gold embroidery;
made in 1941.
Collection The
Girdlers' Company,
London, England
Photo René Brus

Bottom left:
Crown of the Renter
Warden of the
Girdlers' Company.
Gold embroidery;
made in 1942.
Collection the
Girdlers' Company,
London, England
Photo René Brus

Bottom right:
Crown of the Upper
Warden of the
Girdlers' Company.
Gold embroidery;
made in 1941.
Collection The
Girdlers' Company,
London, England
Photo René Brus

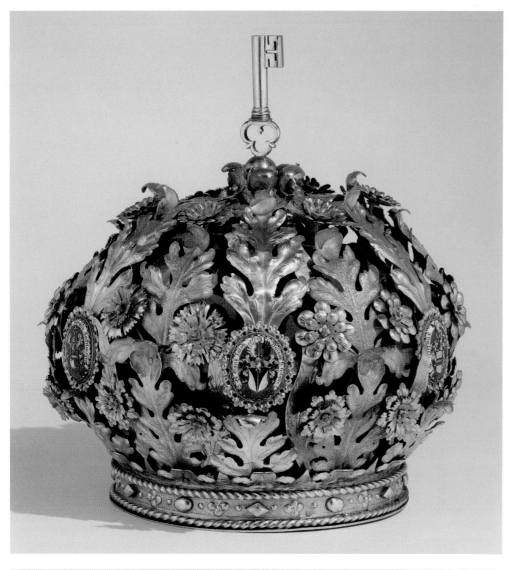

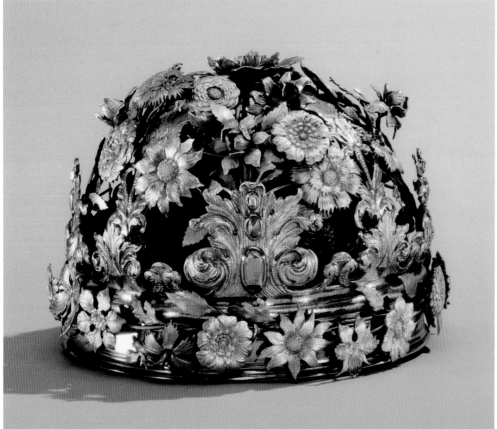

Left:
Meisterkrone der Zunft zum Schlüssel, crown of the guild of Key-makers. Silver and gold; made in 1699 by Christian I. Bavier, Basel.
Collection Historisches Museum, Basel, Switzerland
Photo Historisches Museum Basel/B. Babey

Right:
Meisterkrone der Zunft zu Rebleuten, crown of the Guild of Vintners. This crown is decorated with 70 naturalistic bunches of grapes. Silver and gold; made in 1671 by Christoph I. Beck, Basel.
Collection Historisches Museum, Basel, Switzerland
Photo Historisches Museum Basel/P. Portner

Bottom:
Meisterkrone der Zunft zu Hausgenossen, crown of the Guild of Builders. This crown is decorated with different types of flowers, including the rose and acanthus leaves. Silver and gold; made in 1663 by Christoph I. Beck, Basel.
Collection Historisches Museum, Basel, Switzerland
Photo Historisches Museum Basel/B. Babey

Beauty queens

Beauty queens evolved in the 20th century from the symbolic queens (and sometimes kings) chosen during traditional festivals such as May Day and harvest celebrations. Nowadays, beauty queens are chosen to represent all kinds of places and organisations, from a small village to a country, from a region to the world, and from the South Carolina Watermelon Queen in the United States to the Pearl Princess of Japan. The major contests typically have a coronation ceremony, in which the winner invariably receives a crown, and sometimes a cloak and sceptre as well. In general, the crown and other objects belong to the organisation that organises the festivities and they are loaned out to the queen for a specific period of time.

Left:
1988; Margrit Klein, *Naheweinkönigin* or Wine Queen for the German wine district of Nahe in 1988-1989, with her gilded tiara, set with stones made of gemstone chrysophrase.
Photo collection René Brus

Right:
Crown worn in 1950 by Susanne Erichsen when she was elected as the first Miss Germany after the *Bundesrepublik Deutschland* was established after the Second World War. Gilded metal and paste.
Collection and photo Haus der Geschichte der Bundesrepublik Deutschland, Bonn, Germany

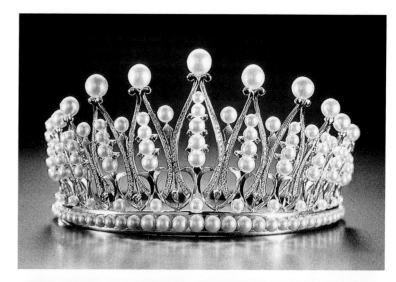

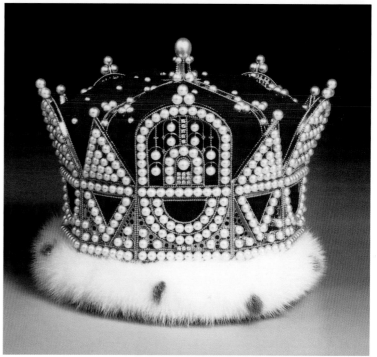

Left:
The 1988 Pearl
Princess.
Photo Japan Pearl
Exporters' Association,
Kobe, Japan

Top right:
The Pearl Princess tiara
of the Japanese Pearl
Exporters Association.
Gold, diamonds,
emeralds and cultured
pearls, including Akoya
and South Sea pearls;
made in the 1980s.
Collection and photo
Japan Pearl Exporters'
Association, Kobe, Japan

Bottom right:
The second Mikimoto
Pearl crown. Gold,
diamonds and cultured
pearls, including one
16 mm silver coloured
pearl in the top;
made in 1979.
Photo K. Mikimoto &
Co Ltd, Toba, Japan

Military headdresses and war booty

The tradition of wearing distinctive military headdresses probably dates back to the time when leaders of nomadic tribes needed visible identification when they went into battle. The hats, caps, bonnets, diadems and crowns worn in the battlefield were created from local and imported materials, which, from the earliest times, included the fur and skins of dangerous wild animals. Powerful and mythical creatures have always frightened humans, so it was natural to decorate the impressive headdresses of leaders with their fearful features. The remarkable shapes, colours and materials of war and military headdresses gave these items such importance that societies gradually began to treasure them, keeping them under guard to protect them.

In ancient Egypt, the cobra was placed upon the brow of the pharaoh's crown to protect him against his enemies. This serpent emblem, or *uraeus*, was the representation of the goddess Wadjet (also called Buto) of Lower Egypt and adorned the *deshret* or red crown of Lower Egypt. The vulture goddess Nekhbet of Upper Egypt adorned the *hedjet* or white crown of Upper Egypt. The pharaohs wore both the cobra and vulture symbols fastened on different crowns and headdresses. These included the blue-coloured *khepresh* or war crown and the *pschent*, the 'Two Powerful Ones', a double crown combining the red and white crowns of Lower and Upper Egypt and symbolising the ruling of the two lands as one. Since none of these crowns has survived, it has been suggested that they must have been made from reed, cloth or leather that must have decayed, unlike the metal crafted uraeus and vulture.

Almost all countries in the world have a conflict-ridden history, and for rulers it was vital to have a strong army in order to hold on to power. Through the centuries, the battlefield was a place to acquire glory and status. Successful warriors and soldiers were rewarded with a range of prizes, a practice that continues to the present day. In ancient societies, such as Rome, different wreaths were used to reward honourable service and as marks of distinction. The *corona obsidionalis*, made of grass, was given by soldiers to their general when a city was conquered. The *corona civica*, fashioned of oak leaves and acorns, was awarded to a soldier who had saved the life of a Roman citizen in battle, while the *corona muralis*, a golden circlet decorated with miniature turrets, was given to the first soldier to scale the walls of a besieged enemy city. The *corona navalis*, decorated with miniature ships' prows, was awarded for a notable victory at sea, or to the first sailor to board an enemy ship. A conqueror received the triumphal crown of laurel. Many examples of ornate headgear, especially those worn by rulers, are uncomfortable to wear. Military headgear is no exception, being more suited to formal or festive occasions than to war.

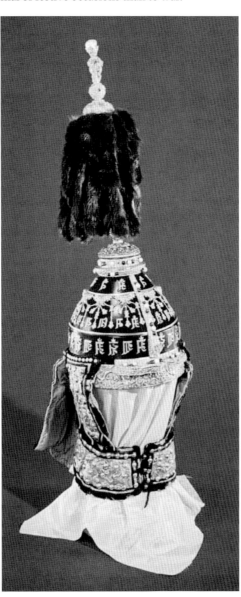

Ceremonial headdress worn by the Emperors of China during inspection of the army troops. Gold, pearls, rubies, leather and fur; made during the Ch'ing Dynasty (1644-1911).
Collection and photo National Palace Museum, Taipei, Taiwan, People's Republic of China

In periods of unrest, succession dispute, war or revolution, valuable treasures such as the sovereign's crown and other emblems of sovereignty have to be protected. This has been a problem for many courtiers over the years. The concerns were not only about the monetary value of the objects, which could attract enemies and lead to the precious objects being dismantled, or the gold and silver melted down. The regalia in particular also had to be protected from falling into the wrong hands; in some monarchies and regions, even to this day, he who has the crown holds the power.

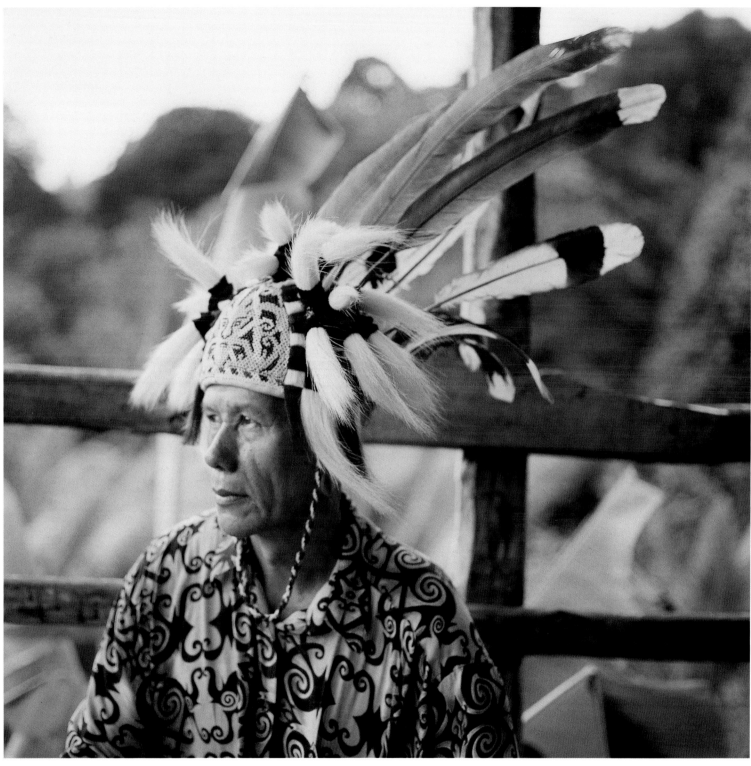

Warriors in the Malaysian
states of Sabah and
Sarawak adorn their
headdresses with the
feathers of the hornbill
bird and argus pheasant
as a symbol of pride.
Photo René Brus

Opposite page:
Left and middle:
Left; Crown of the
Abuna Salama.
Middle; A crown given to
Emperor Tewodros II by
the Patriarch of the
Coptic Church in Cairo
around 1858. Gold and
semi-precious stones;
made in the 16th century.
Collection The Royal
Collection Trust/
Victoria & Albert
Museum, London,
England
Photo René Brus

Right:
The crown of the Abuna
Salama III, taken as booty
by the British Army
during the Magdala War
of 1868. Gold and
semi-precious stones;
made in the 16th century.
Collection The Royal
Collection Trust/
Victoria & Albert
Museum, London,
England
Photo René Brus

War booty

Numerous royal headdresses have become war booty. In some cases, crowns have been sold through auction and acquired by museums as historic relics, but many crowns have vanished completely because the victor did not regard them as important enough to be preserved for future generations. In 1640, for instance, the Dutchman Ernst Brinck went into the meeting room of the Amsterdam-based *West-Indische Compagnie* (Dutch West India Company) and saw a large golden crown with many precious stones that had been taken as booty in the Philippines. Since this crown cannot be found in any present-day Dutch museum, we must assume that the trading company parted with it.

were found by searchers, and in a very short time the rooms of the prize agents were filled with treasures of every kind – jewellery and precious stones, diamonds, rubies, emeralds and pearls without number, from those as large as hen's eggs to the small species used for necklaces; gold ornaments, chains of the most beautiful workmanship, bracelets and bangles all of solid metal. There were heaps, also, of the small, thick, native coin known as gold mohurs, thousands of which were accumulated by the prize agents and helped most materially to swell the amount. I visited one room, the long table in which literally groaned with the riches of 'Ormuz and of Ind', a dazzling sight to the eye.

 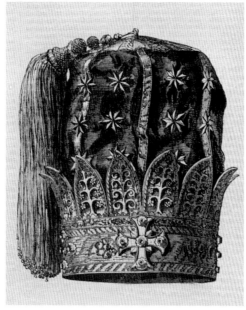 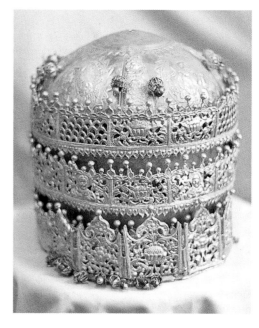

To ensure that war booty did not become the personal property of soldiers but instead filled the treasury of the victor, the British government appointed 'prize agents' during the 19th century. It was their duty to collect all the booty. The English captain Charles John Griffith, commander of the 61st regiment, gave a colourful eyewitness account in his book *A Narrative of the Siege of Delhi*, when the capital of India was taken in 1857.

The accumulation of prize by the agents began shortly after Delhi was taken. At first the articles obtained were of little worth, comprising chiefly wearing apparel of every description and household goods. Soon, however, more costly effects

In the course of the 20th century, people became aware that war booty could not simply be looked upon as valuable property for the victor, but should be regarded as part of the besieged country's heritage. During the Second World War, the Allies set up a regiment to search for art treasures and tried to ensure that the objects were returned to their rightful owners as soon as the war was over. Since then, when former colonies obtained their independence, pressure has been put on their former colonisers to return cultural artefacts that had been removed. This, however, has not always gone smoothly, due to an insufficient or even complete lack of proper documentation on the part of either the coloniser or the former colony. The origin of some crowns and in particular their history has been difficult to determine accurately.

The regalia of the Holy Roman Empire

Very few crowns have gained the status of being the indisputable proof that a monarch is the legitimate ruler. Such crowns have been sought after as symbols of power through many centuries, even though different crowns may have been used in the early years of some of these monarchies. For example, several different crowns were used by the Holy Roman Empire in the 9th century. During this period a new crown was often created for each coronation. When Charlemagne crowned his son, Louis, in 813, he himself wore a crown, a second crown was placed on the altar for his son's crowning ceremony and a third was sent by the Pope for the newly crowned head. No distinction in terms of importance was made between the three crowns. Each emperor had the treasury at his disposal, so a new crown could always be ordered when needed, there was no dispute over ownership of the symbols of sovereignty.

The second half of the 13th century saw decisive changes in how the symbols of empire, or *Reich*, were valued. This began during a period in which the Empire gradually disintegrated and the hereditary monarchy was replaced by a new system. In this new system, the sovereign ruler was elected by select members of the aristocracy. The value attached to the imperial insignia and vestments rose in proportion to the decline of the emperor's actual power and these objects became symbolic of the Empire and imperial majesty. As a result, the imperial insignia were no longer at the disposal of the monarch and he lost the right to take or exchange individual pieces. Once the insignia had been raised to such great significance, in a mediaeval state dominated by the Church, they could not fail to become sacred objects and hence church relics. The sacred status was obtained by attributing the insignia and vestments to the Emperor Charlemagne, who had been canonised in 1165. Thus, the public presentation of the crown jewels became a church festival that was combined with rites of absolution.

The Holy Roman Empire was established with the coronation of Emperor Charlemagne on Christmas Day in the year 800. This event assured the continuation of the Roman Empire in the Christian west. Its ideal king was Christ, Lord of all the world, and his deputy on earth was the emperor. In practice, the Holy Roman Empire coincided with the area ruled by the King of Germany. For this reason, it has been unofficially called the 'Holy Roman Empire of the German nation' since the 15th century. Originally, the ruler of the empire was crowned at Aachen (*Aix-la-Chapelle*) by the Archbishops of Cologne, Mainz and Trier. From the 16th century onward, this ceremony took place at Frankfurt-am-Main. When the Republic of Venice refused Maximilian II (1564-1576) passage through its territory, he received permission from the Pope to assume the title of *'Elected Roman Emperor'*. This title was then passed on to all his successors on the throne of the Holy Roman Empire.

Drawing by Albrecht Dürer of the Crown of the Holy Roman Empire. Made circa 1515. Collection and photo Germanisches Nationalmuseum, Nuremberg, Germany

Not until the coronation of Otto the Great in 936 did the tradition arise of the emperor's crown being considered the highest symbol of the Holy Roman Empire, but it would take until 1424 before it was sent, together with several other crown jewels, to the town of Nuremberg for 'all eternity'. The reason the monarch renounced his right to dispose directly of the imperial crown jewels was his wish to protect them from the Hussites (followers of the religious reformer Jan Hus), who in 1422 dominated almost the whole of Bohemia. Pope Martin V mentions a reason of even greater political significance: the intention of Emperor Sigismund to put an end to the ever-recurring quarrels over ownership of the imperial crown jewels by giving them a permanent home. The city was obliged to return the crown jewels only when there were riots in the empire, particularly in connection with the emergence of a rival king. It seemed natural, however, that the crown jewels should be used for their intended purpose when a coronation took place. So in 1452, the insignia and the imperial vestments were sent to Rome for the coronation of Emperor Frederick III. The jewels were sent to Aix-la-Chapelle three times: in 1486 for the coronation of Maximilian I, in 1520 for the coronation of Charles V and in 1531 for that of Ferdinand I.

In 1796 it was decided to remove the imperial crown jewels from Nuremberg as the French army was dangerously close to the city. The imperial insignia and the imperial vestments were handed over to the Diet (an assembly of the nobility), which was assembled at Regensburg, with the assurance that the imperial insignia would be returned immediately after peace had been established. The years passed, but Nuremberg heard nothing about the regalia, not even after the peace-treaty was signed at Lunéville on 9 February 1801. In a letter dated 14 April 1804, the Nuremberg Council finally expressed its doubts about the

It was only in the 1930s that this situation changed. On 16 March 1933, Willy Liebel became Mayor of Nuremberg and continued to press the old claims of the city as keeper of the imperial regalia. During the Nazi Party Congress held in Nuremberg in 1935, Adolf Hitler gave the promise that, 'after the reunion of Austria with the *Reich*', he would make sure that the imperial regalia were transferred to Nuremberg. Immediately after the annexation of Austria on 13 March 1938, Liebel travelled to Berlin and received the final positive decision of Hitler. Five days later, the mayor came to an agreement with the Reich Governor Arthur Seyss-Inquart

6.9.1938; the return of the regalia of the Holy Roman Empire to Nuremberg during the Party Congress with Adolf Hitler.
Photo collection René Brus

whereabouts of the coronation ornaments and reminded the imperial ambassador, Baron von Hügel, that the jewels should be returned. Von Hügel did not have them in his custody because – for the sake of security – the imperial crown jewels had been deposited in the treasury of the Hofburg Palace in Vienna in 1800, ironically the city from whence the Emperor of the Holy Roman Empire ruled.

Emperor Francis II decided that, with the changing politics in Europe and Napoléon Bonaparte's position as Emperor of France, the Holy Roman Empire should be dissolved. After his resignation as German Emperor on 6 August 1806, he became known as Emperor of Austria, and with the change of empire he also decided that the regalia of the Holy Roman Empire should remain in Vienna as relics of the past. He informed the Council of Nuremberg that he '*deemed extinct the privilege of storing the Crown Jewels at Nuremberg, because the city had ceased to be a free Imperial City*'. But Nuremberg thought they had the right to possess the jewels and requested their return on several occasions.

that the regalia would be sent to Nuremberg for the 1938 Party Congress. On 28 August 1938 a special train left Nuremberg for Vienna at 23.30, with the necessary letters of authority to take possession of the regalia. After the jewels were handed over, the train with its valuable cargo left Vienna's West Station the next evening at 22.08. The transfer and transportation took place under absolute secrecy and onlookers at the Vienna station could hardly believe their eyes when special duty SS troops arrived, faced the train and presented arms as it left the station, saluting the former imperial treasure. In the early hours of 31 August, the party arrived in Nuremberg and the jewels were taken to the Church of St Catherine. On the morning of 6 September, the imperial regalia were officially handed over to the Mayor of Nuremberg by Seyss-Inquart.

For almost an entire year, up to the beginning of September 1939, all the imperial crown jewels were exhibited in ten specially made glass cases. They were seen by thousands of visitors but with the outbreak of the Second World War the objects were carefully packed and stored. Until 1940, they were kept in the fairly safe side-rooms of the convent of St Catherine and then in a bank safe on the *Königstrasse*. As the devastating war continued, the bank was not considered safe enough. Heinrich Himmler, the head of the SS, personally gave the order to open up an old passageway, part of a system of tunnels under the castle of Nuremberg. Here an air-conditioned safe was built with steel doors and the regalia were deposited in it under the cover of darkness. Mayor Willy Liebel was the only person who had the key and knew the code for the safe.

Despite all these precautions, the bombings of Nuremberg by the American and British army on 13 October 1944 exposed the safe, and Himmler gave the order to find a new hiding place for the regalia. The objects, each in a separate copper box, were placed in the ceiling of a cave under a school at the *Paniersplatz* and hidden from view by bricks. To mislead everybody, the same night several large wooden chests were collected from the regalia's former hiding place, loaded onto vans and driven out of the city with sirens wailing. At the same time, rumours were started that Himmler had given the order for the treasure to be thrown into the deep waters of the Zeller lake. The Americans had set up a special unit to search for the regalia of the Holy Roman Empire. When they occupied Nuremberg on 20 April 1945, this group immediately started searching for the city's mayor. They found him five days later, the day after he had committed suicide.

On the day that Adolf Hitler committed suicide, 30 April 1945, by good fortune a soldier noticed a hole of some 60 cm in a ruined wall and, when he used his torch to investigate, he found two enormous steel doors. He had located the air-conditioned safe. Lieutenant Walter Horn, who was attached to the American military government in Nuremberg, had in his custody as prisoners of war Dr Fries and Heinz Schmeissner. Both been involved in searching for the different hiding places of the regalia. After much pressure, the hidden jewels were discovered and described in official army reports:

In the morning of 7 August 1945, Captain Thompson and Lieutenant Horn met with Fries and Schmeissner at the entrance of the Paniersplatz Bunker... Fries and Schmeissner directed the party to the hiding place, a small room of the subterranean corridor system of the Paniersplatz Bunker, approximately 80 feet below the surface of the Paniersplatz. After a hole had been chiselled through the brick wall at one of the small ends of this room, the four copper containers with the insignia were recovered. In the presence of all the persons who witnessed the recovery, the copper containers were transferred to their original place, the art cache underneath the Nuremberg castle, permanently kept behind steel doors. In the afternoon of the same day, 7 August 1945, the copper containers were opened. They were found to contain the missing insignia, e.g. the crown, the sceptre, the two imperial swords and the globe. All objects were found in good condition. They were freed from their spin glass wrapping and put back into their original containers.

A heated dispute arose between the Austrians and Americans over where the imperial jewels should be taken. The Austrian government demanded their restitution, but the Germans thought the regalia belonged in Germany. Eventually, General Eisenhower himself made the decision and said that the Hapsburg crown insignia must be returned to Austria. So on 6 January 1946, General Mark Clark handed the imperial jewels to the Mayor of Vienna, but it was not until 1 July 1954 that the historic regalia of the Holy Roman Empire were finally displayed to the public again, in the Treasury of the former royal Hofburg Palace.

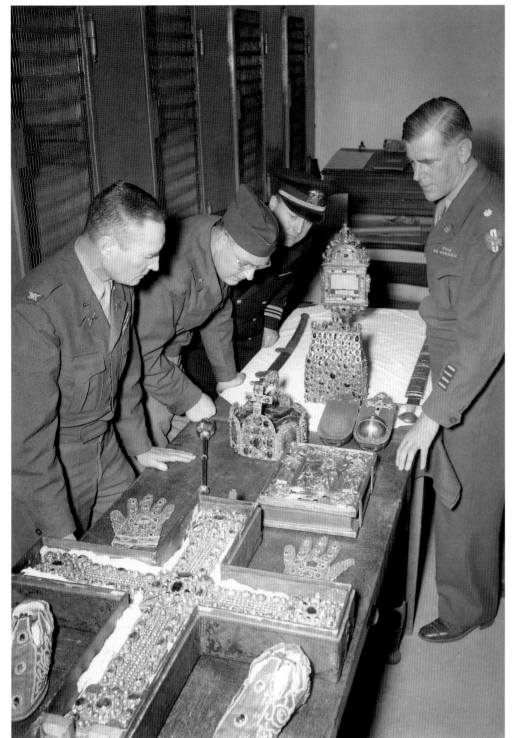

1.5.1946; inspection of the regalia of the Holy Roman Empire by members of the American army before the regalia were returned to the Hofburg Museum in Vienna.
Left to right; Col. Theo. S. Paul, Chief of RDR Div US Allied Control Authority from Philadelphia; Mr Andrew Ritchie, special representative for CG, from Buffalo, NY; Lt Comdr Perry B. Cott, Monuments and Fine Arts Officer, attached to US Forces in Austria; and Lt Col Ernest T. De Wald, Arts and Decorations Division of US Forces in Austria.

1.5.1946; inspection of the regalia of the Holy Roman Empire by members of the American Army.

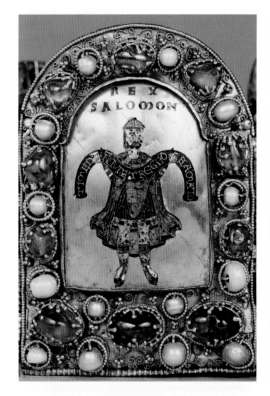

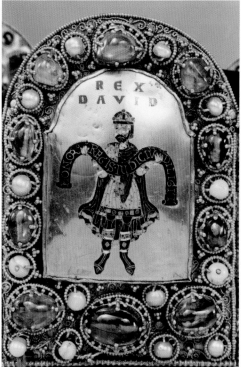

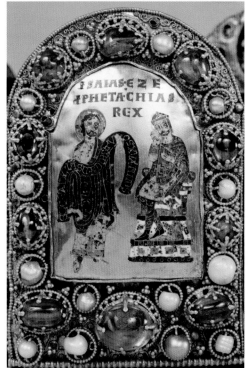

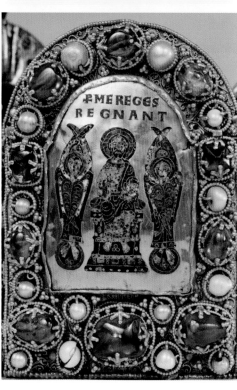

Four details of the Crown of the Holy Roman Empire. Gold, pearls, precious and semi-precious stones including sapphires, rubies, emeralds and amethysts, enamel; made in the second half of the 10th century. Three of these four enamelled plates depict three Old Testament kings, Solomon, David and Ezechias, and the prophet Isaiah bearing a scroll inscribed with quotations from the coronation liturgy.These symbolise the royal virtues of justice, wisdom and faith. The fourth enamelled panel shows Christ as Pantocrator (the "Almighty" or "All-powerful") seated on a throne flanked by two cherubim.
Collection Hofburg Treasury, Vienna, Austria
Photo Kunsthistorisches Museum, Vienna, Austria

Opposite page:
Crown of the Holy Roman Empire. Gold, pearls and precious stones including sapphire and rubies, enamel; made in the second half of the 10th century, probably for the coronation of Emperor Otto I in 962. The circlet of the crown is formed by eight golden plates, which symbolise the eight walls of the Holy city of Jerusalem. The twelve large stones in the front and back plates symbolise the twelve apostles and the twelve tribes of Israel respectively. The single arch is set with pearls forming the name and title of Emperor Konrad II (1024-39).
Collection Hofburg Treasury, Vienna, Austria
Photo Kunsthistorisches Museum Vienna, Austria

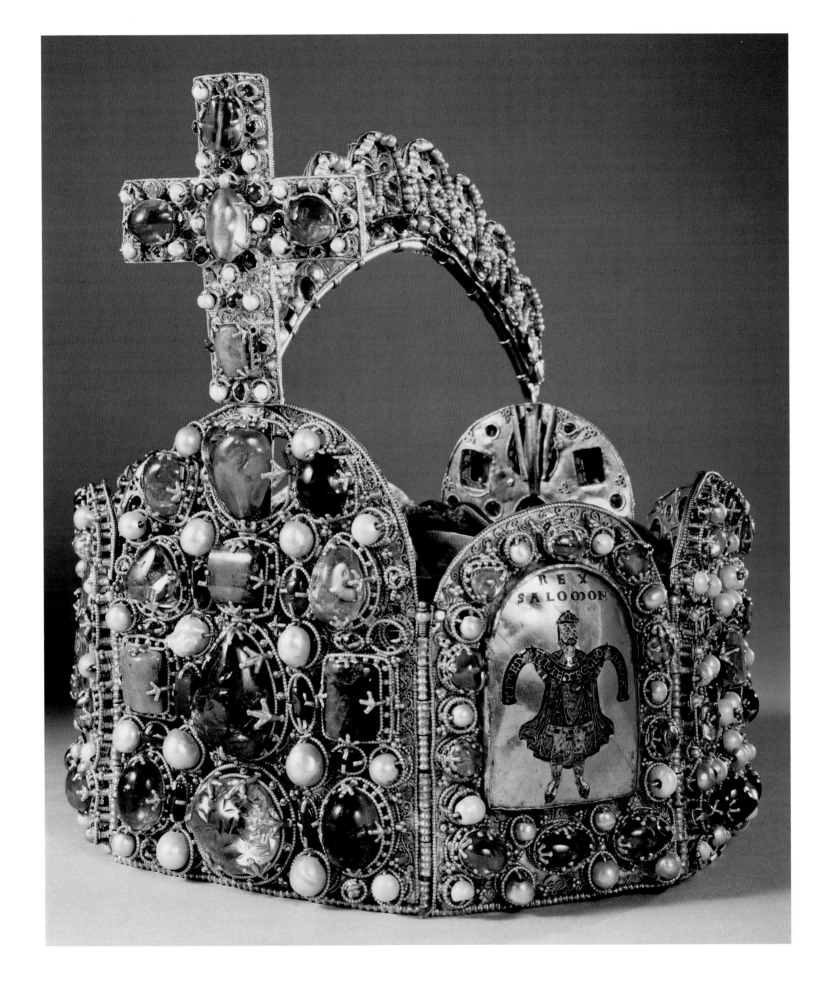

The Crown of Hungary

In 1977, during a parade at the Washington Monument in the city of Washington, D.C., banners were waved saying such things as 'Let the Crown stay in the United States' and 'The symbol of Freedom does not belong to a Tyranny!' Many Americans were trying to persuade their government to keep St Stephen's Crown in the United States and not to give it back to Hungary, as had been decided.

The crown was named after the founder of the Kingdom of Hungary, St Stephen (Szent István), who lived from 970 to 1038 AD. According to tradition, this crown was given to the King of Hungary by Pope Sylvester II after an angel had told him in a dream that the next day an envoy would appear. This envoy would swear allegiance to the Pope on behalf of his lord and entreat a blessing, after which a crown must be given to the sovereign. From research, it is clear that the current crown has been assembled over a period of many years, although opinions are divided about the sequence and origins of the assembled pieces. The four arches, which are decorated with enamelled miniatures, almost certainly belonged to the crown presented by Pope Sylvester II. The headband is thought to have been made in the workshops of the Byzantine emperor Michael VII Ducas, who reigned from 1071 to 1079.

The materials used in St Stephen's crown are gold, pearls, sapphires and red stones (rubies and spinels). The enamelled miniatures show Christ and various apostles, such as John, Bartholomew, Peter, Andrew, Philip, James and Thomas and rulers such as Emperor Michael VII Ducas and his son, Constantine Ducas. For many centuries, the Holy Crown of Hungary, with its characteristic tilted cross (according to many the cross became crooked in 1444), has been used as a coronation crown for the Hungarian kings. Without this crown, nobody could legally rule over Hungary. It has passed through many hands, been buried and saved during periods of war and played an important role in Hungarian history.

The last monarch to wear this illustrious crown during his coronation was Emperor Karl I of Austria who, like several of his predecessors, was also the ruler of Hungary. On 30 December 1916, at nine in the morning, the emperor, known in Hungary as King Karl IV, arrived with his wife Empress Zita and their four-year-old son and heir Otto at the Matthias Church in Budapest. In the Loretta chapel, the king-emperor was anointed and received the traditional coronation mantle and sword, after which the royal couple took their seats near the high altar in the church. Cardinal Czernoch and the Archbishop of Malocja started the ceremony by reading Latin verses. This was followed by the actual coronation. The cardinal took the crown in his hands and while speaking the words *Acipe Coronoam*, 'accept the crown', placed Hungary's symbol of authority on the monarch's head. Not many attending this coronation realised that the fragile, age-old crown had had to be repaired quickly before the ceremony because some of its plates had become loose (again). The repair was done with tin, which caused permanent damage to the gold plate of the bands.

30.12.1916; coronation of Emperor Karl of Austria as King Karl I of Hungary.
Photo collection René Brus

Opposite page:
Front and back view of St Stephen's Crown of Hungary. Gold, rubies, spinel, sapphires, pearls and enamel; made, according to some sources, partly in the 11th century.
Collection The Hungarian Nation Photo Embassy of Hungary, The Hague, The Netherlands

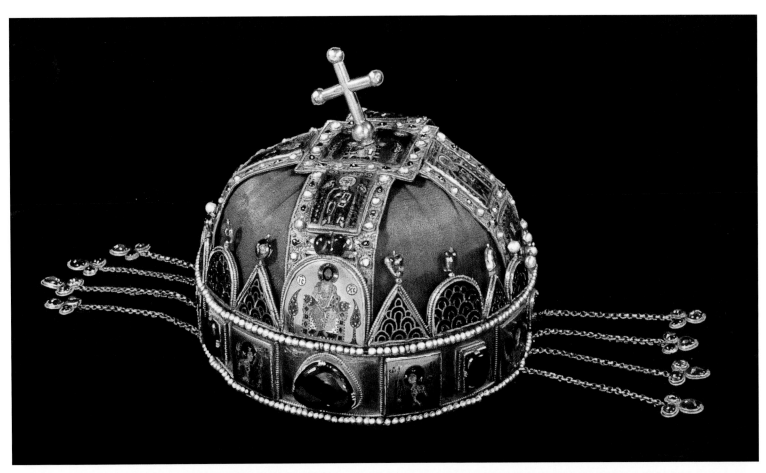

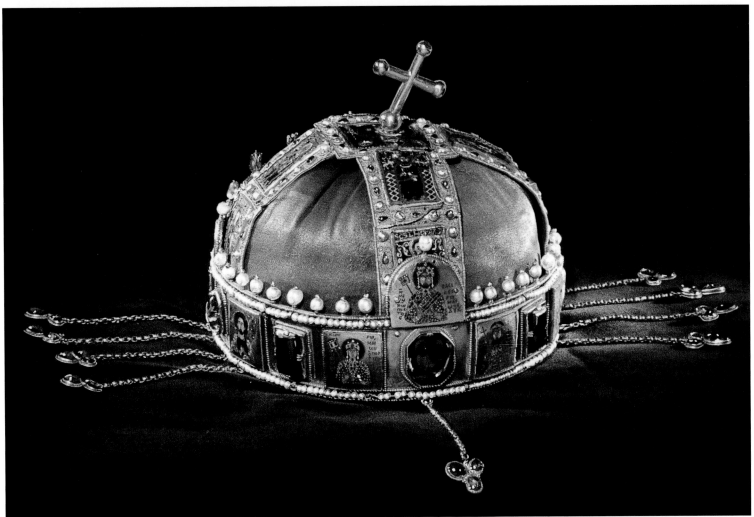

The Queen-Empress Zita also wore a crown during the ceremony. Her crown had originally been made for Empress Maria Ludovika of Austria in 1808. The diamonds could be removed and used for other purposes, and by 1838 the silver crown frame could no longer be used. The court silversmith, Mayerhofer, produced a new frame in which the diamonds and pearls were set permanently, with the exception of the large stones, which were screwed to the frame. The setting of the diamonds was done by the court jeweller Mack. In 1867, the Viennese court jeweller Köchert altered this crown for the Hungarian coronation of Emperor Franz Josef and Empress Elisabeth, and altered it again for the 1916 coronation.

Europe was in the grip of the Great War, and when it ended in 1918 the king-emperor lost his throne when both Austria and Hungary became republics. The communist Béla Kun took control in Hungary and, responding to demands for the crown of St Stephen to be destroyed, he negotiated putting this historic relic up for auction with a dealer in Munich. Fortunately the sale did not take place as, in 1920, Admiral Horty came into power and reinstated the monarchy in Hungary with himself as regent. The exiled king-emperor was under the impression that he could return to his Kingdom and entered Hungary on 26 March 1920. Admiral Horty, however, refused to hand over his regency and the king-emperor was escorted out of Hungary.

Later that year, in October, the monarch again attempted to regain his position as the rightful King of Hungary who had been crowned with the crown of St Stephen. This time his wife accompanied him, but again it was in vain. On the night of 24 October, King Karl IV of Hungary was forced to sign a document in which he gave up all his rights to the throne and once more had to leave the country. It is rumoured that some of the Queen-Empress Zita's jewellery disappeared at around this time. Although it is not clear if this included her diamond crown, this has never been seen since. As for the Crown of Hungary, its history continued. The country remained a kingdom without a king while justice was administered and laws were enforced in the name of the holy crown. To safeguard the crown, it was placed in a special safe in the royal palace in Budapest and kept under constant surveillance by a ceremonial guard of 24 soldiers.

Towards the end of the Second World War, when the Russian army was approaching the borders of Hungary and the Nazis had taken Horty prisoner and brought him to Germany, the Crown Guards wanted to put the crown of St Stephen under the protection of Pope Pius XII. But on 10 October 1944, the deepening crisis forced them to hide the crown in the cellar of the royal palace, with the assistance of Prime Minister Géza Lakatos. Further hiding places were sought and found for the crown as the war progressed. Finally, as the Soviet army approached, Colonel Ernö Patjàs, commander of the Crown Guards, placed the crown into an empty petrol barrel and buried it at Mattsee, near Salzburg. Patjàs and other members of the Crown Guard were soon captured by the Americans, but it was another three months before it was revealed that the Seventh American Army had only found the empty chest in which the regalia of Hungary was normally kept.

Left:
30.12.1916; state portrait of Emperor Karl I of Austria and Empress Zita as King and Queen of Hungary taken shortly after their coronation as King and Queen of Hungary. In the middle of the photo is their son and heir to the throne, Prince Otto.
Photo das Bildarchiv der Österreichischen Nationalbibliothek, Vienna, Austria

Right:
30.12.1916; coronation of Emperor Karl and Empress Zita of Austria as King and Queen of Hungary.
Photo collection René Brus

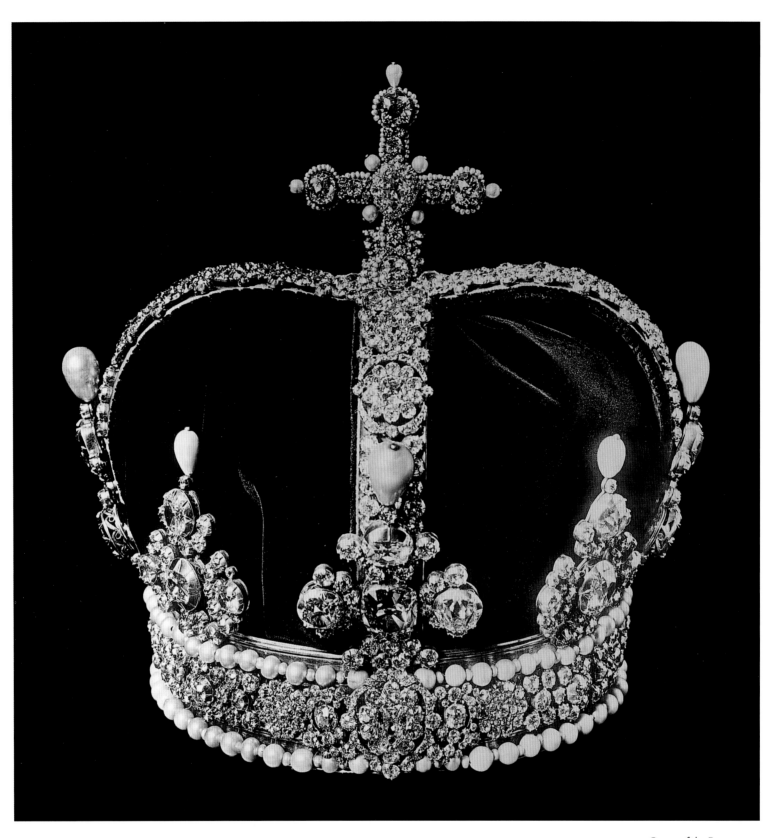

Crown of the Empress
Maria Ludovika of
Austria. Gold, silver and
diamonds; made in 1808,
the frame remade in 1838
and remodelled in 1867
and 1916. Photo end of
the 19th century.
Photo collection
René Brus

Numerous army documents from those days reveal what happened next to the crown of St Stephen. During the night of 25 June, Colonel Patjàs and 2nd Lieutenant Andrews of the US Seventh Army retrieved the muddy petrol barrel and handed it over to Major Kubala of the Seventh Army. Inside the barrel they found three equally muddy and partly damaged leather boxes containing a crown, sceptre and globe. The Hungarian regalia were cleaned in Major Kubala's bathroom and, for the first time in its 1,000-year history, the regalia left Europe. The objects ended up in the vaults of Fort Knox in the American state of Kentucky. The regalia were not described as 'spoils of war' but, as the American government explained year after year, 'We have the crown in safekeeping for the Hungarian people. It is not known when we will return it.'

The crown stayed in the United States with the complete agreement of the many thousands of Hungarians living there, who adopted the view that the Communist government in their motherland in no way represented the Hungarian people. In 1977, the governments of the United States and Hungary decided that relations between the two countries had improved sufficiently for St Stephen's crown to be returned to Hungary. On 6 January 1978, a delegation of no fewer than 250 important Americans accompanied the crown and other regalia to Hungary. They were met at Ferihegy Airport with military honours. The next day at the parliament building in Budapest, Cyrus Vance, the United States Secretary of State, acting on behalf of President Jimmy Carter, handed over the ancient crown in the presence of the entire Hungarian government and senior members of the Catholic Church. Antal Apró, chairman of the Hungarian parliament, received the crown in the name of the Hungarian people, and since then the crown has been on display so that all can see and admire their national symbol.

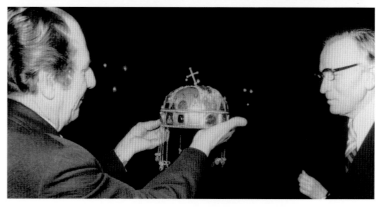

Top left:
Before the Second World War members of the Crown Guard kept a constant watch over the crown of St Stephen.
Photo collection René Brus

Bottom left:
This metal chest containing the Hungarian regalia was discovered at the end of the Second World War and taken by the American army to Switzerland. The chest has triple locks and

has on its front side a plaque showing the Royal Hungarian Coat-of-Arms.
Photo Twining Collection, Library Goldsmiths' Hall, London, England

Right, top and bottom:
6.1.1978; return of the crown of St Stephen and other regalia of Hungary. US Secretary of State Cyrus Vance (top) shakes hands with the President of the Hungarian parliament during the ceremony.

Photo Embassy of Hungary, The Hague, The Netherlands

The Crown of Hanover

War and territorial struggles have created head-aches for many court functionaries charged with finding secure hiding places for the valuables of his sovereign so that they would not be seized as war booty or, in the worst case, melted down. When the Prussian army invaded Hanover in 1866, the task of safeguarding the regalia and Crown Jewels of Hanover fell to the Hanoverian Minister of State. His son, Baron Charles de Malortie, wrote extensively about this adventurous event in his book, *Twixt You and Me – Hanoverian Crown Jewels*. He mentioned that his parents, First Dame du Palais and Lord Chamberlain, took three trips to transfer the queen's private jewellery from the Castle of Herrenhausen to their own house, where it was buried in a corner of their large garden with the help of a trusted valet. When this was done, the baron's father went back to the castle for the '*Crowns, Sceptres, Chains of Office, jewelled swords of state, the Collars of many Orders and endless other gems of great historical value*,' which he carried in two trips to his house, '*confiding it likewise to the earth in another corner of the garden, no one being in the secret beside himself and his old valet – not even my dear mother knew of their whereabouts, as he wished her eventually to be able to deny all knowledge of the presumed hiding place*.'

When the Prussian government began to search for the vanished regalia, a safer place had to be found. Over three dark nights, the minister, along with a number of trustworthy helpers, took the treasure to the royal tomb under the castle. There, three graves were opened and the crown jewels hidden inside them. When war threatened to break out a few years later, it was decided to take the regalia out of the tomb under cover of darkness and to smuggle them out of the country to a friendly nation. The jewels were sewn into the dresses of several aristocratic ladies, including Countess Julie Kielmansegge, who was nearly 80 years old and had the Crown of Hanover hidden in her lace bonnet. Thus dressed, the ladies travelled to Austria. From there the regalia were brought to England and deposited in the Bank of England.

The First World War ended monarchy in all German states, and it was several years before the Hanoverian crown jewels and regalia could return home. In 1925, financial matters were settled between the former Royal House of Hanover and the Braunschweig government, and that year the treasure was brought to the castle of Blankenburg. But the story was not yet over. At the end of the Second World War, Castle Blankenburg was due to fall under the jurisdiction of the Soviet Union and Prince Ernst August IV of Hanover, wishing to prevent his valuables becoming war booty, made contact with the notable English art historian, Anthony Blunt. Blunt had just become the caretaker of the art collection of King George VI of England, and since the Prince of Hanover and the English monarch shared ancestors, the Crown Jewels of Hanover were smuggled out of Germany again and put into a safe in Windsor Castle. In 1964, the jewels went back to Germany once more.

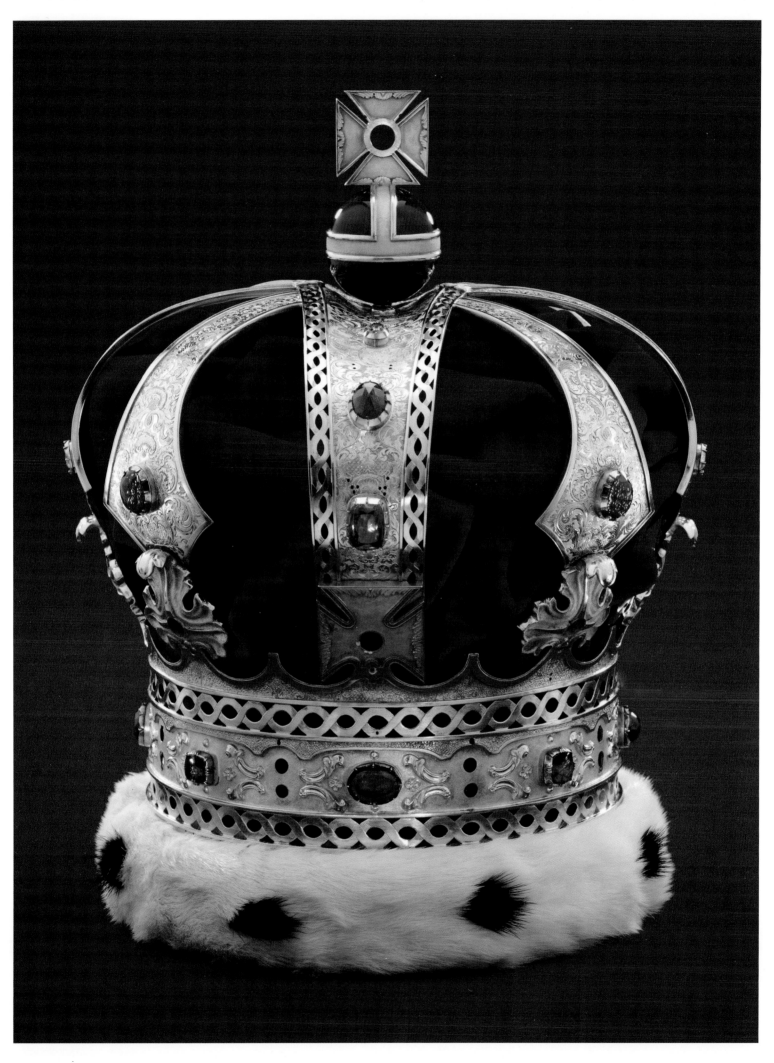

Benin

During the second part of the 17th century, European seafaring nations, including The Netherlands, Portugal and England, sought trading opportunities among the powerful kingdoms of western Africa. To be able to trade with an African kingdom, it was essential to become friendly with the ruler, and in 1664 the Duke of York, later to become King James II of England, decided to send a bed and a crown to the King of Ardra, in what is now Benin, in order to seal their diplomatic relationship.

The Duke of York's gifts never reached Ardra. In that same year, the Dutch Admiral Michiel de Ruyter and his fleet had been given orders to sail to West Africa and retake the forts and other Dutch West India Company possessions that the English had occupied in Goerée Island and Guinea. On 22 October 1664, the Dutch fleet captured an English warship that was accompanying a group of cargo ships bound for West Africa, the *Victoria*, *Martha*, *Hoopwel*, *Africa*, *d'Avis*, *Dolphin*, *Prospere*, and *Spahia*. The captains of these ships surrendered all their cargo

to Admiral de Ruyter, who suddenly found himself in possession of a crown. Admiral de Ruyter returned to the harbour of Delftzijl, The Netherlands on 6 August 1665, and handed the crown over to the Admiralty of Amsterdam on 1 December 1665.

The Admiralty of Amsterdam kept the crown as a curiosity until 1826, when it was presented to the Royal Cabinet of Rarities (*Koninkljk Kabinet van Zeldzaamheden*) in The Hague, together with a letter from the Duke of York describing his sincere intention to present the King of Ardra with the crown as a '*Badge of the highest Authority.*' The low monetary value of this crown is without a doubt the reason that it has been saved for posterity. Despite its deplorable state, with a missing *fleur-de-lys*, broken glass stones and gilding that has lost its splendour, this crown has been part of the collection of the Department of Dutch History in *Het Rijksmuseum* in Amsterdam since the end of the 19th century.

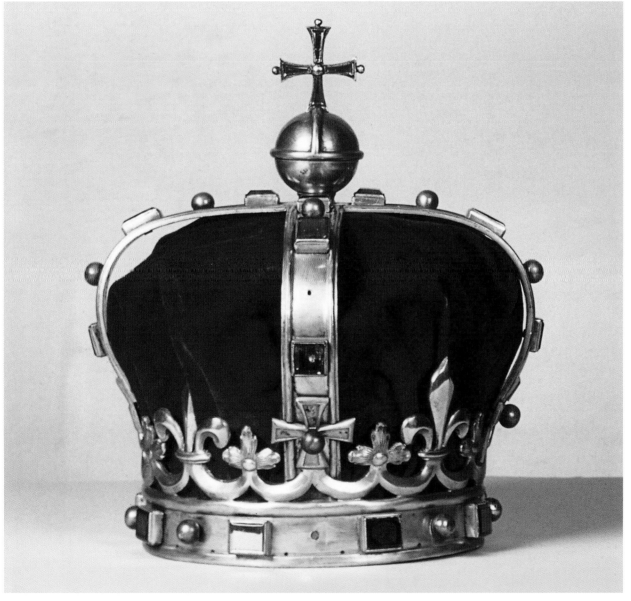

Crown given by James, the Duke of York, to the King of Ardra. Gilded copper and paste; made in 1664.
Collection Rijksmuseum, Amsterdam, The Netherlands
Photo René Brus

Opposite page:
Crown of King Ernst August of Hanover. 14 carat gold, diamonds, emeralds, sapphires and garnets; made in 1842-43 by the court jeweller Knauer and Lameyer.
Collection former Royal House of Hanover
Photo Deutsches Historisches Museum, Berlin, Germany

Nigeria

Colonisers who were not sensitive to cultural differences or who failed to take account of age-old traditions often ran into trouble. In 1897, an English trade mission wanted to travel to the Nigerian city of Benin to discuss a trade agreement with ruler Oba Ovonramwen that dated back to 1892. Unfortunately, the trade mission's planned arrival coincided with the annual celebrations of a ceremony during which the Oba was forbidden to show himself to strangers, and he, quite naturally, requested via an emissary that the Englishmen postpone their visit for a month or two. The English group did not agree to this, and thus the Oba was obliged to arrange for the trade mission to be accompanied to the city of Benin to meet him. He chose a number of chiefs of his realm to escort the group, but these chiefs did not want to break their traditions and almost all the members of the British expedition were massacred.

The Oba was deeply shocked by the actions of his chiefs and made many human sacrifices in order to get the gods on his side and protect his people from retaliation. Despite this, the British sent a punitive expedition and the city of Benin was taken. Oba Ovonramwen sought refuge in the villages around his capital, and almost six months after the invasion, returned with 700 to 800 unarmed followers and reported to the tent of the resident British government representative, Captain Rouspell. The king's body was almost completely covered with enormous quantities of coral necklaces with large pieces of coral between them, and his crown, the shape of which slightly resembled '*a Viking helmet, with wings on either side*', consisted entirely of high-grade coral. This crown, known locally as the *abegan*, must have been enormously heavy, because one of the servants took it off the king's head in order to relieve the pressure for a few moments. Ovonramwen's arms were covered with coral bracelets from wrist to elbow, and his breast was completely invisible behind the necklaces that hung round his neck. About a thousand people stood watching this event, and when Rouspell asked the sovereign to submit, Ovonramwen asked not to have to do so in public. The Englishman haughtily rejected this, whereupon the Oba took his crown off, handed it to Rouspell and then threw himself three times onto the ground. Rouspell informed the Oba of Benin that he had been deposed and was exiled to Calabar, where he died in January 1914.

During the punitive expedition of 1897, Benin lost many of its ancient treasures, including the beaded regalia. Some of these came into the possession of a Mr Harry G. Beasley, who displayed them in the Cranmore Ethnological Museum (Cranmore Museum of Chislehurst) in Kent. After Beasley's death, his widow sold most of his collection of ethnological objects, and they now form the Beasley Collection in the Museum of Mankind, London. Among the collection is a damaged beaded skullcap, which might originally have been the top part of the ceremonial hat of the Oba of Benin, taken in 1897. Other ceremonial items were taken as booty, and at least two headdresses were acquired by Miller Brothers, a company that was part of the United African Group of Companies (eventually to become Unilever). These two headdresses did not remain in the Miller collection for long, because when they were lent to the British Museum in 1935 this prompted a request from Nigeria for the return of these headdresses along with other beaded emblems of the Benin regalia.

Since the death of Oba Ovonramwen in 1914, Benin had already witnessed the arrival of two new rulers: Eweka II was crowned on 27 July 1914 and Akenzua II, his son, on 5 April 1933. On both occasions, a new bloodcoral crown had been used, with the British Resident of Benin State inserting a feather in the Oba's headdress as a sign of his government's authority. So the ruler of Benin did not lack a crown, although the old ones were considered by his subjects to be equally, if not more, important since they were heirlooms of the Oba's forefathers.

On 15 February 1938, Benin city was decorated with flags and banners as Mr George Miller, representing his family, and the Chief Commissioner, Mr Shute, handed Oba Akenzua II items from his ancestor's regalia. The regalia included the crown, known to the people of Benin as *Ikekeze noven Irhue*, and by the population of Lagos, for many years the capital of Nigeria, as 'the dangerous hat'. At the end of the ceremony, members of Iwebo and Enisen palace society arrived in procession to once again become the rightful custodians of the crowns of the Kingdom of Benin.

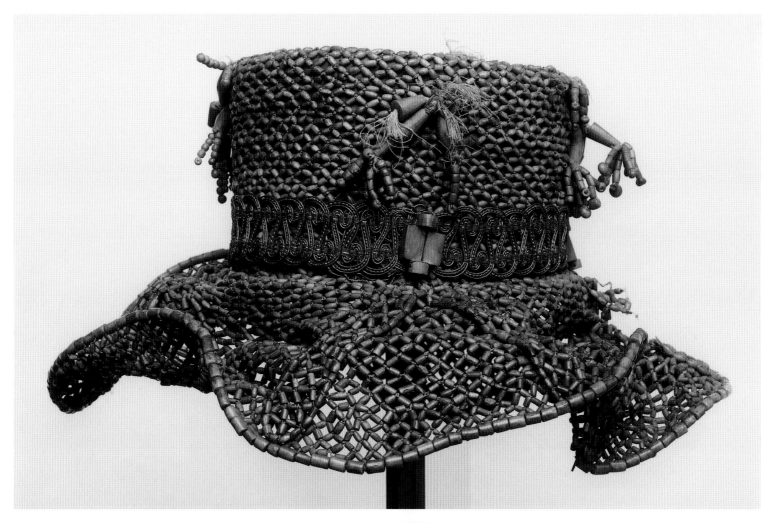

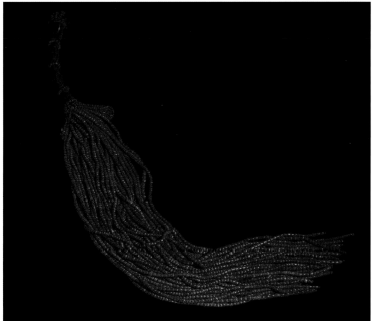

Top:
Ceremonial hat of the
Oba of Benin taken as
booty by the British
Army in 1897. Bloodcoral.
Collection and photo
Museum of Mankind,
London, England

Bottom left:
Among the collection
of Benin objects in the
Museum of Mankind is
also a flywhisk obtained
in 1994 from the widow
of H. G. Beasley, the
owner of the Cranmore
Ethnographical
Museum in Chislehurst,
Kent, England.
Photo René Brus

Bottom right:
The beadwork of this
coral cap is similar in
shape to the top part of
the hat depicted above.
The only certain fact is
that this cap became a
part of the collection of
the museum after 1898
and the entry in the
acquisition register

of that year states only
*"object from Benin,
West Africa"*.
Collection Museum
of Mankind, London,
England
Photo René Brus

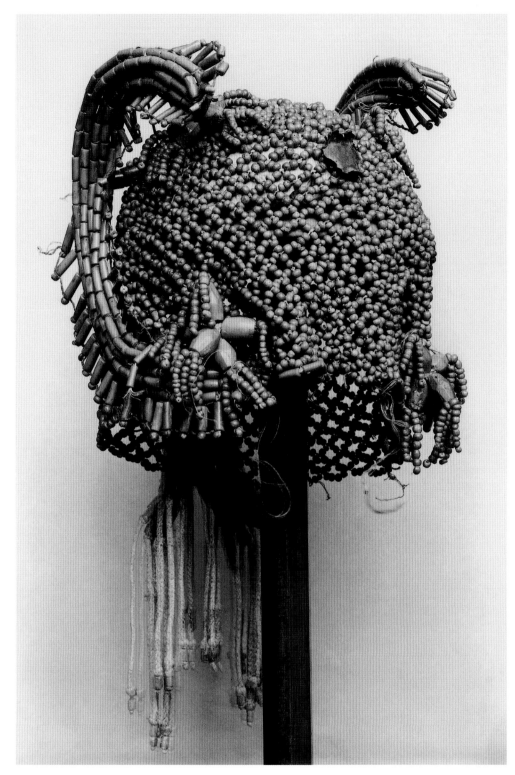

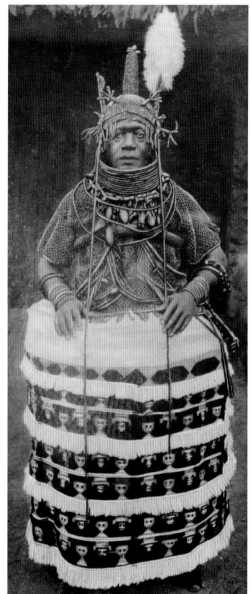

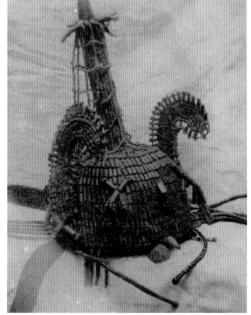

Crown of the Oba of
Benin taken as booty by
the British Army in 1897,
returned to Benin in 1937.
Bloodcoral.
Collection the
Oba of Benin
Photo Museum of
Mankind, London,
England

Top right:
24.7.1914; coronation of
Oba Eweka II of Benin.
Photo collection
Ministry of Information,
Ibadan, Nigeria

Bottom right:
Coronation crown of
Oba Eweka II and his
succesor Oba Akenzua II
of Benin. Bloodcoral;
made in 1914.
Collection the
Oba of Benin
Photo Midwestern
Nigeria Information
Service, Ibadan, Nigeria

Among the large collection of beaded crowns of the Nigerian Okuku dynasty, there is one named the *Ade Eru*, which can be translated as 'the Danger crown'. According to tradition, this crown, made for Oba Adeoba, the ninth Olokuku of Okuku and forefather of the present four royal houses of Okuku, is only worn when danger is imminent, which means in times of war and when the realm is about to be attacked. If the ruler wears the *Ade Eru*, it is believed that he will be immune to arrows and bullets. When this crown was studied and photographed by René Brus in 1976, Olaosebikan Oyewusi II was the 15th Olokuku of Okuku (1961-1981). The beads that decorate this crown are made of glass. It is said that the crown was originally decorated with red coral beads or *ileke okun* (red agate), but since former rulers found the weight of the coral or agate too heavy, glass beads were used instead.

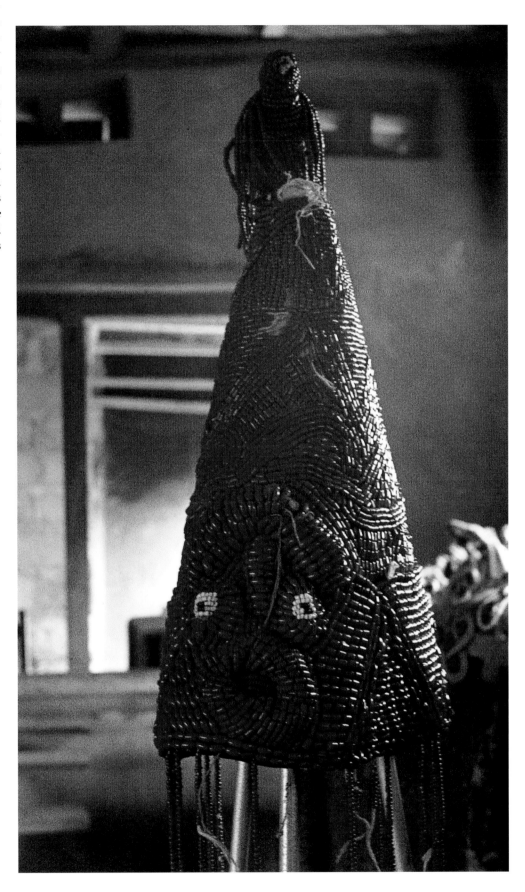

The *Ade Eru* 'the Danger crown' of the Olokuku of Okuku. Glass; made in the 19th century.
Collection of the Olokuku of Okuku, Nigeria
Photo René Brus

Ghana

Throughout the world, gold has always been much sought after. The region of West Africa now known as Ghana was the 'Gold Coast' to Portuguese, Dutch and English traders and explorers of the past because of the abundance of this precious metal. This region was populated by the Ashanti people, who had a tremendous reputation not only as fighting soldiers, but also for the great quantities of gold used by their rulers. In the beginning, encounters between the Ashanti and Europeans were reasonably amicable, but in 1806 the first hostilities broke out between the Ashanti and the English. In 1821, the British proclaimed Ghana a protectorate, and a long and protracted war began. In 1874, the British reached the capital of the Ashanti, Kumasi, where they captured the ruling Asantehene, King Kofi Karikari. He was sent into exile and all the valuables from the Asantehene's palace found their way to England. Most of the booty was auctioned through British prize agents. In May 1874, the jeweller Garrard bought a number of golden objects for £11,000. These objects were displayed to their customers in their shop at Number 23, Haymarket, in London.

In Kumasi, a new king, Prempeh I, ascended the throne. Despite the booty taken by the English soldiers, Prempeh I was given enough gold to build up a new collection of impressive jewellery, including several headdresses. One is often described as being in the shape of a (war) helmet, with the cap made of thin antelope hide, and with lion's tails attached to the rim on either side of the cap above the ears. These ear flaps and the whole cap are decorated with golden ornaments. On the top are two curved golden horns with a golden palm-like structure between them, most likely a charm or talisman to ensure the good luck of the royal wearer. All the golden decorations attached to the crown, including the likenesses of lions' heads, human heads and jaw bones, have symbolic meanings. The royal power is symbolised by the horns, and victory over enemies depicted by the golden heads, while the antelope hide and the lion tails stand for courage and strength.

Despite the fact that the British had conquered the Ashanti Kingdom in 1874, its people did not accept foreign rule and another war broke out in 1895. Again the British were the victors and King Prempeh I was sent into exile. Again all the gold from his treasury went to Great Britain. King Prempeh's crown and all the other booty were first put on display at the Colonial Office in London. According to the *Illustrated London News*, their weight in gold was worth only some £2,000. To bring peace to the Gold Coast colony, in 1926 the government of Great Britain decided to permit the exiled King Prempeh I to return to his Kingdom. But everything that had been taken as booty remained in London.

1970s; part of the Ashanti gold collection as it was on display in the British Museum, London, England; on the right is the crown of King Prempeh I.

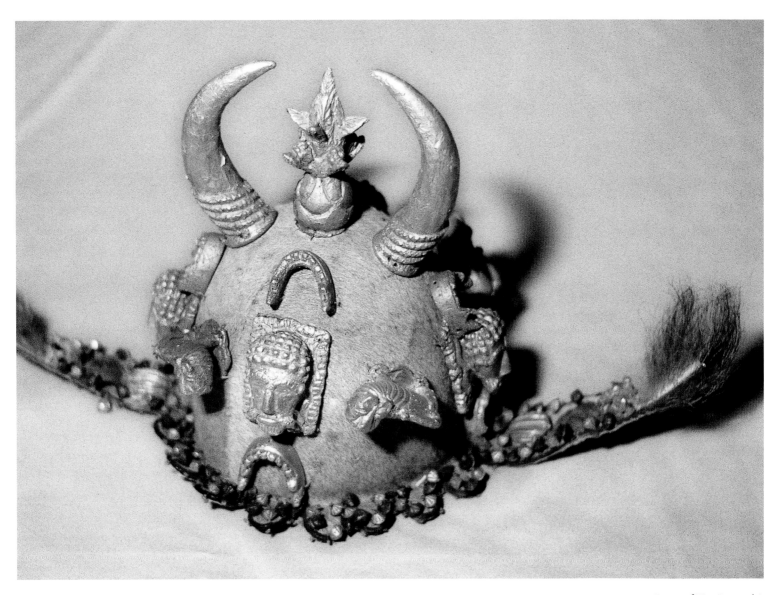

Crown of King Prempeh I
of the Ashanti. Gold,
antelope hide and
lion tails; made during
the second half of the
19th century.
Collection Museum
of Mankind, London,
England
Photo René Brus

Ethiopia

In Ethiopia, a lion's mane headdress was worn by high-ranking officers who, in most cases, had been heroic in battle. This headdress, known as an *anfrro*, was made of an elaborately decorated silver brow band, sometimes adorned with stones, to which a lion's mane was attached in such a way that the hair stood up high above the head.

An Ethiopian warrior who had pledged to die in battle and never to surrender or retreat had a silver, or in some rare cases gold, headdress to prove his courage. This consisted of a rod with short silver chains hanging above the brow and long silver chains hanging on either side of the head, each ending in diamond-shaped or bell-like pendants. This headdress is often referred to as an *aq'edama* (or *akodama* or *aqwedama*), although others give it the name of *kalatscha*, referring to the penis, which is cut off the conquered enemy and which, as recently as the beginning of the 20th century, was a valuable trinket for the Amhara, Kaffa and Wolamo people of Ethiopia.

A third type of headdress was presented to Ethiopian Orthodox (Coptic) warriors who had killed Danakil (also referred to as Afar) tribesmen, because the Danakil were regarded as particularly fierce desert warriors. In the 16th century, Danakil tribesmen marched with the Muslim conqueror Ahmad Gran (also referred to as Ahmad Ibn Ibrahim al-Ghazi), 'the Left-handed'. Ahmad Gran invaded Ethiopia in 1535, killed many Christians and destroyed many churches, including Gabaza Aksum, which was regarded as the first Christian church built in Ethiopia, and had been completed in 424 AD. The tubular headdress awarded for killing Danakil was usually adorned with gilded ornaments. The tassel hung from the closed top indicates that it probably owes its shape to the Islamic *fez*.

All these military headdresses were presented by Ethiopian monarchs, who generally wore similar headdresses themselves during battle. The titles that the Emperor of Ethiopia received during his coronation included 'Chosen God', 'Conquering Lion from the Tribe of Judah' and 'Negus Negesti', which means King of Kings. For many centuries Ethiopia was divided into territories governed independently by powerful nobles, but they had to acknowledge the higher position of their overlord. The title of many of these nobles was *Ras*, while *Negus* was used only for the king.

Left:
1896; Emperor Menelik II of Ethiopia wearing the lion's hair crown *anfrro*. Emperor Menelik II poses as the victorious monarch after he won the battle of Adwa against the invading Italian army.
Collection Alfred Ilg, Völkerkundemuseum, University of Zürich, Switzerland
Photo Völkerkundemuseum, University of Zürich, Switzerland

Right:
Circa 1896; Dajazmach Balcha Aba Nefso, hero of the battle of Adua (Adwa), Ethiopia.
Photo collection René Brus

Opposite page:
Military headdress, known as *anfrro*. Lion mane and silver.
Collection The Royal Collection Trust/ Horniman Museum, London, England
Photo Horniman Museum, London, England

An ancient Ethiopian tradition decreed that 'a great king named Tewodros would bring justice and peace to his realm.' In 1820, a boy called Kassa was born east of Lake Tana. He eventually became so powerful that he was crowned Emperor Tewodros II on 7 February 1858. Tewodros II realised that he had to subdue the various nobles and kings if he wished to make Abyssinia, as Ethiopia was known at the time, a single united realm. The emperor also knew that he could use the skills of foreigners, such as teachers and advisors, to help him reform his Empire. In 1862, Tewodros II sent an Englishman named Cameron as his emissary to London, to seek diplomatic relations with Great Britain and thus help him to prevent parts of Ethiopia from being absorbed by Turkey and Egypt. The letter from the Ethiopian Emperor to the British Queen Victoria was never answered, which led to a diplomatic conflict that resulted in war between the two countries. In 1867, Sir Robert Napier landed with his army on the shores of Ethiopia near Zula, and their superior weaponry, including guns and canons, ensured that Emperor Tewodros II was defeated. On Easter Monday, 13 April 1868, Tewodros II shot himself in the head with, according to some historians, a golden bullet.

A large quantity of valuables, including various crowns, was taken to London as war booty. One golden crown attributed to the Abuna Salama was reportedly made in the 16th century and donated to a church in the city of Gondar by the Ethiopian Emperor Adam Segud in 1560. The crown attributed to Emperor Tewodros II (in England often referred to as Tewedros), which he had given to a church in Magdala, reached England as war booty in a roundabout way. At the request of the Government of Prussia, a certain Gerhard Rohlf had joined the English military in their war against Ethiopia. Despite the fact that the English prize agents had instructed everybody to surrender any booty, Rohlf kept the crown. On the way back to Germany, Rohlf visited the Prussian consul in Suez, Egypt, and asked him to send the crown to Berlin. As soon as the British government discovered this, they asked the Prussian government to send the crown of Tewodros II to London. Once there it was put on display in the South Kensington Museum in March 1869, together with the other Ethiopian war booty.

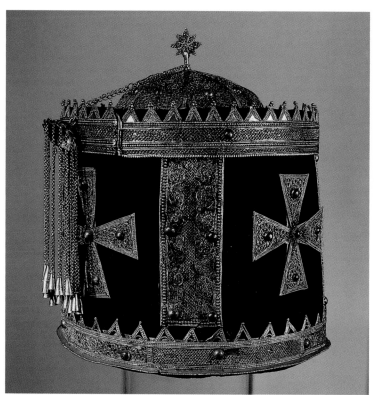
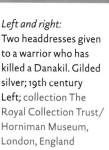
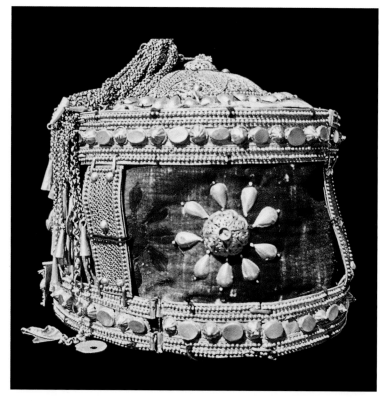

Left and right:
Two headdresses given to a warrior who has killed a Danakil. Gilded silver; 19th century
Left; collection The Royal Collection Trust/ Horniman Museum, London, England

Photo Horniman Museum, London, England
Right; collection Church Gondar, Ethiopia
Photo René Brus

Top:
Warrior headdress
known as *kalatscha*.
The *aq'edama*
(*aqwedama*) of a
courageous warrior.
Leather and silver;
19th century.
Collection
Völkerkundemuseum,
University of Zürich,
Switzerland
Photo Kathrin
Leuenberger/
Völkerkundemuseum,
University of Zürich,
Switzerland

Bottom left:
Warrior headdress
known as *kalatscha*.
Circa 1930; an Ethiopian
warrior wearing the
kalatscha.
Newspaper clipping
from circa 1930
Photo collection
René Brus

Bottom right:
The *aq'edama*
(*aqwedama*) of a
courageous warrior;
19th century.
Collection The Royal
Collection Trust/
Horniman Museum,
London, England
Photo Horniman
Museum, London,
England

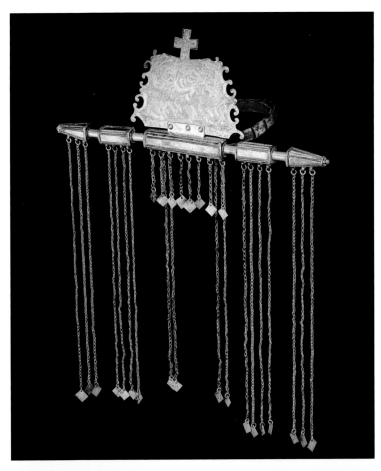

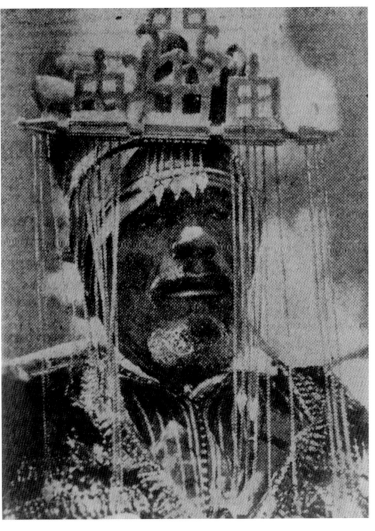

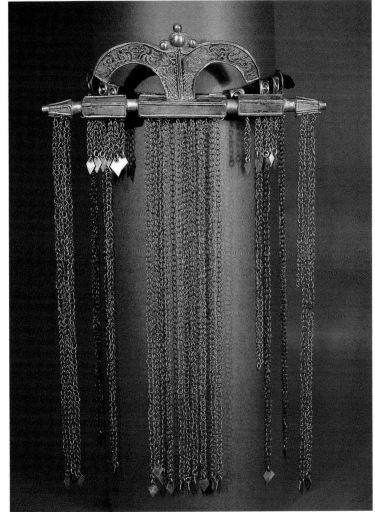

In 1925, Ras Tafari, later known as Emperor Haile Selassie I, visited Great Britain and, during a farewell dinner at Buckingham Palace, King George V informed him that he had decided to return Emperor Tewodros' crown. Towards the end of 1925, the crown was sent from the Victoria & Albert Museum in London to Ethiopia's capital, Addis Ababa. The special envoy of the British government, Charles Henry Bentinck, and the British Consul Mr Bullock arrived at the Menelik II Palace in a coach drawn by four grey horses, bringing the crown of Tewodros II and a throne, a gift from the British government.

The story of Tewodros' crown does not end here. Another chapter began with the assault on Ethiopia by Italy in 1935 and the occupation of Addis Ababa on 5 May the following year under the command of General Pietro Badoglio. Ras Tafari, who had been crowned Emperor Haile Selassie I on 2 November 1930, wanted to stay in his country but was persuaded to leave by his close advisors, who hoped that the nobles, including Ras Imiru and Ras Desta, would be able to defeat the Italian forces. Despite the speech that Haile Selassie I delivered in Geneva to the assembled League of Nations in June 1936, stating that '*Apart from the Kingdom of the Lord there is not on this earth any nation which is superior to any other – God and history will remember your judgement*', he could not prevent his country becoming an Italian colony. The King of Italy assumed the title of Emperor of Abyssinia.

Numerous ancient Ethiopian relics were taken by the occupying forces, including the crown of Tewodros II and the crowns of his successors. In his book *Waugh in Abyssinia*, the English journalist and author Evelyn Waugh mentions that one day Rodolfo Graziani, the Italian viceroy of Ethiopia, asked him if he would recognise the crown that Emperor Haile Selassie I had worn in 1930. A red hatbox was brought into the room and, according to Waugh, it did indeed contain the crown of the exiled emperor. Waugh stated that the crown was neither beautiful nor valuable, but merely a vulgar piece of local workmanship from which each precious stone had been removed. The Englishman did not realise that he was looking at the crown that the emperor had worn in 1928 when he had been crowned as Negus or King of Ethiopia as co-sovereign of his aunt, the ruling Empress Zauditu. That Evelyn Waugh could not appreciate the workmanship of the crown he condescendingly described was no doubt caused by his lack of expertise. When the English Lord Twining, Baron of Tanganyika and Godalming, author of the book *European Regalia and Crown Jewels*, visited Addis Ababa in 1961, he was granted permission to study the regalia specially made for the coronation in 1930. Lord Twining expressed that, in his expert opinion, the crown of Emperor Haile Selassie I was a crown of great workmanship.

What happened to the crowns that the Italians captured in the 1930s? Most of them were taken to Rome, and nine were put on display in the Museo dell'Impero d'Italia, including '*Corona del Negus Giovani, Corona di Menelik I, Corona di Re Teodoro, Corona di Ras Tafari, Corona di Ras Tafari en Corona di Ras Cassa.*' From photographs it can clearly be seen that the crown of Emperor Tewodros II was among these crowns, war booty for the second time in its history. But there is no trace of this unfortunate crown after the end of the Second World War. Italy was obliged to return the other crowns to Ethiopia following the Paris Peace Conference of 1946 and under article 37 of the Peace Treaty of 1947: '*Within eighteen months from the coming into force of the Present Treaty Italy shall restore all works of art, religious objects and objects of historical value belonging to Ethiopia or its nationals and removed from Ethiopia to Italy since October 3, 1935.*' It would take until 1952-1954 before the Italian ministry of Foreign Affairs returned the Ethiopian treasures. Several of the crowns are now part of the collection of the National Museum of Addis Ababa.

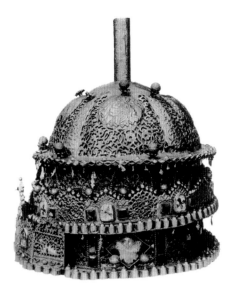
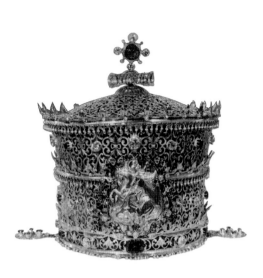
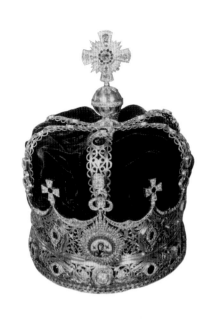

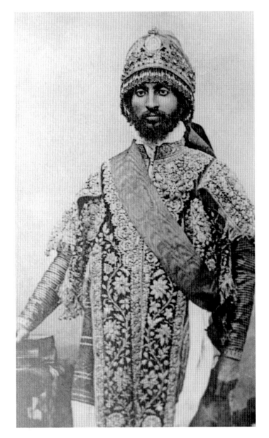
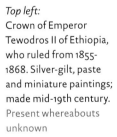
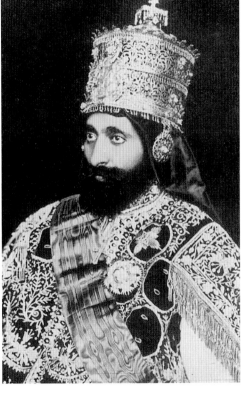
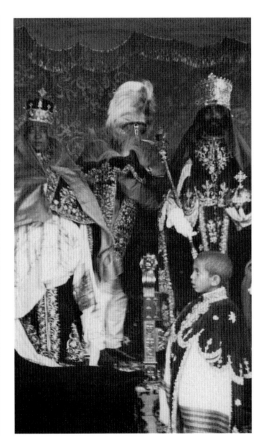

Top left:
Crown of Emperor
Tewodros II of Ethiopia,
who ruled from 1855-
1868. Silver-gilt, paste
and miniature paintings;
made mid-19th century.
Present whereabouts
unknown

Bottom left:
Circa 1917; Emperor Haile
Selassie I photographed
when he was known as
Ras Tafari and Regent
of Ethiopia, wearing one
of the crowns that was
taken as booty by the
Italians in 1935-1936 and
which is now on display
in the National Museum
of Addis Ababa.

Top middle:
Coronation crown
of Emperor Haile
Selassie I of Ethiopia.
Gold, emeralds, rubies,
diamonds and pearls;
made in 1930.
Photo Twining collection,
Library, Goldsmiths' Hall,
London, England

Bottom middle:
7.10.1928; State Portrait
of Ras Tafari after being
crowned as Negus or
King and co-sovereign of
his aunt Empress Zauditu
of Ethiopia.
Photo collection
René Brus

Top right:
Coronation crown
of Empress Wayzaro
Menen of Ethiopia. Gold,
emeralds, diamonds
and enamelled plaque
with a depiction of the
Virgin Mary;
made in 1930.
Photo Twining collection,
Library, Goldsmiths' Hall,
London, England

Bottom right:
2.11.1930; Coronation
of Haile Selassie I and
Wayzaro Menen as
Emperor and Empress
of Ethiopia.
Photo collection
René Brus

There is a region of mountains and primaeval forest in south-west Ethiopia known as Kaffa. The people there believed they were descended from the ancient Egyptians, and regarded their sovereign as a divinity. The founder of the ruling dynasty was Minjo (also referred to as Mindscho), who raised his status to that of a god-king or priest-king during his reign from 1390 to 1425. The title of the ruler of Kaffa is *tato*, and in full *Kafinô tâtô* or Kaffa King, which is often mistakenly translated as King of Kaffa. The position of this ruler, who in later years was seen by many as an emperor, was so sacred that he could not show himself to his subjects: his form was always hidden from view by white silk cloths. His hands were so exalted that they could not touch anything worldly, so his hands and arms were hidden under a cloak. Even when he ate he could not touch anything, so there were special court functionaries who fed him like a child. The Kaffa emperor owed his sacred position to the Kaffa crown, which guaranteed him dominion over the country. Tradition said that he would be free and powerful as long as the crown was in the country. The crown was hereditary, handed down to members of the Bushasho family of the Minjo clan. It is cone- or helmet-shaped and fashioned from silver. Gold and enamelled ornaments are attached to the top, including a crescent-shaped arch and a decoration known as the *kallatscha*, a triple phallus-shaped structure. From the bottom of the crown rim hang silver chains about 75 cm long. On the top of the crown are three snow-white ostrich feathers, about 50 cm high, intended to symbolise the heroism of the crown's wearer.

When the Ethiopian emperors sought to unite the country during the 19th century, they could not ignore Kaffa. In the spring of 1897, the army of Ethiopian Emperor Menelik II conquered Kaffa and captured the magical crown, bringing the 500-year-old Kaffa dynasty to an end. When the Ethiopian army reached the borders of Kaffa, Gaki Sherocho, the 19th Emperor of Kaffa, went to the temple of the Sun god, of whom he was believed to be a descendant, to ask for the Sun god's influence on the forthcoming battle. He ordered all men, women and children to go into hiding in the mountains with their livestock, leaving his warriors to attack the enemy under cover of darkness. The emperor also instructed the high priest to bury the crown in the jungle near the sacred mountain where all the previous rulers of Kaffa were buried. Unfortunately for Emperor Gaki Sherocho, Emperor Menelik II's army had captured modern weapons from the invading Italian army in 1896. The bows and arrows of his warriors were no match for the invaders.

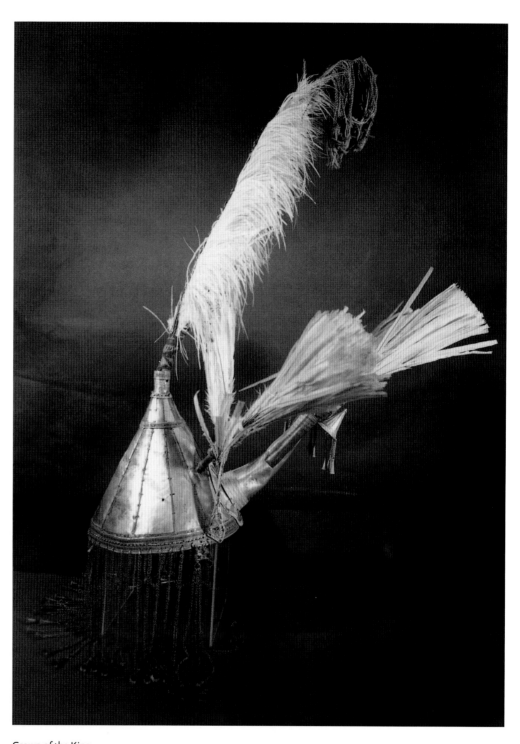

Crown of the King, Emperor-Gods of Kaffa. Gold, silver, enamel and ostrich feathers; made between 1390 and 1397. Collection Ethnological Museum/University of Addis Ababa, Ethiopia Photo Ethnological Museum, Addis Ababa, Ethiopia

On 11 September 1897, the Emperor of Kaffa was captured. The war ended immediately when the Ethiopian soldiers removed Emperor Gaki Sherocho's white robes, because his warriors had to throw themselves to the ground to avoid seeing the human figure of their sovereign. Even with Gaki Sherocho as prisoner, the Ethiopian Emperor Melenik II could not rule Kaffa because he did not possess the crown. Graves were opened, months passed by, but there was no trace of this powerful object. Eventually, the Ethiopians captured the high priest of Kaffa in the Bado forest near the Butto mountain just as he was about to bury the sacred crown. As soon as the crown had fallen into the hands of the enemy, the rule of the last emperor-god of Kaffa was indeed over. During an impressive ceremony at the palace in Addis Ababa, Gaki Sherocho had to submit to Emperor Menelik II. The last *Kafinô tâtô* lived in captivity for 22 years, tied to a slave with a heavy silver chain.

A few months after the submission ceremony, the crown of Kaffa disappeared from Addis Ababa. Emperor Menelik II, realising the power associated with the crown, instructed one of his most trusted generals, Ras Wolde Giorgis, to find it. A couple of weeks later, the crown was again found in Kaffa. This time, the Ethiopian emperor considered the crown too dangerous to keep in his country. He decided to hand the crown to Alfred Ilg, a Swiss national who had become one of his trusted advisors. Alfred Ilg then asked Urs von Berg, a member of a banking family, to collect the crown from Ethiopia and to lock it up in a Swiss bank vault. On the death of Alfred Ilg in 1916, the Ilg family placed the crown and other emblems of the Kaffa regalia in the custody of the *Völkerkundemuseum* of the University of Zürich, Switzerland. Shortly after the Italian occupation of Ethiopia, in 1937-1938, the German Field Marshal Hermann Göring tried to buy the crown, as did the Italian ruler Benito Mussolini in 1939. But the heirs of Alfred Ilg did not wish to sell this symbol of power to a private individual. When the Institute of Ethiopian Studies was founded in Addis Ababa in 1963 and Emperor Haile Selassie I requested that the crown be returned to Ethiopia, it was decided that this new institute was a suitable home for the historic crown of Kaffa.

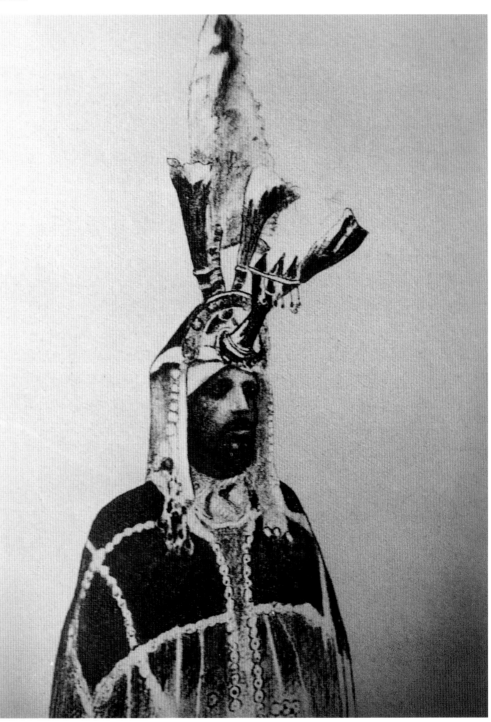

Circa 1890; Gaki
Sherocho, the last
Kaffa King.
Photo collection
University of Addis
Ababa, Ethiopia

India

In the eyes of many 19th-century Europeans, the royal headdresses worn in non-western societies were not regarded as crowns. The Secretary of State for India, Sir Charles Wood, in a letter dated 3 January 1861 to Prince Albert, the husband of Queen Victoria, described:

...an article of headdress which has been brought here... It cannot however be called a crown. It is a very rich skull-cap worn on the head of the Emperor and round the lower part of which the turban was wound and in the turban jewels were placed. This is merely the skull-cap. Sir J. Lawrence saw it yesterday and has no doubt of its being what the Emperor actually wore. It is certified by his physician... There is no great value in this beyond its being the Emperor's headdress, or part of it, on great occasions.

The object Sir Charles Wood was describing had been worn by Abu Zafar Sirajuddin Muhammad Bahadur Shah Zafar (also known as Ubool Mozaffar Sercij-oo-deis Moumed Bahadur Shah as described in English official documents), who ascended the throne of India at the age of 60, on 28 September 1837, after his father died. At the time, the emperor, usually known as the Great Mogul, did not actually rule the whole country. Many parts of India were controlled by powerful aristocratic families. This politically unstable situation had made it possible for England to obtain a rather dominant position in the country, which resulted in the Indian mutiny of 1857. The war ended with the capture of the elderly Great Mogul and the beginning of India's time as an English colony. During this turbulent period, a certain Robert Tytler, a Major in the Bengal Army, got hold of the golden crown of Emperor Bahadur Shah and sold it to Queen Victoria, together with two chairs, for £500 on 8 February 1861.

The crown of the last Mogul emperor is round in shape. It has a headband divided into two bands which are richly worked in *repoussé* and set with floral rosettes in turquoise, rubies and diamonds. From this headband rise four diamond-studded *repoussé* arches connected with triangular floral open-worked plaques, so that the top is more or less covered by a half-spherical cap. An *aigrette* of white feathers is attached above the point where the arches meet This was surmounted by two large pearls, one large emerald, four smaller emeralds and two small rubies, finished with three small bullion tassels. The second rim of the headband has similar hanging bullion tassels, which are adorned with more precious stones and pearls. The inside of the crown is lined with crimson velvet and white cotton decorated with flowers.

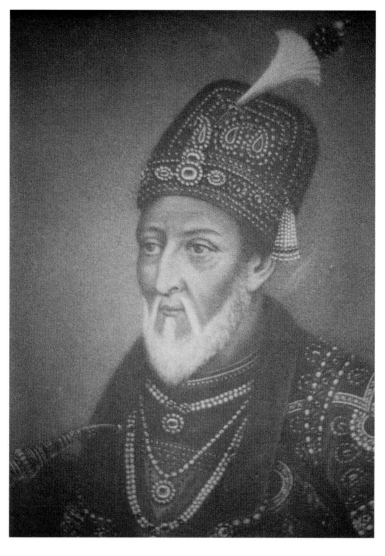

Painting circa 1850 of Emperor Bahadur Shah II of India.
Photo collection René Brus

Opposite page:
Crown of Emperor Bahadur Shah II of India. Gold, diamonds, rubies, turquoise and pearls; made beginning of the 19th century.
Collection The Royal Collection Trust/ Windsor Castle, Berkshire, England
Photo The Surveyor of the Queen's Works of Art, The Lord Chamberlain's Office, London, England

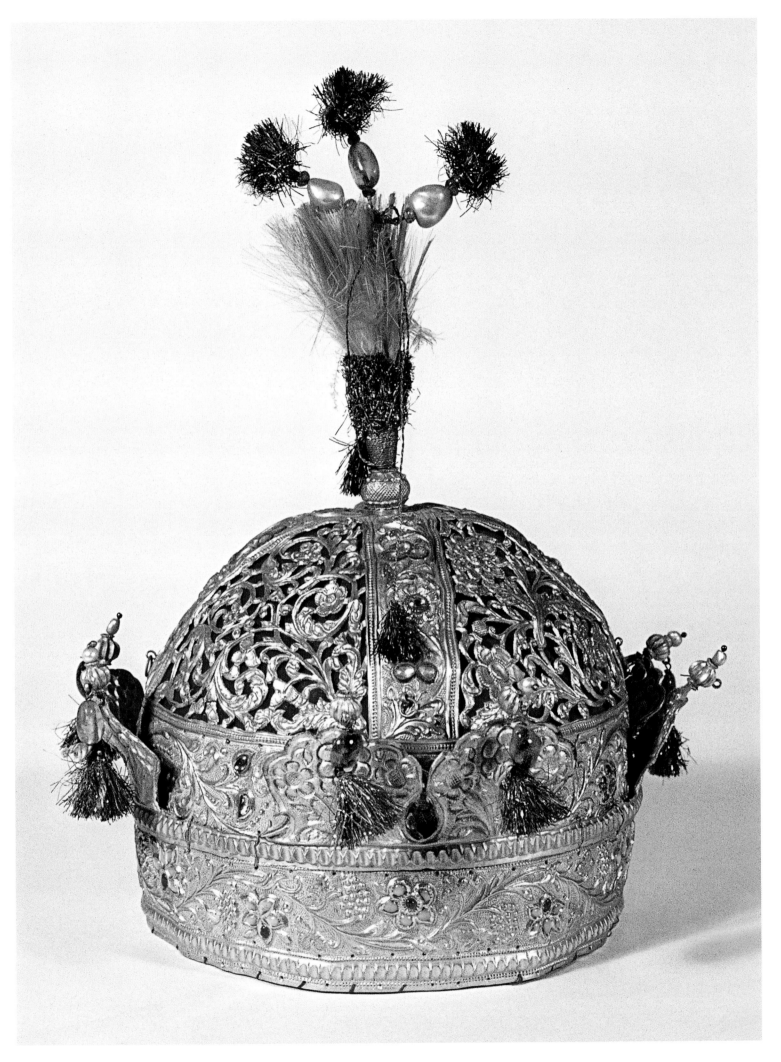

Sri Lanka

The Pearl of the East, the Island of Delight and Precious Stones, Serendib and Ceylon are some of the names that have been given to Sri Lanka. The country is mentioned both by traveller Marco Polo and by Sindbad the Sailor in the tales of The Thousand and One Nights. During his voyages, Sindbad reached the island of Serendib and was impressed by its fabulous rubies and rivers and valleys 'rich with pearls and diamonds.' Throughout the centuries, this island seemed like a fairytale to many of its visitors, particularly if they had the opportunity to be invited to the court of the king. In a letter to Pope Julius II dated 25 September 1507, the Portuguese king wrote that his men had been received in a spacious hall, with the king sitting on a throne and wearing, instead of a headdress, 'horns on his head, after the manner of his ancestors, embellished with most costly gems which the Island produced.'

The capital of this Kingdom, known as Kandy, was a mountain stronghold that had withstood the invasions of India, China, Portugal and Holland, before it finally succumbed to the British. In the early 19th century, Kandyan chiefs sought Great Britain's help to remove their tyrannical King, Sri Wikrama Rajasinha, because they could no longer endure his cruelty. The British army conquered the Kingdom in 1815 and sent the king and his four wives into exile to India. Sir Robert Brownrigg, the British Governor of Ceylon, sent all the valuables that comprised the royal treasury to London. *The Edinburgh Advertiser* of 1820 informed its readers about this treasure:

A chest is recently brought from India, containing the regalia and other articles taken in 1815 from the palace of the deposed King of Kandy, and has been opened at the bank of England. Among the curious and costly articles disclosed to view were a regal crown of pure gold, an entire suit of gold armour, together with a number of tiaras, bracelets, amulets, and other ornaments, for the most part studded with precious stones and many of them suspended by massive gold chains of ingenious workmanship. The whole collection which is of considerable value, has been given up by His Majesty for the benefit of the captors, and will shortly, it is understood, be offered for sale.

To recover part of the cost of the Kandyan campaign, the British authorities decided to put most of the valuables up for public auction. In those days, recovering the cost of a war campaign was more important than the historical value or workmanship of the objects, so the precious stones were taken out of the objects and sold separately. A crown of the former kings of Kandy suffered this fate. According to descriptions it must have been a magnificent object, with an enamelled gold ornament on the front that contained diamonds, emeralds and a very large ruby, described in the sale catalogue as '*an enormous Ruby, 2 inches in length by 1 inch in breadth, through which run in various directions a number of small hairlike tubes – a most interesting specimen to the Mineralogist*'. On top of the crown stood a golden, jewelled flower ornament, called the *mal-gaha* or the tree of life. The jewels were put on view for nine days in the auction rooms of a Mr King at 38 King Street, in the Covent Garden district of London. On the unfortunate day of 13 June 1820, the different parts of this crown were sold to a Mr Delauney, a Mr Devien and a Mr Gilmoor.

No emblems from the Kandy dynasty would have survived intact were it not for some gifts made to the Prince Regent of Great Britain, the future King George IV. In 1815, he was presented with the throne and footstool of Sri Wickrama Rajasinha, the last king of Kandy. The objects were placed in the armoury at Carlton House. Six years later, in June 1821, a crown and sceptre, also used by the last king of Kandy, were added to this small collection, gifts from Sir Robert Brownrigg. This crown, although perhaps less spectacular than the one taken apart, is still a good reminder of the splendour of the court of Kandy's former kings. It is circular in shape, with four projections bearing crimson tufts of silk. The sides are plain gold, laid over with very rich ornamentations of jewel work in rubies, emeralds and sapphires. A large and a small pearl are pendant from each projection. The upper surface of the crown is richly worked in *repoussé* (working on the reverse of the metal to form a raised design on the front) divided into eight sections, and the whole is surmounted by a number of small tufts held on stems of wire. The crown has a crimson velvet edging and is partly lined with silk.

For more than a century, this crown and the few other relics of Kandy's royal past were kept as curios at Windsor Castle. In February 1934, the State Council of Ceylon passed a motion respectfully requesting 'His Majesty's Government in England' that these relics should be restored to the Government of Ceylon, which would keep them 'as a national possession.' Sir Reginald Edward Stubbs, the Governor of Ceylon, forwarded and supported the request. Finally the throne, crown (known as *Jagalat Toppia*) and sceptre were brought back to Ceylon by the Duke of Gloucester, acting as the representative of King George V. Any member of the royal family of England was sure of a loyal and enthusiastic reception in Ceylon in those days, but this occasion

was exceptional. The pageantry of the past was revived in a great *perahera*, a procession of chiefs arrayed in their festal robes, religious dancers in their picturesque dress, musicians and gorgeously decorated elephants through the city of Kandy. Here, in the old capital of the Sinhalese Kingdom, the presentation took place in the audience hall of the former kings on 23 September 1934. The hall had been specially extended for the occasion and no less than 1500 spectators witnessed the governor receiving King George V's gifts from the hands of the duke. At nightfall, a great and colourful fireworks display completed the celebrations. The crown and the other regalia have since become the star attractions in the regalia room of the National Museum in Colombo, Sri Lanka.

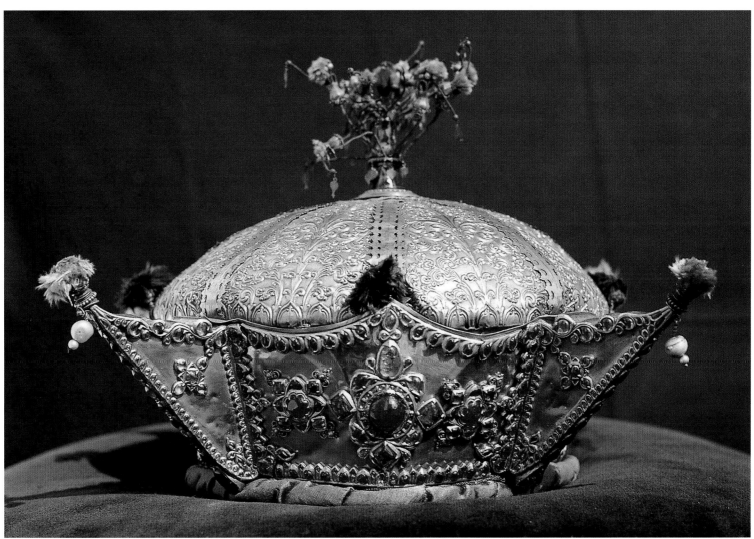

Crown of King Sri Wickrama Rajasinha of Kandy, Sri Lanka. Gold, emeralds, rubies, sapphires and pearls; made beginning of the 19th century.
Collection Sri Lanka National Museum, Colombo, Sri Lanka
Photo René Brus

Nepal

In the first part of the 19th century, the Prime Minister of Nepal, Bhim Sen Thapa, turned his attention to reorganising the Kingdom's army. These included specifications for new uniforms and headdresses which were set with silver or gold coronets of filigree work. After Jung Bahadur Kunwar Rana took control of the government of Nepal in the middle of the 19th century, he claimed hereditary premiership for his family. It became a tradition that almost every male member of the Rana family received the title of general, major-general or colonel. With their military position came military headdresses, and the seemingly limitless wealth of the Rana family meant that these soon became costly crowns. When Prime Minister Jung Bahadur Kunwar Rana and several of his brothers visited England in 1850, contemporary newspapers noted that the British public were impressed by *'their costumes... their bearing... their liberality and their diamonds and pearls.'* Several of the military headdresses of the Rana family were sent to be exhibited in the Colonial and India Exhibition held in London from 1 May to 1 November 1886, in what is now the Victoria & Albert Museum. The catalogue pointed out that these headdresses were *'worn by the highest class, are of great value, and composed almost entirely of diamonds, pearls, and emeralds set in silver.'*

In 1932, Mr C. W. North of the famous jeweller Cartier visited Nepal, and later described the splendour of the Ranas during a ceremony at the impressive Singha Durbar Palace in Kathmandu:
There were assembled a glittering array of the generals, Major-Generals and Colonels of the Nepal ruling family. All were in full uniform, mostly scarlet coated with large quantities of gold lace, and most amazing head dresses. They consist of a close fitting skull cap entirely covered with pearls round the front and sides of which hung pear-shaped drop emeralds. From the centre front a plume of Indian Bird of Paradise feathers curves gracefully over towards the back. The designs worked in pearls vary slightly and the rank of the owners seems to determine the number of emeralds to be worn.

The ranks to which North referred were not merely military ranks. Under Prime Minister Chandra Shumshere (1901-1929), the Rana family was divided into A, B and C classes. The A-Ranas were the sons and daughters of the prime minister, who was also Maharaja of Kasko and Lampung, and his first consort. The B-Ranas were the children of the prime minister's second maharani, and the C-Ranas were his children from his concubines. Chandra Shumshere also decided that only A-Ranas could become the Prime Minister of Nepal, while the other family members had to seek their fortune in military and civil business.

The shape of the Rana military crowns was adapted from the great crown worn by the kings of Nepal during their coronation ceremonies, and all were adorned with bird of paradise feathers. From an ornithologist's point of view, bird of paradise feathers are 'jewels' that are probably of greater rarity than any of the gemstones used in the Rana military crowns. A wealth of myths exist related to these birds. Until well into the 18th century, Europeans thought that they actually came from paradise. Long before the western world knew about the habits and habitat of these birds, their feathers were being used to embellish the costumes and heads of the wealthy and powerful.

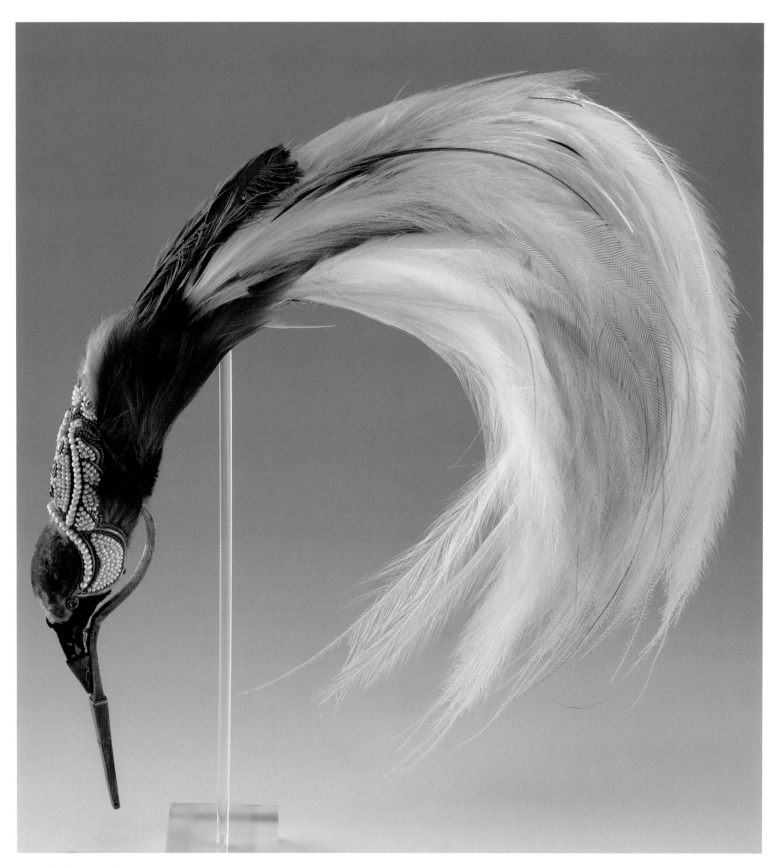

Plume of bird of paradise
feathers, part of the
military crowns of the
Rana family of Nepal.
Gold, rubies, emeralds
and pearls.
Collection Museon
Museum, The Hague,
The Netherlands
Photo René Brus

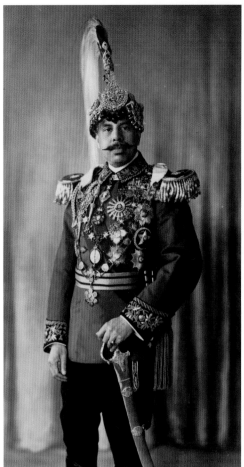

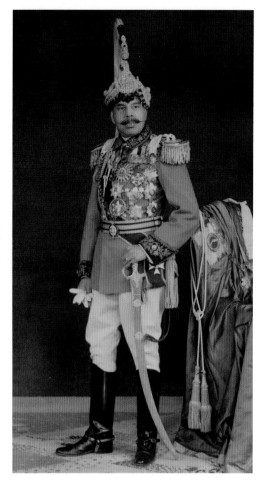

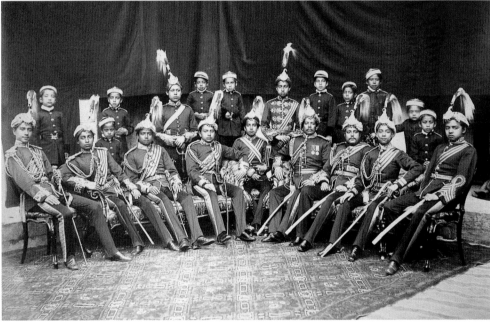

Top left:
1960s; King Mahendra Bir Bikram Shah Dev of Nepal.
Photo collection René Brus

Top middle:
Circa 1935; Baber Shamsher, a member of the Rana family.
Photo collection René Brus

Top right:
Circa 1935; Vaeerab Shamsher, a member of the Rana family.
Photo collection René Brus

Bottom:
Before 1884; Dhir Shumshere Jung Bahadur Rana, Commander-in-Chief of the Nepalese army with 17 of his sons, who are locally referred to as 'the 17 brothers'.
Photo collection René Brus

Opposite page:
Top left:
Circa 1945; Dhir Shumshere Jung Bahadur Rana, General, Commander-in-Chief, Defence Minister and Chief Counsellor of Nepal.
Photo collection René Brus

Bottom left:
Military crown of a member of the Rana family of Nepal. Gold, platinum, diamonds, rubies, emeralds and pearls. The original Bird of Paradise plume with its pearl and gemstone decoration is missing. Made second half of the 19th century.
Collection Nasser D. Khalili Collection of Islamic Art
Photo The Nour Foundation by Courtesy of the Khalili Family Trust, London, England

Right:
Military crown of a member of the Rana family of Nepal. Gold, platinum, diamonds, rubies, emeralds, pearls and feathers of the Bird of Paradise; made second half of the 19th century. Auctioned by Sotheby's London on 18.10.1998 for US$ 134,000.
Photo Sotheby's Picture Library, London, England

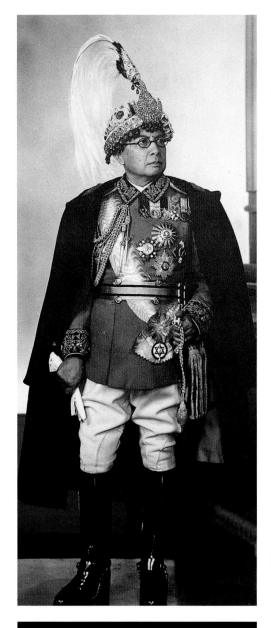

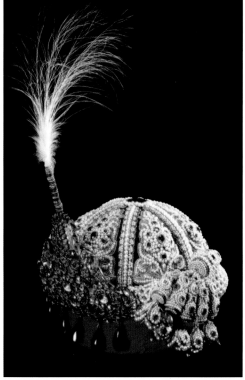

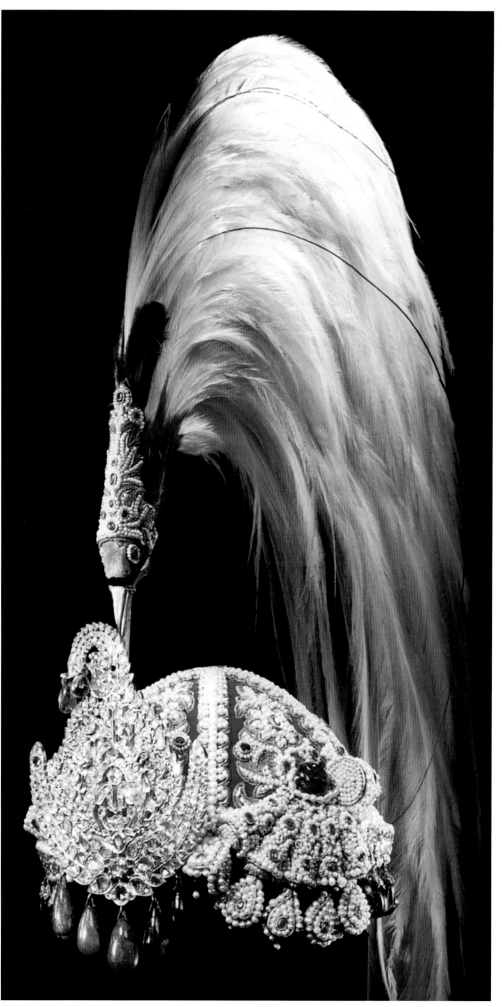

Indonesia

Immediately after his formal enthronement, the Sultan of Yogyakarta appears outside his palace in the *kirab* procession, escorted by his nobles, courtiers and palace soldiers. This procession is seen as the consecration of the ruler by his subjects, and the sultan wears his warrior outfit with the black *mahkuto* for the first time. The *mahkuto* is adorned with diamond-studded golden ornaments, including a representation of the Garuda bird with spread wings at the back. The Garuda is a mythical giant bird, symbol of magnitude and the vehicle of the god Vishnu, who brings his master to all parts of the world where peace, calm and balance is desired. Vishnu is one of the gods from the *Trimurti*, the trinity, together with Brahma and Shiva. Vishnu is the upholder, Brahma, the creator and Shiva, the destroyer and restorer. For Hindus, these gods symbolise the three major milestones in human life; birth, life and death. Despite the fact that the sultans of Yogyakarta have embraced Islam for many centuries, the use of the Garuda as an important feature of the *mahkuto* has been retained from pre-Islamic times. Although the *mahkuto* is not used as a coronation object, it does appear above the royal

crest of Yogyakarta. The *mahkuto* is made of black cloth, shaped into a semi-spherical skullcap which, according to local tradition, represents the world. From behind stretches a high curved structure called the *wengku*, which is the Javanese word for ruling or long-suffering. The term comes from the sultan's official name, Hamengku Buwono, which translates as *'ruling with long-suffering over the realm'*. The top of the skullcap is crowned with a *njamat* or *djoengkat*, a golden knob that contains four miniature dragons with raised heads who together support a large diamond. In the days when the sultans of Yogyakarta wore their long hair in a bun, a heavy diamond comb appeared under the *mahkuto*, through which a diamond-studded butterfly was stuck. In her 1995 publication *Koninklijke Geschenken uit Indonesië* (Royal Gifts from Indonesia), Mrs Rita Wassing-Visser mentions a headdress similar in shape to the *mahkuto*, known as a *kanigara*. This piece is in the collection of the Rijksmuseum of Volkenkunde in Leiden, The Netherlands, and was presented to King Willem I of The Netherlands by Sultan Hamengku Buwono IV in 1819.

Below left:
Mahkuto (rear view) of Sultan Hamengku Buwono IX of Yogyakarta, worn for the first time by the sultan in 1940. Cloth, gold and diamonds; the diamond-set golden ornaments date from the 19th century.
Collection of the Yogyakarta dynasty, Indonesia
Photo René Brus

Below right:
May 1981; during the annual Gerebeg processions, the commander of the *Njoetra* or Throne Guards of the Yogyakarta Sultanate appears in ceremonial military attire wearing an elaborate decorated *kuluk*, large ear decorations and at the back of his head a hairpin in the shape of a Garuda bird.
Photos René Brus

During the 19th and early 20th centuries, the Dutch came into possession of several Indonesian crowns when they ended the monarchies in their colony during periods of unrest. In a Royal Decree issued on 17 June 1906 by the Dutch government, instructions were given that the captured jewels of the royal houses of Gowa and Boni in the colony were to be handed over to three museums: one in the colonial city of Batavia (now the Indonesian capital Jakarta), *het Koningklijk Bataviaasch Genootschap* (the Royal Batavian Society), and two in The Netherlands, *het Rijks Etnografisch Museum* in Leiden and *het Rijksmuseum* in Amsterdam.

Hundreds of objects had been captured by the Dutch colonial army in southern Sulawesi during a period known in history as the Westerling Massacre (*Westerling Bloedbad*). During the skirmishes, the wife of Makoelaoe Da Eng Parani, the ruler of Gowa, had retreated to Pakatto, taking with her all the regalia and crown jewels of the Gowa dynasty as well similar valuables of close relatives. When this town became involved in the war, she and the entire population of Pakatto fled into the jungle, leaving the treasure behind. The valuables were taken by the Dutch forces and shipped to Batavia.

Because the valuables of Gowa included a number of items belonging to members of the former Gowa royal family, letters were sent year after year to the colonial authorities requesting the return of these private possessions. In 1928, after investigating, the Department of Local Government (*Binnenlands Bestuur*) advised the museums not to return anything. One reason for this decision was that it was not known which items belonged to the *Gaoekang* or regalia of Gowa and which items were originally privately owned. The greatest fear for this department, however, was that if a member of the deposed royal family of Gowa took possession of any true regalia, he or she could, according to ancient traditions, claim the throne. The second reason expressed by the department was the fear that once belongings were returned, '*similar requests would come from other parts of the Archipelago in regard to valuables which had once been taken as booty*'. A third important reason for keeping the objects was the possibility that the poorer members of the former royal family might sell them off, either to be melted down or as ornaments for tourists, and thus these historic objects would be lost.

In the early 20th century, some regions of Indonesia were sufficiently under Dutch control that they felt it safe to reinstate the monarchy. In Gowa, the two remaining brothers of the last raja, Boenta Karaeng Mandalla and Mangi-Mangi Karaeng Bontonompo, were eligible as heirs to the throne. The first prince had, however, reached an advanced age, so Karaeng Bontonompo was seen as the most suitable candidate. On 17 November 1936, the freighter *S. S. Melchior Treub* left the harbour of Tandjong Priok, Batavia, carrying in its mail chamber a valuable cargo of three chests containing ten small boxes. During the next few weeks the governor spent time with members of the Gowa aristocracy and courtiers deciding which items were to be regarded as regalia. As soon as each object had been carefully examined and identified, there were no more obstacles to installing and crowning I Mangi Mangi Daeng Mattutu Karaeng Bontonompo as the rightful Raja of Gowa; the coronation took place on 4 January 1937.

The importance of the regalia of Gowa was demonstrated by the large number of servants, known as the *toekadjannangang* and comprising no less than 40 palace societies, who were responsible for the safety and maintenance of these ornaments. The *paoemoeng*, for instance, were responsible for burning incense; the *pabarasa* cleaned the room in which the regalia were kept, while the *pariwaja* kept the regalia of Gowa on their laps during ceremonies. The *pasongko* (derived from *songkok*, the local male headwear) had the duty of crowning the ruler, although in 1937 it was the Dutch colonial representative who performed this act.

Crown originally part of the Gowa regalia. Gilded, most of the precious stones are missing.
Collection Museum Nasional, Jakarta, Indonesia
Photo René Brus

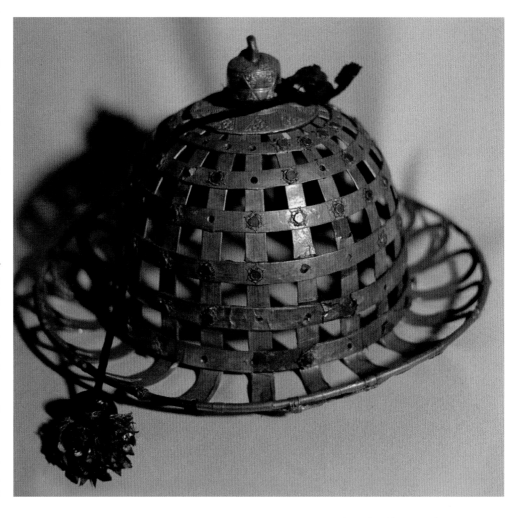

During preparations for the 1937 coronation in Gowa, the original use of some items could not be established, including that of a crown which had been kept in the treasury of the museum in Batavia since 1906. Nobody knew what it was for or when it was made. Early 20th-century documents described it only as *'shaped like a round hat with rim'* and even as *'shaped like a cheese-cover'*, undoubtedly by a museum curator of Dutch birth. This crown, originally studded with gemstones, was mainly made of flat metal bands plated with gold leaf, which crossed over each other creating a kind of tracery. Could this crown have been worn by the ruler of Gowa on the way to his coronation, or perhaps as leader of his army when he went into war? Was it perhaps a crown worn by the first consort of the raja, or did a religious dignitary wear it during the coronation at the moment when the sovereign received the coronation crown of Gowa? Or was the crown of unknown provenance an object sent from heaven? For many centuries, the kings of Gowa

The crown, which is now referred to as the *Salokoa*, was originally set with a number of diamonds, although few of these precious stones remain. The finial, however, is still adorned with a large emerald. Due to the crown's workmanship and enamelling, one might wonder if it was the gift of a Thai or Chinese ruler to one of the rulers of Gowa, or if it was ordered from a goldsmith in India who used the helmet of a Spanish or Portuguese soldier as a model. The front of the crown has an outward, curved structure with a small tube, which at some point held the feathers of a special bird. The coronation crown of Gowa is too large for the average head, suggesting that either a cap was placed inside the crown or that the ruler wore a head cover over which the crown was placed. Questions such as these are now difficult to answer because when the Dutch colonial authorities took the Gowa treasures as booty, no effort was made to learn about the rituals and stories associated with the regalia from courtiers or members of the former royal family.

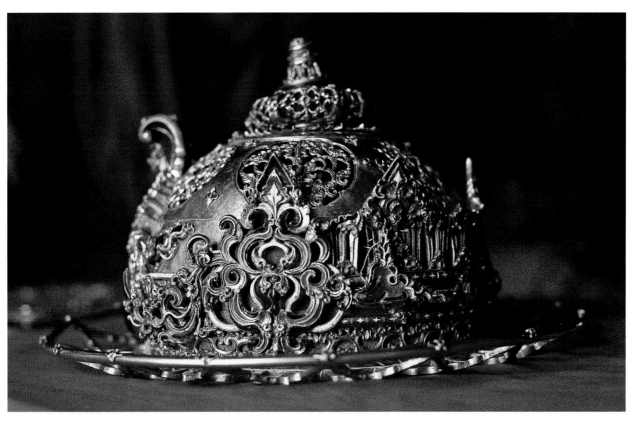

Salokoa of Gowa. Gold, silver, enamel and emeralds; most of the precious stones are missing; made in the 14th-15th century.
Collection Treasury Room of the palace of Sungguminasa, Sulawesi, Indonesia
Photo René Brus

had been crowned, in a ceremony known as *Lanti*, at Tamalate, a hill in the cemetery of the Gowa royal house. According to tradition, on this spot Tomanurung descended from heaven and became the first female ruler and founder of the Gowa dynasty. In some legends, this illustrious queen brought with her the *Salokoa* or *Saloloko*, the gem-studded and enamelled coronation crown of Gowa. Historians claim that this crown, with its stylised foliated *à-jour* motifs and stupa or helmet-like shape, was made in the 14th or 15th century.

Fortunately, some traditions have been passed on, such as the burning of incense and the offering of rice and ingredients for chewing *sirih* to the historic crown of Gowa. Every Thursday, female *penati* priestesses sing traditional songs to pay their respects to the crown. This relic is now kept in the treasury room of the Sungguminasa Palace, where *kanjoli* candles burn 24 hours a day. Since the establishment of the Indonesian Republic, the status of this crown and other emblems of royalty has changed, but its importance is still strong and the crown is treated with great respect by the Gowa people.

Crowns in religion

Monasteries, churches and other religious institutions possess many crowns, generally received as *ex-voto* or votive gifts in honour of gods and deities. For the believer, such a gift can be a humble gesture of gratitude for the supposed intervention of the Almighty or possibly an attempt to guarantee a place in the hereafter. Some votive gifts are set with precious stones and pearls and are extremely valuable. These might only be seen occasionally, carried in processions or placed on the statues of deities or saints during religious festivals. A votive gift is not necessarily given by one person; sometimes it is the result of contributions from many believers over many years.

The shape and decoration of many religious crowns are dictated by tradition and generally carry symbols important to believers and closely connected with the powers of nature or dieties. In ancient Egypt, a golden disc symbolised the Sun god, *Ra*, the cosmic divinity who governed the Earth when the gods and mortals lived in peace alongside each other. Since pharaohs were regarded as gods in this civilisation, it is no wonder that their crowns were often similar or identical in design and shape to those that adorned the gods and goddesses. Crowns have also played an important role in divine worship since ancient times, especially when the clergy were involved in state rule. The symbols of authority worn by religious officers have sometimes been inspired by those of worldly sovereigns, while in other cases completely different crowns, worn only by religious functionaries, have evolved.

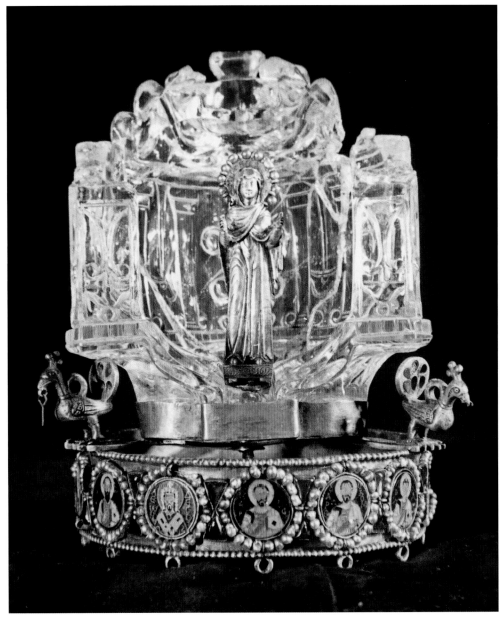

Left:
Crowned statue of the Hindu deity Gopala. The crown is made of gold and set with precious stones including rubies; probably made at the end of the 19th century.
Radha Gopala temple, Gwalior city, India
Photo René Brus

Right:
Votive crown attributed to Emperor Leo VI of Constantinople. Gold, rock crystal, pearls, rubies, enamel; the crystal structure made in the 4th-5th century AD, headband made in the 9th-10th century, statue of the Holy Mary made in the 13th century. The whole assembled in the 14th century.
Collection The Treasury of Basilica di San Marco, Venice, Italy
Photo Procuratoria di San Marco, Venice, Italy

Religious symbols – stars

For Christian believers, the Star of Bethlehem is the bright star that stood above the city of Bethlehem on the night Jesus was born, to guide those who came to visit the new-born child. The shape of the Star of Bethlehem is not regulated, and it may have four, five, six or more points or rays. When two equilateral triangles are entwined a six-pointed star is formed. This is known to the Jews as the Star of David and to the Ethiopian Orthodox Church as the Seal of Solomon.

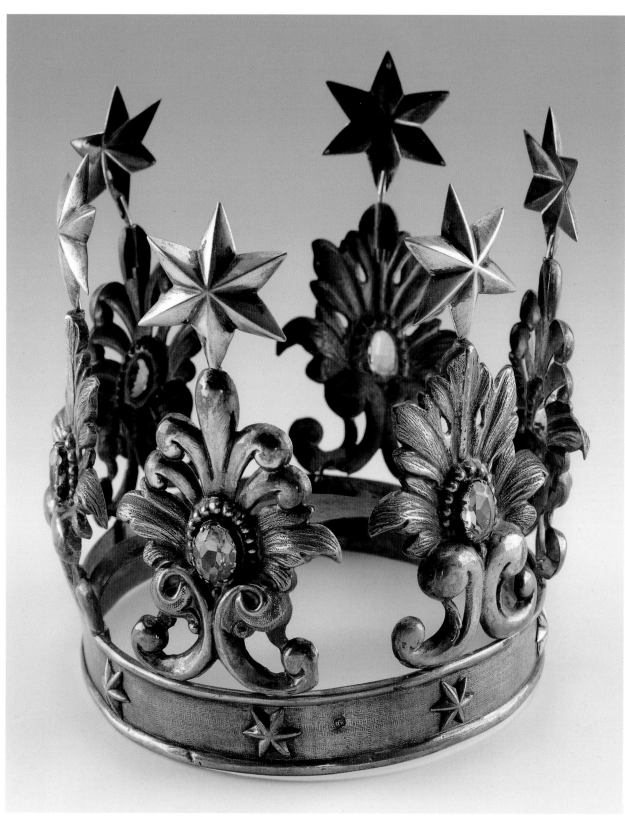

Crown intended for a statue in the Catholic Church. Silver, amethysts and citrines; made in 1831, Haarlem mark.
Collection and photo René Brus

Opposite page:
Top left:
Crown of the statue of the Virgin Mary, topped with a Latin cross. Copper-gilt, enamel and paste; made in the 17th century, Spain.
Collection and photo Victoria & Albert Museum, London, England

Bottom left:
Crown of the infant Jesus with an ornamental Latin Cross; used to adorn the statue of the Virgin Mary of the church of the Notre Dame d'Albert. Gold, pearls and diamonds; made in 1900 by Mellerio dits Meller, Paris, France.
Collection and photo Cathedral Notre Dame d'Amiens, France

Religious symbols – cross

The cross appears in many variations and is often connected with Christianity and the crucifixion of Jesus Christ. The cross design used typically resembles that of the crucifixion, but it is sometimes based on the aureole, the light that radiates around the head of saints, and is therefore known as a radiated cross. The different shapes of the cross are often named after the country where the design was first found, such as the Egyptian, Greek or Russian cross. The Lalibela, Gonder and Axum crosses came from former kingdoms in Ethiopia. Ethiopian religious crowns are often also topped with a unique feature not found anywhere else in the world, namely a miniature replica of the Ark of the Covenant, and this has been regarded as the national symbol for many centuries.

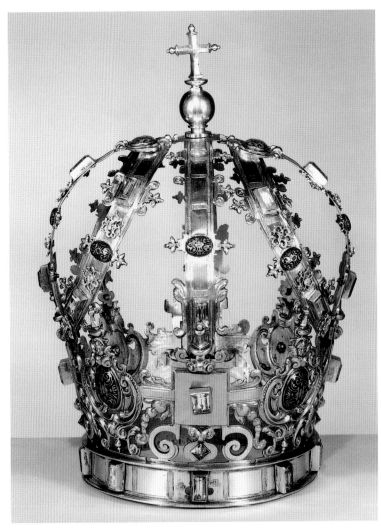

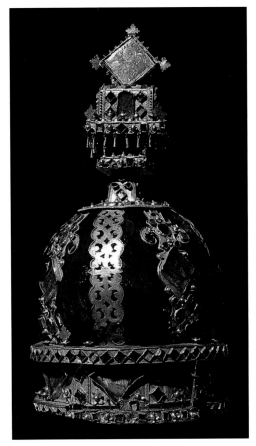

Top right:
Ethiopian crown with, on its top, a miniature ark of the covenant, placed under the ornamental cross. This crown is believed to have been worn by Emperor Fasilidas. Gold, silver, gilt, agate, paste, and icons under glass; made in the 17th century.
Collection the Treasury of St Mary of Zion, Axum, Ethiopia
Photo René Brus

Bottom right:
Crown of the statue of the Virgin Mary, topped with a Greek cross. Silver; made second half of the 17th century, Palermo mark.
Collection and photo Victoria & Albert Museum, London, England

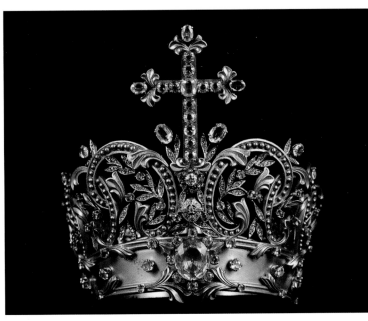

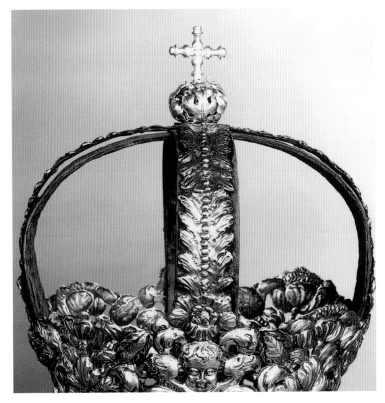

Religious symbols – bells

Several Ethiopian crowns are also decorated with tiny, bell-shaped pendants which make a tinkling sound when the crown is worn. These pendants are not unique to the Ethiopian Orthodox Church. They originated from the golden bell of the Jewish High Priest, which is mentioned in Exodus 28.34, where the garb of the high priest is described as, '*the gold bells and the pomegranates are to alternate around the hem of the robe*'. The bell is often seen on crowns that decorate the Jewish law scroll, the Torah. In the Jewish faith, the Torah and its finial ornaments are the most visible and venerated decorations in the synagogue. The headpieces of the scroll are referred to as *rimmonim*, meaning pomegranates, a symbol of fertility and life throughout the Near East. The shape of the *keter* (*ktr* is Hebrew for crown, which means literally 'to encircle') or crown-type finials of the Torah developed differently in various countries. The earliest mention of an actual Torah crown appears in the year 1000 AD, in the response of a Spanish rabbi to a question about the use of women's jewellery in making a Torah crown.

In the Bible, three different terms are used for the crown or ornate headdress, namely *nezer*, *atarah* and *keter*. In Ezekiel 21:26 *atarah* appears as part of the priestly headgear and such crowns were apparently made of precious materials, as indicated in Zechariah 6:11 '*Take the silver and gold and make a crown, and set it on the head of the high priest, Joshua son of Jehozadak.*' Because three words are used for crown, several references, like the ancient Jewish book *Pirkei Avot*, state that, '*There are three crowns. The crown of Torah, the crown of priesthood, and the crown of kingship. But the crown of a good name excels them all.*'

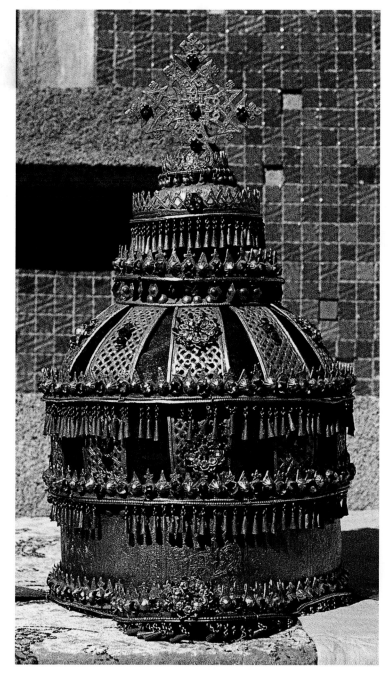

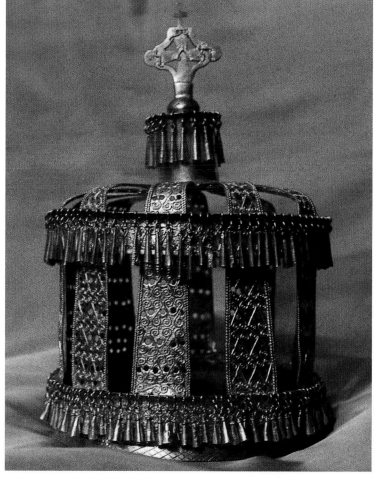

Left:
Crown topped with an Axum cross. Votive offering of Ras Seyum to the church of St Mary of Zion in 1922. Gold, paste; made early 20th century. Collection the Treasury of St Mary of Zion, Axum, Ethiopia Photo René Brus

Right:
Crown of a deacon. Gilded silver; made beginning of the 20th century. Collection Menelik Mausoleum, Addis Ababa, Ethiopia Photo René Brus

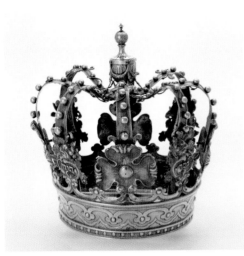

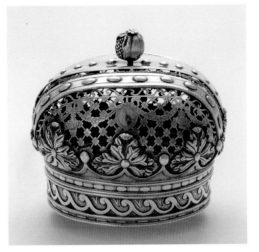

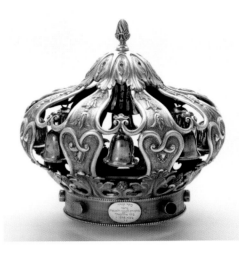

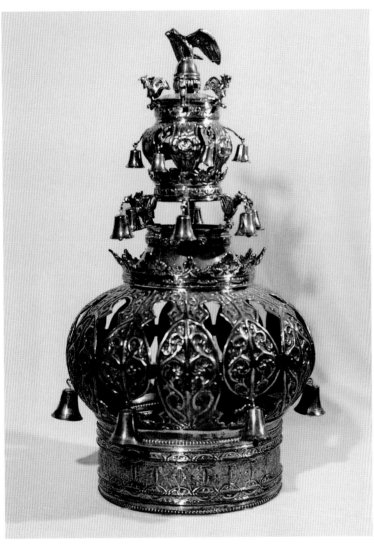

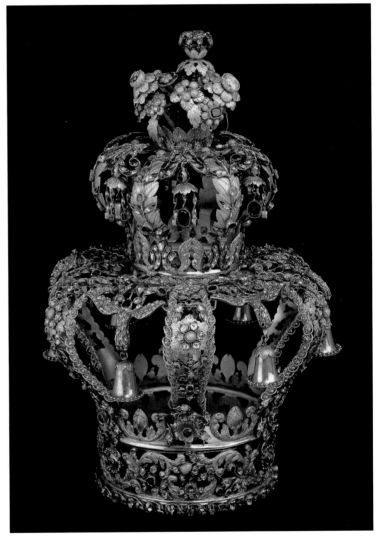

Top left:
Torah crown, the shape
that resembles the
Dutch royal crown made
in 1840. Gilded silver;
made in 1775 by
Wijnand Warneke.
Collection and photo
Joods Historisch
Museum, Amsterdam,
The Netherlands (on
loan from De Portugees-
Israëlietische Gemeente,
Amsterdam,
The Netherlands)

Top middle:
Torah crown, (side view)
the shape has been
adopted from the so-
called Imperial crown,
being the mitre-crown
of Emperor Rudolf II
of Habsburg. These
two crowns (top left
and top middle) adorn
the Torah scrolls of the
Amsterdam Portuguese
synagogue every year
during the celebration of
Simchat Torah. Gilded

silver and glass; made
in 1775.
Collection Joods
Historisch Museum,
Amsterdam,
The Netherlands (on
loan from De Portugees-
Israëlietische Gemeente,
Amsterdam,
The Netherlands)
Photo Joods Historisch
Museum, Amsterdam,
The Netherlands

Top right:
Torah crown. Silver
and gilded silver;
made in 1883 by Jacob
Hendrik Helweg.
Collection Joods
Historisch Museum,
Amsterdam,
The Netherlands (on
loan from Nederlands-
Israëlietische Gemeente,
Alkmaar)
Photo Joods Historisch
Museum, Amsterdam,
The Netherlands

Bottom left:
Torah crown. Silver;
made in the second half
of the 19th century.
Collection Jürgen Abeler,
Wuppertal-Elberfeld,
Germany
Photo René Brus

Bottom right:
Torah crown probably
made in Vienna for a
Galician Hassidic court.
Gold, diamonds, rubies,
emeralds, turquoises
and amethysts; made
circa 1825.
Collection Gilbert
Collection/Victoria
& Albert Museum,
London, England
Photo Sue Bond
Public Relations,
London, England

The papal tiara of the Catholic Church

In the early years of the Catholic Church, the power and position of its highest priest, the pope, did not merit much pomp and splendour. But when the last Roman Emperor Romulus Augustulus was deposed in 476 AD and the worldly power of the Church increased, religious ceremonies evolved in which the clergy started to wear valuable objects. In early church records, there is no mention of the papal triple crown or tiara, and even mitres were rarely described, but a great deal changed as European rulers started recognising the Pope as Christ's representative on earth.

The *triregnum* or *tricorona*, as the papal tiara is also referred to, got its name from the three crowns that decorate this religious headdress. Various symbolic meanings are attached to these three crowns, including the threefold dignity of the Pope as priest, king and teacher. There is also the obvious interpretation that the crowns correspond to the Holy Trinity – God the Father, God the Son and God the Holy Ghost – and a further possibility that the crowns symbolise the spiritual, kingly and imperial power of the Pope. The first papal tiara decorated with a circlet was described in 1295, in the inventory of the papal treasures of Pope Boniface VIII. During the pontificate of this Pope, a second circlet was placed above the first circlet. The first record of three circlets on the papal tiara date from an inventory of the papal treasure in the year 1315 or 1316. In the year 1456 a tiara with three circlets is mentioned when Pope Callixtus III sold all his valuables, including the tiara, to raise money to finance a war against the Turks with the aim of re-conquering Constantinople. Thus the papal tiara has not always been seen as an indispensable religious object. On another occasion, at the end of the 15th century, Pope Julius II pawned the tiara of his predecessor Pope Paul II to the Chigi banking family for 40,000 florins.

The collection of papal tiaras kept in the Vatican dates almost entirely from the 19th and 20th centuries and all were gifts. There is one from a shopkeeper from Lyon, a much more valuable one from Queen Isabel II of Spain, and others from the city of Paris, from the Belgians and from the Catholic people of Milan, to mention just a few. In 1877, the Palatine Guard (a military unit of the Vatican City) gave Pope Pius IX a tiara very richly decorated with different precious stones, and this tiara was used frequently by him and his successors, including Pope Pius XII, who wore it during his coronation in 1939.

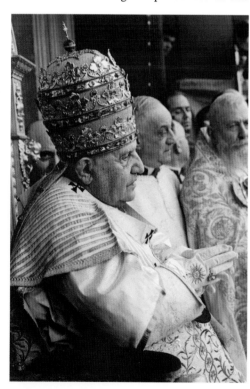

4.11.1958; coronation of
Pope John XXIII wearing
the tiara given by the
Palatine Guard in 1877.
Photo Pontificia
Fotografia Felici,
Rome, Italy

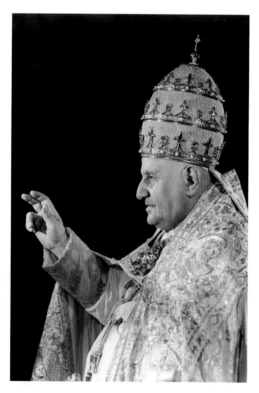

1959; Pope John XXIII
wearing a tiara given by
the people of Bergamo
that same year.
Photo Pontificia
Fotografia Felici,
Rome, Italy

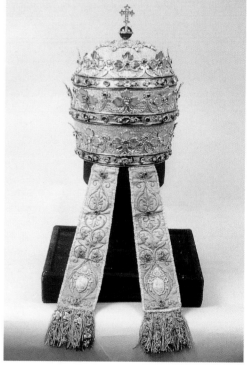

Tiara given by the
Palatine Guard to Pope
Pius IX in 1877. Gold,
silver, pearls, diamonds,
rubies, emeralds,
garnets, amethyst,
topazes and lapis lazuli;
made in 1877.

Collection Papal
Treasury, Vatican, Italy
Photo collection
René Brus

The papal tiara has not been used at papal anointments since 1978, the 'year of the three Popes' (Paul VI, John Paul I and John Paul II), when the Pope was twice chosen and anointed without making use of the tiara, the sedan chair or the ritual where the cardinals kissed the Pope's toe. The simplified ceremony had originally been instituted by Pope Paul VI, who had been elected successor to Pope John XXIII in 1963. For Pope Paul VI's coronation, his former bishopric of Milan had given a new tiara made from silver, embellished with golden bands and set with diamonds, sapphires and rubies. The next year, during the Second Vatican Council, a mass was held at which the Pope unexpectedly took off his tiara and placed it on the altar, announcing that he had given his tiara to the poor of the world.

Monsignor McDonough, the Director of the National Shrine of the Immaculate Conception in New York, recalled this memorable moment; '*Everyone present sensed the historical importance of the act. The tiara, which has been the symbol of Pontifical dignity, became the new spirit of the Church purified. It manifested the renunciation of human glory and power. It will remain forever a reminder that the energy and resources of the Church must be employed for the good of souls and the betterment of individuals.*' The tiara was not sold for the benefit of the poor, but sent to the New York National Shrine of the Immaculate Conception because it '*belongs to all Americans.*' Cardinal Spellman accepted the gift of Pope Paul VI on behalf of the American Catholics and thanked His Holiness with the following words '*I am deeply grateful to your Holiness for the precious gift of your Tiara, which I humbly accept as a tribute to the charity of Americans and as an evidence of the desire of assisting your Holiness in helping the poor of the world. This Tiara will be treasured as an object of veneration and a symbol of the merciful heart of Your Holiness.*' Since then this tiara has been admired by many and the money given during its public display has been donated to charitable organisations.

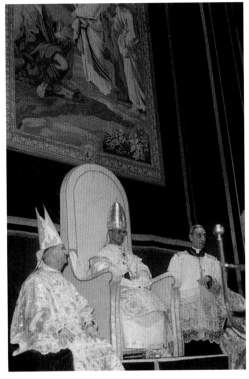

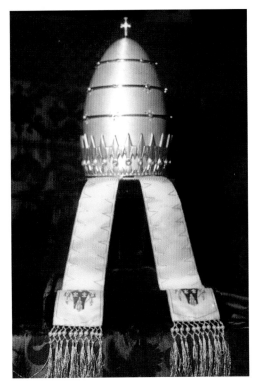

Left:
6.2.1968; Archbishop Luigi Raimondi, Apostolic Delegate to the United States of America, presents the tiara of Pope Paul VI to the shrine of the Immaculate Conception in Washington. On the right is Monsignor McDonough.
Photo Apostolic Nunciature of the United States of America, Washington, USA

Middle:
30.6.1963; coronation of Pope Paul VI.
Photo Pontificia Fotografia Felici, Rome, Italy

Right:
Tiara of Pope Paul VI, made by the order of the diocese of Milan and given to the Pope in 1963. Gold, silver, diamonds, rubies and sapphires.
Collection the National Shrine of the Immaculate Conception, Washington, USA
Photo Pontificia Fotografia Felici, Rome, Italy

Mitre

The word *mitre* is usually used in the Christian world to refer to the liturgical head covering made from cloth with two raised tips worn by senior representatives of the Catholic Church. In the Orthodox Christian Church, however, the mitre developed into a headdress that is generally spherical on the top. Such mitres are often made of a cloth frame decorated with depictions of different saints and angels embroidered in gold or as small icons in embossed metal or painting. Whatever shape or material is used for these liturgical Christian head coverings, they are always adorned in one way or another with the cross, the symbol of the Christian faith.

The mitre shape is also found in other religions, where it has evolved into a dome, pagoda or stupa, typically a conical structure made from cloth onto which metal or gem-studded decorations are sewn. The headdress of a Buddhist priest, for instance, includes symbols representing the thunderbolt or *vajra*.

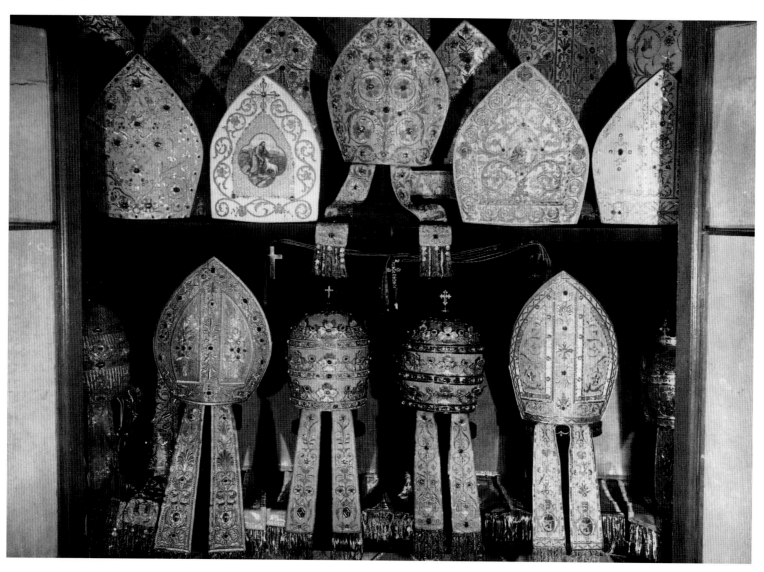

1974; Some of the papal tiaras and mitres on display in the Private Papal Treasury.
Photo collection
René Brus

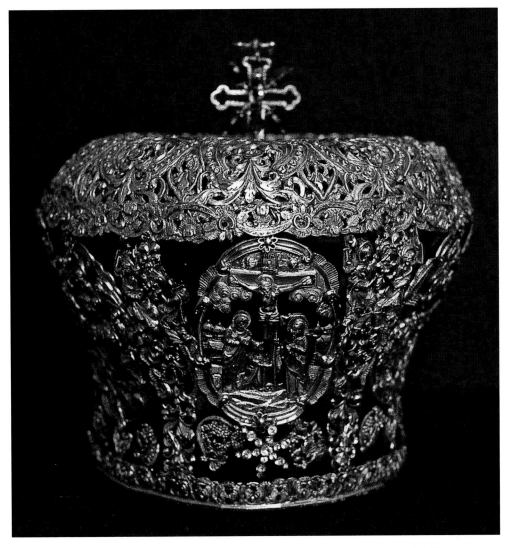

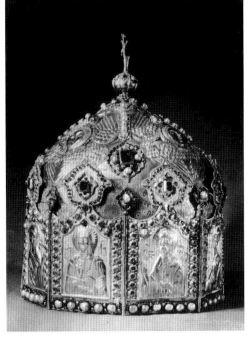

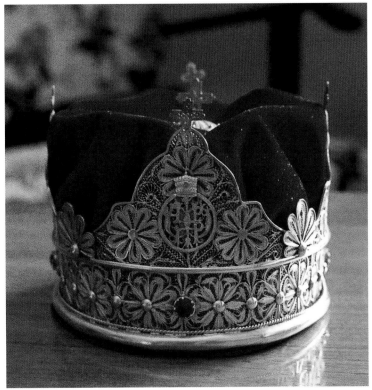

Bottom:
Crown of the Ethiopian Orthodox Dean of the Emperor Menelik II Mausoleum. Gold and garnet; made after the Second World War.
Collection Private Apartments of the Dean of the Menelik Mausoleum, Addis Ababa, Ethiopia
Photo René Brus

Top left:
Mitre used in the Russian or Armenian Orthodox Church. Silver-gilt, coral, paste; made second half of the 18th century with 19th century additions.
Collection Victoria & Albert Museum, London, England
Photo René Brus

Top right:
Mitre used by the Head of the Catholic Church of Georgia. Gold, pearls, rubies and emeralds; possibly made in the 19th century.
Collection unknown
Photo Twining Collection, Library, Goldsmiths' Hall, London, England

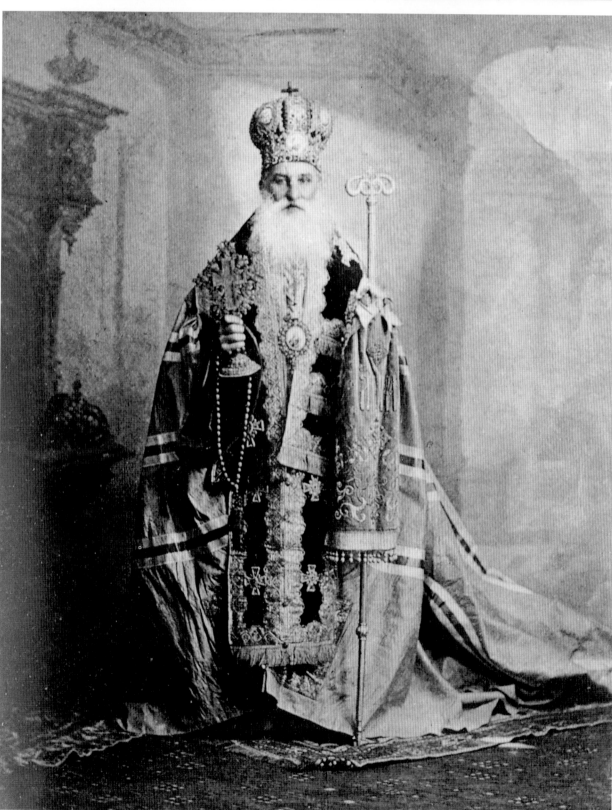

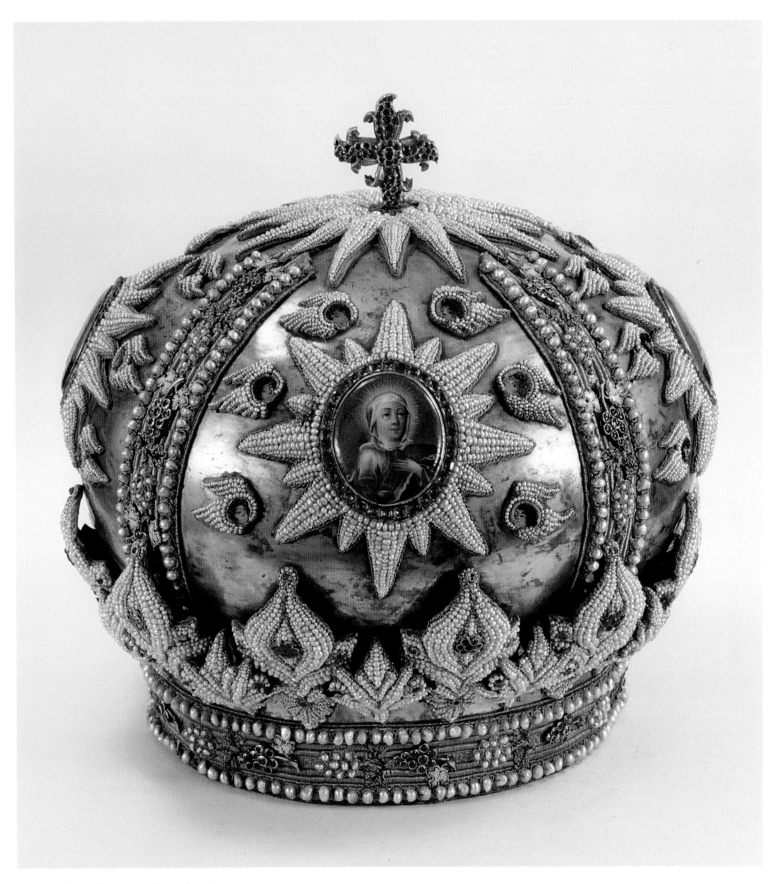

Mitre used by Kyrillos IV, Metropolitan of Andrianople (1775-1821). Like many other prelates, Kyrillos IV was tortured and executed by the Turks in reprisal for the outbreak of the Greek Revolution in Moldavia. The mitre and other heirlooms were saved by refugees from Eastern Thrace. Silver gilt, pearls, rubies, emeralds, enamel, and icons under glass; made end of the 18th, beginning of the 19th century. Collection and photo Benaki Museum, Athens, Greece

Top, left and right:
1970s; A Newar priest in
Nepal making offerings.
Photo Ruud de Clerc

Bottom:
1980s; A Hindu priest or
pendamda performing at
a Balinese wedding.
Photo Fransje
Brinkgreve, Leiderdorp,
The Netherlands

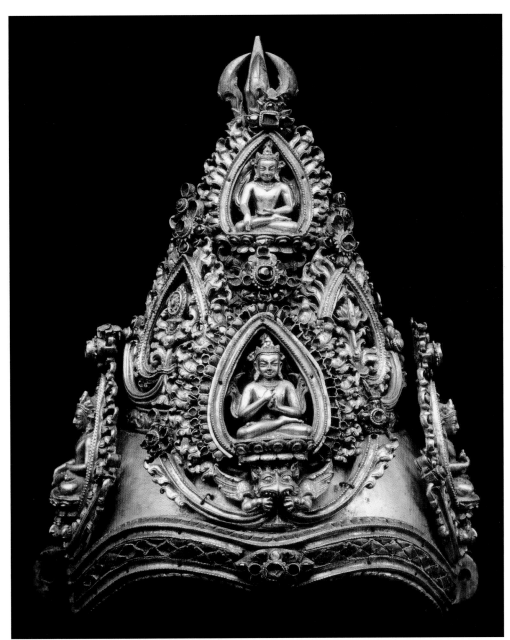

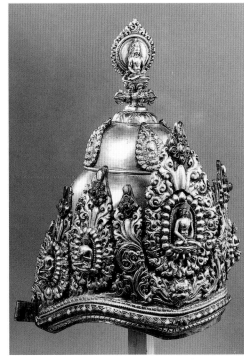

Top left:
This type of crown is worn by Tantric Masters in Nepal during religious ceremonies. On the lower band, a Sanskrit inscription bears a date corresponding to the year 1145. The top is decorated with a half-sized thunderbolt-diamond or *varja*. The figures are either *jinas* or a depiction of the 'victorious' Buddha, in permanent meditation and each Buddha is performing his own specific conical gesture or *mudra*. Gilded copper, some fragments of red and blue stones have survived.
Collection Musée Guimet & Musée de l'Homme, Paris France

Bottom:
This type of headdress was worn by the Lama when performing religious rituals. Gold, turquoises, pearls and leather; made in the 18th or 19th century.
Collection and photo National Palace Museum, Taipei, Taiwan, Republic of China

Top right:
Dhu-rmog of a Buddhist priest worn at the *homa* or *sbyin sreg* ceremony to indicate his five-fold power. The shape of this crown is often considered to be that of a helmet, and it was once an essential piece of the armour of the early Tibetan kings. *Gubhaju* is another name for this kind of religious crown. Gilt copper, paste and semi-precious stones such as turquoise and blood coral; made end of the 18th, beginning of the 19th century.
Collection Victoria & Albert Museum, London, England
Photo René Brus

Rigs Inga

Tibetan Buddhism embraces ancient habits and traditions that have developed through the centuries. One ancient custom is the wearing of different coloured headdresses to distinguish religious authorities from others, and includes, for instance, the black *usnisa*. This is a close-fitting cap made of cloth, which is crowned with a double, spherical peak symbolising the bump of the divine wisdom on the head of Buddha. A five-leaf crown, the consecrated crown of the *Samboghakaya*, the Buddha who is immortal and resides till the end of time in the 'not down-under' paradise, is traditionally tied to this headdress. The crown is known as the *rigs Inga* and its five segments represent the five Celestial Buddhas, who correspond to the five points of the compass, including the centre. Each of these Buddhas is associated with a specific name, colour, particularities, symbolism and animal. According to the Namgyal Monastry, Dharamsala in India (Namgyal Tibetan Monastry), the *rigs Inga* has the following icons; yellow for Vairocana, red for Ratnasambhava, white for Amitabha, green for Akshobhya and black for Amogghasiddhi.

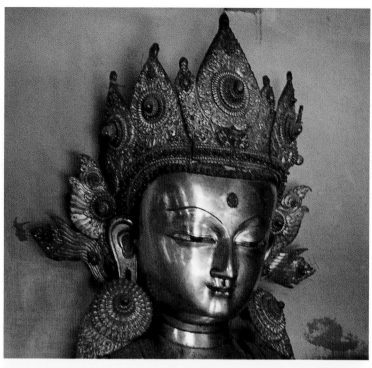

Crowned Buddha statue. Gilded, turquoise and red coral.
Golden Temple, Hiranya Varna, Mahavihar, Patan, Nepal
Photo René Brus

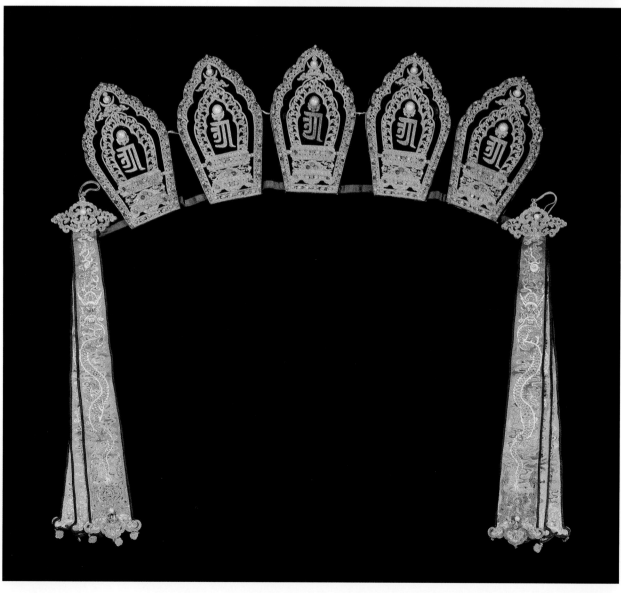

Five-leaved crown with Sanskrit characters, worn by the Lamas on special ceremonies over their black usnica cap. Gilded, pearls, blue, red and green stones; made 18th or 19th century.
Collection and photo National Palace Museum, Taipei, Taiwan, Republic of China

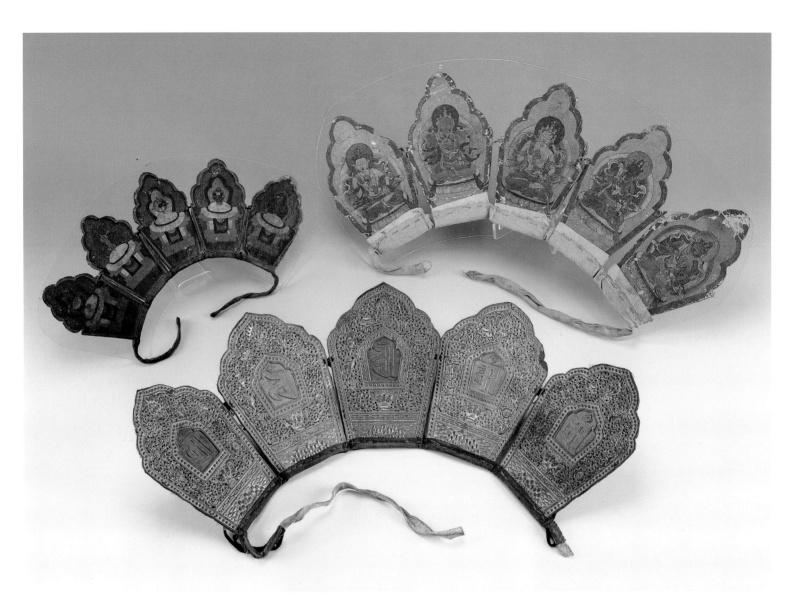

Top:
Tibetan religious *rigs Inga* crowns, worn over an *usnisa* cap with a double, spherical peak. Left; this *rigs Inga* has representations of the so-called jewels, which as symbols belong to the Celestial Buddhas of *Vajrayana* Buddhism. The *dorje*, the sacred flash of lightning, is depicted on the second panel from the left. Middle; this *rigs Inga* is decorated with different versions of the mystical word *Om*, depicted in the *ranja* writings, and is worn by monks at *tantric* initiation ceremonies. Right; this *rigs Inga* has representations of the *Dhyani* Buddhas or *Tathagatas*, who are sitting cross-legged on lotus-thrones. Left and right; cardboard. Middle; white metal. All made end of the 19th, beginning of the 20th century.
Collection and photo René Brus

Bottom:
24.2.1975; a religious ceremony to celebrate the coronation of King Birendra of Nepal. The Tibetan religious men are wearing the rigs Inga over their black usnica cap. The lamas and monks are saying their traditional prayers in the streets of Kathmandu, the capital of Nepal, to wish for a prosperous reign for the new king.
Photo Guus Geesink

Votive – crown of thorns

In Christianity, the Crown of Thorns of Jesus Christ undoubtedly ranks among the most revered and sacred of all relics. This crown, a wreath made of thorny branches, was pressed onto Jesus Christ's head before he was crucified. The purported thorns from this crown have been venerated throughout the centuries and are kept as relics in reliquaries in several churches and monasteries. One notable reliquary is the crown of Saint Louis, named after the saintly King Louis IX of France, who gave it to the Dominican church of Saint Catherine of Liège, Belgium, in around 1267.

Another reliquary crown that contains a few thorns from the purported Crown of Thorns and went to Belgium was the one given by Philip I, Margrave of Namur, to the Cathedral of Namur between 1207 and 1218. This nobleman was the brother of Emperor Henry of Constantinople, who died childless in 1216. There are some indications that this reliquary crown was originally made by order of Philip I, for his own use, to be worn when he was called upon to succeed his brother Henry. This, however, never took place. The reliquary crown was forgotten until 1867, when it was discovered in an old casket and placed in the Diocesan Museum of Namur in Belgium.

According to history, the main part of the sacred Crown of Thorns was taken to Byzantium in about 1063 and was presented to King Louis IX of France (Saint Louis) by Emperor Baldwin II of Constantinople in 1238. Ten years later, on 25 April 1248, this relic was placed in the famous Sainte-Chapelle, built in Paris especially to house the Crown of Thorns. Once a year, the King of France made a pilgrimage to Saint-Chapelle, until this tradition ended with the French Revolution and the fall of the monarchy. In 1794, the Crown of Thorns was placed in the collection of the National Library of Paris. When Napoléon Bonaparte created himself Emperor of France, the relic was put into the custody of Cardinal de Belloy on 26 October 1804. Its authenticity was finally established on 5 August 1806, and five days later, the Crown of Thorns was handed over to Notre Dame de Paris, where it has remained in the treasury ever since.

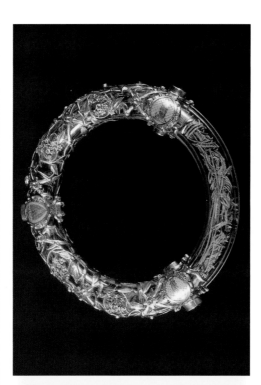

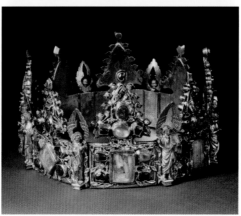

Left and top right:
Left; The whole reliquary. Top right; Top of the reliquary containing the Crown of Thorns. Gold, precious and semi-precious stones and enamel. To protect the fragile branches and thorns, the relic is placed in a circular container made of rock crystal, which in turn is placed in an elaborately decorated reliquary, topped with a *fleur-de-lys* crown that was made in 1862 by Placide Poussièlgue-Rusand after a design by Eugene Viollet-le-Duc. (Some references mention Jean-Charles Cahier as the maker of this reliquary.)
Collection Treasury of the Cathédrale Notre-Dame de Paris, France
Photo P. Rousselot, l'Intendant Basilique Métropolitaine de Notre-Dame de Paris / Ordo Equestris Sancti Sepulcri Hierosolymitani, Paris, France

Bottom right:
Crown of St Louis containing the purported thorns from the Crown of Thorns. Gold, precious stones including emeralds from Austria; made in the 13th century. The crown of St Louis consists of eight silver-gilt plaques with *fleur-de-lys* terminals linked by eight winged angels. The plaques are decorated with oak leaves and set with gemstones. The pieces from the purported Crown of Thorns are placed behind clear rock crystal in two small cases. When the Dominican Monastery was closed in 1796, this reliquary crown came into the possession of the House of Wettin. After the Second World War, the crown was acquired by the French government and placed in the Louvre Museum.
Collection and photo Musée du Louvre, Paris, France

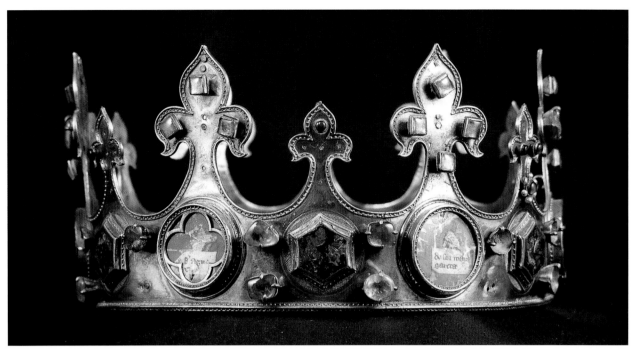

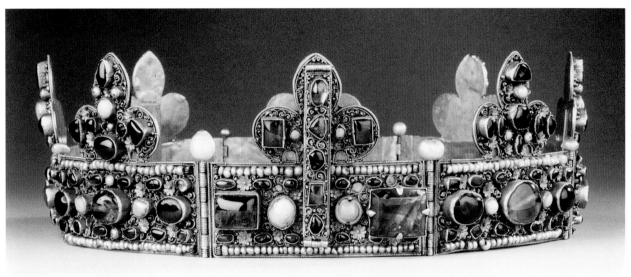

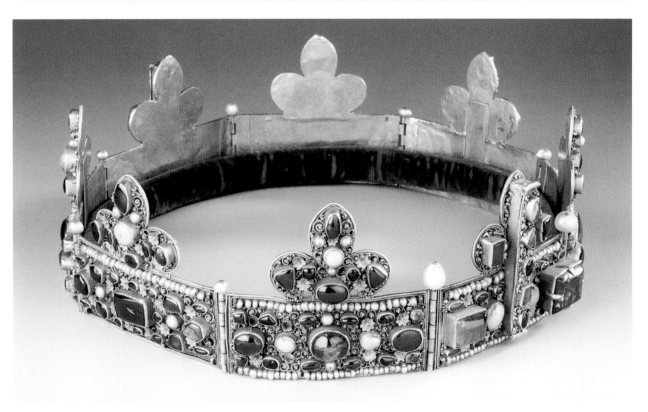

Top:
Reliquary crown that originally adorned the statue of the Virgin Mary in the Abbey of Paraclet. Below each *fleur-de-lys* ornament is a medallion containing different relics, including a thorn purporting to come from the Crown of Thorns placed on Jesus' head before his crucifixion. Gilded silver, enamel and different gemstones including pearls, emeralds, garnets and rock crystal; made between 1320 and 1340.
Collection and photo Cathédrale Notre Dame d'Amiens, France

Middle and bottom:
Reliquary crown containing a few thorns from the purported Crown of Thorns. Gold, pearls, rubies, emeralds and sapphires; made beginning of the 13th century.
Collection Treasury of the Cathedral of Namur, Musée diocésain et Trésor de la Cathédrale Saint Aubain, Namur, Belgium
Photo Musée diocésain et Trésor de la Cathédrale Saint Aubain, Namur, Belgium

Votive – crown of the Andes

One of the most spectacular crowns to have adorned the statue of the Virgin Mary is undoubtedly the Crown of the Andes. In 1590, a terrible epidemic wiped out half the population on the west coast of South America. The inhabitants of the city of Popayán (in present-day Colombia) were waiting in terror for the epidemic to reach their town, but by a miracle the city was spared. To express their gratitude, the richest families of the town decided to donate a crown to the statue of Mary that stood in the cathedral. The crown had to outdo all the other crowns of all the monarchs on earth in beauty, splendour and worth, because otherwise it would not be a fitting gift for the Queen of Heaven. The populace of Popayán collected about 50 kg of pure gold and 453 emeralds from the treasures of the vanished Incan Empire of Emperor Atahualpa. In 1593, 24 goldsmiths and silversmiths began a herculean task that was to take them six years. Eventually, they produced a crown unique throughout the world. At first, it was made of a headband, to which (as several jewellery experts have established) arches and an orb with cross were added in the 17th century. All the parts were joined together with golden screws, making it possible to dismantle the crown quickly in times of emergency and to hide the parts separately. From the arches that meet at the top hung 17 drop-shaped emeralds of between 12 and 24 carats, and the cross on top was set with ten more large stones. The crown, with 1521 carats of emeralds in total, was placed on the head of the statue of the Virgin Mary in the cathedral for the first time at the feast of the Immaculate Conception on 8 December 1599, and this was repeated every year on the same day until the early 20th century, the only exceptions being in times of war and danger. In order to protect the crown from pirates, and later from revolution and war, the Confraternity of the Immaculate Conception was formed by an influential group of local noblemen. The members have all pledged to guard the crown with their lives.

At the beginning of the 20th century, this Catholic Brotherhood of the Immaculate Conception and the Archbishop of Popayán needed money to build an orphanage, a hospital and a nursing home for the elderly, and were convinced that as an act of Christian neighbourly love, it was correct to sell the Crown of the Andes for this purpose. Since such valuable church property was not generally sold, permission had to be obtained from the Vatican. Permission was not granted until 1914, when Pope Pius X signed decree number 71863 dated 17 June. Unfortunately, while Tsar Nicholas II had shown much interest in buying the crown in 1910, by the time permission was granted the First World War had started and Tsar Nicholas II was soon to lose his power and his life.

The Crown of the Andes was not sold until 6 June 1936. A North American buying syndicate chaired by the gem merchant Warren Piper bought it. There was talk of removing the valuable emeralds and donating the empty golden crown frame to the Metropolitan Museum in New York or the Art Institute of Chicago. Fortunately this idea was abandoned and the Crown of the Andes travelled throughout the United States for many years, being put on display at countless events. When the crown was displayed, 50% of the entry fee was usually donated to charitable organisations. In 1963 the 'Crown of the Andes Company' decided to sell the crown at Sotheby's in London. Within one and a half minutes of the auction starting, the crown was sold to the Amsterdam diamond company Asscher for £55,000. Asscher purchased the historical crown on behalf of the New York company of Oscar Heyman & Brothers, and for many years it was hidden from the general public. In 1982, the American jewellery historian Neil Letson tracked it down and published an article on the history of the crown in the *Connoisseur*, together with wonderfully detailed photographs. Although the name of the owner was not revealed, it was at least now known that the Crown of the Andes still existed in its original splendour. In 1995, the unknown owner decided to part with the crown and the auction house Christie's took the Crown of the Andes on a world tour from 5 April to 20 September to attract potential buyers. Apparently the estimated value of between three and five million American dollars was too high, as the crown failed to sell.

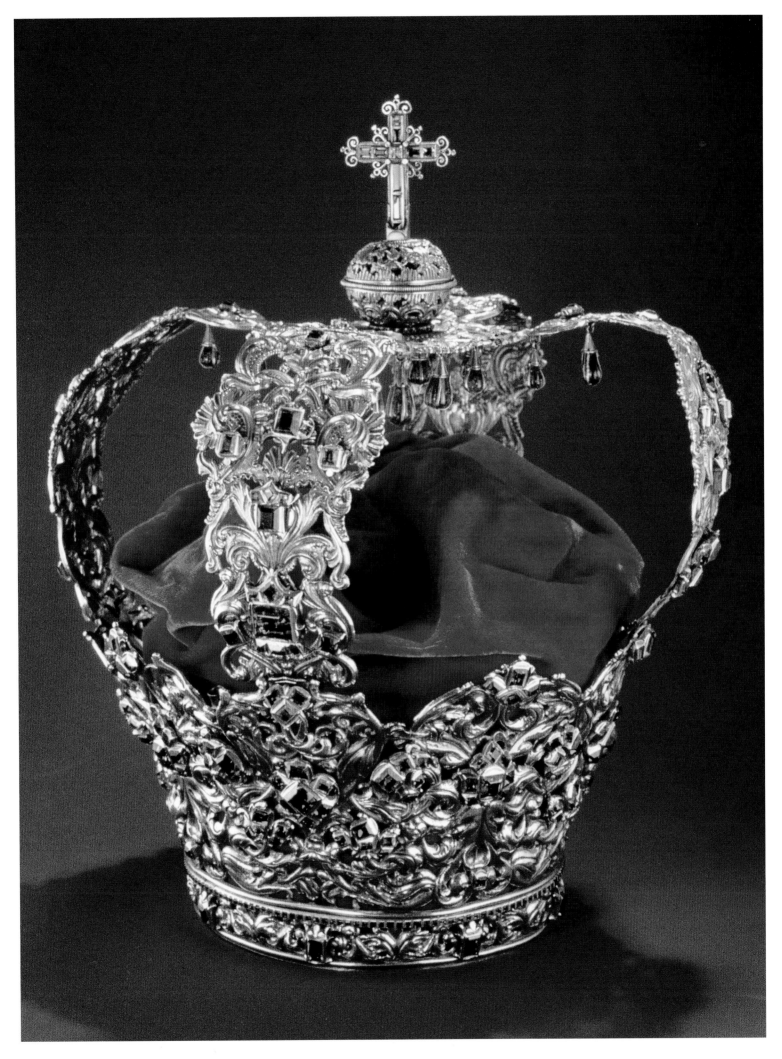

Votive – the Guarrazar Treasure

In Catholic churches, crowns not only adorn the statues of saints, but sometimes hang over the altar on chains to decorate the Holy Host during mass. When this tradition began is difficult to establish, although it is known that several crowns were given for this purpose during the reign of the Western Goths in the 7th century AD. This was discovered by good fortune in 1858. A poor farmer and his wife, who lived in the village of Guarrazar, near Toledo in Spain, were cultivating a piece of virgin land on 25 August 1858, when they found some hidden masonry near a well. The earth that had previously hidden it had been washed away by heavy rain. There, in the mud, the couple discovered a remarkable collection of gold, now known as the Treasure of Guarrazar. Details of the location and the precise circumstances and size of the treasure have never been fully revealed, but it is known that a goldsmith, José Navarra, took possession of most of the discovered objects and succeeded in reconstructing nine crowns from them.

José Navarra apparently had so little trust in the Spanish government paying him an appropriate amount for his work that the crowns next turned up in the French capital of Paris in January 1859, where the Ministry of Public Affairs bought all of them on behalf of the National Collections. Their unrecorded discovery and the fact that these unique objects had been smuggled into France caused much disturbance in the world of archaeologists and historians. Scientists in particular criticised the way the Spanish goldsmith had reconstructed the crowns. They did, however, agree that the crowns were votives that had hung over the altar and that the treasure had been hidden after the defeat of King Roderic in the year 711, when the invasion of Spain by the Saracens ended the rule of the last of the Visigoths. As soon as the location where the treasure was discovered became known, a more scientific excavation began. This resulted in two more crowns being found in 1861. Both objects were put into the Royal Armoury of the Royal Palace in Madrid, from where one crown was stolen in 1921, leaving Spain with just a small portion of the Guarrazar treasure. In 1940, an agreement was signed between the Spanish Head of State General Franco and the French Prime Minister Marshal Pétain, and six crowns left the Cluny Museum in Paris and returned to their country of origin, where they were put on display at the Archaeological Museum of Madrid.

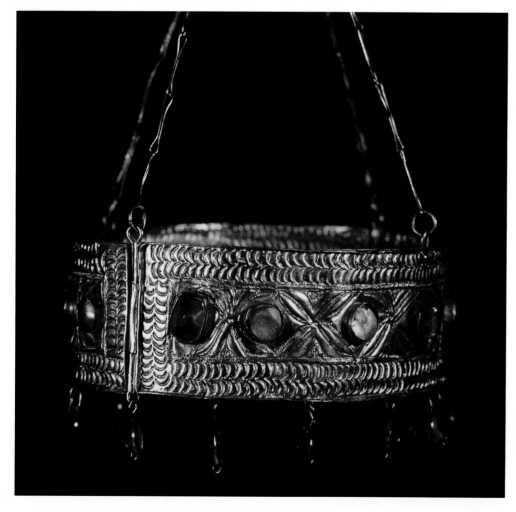

Votive crown from the Guarrazar treasure. Gold and precious stones including sapphire; circa 7th century AD. Collection and photo Museo Arquelógico Nacional, Madrid, Spain

Top left:
Votive crown with hanging letters forming the word *Reccesvinthus* (generally referred to as King Recceswinth or Recesvinto) from the Guarrazar treasure. Gold, pearls, rock crystal and precious stones including aquamarine; circa 7th century AD.
Collection and photo Museo Arquelógico Nacional, Madrid, Spain

Bottom left:
Votive crown from the Guarrazar treasure. Gold, pearls, aquamarine and amethyst; circa 7th century AD.
Collection and photo Museo Arquelógico Nacional, Madrid, Spain

Right:
Votive crown from the Guarrazar treasure. Gold and aquamarine; circa 7th century AD.
Collection Treasury Royal Palace, Palacio Real de Madrid, Madrid, Spain
Photo René Brus

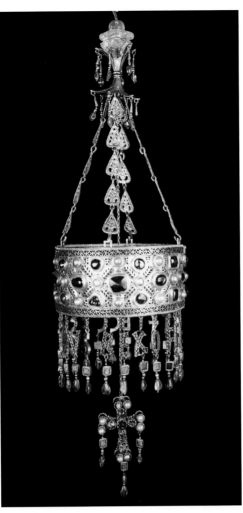

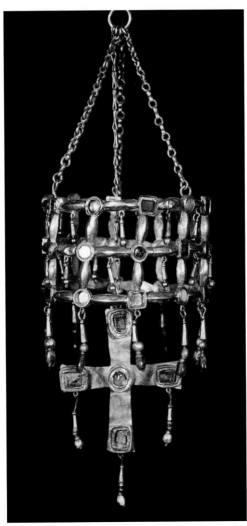

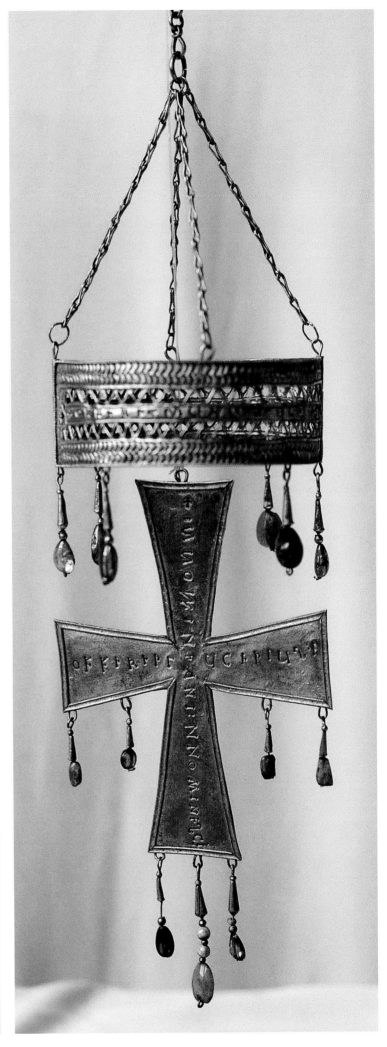

Votive – the treasure of the St Jacob's Church

When a grave was being dug in the Great or St Jacob's Church in The Hague (The Netherlands), in 1792, a collection of mainly silver-gilt liturgical articles was found. It is assumed that this church treasure was hidden in 1574, during the Eighty Years' War between Spain and The Netherlands (started in 1568). The find included three crowns, one of which was very small (3.5 cm in diameter) and probably adorned the head of a statue representing the infant Jesus. The other two crowns were large enough to be worn by adults, and, judging by their decorations, originally functioned as bridal crowns.

These crowns were probably donated to the church as a votive offering, but who wore them as brides, or who donated them to the church, is unknown. However, one of the crowns is decorated with an enamelled shield depicting a crest that might one day reveal more about its origin.

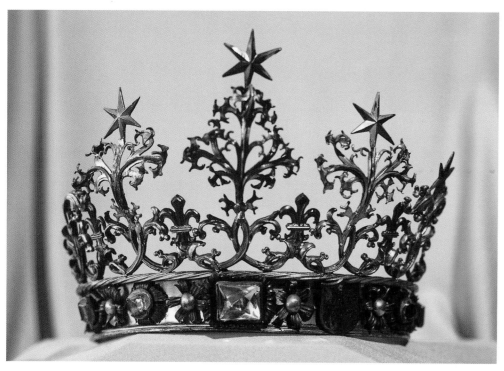

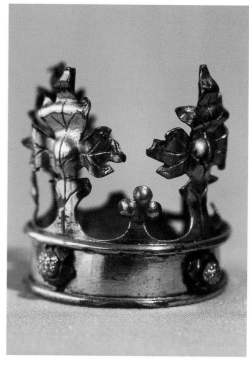

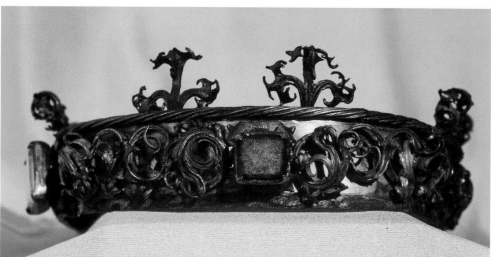

Top left:
Votive crown. Gilded silver, rock crystal and enamel; made circa 1500. Collection St Jacob's Church, The Hague, The Netherlands Photo René Brus

Top right:
Votive crown. Gilded silver; made around 1500. Collection St Jacob's Church, The Hague, The Netherlands Photo René Brus

Bottom:
Votive crown. Gilded silver, rock crystal and enamel; made circa 1500. Collection St Jacob's Church, The Hague, The Netherlands Photo René Brus

Votive – the crown of Margaret of York

In 1468, King Edward IV of England gave permission for Charles the Bold, Duke of Burgundy, to marry his sister Margaret of York. The marriage took place on 3 July in Bruges, and tradition says that the bride wore this silver gilded open crown, which is 12.5 cm in diameter and 13.2 cm high. On the headband are enamelled letters forming the words 'MARGARITA DE YORK', placed between enamelled ornaments in the shape of a cross, the coats of arms of Burgundy and England, and the White Rose of York, a badge of the bride's family. The white enamelled rose has a glowing red ruby as its central stone, which might have been set in the crown when it was made, or added when it was restored in 1865. The combination of white and red may signify the victory of the York dynasty over the Lancaster family (whose symbol was a red rose) in the Wars of the Roses, which had taken place in England earlier in the 15th century. In 1475, Margaret of York donated her nuptial crown to the minster of the German city of Aachen (Aix-la-Chapelle) as a votive offering, where it has adorned the head of the Madonna on special occasions ever since.

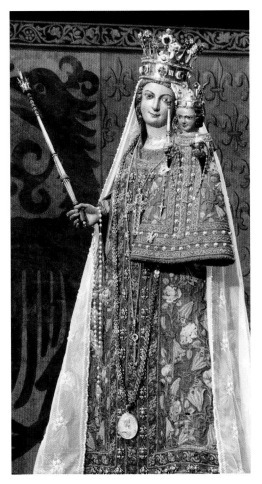

The crown of Margaret
of York is placed on the
statue of the Madonna
once every seven years.
For this ceremony, a large
pilgrimage takes place
for a period of ten days to
the Cathedral of Aachen.
Collection Treasury
of the Cathedral,
Aachen, Germany
Photo Pit Siebigs,
Treasury of the
Cathedral, Aachen,
Germany

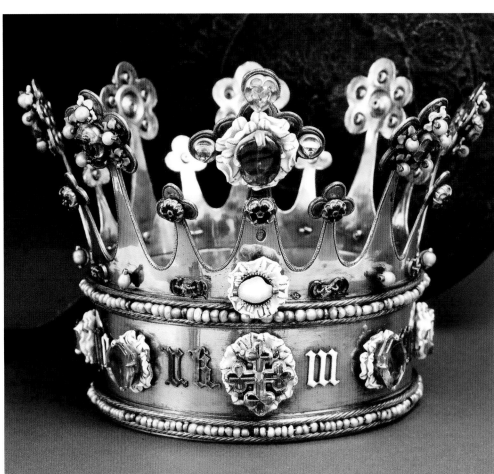

Nuptial crown of
Princess Margaret of
York. Gold, diamonds,
rubies, sapphires, pearls
and enamel; made
in 1475.
Collection Cathedral
Treasury Aachener Dom,
Aachen, Germany
Photo Aachener Dom,
Aachen, Germany

Votive – Spain

Many valuable votive crowns have been given to churches and monasteries in Spain, for a variety of reasons. In 1852, the 22-year-old Queen Isabel II visited the monastery of Atocha, where an unsuccessful attempt was made to assassinate her. As thanks for the Virgin's protection, the queen donated two splendid crowns made of gold and silver and set with diamonds and gold-coloured topazes to the monastery. The larger crown, 14 cm in diameter, was intended for the statue of the Virgin Mary and the smaller crown, 6 cm in diameter, for the statue of the infant Jesus.

The queen possessed a *parure* set with diamonds and topazes and, to express her gratitude, she gave the goldsmith the tiara and necklace from this set of jewellery for the making of the two crowns. The votive crowns are modelled on the crown that was part of the queen's *parure*. Some historians believed that Queen Isabel II donated her own crown to be used for the statue of the Virgin Mary. However, she went into exile in 1868 and when she needed money, some of her jewellery was auctioned at the Hôtel Druot in Paris on 1 July 1878. The sale catalogue describes, under Lot Number 102, a crown that was a '*magnifique et très-riche couronne formée de fleurons de brillants et ornée de quarante-neuf topazes roses*' (a magnificent and very valuable crown fashioned out of brilliant cut diamonds in rosette shapes and decorated with 49 rose-cut topazes).

The two votive crowns of the monastery of Atocha were kept there until the onset of the Spanish Civil War in 1936. For safety reasons, it was decided to include the crowns as Property of the State, or *Patrimonio Nacional*, and they were placed in the Treasury of the Royal Palace in Madrid.

The statue of the Virgin Mary in the Basilica of the Macarena in the Spanish city of Seville wears a crown on religious feast days that has been successively enriched with a number of gemstones. According to tradition, this statue of the Virgin will only wear jewels that are regarded as her own property, and which have been donated by devout worshippers. In 1912, Juan Manuel Rodríguez Ojeda was asked by the church authorities to design a crown using the votive gifts of jewellery that they had received over the years. The crown was made at the workshop of the jeweller José de Los Reyes by a team of craftsmen under the supervision of Francisco Ternero, and was finished in 1913. From then on, the crown of the Virgin was successively enriched with gemstones, and each time the alterations were carried out at the workshop of José de Los Reyes. The last major change took place in 1953, when 18 diamonds were set in each of the stars that adorned the crown. The Hermandad of the Macarena, the church authorities, agreed to donate the crown to the Town Hall of Seville on 18 October 1936, during the Spanish Civil War of 1936. The civil servants had decided that the crown could be sold to raise funds for the needy. Fortunately, it was eventually agreed that the crown's artistic and sentimental value was much higher than its monetary value and the crown was not dismantled. Instead, the catholic community gave donations in gold so that, on 27 October 1937, the crown was returned to the Basilica of Macarena.

Above:
Votive crown of the monastery of Atocha. Gold, silver, diamonds and topazes; made around 1852 by Narciso Soria.
Collection Treasury Royal Palace, Palacio Real de Madrid, Madrid, Spain
Photo René Brus

Left:
Circa 1865; Queen Isabel II of Spain.
Collection Deutsches Filmmuseum, Frankfurt, Germany
Photo by M. de Hebert

Right:
Crown and statue of the Virgin of the Macarena. Crown made of gold, silver, diamonds, emeralds and enamel; crown made in 1913, altered in 1953 and 1963 at the workshop of the jeweller José de Los Reyes, Seville.
Collection La Basílica de la Macarena, Seville, Spain
Photo Hermandad de la Esperanza Macarena, Seville, Spain

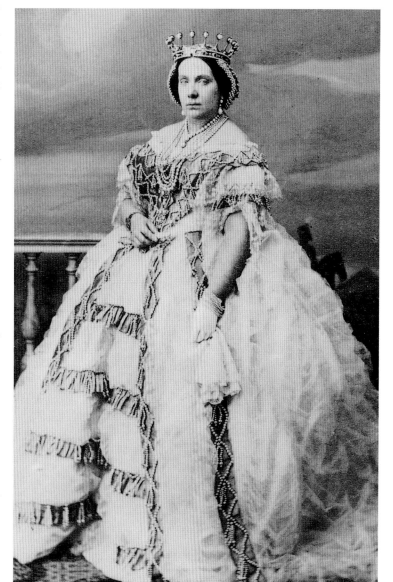

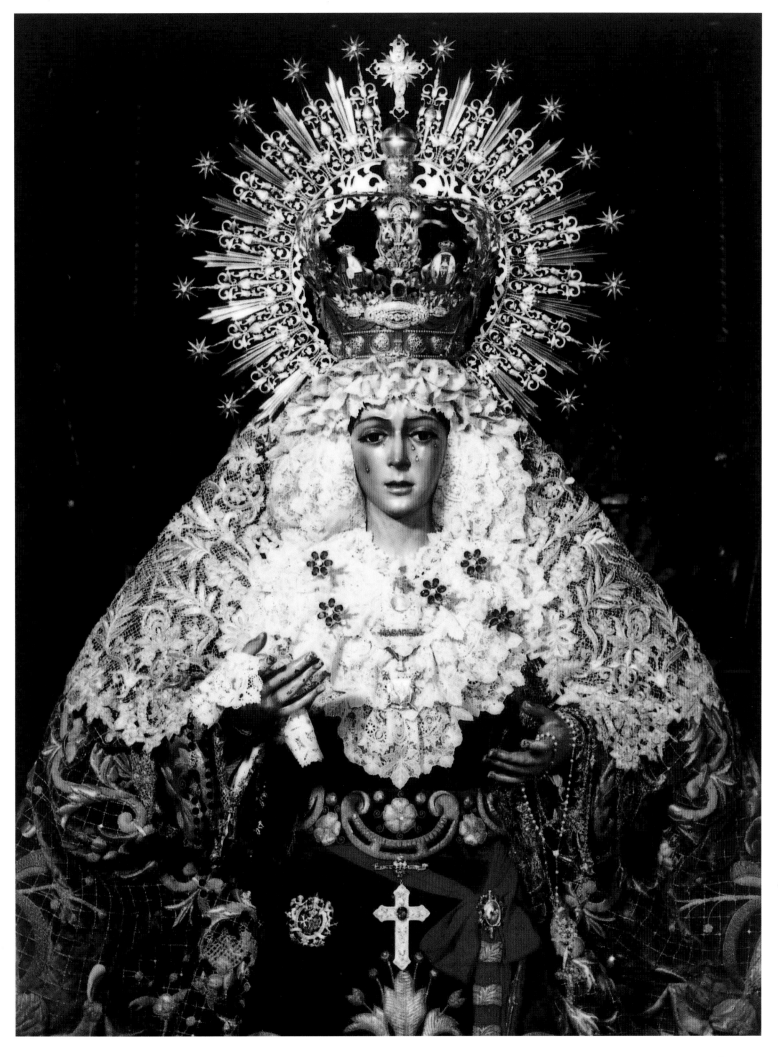

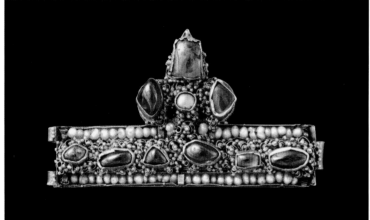

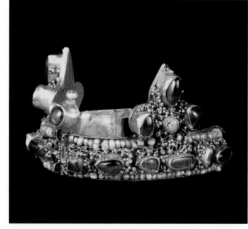

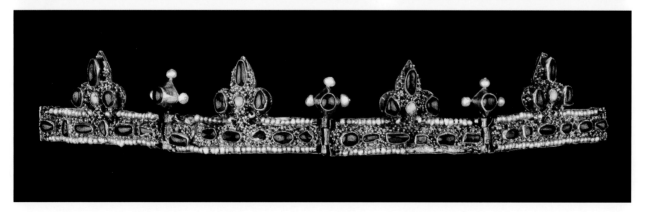

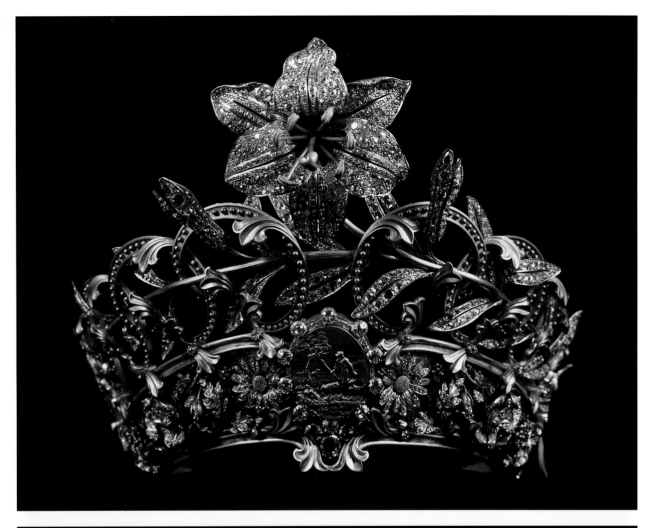

Crown that used to adorn the statue of the Virgin Mary of the church of the Notre Dame d'Albert. Gold, pearls and diamonds; made in 1900 by Mellerio dits Meller, Paris, France.
Collection and photo Cathedral Notre Dame d'Amiens, France

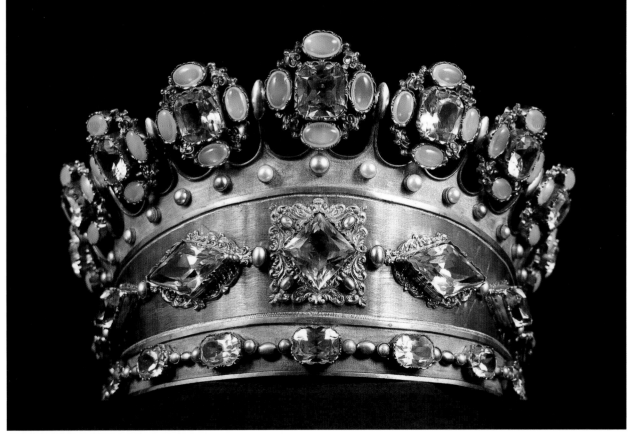

Crown that used to adorn a statue of the Virgin Mary. Gilded metal, moonstones, aquamarines and pearls.
Collection and photo Cathédrale Notre Dame d'Amiens, France

Votive – Ethiopia

Ethiopia has perhaps more crowns donated to the treasuries of churches and monasteries as votive offerings from emperors, kings and nobles than any other country in the world. Due to their age, many of the crowns have become so fragile that parts have broken off and gone missing. If these *akil*, or crowns, were treated as works of art, they would certainly be placed behind glass, but in Ethiopia they are regarded as religious objects to be used. These crowns are not used to adorn the heads of statues of the Virgin Mary and other saints, but are worn by priests and deacons during important religious festivals and marriages. Over the years, it has become traditional for the representative of the highest religious rank to wear the most elaborate crown, or the one with the most illustrious history.

One of the largest collections of votive crowns in Ethiopia is to be found in the town of Axum, former capital of the Axumite Empire. Christianity was introduced here in 4th century AD during the reign of Emperor Ezana, and each ruler since then has generally donated his coronation crown to the coronation church of Axum, also known as the church of Our Lady Mary of Zion. This church was not only destroyed twice – first in the 11th century by the pagan Queen Gudit (or Judith) and again in the 16th century by the Islamic Ahmad ibn Ibrihim al-Ghazi – but most of its valuable contents had also vanished. Emperor Fasilidas, who ruled Ethiopia from 1632 to 1667, ordered the church to be rebuilt. As soon as the new Cathedral of Saint Mary of Zion was completed in 1665, the crown of the emperor became the first of many similar votive gifts.

Several of the Ethiopian crowns are unusually shaped. Some of them are set on a rectangular base, while others appear too large to be worn. These larger crowns were actually worn over a kind of turban known as a *tentem* or *halo*, hence their large diameter. Some Ethiopian crowns have an interesting and unusual ornament, rarely found on crowns from other parts of the world, which consists of a semicircle attached to the headband. This visor protects the eyes of the wearer against the fierce Sun, just like the visor of a baseball cap.

For a long time, the only contact that Ethiopia had with the outside Christian world was by way of Alexandria in Egypt, where the Patriarch of the Coptic Church resided. Friendly, respectful contact between Ethiopian rulers and the patriarch was essential, resulting in a number of crowns being sent to Egypt as gifts. At the end of the 19th century, the Coptic Patriarch Cyril V (1874-1928) received a crown from Emperor Menelik II, which is very similar in shape to the emperor's own coronation crown. Like the tiara of the Pope of the Catholics, the coronation crown of Emperor Menelik II has three circles arranged vertically. It also has several plaques depicting religious figures and scenes, including Tekle Haimanot, David, St Michael, the Virgin with Child, a crowned Christ surrounded by Matthew, John, Luke and Mark and, on the front, St George slaying the dragon. This last figure is seen by many Ethiopians as the most appropriate decoration for the ruler's crown, since it symbolises a free and independent country. This sentiment dates back to Emperor Menelik II who, at the end of the 19th century, managed to unite the Empire against the invading Italian army and won victory in the crucial Battle of Adwa by combining the armies of his allies, including that of his wife Empress Taitu. After the battle, the Ethiopian Emperor wanted to present a token of his gratitude to the Cathedral of St Mary of Zion, and he could think of nothing better than to offer another duplicate of his coronation crown.

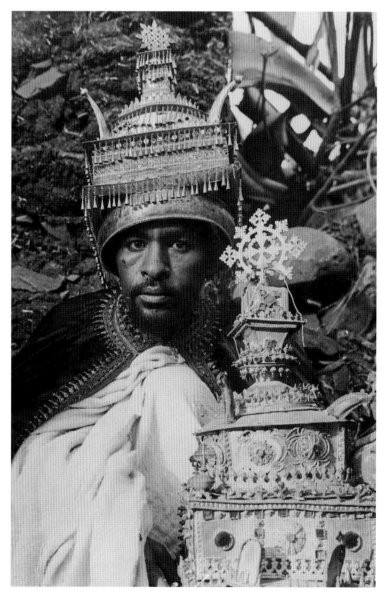

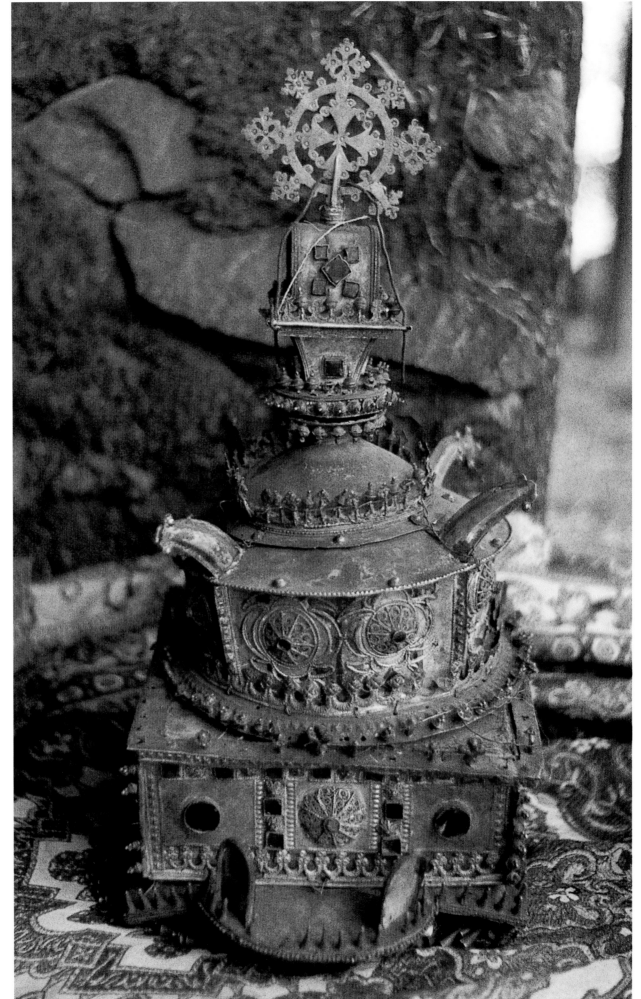

This and opposite page:
Votive crown of Emperor
Tewodros II of Ethiopia.
Opposite page; the priest
holds the heavy crown
in his hands, while he
wears the votive crown of
King Tekle Haimanot of
Gojjam. Silver and paste;
made 19th century.
Collection Ura Kidane
Meret Church, Peninsula
Zeghie, Lake Tana,
Ethiopia
Photo René Brus

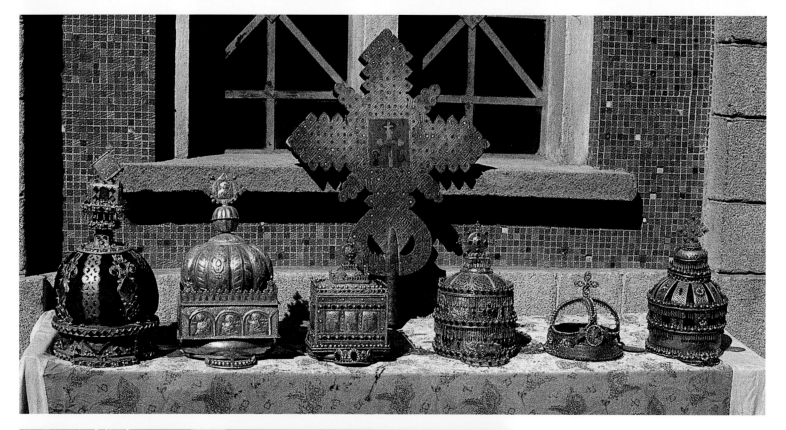

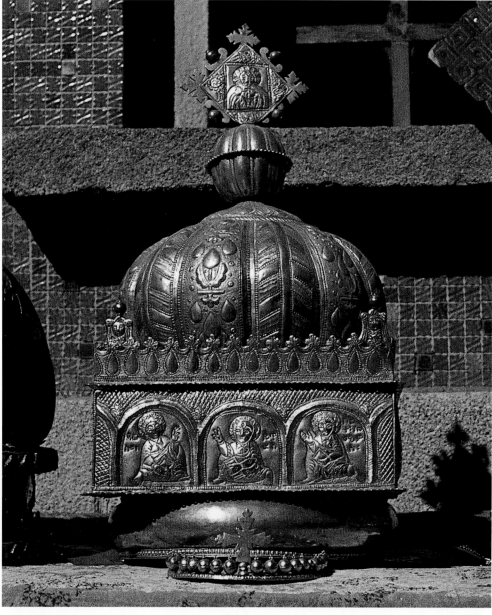

Top:
Part of the extensive
votive crown collection
of the Cathedral of
St Mary of Zion.
Left to right; crown
donated by Emperor
Fasilidas; crown of
unknown provenance;
crown donated by
Emperor Yohannes IV;
crown donated by
Emperor Menelik II;
crown donated by
Emperor Haile Selassie I;
crown donated in 1922 by
Ras Seyoum Mengesha.
Collection Cathedral
of St Mary of Zion,
Axum, Ethiopia
Photo René Brus

Bottom:
Votive crown. Gold and
silver gilt; made in the
16th-17th century.
Collection Treasury,
Cathedral of St Mary of
Zion, Axum, Ethiopia
Photo René Brus

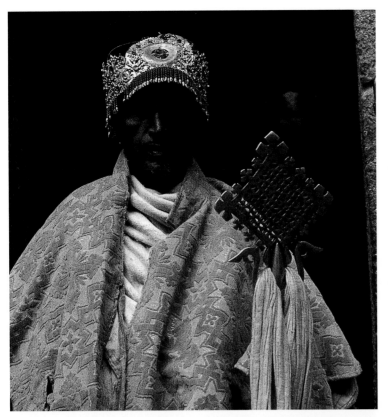

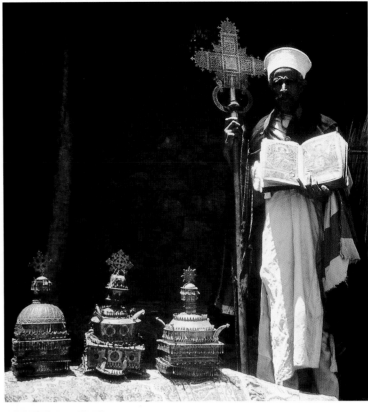

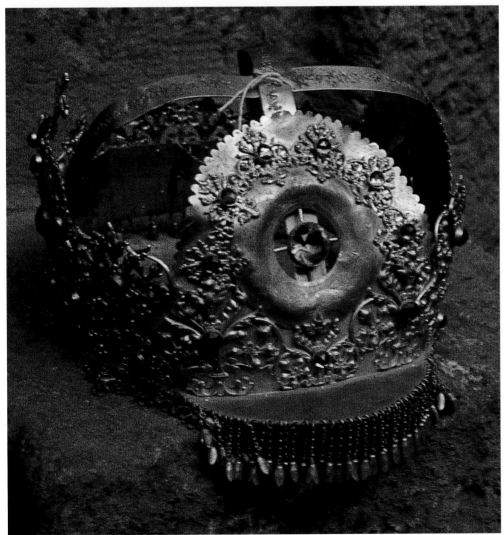

Left, top and bottom:
Votive crown intended to be worn by an Ethiopian Orthodox priest which, according to oral tradition, belonged to a king of the Zagwe dynasty. Gold and paste; made in the 14th-15th century, according to oral tradition.
Collection
Biet Emanuel Church, Lalibela, Ethiopia
Photo René Brus

Right:
1974; a guardian priest of the Ura Kidane Meret Church shows some of the church's treasures, including three crowns that date back several centuries.
Collection peninsula Zeghia, Lake Tana, Ethiopia
Photo René Brus

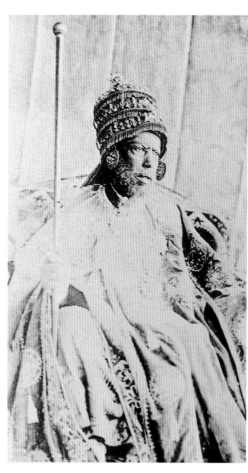

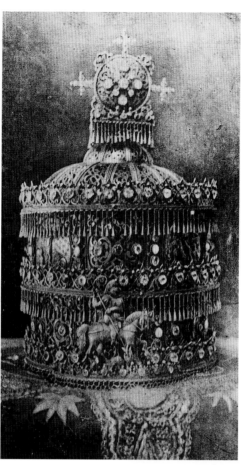

Top left:
Circa 1903; Emperor
Menelik II of Ethiopia.
Photo collection
René Brus

Top right:
Coronation crown of
Emperor Menelik II.
Gold, originally set with
diamonds, reset in the
20th century with
semi-precious stones
and paste; made in 1889
in Addis Ababa by the
Armenian goldsmith
Dicran Ebeyan.
Collection National
Museum, Addis Ababa,
Ethiopia
Photo collection
René Brus

Bottom left:
Votive crown of Emperor
Menelik II of Ethiopia
to the Patriarch Cyril V
of the Coptic Orthodox
Church. Silver gilt and
multicoloured paste;
made end of the
19th century.
Collection Coptic
Museum, Cairo, Egypt
Photo Coptic Museum,
Cairo, Egypt

Bottom right:
Votive crown of Emperor
Menelik II of Ethiopia.
Gold, precious,
semi-precious stones
and paste; made
circa 1896.
Collection Cathedral of
St Mary of Zion, Axum,
Ethiopia
Photo René Brus

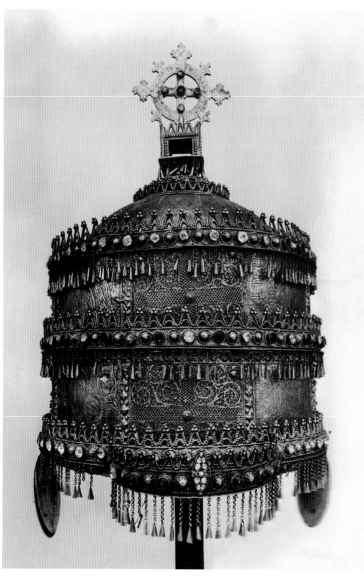

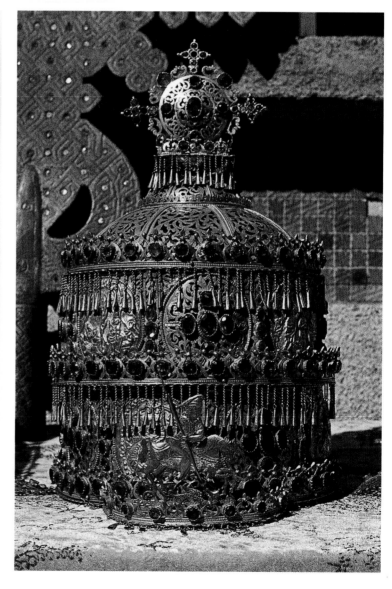

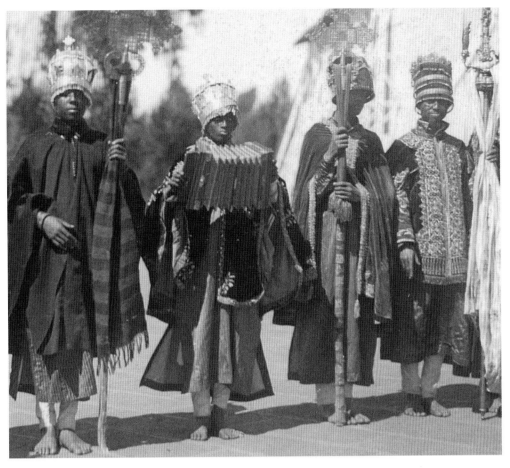

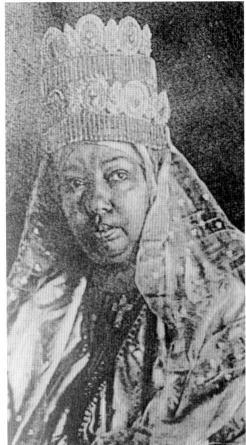

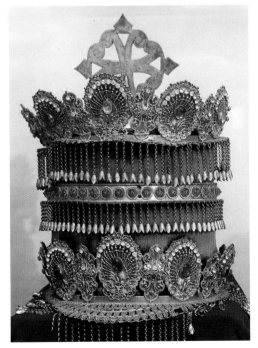

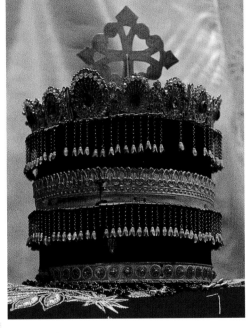

Top left:
Circa 1930; Ethiopian
Orthodox priests and
deacons in festive
costumes wearing
crowns that have been
donated to the Entoto
Mariam Church, Addis
Ababa, Ethiopia
Photo collection
René Brus

Top right:
Circa 1906; Empress
Taitu, the consort of
Emperor Menelik II of
Ethiopia, wearing her
coronation crown.
Photo collection
René Brus

Bottom left:
Coronation crown of
Empress Taitu. Gold,
originally set with
precious stones, reset
in the 20th century with
paste; made in 1889
in Addis Ababa by the
Armenian goldsmith
Dicran Ebeyan.
Collection National
Museum, Addis Ababa,
Ethiopia
Photo René Brus

Bottom right:
Votive crown of
Empress Taitu, which
strongly resembles
her coronation
crown in shape and
decoration. Offered to
the coronation church
Entoto Mariam shortly
after she and her
husband were crowned
in 1889 as Emperor and
Empress of Ethiopia
by the Abuna Mateos,
the Archbishop of the
Ethiopian Orthodox
Church. Gold and paste;
made end of the
19th century.
Collection Entoto
Mariam Church, Addis
Ababa, Ethiopia
Photo René Brus

Votive – the treasure of Wat Rachaburana

The fame of the Thai city of Ayutthaya comes from the many magnificent ruins which testify to the splendour of 33 kings of different dynasties who ruled from 1350 to 1767 when Ayutthaya was sacked by the Burmese King Hsinbyushin. Among the numerous ancient remains is the monastery of Ratchaburana, where a wealth of golden objects was found in 1957. The ornaments include two headdresses, one intended for a prince and studded with green and white stones and one – believed to have been worn by a princess – made of very thin wire and with a disc-shaped ornament with several green stones on top.

It is believed that this treasure was a collection of votive objects placed in the monastery by order of King Boromrachathirat II (also referred to as Borom Raja II or Chao Samphraya) around the year 1424 to honour his two dead brothers after their cremation. These two Princes, Chao Ai and Chao Yi, killed each other in single combat (riding elephants) during a battle over succession to the throne.

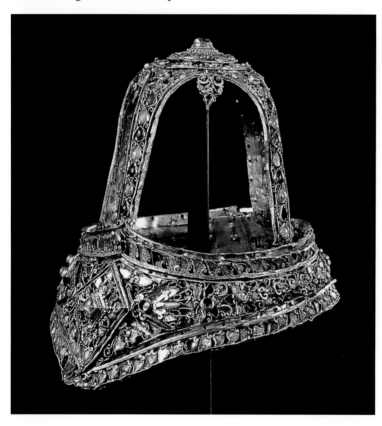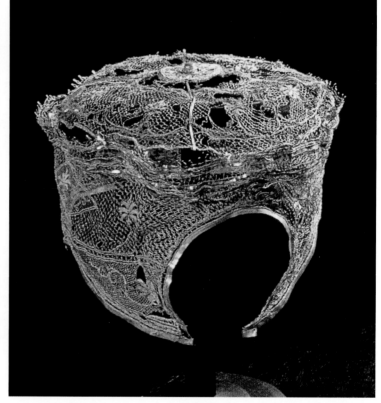

Two votive crowns
from the crypt of Wat
Rachaburana. Gold and
semi-precious stones;
made early 15th century.
Collection and photo
Chao Sam Phraya
National Museum,
Ayutthaya, Thailand

Crowns and the performing arts

In many societies, crowns and elaborate jewellery are essential to the performing arts, especially when gods, spirits or royalty are portrayed. Some court and religious dances practised today date back thousands of years. They portray dramatic stories from myths and legends of gods, demons and beautiful heroines being rescued by brave heroes. Ancient buildings and temples are often decorated with images and reliefs and the performers were usually dressed in colourful garments and adorned with impressive jewellery.

In civilisations where the king was venerated as the incarnation of a god or god-like being, religious dances were performed at court. Over the centuries, these dances have been raised to an art form in which the performers often display subtle, controlled movements, regarded with delight by local eyes but often seen as bizarre or grotesque by visiting foreigners. The layman does not always realise that such court dances must be learned from childhood, often starting as early as the age of nine or ten. The late Prince Surjobrongto, dance master at the palace of the Sultan of Yogyakarta until the mid-1980s, pointed out that '*Javanese dance is bound by tradition, principles, and rules through the ages of development. It is therefore not an individual art but a collective one, and because of this there is an element of self denial in it.*' Only after many years of practice may the dancers wear richly embroidered or otherwise impressive costumes and jewellery and are allowed to perform before their sovereign.

Elaborate dance headdresses are sometimes regarded as sacred objects because in some societies the head is the most sacred part of the body. Sometimes prayers are said and incense is burned before a performer puts on their headdress. Balinese dancers hang their dance headdresses near the ceiling or in another carefully chosen location when they are not being used. For them, the biggest sin that anyone can commit is to place the dance headdress on a seat or on the ground. The monetary value of the materials used in these headdresses is clearly of far less importance than their symbolic value.

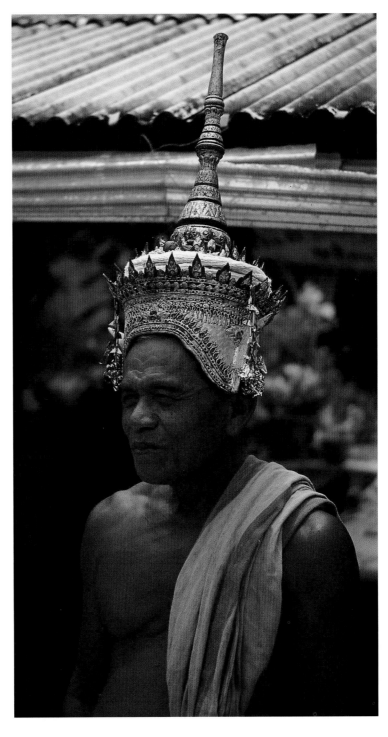

A *Menora* dance crown. The *Menora* is a form of dance drama seen only in southern Thailand and northern Malaysia. According to oral tradition, it was developed in the ancient Kingdom of Ligor some two thousand years ago. The making and wearing of the *Serb,* or *Menora* crown is bound to many traditional rules. Gold leaf, mirror glass, *morinda* wood, cow leather, paint and wax; made in 1998 by the *Menora* dancer Arun Keaosatay from Songkkhla, Thailand.
Private collection
Photo René Brus

Nigeria – Benin dynasty

In the Benin dynasty in Nigeria, the ruler, or oba, performs dances in public during his enthronement and at particular festivals. The divine kingship in Benin is centuries old and successive rulers have added new rites and ceremonies. The coronation of the oba is a complex and extended affair, involving a series of rituals spread over several weeks. On the last day, the oba, who has already been crowned and has assumed authority over the palace and realm, joins the Ogbelaka and Eguadase palace officials in their *ekasa* dance, which is a part of the royal funeral ceremonies. The oba usually attends the annual *Ugie-Erhoba* festival, where the spirits of his predecessors are worshipped in public.

He wears a long gown of coral beads and one of his blood coral crowns, either the simple beaded cap known as the *erhuomenmen*, the *abegan* crown with its two wing-shaped decorations or the *aitolaekpengh* headdress with 'spectacles'. Regally adorned, the oba dances to the *ewini* drums at the *Emobo* festival to drive away any spirits still unsatisfied by the year's sacrifices. The evil spirits are asked to go to Udo, once the centre of a rival kingdom, where they may yet find food. At the end of the ceremony, the oba returns to his palace, where he turns four times to face the drums, moving his hands in time to their joyful beat as if to welcome all good things into his palace.

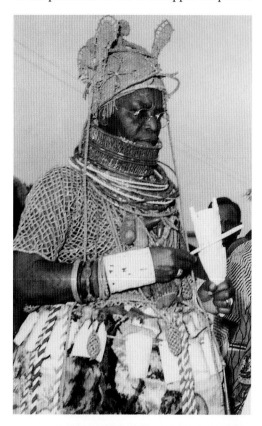
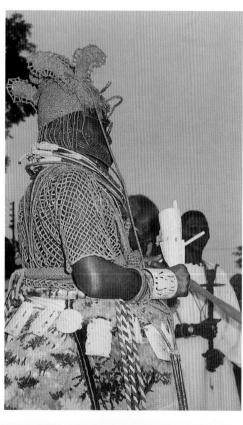

Top, left and right:
Oba Akenzua II of Benin at the festival *Emobo*, held in memory of the defeat of Arhuanran by Oba Esigie at Udo in the 16th century. The oba is dressed in full regalia, accompanied by the Esekhurhe, the priest of his divinity, who dances to the beat of the ewini drums.
Photo Ministry of Information, Ibadan, Nigeria

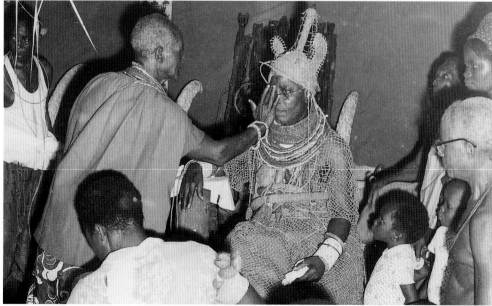

1957-58; Oba Akenzua II of Benin wearing the *abegan* blood coral crown during the *Ugie-Erhoba* festival in memory of the reigning Oba's predecessors.
Photo Ministry of Information, Ibadan, Nigeria

China

Actors and actresses in Chinese (Cantonese) opera wear clothes and headdresses that denote the status and moral quality (good or evil) of the characters they portray. The lavish headdresses are made from all kinds of materials, from the simple, such as papier-mâché, mirrors, feathers, and pompoms, to genuine precious stones, such as jade, blood coral or pearls. The splendour of these headdresses ranges from the elaborate to the highly elaborate, largely depending on the amount of financial support each particular theatre group has received over the years.

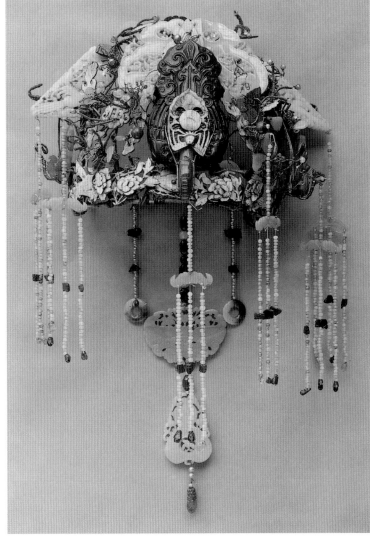

Top left:
21.3.1981; an actress of the Chinese Opera Company performing in the Malaysian town of Kuala Terengganu during the festivities held in conjunction of the coronation of the Sultan Mahmud al-muktafi Billah Shah of Terengganu, Malaysia. This performance was sponsored by the Chinese community.
Photo René Brus

Bottom left:
Impressive crowns for Chinese opera are made in great variety and sold throughout the world in regions with a large Chinese community.
Photo taken at Central Market, Kuala Lumpur, Malaysia by René Brus

Right:
Theatrical crown, as described by the Metropolitan Museum of Art *'colour is derived from gardens too, with touches of pink and green and coral, petals of seed pearls, a glint of gold outlines, and a background of vibrant kingfisher blue to suggest heaven itself.'* The use of large plaques of openwork white jade as the chief foundation of this headdress suggest that it might have been part of the imperial theatre equipment of the Ch'ien-lung period (1735-1796).
Collection Fletcher Fund/The Metropolitan Museum of Art, New York, USA
Photo The Metropolitan Museum of Art, New York, USA

Japan

A court dance known as the five movement dance or *Gosechi no mai* was performed in 1915 at a banquet to mark the enthronement in 1912 of Emperor Taisho. The five young female dancers wore headdresses consisting of a gold-plated copper comb (*Kushi*), three gold-plated copper hair pins (*Kanzasi*), two violet silk strings (*Kohimo*) and white knitted silk strings (*Hikage-No-Kazura*). The white strings symbolised that which is 'holy' while the flowering tree-like comb symbolised the teachings of Zen Buddhism. It is interested to note that such tree-like structures, worn high on top of the head, are repeatedly seen elsewhere.

Hair decorations worn by a female dancer commemorating the enthronement of Emperor Taisho of Japan. Copper plated with gold, silk and lacquer; made in the 19th century.
Collection Takakura Cultural Institute, Tokyo, Japan
Photo Munehisa Sengoku, Tokyo, Japan

India

Information from the Museum für Völkerkunde in the German city of Munich suggests that this crown is known as a *pansngiat rupa* and was worn by girl dancers from in the Khasi hills of Assam. However, other sources claim that this type of crown is worn by priests of the Jain sect. Another source of disagreement could be the lanceolate plaque with silver chain pendants, which is attached to the headband, and which might represent a feather or a horn, or possess some hidden religious significance.

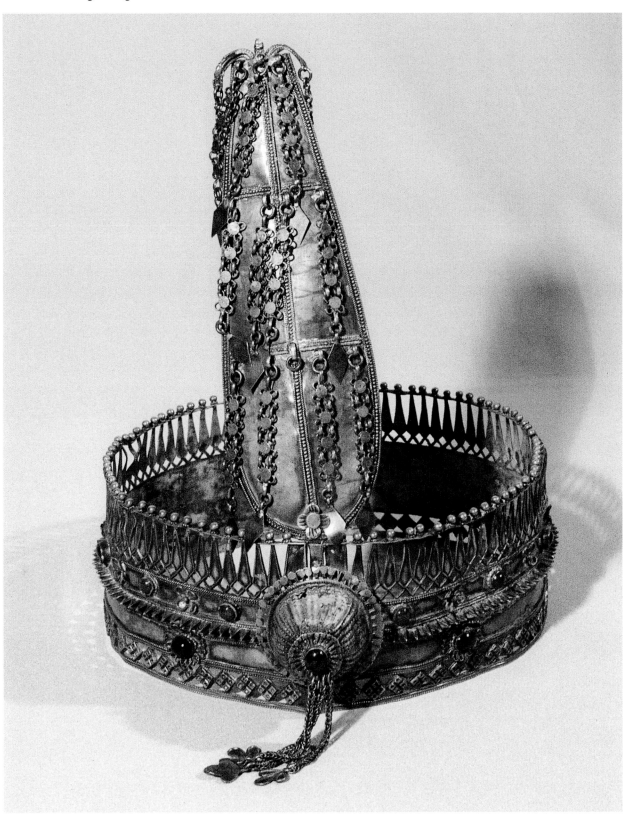

Silver crown purported to be worn by a priest of the Jain sect or by Khasi girls from Assam. Made circa 1850.
Collection Jürgen Abeler, Wuppertal-Elberfeld, Germany
Photo René Brus

Burma

The writings of some Europeans suggest that they did not really enjoy the sort of court dances performed for honoured foreign guests. The Italian Catholic priest Sangermano, who lived in Burma (now Myanmar) between 1783 and 1808, wrote that dancers or *nandwin thabinthee* of both sexes moved slowly, bending wrists, elbows, knees, ankles, fingers and toes in such stylised directions that '*the first time I saw these dances I took them for a troop of mad people.*' Lady Dufferin and her husband, the English Viceroy of India, were entertained in Mandalay Palace in 1886 by dancers of the deposed Burmese King Thibaw. In her book *Our Viceregal Life in India* (1890), she described how she thought that '*the extraordinary postures*' of the performers '*suggested a bad pain somewhere.*'

The Burmese court dances and costumes adhered to precise rules made by U Khit, the 'Trabin Woon' or Minister of Dance and Drama during during the reign of King Bagyidaw (1819-1837). The shape of the crown worn by dancers at the palace was an imitation of crowns worn by members of the royal family. These crowns were described in 1829 by John Crawfurd, the civil commissioner of Great Britain in Rangoon in his *Journal of an Embassy to the Court of Ava*. He stated that the king's crown '*was a helmet with a high peak, in form not unlike the spire of a Burman Pagoda, which it was probably intended to resemble. I was told that it was of entire gold, and it had all the appearance of being studded with abundance of rubies and sapphires,*' while that of the queen was '*of gold, like his and equally studded with gems, different in form and much resembled a Roman helmet.*'

The origin of the Burmese dance crowns, however, came from the Thai Ayutthaya Empire, when captives from Ayutthaya were taken to Burma after a devastating war in 1767. The Thai captives started to teach the court dancers how to incorporate the rich assortment of characters from Thai epic stories into their own, Burmese, tradition. This led to a new style known as *Yodayar* and can be described as the pinnacle of refinement in the Burmese dance tradition. This evolution reached its height during the reign of King Singu Min (1776-1781) and under the influence of his Chief Queen, Shin Minn. In this period, the costumes and accessories used in the palace performing arts gradually evolved to incorporate the new stories and ideas.

Burma was made up of many small principalities and kingdoms until 1885 when it became a colony of Great Britain. Much of the regalia of the last Burmese monarch, King Thibaw, were taken as booty and sent to England in 1886, where they were put on display at the London Colonial and Indian Exhibition. After independence, most of the Burmese regalia were returned between December 1964 and July 1965. A few pieces were left in the Victoria & Albert Museum in London to serve as an introduction to the art of Burmese culture, donated by the government and people of Burma. The donation included a dance crown covered with gold leaf. Researchers from the Victoria & Albert Museum believe that this crown might have been worn with a *Yodayar*-style costume of a prince or *mintha*, or by a young girl performing the dance of the *pin-taing-san* or crown princess.

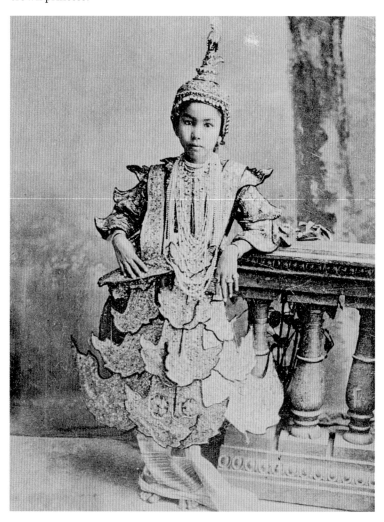

Second half of the 19th century; this young girl is – according to the information written on this photocard – a Burmese princess; however, she could have been a girl in dance attire imitating a princess.
Photo collection
René Brus

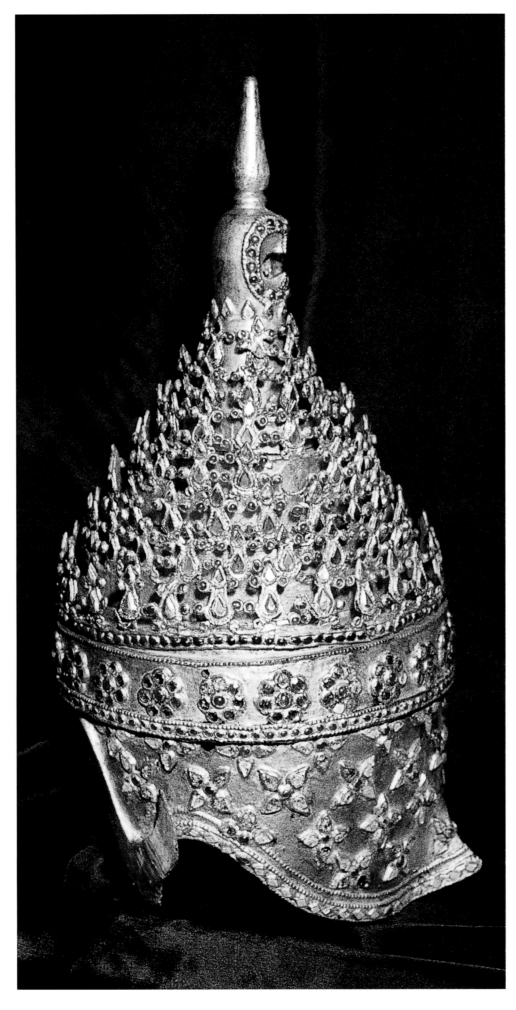

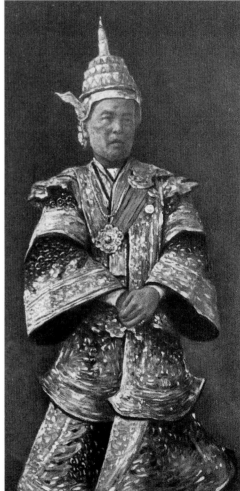

Thailand

Khon is a mixture of dance, acrobatics, and theatre found in Thailand and consists of four categories of performers: the chorus, who are in charge of the dialogue; the singers; the orchestra; and the dancers. *Khon* represents the Thai national epic of Ramakien, derived from the Indian Ramayana epic. The roles of the male and female dancers are signified not only by their elaborate costumes, but also by their crowns and how they wear them. The performer playing the hero has to wear a flower, *Dawk mai that*, under his crown above his right ear. His female counterpart wears a similar flower above her left ear. The hero's crown is further decorated with the 'diamond flower', *Dawk mui phet*, while this is absent from the heroine's crown. The peaked headdress or *yodbat*, which indicates high royal rank, is worn by the monkey kings Phali and Sukhrip and the king of Chompu. A sharp pointed crown or *yodchai* is worn by Chompoopan, one of Rama's generals. The green monkey warrior Ongkot uses a headdress known as *Yodsamkleep*. Those who portray noble characters, generally royalty, wear pagoda-shaped crowns with embellishments that hang from the headband behind the ear (known in Thai as *Kan Chiak or Chorn-Hu*), making them a perfect imitation of the *Phra Maha Phichai Mongkut* (or *Brah mahabijdija mankut*), the 7.3 kilogram Great Crown of Victory of the Kingdom of Thailand.

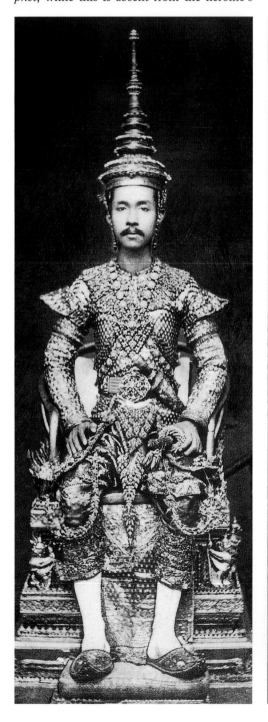

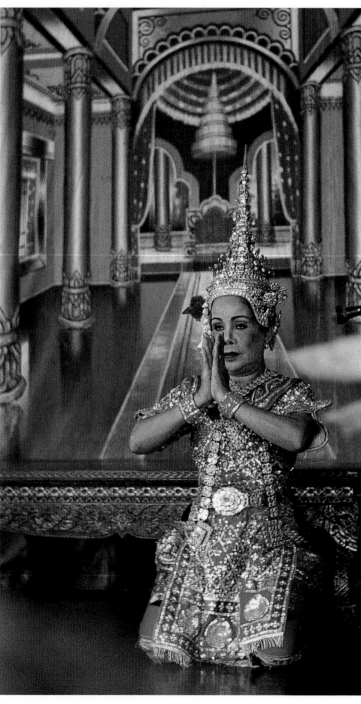

Left:
Portrait of King Chulalongkorn on the occasion of his second coronation, which took place on 16 October 1873. At the age of 16 he had ascended the throne of Thailand and was crowned on 1 October 1868. He had taken up the yellow robe to become a Buddhist monk for a short while – from 15 September to 11 October 1872 – so it was decided to crown him for a second time in 1873.
Photo collection Grand Palace, Bangkok, Thailand

Right:
1995; to celebrate King Bhumibol Adulyadej's 50 year reign, a number of traditional dancers performed at several Buddhist temples in Thailand's capital Bangkok.
Photo René Brus

Opposite page:
Two dance crowns worn by a dancer who plays the part of a hero.
Left; wood, cardboard, basketry, gold foil, strass (paste) stones; made in the 1970s.
Right; silver, paste and leather; made in the second half of the 19th century.
Collection and photo René Brus

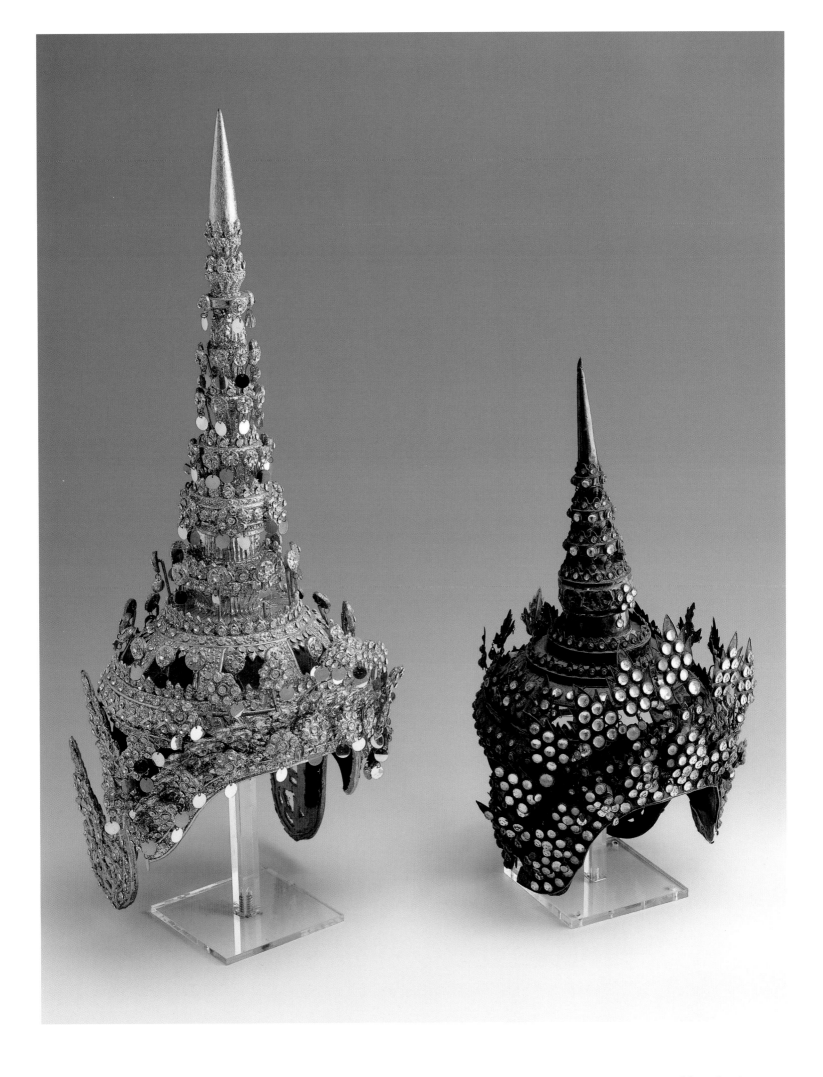

Malaysia – Sarawak

One of the most impressive pieces of jewellery worn by Iban women (the largest indigenous people of the Malaysian state of Sarawak) during festivities, such as weddings or the harvest festival *Gawai Antu*, is undoubtedly the *sugu tinggi* headdress. In the Malay language the *sugu tinggi* is literally translated as 'comb high'. This piece of jewellery is fixed to the hair knot with a comb so that it stands high above the head. Thin, diamond-shaped silver plates are fixed to the comb by very thin silver spring wires. These move and glitter with the slightest movement of the wearer's head while she performs the *ngajat*, the traditional dance of the Iban. The part of the headdress attached to the comb is generally decorated with chased motifs of flowers, tendrils and climbing plants.

In Brunei, where the Iban also live, these are referred to as *bunga air muleh*, and the scroll pattern consists of leaves and tendrils.

These *sugu tinggi* are not the work of Iban craftsman but were originally made by the *Malohs* or *Memalohs*, members of the indigenous Dayak people of Borneo from the upper Kapuas river region. Since the beginning of the 18th century, the silversmiths of the *Malohs* have crafted a great variety of silver jewellery. Descendants of Chinese immigrants gradually took over the silver craft and traded more widely, particularly in more populated places along the coastal areas of Borneo and the Malay Peninsula.

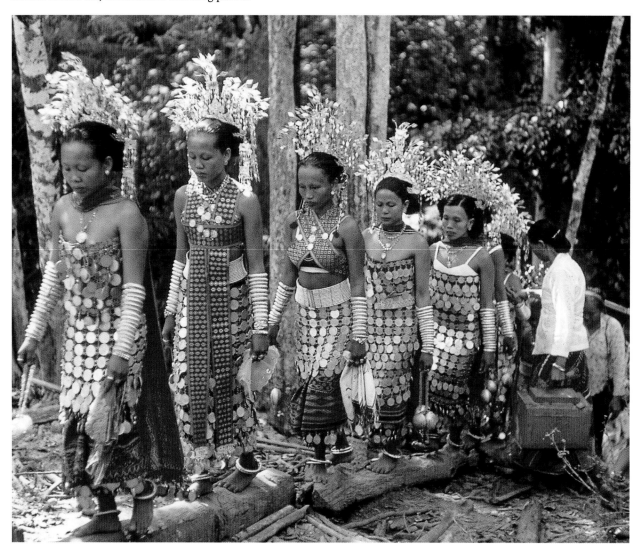

1990s; Iban women in festive costumes and jewellery, including the sugu tinggi headdress, during one of the annual festivals.
Photo René Brus

Opposite page:
Sugu ganging or *sugu tinggi* of Iban women. Silver; made in the 19th century.
Collection and photo René Brus

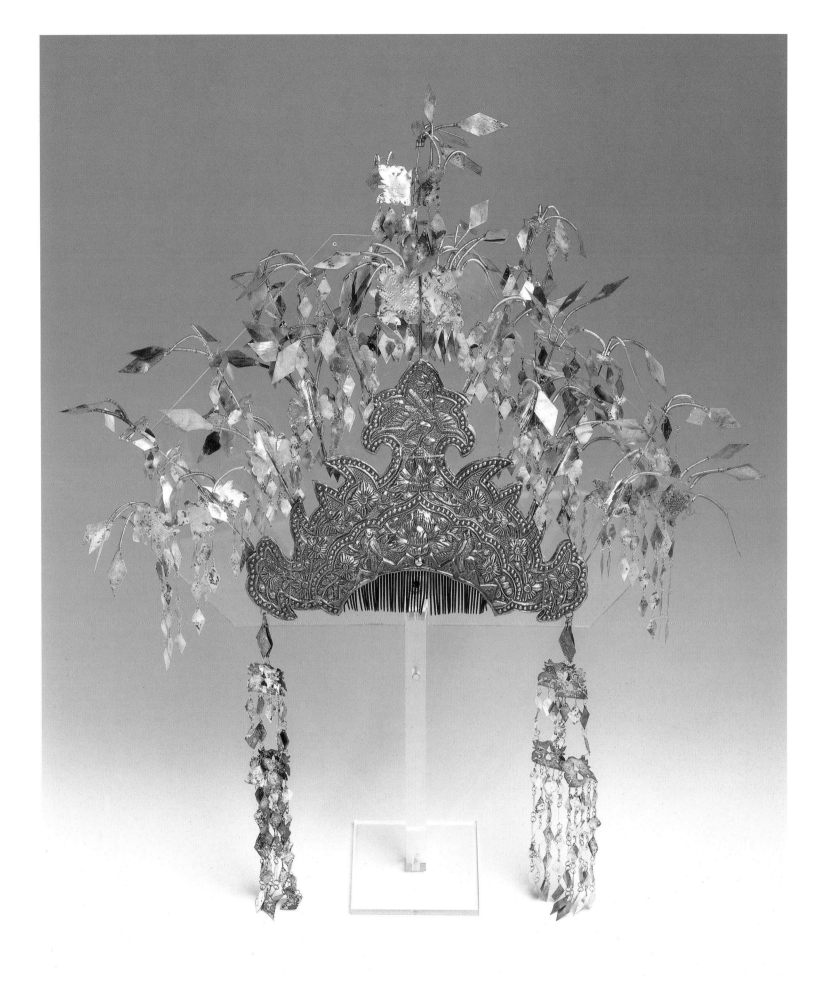

Indonesia

The 20th century has seen significant changes to royal patronage of the performing arts in Indonesia. With independence in 1949, most royal families lost their positions as ruling dynasties. Despite efforts of individual members of the aristocracy to maintain the age-old traditions, many found it impossible to support the necessary large retinues of court dancers. A number of palaces were turned into museums, and valuable jewellery was sold, lost or given away. The heirs to the ancient dynasties, particularly in mid-Java, still regard the court dances as an important part of their cultural heritage but have had to find ways to reduce the cost of maintaining that heritage. The old and valuable dance jewellery such as crowns, ear decorations, bracelets and breast and back adornments are now kept under lock and key as heirlooms. The pieces worn for today's performances are now made from filigree leather and covered with gold leaf, gold embroidery and glass stones.

Dance performances across Southeast Asia are influenced to a large extent by the classic Sanskrit epics *Ramayana* and *Mahabharata*. These originated in ancient India and have been translated, transformed and performed in many different countries for centuries. The sagas were incorporated into court culture to such an extent that in some regions these epics became part of the chronicles of the royal dynasty. Eventually, the style of dress and dance jewellery came to have closer ties to existing local traditions than to ancient Hindu India. *Wajang orang* is a theatrical dance form stemming from Hindu myths in which *Sita*, the wife of Prince *Rama*, plays a major role. Performances were originally staged by itinerant theatre groups, but later the Javanese palaces adopted the *wajang orang* repertory.

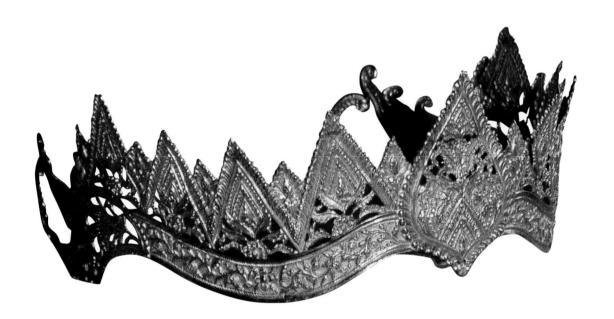

Top:
Gold female dance crown. Made before 1889.
Collection the Mangkunegaran Princely Family, Surakarta, Indonesia
Photo René Brus

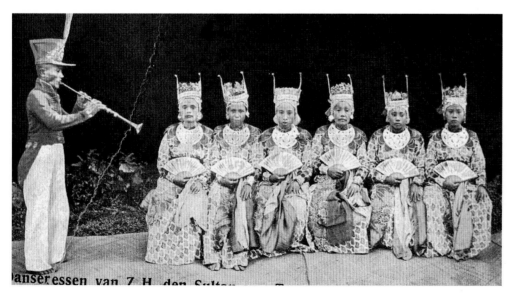

Bottom:
End 19th century; dance girls from the court of the Sultan of Ternate. In 1821, a Professor Reinwardt and his companions were feted at the palace of the Sultan of Ternate. One of the visitors, J. T. Bik, wrote that the 12 dance-girls were dressed in 16th-century-inspired Spanish costumes, and wore gilded crowns, heavy earrings, necklaces, a large silver breastplate and elaborate belts.

Their dances were accompanied by the music of four elderly ladies who created a *'true kettle music'* that was played on gongs, a tambourine known as the *raban* and an *'ear-splitting clarinet'*. Mr Bik was more impressed by the way the female dancers handled their fans and red and blue scarves, creating *'graceful figures'*. Photo collection René Brus

The choice of material for dance jewellery depends of course on the wealth of the court. In the case of the Mangkunegaran Principality, much of the dance jewellery was made during the second half of the 19th century, probably at the instigation of Prince Mangkunagoro IV (1857-1894), who was a noted patron of the arts. The jewellery is kept inside the royal residence, the Mangkunegaran palace (built in 1757), in glass cabinets. Nine crowns, armlets, belts and neck-ornaments are displayed. The curving, undulating profile and embossed designs on the jewellery are based not only on temple bas-reliefs and sculptures of the Majapahit era, but also on the *megamendung* and *wadasan* cloud and rock motif traditions of the Ceribon Sultanate. The golden and diamond-studded pieces of dance-jewellery of the Mangkunegaran dynasty were probably made by the Dutch Crown Jeweller Begeer, or J. M. van Kempen & Zonen, a company that had already created some items for the *hampilan* and *hoepotjoro* regalia of the Mangkunegaran dynasty.

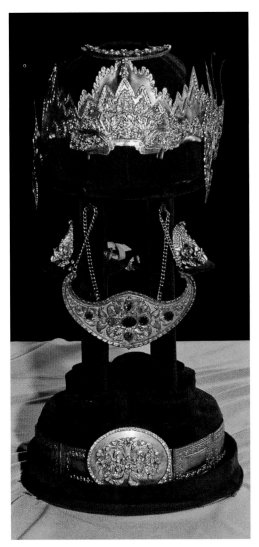

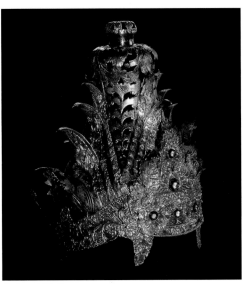

Top left:
Set of female dance jewellery. Gold and semi-precious stones; made before 1889.
Collection the Mangkunegaran Princely Family, Surakarta, Indonesia
Photo René Brus

Bottom left:
Male dance crown. Gold and diamonds; made before 1889.
Collection the Mangkunegaran Princely Family, Surakarta, Indonesia
Photo René Brus

Right:
Circa 1900; *wajang orang* performers at '*Buitenzorg*', the residence of the Governor General in the Dutch East Indies.
Photo collection Mangkunegaran Palace, Surakarta, Indonesia

The dance crowns worn on Bali have different names depending on their shape and the particular dance for which they are used. There are numerous Balinese dances, so only a few can be described. The *lelong* dance is a graceful dance performed by young female dancers who represent angels. They are firmly bound in shiny, golden costumes and wear headdresses decorated with fresh flowers. The *Gulung Keraton*, a special headdress for the *lelong* dance, is made of different components; a back part (*udeng*), a forehead decoration (*petitis*) and side components named *ronronan*. Some crowns for other Balinese dances have the upswept *kekayong* form; an standing point made of cloth. To some scholars this resembles the *gunungan*, a mountain of food used for ceremonies. The rear of one type of dance crown is decorated with talismanic ornaments such as the *garuda mungkur*, or an ornament that Dutch colonisers described as the elephant-fish.

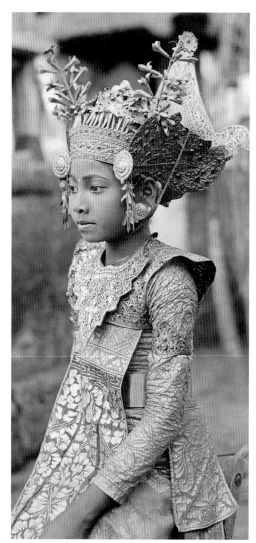

Top left:
Beginning of the
20th century; a Balinese
legong female dancer.
Photo collection
René Brus

Bottom:
Dance crown worn at
the palace of the Raja of
Badung. Gold and rubies;
made in the 19th century.
Collection and photo
Museum Nasional,
Jakarta, Indonesia

Right:
1982; a Balinese *legong*
female dancer.
Photo René Brus

Balinese dance crowns are generally referred to as *sekar taji*. They are made from carved gilded leather or gilded cardboard and are adorned with mirror glass. The monetary value of the materials used is of far less importance to the Balinese than the symbolic value of the crown. Most Balinese maintain a profound contact with their gods and ancestors. The numerous temples, which seem to almost cover the Balinese landscape, play an important role in daily life. Offering traditional dances such as the *renjang* at the temple is believed to be of equal importance to offering rice, fruits, flowers or incense. The Indonesian theatre and movie world makes full use of ancient sagas and legends, allowing designers and others to create fanciful sets and impressive costumes. Tien Samantha, wife of the Indonesian actor Ratna Timur, ordered a magnificent head decoration from Toko Tjokrosoekarso of Yogyakarta in 1985. The result was a number of large hair combs and pins, which incorporated the traditional flower designs seen on antique hair adornments. The two wing-shaped ornaments, worn on either side of the head, are influenced by the feathers of colourful birds, such as the bird of paradise and peacock, and by the impressive *Ashean Gedhe*, the royal costume of the Buddhist Kingdom Srivijaya. This 'heavenly' gilded metal and paste crown was used by the film company P. T. Daya Isteri.

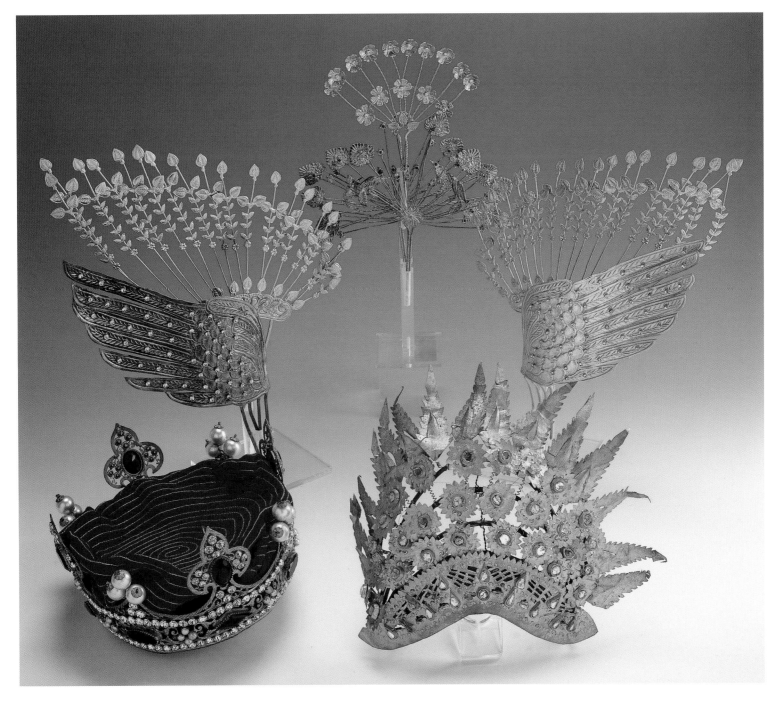

Index

Bibliography

A

Jürgen ABELER. Kronen Herrschaftszeichen der Welt.

ABDUL Halim Abu Bakar. Istiadat Pertabalan Berjalan Gemilan.

ABDUL Rahman Adnan. The King is Installed, New Straits Times Annual 1981.

ABDUL Rahman Ismail. Kewibawaan Mutlak Raja dan Ketaatsetiaan Mutlak Rakyat Kepada Raja.

ABDULLAH bin Mohamed. Keturunan Raja-raja Kelantan dan peristiwa-persitiwa bersejarah.

ABDURACHMAN. Cerbon.

ACARA. Resmi Sultan Haji Ahmad Shah of Pahang.

Cyril ALDRED-. Jewels of the Pharaohs.

L. ALECTRINO. Drie Koningen van Nederland.

Charles ALLEN & Sharada DWIVEDI-. Lives of the Indian Princes.

ALWI bin Sheikh Alhady. Malay Customs and Traditions.

AMIN Sweeny. P.L.Silsilah Raja-Raja Berunai.

Iradj AMINI. The Koh-I-noor Diamond.

Mary Jo ARNOLDI & Christine Mullen KREAMER. Crowning Archievements, African Arts of Dressing the Head.

S. ASSCHER. Diamant, wonderlijk kristal.

Anthony ATMORE & Gillian STACEY. -Schwarze Königreiche das Kulturerbe Westafrikas..

Jeannine AUBOYER. La vie quotidienne dans l'Inde ancienne.

Pierre Marie AUZAS. Catalogue Notre-Dame de Paris, le Trésor.

AZAH Aziz. Traditional Malay Jewellery.

B

Silvia BADESCO. Farah Dibah, 1001 dagen met de Sjah.

Kornél BAKAY. Sacra Corona Hungariae.

Ian BALFOUR. Famous Diamonds.

Prof. Dr. H. BANK. Mein Kleines Diamantbuch.

Prof. Dr. H. BANK. Von Edelsteinen und Perlen.

Magda von BARANY-OBERSCHALL. Die Eiserne Krone der Lombardei.

Jean Paul BARBIER. Indonesie et Melanesie.

Brian BARKER. When the Queen was Crowned.

Isa Belli BARSALI. Medieval Goldsmith's Work.

J. & A. BAUER. A Book of Jewels.

Hans BAUMANN. Goud en goden van de Inca's.

John BEATTIE. Bunyoro, an African Kingom.

Ulli BEIER. Yoruba Beaded Crowns, Sacred Regalia of the Olokuku of Okuku.

David BENNETT & Daniel MASCETTI. Understanding Jewellery.

Wendell C. BENNETT. Ancient Arts of the Andes.

Max BERGER, Wolfgang HÄUSLER, Erich LESSING. Judaica, die Sammlung Berger, Kult und Kultur des europäischen Judentums.

Adya Chanran Raj BHANDARY. The Coronation Book of their Majesties of Nepal.

Jamila Brij BHUSHAN. Indian Jewellery, Ornaments and Decorative Designs.

Daniel P. BIEBUYCK & Nelly van den ABBEELE. The Power of Headdresses.

Heinz BIEHN. Alle Kronen dieser Welt.

Heinz BIEHN. Die Kronen Europas.

Heinz BIEHN. Juwelen und Preziosen.

A. J. BIK. Dagverhaal eener reis gedaan in 1824 tot nadere verkenning der eilanden Keffing, Goram, Groot-en Klein kei en de Aroe-eilanden.

BINTANG djaoeh. Huldeblijk van den Sultan van Koetei.

George G. BLAKEY. The Diamond.

Gudmund BLOESEN. Danmarks Riges Regalier.

Carl BOCK. The head-hunters of Borneo.

Ernle BRADFORD. Four Centuries of European Jewellery.

Bea BROMMER. Reizen door Oost-Indië; prenten en verhalen uit den 19de eeuw.

K.P.H. BRONGTODININGRAT. The Royal Palace, (Kraton) of Yogyakarta, its architecture and its meaning.

Sylvia BROOK. Ranee of Sarawak: Queen of the Headhunters.

René BRUS.

Arts of Asia:

Jan|Feb 1981; The Sacred Regalia of Perak

Jul|Aug 1984; Family Portraits, A Rana Album Chronicle

Nov|Dec 1984; Sacred Heirlooms, the Regalia of Yogyakarta and Paku Alam

Sep|Oct 1985; The Royal Regalia of Thailand

Jan|Feb 1988; Wedding Jewellery in Malaysia

Nov|Dec 1989; Gems of the Orient, Diamonds and Pearls

Jul|Aug 1989; Crowns in Asia

African Arts, Summer 1975; Ethiopian Crowns

The Antique Collector, June 1989; The Coronation of King William III and Queen Mary II

Jewel, Winter 1988; Coronation in the Land of Lightning

Diamond World Review, January/February 1989; The Hidden Bandjermasin Diamond

Diamond World Review, May/June 1987; The Crown Jewels of Southeast Asia

Wings of Gold, Volume 10, Number 2, 1984; Puja Umur

Wings of Gold, March 1988; Treasures of Mother Earth

Spiegel Historiael, Januari 1976; Kroning in een Himalayarijk

Plasir de France, Février 1976 ; Les Couronnes du Roi des Rois

Orion, Maart/April 1984 ; Het Sultanaat Yogyakarta

Orion, 1985; Diamanten uit Kalimantan

The Monarchist, February 1987; The Installation of the Sultan of Perak

Kronen van de Wereld

De Juwelen van het Huis Oranje-Nassau

Colonel Sir Thomas BUTLER. The Crown Jewels and Coronation Ceremony.

C

Jeanny Vorys CANBY. The Ancient Near East in The Walters Art Gallery.

Una CAMPBELL. Robes of the Realm, 300 Years of Ceremonial Dress.

Hatje CANTZ. Schmuck, kostbarkeiten aus Afrika, Asian, Ozeanien und Amerika.

Margret CAREY. Beads and Beadwork of East and South Africa.

Arnaud CHAFFANJON. La merveilleuse histoire des couronnes du monde.

CHEO Kim Ban. A Baba Wedding.

Edmond CHIN. Guilding the Phoenix, the Straits Chinese and their jewellery.

Lucas CHIN. Cultural heritage of Sarawak.

David CH'MG. Malay Silver, Arts of Asia march-april 1986.

H.J.M. CLAESSEN. Van Vorsten en Volken.

W.D. COLLIER. The Scottish Regalia.

Derek J. CONTENT. Glyptic Arts-Ancient Jewelry; an annotated bibliography.

William el CONZELMAN. Chronique de Galâwdêwos, roi d'Ethiopie.

Dr. H.E. COOMANS & René BRUS. Parels en Parelmoer.

Leonard COTTRELL. The Secret of Tutankhamen.

D

Memoires of the DALAI LAMA of Tibet. My Land and My People.

Prince DAMRONG. Selected papers.

Jo-Anne Birnie DANZKER. Art Nouveau Buckles, the Kreuzer Collection.

Cyril DAVENPORT. Jewellery.

Basil DAVIDSON. Africa, history of a Continent.

C. DESROCHES-NOBLECOURT. Toetanchamon.

Prince DHANI NIVAT. Collected Articles.

Joan Younger DICKINSON. The Book of Diamonds.

Frederick J. DOCKSTADER. L'Art Indien de l''Amérique du Sud.

Jean DORESSE. l'Ethiopie.

Lois Sherr DUBIN. The History of Beads from 30.000 BC to the Present.

E

Prof. J.C. van EERDE. De Volken van Nederlandsch Indië.
Jacob EGHAREVBA. A Short History of Benin.
Kit ELLIOT. Benin.
M. G. EMEIS Jr.. Bonebakker 1792-1967.
John EVANS. A History of Jewellery 1100-1870.

F

William FAGG. Yoruba Beadwork, Art of Nigeria.
Richard FALKINER. Investing in antique jewellery.
Christian F.FEEST. Noord-Amerikaanse indianen, cultuur en levenswijze.
Jean FERAY. Saint-Denis, le trésor de l'abbaye.
Leslie FIELD. The Queen's jewels; the personal collection of Elizabeth II.
Herman FILLITZ. The Crown Jewels and the Ecclesiastical Treasure Chamber, Vienna.
Herman FILLITZ. Die Österreichische Kaiserkrone.
Herman FILLITZ. Die Schatzkammer in Wien.
J. FILLIOZAT & P. Z. PATTABIRAMIN. Parures Divines du Sud de l'Inde.
William FISH. Royal Installation, New Straits Times Annual 1959.
H.W. FISCHER. Catalogue van 's Rijks Ethnographisch Museum.
Eberhard FISCHER and Hans HIMMELHEBER. Das Gold in der Kunst Westafrikas.
Ruth FISCHER. Twilight Tales of the Black Baganda.
Werner FLEISCHHAUER. Kunstkammer und Kronjuwelen.
Compte FLEURY. Memoires of the Empress Eugénie.
Margaret FLOWER. Victorian Jewellery.
Történelmi FORRASOK. A Korona Kilenc évszázada.
F.Chr.van FRAASEN. Ternate, de Molukken en de Indonesische Archipel.
Douglas FRASER & Herbert M.COLE. African Art & Leadership.
Claude FREGNAC. Jewellery from the Renaissance to Art Nouveau.

G

Danielle GABORIT-CHOPIN. Regalia, les Insdtrument du Sacre des Rois de France.
Axel Freiherr von GAGERN & Hans-Joachim KOLOSS & Wulf LOHSE. Ostafrika, Figure und Ornment.
Paul GALLICO. Coronation.
Miguel Mujica GALLO. The Gold of Peru.
M.H.GANS. Juwelen en Mensen.
Bamber GASCOIGNE. De Groot Mogols.
Haags GEMEENTEMUSEUM. Kunstbezit Parkstraatkerk.
Charlotte GERE and Geoffrey C.MUNN. Artists' Jewellery, pre-raphaelite to Arts and Crafts.
Charlotte GERE and John CULME with William SUMMERS. Garrard The Crown Jewellers for 150 years.
GHULAM-Sawar Yousof. Dictionary of traditional South-east Asian theatre.
Isabel da Silveira GODINHO. Jóias do Quotidiano da Família Real.
Isabel da Silveira GODINHO. Tesouros Reais.
Vitold de GOLISH. Splendeur et Crépuscule des Maharajahs.
Olga W.GOREWA & Irina F.POLYNINA & Alfons RAIMANN. Die Schatzkammer der Sowjetunion.
Dr.H.J.de GRAAF. Over de Kroon van Madja-Pait, Bijdragen tot de Taal-Land-en Volkenkunde, part 104, 1947/48.
Charles John GRIFFITHS. A narrative of the Siege of Delhi.
Marianne GROEN-VAN ANDEL. Gesneden Stenen.
J.GRONEMAN. De Garebeg's te Ngajogyakarta.
Gianni GUADALUPI. Goud, Zilver en Juwelen.
J.M.GULLICK. A survey of Malay weavers and silversmiths in Kelantan in 1951.

H

Géza von HABSBURG & Marina LOPATO. Fabergé: Imperial Jeweller.
Zillah HALLES. Coronation Costume 1685-1953.
HAN Suyin. Llasa, the Open City.

B.Ph. van HARINXMA THOE SLOOTEN. Dwars foor Abessinië.
Norman HARTNELL. Silver and Gold.
Christopher HARTOP. Royal Goldsmiths: The Art of Rundell & Bridge 1797-1843.
Ernst & Jean HEINIGER. The Great Book of Jewels.
M.HEINS & F.J.M.van MAANEN. De geschiedenis van het rijk Ngayogyakarto Hadiningrat en de symboliek van de kraton Ngayogyakarto Hadiningrat.
Sue HEADY. Jewels.
A.H.HILL. Kelantan Silverwork, Imbras vol.24.no.1.1951.
A.H.HILL. The Keris and other Malay Weapons, Journal of the Malaysian Branch of the Royal Asiatic Society 1956 .
Peter HINKS. Viktorianischer Schmuck.
HO Wing Meng. Straits Chinese Silver, a collector's guide.
Martin HOLMES. The Crown Jewels in the Wakefield Tower at the Tower of London.
Martin HOLMES & Major-General H.D.W.SITWELL. The English Regalia.
Martin HOLMES. The Crown Jewels.
D.C.HOLTOM. The Japanese Enthronement Ceremonies.
Ljuba HORáKOVá. Ceské Korunovacní Klenoty/ Die Böhmischen Krönungskleinodien.
Stephen HOWARTH. The Kon-I-noor Diamond.
Graham HUGHES. Modern Jewelry.
Graham HUGHES. The Art of Jewelry.
Graham HUGHES. Jewelry.

I

Philip Aigbona IGBAFE. Obaseki of Benin.
H.N.IVOR Evans. Malay Arts and Crafts.

J

Beverley JACKSON. Kingfisher Blue, treasures of an ancient Chinese art.
J.P.JASPER & Mas PIRNGADIE. De Inlandsche Kunstnijverheid in Nederlandsch-Indië, de goud-en zilverkunst.
Bjarne Steen JENSEN. Juvelerne i det Danske Kongehus.
Helen Ibbitson JESSUP. Court Arts of Indonesia.
The Rev.Samuel JOHNSON. The History of the Yorubas.
William JONES. Crowns and Coronations.
Dr.Jane de JONGH & drs.M.KOHNSTAMM. Wilhelmina.

K

W.H.KAL. Old Javanese Gold, an archaeometrical approach.
Mohd.KASSIM Haji Ali. Barang kemas Melayu tradisi.
Mohd.KASSIM Haji Ali. Gold Jewelry and Ornaments of Malaysia.
Manuel KEENE & Salam KAOUKJI. Treasury of the World; jewelled arts of India in the Age of the Mughals.
Teresa Keet. Metals in Malaysia.
K.U.KHAN. King George V.
Rainer KOCH & Patricia STAHL. Wahl und Krönung in Frankfurt.
KHOO Joo Ee. The Straits Chinese.
Kay Kim KHOO. Succession to the Perak Sultanate, IMBRAS, Vol.LVI, Part 2, 1983.
Éva KOVáCS. Romanische Goldschmiedekunst in Ungarn.
Tanin KRAIVIXIEN. His Majesty King Bhumibol Adulyadei.
Laurence S.KRASHES. Harry Winston, the Ultimate Jeweller.
Mary H.KROUT. Hawaii and a Revolution.
Usha R. Bala KRISHNAN. Jewels of the Nizams.
George Johannes KUGLER. Die Reichskrone.
Otoo KUIJK en Bart van VEEN. Sjah van Perzië, Verdiende Kroon.
George Frederick KUNZ and Charles Hugh STEVENSON. The Book of the Pearl, the history, art, science and industry of the Queen of Gems.
Simon KWAN Sun Ji. Chinese Gold Ornaments.
A.A.Y.KYEREMATEN. Panoply of Ghana.

L

Daniel LAINé. Rois d'Afrique.

Parker LESLEY. Renaissance Jewels and Jewelled Objects from the Melvin
 Gutman Collection.

Erika LEUCHTAG. Met Mijn Koning in de Wolken.

Herbert S.LEWIS. A Galla Monarchy.

Simone LIPSCHITZ. De Amsterdamse Diamantbeurs.

W.J.LOFGIE. The Coronation Book of Edward VII.

Marten LOONSTRA. Uit Koninklijk Bezit, Honderd jaar Koninklijk
 Huisarchief :de verzamelingen van de Oranjes.

Frederick LUMLEY. Nigeria, the Land, its Art and its People.

M

John MACK. Madagascar, island of the ancestors.

Bernard MAHIEU. Notre-Dame de Paris.

M.A.MANKINDE. Ile-Ife.

Jean MARçADé. Alte Kunst der Menschheit; Geschmeide.

Brigitte MARQUARDT. Schmuck, realismus und historismus
 1850-1895-Deutschland, Österreich, Schweiz.

Brigitte MARQUARDT. Eisen, Gold und Bunte Steine; Bürgerlicher Schmuck
 zur Zeit des Klassizismus und des Biedermeier Deutschland, Österreich,
 Schweiz.

Brigitte MARQUARDT. Schmuck aus dem Hause Hohenzollern.

Bridadier Kenneth MEARS. The Crown jewels.

MEEN & TUSHINGHAM. Crown Jewels of Iran.

Suzy MENKES. The Royal Jewels.

Prince MICHAEL of Greece. Crown Jewels of Europe.

Harry MILLER. Prince and Premier, a biography of Tunku Abdul Rahman Putra
 Al-Haji, First Prime Minister of the Federation of Malaya.

Anna M.MILLER. Cameos, Old & New.

Michel le MOEL. Le Sacre des Rois de France.

Maggie de MOOR. Gold Jewellery in Nias culture, Arts of Asia July-August 1989.

Maggie de MOOR & Wilhelmina H.KAL. Indonesische Sieraden.

David R.MOORE. Arts and Crafts of Torres Strait.

Bernard MOREL. The French Crown Jewels.

Geoffrey C.MUNN & Charlotte GERE. Artists' Jewellery .

Geoffrey MUNN. Tiaras, Past and Present.

Geoffrey C.MUNN. Tiaras, a history of Splendour.

Roelof MUNNEKE. Van Zilver, Goud en Kornalijn; Turkmeense sieraden uit
 Centraal-Azië.

G.M.MURRAY. Our King and Queen and the Coronation.

Haji MUSTAPHA Albakri. The Regalia of the Yang di-Pertuan Agong, Malaysa in
 History Vol.4, No.1.1958.

N

Hans NADELHOFFER. Cartier; Jewellers Extraordinary.

David NEIL. Our chiefs and elders.

Beverly NICHOLS. The Queen's Coronation.

M.L.NIGAM. Indian Jewellery.

Volkenkundig Museum NUSANTARA. Sieraden en Lichaamsversiering uit
 Indonesië.

J.W.N.NYAKATURA. Anatomy of an African Kingdom, a History of Bunyoro-
 Kitara.

O

G.J.A.OJO. Yoruba Palaces.

Dr.ONG Hean-Tatt. Legend of the Chinese Lung, the Chinese "Dragon".

Leonor d'OREY. Five Centuries of Jewellery; National Museum of Ancient Arts,
 Lisbon.

P

Clare PHILLIPS. Jewelry from Antiquity to the Present.

Clare PHILLIPS. Jewels and Jewellery.

E.D.PHILLIPS. De Koninklijke Horden.

Ivor POWELL. Ndebele, leven tussen kleuren.

R

Fernando RAYóN & José Luis SAMPEDRO. Las joyas de las reinas de España, la
 desconocida historia de las lahajas reales.

Sydney REDWOOD. The Crown jewels and Coronation Chair.

M.A.RHEDE van der Kloot. De gouverneurs-generaal en commissarissen-
 generaal van Nederlandsch-Indië.

Lieutenant General Pitt RIVERS. Antique Works of Art from Benin.

David RODGERS. Coronation Souvenirs and Commemorativces.

Susan RODGERS. Power and Gold, Jewelry from Indonesia, Malaysia and the
 Philippines from the Collection of the Barbier-Mueller Museum, Geneva.

Mehta RUSTAN. Indian Jewellery.

B.A.Rybakov. Treasures in the Kremlin.

S

Bo.S.SAFSTROM. Uppsala Cathedral, a Guide.

Colombe SAMOYAULT-VERLET, Jean-Paul DESROCHES, Gilles BéGUIN &
 Albert le BONHEUR. Le Musée chinois de l'impératrice Eugénie.

Peter SARPONG. The Sacred Stools of the Akan.

Joseph SATALOFF and Alison RICHARDS. The Pleasure of Jewelry and
 Gemstones.

Naria Gabriella di SAVOIA & Stefano PAPI. Gioielli di Casa Savoia.

Diana SCARISBROCK. Ancestral Jewels.

Diana SCARISBRICK. Chaumet, master jewellers since 1780.

Diana SCARISBROCK. Tiaras.

Diana SCARISBRICK. Timeless Tiaras, Chaumet from 1804 to the Present.

F.M.SCHNITGER. Forgotten Kingdoms in Sumatra.

Percy Ernst SCHRAMM. Herrschatszeichen und Staatssymbolik.

Percy Ernst SCHRAMM. A History of the English Coronation.

Datin SELAMAH binti Ambak & Dato Haji Abdul Rahman bin Mohd Yassin.
 Justar di-Raja; a Royal Bridgegroom's headdress from Johore, Malaysa in
 History, 1964.

Timothy SEVERIN. Afrikaans Avontuur, vier eeuwen ontdekkingsreizen.

Rita Devi SHARMA and M.VARADARAJAN. Handcrafted Indian Enamel
 Jewellery.

Mubin SHEPPARD. Taman Indera, Malay Decorative Arts and Pasttimes.

Durga Bahadur SHRESTHA & Chandra Bir KANSAKAR. The History of
 Modern Nepal.

Attila L.SIMONTSITS. The Last Battle for St.Stephen's Crown; a documentary
 presentation of the Holy Crown of Hungary.

K.de SMET. The Great Blue Diamond.

Reinhart STAATS. Die Reichskrone.

Mr.M.L.STIBBE. Edelsteen en Mens.

Ludwig F.STILLER. The Rise of the House of Gorkha.

E.W.STREETER. The Great Diamonds of the World.

Patrick STREETER. Streeter of Bond Street, a Victorian jeweller.

G.T.STRIDE & C.IFEAK. Peoples and Empires of West Africa.

W.F.STUTTERHEIM. Het Hinduisme in den Archipel.

Frank SWELLENGREBEL. Een Vorstenwijding op Bali.

Fran SWETTENHAM. British Malaya.

J.B.TAVENIER, baron d'Aubonne. De zes reizen naar Rurkijen, Persien en d'Idien
 langs alle de wegen, die derwaarts strekken.

T

J.TADEMA SPORRY. De Geschiedenis van China.

Ken TEAGUE. Metalcrafts of Central Asia.

Hans THOMA. Kronen und Kleinodien.

Hans THOMA. Schatzkammer der Residenz München.

Ulla TILLANDER-GODENHIELM. smycken, från det keiserliga S:t Petersburg.

Émile TILMANS. Le Bijou.

J.W.TUFUO & C.E.DONKER. Ashantis of Ghana.

Lord TWINING. European Regalia.
Lord TIWNING. A History of the Crown Jewels of Europe.

V

Christophe VACHAUDEZ. Koninklijke Juwelen van de koninginnen en
 prinsessen van België.
Jermias van VLIET. The Short History of the Kings of Siam.
Drs.H.B.VOS. Kratonkoetsen op Java.
Arthur VOYCE. The Moscow Kremlin.
Ivanka VRTOVEC. Croatian National Jewelry.
Edwald VANVUGHT. De schatten van Lombok.

W

H.G.Quartich WALES. Siamese State Ceremonies and their History and
 Function.
Jan WALGRAVE. Het Versierde Ego, het Kunstjuweel in de 20ste eeuw.
Anton WALTER. Die Wiener Schatzkammer.
Oliver WARNER. The Crown Jewels.
Rita WASSING-VISSER. Sieraden en Lichaamsversieringen uit Indonesië.
Rita WASSING-VISSER. Koninklijke Geschenken uit Indonesië, historische
 banden met het Huis Oranje-Nassau 1600-1938.
Joachim WERNER. Zur Chronologie der frühsilla-zeitlichen Gräber in Süd
 Korea.
George O.WILD en J.M.VISSER. Edelstenen en Hoe ze te Herkennen.
C.A.S.WILLIAMS. Outlines of Chinese Symbolism & Art Motives.
Mab WILSON. Gems.
Sir Leonrrard WOOLEY. Excavations at Ur.
Linda WRIGGLESWORTH. Imperial Wardrobe .

Y

Yigael YADIN. Bar Kochba, de herontdekking van de legendarische held van de
 laatste joodse opstand tegen het Romeinse keizerrijk.
George YOUNGHUSBAND & Cyril DAVENPORT. The Crown jewels of
 England.

Z

Prof.Dr.J.ZANDEE. De Schatten van Egypte.
Herbert S.ZIM & Paul R.SHAFFER. Gesteenten en Mineralen.

Exhibition catalogues

Schatten van de Tsaar, hofcultuur van Peter de Grote uit het Kremlin; Museum
 Boymans-van Beunungen Rotterdam 10.12.1995-4.2.1996.
Treasures of Ancient Indonesian Kingdoms; Tokyo National Museum 1997.
Precious Gems, jewellery from eight centuries; Nationalmuseum, Stockholm
 9.6-15.10.2000.
Jewellery from Renaissance to Art Déco 1540-1940; Tokyo, Fukuoka, Nagoya and
 Kyoto 2003.
Die Braut, Geliebt, verkauft, getauscht, geraubt; zur Rolle der Frau im
 Kulturvergleich; Rautenstrauch-Joest-Museums für Völkerkunde, Köln 26.6-
 13.10.1985.
Masterpieces of Chinese Miniature Crafts in the National Palace Museum, Taipei,
 1971.
Masterpieces of Chinese Tibetan Buddhist Altar Fittings in the National Palace
 Museum, Taipei, 1971.
Sieraden en Lichaamsversieringen uit Indonesië; Volkenkundig Museum
 Nusantara, Delft, 1984.
Een Eeuw van Schittering, diamantjuwelen uit de 17de eeuw/ A Sparkling Age,
 17th-century diamond jewellery, Diamantmuseum Antwerpen, 1993.
Ethnic Jewellery from Africa, Asia and Pacific Islands, the René van der Star
 Collection; The Rotterdam Kunsthal, 2002.
Cartier, Splendeurs de la Joaillerie; 1996.

Princely Magnificence, court jewels of the Renaissance, 1500-1630; Victoria and
 Albert Museum 15.10.1980-1.2.1981.
One Hundred Tiaras, an evolution of Style 1800-1990, Wartski, London,
 5-19.3.1997.
Dix siècles de joaillerie française ; Louvre Museum, Paris, 3.5-3.6.1962.
Sieraden en Lichaamsversiering uit Indonesië, Volkenkundig Museum
 Nusantara, Delft; 1984.
Stralende Sterren, de huwelijksdiadeem van Prinses Maxima/Shining Stars:
 Princess Maxima's Bridal Tiara/ 21 Tiaras for Maxima; Museum Het
 Kruithuis, 's Hertogenbosch, 2002.
Sieraad Symbool Signaal/ The Jewel-Sign and Symbol; Koningin Fabiolazaal,
 Antwerp, 9.6-15.10.1995.
Een Vorsterlijk Imago, het beeld van de heerser sedert Antoon van Dyck/ A Royal
 Image, the image of the sovereign since Sir Anthony van Dyck; Koningin
 Fabiolazaal, Antwerp, 25.6-17.10.1999.
Pariser Schmuck, vom Zweiten Kaiserreich zur Belle Epoque; Bayerischen
 Nationalmuseums, München, 1.12.1989-4.3.1990.

Other publications

Garrard's 1721-1911, Crown Jewellers and Goldsmiths during Six Reigns and in
 Three Centuries; Stanley Paul & Co., 31 Essex Street, WC, London.
Weltliche und Geistliche Schatzmakker, Wien.
Smycken för Drottninger, Stockholm.
Skattkammaren pa Stockholms Slott.
Kroninger og Regalier, Nidaros Domkirkes.
Rosenborj, The Royal Danis Collection.
Coronation in Teheran, Burda Druck.
The Coronation Album HM Queen Elizabeth II.
Golden Book of the Coronation.
The Coronation of Her Majesty Queen Elizabeth II, the Form and Order of the
 Service, 2 June 1953.
The Coronation of King George VI and Queen Elizabeth.
Images of Power, Benin, Art of the Royal Court of Benin.
National Museum of Ghana Handbook.
Aturcara Rsami Sultan Petra of Kelantan 1.4.1982.
Coronation celebrations of His Royal Highness Tuanku Ismail Petra ibni Al-
 Marhum Sultan Yahya Petra, Sultan of Kelantan, 30.3.1980.
Gids voor den bezoeken van de Schatkamer, Bataviaasch Genootschap van
 Kunsten en Wetenschappen 1917.
Hari Keputeraan Sultan Salahuddin Abdul Aziz Shah of Selangor 10.3.1970.
Istiadat Perkahwinan diRaja Tengku Ibrahim Petra of Kelantan & Tengku Mujaini
 of Pahang, June 1981.
Jubileumuitgave i.v.m. het 60-jarig bestaan van de Fabriek van Gouden en
 Zilveren Werken van J.M.van Kempen & Zxoonen, 1896.
Lawatan di Raja Sultan Ismail of Johor, 23.12.1979.
Nederlandsch-Indie Oud en Nieuw – De sultan van Boeloengan, 8e jrg.Sept.1923.
Pertabalan Kebawah Duli Yang Maha Mulia Sultan Pahang, 8.5.1975.
The Illustrated London News Coronation Record Number 1937.
The Illustrated London News Coronation Number Queen Elizabeth II 1953.
Commemorative volume of "Support" published in regard with the 60th birthday
 of Her Majesty Queen Sirikit of Thailand